Art and the Human Experience

ART

A Global Pursuit

Teacher's Edition

Acknowledgments

Authors

Marilyn G. Stewart is professor of Art Education at Kutztown University in Kutztown, Pennsylvania, where she teaches courses in art criticism, aesthetics, and art education. She was the 1997–1998 Visiting Scholar with the Getty Education Institute for the Arts. Known for her ability to translate difficult art education concepts into practical, inquiry-based activities for the classroom, Marilyn is General Editor of the *Art Education in Practice* series (Davis Publications), and author of *Thinking Through Aesthetics*, one title in the series. Dr. Stewart is a frequent keynote speaker at meetings and seminars around the country, and serves as a consultant in a variety of national curriculum development and assessment projects.

Eldon Katter is editor of *SchoolArts* and was president of the National Art Education Association from 1999–2001. He was a professor of art education at Kutztown University for twenty-five years, retiring in 1997. He has taught at the elementary and secondary levels in Illinois, Pennsylvania, and Massachusetts. As a Peace Corps volunteer in the 1960s, Eldon taught art at the Teacher Training Institute in Harar, Ethiopia. He later became an education officer in the Ministry of Education in Kampala, Uganda, while working on the Teacher Education for East Africa Project at Teachers College, Columbia University. Eldon continues to serve as a consultant for school districts on staff and curriculum development and to exhibit his handmade paper works in juried art shows.

Contributing Author

Kaye Passmore is the art teacher at Notre Dame Academy in Worcester, Massachusetts. She is the visual arts director for the Notre Dame Academy Summer Arts Institute (grades 3–10) and an adjunct faculty member in Lesley College's national Creative Arts in Learning Master of Education program. She has been an educational media consultant and junior high art teacher in Texas, and has taught Educational Media Production at Boise State University in Idaho.

Editorial Consultants

Kathleen Blum, Director, Southeast Institute for Education in Theatre, The Southeast Center for Education in the Arts, University of Tennessee at Chattanooga

Lee Harris, Assistant Professor of Music Education, University of Tennessee at Chattanooga

Laurie Krueger, Special Needs Teacher, Northborough Middle School, Northborough, Massachusetts

Donna Pauler, MacLady, Austin, Texas

Abby Remer, A.R. Arts and Cultural Programs, New York, New York

Ann Rowson, Director, Southeast Institute for Education in the Visual Arts, The Southeast Center for Education in the Arts, University of Tennessee at Chattanooga

Sharon Seim, Education Consultant, Bellevue, Nebraska

Nancy Walkup, Project Coordinator, North Texas Institute for Educators on the Visual Arts, University of North Texas, Denton, Texas

Diana Woodruff, Art Supervisor, Acton-Boxborough Public Schools, Acton, Massachusetts

Educational Consultants

Louisa Brown, Atlanta International School, Atlanta, Georgia

Monica Brown, Laurel Nokomis School, Nokomis, Florida

Doris Cormier, Turkey Hill Middle School, Lunenburg, Massachusetts

Cappie Dobyns, Sweetwater Middle School, Sweetwater, Texas

Reginald Fatherly, Andrew G. Curtin Middle School, Williamsport, Pennsylvania

Donna Foeldvari, Reading-Fleming Middle School, Flemington, New Jersey

Diane Fogler, Copeland Middle School, Rockaway, New Jersey

Carolyn Freese, Yorkville Middle School, Yorkville, Illinois

Cathy Gersich, Fairhaven Middle School, Bellingham, Washington

Connie Heavey, Plum Grove Junior High School, Rolling Meadows, Illinois

Darya Kuruna, McGrath School, Worcester, Massachusetts

Mary Ann Horton, Camel's Hump Middle School, Richmond, Vermont

Craig Kaufman, Andrew G. Curtin Middle School, Williamsport, Pennsylvania

Bunki Kramer, Los Cerros Middle School, Danville, California

Karen Lintner, Mount Nittany Middle School, State College, Pennsylvania

Betsy Logan, Samford Middle School, Auburn, Alabama

Sallye Mahan-Cox, Hayfield Secondary School, Alexandria, Virginia

Patti Mann, T. R. Smedberg Middle School, Sacramento, California

Karen Miura, Kalakaua Middle School, Honolulu, Hawaii

Deborah A. Myers, Colony Middle School, Palmer, Alaska

Gary Paul, Horace Mann Middle School, Franklin, Massachusetts

Lorraine Pflaumer, Thomas Metcalf School, Normal, Illinois

Sandy Ray, Johnakin Middle School, Marion, South Carolina

Amy Richard, Daniel Boone Middle School, Birdsboro, Pennsylvania

Connie Richards, William Byrd Middle School, Vinton, Virginia

Katherine Richards, Bird Middle School, Walpole, Massachusetts

Susan Rushin, Pocono Mountain Intermediate School South, Swiftwater, Pennsylvania

Roger Shule, Antioch Upper Grade, Antioch, Illinois

Betsy Menson Sio, Jordan-Elbridge Middle School, Jordan, New York

Karen Skophammer, Manson Northwest Webster Community School, Barnum, Iowa

Evelyn Sonnichsen, Plymouth Middle School, Maple Grove, Minnesota

Ann Titus, Central Middle School, Galveston, Texas

Sindee Viano, Avery Coonley School, Downers Grove, Illinois

Karen Watson-Newlin, Verona Area Middle School, Verona, Wisconsin

Shirley W. Whitesides, Asheville Middle School, Asheville, North Carolina

Frankie Worrell, Johnakin Middle School, Marion, South Carolina

Printed in U.S.A.
ISBN: 0-87192-490-0
10 9 8 7 6 5 4 3 2 1 BC 05 04 03 02 01

Teacher's Edition Contents

1

Art History Lessons

Short on time, but long for history?
These lessons extend the CORE with added historical insight. Together, these interrelated lessons provide a chronological study of **Western Art History.**

1.1 Art of the Ancient World

2.1 The Art of Three Empires

3.1 Art of the Medieval World

4.1 The Art of the Renaissance

5.1 European Art: 1600–1750

6.1 European Art: 1750–1875

7.1 European Art: 1875–1900

8.1 European Art: 1900–1950

9.1 Art Since 1950

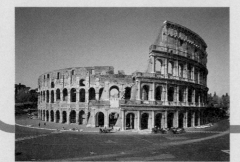

Foundations

Begin with a sound foundation in art education. These chapters set the stage for a comprehensive art program or they can serve as a course in themselves.

C O

A thematic approach. Providing a comprehensive overview of the topic, these lessons **explore art's universal themes.**

Core Lessons

1 Messages in Art

2 The Art of Special Groups

3 Understanding Art's Lessons

4 Organizing Artworks

5 Art and Daily Life

6 Telling About Places

7 Art Connects with Nature

8 Continuity and Change in the Art World

9 Expanding the Possibilities of Art

2

Elements & Principles Lessons

Focus on the building blocks of art!
Individually these lessons reinforce the theme with an exploration of the elements and principles of design. Combined, these design lessons provide an overview of **the building blocks of art.**

1.2 Line and Pattern

2.2 Texture and Rhythm

3.2 Shape and Balance

4.2 Unity and Variety

5.2 Light, Value, and Contrast

6.2 Space and Emphasis

7.2 Color

8.2 Shape and Form

9.2 Proportion and Scale

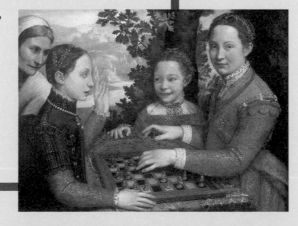

For a comprehensive art education, teach each theme with its CORE lesson and four follow-up lessons. Or, choose a series of lessons that match your interests and your schedule.

F1 The Whys and Hows of Art
F2 Forms and Media
F3 Elements and Principles of Design
F4 Approaches to Art

R E

Create more with the CORE. In addition to concluding the CORE lesson, these art activities **add to your bank of studio opportunities.**

Core Studios

1 Creating Your Own Message

2 Sculpting Your Identity

3 Teaching Triptychs

4 Organizing a Sculpture

5 A Still-Life Painting

6 Creating a Place for Thought

7 Nature in Relief

8 Making an Assemblage

9 Making a Painting/Sculpture

3

Global View Lessons

Tour world cultures past and present.
While supporting the CORE with a global viewpoint, these lessons also collaborate to provide **a multicultural art education**.

1.3 The Art of African Kingdoms

2.3 Native North American Art

3.3 The Art of India

4.3 The Art of China and Korea

5.3 The Art of Latin America

6.3 Oceanic Art

7.3 The Art of Japan

8.3 The Art of Southeast Asia

9.3 Global Possibilities

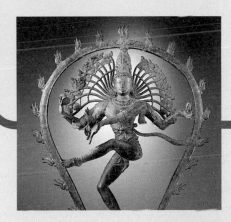

4

Studio Lessons

Make the most with hands-on learning.
Each studio lesson caps off the theme with a summarizing hands-on experience. Together, these activities provide **a bank of art activities that explore a range of media and techniques.**

1.4 Making a Bas-Relief

2.4 Drawing Architectural Forms

3.4 Creating a Folded Box of Lessons

4.4 Drawing in Perspective

5.4 Decorating a Container

6.4 Stitching an Artwork

7.4 Making a Paper Relief Sculpture

8.4 Creating a Montage

9.4 Making a Book

Chapter Organizer

At-a-glance chapter organizers help you teach as much — or as little — as you wish. Teach the entire theme or just a single lesson. Plan for an individual, a small group, or an entire class. This easy-to-use chart allows you to scan the entire chapter and select the topics, activities, and extensions that match your course structure.

Clear lesson objectives and correlations to the **National Visual Arts Standards** are provided both at the *chapter and lesson levels*.

This **quick-check pacing chart** helps you modify lesson plans to meet your individual time constraints.
Choose from:
- nine-week course
- one semester course
- two-semester course

Highlighting the **studio opportunities** that extend each lesson allows you to plan ahead.

This list of **Featured Artists** helps you quickly review the diverse artists whose works are profiled in the chapter. *An artist profile and pronunciation guide are provided in the back of the Teacher's Edition*

This **Vocabulary** list highlights the key terms taught in each chapter.

1 Messages

Chapter Organizer

Chapter 1 Messages
Chapter 1 Overview
pages 68–69

Chapter Focus
- **Core** Art helps people communicate stories, lessons, important ideas, and feelings.
- **1.1** Art of the Ancient World
- **1.2** Line and Pattern
- **1.3** Art of Africa
- **1.4** Making a Bas-relief

Chapter National Standards
2 Use knowledge of structures and functions.
4 Understand arts in relation to history and cultures.
5 Assess own and others' work.

Featured Artists
Kenneth B. Haas, III
Käthe Kollwitz
Jacob Lawrence
William Lishman
Sa'di
Rand Shiltz

Chapter Vocabulary
bas-relief
contour lines
cultural meaning
cuneiform
line
narrative
pattern
stele
symbol

Lesson
Messages in Art
One 45-minute

Objectives
- Use examples to explain the statement "Art sends messages."
- Describe artworks' features that convey messages.

National Standards
5b Analyze contemporary, historical meaning through inquiry.

Your Own
- Use line and pattern to create a message about contemporary life.

1a Select/analyze media, techniques, processes, reflect.

Teaching Options
Teaching Through Inquiry
More About...Käthe Kollwitz
More About...Jacob Lawrence
Meeting Individual Needs
Using the Overhead
Using the Large Reproduction

Technology
CD-ROM Connection
e-Gallery

Resources
Teacher's Resource Binder
Thoughts About Art:
1 Core
A Closer Look. 1 Core
Find Out More: 1 Core
Studio Master: 1 Core
Assessment Master:
1 Core

Large Reproduction 1
Overhead Transparency 2
Slides 1a, 1b, 1c

Teacher's Resource Binder
Studio Reflection: 1 Core

Lesson 1.1

Objectives
- Explain how people in ancient times communicated through their art.
- Describe the subject matter in selected artworks of the ancient world.

minute

National Standards
4a Compare artworks of various eras, cultures.

Teaching Options
Meeting Individual Needs
Teaching Through Inquiry
More About...Why people draw
More About...Blind contour drawing
Assessment Options

Technology
CD-ROM Connection
Student Gallery

Resources
Teacher's Resource Binder
Names to Know: 1.1
A Closer Look: 1.1
Map: 1.1
Find Out More: 1.1
Assessment Master: 1.1

Overhead Transparency 1
Slides 1d

- Communicate movement and action of the human figure through gesture drawing

2b Employ/analyze effectiveness of organizational structures

Teaching Options
Teaching Through Inquiry
More About...Radiocarbon dating
Using the Overhead

Technology
CD-ROM Connection
e-Gallery

Teacher's Resource Binder
Check Your Work: 1.1

Objectives
- Describe qualities of line and pattern in artworks and explain how these elements are used to communicate messages

National Standards
2c Select, use structures, functions.

Teaching Options
Meeting Individual Needs
Teaching Through Inquiry
More About...Gesture Exercises
Assessment Options

Technology
CD-ROM Connection
Student Gallery

- Use line and pattern to decorate a CD label or book cover that conveys information about the contents.

2c Select, use structures, functions.

Teaching Options
Teaching Through Inquiry
Using the Overhead
Assessment Options

Technology
CD-ROM Connection
e-Gallery

Resources
Teacher's Resource Binder
Finder Cards: 1.2
A Closer Look: 1.2
Find Out More: 1.2
Assessment Master: 1.2

Overhead Transparency 1

CD-ROM Connection
Student Gallery

Teacher's Resource Binder
Check Your Work: 1.2

T68b

T68d

Are your art classes cutting-edge? There are a **rich assortment of technology components** that support each lesson.

The **wealth of additional resources** that support each chapter are listed at point-of-use. *For a complete description of these resources see pages T12–T13.*

Lesson Highlights

Point-of-use wrap-around support organizes your teaching strategies and highlights teaching options. The gray side margins provide step-by-step lesson plans that focus in on the the book's narrative and artwork. The gold band across the bottom highlights teaching options that take you beyond the text.

A sensible 3-step lesson plan keeps you on track and on time.

1

Prepare outlines:
- Pacing Suggestions
- Lesson Objectives
- Key Vocabulary and definitions
- Studio Supplies

2

Teach presents strategies for:
- Engaging Students
- Using the Text
- Using the Art
- Extending the Lesson
- Critical Thinking

Correlations to the **National Visual Arts Standards** are provided at the lesson level.

Reduced **facsimile pages of the student book** allow you to see exactly what your students see.

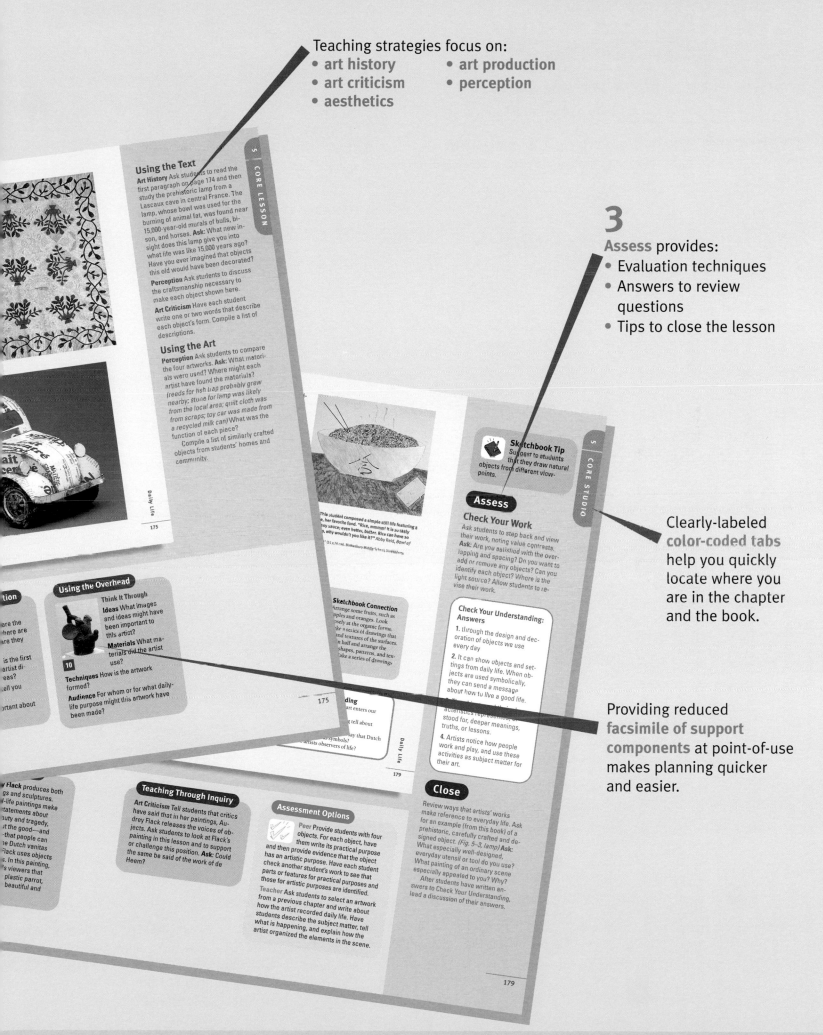

Teaching strategies focus on:
- art history
- art criticism
- aesthetics
- art production
- perception

3

Assess provides:
- Evaluation techniques
- Answers to review questions
- Tips to close the lesson

Clearly-labeled **color-coded tabs** help you quickly locate where you are in the chapter and the book.

Providing reduced **facsimile of support components** at point-of-use makes planning quicker and easier.

Studio Lesson

Step-by-step instructions guide you through a wealth of studio opportunities. Safety issues, assessment strategies, studio supplies, and classroom organization present unique challenges for art instructors. This wrap-around lesson support addresses these unique demands providing practical tips and sensible solutions when and where you need them.

The **Studio Experience** is a concise **step-by-step walk through** of the studio activity.

Idea Generators are a series of prompting questions that encourage **critical reflection** and **creative problem solving.**

Practical pacing strategies chronicle each stage of the studio project.

In addition to organizing **inexpensive, readily-available supplies,** lesson plans also highlight **alternative materials and techniques.**

Safety Tips alert studio teachers to precautions they may want to consider as well as accident-preventing tools and techniques.

Strategies for **meeting individual needs** enhance each student's opportunity for success in the studio.

5.4 Studio Lesson
Decorating a Container

Studio Experience
Have students complete the following steps:

1. Study the shape of your container. Does the shape remind you of anything?

2. Cut out cardboard shapes for extensions such as handles; tape to the main form.

3. Tear newspaper into 1"-to-2"-wide strips.

4. Dip each strip into wheat paste. Squeegee off excess between two fingers.

5. Spread the strip on the form, smoothing out bumps.

6. Cover the form and extensions with five layers. Add a layer of paper towels as a final, smooth surface.

7. Allow to dry overnight or for several days.

8. Paint large areas of color first. Use a finer brush for details.

9. Glue on found objects and textures.

10. Sign the bottom of your container.

Idea Generators
Ask: What are your interests? Do you have a favorite sports team or music group? What do you do after school?

Studio Tips
- Have several students...
large cont...

5.4 Studio Lesson
Decorating a Container

Prepare

Pacing
Three or four 45-minute class periods: one to introduce and build armature, one to papier-mâché, one to paint, and one to add final touches

Objectives
- Describe details and features of functional and decorative objects.
- Distinguish between Rococo and pre-Columbian decorative styles.
- Embellish a functional container with papier-mâché to express something about daily life.

Supplies
- wheat paste: mix water with powder, stirring constantly until thick and creamy; store up to several days in covered containers; thin with water as necessary
- alternative to wheat paste: diluted white school glue (dries faster)
- clear acrylic or varnish, to protect tempera-painted forms

Safety Note
Commercial wallpaper paste may contain chemicals that are harmful to skin.

National Standards
5.4 Studio Lesson

3b Use subjects, themes, symbols that communicate meaning.
4a Compare artworks of various eras, cultures.
5a Compare multiple purposes for creating art.

Sculpture in the Studio
Decorating a Container

Adding Meaning to Daily Life

Studio Introduction
Picture your favorite drinking glass, lunchbox, or other container that you use every day. How is it decorated? Is it painted with a design? Were decorations added to its surface? Is the form itself decorative?

Now think about other things you see in your daily life: furniture, lamps, linens, dinnerware. Cultures all over the world decorate objects like these. Many objects are simply patterned, while others appear complicated and overdone. Some are not decorated at all.

In this studio lesson, you will decorate an everyday container. Pages 192 and 193 will tell you how to do it. The features and decorations you add to the container should express something about your daily life.

Studio Background

Decorating for Daily Life
The Rococo art style, which started in eighteenth-century France, is known for its extreme amount of detail. Porcelain pieces (Figs. 5–29 and 5–30) from this period are highly decorated and playful. You might think that Rococo artists "went overboard" with intricate detail, but the ornate style was an expression of a new lighthearted spirit in Europe.

Pre-Columbian vessels and sculpture contrast sharply with the delicate forms and pastel colors of Rococo objects. Pottery form the pre-Columbian period (Fig. 5–27) is fairly plain and is decorated with simple, often geometric, shapes that resemble symbols. Its colors are usually soft and dull. Most pre-Columbian objects that have lasted to the present had ceremonial uses. They generally have a more serious tone than Rococo objects.

Fig. 5–37 Stirrup vessels have a hollow handle and spout through which liquid is poured. Many take the form of an animal or human head and are painted with colored clay slips. What might the forms and decorations you see on this vessel represent? What main shapes do you see? Peru (Mochica culture), Stirrup Vessel representing seated ruler with pampas cat, 250–550 AD. Ceramic, 7 1/4" x 7 1/2" (18.4 x 19.1 cm), Kate S. Buckingham Endowment, 1955.2281. Photograph ©1999 The Art Institute of Chicago. All Rights Reserved.

190

Teaching Options

Resources
Teacher's Resource Binder
Studio Master: 5.4
Studio Reflection: 5.4
A Closer Look: 5.4
Find Out More: 5.4
Large Reproduction 9
Overhead Transparency 10
Slides 5f

Meeting Individual Needs
Adaptive Materials Provide large containers. Soften ceramic clay by adding more water, or provide a softer material, such as Model Magic or a sculpting foam.

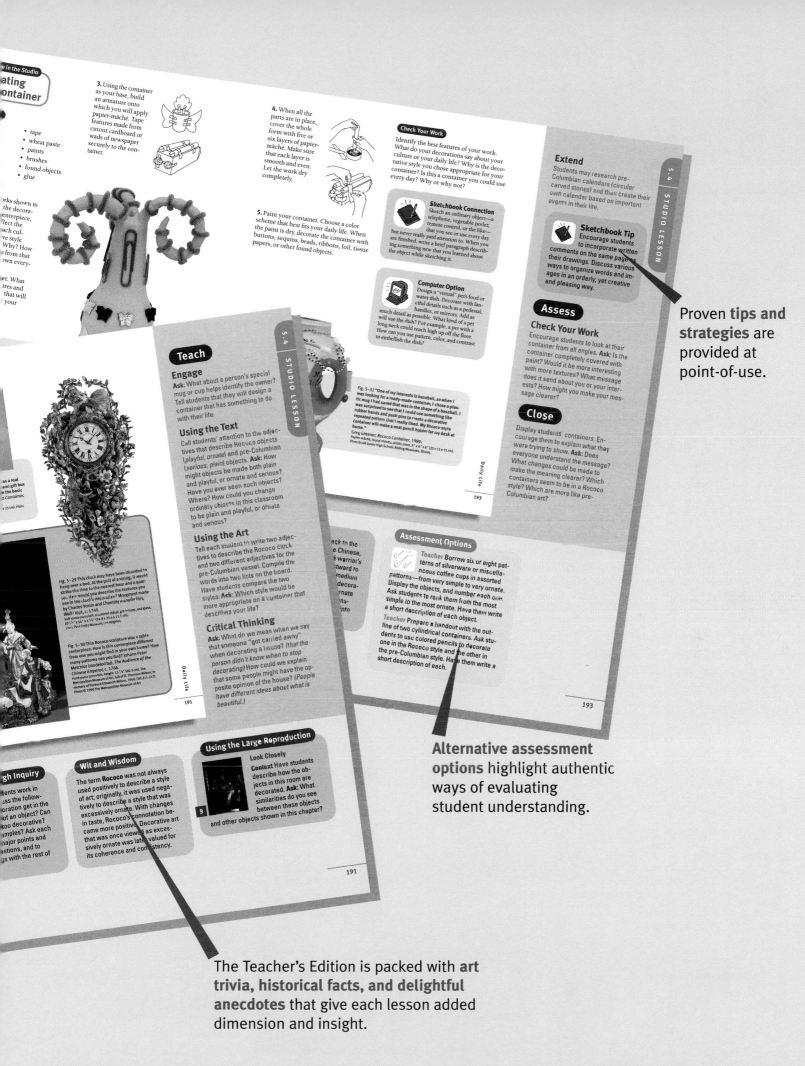

ating
ontainer

- tape
- wheat paste
- paints
- brushes
- found objects
- glue

orks shown in
the decora-
enterpiece,
ect the
ach cul-
ve style
s from that
Why? How
wn every-

er. What
res and
that will
your

3. Using the container as your base, build an armature onto which you will apply papier-mâché. Tape features made from cutout cardboard or wads of newspaper securely to the container.

4. When all the parts are in place, cover the whole form with five or six layers of papier-mâché. Make sure that each layer is smooth and even. Let the work dry completely.

5. Paint your container. Choose a color scheme that best fits your daily life. When the paint is dry, decorate the container with buttons, sequins, beads, ribbons, foil, tissue papers, or other found objects.

Check Your Work

Identify the best features of your work. What do your decorations say about your culture or your daily life? Why is the decorative style you chose appropriate for your container? Is this a container you could use every day? Why or why not?

Sketchbook Connection
Sketch an ordinary object—a telephone, vegetable peeler, remote control, or the like—that you see or use every day but never really paid attention to. When you are finished, write a brief paragraph describing something new that you learned about the object while sketching it.

Computer Option
Design a "virtual" pet's food or water dish. Decorate with fanciful details such as a pedestal, handles, or mirrors. Add as much detail as possible. What kind of a pet will use the dish? For example, a pet with a long neck could reach high up off the floor. How can you use pattern, color, and contrast to embellish the dish?

Fig. 5–32 "One of my interests is baseball, so when I was looking for a ready-made container, I chose a plastic mug I had saved that was in the shape of a baseball. I was surprised to see that I could use something like rubber bands and push pins to create a decorative repeated pattern that I really liked. My Rococo-style container will make a neat pencil holder for my desk at home."
Greg Greener, *Rococo Container*, 1999, Papier-mâché, found objects, acrylic paint, 8" x 6" x 6" (20 x 15 x 15 cm), Plum Grove Junior High School, Rolling Meadows, Illinois.

Extend
Students may research pre-Columbian calendars (circular carved stones) and then create their own calendar based on important events in their life.

Sketchbook Tip
Encourage students to incorporate written comments on the same page as their drawings. Discuss various ways to organize words and images in an orderly, yet creative and pleasing way.

Assess

Check Your Work
Encourage students to look at their container from all angles. **Ask:** Is the container completely covered with paint? Would it be more interesting with more textures? What message does it send about you or your interests? How might you make your message clearer?

Close
Display students' containers. Encourage them to explain what they were trying to show. **Ask:** Does everyone understand the message? What changes could be made to make the meaning clearer? Which containers seem to be in a Rococo style? Which are more like pre-Columbian art?

Proven tips and strategies are provided at point-of-use.

Teach

Engage
Ask: What about a person's special mug or cup helps identify the owner? Tell students that they will design a container that has something to do with their life.

Using the Text
Call students' attention to the adjectives that describe Rococo objects (*playful, ornate*) and pre-Columbian (*serious, plain*) objects. **Ask:** How might objects be made both plain and playful, or ornate and serious? Have you ever seen such objects? Where? How could you change ordinary objects in this classroom to be plain and playful, or ornate and serious?

Using the Art
Tell each student to write two adjectives to describe the Rococo clock and two different adjectives for the pre-Columbian vessel. Compile the words into two lists on the board. Have students compare the two styles. **Ask:** Which style would be more appropriate on a container that describes your life?

Critical Thinking
Ask: What do we mean when we say that someone "got carried away" when decorating a house? (that the person didn't know when to stop decorating) How could we explain that some people might have the opposite opinion of the house? (People have different ideas about what is beautiful.)

Fig. 5–29 This clock may have been intended to hang over a bed. At the pull of a string, it would strike the time to the nearest hour and a quarter. How would you describe the textures you see in the clock's decoration? *Movement* made by Charles Voisin and Chantilly manufactory, *Wall Clock*, c. 1740. Soft-paste porcelain, enameled metal, gilt bronze, and glass, 29 1/4" x 14" x 6 1/4" (74.9 x 35.6 x 11.1 cm), The J. Paul Getty Museum, Los Angeles.

Fig. 5–30 This Rococo sculpture was a table centerpiece. How is this centerpiece different from one you might find in your own home? How many patterns can you find? Johann Peter Melchior (modeled by), *The Audience of the Chinese Emperor*, c. 1766. Hard-paste porcelain, height: 15 7/8" (40.3 cm), The Metropolitan Museum of Art, Gift of R. Thornton Wilson, in memory of Florence Ellsworth Wilson, 1950, (50.211.217) Photo © 1990 The Metropolitan Museum of Art

ack to the
e Chinese,
e warrior's
stward to
medium
decora-
rnate
s
nto

Assessment Options

Teacher Borrow six or eight patterns of silverware or miscellaneous coffee cups in assorted patterns—from very simple to very ornate. Display the objects, and number each one. Ask students to rank them from the most simple to the most ornate. Have them write a short description of each object.

Teacher Prepare a handout with the outline of two cylindrical containers. Ask students to use colored pencils to decorate one in the Rococo style and the other in the pre-Columbian style. Have them write a short description of each.

Alternative assessment options highlight authentic ways of evaluating student understanding.

gh Inquiry

nts work in
ss the follow-
oration get in the
of an object? Can
oo decorative?
amples? Ask each
ajor points and
stions, and to
s with the rest of

Wit and Wisdom
The term **Rococo** was not always used positively to describe a style of art; originally, it was used negatively to describe a style that was excessively ornate. With changes in taste, Rococo's connotation became more positive. Decorative art that was once viewed as excessively ornate was later valued for its coherence and consistency.

Using the Large Reproduction

Look Closely
Context Have students describe how the objects in this room are decorated. **Ask:** What similarities do you see between these objects and other objects shown in this chapter?

The Teacher's Edition is packed with **art trivia, historical facts, and delightful anecdotes** that give each lesson added dimension and insight.

Support Materials

A wealth of support components address any teaching style and meet any instructional need! This rich assortment of support components and visual resources are designed to meet the varied learning needs of the contemporary classroom.

ALL Support Components are correlated at **point of use** throughout the Teacher's Edition

Large Reproductions
18 durable, full-color fine art reproductions (18 x 24") are ideal for classroom display or small-group analysis. Background information on the art and artist is provided on the reverse of each laminated visual.

Teacher's Resource Binder
The ultimate in teaching support, these reproducible resources reinforce and extend the text through a range of diverse learning strategies. These resources include:

- **Chapter Support**
- **Home/Community Connections**
- **Manipulatives**

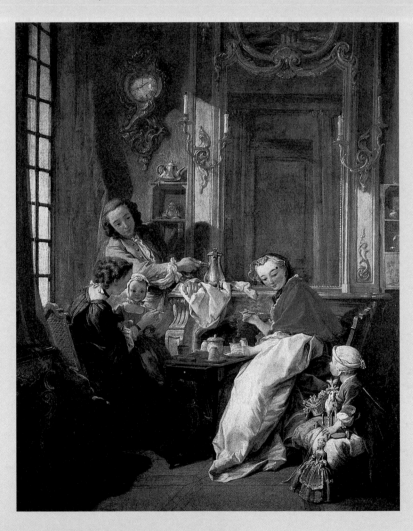

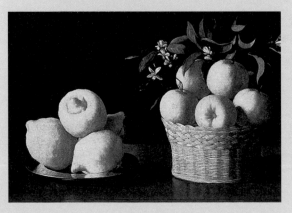

Overhead Transparencies
27 overhead transparencies, including 9 instructional overlays, add to your visual library in a format that encourages class discussions and detailed group examination.

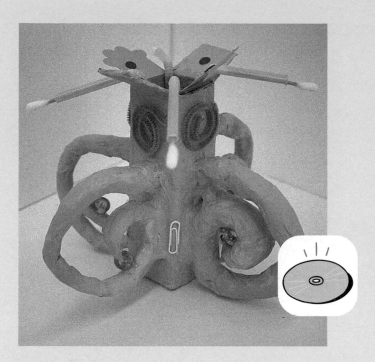

Slide Sets
10 correlated slide sets (72 slides total) extend the visuals in each theme with a host of vivid slide images. Each set displays a diverse array of art-works reflecting different artists, styles, periods, cultures, and media.

Student Art Gallery
This CD-ROM of student art extends the samples of student art provided in the text. Directly inspired by a studio lesson, these samples graphically show the scope of each activity and encourage peer sharing and review.

The Davis e-Gallery
This electronic museum provides a wealth of images ranging from fine art to architecture to objects designed for everyday use. Easy to search and select, this resource is ideal for lesson support or for individual research.

Careers Videos
Introduce your students to a variety of art-related occupations. These in-depth interviews with working professionals explore how each person came to their career, their typical workday, and the skills and training their jobs require. *(3 10-minute interviews per tape / 9 interviews per set)*

The Davis Web Site
The Davis site contains lesson support, links to instructional sites, student art, and much, much more.

www.davis-art.com

Scope & Sequence: Foundations

National Standard 1a Students select media, techniques, and processes; analyze their effectiveness; and reflect upon their choices.

National Standard 1b Students take advantage of qualities and characteristics of art media, techniques, and processes to enhance communication of ideas.

National Standard 2a Students generalize about the effects of visual structures and functions.

National Standard 2b Students employ organizational structures and analyze their effectiveness.

National Standard 2c Students select and use the qualities of structures and function of art to improve communication of ideas.

National Standard 3a Students integrate visual, spatial, and temporal concepts with content to communicate intended meaning.

National Standard 3b Students use subjects, themes, and symbols that demonstrate knowledge of contexts, values, and aesthetics that communicate intended meaning.

National Standard 4a Students know and compare characteristics of artworks in various eras and cultures.

National Standard 4b Students describe and place a variety of art objects in historical and cultural contexts.

National Standard 4c Students analyze, describe, and demonstrate how factors of time and place influence visual characteristics that give meaning and value to artworks.

National Standard 5a Students compare multiple purposes for creating artworks.

National Standard 5b Students analyze contemporary and historic meanings in specific artworks through cultural and aesthetic inquiry.

National Standard 5c Students describe and compare responses to their own artworks and to artworks from various eras and cultures.

National Standard 6a Students compare the characteristics of works in two or more art forms that share similar subject matter, historical periods, or cultural context.

National Standard 6b Students describe how the principles and subject matter of other disciplines are interrelated with the visual arts.

Student Abilities in Art

Perception	**Using knowledge of structures and functions**
	Observing visual, tactile, spatial, and temporal elements in the natural and built environments
	Observing visual, tactile, spatial, and temporal elements in artworks
	Considering use of elements and principles of design
Art Production	**Understanding and applying media, techniques, and processes**
	Generating ideas for artistic expression
	Choosing and evaluating a range of subject matter, symbols and ideas
	Developing approaches for expressing ideas
	Exploring expressive potential of art forms, media, and techniques
	Reflecting on artistic process, meaning, and quality of work
	Safety in art making
Art History	**Understanding the visual arts in relation to history and cultures**
	Investigating historical/cultural meaning of artworks
	Understanding historical/cultural context
	Developing global and multicultural perspectives
	Considering styles, influences, and themes in art
Art Criticism	**Reflecting upon and assessing the characteristics and merits of their work and the work of others**
	Describing and analyzing details in artworks
	Interpreting meanings in artworks
	Judging merit and significance in artworks
Aesthetics	**Reflecting upon and assessing the characteristics and merits of their work and the work of others**
	Understanding reasons for valuing art
	Raising and addressing philosophical questions about art and human experience
	Forming opinions about art
Presentation Exhibition, and Critique	**Reflecting upon and assessing the characteristics and merits of their work and the work of others**
	Keeping a portfolio and sketchbook
	Making work public
	Evaluating progress and accomplishments
Learning for Life	**Making connections between visual arts and other disciplines**
	Performing arts connections
	Daily life connections
	Interdisciplinary connections
	Careers
	Community connections
	Parent/home involvement
	Technology/internet/computer connections

	F1 The Whys and Hows of Art				F2 Forms and Media			F3 Elements and Principles			F4 Approaches to Art				
	F1.1 The Functions of Art	F1.2 Subjects and Themes	F1.3 Styles of Art	Connect, Portfolio, Review	F2.1 Two-dimensional Art	F2.2 Three-dimensional Art	Connect, Portfolio, Review	F3.1 Elements of Design	F3.2 Principles of Design	Connect, Portfolio, Review	F4.1 Art History	F4.2 Art Criticism	F4.3 Art Production	F4.4 Aesthetics	Connect, Portfolio, Review
	5a	3b 1a	6a 2b		1a	2a 2b		2a 2c	2a 2b		5a 5b 5c				
				•		•	•		•	•					•
	•	•	•	•	•		•	•		•		•			•
								•	•	•		•			•
	•	•	•	•	•	•	•	•	•		•			•	
	•	•	•	•	•	•	•	•	•					•	
	•	•	•	•	•	•	•	•	•				•	•	
	•	•	•	•	•	•	•	•	•				•		
									•		•		•		•
	•	•			•			•			•				
	•	•				•					•				
			•	•							•				
		•		•	•	•	•	•	•	•		•	•		•
		•	•									•			
				•			•			•		•	•		•
	•			•		•								•	
	•	•												•	
	•		•		•	•		•						•	
				•		•				•			•		•
	•	•	•	•	•	•	•	•	•	•	•	•	•	•	•
				•		•				•					•
				•		•				•					•
				•		•				•					•
				•		•				•					•
				•		•				•			•		•
				•		•				•					•
				•		•				•					•

National Standards

National Standard 1a Students select media, techniques, and processes; analyze their effectiveness; and reflect upon their choices.

National Standard 1b Students take advantage of qualities and characteristics of art media, techniques, and processes to enhance communication of ideas.

National Standard 2a Students generalize about the effects of visual structures and functions.

National Standard 2b Students employ organizational structures and analyze their effectiveness.

National Standard 2c Students select and use the qualities of structures and function of art to improve communication of ideas.

National Standard 3a Students integrate visual, spatial, and temporal concepts with content to communicate intended meaning.

National Standard 3b Students use subjects, themes, and symbols that demonstrate knowledge of contexts, values, and aesthetics that communicate intended meaning.

National Standard 4a Students know and compare characteristics of artworks in various eras and cultures.

National Standard 4b Students describe and place a variety of art objects in historical and cultural contexts.

National Standard 4c Students analyze, describe, and demonstrate how factors of time and place influence visual characteristics that give meaning and value to artworks.

National Standard 5a Students compare multiple purposes for creating artworks.

National Standard 5b Students analyze contemporary and historic meanings in specific artworks through cultural and aesthetic inquiry.

National Standard 5c Students describe and compare responses to their own artworks and to artworks from various eras and cultures.

National Standard 6a Students compare the characteristics of works in two or more art forms that share similar subject matter, historical periods, or cultural context.

National Standard 6b Students describe how the principles and subject matter of other disciplines are interrelated with the visual arts.

Student Abilities in Art

Perception	**Using knowledge of structures and functions**
	Observing visual, tactile, spatial, and temporal elements in the natural and built environments
	Observing visual, tactile, spatial, and temporal elements in artworks
	Considering use of elements and principles of design
Art Production	**Understanding and applying media, techniques, and processes**
	Generating ideas for artistic expression
	Choosing and evaluating a range of subject matter, symbols and ideas
	Developing approaches for expressing ideas
	Exploring expressive potential of art forms, media, and techniques
	Reflecting on artistic process, meaning, and quality of work
	Safety in art making
Art History	**Understanding the visual arts in relation to history and cultures**
	Investigating historical/cultural meaning of artworks
	Understanding historical/cultural context
	Developing global and multicultural perspectives
	Considering styles, influences, and themes in art
Art Criticism	**Reflecting upon and assessing the characteristics and merits of their work and the work of others**
	Describing and analyzing details in artworks
	Interpreting meanings in artworks
	Judging merit and significance in artworks
Aesthetics	**Reflecting upon and assessing the characteristics and merits of their work and the work of others**
	Understanding reasons for valuing art
	Raising and addressing philosophical questions about art and human experience
	Forming opinions about art
Presentation Exhibition, and Critique	**Reflecting upon and assessing the characteristics and merits of their work and the work of others**
	Keeping a portfolio and sketchbook
	Making work public
	Evaluating progress and accomplishments
Learning for Life	**Making connections between visual arts and other disciplines**
	Performing arts connections
	Daily life connections
	Interdisciplinary connections
	Careers
	Community connections
	Parent/home involvement
	Technology/internet/computer connections

1 Messages

Core Messages in Art	1.1 Ancient World	1.2 Line and Pattern	1.3 African Art	1.4 Relief Sculpture	Connect, Portfolio, Review
5b	4a	2c	5b 4b		

2 Identity and Ideals

Core Art of Special Groups	2.1 Art of Three Empires	2.2 Texture and Rhythm	2.3 Native American Art	2.4 Elevation Drawing	Connect, Portfolio, Review
5c 3b	4a	2b	4a 3a	1a 4a	

3 Lessons

Core Understanding Art	3.1 Medieval Art	3.2 Shape and Balance	3.3 Art of India	3.4 Folded Box Sculpture	Connect, Portfolio, Review
3b 4a	4a	2b	4a 1b	3a	

National Standards

National Standard 1a Students select media, techniques, and processes; analyze their effectiveness; and reflect upon their choices.

National Standard 1b Students take advantage of qualities and characteristics of art media, techniques, and processes to enhance communication of ideas.

National Standard 2a Students generalize about the effects of visual structures and functions.

National Standard 2b Students employ organizational structures and analyze their effectiveness.

National Standard 2c Students select and use the qualities of structures and function of art to improve communication of ideas.

National Standard 3a Students integrate visual, spatial, and temporal concepts with content to communicate intended meaning.

National Standard 3b Students use subjects, themes, and symbols that demonstrate knowledge of contexts, values, and aesthetics that communicate intended meaning.

National Standard 4a Students know and compare characteristics of artworks in various eras and cultures.

National Standard 4b Students describe and place a variety of art objects in historical and cultural contexts.

National Standard 4c Students analyze, describe, and demonstrate how factors of time and place influence visual characteristics that give meaning and value to artworks.

National Standard 5a Students compare multiple purposes for creating artworks.

National Standard 5b Students analyze contemporary and historic meanings in specific artworks through cultural and aesthetic inquiry.

National Standard 5c Students describe and compare responses to their own artworks and to artworks from various eras and cultures.

National Standard 6a Students compare the characteristics of works in two or more art forms that share similar subject matter, historical periods, or cultural context.

National Standard 6b Students describe how the principles and subject matter of other disciplines are interrelated with the visual arts.

Student Abilities in Art

Perception	**Using knowledge of structures and functions**
	Observing visual, tactile, spatial, and temporal elements in the natural and built environments
	Observing visual, tactile, spatial, and temporal elements in artworks
	Considering use of elements and principles of design
Art Production	**Understanding and applying media, techniques, and processes**
	Generating ideas for artistic expression
	Choosing and evaluating a range of subject matter, symbols and ideas
	Developing approaches for expressing ideas
	Exploring expressive potential of art forms, media, and techniques
	Reflecting on artistic process, meaning, and quality of work
	Safety in art making
Art History	**Understanding the visual arts in relation to history and cultures**
	Investigating historical/cultural meaning of artworks
	Understanding historical/cultural context
	Developing global and multicultural perspectives
	Considering styles, influences, and themes in art
Art Criticism	**Reflecting upon and assessing the characteristics and merits of their work and the work of others**
	Describing and analyzing details in artworks
	Interpreting meanings in artworks
	Judging merit and significance in artworks
Aesthetics	**Reflecting upon and assessing the characteristics and merits of their work and the work of others**
	Understanding reasons for valuing art
	Raising and addressing philosophical questions about art and human experience
	Forming opinions about art
Presentation Exhibition, and Critique	**Reflecting upon and assessing the characteristics and merits of their work and the work of others**
	Keeping a portfolio and sketchbook
	Making work public
	Evaluating progress and accomplishments
Learning for Life	**Making connections between visual arts and other disciplines**
	Performing arts connections
	Daily life connections
	Interdisciplinary connections
	Careers
	Community connections
	Parent/home involvement
	Technology/internet/computer connections

4 — Order and Organization

Core Organizing Artworks	4.1 Art of the Renaissance	4.2 Unity and Variety	4.3 Art of China and Korea	4.4 Perspective Drawing	Connect, Portfolio, Review
5b 2b 2a 4a	3b 4b	2a 2b	4a 2c	3a	

5 — Daily Life

Core Art and Daily Life	5.1 European Art: 1600–1750	5.2 Light, Value, Contrast	5.3 Native American Art	5.4 Decorated Container	Connect, Portfolio, Review
5a 3b	4a 1a	2c	4c 1a		

6 — Place

Core Telling About Places	6.1 European Art: 1750–1875	6.2 Space and Emphasis	6.3 Oceanic Art	6.4 Stitched Wall Hanging	Connect, Portfolio, Review
6a 5b 1b	1b 4a 5b	2b	4c 4a 3a	3a 1b	

National Standards

National Standard 1a Students select media, techniques, and processes; analyze their effectiveness; and reflect upon their choices.

National Standard 1b Students take advantage of qualities and characteristics of art media, techniques, and processes to enhance communication of ideas.

National Standard 2a Students generalize about the effects of visual structures and functions.

National Standard 2b Students employ organizational structures and analyze their effectiveness.

National Standard 2c Students select and use the qualities of structures and function of art to improve communication of ideas.

National Standard 3a Students integrate visual, spatial, and temporal concepts with content to communicate intended meaning.

National Standard 3b Students use subjects, themes, and symbols that demonstrate knowledge of contexts, values, and aesthetics that communicate intended meaning.

National Standard 4a Students know and compare characteristics of artworks in various eras and cultures.

National Standard 4b Students describe and place a variety of art objects in historical and cultural contexts.

National Standard 4c Students analyze, describe, and demonstrate how factors of time and place influence visual characteristics that give meaning and value to artworks.

National Standard 5a Students compare multiple purposes for creating artworks.

National Standard 5b Students analyze contemporary and historic meanings in specific artworks through cultural and aesthetic inquiry.

National Standard 5c Students describe and compare responses to their own artworks and to artworks from various eras and cultures.

National Standard 6a Students compare the characteristics of works in two or more art forms that share similar subject matter, historical periods, or cultural context.

National Standard 6b Students describe how the principles and subject matter of other disciplines are interrelated with the visual arts.

Student Abilities in Art

Perception	**Using knowledge of structures and functions**	
	Observing visual, tactile, spatial, and temporal elements in the natural and built environments	
	Observing visual, tactile, spatial, and temporal elements in artworks	
	Considering use of elements and principles of design	
Art Production	**Understanding and applying media, techniques, and processes**	
	Generating ideas for artistic expression	
	Choosing and evaluating a range of subject matter, symbols and ideas	
	Developing approaches for expressing ideas	
	Exploring expressive potential of art forms, media, and techniques	
	Reflecting on artistic process, meaning, and quality of work	
	Safety in art making	
Art History	**Understanding the visual arts in relation to history and cultures**	
	Investigating historical/cultural meaning of artworks	
	Understanding historical/cultural context	
	Developing global and multicultural perspectives	
	Considering styles, influences, and themes in art	
Art Criticism	**Reflecting upon and assessing the characteristics and merits of their work and the work of others**	
	Describing and analyzing details in artworks	
	Interpreting meanings in artworks	
	Judging merit and significance in artworks	
Aesthetics	**Reflecting upon and assessing the characteristics and merits of their work and the work of others**	
	Understanding reasons for valuing art	
	Raising and addressing philosophical questions about art and human experience	
	Forming opinions about art	
Presentation Exhibition, and Critique	**Reflecting upon and assessing the characteristics and merits of their work and the work of others**	
	Keeping a portfolio and sketchbook	
	Making work public	
	Evaluating progress and accomplishments	
Learning for Life	**Making connections between visual arts and other disciplines**	
	Performing arts connections	
	Daily life connections	
	Interdisciplinary connections	
	Careers	
	Community connections	
	Parent/home involvement	
	Technology/internet/computer connections	

7 Nature

	Core Connect with Nature	7.1 European Art: 1875–1900	7.2 Color	7.3 The Art of Japan	7.4 Paper Relief Sculpture	Connect, Portfolio, Review
	5a 3b 1b	4a 2c 1b	1b 2c 2a 4a	1b 4c 4b 5c	1b 3a	

8 Continuity and Change

	Core Continuity and Change	8.1 European Art: 1900–1950	8.2 Shape and Form	8.3 Art of Southeast Asia	8.4 Montage	Connect, Portfolio, Review
	4c 5b 1a	1b 4a	2b	4a 4c	1b 2b 3a	

9 Possibilities

	Core Possibilities of Art	9.1 Art Since 1950	9.2 Proportion and Scale	9.3 Global Possibilities	9.4 Handmade Book	Connect, Portfolio, Review
	1b 4c 5b	4a 3a	2a 2c	4a 5c	1b	

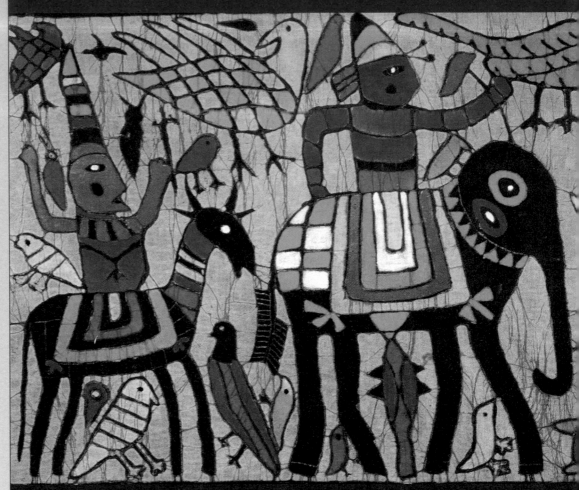

Cover, and above: Yunan Province, China, Wall Hanging, 20th century.
Batik on cloth, 20" x 32" (50.8 x 81.2 cm). Private Collection.

Art and the Human Experience

ART

A Global Pursuit

Eldon Katter
Marilyn G. Stewart

Davis Publications, Inc.
Worcester, Massachusetts

Foundations What Is Art?

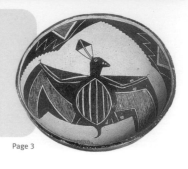
Page 3

Page 24

Page 40

Page 56

Themes Art Is a Global Pursuit

Page 73

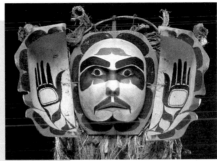

Page 96

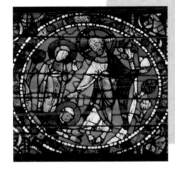

Page 131

Printed in U.S.A.
ISBN: 0-87192-489-7
10 9 8 7 6 5 4 3 2 1
WPC 05 04 03 02 01

v

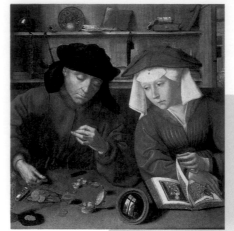

Page 156

Page 187

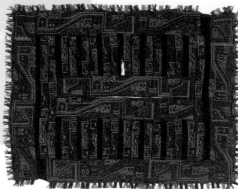

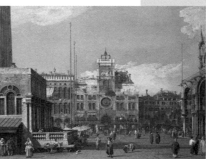

Page 202

VI

Page 241

Page 260

Page 288

Resources

While all artists possess and express a unique perspective, art from across the globe reflects certain shared ideas or themes. *Art: A Global Pursuit* **dedicates a chapter to each of art's universal themes.**

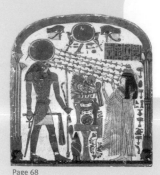

Page 68

From cave painting to music videos, artists use signs and symbols to communicate **Messages**

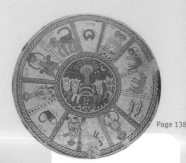

Page 138

Tapestries, temples, statues, and stained glass teach **Lessons** about art and life

Background, foreground, perspective and line provide **Order & Organization** to our visual lives

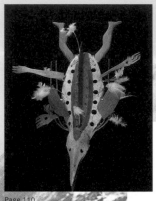

Page 110

Logos and totems, monuments and masks reflect a culture's **Identity & Ideals**

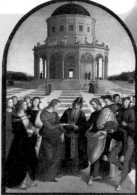

Page 146

Whether it's soup tureens or computer screens, quilts or clocks, artists record and shape **Daily Life**

Page 175

A Global Pursuit

Page 227

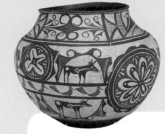

Through landscape paintings, plazas, and parks, artists celebrate the magic and wonder of **Place**

Page 203

Artists are inspired by and respond to the forms, patterns, power, and moods of **Nature**

Through new materials, techniques, subjects, and styles artists push boundaries and explore **Possibilities**

By breaking, borrowing, and building on tradition the arts embrace **Continuity & Change**

Page 256

Page 296

Foundations in Art

This text opens with an exploration of the fundamental **hows and whys of art.**

- Why do people make art?
- Does art serve a function?
- How do artists choose their subjects?
- Are there different styles of art?
- What is a 2-D art form?
- Why are the elements of design important?
- How are art historians and critics different?

In answering these questions, these introductory lessons provide a foundation on which to build your understanding of art.

Make the most of each chapter!
A unique **CORE PLUS 4** chapter organization provides a structured exploration of art with the flexibility to zoom in on topics that interest you.

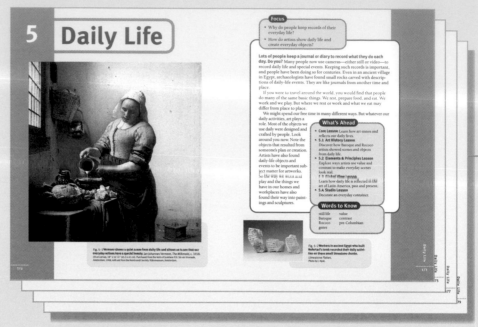

Sample pages from Chapter 5

Each theme opens with a Core Lesson that provides a comprehensive overview of the topic.

This theme examines how artists record and shape daily life.

Each theme concludes with a studio activity that challenges you to apply what you have learned in a hands-on art project.

This studio exercise creates a still-life painting using objects from daily life.

PLUS 4

4 regular follow-up lessons reinforce and extend the Core Lesson.

1 The first lesson examines the theme from the perspective of **art history**. *This lesson studies how Europeans used an ornate style of art to decorate and chronicle daily life during the 1700s.*

2 The second lesson explores the theme using the **elements and principles of design**. *This lesson examines how artists use value and contrast to make common objects look real.*

3 The third lesson looks at the theme from a **global or multicultural viewpoint**. *This lesson considers how ancient and contemporary artists have used a range of art forms to chronicle daily life in Latin America.*

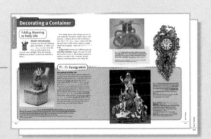

4 The fourth lesson studies the theme through a **studio activity**. *In this project you design and decorate a container that is useful to and expressive of your daily life.*

At the end of each chapter the themes **Connect to...**
- **Careers**
- **Technology**
- **Other Subjects**
- **Other Arts**
- **Your World**

Make the most of each lesson!
There are a number of carefully-crafted features that will help you read, understand, and apply the information in each lesson.

Connecting

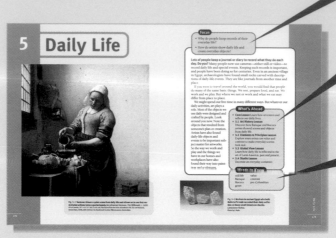

Read with purpose and direction.
Thinking about these Focus questions will help you read with greater understanding.

Prepare for What's Ahead!
See how all the lessons are related? Like a map, this will help you plan where you want to go.

Build your vocabulary.
The first time these terms are used they are highlighted in bold type and defined. *These terms are also defined in the Glossary.*

Organize your thoughts.
By dividing the lesson into manageable sections, these headings will help you organize the key concepts in each lesson.

"Read" the visuals with the text.
Note how the visuals are referenced in the text. Following these connections will help you understand the topic.

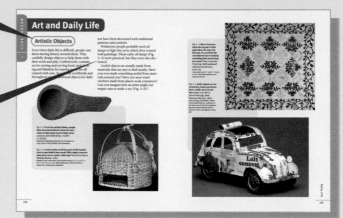

Images and Ideas

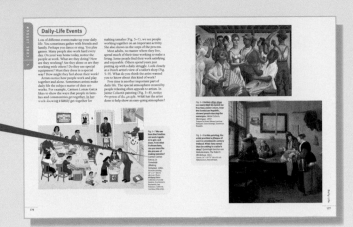

Use the captions to "see" the art.
These statements and questions direct you to key aspects of the artwork. Responding to the captions will help you see how the image relates to the text.

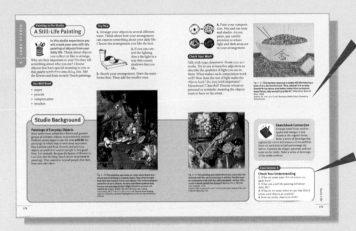

Who made this?
When was it made?
What is it made of?
These and other important questions are answered by the credits that accompany each visual. This information will help you appreciate the art more fully.

Check Your Understanding!
In addition to helping you monitor your reading comprehension, these questions highlight the significant ideas in each lesson.

Don't Miss

Timelines
Each **Art History** lesson is supported by a timeline that locates the lesson in history. As you read this timeline consider how the art reflects the historic events that surround it.

Locator Maps
Each **Global View** lesson is supported by a map that highlights the lesson's location in the world. As you read this map, consider how the art reflects the geography and culture of the place.

Work with Your Mind

Make the most of each studio opportunity!

Core Studio
An expansive studio assignment concludes and summarizes each Core Lesson.

Studio Lesson
A comprehensive studio lesson caps off each chapter by tying the theme's key concepts together.

Sketchbook Connections
Quick process-oriented activities help you hone your technical and observations skills.

Studio Connections
Practical real-world studio projects explore concepts through hands-on activities.

Computer Options

An alternative to traditional art materials, the computer can be used to do all or part of the lesson.

Build background knowledge
Artists regularly draw from the lessons of history. This background information chronicles how artists from the past approached similar artistic endeavors.

Learn from your peers.
An example of student artwork allows you to see how others responded to these hands-on exercises.

Think with Your Hands

Try This!

These directions and illustrations guide you step-by-step through the studio experience.

Check Your Work

One way to evaluate your art is through constructive group critiques. These strategies help you organize peer reviews.

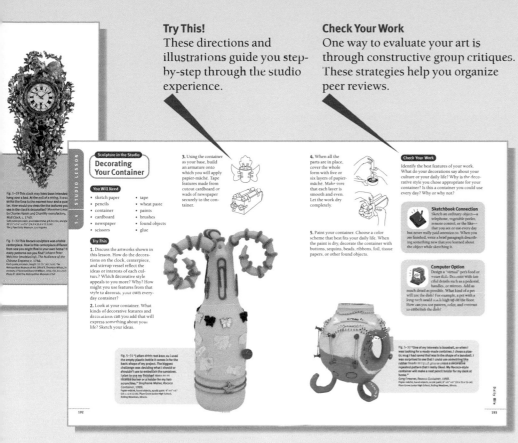

This book will take you on a journey around the world and through time. In your travels you will explore the universal language of art and learn why the joy of making and perceiving art is a global pursuit.

Student Gallery

As you become fluent in the universal language of art, a wealth of studio opportunities will help you find your own voice. The artworks on these four pages show how students just like you express their own unique insights and concerns.

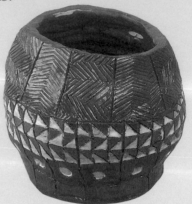

Page 5 **Tyler Goff,** *Clay Coil Pot with Line Design,* **1999.**
Clay, glazes, 7" (18 cm). Verona Area Middle School, Verona, Wisconsin.

Page 21 **Travis Driggers,** *Torn,* **1997.**
Montage, 17" x 12" (43 x 30 cm). Johnakin Middle School, Marion, South Carolina.

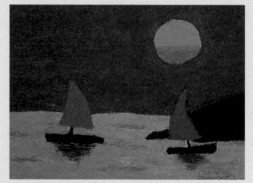

Page 33 **Clare Kennedy,** *Sunset Sailing,* **1999.**
Oil pastels, 9" x 12" (23 x 30 cm). Avery Coonley School, Downers Grove, Illinois.

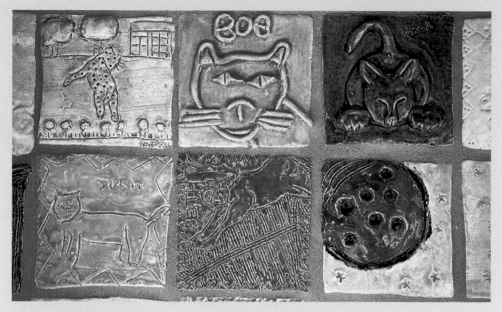

Page 87 **Panther tiles.**
Ceramic, 8' x 8' (2.45 x 2.45 m). Students of Plymouth Middle School, Maple Grove, Minnesota.

Page 101 **Kelly O'Connor,** *Field Hockey Girl #10,* **1999.**
Plaster gauze, over a wire and newspaper armature, and acrylic paint. 12" (30.5 cm) high. Pocono Mountain Intermediate School South, Swiftwater, Pennsylvania.

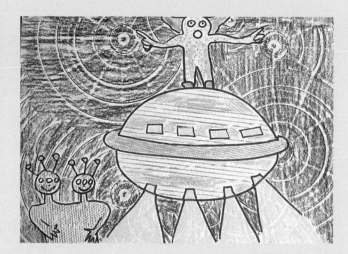

Page 53 **Jenna Skophammer,** *Alien UFO,* **1998.**
Crayon, 8 1/2" x 11" (21 x 28 cm). Manson Northwest Webster, Barnum, Iowa.

Student Gallery

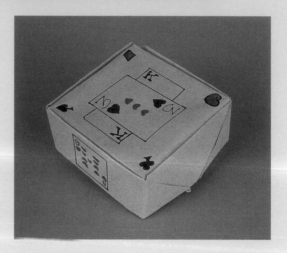

Page 139 **Abby Reid, *Untitled*, 1999.**
Paper, markers, 3 ¼" x 3 ¼" x 1 ⅝"
(8 x 8 x 4 cm). Shrewsbury Middle School,
Shrewsbury, Massachusetts.

Page 153 **Amanda Sacy, *Strings of Life*, 1999.**
Mixed media, 22" x 14" x 6" (56 x 36 x 15 cm). Avery Coonley School,
Downers Grove, Illinois.

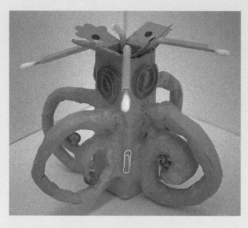

Page 191 **Claire Whang, *Rococo Container*, 1999.**
Papier-mâché, acrylic, found objects, 7" x 9" x 9" (18 x 23 x 23 cm).
Plum Grove Junior High School, Rolling Meadows, Illinois.

Page 219 **Ashley Dieter,** *Imagination Space,* **1999.**
Fabric, 12" x 19" (30 x 48 cm). Yorkville Middle School, Yorkville, Illinois.

Page 274 **Dustin Bennett,** *Untitled,* **1997.**
Ink, pastel, 17" x 23" (43 x 58 cm). Sweetwater Middle School,
Sweetwater, Texas.

Page 283 **Nick Hampton, Rebakah Mitchell, Alexander Moyers Marcon,** *Earthquake,* **1999.**
Tempera, 33" x 52" (84 x 132 cm). Mount Nittany Middle School, State College, Pennsylvania.

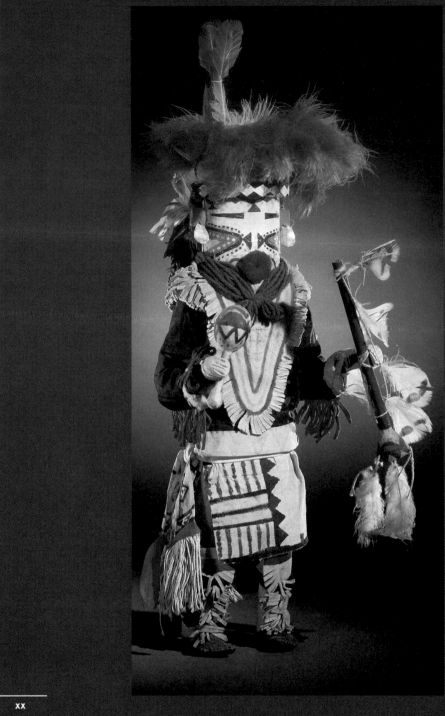

Foundations

What Is Art?

If you ask three friends what art is, they probably won't give the same answer. Throughout history, art has meant different things to different people. And that remains true today.

Many art museums display beautiful objects from different cultures. Even though we call these objects works of art, the people who made them may not have thought of them as art. In fact, some cultures have no word for art. Yet they take great care in making beautiful pottery, jewelry, and masks.

Whether or not it is intended as art, an object made by a person shows that individual's creativity and skill. The artist, designer, or craftsperson must have thought about why he or she was making the object. Something he or she saw or imagined must have provided inspiration. Once the object is made, other people may see it as a work of art, or they may not. How they see and appreciate the object depends on their sensitivity and their own ideas about what art is.

Look carefully at some of the objects pictured in this book. Write down the names of the ones that interest you, including their page numbers. Which objects do you consider works of art? Why? Why do you feel that other objects are not art? Write down your answers. When you are finished with Part 1 of this book, look at the objects again. How have your opinions changed?

Foundation Organizer

9 weeks	18 weeks	36 weeks*

Foundation Focus

National Content Standards

Foundation 1
The Whys and Hows of Art

Foundation 1 Overview
page 2–3

- Understand why humans produce art.
- **1.1** Practical, cultural, and personal functions of art.
- **1.2** Subjects and themes in art.
- **1.3** Expressionist, abstract, fantasy, and realistic styles of art.

1 Understand media, techniques, and processes.
2 Use knowledge of structures and functions.
3 Choose and evaluate subject matter, symbols, and ideas.
5 Assess own and others' work.
6 Make connections between disciplines.

9 weeks	18 weeks	36 weeks*
1	2	1

Objectives

National Standards

Foundation 1.1
The Functions of Art
page 4
Pacing: One or two
45-minute periods

- Understand that art is created for practical, cultural, and personal functions.

1a Select/analyze media, techniques, processes, reflect.
3b Use subjects, themes, symbols that communicate meaning.

Try This
Drawing, Painting, or Sculpture
page 4

- Create a drawing, painting, or sculpture that fulfills one of these functions.

1a Select/analyze media, techniques, processes, reflect.

9 weeks	18 weeks	36 weeks*
2	2	1

Objectives

National Standards

Foundation 1.2
Subjects and Themes
page 6
Pacing: One or two
45-minute periods

- Understand the difference between subject and theme in artworks.

3b Use subjects, themes, symbols that communicate meaning.

Try This
Drawing
page 8

- Create a drawing with a subject and theme.

1a Select/analyze media, techniques, processes, reflect.

9 weeks	18 weeks	36 weeks*
2	2	1

Objectives

National Standards

Foundation 1.3
Styles of Art
page 10
Pacing: One or two
45-minute periods

- Understand that art may be created in individual, cultural, or historical styles.
- Perceive and identify expressionism, realism, abstraction, and fantasy art styles.

2b Employ/analyze effectiveness of organizational structures.
6a Compare characteristics of art forms.

Try This
Drawing
page 12

- Create a drawing in a chosen style.

2b Employ/analyze effectiveness of organizational structures.

*** Assumes 3 classes per week for 36 weeks**

Featured Artists

Marc Chagall	Barbara Kruger
Eugène Delacroix	Leopoldo Méndez
Vincent van Gogh	Claude Monet
Jan Groover	Pablo Picasso
Jean-Auguste	Liubov Popova
Dominique Ingres	Frank Lloyd Wright
Frida Kahlo	

Vocabulary

subject
theme
style

Teaching Options

Teaching Through Inquiry
Using the Large Reproduction
Using the Overhead
Assessment Options

Technology

CD-ROM Connection
e-Gallery

Resources

Teacher's Resource Binder	Large Reproduction 5
A Closer Look: F1.1	Overhead Transparency 12
Assessment Master:	Slides 1, 2, 3
F1.1	

CD-ROM Connection
Student Gallery

Teacher's Resource Binder
Thoughts About Art: F1.1

Teaching Options

Teaching Through Inquiry
Using the Large Reproduction
Using the Overhead

Technology

CD-ROM Connection
e-Gallery

Resources

Teacher's Resource Binder	Large Reproduction 3, 10
A Closer Look: F1.2	Overhead Transparency 9
Assessment Master:	Slides 1, 3, 4
F1.2	

Teaching Through Inquiry
More About…Frida Kahlo
More About…Linoleum block prints
Using the Large Reproduction
Assessment Options

CD-ROM Connection
Student Gallery

Teacher's Resource Binder
Thoughts About Art: F1.2

Teaching Options

Meeting Individual Needs
Teaching Through Inquiry
More About…Expressionism

Technology

CD-ROM Connection
e-Gallery

Resources

Teacher's Resource Binder	Large Reproduction 7,8
A Closer Look: F1.3	Slides 4, 6, 8, 10, 11
Assessment Master:	
F1.3	

Teaching Through Inquiry
More About…Cubism
Using the Large Reproduction
Assessment Options

CD-ROM Connection
Student Gallery
Computer Option

Teacher's Resource Binder
Thoughts About Art: F1.3

These dots represent optional lessons.

Objectives

National Standards

Connect to...
page 14

- Identify and understand ways other disciplines are connected to and informed by the visual arts.
- Understand a visual arts career and how it relates to chapter content.

6 Make connections between disciplines.

Objectives

National Standards

Portfolio/Review
page 16

- Learn to look at and comment respectfully on artworks by peers.
- Demonstrate understanding of chapter content.

5 Assess own and others' work.

Teaching Options

Museum Connection
Interdisciplinary Planning

Technology

Internet Connection
Internet Resources
Video Connection
CD-ROM Connection
 e-Gallery

Resources

Teacher's Resource Binder
 Using the Web
 Interview with an Artist
 Teacher Letter

Teaching Options

Advocacy
Community Involvement
Family Involvement

Technology

CD-ROM Connection
 Student Gallery

Resources

Teacher's Resource Binder
 Chapter Review F1
 Portfolio Tips
 Write About Art
 Understanding Your Artistic Process
 Analyzing Your Studio Work

Foundation 1

If we understand the reasons that humans produce art, we will be better able to understand and appreciate their art. By recognizing both cultural and individual styles in artists' shared themes and subjects, students will appreciate the uniqueness of individual artworks.

Featured Artists

Marc Chagall
Eugène Delacroix
Vincent van Gogh
Jan Groover
Jean-Auguste-Dominique Ingres
Frida Kahlo
Barbara Kruger
Leopoldo Méndez
Claude Monet
Pablo Picasso
Liubov Popova
Frank Lloyd Wright

Chapter Focus

Universally, people create art for practical, cultural, and personal functions. Although all artworks can be classified by styles—such as expressionism, realism, abstraction, and fantasy—each individual artwork has a style unique to the artist and his or her culture.

**National Standards
Foundation 1
Content Standards**

1. Understand media, techniques, and processes.

2. Use knowledge of structures and functions.

3. Choose and evaluate subject matter, symbols, and ideas.

5. Assess own and others' work.

6. Make connections between disciplines.

FOUNDATION 1

The Whys and Hows of Art

Focus

- Why do people all over the world create works of art?
- How do artists make their work unique?

Do you remember the first time you painted a picture? You might have painted an animal or a scene from nature. Or perhaps you just painted swirling lines and shapes because you liked the way the colors looked together. No matter what the subject of the painting, there are many questions we can ask about how your first painting came to be. For example, what made you want to create it? How did you use paint to express your ideas? Why did you decide to paint the picture instead of draw it with crayons or a pencil? How was your painting similar to others you had seen?

These are questions we can ask about any work of art, whether it be your creation or someone else's. When artists work, they might not always think about these questions, but the answers are there. And while the answers might differ from one artist to the next, the whys and hows of art can lead us to a world of wonder.

What's Ahead

- **F1.1 The Functions of Art**
 Learn about the many roles that art plays in peoples' lives.
- **F1.2 Subjects and Themes for Artworks**
 Recognize that objects, ideas, and feelings inspire people to create art.
- **F1.3 Styles of Art**
 Understand why there can be similarities among certain artworks, even though every work of art is different.

Words to Know

subject
theme
style

Teaching Options

Meeting Individual Needs

English as a Second Language Write the words *bowl, mask,* and *painting* on the board, along with a simple definition of each. Have students identify the examples on page 3. Next, have them draw one of the types of objects, and write its name in both English and their native language at the top of the page. Reinforce that these are all kinds of art.

Fig. F1–1 **The inside of this bowl shows a bat with outstretched wings. In Pueblo and Mesoamerican cultures, bats can suggest death and the underworld. What might a bowl like this be used for?** Mimbres people, New Mexico. *Bowl*, 1200–1300 AD.
Earthenware, pigment, height: 4" (10.2 cm), diameter: 9" (22.9 cm). Purchase 113:1944. St. Louis Art Museum.

Fig. F1–2 **Barbara Kruger's art combines photographs and words. Through her artworks, she often expresses her opinions about the ideas and issues that a culture cares about.** Barbara Kruger, *Untitled* (A Picture Is Worth More than a Thousand Words), 1992.
Photographic silkscreen and vinyl, 82" x 123" (208 x 312.4 cm). Collection of New Line Cinema, New York. Courtesy Mary Boone Gallery, New York.

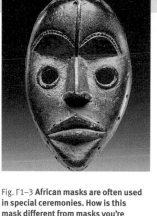

Fig. F1–3 **African masks are often used in special ceremonies. How is this mask different from masks you're familiar with?** Dan culture, Ivory Coast, *African Mask*, 19th/20th century.
Wood, 8" x 4 7/8" x 2 1/2" (20.3 x 12.4 x 6.3 cm). Virginia Museum of Fine Arts, Richmond. Gift of Robert and Nancy Nooter. Photo: Katherine Wetzel. © Virginia Museum of Fine Arts.

Fig. F1–4 **During the late 1800s, a group of French painters was interested in how light affected the color of their subjects. They showed these effects in their artworks. How would you describe what you see in this example?** Claude Monet, *The Seine at Giverny, Morning Mists*, 1897.
Oil on canvas, 35" x 36" (89 x 91.4 cm). North Carolina Museum of Art, Raleigh. Purchased with funds from Sarah Graham Kenan Foundation and the North Carolina Art Society (Robert F. Phifer Bequest).

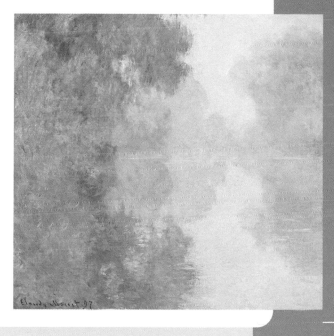

The Hows and Whys of Art

3

Chapter Warm-up

Show students any artwork. **Ask:** Why would someone take the time to make this? Why do people make things?

Using the Text

Aesthetics After students have read the first two paragraphs, ask them to recall some things that they have both made and kept. **Ask:** Why did you make it? Why did you keep it?

Using the Art

Aesthetics As students study the images, ask them what they think is the reason that each work was created. Discuss the questions in the captions. Have students compare the Mimbres bowl to a bowl in their home. **Ask:** How are the bowls alike? How are they different? Why would this bowl be in an art book?

Art History Barbara Kruger offers an analysis of social messages in her mass-media advertising style. Trained as a graphic artist, she was chief designer of *Mademoiselle* magazine when she was twenty-two years old.

Art History From about A.D. 200 to 1350, the Mimbres lived in what is now southwestern New Mexico. Some of the designs on their bowls include symbols relating to nature.

Teaching Through Inquiry

Aesthetics Ask: How is art similar to and different from other things in the world? Have students consider a variety of art objects and nonart objects and try to reach agreement regarding the art or nonart status of at least two objects. Discuss ways the objects are similar to and different from one another. Ask students to make some generalizations about how artworks are similar to and different from other things in the world. Keep a list of their statements and encourage revisiting these ideas throughout the year.

Aesthetics Have students work in groups of three. Provide an artwork reproduction for each group, and instruct one member to talk for one minute about the artwork. Have the other two students summarize what the first student said. The first student must then decide which summary best captures his or her intended meaning.

More About...

In **West African** culture, especially before the influx of European influence, **masks were revered** as habitations of spirits having awesome power. A mask like the one in Fig. F1–3 was worn by the Poro school (bush school) leader who served as advocate and mentor to tribal initiates. The man who donned such a mask took on the voice, mannerisms, and identity of the mask spirit.

Mask appearances were deeply ceremonious—sometimes public but more often very secret. Each mask/spirit had a purpose such as healing, fertility, and judging. Masks were carved in a ritual manner, smoothed using sandpaper-like leaves, and coated with plant juices.

Prepare

Pacing
One or two 45-minute periods

Objectives
- Understand that art is created for practical, cultural, and personal functions.
- Create a drawing, painting, or sculpture that fulfills one of these functions.

Teach

Engage
Display an object. **Ask:** What is the function of this object? Why was it created? How does its function determine its design? Now think about artworks. **Ask:** Should the function of an artwork determine how it is made?

Using the Text
Aesthetics After students have read Practical Functions, discuss the questions. Do likewise for Cultural Functions and Personal Functions.

Using the Art
Aesthetics Ask students to consider the function of the Wright window and that of a classroom window. **Ask:** Why might one be a work of art?

Try This
Offer various media, and suggest examples (such as a fan, a certificate of achievement, and an expressive painting) for each function.

National Standards
Foundation 1.1

1b Use media/techniques/processes to communicate experiences, ideas.

5a Compare multiple purposes for creating art.

5b Analyze contemporary, historical meaning through inquiry.

The Functions of Art

Although people create art for many reasons, most artworks belong to one of three broad categories: practical, cultural, or personal. These categories describe the function, or role, of an artwork.

4

Practical Functions

Much of the world's art has been created to help people meet their daily needs. For example, architecture came from the need for shelter. People also needed clothing, furniture, tools, and containers for food. For thousands of years, artists and craftspeople carefully made these practical objects by hand. Today, almost all everyday objects that are designed by artists are mass-produced by machines.

Think about the clothes you wear and the items in your home and school. How do they compare to similar objects from earlier times or from other cultures? Which do you think are beautiful or interesting to look at? Why?

Fig. F1–5 Practical. Windows serve the practical function of letting natural light into buildings and homes. Why might this window also be considered a work of art? Frank Lloyd Wright, *Stained-Glass Window*.
Glass, lead, and wood, 86 ¹⁄₄" x 28" x 2" (219 x 71 x 5 cm). The Metropolitan Museum of Art, Purchase, Edward C. Moore, Jr. Gift and Edgar J. Kaufmann Charitable Foundation Gift, 1967. (67.231.3) Photograph © 1978 The Metropolitan Museum of Art.

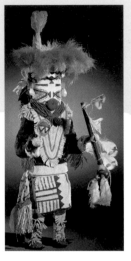

Fig. F1–6 Cultural. The Pueblo people of the American Southwest make Katsina dolls to represent important spirits. The dolls are given to young girls as a blessing and to teach them about the spirits. Zuni, New Mexico, *Katsina Doll*.
Wood, pigments, wool, hide, feathers, cotton, tin, 9" x 22 ¹⁄₂" (23 x 57 cm). Brooklyn Museum of Art, Museum Expedition 1903, Museum Collection Fund. 03.325.4631. ©Justin Kerr.

Teaching Options

Resources

Teacher's Resource Binder
 Thoughts About Art: F1.1
 A Closer Look: F1.1
 Assessment Master: F1.1
Large Reproduction 5
Overhead Transparency 12
Slides 1, 2, 3

Teaching Through Inquiry

Aesthetics Make and display a list of places where students have seen artworks or where they could imagine seeing them. Discuss the purposes served by the artworks in the various places. **Ask:** Do your responses to artworks have anything to do with the purposes served by them? For future discussions, keep a list of issues raised in this exercise.

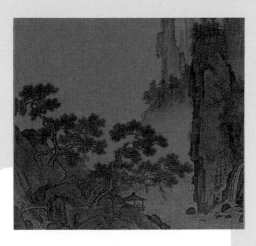

Fig. F1–7 **Personal. This Chinese landscape painting is an expression of the artist's deep respect for nature. Notice how tiny the human figure appears to be in the larger natural world.** Southern Sung Dynasty, China (1127–1279), *Gazing at a Waterfall*, late 12th century. Album leaf, ink and color on silk, 9 3/8" x 9 7/8" (23.8 x 25.2 cm). The Nelson-Atkins Museum of Art, Kansas City, Missouri (Gift of Mr. Robert H. Ellsworth). © 1999 The Nelson Gallery Foundation. All Reproduction Rights Reserved.

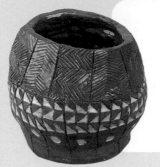

Fig. F1–8 **"The most difficult part was to make the coils the same thickness."** Tyler Goff, *Clay Coil Pot with Line Design*, 1999. Clay, glazes, 7" (18 cm). Verona Area Middle School, Verona, Wisconsin.

Cultural Functions

We can learn a lot about different cultures by studying their art. People have created architecture, paintings, sculpture, and other objects for a variety of reasons. Some buildings and artworks were made to honor leaders and heroes. Other works help teach religious and cultural beliefs. Sometimes art commemorates important historical events or identifies an important person or group.

Many artists continue to create artworks for cultural reasons. What examples can you think of in your community or state that serve a social, political, religious, or historical purpose? How are these examples of art different from artworks that have a practical function?

Personal Functions

An artist often creates a work of art to express his or her thoughts and feelings. The materials an artist chooses and the way he or she makes the artwork reflect the artist's personal style. The work might communicate an idea or an opinion that the artist has about the subject matter. Or it might simply record something that the artist finds particularly beautiful. Such personal works are created in many forms, including drawing, painting, sculpture, cartooning, and photography. What artworks do you know about that were created for personal expression or sheer beauty?

Try This

Create a drawing, painting, or sculpture that fulfills one of the three functions explained in this lesson. Describe how your artwork fits its function.

Foundation Lesson 1.1

Check Your Understanding
1. Describe at least four reasons why people create art. (These reasons may be from any of the function categories.)
2. Find a piece of art in this section created for a practical function, one for a cultural function, and one for a personal function. Explain how one of these works might fulfill two of these functions.

The Hows and Whys of Art

5

Critical Thinking

Different societies have different views about art. In some societies, "good" art is similar to previous art, and is not an individual, creative expression. For example, Egyptian and Byzantine styles remained the same for hundreds of years. **Ask:** Have you ever copied artwork and been praised because your work looks like the original? Why do artists in some societies not express their personal thoughts and feelings in their artworks?

Assess

Check Your Understanding: Answers

1. for shelter (architecture), for ceremonies (religious objects), to commemorate (historical monuments), for individual communication (expressive paintings or sculptures)

2. practical: Mimbres bowl, Wright window; cultural: Dan mask, Katsina doll; personal: Monet and Kruger pieces. The bowl may have been created for practical and cultural purposes. Other answers possible.

Close

Discuss students' answers to Check Your Understanding. Display the art created in Try This, and have students arrange the works by their function.

Using the Large Reproduction

5

Consider to what degree this work might serve practical, cultural, and personal functions.

Using the Overhead

12

Lead a discussion of how this work might serve practical, cultural, and/or personal functions.

Assessment Options

Teacher Ask students to match types of artworks in List B with a function in List A and an artwork from the text in List C.

List A, functions: (1) Personal; (2) Cultural; (3) Practical

List B, artworks that: (a) provide for basic human needs, such as clothing, shelter, tools; (b) are primarily expressions of thoughts, feelings, beauty or style; (c) are primarily about social, political, religious, historical, or educational topics

List C: (x) Fig. F1–6 *Katsina Doll;* (y) Fig. F1–4 *The Seine at Giverny, Morning Mists;* (z) Fig. F1–5 *American Stained-Glass Window*

Prepare

Read over the lesson and jot down some subjects and themes that will be familiar to students. For Try This, gather drawing supplies, such as paper, pencils, erasers, markers, or oil pastels.

Pacing

One or two 45-minute periods, depending on the scope of Try This

Objectives

- Understand the difference between subject and theme in artworks.
- Create a drawing with a subject and theme.

Vocabulary

subject What is shown in an artwork, such as a landscape, people, animals, or objects.

theme The overall topic of an artwork. For example, the theme of a landscape might be harvest time.

Teach

Engage

Students are probably familiar with themes and subjects from literature and movies. Remind them of a familiar story, such as "The Three Little Pigs." **Ask:** What is the subject of the story? What is the theme?

National Standards Foundation 1.2

1a Select/analyze media, techniques, processes, reflect.

3b Use subjects, themes, symbols that communicate meaning.

Subjects and Themes for Artworks

Artists are observers. They find subjects and themes for their work in almost everything they see and do. The **subject** of an artwork is what you see in the work. For example, the subject of a group portrait is the people shown in the portrait. Other familiar subjects for artworks include living and nonliving things, elements of a fantasy, historical events, places, and everyday activities.

You can usually recognize the subject of an artwork. Sometimes, however, an artist creates a work that shows only line, shape, color, or form. The artwork might suggest a mood or feeling, but there is no recognizable subject. This kind of artwork is called *nonobjective*.

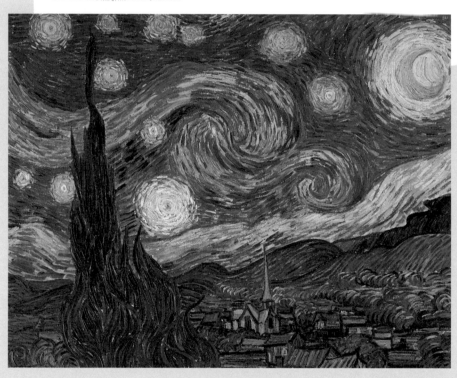

Fig. F1–9 Artworks that show natural scenery, such as mountains, trees, and rivers, are called *landscapes*. Those that show buildings, streets, and bridges are called *cityscapes*. Would you call this image a landscape or a cityscape? Why? Vincent van Gogh, *Starry Night*, 1889.
Oil on canvas, 29" x 36 ¼" (73.7 x 92.1 cm). The Museum of Modern Art, New York. Acquired through the Lillie P. Bliss Bequest. Photograph ©2000 The Museum of Modern Art, New York.

6

Teaching Options

Resources

Teacher's Resource Binder
 Thoughts About Art: F1.2
 A Closer Look: F1.2
 Assessment Master: F1.2
Large Reproduction 3, 10
Overhead Transparency 9
Slides 1, 2, 3

Teaching Through Inquiry

Art Criticism Show a variety of artworks, and ask students to name the people, places, and things depicted. Focus on one work, and ask students to describe the subject-matter details.

Aesthetics Show students a variety of artworks, and discuss whether or how the world is represented in them. **Ask:** Does art represent the world? Are there various ways that the term "represents" can be used? What ways? Are there various ways to understand the term "world"? Return to these issues periodically throughout the year.

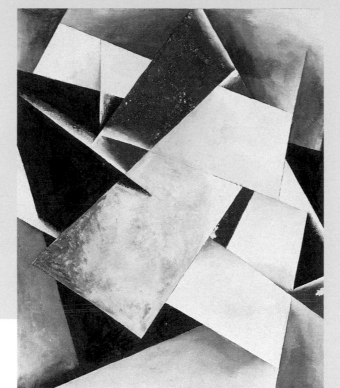

Fig. F1–10 **As you can see, this painting shows only shapes and colors. How does this painting make you feel? Why?** Liubov Popova. *Painterly Architectonics*, 1918. Gonache and watercolor with touches of varnish, 11 9/16" x 9 1/4" (29.3 x 23.5 cm). Yale University Art Gallery, Gift from the Estate of Katherine S. Dreier.

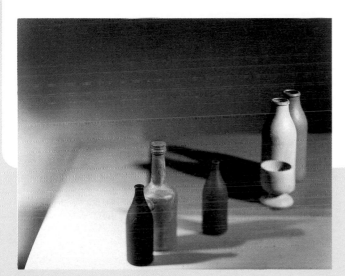

Fig. F1–11 **A *still life* is an arrangement of objects, such as flowers, fruit, or tableware, that are not alive or cannot move. Still-life arrangements are popular subjects in art. How is the still life you see here different from the one by Chardin on page 184?** Jan Groover, *Untitled*, 1987. Print, 30" x 40" (76 x 101.6 cm). Janet Borden, Inc.

Using the Text

Art Criticism After students have read the first paragraph, have them study *Starry Night.* **Ask:** What is the subject of this artwork? What feeling do the swirling colors suggest?

Art History Van Gogh painted this scene from a window at Saint-Rémy-de-Provence, the sanatorium where he stayed voluntarily. He wrote "... looking at the stars always makes me dream," and "I have a terrible need for a religion. Then I go out at night to paint the stars."

Art Criticism Have students read the second paragraph. Explain the meaning of *nonobjective*. Ask students to find at least one nonobjective piece of art in this book, such as *Conception Synchromy*, Fig. F3–8.

Using the Art

Art Criticism Have students look at the Popova and Groover works. **Ask:** What seems to be the subject of these works?

Critical Thinking

Challenge each student to pretend that he or she is either Vincent van Gogh or Jan Groover, and "he" is creating one of the works on these pages. Have each "artist" write a diary page or a letter to a friend, explaining what he is trying to express in this work, what inspired him to paint this, and whether he thinks he has been successful.

The Hows and Whys of Art

7

Using the Large Reproduction

Compare subject and theme with Fig. F1–9, *Starry Night.*

3

Using the Overhead

Compare subject and theme with Fig. F1–11, *Untitled.*

9

Subjects and Themes

Using the Text

Art Criticism Have students read the text and then discuss the subjects and themes of the artworks on these pages. Ask students to recall the previous lesson and tell what they think is the function of each artwork shown here.

Using the Art

Art Criticism Discuss students' answers to the caption questions with the Méndez print, and have students compare the theme of this scene to that of *Starry Night*. Encourage students to look at the lines in the land and sky of each image and to explain how they affect the theme.

Art Criticism Focus on Fig. F1–13. Ask students to describe what they see—the subject. Tell them this is Kahlo's self-portrait and that the image on her forehead is Diego Rivera, Kahlo's husband. **Ask:** What do you think this picture is about? What is the theme? *(The tears and the placement of Diego inside Kahlo's head suggest that the theme is the anguish caused by her love for him.)*

Art History Frida Kahlo and Diego Rivera, the famous Mexican muralist (see Figs. F1–20, 5–26), had a tumultuous marriage—divorcing and then remarrying. At eighteen, Kahlo was injured in a bus accident and became an invalid for the rest of her life.

Try This

Before they begin drawing, help students identify possible subjects and the means of conveying various themes for a particular subject. For example, French fries could be shown as either delicious or unhealthy, or a forest scene could depict either scary shadows or the beauty of nature. Ask students to write their subject and theme on the back of their drawing.

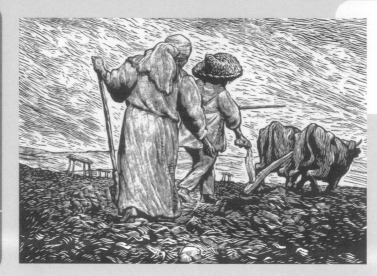

Fig. F1–12 **What activity is taking place in this scene? What theme does it suggest?** Leopoldo Méndez, *Arando*, c. 1943. Linoleum cut. Collection of McNay Art Museum, Museum purchase from the Margaret Pace Fund.

The **theme** of an artwork is the topic or idea that the artist expresses through his or her subject. For example, the theme of the group portrait might be family togetherness or community support. Themes in art can be related to work, play, religion, nature, or just life in general. They can also be based on feelings, such as sadness, love, anger, and peace.

Artworks all over the world can reflect the same theme, but will still look entirely different. Why? Because the subjects used to express the theme probably won't be the same. For example, imagine that an artist in Australia and an artist in Canada each create a painting about natural beauty. Would the Canadian artist show a kangaroo? Probably not.

Look at the artworks in this lesson. What subjects do you see? What themes are suggested?

Try This

Look around you. What do you think would make a good subject for an artwork? An object? An animal? A particular view of your schoolyard? What kinds of themes come to mind that are related to the subject? Choose a subject and theme and create a drawing.

8

Sketchbook Connection

Choose a small object that interests you. Spend some time looking at it carefully. Turn it over in your hands and observe how it feels to the touch. Notice the object's shape, color, and detail. When you are familiar with the object, sketch it from at least three different angles. How are the three sketches different from one another?

Foundation Lesson 1.2

Check Your Understanding
1. Look through other chapters of this book. Select an artwork that interests you and write about it. Describe the image. What subject is depicted? What seems to be the theme of the artwork? Why do you think so?
2. What is a landscape? Identify a landscape in this book.

Teaching Options

Teaching Through Inquiry

Art Production Tell students that one way to get ideas for making art is to think about people, places, and things that have special meaning. Have students examine artworks based on broad humanistic themes. **Ask:** How might an artist be inspired by personal feelings and concepts such as love, friendship, joy, sadness, dislike, and pain?

More About...

Mexican artist **Frida Kahlo** (1910?–54) is associated with an art movement called **Surrealism** in which artists created images that presented a different, or "sur-real" reality rather than that ordinarily perceived by the logical mind. Kahlo specialized in self-portraits that communicated a deep inner truth about herself, instead of focusing exclusively on exterior physical details.

Fig. F1–13 **A *portrait* is an artwork that features a specific person, group of people, or animal. This artist has created a portrait of her husband within a *self-portrait*—a portrait of herself. What feeling does this image suggest?** Frida Kahlo, *Diego y yo*, 1949.
Oil on masonite, 11 5/8" x 8 13/16" (30 x 22 cm). Courtesy Mary Ann Martin/Fine Art, New York.

The Hows and Whys of Art

9

Extend

- Have students work in groups to sort by subject matter a variety of post-card reproductions that you provide.
- Have students draw or paint a second picture of the subject they used in Try This, but this time with a different theme. Or they may use their theme and portray it with a different subject.

Assess

Check Your Understanding: Answers

1. Answers will vary.

2. Landscapes are artworks that show natural scenery. Answers may vary, but van Gogh's *Starry Night* is one possibility.

Close

Discuss students' written answers for Check for Understanding.

To help students evaluate the effectiveness of communicating their theme, have them exchange drawings and explain the theme of their partner's art. **Ask:** How well did you understand the artist's intent? How could the artist clarify his or her theme?

More About...

Artists create **linoleum, or lino, block prints** by first cutting into a piece of linoleum with a sharp, wedged tool. After removing lines and shapes, the artist inks the remaining block for printing. Only the surface that has been left behind will print. The Englishman, Frederick Walton, invented the material in 1863, coining the term linoleum, which comes from the Latin word *linum*, meaning flax, and *oleum*, meaning oil.

Using the Large Reproduction

Compare subject and theme with Fig. F1–12, *Arando*.

10

Assessment Options

Peer To demonstrate a clear understanding of the difference between subject and theme in artworks, ask students to select a subject such as the human figure, apples, a house, trees, etc., and use that same subject in three drawings, each with a different theme such as loneliness, joy, anger, conflict. Have students work in pairs to discuss each other's work and to see if communication of the theme is clear.

Prepare

Pacing

One or two 45-minute periods, depending on the scope of Try This

Objectives

- Understand that art may be created in individual, cultural, or historical styles.

- Perceive and identify expressionism, realism, abstraction, and fantasy art styles.

- Create a drawing in a chosen style.

Vocabulary

style An artist's chosen means of expression through use of materials, design, work methods, and subject matter. In most cases, these choices show the unique qualities of an individual, culture, or time period.

Teach

Engage

Have several students write their name on the board, large enough so that the whole class can see it. Have students analyze the signatures by noting the slant, how far the ascenders and descenders extend above and below the rest of the writing, how rounded or pointed the tops of the letters are, whether the *a*'s and

Styles of Art

A **style** is a similarity you can see in a group of artworks. The artworks might represent the style of one artist or an entire culture. Or they may reflect a style that was popular during a particular period in history.

You can recognize an artist's *individual* style in the way he or she uses art materials, such as paint or clay. An artist can adopt certain elements of design and expression that create a similar look in a group of his or her works. Sometimes an artist uses the same kind of subject matter again and again.

Artworks that reflect *cultural* and *historical* styles have features that come from a certain place or time. For example, Japanese painters often depict scenes from nature with simple brush-strokes. From an historical perspective, the columns used in ancient Greek architecture have characteristics that are immediately recognizable.

As explained in the following sections, there are also four *general* style categories that art experts use to describe artworks from very different times and cultures.

Expressionism

In an expressionist artwork, the mood or feeling the artist evokes in the viewer is more important than creating an accurate picture of a subject. The artist might use unexpected colors, bold lines, and unusual shapes to create the image. Expressionist artists sometimes leave out important details or exaggerate them. When you look at an expressionist work of art, you get a definite feeling about its subject or theme.

Fig. F1–14 **In this expressionist portrait, the artist captured the musician's performance, instead of a true likeness of the man. What features of expressionist art do you see here?** Eugène Delacroix, *Paganini*, 1831.
Oil on cardboard on wood panel, 17 5/8" x 11 7/8" (44.8 x 30 cm). The Phillips Collection, Washington, DC.

10

National Standards
Foundation 1.3

2b Employ/analyze effectiveness of organizational structures.

6a Compare characteristics of art forms.

Teaching Options

Resources

Teacher's Resource Binder
 Thoughts About Art: F1.3
 A Closer Look: F1.3
 Assessment Master: F1.3
Large Reproduction 7, 15
Slides 4, 6, 8, 10, 11

Meeting Individual Needs

Multiple Intelligences/Intrapersonal, Musical, and Linguistic Play an example of Paganini's work as students examine Fig. F1–14 and Fig. F1–15. Ask them to imagine being the virtuoso violinist looking at these two portraits. Based on the music they heard, have students write a letter to each of the artists as Paganini, describing what he thinks they captured correctly or missed about his personality in their artwork.

Realism

Some artists want to show real life in fresh and memorable ways. They choose their subjects from everyday objects, people, places, and events. Then they choose details and colors that make the subjects look real.

Sometimes a particular mood is suggested in the artwork. Artists who work in this style often make ordinary things appear extraordinary. Some of their paintings and drawings look like photographs.

Fig. F1 15 **This artist shows us a realistic likeness of the violinist Paganini. Notice how the face, hands, and instrument are drawn in detail, while the clothing appears to be sketched. Why might the artist have drawn the portrait this way?** Jean-Auguste-Dominique Ingres, *Paganini*, 1819. Black chalk drawing, 12" x 8 1/2" (30.5 x 21.6 cm). Louvre, Paris. Giraudon/Art Resource, NY.

The Hows and Whys of Art

11

o's are open or closed, how light or dark the letters are, and how the *t*'s are crossed and the *i*'s are dotted. Point out that each student's development of a distinctive handwriting style is similar to an artist's development of his or her own art style.

Using the Text

Art History After students have read the first three paragraphs, refer them to Fig. F1–2, by Barbara Kruger, and then Fig. F1–4, by Claude Monet. Explain that both artists developed their own distinctive styles, and that students will probably be able to identify other works by these artists. For examples of easily recognizable cultural styles, refer students to Fig. F1–6, *Katsina Doll,* and Fig. F1–7, *Gazing at a Waterfall.*

Using the Art

Art Criticism Challenge students to discover what the artworks on pages 10–13 have in common. They should notice that all are two-dimensional pieces with a common subject—a man with a violin. Discuss the questions in the captions, and ask what the message is in each piece. Encourage students to use precise words when they talk about artworks. For example, if students call a sculpture "great," ask if they mean "big," or "powerful," and so on.

11

Using the Text

Art History Ask students to categorize the styles of Figs. F1–14 through F1–17 (expressionism: Delacroix; realism: Ingres; abstraction: Picasso; fantasy: Chagall). Explain that the categories might overlap; for instance, Chagall's fantasy includes abstracted forms.

Try This

Have students first make a few quick gesture drawings and a contour drawing of their shoe. Before students begin their color drawing, have them decide on the style they will use and write its name on the back of their paper. Students might use markers or oil or chalk pastels.

Critical Thinking

Assign students to find other artworks of the four general style categories. Ask them to classify each piece and then explain why the work fits into its category. Challenge students to find pieces that fit into more than one category.

Extend

Encourage students to draw or paint their shoe or another subject in several different styles. Display the three different works together, and discuss which style each student believes best expressed his or her feeling about the subject.

Abstraction

Artists who work in an abstract style arrange colors, lines, and shapes in fascinating ways. They find new ways to show common objects or ideas. Their artworks appeal to the mind and senses. For example, most people see and feel flowing curved lines as graceful. Jagged lines remind people of sharp objects or sudden, unexpected events, such as lightning. Nonobjective artworks usually fall into this style category.

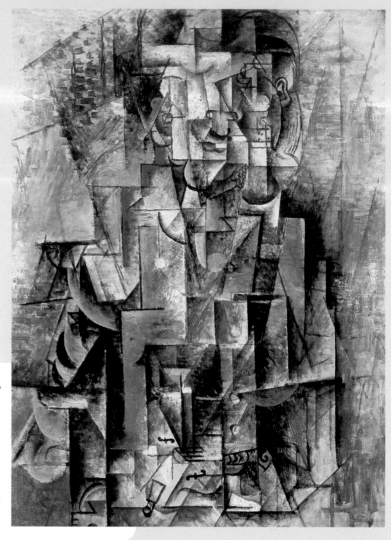

Fig. F1–16 **In this painting, Pablo Picasso shows his subject from many different angles at once. His use of lines and angles creates an abstract kaleidoscope effect.** Pablo Picasso, *Man with Violin*, 1911–12.
Oil on canvas, 39 3/8" x 29 7/8" (100 x 76 cm). Philadelphia Museum of Art: Louise and Walter Arensberg Collection. © 2000 Estate of Pablo Picasso/Artists Rights Society (ARS), New York.

12

Teaching Options

Teaching Through Inquiry

Art History Tell students that art historians use the **idea of style** to explain changes in art through time. With students, analyze today's fashions to determine their significant characteristics. Discuss how these characteristics compare to fashions of ten, twenty, thirty, or 100 years ago; and reasons why fashions have changed. Review the art styles introduced in this chapter, and ask students to identify characteristics within a style and to contrast that style with another. Discuss why artworks generally might have different styles at different times or in different cultures.

More About...

Pablo Picasso (1881–1973) helped invent a famous early twentieth-century abstract style—**Cubism**. In this movement, artists shattered a three-dimensional subject into flat, two-dimensional planes, and then rearranged them onto the surface of the canvas. When discussing Fig. F1–16, ask students to imagine walking around the man with his violin, snapping instant pictures every few moments, then splicing them, and finally pasting the pieces onto a flat rectangle.

Fantasy

The images you see in fantasy art often look like they came from a dream. When fantasy artists put subjects and scenes together, they create images that appear unreal. While the subject might be familiar, the details in the artwork might not seem to make sense. You won't find scenes from real life in fantasy artworks!

Try This

Choose the style category that interests you the most. Make a color drawing of your shoe in that style. Include details that suggest where the shoe is. Be as imaginative as you can. Compare your finished drawing to those by other members of your class. Discuss the differences you see in personal and general styles.

Foundation Lesson 1.3

Check Your Understanding
1. What is the difference between abstract art and expressionist art?
2. Choose an image from this lesson. How might it look different if it were recreated in one of the other styles?

Computer Option

In a painting program, draw a shoe or a hat. Keep your drawing simple. Save the file. Now create three different versions, in these three styles: Expressionist, Realist, and Fantasy. Add colors, backgrounds, and details to each version to achieve the desired styles. Without discussing your work with your classmates, print out your finished work. Have classmates take turns identifying the styles of your work.

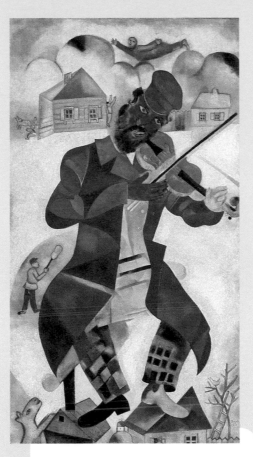

Fig. F1–17 **What details of this painting are things you might see in real life? What features make the scene look unreal?** Marc Chagall, *The Green Violinist*, 1923–24.
Oil on canvas, 78" x 42 ¾" (198 x 108.6 cm). Solomon R. Guggenheim Museum, New York. Gift, Solomon R. Guggenheim, 1937. Photograph by David Heald ©The Solomon R. Guggenheim Foundation, New York. (FN 37.446). © 2000 Artists Rights Society (ARS), New York.

The Hows and Whys of Art

13

Computer Option
• Have students consider drawing the object in contour line, without looking at their "mouse" hand; drawing with various paintbrush thicknesses; and embellishing the shoe or hat by applying special effects or filters available in most paint programs (Apple-Works paint, Color It, Painter, Photoshop). Explain that these filters may simulate some of the paint styles, such as "Impressionist." Discuss how effectively the filters imitate these styles.
• A fun way to reinforce concepts taught in this lesson is for students to visit "A. Pintura: The Case of Grandpa's Painting" at: www.eduweb.com/pintura/.

Assess

Check Your Understanding: Answers

1. In abstract art, the artist is most interested in arranging art elements, such as color, line, and shape; whereas in expressionist art, the mood or feeling evoked in the viewer becomes most important.

2. Answers will vary.

Close

Review with students the different types of styles. After they have answered the questions in Check Your Understanding, discuss their answers. Encourage students to arrange a class display of the art that they created in Try This, by grouping the art according to style.

Using the Large Reproduction

Ask students where this work might fit in the four general style categories discussed in this chapter.

15

Assessment Options

Teacher Have students use the five images in the previous lesson and the four images in this lesson. Ask them to explain where and why they would exhibit these works in an art museum in four separate galleries that are labeled Expressionism, Realism, Abstract Art, and Fantasy Art. Also ask them to write a short one- or two-sentence statement that would explain to museum visitors what was meant by each of these terms.

Careers

Remind students that philosophers concerned with art are called *aestheticians*. To begin a discussion about aesthetics, brainstorm with students questions that an aesthetician might ask, such as:

- What conditions must be met for an object to be considered art?

- Must art be beautiful? What does "beautiful" mean?

- Must art be made by hand?

- Muct art be enjoyed?

- Must art cause an emotional response in the viewer?

- Is there only one true meaning of a work of art? Why or why not?

- Can an object be art if the person making it did not intend it to be? Why or why not?

Bring to class a number of objects that might be considered art, and give one object to each group of three or four students. Ask students to imagine they are aestheticians. They must make a case for categorizing their object as art. Have groups take turns sharing their response with the class.

Connect to...

Careers

When you question ideas about art in thoughtful and deliberate ways, you are thinking like a philosopher. Philosophers since the time of the ancient Greeks have discussed the nature of art, sharing an age-old search for understanding. The philosophy of art is known as aesthetics, a word that, in the 1700s, came to mean "the science of the beautiful."

Historically, **aestheticians** have had quite rigid ideas about what artists should create and what people should like. Present-day aestheticians—most of whom teach college-level philosophy—are concerned with the way we think about art, especially art's "big" questions.

F1–18 **"I challenge people to think about what makes something a work of art, by showing them this cake pan. Is it a work of art when it sits in my cupboard at home? Suppose you came across it in a museum and saw that it was titled *Women's Destiny.* Would you think it was a work of art in this context?"** — Marcia Muelder Eaton, professor of philosophy, University of Minnesota

Other Arts

Theater

Like art, theater is part of our lives. At a very basic level, we have theater when one person communicates an idea physically and/or verbally to another person. So, theater can be the telling of a story to a friend or the playing of charades at a party.

Would a two-way conversation be theater? Why or why not? If a third person listened to the conversation, would this be theater? Why or why not?

Write a list of **everyday theatrical events** that you participated in last week—as actor or audience. Circle the three most dramatic events. What characteristics do these three events share?

F1–19 **In this photograph, we see a teacher working with her class. Could the act of teaching be considered theater? Why or why not?**
Photo courtesy of Kathy Burke, Lusher Alternative Elementary, New Orleans, Louisiana.

14

Teaching Options

Resources

Teacher's Resource Binder
Using the Web
Interview with an Artist
Teacher Letter

Internet Resources

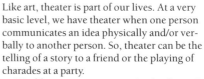

Louvre Museum
http://mistral.culture.fr/louvre/louvrea.htm

Take a virtual tour of one of the most famous museums in the world.

National Museum of American Art
http://www.nmaa.si.edu/

Browse the collection of more than 3,000 digitized images classified by subject and artist.

Nelson-Atkins Museum of Art
http://www.nelson-atkins.org/

This Kansas City museum is not to be missed.

Other Subjects

Social Studies

Look through your social studies or history text-book, and count the number of artworks in it. Surprised? The **works of art** you found most likely were created to **serve a cultural function**—perhaps to commemorate an event or to provide a portrait of an important person. Why do you think these images are important to us? We have learned much of what we know of past cultures and peoples from their art. Do you think that will still be the case when the people of the future look back at us?

Science

Artists have long used subjects and themes from the life sciences in their work. In land-scapes, they might portray the violent forces of nature, or show scenes of breathtaking natural beauty. They might depict animals in real or imagined settings; they might paint still lifes of flowers and fruits. Some artists' works depict life cycles and ecosystems, and might even serve as warnings of damage to the environment.

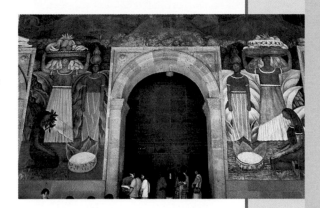

F1–20 **Can you imagine finding this photograph in your social studies textbook? Why or why not? What purpose might this artwork serve?** Diego Rivera, *Tropical Resources*, 1923–28.
Education Ministry, Court of Labor, Mexico City. Courtesy of Davis Art Slides.

The generally accepted domains, or areas, of science are life science, physical science, and earth and space science. Can you identify an art-work for each domain?

Social Studies

Have students categorize the text-book artworks by (1) media and tech-niques, (2) cultures represented, (3) historic events, (4) portraits, and (5) other. **Ask:** Why were these images included in a social-studies text-book? To what degree do the images "tell the truth"? Were these artworks appropriately chosen? Why or why not? What images from today might be included in a social-studies text published 100 years from now?

Science

Collect and display several examples of artworks based on each domain. Ask students to identify and explain how the domain is represented in each image.

Daily Life

You encounter the **work of artists and design-ers** daily, probably more than you realize. Start with this morning—with the clothes you put on, the words and pictures on your cereal box, and the TV you may have watched while you were eating. If you came to school in a vehicle, it was designed and promoted through the efforts of transportation, graphic, and computer designers. On your way, you may have passed public artworks made by sculptors or muralists. Even your school was designed by an architect, and a landscape designer may have planned its grounds.

These examples of purposeful design serve different functions, but each was skillfully developed. What are some more examples of the role that art plays in your life?

Internet Connection
For more activities related to this chapter, go to the Davis website at **www.davis-art.com**.

The Hows and Whys of Art

15

Museum Connection

Work with students to create a "local artworld" center in the classroom, with information about museums, historic homes, nature centers, zoos, and cultural events. Throughout the year, help students appreciate the advantages of visiting museums and other cultural sites.

Interdisciplinary Planning

Many textbooks are richly illustrated with artworks. Review textbooks used in other disciplines in your school to see what im-ages are used. Work with your colleagues to develop handouts with information about the images.

Video Connection

Show the Davis art ca-reers video to give stu-dents a real-life look at the career highlighted above.

Talking About Student Art

Tell students that we can learn from looking respectfully at one another's artworks and considering their intended functions or purposes. Have students consider one another's artworks and propose whether the intended function is personal, cultural, or practical.

Portfolio Tip

 Provide materials and guidance to help students make their own portfolio.

Sketchbook Tip

 Students might wish to make their own book of blank pages to use as their sketchbook.

Portfolio

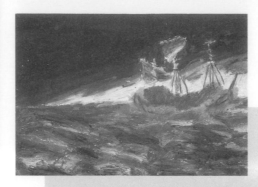

F1–22 Brad Baxley, *Fountain Boys*, 1999.
Pencil, 12" x 18" (30 x 46 cm). Johnakin Middle School, Marion, South Carolina.

F1–21 Priyanka Patel, *Storm Night at Sea*, 1998.
Oil pastel, 9" x 12" (23 x 30 cm). Avery Coonley School, Downers Grove, Illinois.

"We got the idea for these buildings from foods we know. The cheese is a mall, the french fries building is a restaurant. A tube connects them together and cars can go through the tubes."
Kristine Chan / Lindsay Weisberg

F1–23 Kristine Chan and Lindsay Weisberg, *Future City*, 1999.
Watercolor, 11" x 30" (30 x 76 cm). Plymouth Middle School, Plymouth, Minnesota.

 CD-ROM Connection
To see more student art, check out the Global Pursuit Student Gallery.

Teaching Options

Resources

Teacher's Resource Binder
 Chapter Review F1
 Portfolio Tips
 Write About Art
 Understanding Your Artistic Process
 Analyzing Your Studio Work

CD-ROM Connection

 Additional student works related to studio activities in this chapter can be used for inspiration, comparison, or criticism exercises.

Foundation 1 Review

Recall

List three functions and at least three different styles of art.

Understand

Explain the possible functions of a stained-glass window.
(example at right)

Apply

Design a work that has artistic qualities and a practical function. Consider what style and theme you will use and how these will relate to the piece's function. Write an explanatory label describing why your work is art and also a functional object.

Page 4

Analyze

Examine pictures of musicians on pages 10–13. Compare and contrast them in terms of style, theme, and function.

Synthesize

Write two poems, one based on a realistic artwork and the other based on an artwork that is very abstract. How will your words and images correspond to the visual compositions and communicate something about their style?

Evaluate

Imagine being an art critic for your local newspaper, and write a review of an exhibition consisting of Figs. F1–1, F1–2, and F1–3. Create arguments to convince readers that these objects are artworks, making sure to address their function as well as style.

Keeping a Sketchbook

Your sketchbook is a place for you to develop ideas for projects, collect images that interest you, and write your thoughts about art and your experiences. Think of your sketchbook as a place to plan the artworks that you may later put into your portfolio.

Keeping a Portfolio

A portfolio is a record of your growth in art. What you put into your portfolio can be such things as your completed artworks; statements of what you think about art; and reports and research papers about artists, art styles, and art of a certain time or culture. You might even include a regular review of your progress in art.

For Your Portfolio

For your portfolio, set aside a page on which you will make an entry when you complete each chapter. In the entry, you may tell how you think your ideas about art are progressing. You may also write a few sentences that compare what you once thought about a certain area of art and what you think now.

The Hows and Whys of Art

17

Advocacy

Have students design a logo and write a statement about the value of art in society. Suggest to students that they choose one logo and statement to add to all printed programs for school events.

Community Involvement

Arrange for exhibitions of student work in such places as the public library, mayor's office, town hall, malls and storefronts, hospitals, doctors' offices, physical-therapy facilities, and senior centers.

Foundation 1 Review Answers

Recall

Art can have a practical, cultural, and/or personal function. Styles of art include abstraction, realism, expressionism, and fantasy.

Understand

A stained-glass window is practical, because it lets in light and keeps out the cold, rain, and wind. It is a personal expression if the artist wanted to create a particular mood in the interior, or to communicate a particular message visually, by the use of light and glass.

Apply

Students' work should integrate artistic qualities and practical function, and students should clearly articulate how the piece meets both criteria.

Analyze

Students should present an understanding that two artworks can share the same style or function, yet appear different from each other.

Synthesize

Students' words and mental images evoked should be abstract or realistic, just like art. For their art-inspired poetry, students might play with words; for instance, the sounds the words make, or the words' placement on the page.

Evaluate

Check that students have made reference to the objects themselves so as to help justify their arguments.

Reteach

Have students create a time capsule of art objects (that they create, bring in from home, or select from reproductions) to tell future generations something about their culture and society today. Have each student write an explanation of what the items communicate through their function, subject, and style.

Foundation Organizer

Foundation Focus

National Content Standards

Foundation 2
Forms and Media
Foundation 2 Overview
page 18–19

Foundation Focus
- Understand that art forms may be two-dimensional or three-dimensional.
- **2.1** Two-dimensional Artworks
- **2.2** Three-dimensional Artworks

National Content Standards
1 Understand media, techniques, and processes.
2 Use knowledge of structures and functions.

9 weeks	18 weeks	36 weeks		Objectives	National Standards
2	2	1	**Foundation 2.1 Two-dimensional Artworks** page 20 Pacing: One or two 45-minute periods	• Identify and distinguish between two-dimensional art forms and media.	**1a** Select/analyze media, techniques, processes, reflect.
			Try This Mixed-media page 21	• Choose two forms of media to create a two-dimensional mixed-media artwork.	**1a** Select/analyze media, techniques, processes, reflect.

Objectives

National Standards

9 weeks	18 weeks	36 weeks		Objectives	National Standards
2	2	1	**Foundation 2.2 Three-dimensional Artworks** page 24 Pacing: One or two 45-minute periods	• Understand that three-dimensional art forms have height, width, and depth.	**2a** Generalize about structures, functions.
•	•	•	**Try This Describe artworks** page 26	• Recognize architecture, environmental design, sculpture, crafts, and industrial design as three-dimensional art forms.	**2a** Generalize about structures, functions.

Objectives

National Standards

9 weeks	18 weeks	36 weeks		Objectives	National Standards
•	•	•	**Connect to...** page 28	• Identify and understand ways other disciplines are connected to and informed by the visual arts. • Understand a visual arts career and how it relates to chapter content. • Learn to look at and comment respectfully on artworks by peers. • Demonstrate understanding of chapter content.	**6** Make connections between disciplines.

Objectives

National Standards

9 weeks	18 weeks	36 weeks		Objectives	National Standards
•	•	•	**Portfolio/Review** page 30	• Learn to look at and comment respectfully on artworks by peers. • Demonstrate understanding of chapter content.	**5** Assess own and others' work.

Featured Artists

David Hockney
Andy Lackow
Ludwig Mies van der
 Rohe
Gertrude and Otto
 Natzler

I. M. Pei
Henri de Toulouse-
 Lautrec
Filepa Yepa

Vocabulary

art form
art media
fresco
montage

mobile
relief sculpture
ceramics
mosaic

Teaching Options

Teaching Through Inquiry
More About…Fresco
Using the Large Reproduction
Using the Overhead

Technology

CD-ROM Connection
 e-Gallery

Resources

Teacher's Resource Binder
 A Closer Look: F2.1
 Assessment Master:
 F2.1

Large Reproduction 14
Overhead Transparency 7
Slides 3, 4, 7, 11, 13, 15

Teaching Through Inquiry
More About…Paper and printing
Assessment Options

CD-ROM Connection
 Student Gallery
Computer Option

Teacher's Resource Binder
 Thoughts About Art: F2.1

Teaching Options

Teaching Options
Meeting Individual Needs
Teaching Through Inquiry
More About…I. M. Pei
More About…Ludwig Mies van der Rohe
Assessment Options

Technology

CD-ROM Connection
 e-Gallery

Resources

Teacher's Resource Binder
 A Closer Look: F2.2
 Assessment Master:
 F2.2

Large Reproduction 11
Overhead Transparency 12
Slides 1, 2, 6, 5, 8, 12, 18

CD-ROM Connection
 Student Gallery

Teacher's Resource Binder
 Thoughts About Art: F2.2

Teaching Options

Museum Connection

Technology

Internet Connection
Internet Resources
Video Connection
CD-ROM Connection
 e-Gallery

Resources

Teacher's Resource Binder
 Using the Web
 Interview with an Artist
 Teacher Letter

Teaching Options

Advocacy
Family Involvement

Technology

CD-ROM Connection
 Student Gallery

Resources

Teacher's Resource Binder
 Chapter Review F2
 Portfolio Tips
 Write About Art
 Understanding Your Artistic Process
 Analyzing Your Studio Work
 Home Connections Checklist

FOUNDATION 2

Forms and Media

FOUNDATION 2

Chapter Overview

Foundation 2

Depending on the function of their art and their message, artists use either two-dimensional or three-dimensional art forms. To select the most appropriate materials for their expression, artists know about and understand how to use a wide variety of media.

Featured Artists

David Hockney
Andy Lackow
Ludwig Mies van der Rohe
Gertrude and Otto Natzler
I. M. Pei
Henri de Toulouse-Lautrec
Filep Yepa

Chapter Focus

Art forms may be two-dimensional (with height and width) or three-dimensional (with height, width, and depth). Artists consciously choose to use either two-dimensional art media, such as paint, drawing materials, collage, printmaking, and photography; or three-dimensional media, such as architecture, sculpture, or crafts.

Chapter Warm-up

To introduce students to the difference between two- and three-dimensional objects, hold up a sheet of paper. Point out that it has height and width, but so little depth that we usually consider it to be two-dimensional. Challenge students to make a sheet of notebook paper three-dimensional. They may roll it, crumple it, or fold it into an airplane.

Focus

- What are the differences between two-dimensional art forms and three-dimensional art forms?
- What materials do artists use to create two-dimensional and three-dimensional artworks?

When you tell someone that you just created a painting or a sculpture, you are naming the art form you used to express yourself. Art forms can be two-dimensional, as in painting, drawing, printmaking, and collage. Or they can be three-dimensional, as in sculpture, architecture, and even furniture.

When artists plan a work of art, they decide which art form will best express their idea. Then they work in that art form. For example, an artist who wants to express an opinion about nature might create a painting or a drawing. An artist who wants to honor an important person might create a sculpture.

The differences you see between artworks of any one form are vast. This is because artists use a wide variety of materials, or **art media,** to create their artworks. For example, a painter might choose to use oil paints or watercolor. He or she might paint on paper, canvas, or even glass. Similarly, a sculptor might work with clay, stone, or any object that best expresses his or her idea. Imagine seeing a sculpture made from a beach umbrella or a car!

The lessons in this chapter explore art forms and the media most commonly used by artists.

What's Ahead

- **F2.1 Two-dimensional Artworks**
 Explore a variety of two-dimensional art forms and the media artists use to create them.
- **F2.2 Three-dimensional Artworks**
 Explore a variety of three-dimensional art forms and the media artists use to create them.

Words to Know

art form	mobile
art media	relief sculpture
fresco	ceramics
montage	mosaic

Teaching Options

Teaching Through Inquiry

Art Production Have students compare artworks that have similar themes or subject matter but are made from different materials. Discuss the visual effects of different media.

Art Criticism Tell students that one way to look at an artwork is to focus on its technical features and how it was made. Collect examples of artwork (preferably original artwork), each executed in a different medium, such as a watercolor, an oil painting, and a collage. Have students compare and contrast the effects achieved with each medium; for instance, wet-on-wet brushwork, built-up paint, and torn vs. cut edges.

Fig. F2–1 **This artist has combined "instant" photographs into a collage. What idea might he be trying to express about the man in the image?** David Hockney, *Stephen Spender, Mas St. Jerome II,* 1985.
Photographic collage, 20 ½" x 19 ¾" (52 x 50 cm). © David Hockney.

Fig. F2–2 **Basket weaving is a popular art form in Native-American cultures. Baskets are made from grass, cornhusks, reeds, strands of willow, and other natural materials. Their decorative designs and symbols often have special meaning. Native-American baskets are used as ceremonial objects, hats, cooking and storage vessels, and carrying vessels.** Filepe Yepa, *Unfinished Basket.*
Coiled plant fibers, dyes, height: 1 ½" (3.8 cm), diameter: 5" (12.7 cm). Brooklyn Museum of Art, Museum Expedition 1907, Museum Collection Fund. 07.467.8229. ©Justin Kerr.

Fig. F2–3 **In this artwork, a student expressed her appreciation of "the life we use every day." If you made a drawing like this, how would it look different? Why?** April J. Brown, *Fruit and Veggie Delight,* 1999.
Pastel chalk, colored construction paper, 16" x 20" (40.5 x 51 cm). Johnakin Middle School, Marion, South Carolina.

Forms and Media

19

Vocabulary

art form A category of art, either two-dimensional (painting, photography, collage, and the like) or three-dimensional (sculpture, architecture).

art media The materials used to create artworks.

Using the Text

Art Production After students have read the text, discuss the difference between art forms and art media, and ask them to name some art forms. *(painting, sculpture, printmaking, architecture, furniture)* Then ask students what materials or media they could use to make a drawing and a sculpture. *(pens, markers; clay, stone, umbrellas)*

Using the Art

Perception Ask students for the number of dimensions in each artwork shown on page 19. **Ask:** What art form is the basket? *(basket weaving)* What media, or materials, were used to create the basket? *(plant fibers, dye)* What art form is *Stephen Spender, Mas St. Gerome II? (collage or montage)* What is the medium? *(instant photos)*

Teaching Tip

Tell students one consideration when making art is how to use the materials and take care of them.

More About...

The British artist **David Hockney** (b. 1937) is a painter, photographer, stage designer, and has illustrated children's books. He achieved success by his mid-twenties, and a movie about him, *A Bigger Splash* in 1974, enjoyed considerable commercial popularity. Hockney infuses virtually all his work with a sensitivity to light, optimistic wit, and economy of style.

F2.1 FOUNDATION LESSON

Two-dimensional Artworks

Drawing, painting, and other two-dimensional (2-D) art forms have height and width but no depth. To create 2-D artworks, such as those you see in this lesson, artists work with different types of art media.

Drawing and Painting

The most common media for drawing are pencil, pen and ink, crayon, charcoal, chalk, pastel, and computer software programs. Artists who draw choose from a wide range of papers on which to create their images. Although many artists use drawing media to plan other artworks, drawings can also be finished works of art.

Oils, tempera, watercolor, and acrylics are common media used to create paintings. An artist might apply paint to a variety of surfaces, including paper, cardboard, wood, canvas, tile, and plaster. A **fresco,** for example, is a tempera painting applied onto a wet plaster surface.

Collage

To create a collage, an artist pastes flat materials, such as pieces of fabric and paper, onto a background. Some artists combine collage with drawing and painting. Others use unexpected materials, such as cellophane, foil, or bread wrappers. Look back at Fig. F2–1, the collage created by David Hockney, on page 19. A collage made from photographs is called a **montage.** How does Hockney's montage compare with the montage in Fig. F2–5?

Fig. F2–4 **Frescoes are painted directly on a wet plaster wall. Why might some people choose this method of wall decoration over framed paintings? Why might other people prefer framed paintings on their walls?** Pre-Columbian, Tulum (Maya) Mexico, *Temple of Frescoes*, interior, after 1450.
Courtesy of Davis Art Slides.

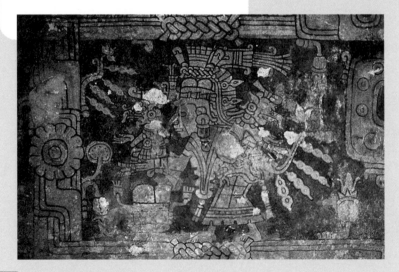

20

Teaching Options

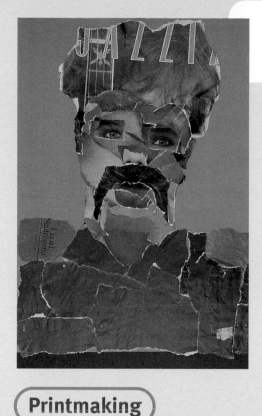

Fig. F2–5 **Through thoughtful choice of imagery and color, this young artist created an expressive, though imaginary, portrait.** Travis Driggers, *Torn*, 1997. Montage, 17" x 12" (43 x 30 cm). Johnakin Middle School, Marion, South Carolina.

Try This

Many contemporary artists combine materials from two art forms to create mixed-media artworks. Choose two forms of 2-D art to combine in your own mixed-media work. Some possibilities are mixing pen and ink with watercolor, computer art with collage, and photography with drawing or painting. Experiment with a few combinations to find one that works for you.

Computer Option
Create a simple scene and, separately, a character (person or animal) in a painting program. Draw the scene using just one tool, such as the paintbrush. Save the file. Draw the character using a different tool, perhaps the pencil or the pen. Save the file. Import the scene and character into an animation program. How might your character move—will it run or fly? Will you add sound? When you are satisfied with your animated artwork, consider how it might change if you created the scene and the character using different tools.

Sketchbook Connection
Landscape artists often sketch scenes outdoors before they create paintings or drawings of them. Find a scene that you like and make a sketch of it in color. Which elements of the scene appeal to you most? Include as many or as few of the elements as you like. Take your sketch home or to class and make a finished painting or drawing from it.

Printmaking

This form of art can be broken down into several different kinds of processes. The main idea is the same for all: transferring an inked design from one surface to another. The design itself might be carved into wood or cut out of paper before it is inked. Then it is pressed by hand onto paper, fabric, or some other surface.

The most common printmaking processes are gadget, stencil, relief, and monoprint. Other more complex processes include lithography, etching, and silkscreen. An artist can print a single image many times using any printmaking process, except monoprinting; as the "mono" in its name suggests, an image can only be printed once.

Forms and Media

21

Using the Art

Art History As students study Fig. F2–4, explain that fresco is an ancient technique found on the walls of Egyptian tombs. Later, Michelangelo used it in the Sistine Chapel. More recently, Diego Rivera used it for murals.

Try This

Provide glue, scissors, and a heavy paper or board and a wide choice of two-dimensional media for students to combine. From Hockney's work (Fig. F2–1), they may be inspired to combine faces from magazines, instant-camera images, or photocopies.

Computer Option
Guide students to create a background, then create objects to animate in front of the background. Objects can be moved along a path, or, if multimedia software is not available, moved from page to page for "flip book" animation.

Backgrounds created in a paint program can be imported into a draw program with a slide-show feature such as AppleWorks Draw, or a program such as PowerPoint. Duplicate the background on multiple pages (or slides). Objects can be inserted in front of the background. The objects will "float" on the background and can be duplicated and repositioned to simulate motion. Run the slide show fast for a flip-book effect.

Using the Text

After reading the text, ask students to discuss examples of graphic design found in the classroom. **Ask:** What kinds of graphic design appeal to you? Can you recognize computer-generated images in TV commercials? How do you recognize them?

Using the Art

Art History Henri de Toulouse-Lautrec created prints and graphic designs such as Fig. F2–6 for the cover of *La Revue Blanche*, one of the most influential French art and literary magazines of the 1890s. This design, with its asymmetrical balance and simplified dark form contrasted against the light background—was influenced by Japanese block prints.

Critical Thinking Ask students to compare the indication of depth in *La Revue Blanche* with that in *Birth of a New Technology*. Challenge them to explain how Lackow represented three-dimensional space and forms on a two-dimensional surface.

Teaching Tips

- Provide each student with an artwork or reproduction, and ask each to role-play the part of the artist and to describe the process employed to make the work.

- Tell students that one thing to consider in expressing an idea is the appropriateness of the media and technique to the idea being presented.

Graphic Design

Graphic designers create original designs, but unlike printmakers, they do not print their designs by hand. They combine type and pictures to create posters, signs, corporate logos or symbols, advertisements, magazines, and books. Most graphic designs are mass-produced on high-speed printing presses. Look around you. What examples of graphic design can you find in your classroom?

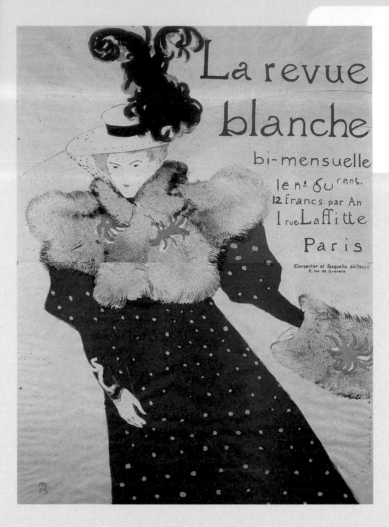

Fig. F2–6 **This artist often portrayed dancers, circus people, and the nightlife of Paris. Notice how he has combined type and image in this artwork. Why might it be useful to combine type and image on a poster or in an advertisement?** Henri de Toulouse-Lautrec, *La Revue Blanche Poster*, 1895. Collection of the McNay Art Museum, Mary and Sylvan Lang Collection.

Teaching Options

Teaching Through Inquiry

Aesthetics Ask: How are various art forms similar to and different from one another? Have students choose two art forms to discuss (for example, painting vs. photography), and engage them in a discussion in which they consider the similarities and differences. To stimulate discussion, use photographs that look like paintings and paintings that look like photographs. Ask students to generalize. Return to the issues raised when you discuss additional art forms throughout the year.

More About...

The Chinese invented **paper** in the second century, and printed with carved wood blocks more than a thousand years ago. **Printing** did not develop in Europe until the fifteenth century. It initially was used to reproduce religious pictures and playing cards before being used to publish books. Eventually, artists explored printing as a viable method for their work.

Fig. F2–7 **Today, computers offer artists the same kinds of "tools" and "materials" that traditional artists have, only in electronic form. In addition to painting and drawing, software programs allow artists to blend and manipulate images. They also create special effects, and do many other things that traditional artists would find difficult or impossible.** Andy Lackow, *Birth of a New Technology*, 1995. Digital art, 3D modeling and rendering, 5" x 7" (12.7 x 17.5 cm). Courtesy of the artist.

Photography, Film, and Computer Art

These 2-D art forms are fairly new in the history of art. The camera was invented in the 1830s, followed by moving pictures about sixty years later. Since their invention, photography and film have become two of the most popular media. Today, video cameras and computers offer even more media for artists working in the film or TV industry.

Although individuals may use a single camera or computer to create art, feature films and television shows are usually created by a team of artists.

Foundation Lesson 2.1

Check Your Understanding
1. What is the difference between art forms and media? What is one art form that you have worked with? What media did you use when you worked in this form?
2. In your own words, describe the difference between printmaking and graphic design. Name an example of a graphic design.

Forms and Media

23

Assess

Check Your Understanding: Answers

1. The art forms are the more general, large categories of types of art, such as sculpture, drawing, and weaving; whereas media are the materials used, such as clay, pencils, or plant fibers. Possible art forms and media are drawing with pencil or sculpture with clay.

2. Printmaking is the transferring of an inked design from one surface to another, but graphic designs are usually reproduced by commercial processes. Answers will vary.

Close

Display students' mixed-media, two-dimensional designs, and encourage each student to explain why he or she chose particular media. **Ask:** If you were to repeat this project, would you use the same media? Why or why not?

Using the Large Reproduction

Use as an example of printmaking. Lead a discussion about the technical aspects of the process.

Using the Overhead

Use as an example of drawing/painting. Discuss technical aspects and effects.

Assessment Options

Peer Have students imagine they are helping to order art supplies for next year. **Ask:** Which materials in List B would you need for each of the art experiences in List A?

List A
1. drawing 2. painting 3. collage 4. printmaking
5. graphic design 6. photography

List B
a. cameras, film. b. pencils, charcoal, chalk. c. watercolors, oils, acrylics. d. rulers, markers, letter guides. e. carving tools, wood, ink, press. f. glue, scissors, assorted materials

Have students work in pairs to compare responses.

Prepare

Pacing

One or two 45-minute periods

Objectives

- Understand that three-dimensional art forms have height, width, and depth.
- Recognize architecture, environmental design, sculpture, crafts, and industrial design as three-dimensional art forms.

Vocabulary

mobile A hanging sculpture with movable parts.

relief sculpture A three-dimensional artwork that includes a raised surface which projects from a background.

ceramics Artworks made from clay, fired at high temperatures in a kiln.

mosaic Artwork made by fitting together tiny pieces of colored glass, tiles, stones, paper, or other materials, which are known as tesserae.

Teach

Engage

Ask: What is distinctive about our school building—an arch, window, or roofline? Remind students that architecture is an art form, and that an architect probably designed the building to include distinctive features. **Ask:** What media were used to build our school?

National Standards Foundation 2.2

2a Generalize about structures, functions.

Three-dimensional Artworks

Architecture, sculpture, and other three-dimensional (3-D) art forms have height, width, and depth. To create 3-D artworks, such as those you see in this lesson, artists work with different types of art media.

Architecture and Environmental Design

Architects design the buildings in which we live, work, and play. They think about what a building will be used for, how it will look, and the way it will relate to its surroundings.

Architects combine materials such as wood, steel, stone, glass, brick, and concrete to create the buildings they design. Then interior designers plan how spaces inside the buildings will look. They choose paint colors or wallpaper, carpeting, and upholstery fabrics. They also suggest how the furniture should be arranged.

Environmental and landscape designers plan parks, landscape streets, and design other outdoor spaces. They use trees, shrubs, flowers, grasses, lighting fixtures, and benches. They also use materials such as stone, brick, and concrete to create paths, sidewalks, and patios.

Fig. F2–8 **Natural daylight provides the best light for viewing fine art. When an architect designs a museum, he or she often creates sources of natural light, such as windows and skylights. You might not know by looking at this view of the East Building that the museum is flooded with natural light. What other things might museum architects have to think about?** I. M. Pei. *East Building of the National Gallery of Art*, 1978.
Exterior view, Washington, DC. Photograph © Board of Trustees, National Gallery of Art, Washington, DC. Photo by Dennis Brack.

24

Teaching Options

Resources

Teacher's Resource Binder
 Thoughts About Art: F2.2
 A Closer Look: F2.2
 Assessment Master: F2.2
Large Reproduction 11
Overhead Transparency 12
Slides 1, 2, 6, 5, 8, 12, 18

Teaching Through Inquiry

Art History Identify an old building, object, or sculpture in the community. Arrange to visit or provide detailed photographs of it. Ask students to describe its scale, production process, subject matter, and visual qualities. Students might choose an object and do this assignment as an individual writing task.

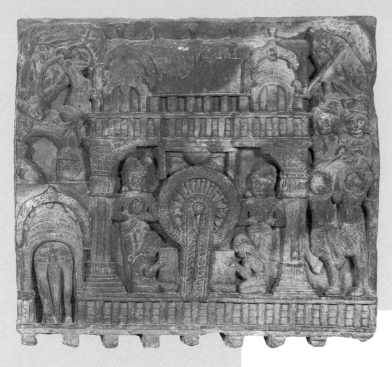

Fig. F2–9 **Relief sculptures often show scenes. How might this sculpture look different if it were created to be seen from all sides?** India, *King Prasenajit Visits the Buddha.* Detail of a relief from the Bharhut Stupa, early second century BC. Hard reddish sandstone, 19" x 20 ¾" x 3 ½" (48 x 52.7 x 9 cm). Courtesy of the Freer Gallery of Art, Smithsonian Institution, Washington, DC.

Sculpture

Sculptures come in many forms. Most are designed to be viewed from all sides. You are probably most familiar with statues. A statue is a sculpture that stands alone, sometimes on a base. It can be life-size, as are the monuments you see in some parks. Or it can be small enough to place on a table or mantelpiece. A **mobile** is a hanging sculpture that has moving parts. The design on a **relief sculpture** is raised from a background surface and is intended to be viewed from only one side.

In addition to having many forms of sculpture to choose from, a sculptor can select from a great variety of media. Traditional materials include wood, clay, various metals, and stone such as marble. Sculptors also work with glass, plastic, wire, and even found objects.

Forms and Media

25

Using the Text

Critical Thinking After students have read page 24, discuss the *East Building of the National Gallery of Art,* Fig. F2–8, and possible answers to the caption question. Encourage students to guess how I. M. Pei might have allowed light into this almost windowless structure. Point out the glass pyramids on top of the center section—these are part of a skylight over a huge central lobby, from which visitors move into smaller galleries. **Ask:** Why might an architect want to flood this entry court with natural light?

Have students read page 25, study the relief sculpture, and answer the caption question. **Ask:** What media is this sculpture? If this work were on the ground next to you, where would it be in relation to your body?

Using the Art

Perception Ask students what geometric shapes they see in the *East Building of the National Gallery of Art.* Note the triangles in the skylight and the front of the building. The whole building is based on triangles.

Critical Thinking

Challenge students to think of an analogy for two and three dimensions. On the chalkboard, write:
2-D is to 3-D as _____ is to _____.
A possible answer is "as circle is to sphere."

Meeting Individual Needs

Multiple Intelligences/Musical Ask students to examine the different three-dimensional art forms on pages 24–27, and to find examples of music, songs, or instruments from different eras and cultures that they would pair with each art form. Have students explain the reasons for their selections, telling what correlation they discovered between what they see and what they hear.

More About...

When Chinese-American architect **I. M. Pei** (b. 1917) designed this addition to the National Gallery, he had to unite his new structure physically and visually with the existing classical building. He clad the new wing with the same kind of pink marble used in the older structure.

Using the Large Reproduction

Compare aspects of sculptural form, architecture, and environmental design with Fig. F2–8.

11

Using the Text

Aesthetics Have students read pages 26 and 27 and the caption questions. **Ask:** What is the art form and medium of each artwork? What is the function of each piece? How does the function influence which media were used to create these pieces? What objects in the classroom would you consider to be a craft? What pieces are industrial designs?

Using the Art

Aesthetics "Less is more" is how Mies van der Rohe summarized his designs. Ask students to look at his armchair and speculate about what he meant by this description. **Ask:** Would you be able to live by this rule?

Try This

Students may either write or sketch this description of architecture, sculpture, and industrial design, or describe it in a class discussion.

Teaching Tip

Tell students that one way to get ideas for making art is to think about how the artwork will be used.

Extend

Assign students to learn more about the National Gallery of Art. They may take virtual tours of it on the Internet (at: www.nga.gov); view pictures of the inside of the court of the East Building, with its huge Alexander Calder mobile; or research I. M. Pei's design process for his addition.

Crafts

The term *crafts* applies to artworks made by hand that are both practical and beautiful. Among the many crafts are ceramics, fiber arts, mosaics, and jewelry making. **Ceramics** are objects that have been made from clay and then fired in a kiln. Fiber arts include objects that have been woven, stitched, or knotted from materials such as wool, silk, cotton, and nylon. A **mosaic** is a design made of tiny pieces of colored glass, stone, or other materials. Artists who make crafts such as jewelry and other personal adornments might use gold, silver, wood, fabric, leather, and beads. Look at the clothing and jewelry your classmates are wearing. What materials are they made of?

Fig. F2–10 **If you owned a ceramic bowl like this, what would you use it for? Would you ever consider using it just as a decorative object? Why or why not?** Gertrude and Otto Natzler, *Bowl* (O437), 1971. Earthenware, grey-green celadon glaze with melt fissures and fire marks, 3 5/16" x 7 7/16" (8.28 x 8.9 cm). American Craft Museum, New York. Gift of Ann and Paul Sperry, 1991. Photo by Eva Heyd.

Fig. F2–11 **Weaving is a popular craft in many cultures. The designs you see in some blankets, clothing, and wall hangings have special meaning. The designs you see in others are purely decorative. Would you consider this wall hanging meaningful or decorative? Why?** Sabrina Cogburn, *Untitled*, 1999. Yarn, 11" x 13" (28 x 33 cm). Asheville Middle School, Asheville, North Carolina.

26

Teaching Options

Teaching Through Inquiry

Art Production Ask students to examine and suggest improvements in the design of tools, functional objects, and spaces for living. To help them identify ways the design of objects might be improved, suggest that they observe people using objects and also consider their own experiences.

Art Production Ask students to compare the designs of useful objects in the everyday environment, and to examine ordinary objects (such as chairs, utensils, and houses) to consider how different cultures have solved problems of daily living.

More About...

Ludwig Mies van der Rohe (1886–1969) immigrated from Germany to America in the 1930s, fleeing the hostile environment Hitler established toward modern art. Mies van der Rohe became best known for his tall, refined modern skyscrapers. His buildings with skins of elegant glass and metal are minimal abstract compositions in three-dimensional form.

Industrial Design

Artists who design three-dimensional products for mass production are called industrial or product designers. They design everything from spoons and chairs to bicycles and cruise ships. Industrial designers pay great attention to a product's function and appearance. They use materials such as metal, plastic, rubber, fabric, glass, wood, and ceramics. The next time you're in a grocery or department store, note the many examples of industrial design all around you.

Fig. F2–12 **How is this chair different from a chair you would find in a living room or in your school?** Ludwig Mies van der Rohe, *Armchair*, designed 1927. Nickel-plated tubular steel, horsehair, ebonized wood, 30 ½" (77.4 cm) high. Purchase: Museum Shop Funds 53. 1997. St. Louis Art Museum.

Try This

Think of an interesting example of architecture, sculpture, and industrial design that you have seen. Describe each work. What makes each one interesting to look at? How does each one compare to the other works? Share your choices with the class.

Foundation Lesson 2.2

Check Your Understanding
1. Explain why the East Building of the National Art Gallery is considered to be a three-dimensional art form.
2. If someone asked you to create a craft of some sort, what would you make? What media would you use? Why?

Forms and Media

27

Assess

Check Your Understanding: Answers

1. The East Building, like other three-dimensional art forms, has height, width, and depth; and was built to express an idea or concept.

2. Answers will vary.

Close

Review the three-dimensional art forms discussed in class and in the text. Discuss students' answers to the Check Your Understanding questions. **Ask:** Why might people consider architecture and industrial design to be art forms? Why might architects and industrial designers study art?

Using the Overhead

Use as an example of crafts.

12

Assessment Options

 Teacher Tell students to pretend that they are giving advice for career planning. Their job is to help students select an art course from List A that would help them to prepare for their chosen career in List B. Have them choose one art course for each career and explain why that area of study would be good for the student to experience.

List A: Art Courses
1. sculpture 2. environmental design 3. industrial design 4. architecture 5. crafts

List B: Career Choices
a. jeweler b. dentist c. landscaper d. construction engineer e. furniture maker

Peer Ask students to identify at least five ways that three-dimensional art forms serve a practical function in their home, school, or community. Have students share lists in small groups and rank the selections.

Daily Life

From a class discussion, elicit and tally students' results, and then graph them on the board or large piece of paper. **Ask:** What conclusions can you draw from the results?

Math

Display physical examples of shapes and forms with the appropriate art and math vocabulary, and discuss these comparisons with students.

Social Studies

Form small groups of students, and assign each group a specific media (such as papyrus) or time period (such as ancient Egypt) to research. Have students compile results and then make and illustrate a class time line of art media. Discuss any findings that students had not been aware of prior to the assignment.

Connect to...

Careers

When asked to name a type of art form, people often select an oil painting. Although **painters of recent centuries** worked primarily with oils on canvas or board, **painters today** might use acrylic paints, automobile paints, or any other pigments that will adhere to a surface.

Some painters begin their career upon completion of their formal education. Many painters teach at the college level, and often paint and exhibit artworks in addition to their teaching duties. Others become graphic artists or work at non-art-related jobs while continuing to paint independently. Not all painters seek professional training: some are self-taught.

F2–13 **Julia May Starr prepares a canvas in her Houston, Texas, studio. Starr soaks paper, cardboard, and other material in water and then uses acrylic gel medium to apply the items to the gessoed canvas. The collaged surface of the canvas, when dry, is ready to be painted with acrylic paint. Even covered with paint, the shapes are visible.**
Photo by G. Young.

Other Arts

Theater

Scene designers and **scenic artists** work in both two- and three-dimensional media as they create the set design for a theatrical performance. Examples of two-dimensional scene design are representational paintings, such as a backdrop that depicts a park; painted designs on wall flats to indicate wallpaper; and *trompe l'oeil*, the art of painting 3-D, photographic details, such as windows or doors, on a 2-D surface.

Three-dimensional scenic elements include working windows and doors, stairways, and furniture. When you next see a play, note the difference in how actors interact with the 2-D scenic elements and with the 3-D elements.

F2–14 **Which scenic elements in this photograph are two-dimensional and which are three-dimensional? How would actors interact with each type of scenery?** Scott Dunlap, set design, *The House at Pooh Corner*, 1998.
Photo courtesy of The Chattanooga Theatre Center, Andrew D. Harris, director.

28

Teaching Options

Resources

Teacher's Resource Binder
Using the Web
Interview with an Artist
Teacher Letter

Internet Resources

The Saint Louis Art Museum
www.slam.org/
 A beautifully designed site: works from the collections, featured exhibitions.

Winsor & Newton
http://www.winsornewton.com/
Take an online factory tour and browse an encyclopedia of hints, tips, and techniques for using pastels and watercolor, acrylic, and oil paints.

Daily Life

How many **art forms** and **media** do you think you encounter in one day? Find out by writing a list on paper. First, list art forms—painting, drawing, printmaking, collage, and so on. Then list art media—oil paints, watercolor, clay, stone, metal, and so on. For an entire day, carry the list with you, and keep a tally of the art forms and media you come upon.

Do any of the results surprise you? Did you find that writing down the art forms and media made you more aware of art than usual? Did you see anything in a new or different way?

Other Subjects

Mathematics

You might be surprised to learn that **art and mathematics share** some concepts but have different vocabulary for them. For example, in art, shapes that have only height and width are called two-dimensional shapes. In math, the term for these same shapes is plane figures. In art, shapes that have height, width, and depth are termed three-dimensional forms. In math, they are called space figures or space solids.

Social Studies

Paper has played an important role across cultures and over time. Paper began with the ancient Egyptians in 3000 BC. By pressing together thin stems of papyrus reeds, they developed papyrus. In 100 AD, the Chinese invented paper made from mulberry and bamboo bark. In Europe and the Mediterranean, animal-skin parchment and vellum was developed as early as 200 BC. Sheepskins or calfskins were soaked, and then stretched on a frame and scraped. Rubbing with pumice smoothed the final surface.

F2-15 **Brazilian artist Sonia von Brusky focuses on mathematical concepts in her work.** Sonia von Brusky, *Fractalization of a Circle*, 1997.
Tempera on canvas, 59" x 59" (150 x 150 cm). Courtesy of the artist.

Paper became popular in Europe during the thirteenth century. Though less durable than parchment, paper was cheaper and easier to make. Early paper was made from a pulp of water and rags. With a press, water was removed from the pulp and the fibers flattened.

Internet Connection
For more activities related to this chapter, go to the Davis website at **www.davis-art.com.**

Other Arts

Distribute large sheets of paper. Have students work in groups to draw a life-size park bench and a lamppost. Hang the paper on a wall, and ask two volunteers to act out a scene in front of the paper backdrop (meeting for lunch in the park, for example). Encourage students to watch the scene closely, paying special attention to how the actors interact with the two-dimensional scenery.

Next, place two chairs side by side to represent a park bench, and place a coat rack next to the chairs to represent a lamppost. Ask the actors to replay the scene, this time using the three-dimensional scenic elements. Again, everyone should watch closely.

Lead a discussion of how the two scenes differed. **Ask:** What possibilities for use does the scenery present for the actors? How did the actors interact with the scenery in each scene? Which scene was more believable? Why?

Forms and Media

29

Museum Connection

Before taking students to a museum, describe what they will be seeing. Select one or more of the Museum Warm-up Exercises in the Teacher's Resource Binder before the museum visit.

Video Connection

Show the Davis art careers video to give students a real-life look at the career highlighted above.

Talking About Student Art

Remind students that one way to understand an artwork is to imagine the steps the artist took and the way he or she used the materials. Encourage students also to imagine the decisions that the artist had to make along the way.

Portfolio Tip

 For keeping track of each portfolio entry, have students attach a table of contents with item number, date, title, and description.

Sketchbook Tip

 Students might need several sketchbooks in various sizes. They might use large sketchbooks at home or in the classroom, and small sketchbooks on field trips or for outdoor sketching.

Portfolio

"For *Space Kitty*, I wanted to be creative and do a space theme. Normally you see cats doing the usual thing: sitting or playing with a ball. I did use the ball of yarn, but thought it would be neat with stars and planets and not colored polka dots." **Kiera Hartnett**

F2–16 Jenetta Tart, *Ancestor's Face*, 1997.
Relief print, 9" x 6" (23 x 15 cm). Johnakin Middle School, Marion, South Carolina.

F2–17 Kiera Hartnett, *Space Kitty*, 1999.
Papier-mâché, tempera paint, 20" x 16 ½" x 8" (51 x 42 x 20 cm). Copeland Middle School, Newton, New Jersey.

 CD-ROM Connection
To see more student art, check out the Global Pursuit Student Gallery.

F2–18 Christina Marshburn, *Ceramic Pin*, 1999.
Clay, 2" x 2" (5 x 5 cm). Colony Middle School, Palmer, Alaska.

30

Teaching Options

Resources

Teacher's Resource Binder
 Chapter Review F2
 Portfolio Tips
 Write About Art
 Understanding Your Artistic Process
 Analyzing Your Studio Work
 Home Connections Checklist

CD-ROM Connection

 Additional student works related to studio activities in this chapter can be used for inspiration, comparison, or criticism exercises.

Foundation 2 Review

Recall

Give three or more examples of both two-dimensional and three-dimensional artworks.

Understand

List the different media that artists might use when creating three- and two-dimensional artwork.

Apply

Select a reproduction of a two-dimensional artwork in this book (*example below*), and transform it into three dimensions. Consider what materials will work best as you translate a flat image into one with actual depth.

Analyze

Describe how a mosaic is both a two- and three-dimensional artwork. (See also page 122.)

Synthesize

Write explanatory labels for a two-dimensional artwork and a three-dimensional artwork, providing information about their materials and form. (You might select works from this book, from another book, or from an art display in your school.) How do the form and media work together to express the artist's intent? Interview a viewer to see if she or he understands your labels, and amend the labels if necessary.

Evaluate

Imagine shopping for a beautiful new desk for your home. In the showroom, you see a hand-carved wooden desk by a craftsperson and a sleek metal-and-leather desk by an industrial designer. Write a dialogue between you and the salesperson in which you explain your final choice of one desk over the other.

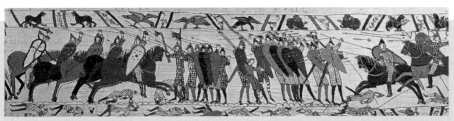

Page 124

For Your Sketchbook

Paste in your sketchbook some images of artworks made with different media. These might be from magazines, printouts of web pages, or photocopies from books. For each image, write notes about features that interest you.

For Your Portfolio

Carefully select artworks for your portfolio. You may want to include work that shows how you have grown as an artist. Or you may want to choose works that show your use of different media and techniques. With each portfolio artwork, include your name, the completion date, the purpose of the assignment, what you learned, and why you selected the work.

Advocacy

Collect relevant press clippings or magazine articles on the value of art in society and the value of art education in the school curriculum. Make copies, and distribute them to school-board members and administrators.

Family Involvement

Use the Home Connections Checklist in the Teacher's Resource Binder to communicate ways for family members to support schooling efforts.

Foundation 2 Review Answers

Recall

two-dimensional: paintings, prints, collage, and photography; three-dimensional: sculpture, architecture, jewelry, and furniture.

Understand

Students' lists should show an understanding of the materials and techniques for each art form discussed in Foundation 2.1 and Foundation 2.2.

Apply

Students' work should show a thoughtful expression and approach to translating a two-dimensional image into a three-dimensional form, and to paying particular attention to the use of real space.

Analyze

Mosaics are flat, two-dimensional art meant to be viewed straight on, like a painting or photograph. However, mosaics are created from small pieces of solid materials and therefore take on some depth, making them three-dimensional.

Synthesize

Look for labels that articulate the specific forms and media of each example.

Evaluate

Check students' work for an understanding of the difference between handcrafted and industrially produced designs.

Reteach

Have students write a short story for children about a character—an animal or person—that explores two- and three-dimensional artwork for the first time. How will the experience be different for the character as she or he examines each type of work? What adventurous tales will your character tell upon returning home?

Foundation Organizer

9 weeks	18 weeks	36 weeks			

Foundation Focus

- Understand that artists use the elements and principles of design to best express their ideas.
- **3.1** Elements of Design
- **3.2** Principles of Design

National Content Standards

2 Use knowledge of structures and functions.

9 weeks	18 weeks	36 weeks			
2	3	2			

Foundation 3.1: Elements of Design
page 34
Pacing: Two or three 45-minute periods

Objectives

- Perceive and identify the art elements line, shape, form, color, value, space, and texture in artworks.

National Standards

2a Generalize about structures, functions.

Try This Mixed-media
page 40

- Create a rubbing, using an understanding of color and texture.

2c Select, use structures, functions.

9 weeks	18 weeks	36 weeks			
2	2	2			

Foundation 3.2 Principles of Design
page 42
Pacing: Two 45-minute periods

Objectives

- Understand and perceive the principles of design in artworks.

National Standards

2a Generalize about structures, functions.

9 weeks	18 weeks	36 weeks
•	•	•

Try This Painting or Drawing
page 42

- Create a painting or drawing illustrating symmetrical, asymmetrical, or radial balance.

2b Employ/analyze effectiveness of organizational structures.

9 weeks	18 weeks	36 weeks
•	•	•

Connect to...
page 48

Objectives

- Identify and understand ways other disciplines are connected to and informed by the visual arts.
- Understand a visual arts career and how it relates to chapter content.

National Standards

6 Make connections between disciplines.

Portfolio/Review
page 50

Objectives

- Learn to look at and comment respectfully on artworks by peers.
- Demonstrate understanding of chapter content.

National Standards

5 Assess own and others' work.

Featured Artists

Giacomo Balla	Lori Kammeraad	Rene Robinson
Claudio Bravo	Ellsworth Kelly	Charles Sheeler
Helen Escobedo	Christine Kidder	Howard Storm
Jacques Hnizdovsky	Stanton MacDonald-Wright	Laura Wheeler Waring
Edward Hopper	René Magritte	Jackie Winsor
	Georgia O'Keeffe	

Vocabulary

Elements of Design	Principles of Design
line	balance
shape	unity
form	variety
color	emphasis
value	proportion
space	pattern
texture	movement and rhythm

Teaching Options

Teaching Through Inquiry
Meeting Individual Needs
More About…Sculpture
Using the Large Reproduction
More About…Still Life
Using the Overhead
More About…Laura Wheeler Waring

Technology

CD-ROM Connection
e-Gallery

Resources

Teacher's Resource Binder
A Closer Look: F3.1
Assessment Master: F3.1

Large Reproduction 12, 17
Overhead Transparency 9, 13
Slides 1, 4, 6, 7, 9, 10, 11, 17

Teaching Through Inquiry
More About…Australian Aboriginal artists
Assessment Options

Computer Option
CD-ROM Connection
Student Gallery

Teacher's Resource Binder
Thoughts About Art: F3.1

Teaching Options

Teaching Through Inquiry
More About…Watercolor
Using the Large Reproduction
Using the Overhead
More About…Silkscreen printing
More About…Futurism
Assessment Options

Technology

Computer Option
CD-ROM Connection
e-Gallery

Resources

Teacher's Resource Binder
A Closer Look: F3.2
Assessment Master: F3.2

Large Reproduction 8, 14
Overhead Transparency 5, 17
Slides 2, 9, 11, 12

CD-ROM Connection
Student Gallery

Teacher's Resource Binder
Thoughts About Art: F3.2

Teaching Options

Museum Connection

Technology

Internet Connection
Internet Resources
CD-ROM Connection
e-Gallery

Resources

Teacher's Resource Binder
Using the Web
Interview with an Artist
Teacher Letter

Teaching Options

Advocacy
Community Involvement

Technology

CD-ROM Connection
Student Gallery

Resources

Teacher's Resource Binder
Chapter Review F3
Portfolio Tips
Write About Art
Understanding Your Artistic Process
Analyzing Your Studio Work

FOUNDATION 3

Chapter Overview

Foundation 3

Artists use the elements and principles of design to create their art. To communicate effectively through art, artists must understand how the elements and principles interact.

Featured Artists

Giacomo Balla
Claudio Bravo
Helen Escobedo
Jacques Hnizdovsky
Edward Hopper
Lori Kammeraad
Ellsworth Kelly
Christine Kidder
Stanton MacDonald-Wright
René Magritte
Georgia O'Keeffe
Claes Oldenburg and Coosje Van Bruggen
Rene Robinson
Charles Sheeler
Howard Storm
Laura Wheeler Waring
Jackie Winsor

Chapter Focus

The elements of design are line, shape, form, color, value, space, and texture. The principles of design are balance, unity, variety, emphasis, proportion, pattern, and movement and rhythm.

By understanding the elements and principles, artists can choose and manipulate them to best express their ideas.

Elements and Principles of Design

Focus

- What are the elements and principles of design?
- How do artists use the elements and principles of design in their artworks?

Artists use their imagination when they work. They experiment with ideas and art media, and invent new ways to create artworks. But before they actually get down to making a work of art, they must have a plan, or design, in mind.

In art, the process of design is similar to putting a puzzle together. The basic pieces or components that an artist has to choose from are called the *elements of design*. Line, shape, form, color, value, space, and texture are the elements of design. The different ways that an artist can arrange the pieces to express his or her idea are called the *principles of design*. Balance, unity, variety, movement and rhythm, proportion, emphasis, and pattern are the principles of design. When an artist is happy with the arrangement, the design is complete.

As you learn about the elements and principles of design, think about how they can help you plan and create your own art. Soon you will see that they can also help you understand and appreciate the artworks of others.

What's Ahead

- **F3.1 Elements of Design**
 Learn how artists can use the elements of design to create certain effects in their artworks.
- **F3.2 Principles of Design**
 Learn ways that the principles of design can make an artwork exciting to look at.

Words to Know

Elements of Design		Principles of Design	
line	value	balance	proportion
shape	space	unity	pattern
form	texture	variety	movement
color		emphasis	rhythm

National Standards Foundation 3 Content Standards

2. Use knowledge of structures and functions.

Teaching Options

Teaching Through Inquiry

Art Criticism Discuss some artworks with students, and ask them to note line, shape, and color in each work. On 3" x 5" cards, print appropriate descriptive terms for each element (for instance, for line: curvy, rigid, zigzag; for shape: soft, bold; for color: loud, soft, bright). Distribute the cards, and have students point to lines, shapes, and/or colors that correspond to the terms on their cards.

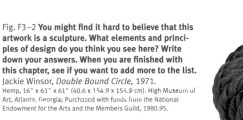

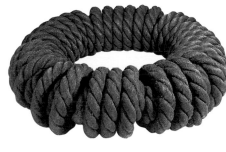

Fig. F3–1 **This artist used a print-making process called etching to create this image. Notice how the image is made from hundreds of tiny lines. How has the artist used line to create light and dark areas?** Edward Hopper, *Night Shadows*, 1921. Etching. Collection of the McNay Art Museum, Gift of the Friends of The McNay.

Fig. F3–2 **You might find it hard to believe that this artwork is a sculpture. What elements and principles of design do you think you see here? Write down your answers. When you are finished with this chapter, see if you want to add more to the list.** Jackie Winsor, *Double Bound Circle*, 1971. Hemp, 16" x 61" x 61" (40.6 x 154.9 x 154.9 cm). High Museum of Art, Atlanta, Georgia; Purchased with funds from the National Endowment for the Arts and the Members Guild, 1980.95.

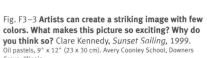

Fig. F3–3 **Artists can create a striking image with few colors. What makes this picture so exciting? Why do you think so?** Clare Kennedy, *Sunset Sailing*, 1999. Oil pastels, 9" x 12" (23 x 30 cm). Avery Coonley School, Downers Grove, Illinois.

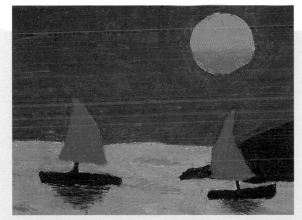

Elements and Principles of Design

33

More About...

Most Minimalist art, which flourished from the mid 1960s through the first half of the 1970s, was hard-edged and clean with uninflected surfaces. The sculptor **Jackie Winsor** (b. 1941), however, built reduced abstract art using unusual materials such as metal, cement, wood, rope, and nails that created rough, impetuous surfaces.

Supplies for Warm-up

For discussion, have a large art reproduction available. A nonobjective print focuses attention more on the elements and principles, rather than on the subject.

Chapter Warm-up

Refer students to the list of design elements and principles on page 32. Display the art reproduction, and lead students in describing the artwork. Encourage them to notice not only the subject, but also the lines, shapes, forms, colors, space, and textures. **Ask:** What elements seem most important in this artwork? Tell students that the principles of design have to do with different ways of arranging the elements.

Using the Text

Art Criticism After students have read the text and thought about the caption questions, **ask:** Which art elements and principles are most effective in each artwork shown on page 33? For each piece, have students also note the art form and media.

Using the Art

Art Criticism Ask students to study Edward Hopper's *Night Shadows*. **Ask:** What seems to have been most important to this artist? Explain that light and shadows play a major role in Hopper's art. **Ask:** Where is the viewer? What mood is portrayed? How might the man feel? What devices did Hopper use to convey this emotion?

Perception Refer students to *Double Bound Circle*. **Ask:** What is this sculpture's main form? Point out that the repeated ropes create a regular pattern and rhythm around the donut shape.

Aesthetics Ask: Is *Double Bound Circle* a sculpture or just a coil of rope? Ask students to support their answer.

The Elements of Design

Prepare

Pacing

One to two 45-minute period to discuss the art elements

One 45-minute period for Try This

Objectives

- Perceive and identify the art elements line, shape, form, color, value, space, and texture in artworks.
- Create a rubbing, using an understanding of color and texture.

Vocabulary

elements of design The ingredients that artists use to create an artwork (line, shape, form, color, value, texture). For individual definitions, see the glossary on page 312.

Supplies for Engage

- paper and pencils or markers
- red, yellow, and blue paint or chalk pastels (to demonstrate color mixing)

Teach

Engage

Have students draw a line to represent how they feel right now. Display and discuss the variety of lines—straight, rounded, zigzag, dark, and so on. Explain that line, an art element, can have many different qualities that may be used expressively.

National Standards Foundation 3.1

2a Generalize about structures, functions.

2c Select, use structures, functions.

Line

Many people think of a **line** as the shortest distance between two points. To artists, a line is a mark that has length and direction. Lines can have many different qualities that help artists express their ideas. They can be thick or thin, wavy, straight, curly, or jagged. Artists use lines to outline shapes and forms or to suggest different kinds of movement. Sometimes artists use *implied* line. An implied line is not actually drawn, but is suggested by parts of an image or sculpture, such as a row of trees or a path of footprints.

If you look closely, you can find examples of line in every work of art you see. Notice how they affect the mood of an artwork. For example, how might a drawing with thick, zigzag lines be different from one with light, curved lines?

Fig. F3–4 Artists sometimes use *contour* lines to show the edges, ridges, or outlines of an object. What shapes do the lines in these drawings suggest? Are the shapes geometric or organic? Why do you think so? Ellsworth Kelly, *Sweet Pea*, 1960.
Graphite on white wove paper, 22 ¹/₂" x 28 ¹/₂" (57 x 72 cm). The Baltimore Museum of Art.

Fig. F3–5 This student used lines and shapes to create the look of action. How might this drawing be different if all the lines were horizontal and vertical? Michael Byrd, *In Every Direction*, 1997.
Watercolor marker, 18" x 12" (46 x 30 cm). Johnakin Middle School, Marion, South Carolina.

34

Resources

Teacher's Resource Binder
 Thoughts About Art: F3.1
 A Closer Look: F3.1
 Assessment Master: F3.1
Large Reproduction 12, 17
Overhead Transparency 9, 13
Slides 1, 4, 6, 7, 9, 10, 11, 17

Teaching Through Inquiry

Art Production Have students experiment by arranging an assortment of cut shapes. Ask students to **make sketches or small models** to anticipate how a work might look if certain parts were changed. Discuss how they could make changes in contrast, shapes, size, directionality, color, and so on, to create different visual effects when expressing ideas.

Fig. F3–6 **This artist used geometric shapes to build the forms of her sculpture. Notice how the corners of the squares create implied lines. Where do you see positive shapes? Where do you see negative shapes?** Helen Escobedo, *Coatl (snake)*, 1982. Steel I-beams, 19' 6" x 48' 9" (6 x 15 m). National University of Mexico.

Shape and Form

A line that surrounds a space or color creates a **shape.** Shapes are flat, or two-dimensional. A circle and a square are both shapes. A **form** is three-dimensional: It has height, width, and depth. A sphere and a cube are examples of forms.

Shapes and forms may be organic or geometric. *Organic* shapes and forms—such as leaves, clouds, people, ponds, and other natural objects—are often curved or irregular. *Geometric* shapes and forms—such as circles, spheres, triangles, pyramids, and cylinders—are usually precise and regular.

Most two-dimensional and three-dimensional designs are made up of both *positive* shapes and *negative* shapes. The figure in a painted portrait is the painting's positive shape. The pieces of fruit in a still-life drawing are the positive shapes in the drawing. The background or areas surrounding these objects are the negative shapes. The dark, solid shape of a statue is a positive shape. The area around and inside the forms of the statue make the negative shapes. Artists often plan their work so that the viewer's eyes move back and forth between positive and negative shapes.

Elements and Principles of Design

35

Using the Text

Perception After students have read page 34, discuss their answers to the caption questions for Ellsworth Kelly's *Sweet Pea*. **Ask:** What type of lines, geometric or organic, are in Helen Escobedo's *Coatl?* Challenge students to describe the implied line in *Coatl.*

Perception Have students read page 35, and discuss the positive and negative shapes in Helen Escobedo's *Coatl.* Encourage students to find other examples of positive and negative shapes in artworks in this book.

Using the Art

Art Criticism Have students compare Ellsworth Kelly's drawing style in *Sweet Pea* with Hopper's style in *Night Shadows,* Fig. F3–1. **Ask:** What types of lines are used in each? Which is more finished? Why? What was each artist most interested in showing? Guide students in imagining that they are drawing these pictures. **Ask:** How would your hands move?

Art Production Set up nature objects so that students may draw contour lines such as those in *Sweet Pea.* To focus their attention on drawing the details of their subject, guide students to look only at the object, not their paper.

Meeting Individual Needs

English as a Second Language Write *square* and *circle* on the chalkboard. Provide definitions. Ask students to find the shapes in Fig. F3–5, then draw their own design with circles and squares and label these shapes using English.

Multiple Intelligences/Spatial Ask students how Helen Escobedo created a three-dimensional form from two-dimensional shapes in *Coatl.* Discuss the major difference between the flat photograph of the work and the three-dimensional, real artwork. **Ask:** How did Escobedo use shape and form to draw you into the piece? *(The squares move back, creating a tunnel.)*

More About...

Humans from prehistory to the present have created **sculpture.** Traditionally, artists built up or carved out their work—using metal, wood, clay, or other malleable material. In recent decades, artists have created kinetic sculpture, which moves by mechanical or natural means. Although stable, Helen Escobedo's *Coatl* (Fig. F3–6) implies the arching movement of a snake.

Using the Large Reproduction

Compare shape, form, and materials with Fig. F3–6, *Coatl,* by the same artist.

17

Using the Text

Perception Tell students to refer to the color wheel as they read pages 36 and 37. Demonstrate the mixing of the primary colors to create the secondary and intermediate hues. If time allows, let students experiment with color mixing.

In science class, students may have learned about additive color theory, in which all colors mixed together make white. Explain that blending pigments is different. If all pigment colors are mixed, the result is a muddy gray.

Using the Art

Art Criticism Focus students' attention on Stanton MacDonald-Wright's *Conception Synchromy,* and discuss their answers to the caption questions. **Ask:** How is this painting like a color wheel? Where are the lightest and darkest values?

Ask students to identify the darkest and lightest values in Claudio Bravo's *Still Life.* **Ask:** Where is the light source? How did the artist use contrasts of value to emphasize the fruit? Where are the organic and geometric lines and shapes?

Critical Thinking

Tell students that colors can be very powerful in conveying a mood or feeling in an artwork. Challenge students to write a description of the mood that MacDonald-Wright created with his choice of color in *Conception Synchromy.*

Color and Value

Without light, you cannot experience the wonderful world of **color.** The wavelengths of light that we can see are called the color spectrum. This spectrum occurs when white light, such as sunlight, shines through a prism and is split into bands of colors. These colors are red, orange, yellow, green, blue, and violet.

In art, the colors of the spectrum are re-created as dyes and paints. The three *primary hues* are red, yellow, and blue. *Primary* means "first" or "basic." *Hue* is another word for "color." You cannot create primary colors by mixing other colors. But you can use primary colors, along with black and white, to mix almost every other color imaginable.

Fig. F3–7 **A color wheel arranges the colors of the spectrum and related colors in a circle. It can help you remember some of the basic principles of color. Refer to a color wheel whenever you plan an artwork.** (See page 308.)

Y=yellow V=violet
G=green R=red
B=blue O=orange

Fig. F3–8 **Artists can mix colors of paint to create any color on the color wheel and many more. Look carefully at this painting. Where do you see primary colors? Secondary colors? Intermediate colors?** Stanton MacDonald-Wright, *Conception Synchromy,* 1914.
Oil on canvas, 36" x 30 1/8" (91.4 x 76.5 cm). Hirshhorn Museum and Sculpture Garden, Smithsonian Institution, Gift of Joseph H. Hirshhorn, 1966. Photo: Lee Stalsworth.

36

Teaching Options

Teaching Through Inquiry

Perception Have students sort visuals or art reproductions into categories of dark or light values.

Art Production Have students observe objects under different lighting conditions and then record those observations with gradations of pencil values.

More About...

The ancient Romans sometimes painted **still-life** images on the walls of their villas. The art form, however, was not held in high regard until after the Renaissance. It was considered a minor subject compared to large multifigure works along historical, literary, mythic, or biblical themes. Seventeenth-century Dutch artists were the first to consider still lifes an independent genre worthy of serious pursuit.

Fig. F3–9 **This value scale shows a range of grays between white and black. Hues can also be arranged by their value.**

Fig. F3–10 **Artists use shading to create a gradual change in value and to make a smooth transition between light and dark areas in an artwork. How does this artist use shading to make the fruit look realistic?** Claudio Bravo, *Still Life*, 1980. Pencil on paper, 14 9/16" x 20 13/16" (37 x 52.7 cm). Jack S. Blanton Museum of Art, The University of Texas at Austin, Barbara Duncan Fund, 1980. Photo: George Holmes.

Teaching Tip

Ask students to squint their eyes and look at some artworks. Explain that this will help them identify the dark, middle, and light areas.

Extend

Teach students to create a color wheel by mixing primary colors of watercolors, tempera, acrylics, or chalk pastels. After their work has dried, suggest that they cut up the wheel and rearrange the colors to form designs.

The *secondary* hues are orange, green, and violet. You can create these by mixing two primary colors: red and yellow make orange; yellow and blue make green; red and blue make violet.

To create *intermediate* hues, you mix a primary color with a secondary color that is next to it on the color wheel. For example, mixing yellow and orange creates the intermediate color of yellow-orange.

Value refers to how light or dark a color is. A light value of a color is called a *tint*. A tint is made by adding white to a color. Pink, for example, is a tint made by adding white to red. Artworks made mostly with tints are usually seen as cheerful, bright, and sunny.

A dark value of a color is called a *shade*. A shade is made by adding black to a color. For example, navy blue is a shade made by adding black to blue. Artworks made mostly with dark values are usually thought of as mysterious or gloomy.

Elements and Principles of Design

37

Using the Overhead

Compare light, value, contrast, and color with Fig. F3–10, *Still Life*.

9

Elements of Design

Using the Text

Perception Have students read the text and then identify the complement of each primary and secondary color. Ask students to suggest ways to mix brown. Then lead students in analyzing the color intensity and value of the clothes they are wearing.

Using the Art

Art Criticism Ask students to identify the color schemes in the artworks on page 39. To check understanding, provide pairs of students with a box of pastels, crayons, or oil pastels, and have them select the colors that make up each of the schemes. Discuss what mood is created by the colors in each painting.

Teaching Tip

Tell students that one thing to consider when expressing an idea is how value changes affect the artwork.

The intensity of a color refers to how bright or dull it is. Bright colors are similar to those in the spectrum. You can create dull colors by mixing complementary colors. *Complementary* colors are colors that are opposite each other on the color wheel. Blue and orange are complementary colors. If you mix a small amount of blue with orange, the orange looks duller. Many grays, browns, and other muted colors can be mixed from complementary colors.

When artists plan an artwork, they often choose a *color scheme*—a specific group of colors—to work with. An artist might use a primary, secondary, intermediate, or complementary color scheme. Or the artist might choose any of the color schemes illustrated in the chart below.

Common Color Schemes

warm: colors, such as red, orange, and yellow, that remind people of warm places, things, and feelings.

cool: colors, such as violet, blue, and green, that remind people of cool places, things, and feelings.

neutral: colors, such as black, white, gray, or brown, that are not associated with the spectrum.

monochromatic: the range of values of one color (monochrome means "one color").

analogous: colors that are next to each other on the color wheel; the colors have a common hue, such as red, red-orange, and orange.

split complement: a color and the two colors on each side of its complement, such as yellow with red-violet and blue-violet.

triad: any three colors spaced at an equal distance on the color wheel, such as the primary colors (red, yellow, blue) or the secondary colors (orange, green, violet).

Teaching Options

Teaching Through Inquiry

Art Production Challenge students to plan a series of pictures that depict different kinds of weather or different times of day: foggy, rainy, sunny, moonlit, dark, early, and so on. They should consider how color and value play important roles in portraying these effects.

More About...

The noted African-American educator and realist painter **Laura Wheeler Waring** (1887–1948) was a Hartford, Connecticut native. She is best known for her landscape paintings and portraits of African-American celebrities, including historian W.E.B. DuBois, artist Alma Thomas, and opera singer Marian Anderson.

Fig. F3–11 **Georgia O'Keeffe used a warm color scheme to create this painting of a mountain. Why might she have chosen a warm color scheme? How does the painting make you feel?** Georgia O'Keeffe, *The Mountain, New Mexico*, 1931.
Oil on canvas, 30 ¼" x 36 ⅛" (76.4 x 91.8 cm). Collection of Whitney Museum of American Art, New York. Photo by Sheldon C. Collins. © 2000 The Georgia O'Keeffe Foundation/Artists Rights Society (ARS), New York.

Fig. F3–13 **Howard Storm chose a cool color scheme to show a wintry land-scape. Why might someone also call this an analogous color scheme?** Howard Storm, *Winter House*, 1980.
Oil on canvas, 26" x 26" (66 x 66 cm). Courtesy of the artist.

Fig. F3–12 **The color scheme you see here includes neutral browns, tans, and whites. What feeling might the artist be expressing with this color scheme?** Laura Wheeler Waring, *Anna Washington Derry*, 1927.
Oil on canvas, 20" x 16" (51 x 41 cm). ©National Museum of American Art, Smithsonian Institution, Washington, DC (Gift of the Harmon Foundation)/Art Resource, New York.

Sketchbook Connection

Use colored pencils to create a value scale in the color of your choice. Refer to Fig. F3–9 as needed. Next, diagram your own example of each of these color schemes: complementary, split complement, analogous, and triad. Which color scheme interests you the most? Why?

Extend

Perception Ask: How do we perceive complementary colors? Have students gaze at a red square on a white background for at least twenty seconds. When they look away from the red square, most students will see a green afterimage, which is the complement of the red image. Explain that this happens because the receptors in our eyes that perceive red are also the receptors that perceive green.

Art Production Challenge students to paint a composition in one of the common color schemes. Ask them to label the back of their artwork with the color scheme they used.

Elements and Principles of Design

39

Using the Overhead

Compare use of color with Figs. F3–11 and F3–12.

13

Using the Text

After students have read page 41, ask them to explain the difference between actual and implied texture. **Ask:** Which artworks on pages 40 and 41 have implied textures? Which have actual texture?

Using the Art

Perception Discuss the illusion of space in *New York Subway*. Encourage students to finger-trace the linear-perspective lines in the platform, tracks, and walls, and to notice that they all meet at the same point. **Ask:** How did Hnizdovsky direct our attention?

Perception Ask students to study Robinson's *Snake Dreaming*. **Ask:** How did the artist indicate textures? What types of lines represent each texture?

Try This

The paper for this frottage (French for "rubbing") should be at least as thin as photocopy paper. If students rub with crayons or oil pastels, they may carry this project further by painting with a contrasting color of watercolor to create a resist; or they may create a collage with shapes cut from the rubbing.

Extend

Have students draw negative spaces. Set a chair on a desk so that the whole class can see it well. Demonstrate how to frame the chair in a viewfinder so that the chair touches the edge of the viewfinder in at least two places. Instruct students to draw the shapes between the edge of the viewfinder and the chair, and any interior negative shapes within the chair.

Space

Sculptors and architects work with actual **space.** Their designs occupy three dimensions: height, width, and depth. *Positive* space is filled by the sculpture or building itself. *Negative* space is the space that surrounds the sculpture or building.

In two-dimensional (2-D) art forms, artists can only show an illusion of depth. They have simple ways of creating this illusion. For example, in a drawing of three similar houses along a street, the one closest to the viewer appears larger than the middle one. The house farthest away appears smaller than the middle one. Artists can also create the illusion of depth by overlapping objects or placing distant objects higher in the picture.

Artists working in two dimensions also use linear perspective, a special technique in which lines meet at a specific point in the picture, and thus create the illusion of depth.

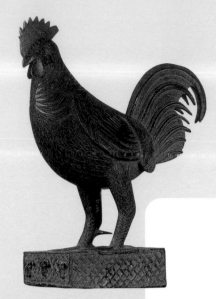

Fig. F3–14 **The positive space of this African sculpture is filled by the cock and the base it stands on. The negative space is the area that surrounds the sculpture. Notice how the surface of the sculpture is decorated with details of feathers, scales, and other designs. If you could touch this sculpture, how would it feel?** Nigeria, Benin. *Cock*, 17th century. Brass, 20 ⁷/₈" (53 cm) high. Museum für Völkerkunde Wien, Foto-Archiv, Foto-Nr. 66.139.

Fig. F3–15 **Here is a clear example of linear perspective. Notice how the lines of the subway platform, tracks, and walls seem to meet behind the group of people on the left. How does the illusion of space that you see here compare to the illusion of space in Fig. 3–5 (page 124)?** Jacques Hnizdovsky, *New York Subway*, 1960. Oil on canvas, 24" x 36" (61 x 91 cm). The Butler Institute of American Art, Youngstown, OH.

40

Teaching Through Inquiry

Art Production Provide some interior scenes and vast landscapes, and lead a discussion of how deep space is represented. As a way of showing objects near and far away, have students use cut paper to experiment with placement of large and small shapes, overlapping, and dark and light.

Art Production Provide and discuss artworks that have a variety of surface qualities. Then ask students to practice a variety of techniques with one medium. Challenge students to consider the suitability of various media techniques for creating specific visual textures.

More About...

Australian Aboriginal artists have created work for thousands of years that connects deeply to the people's sense of the land and their ancestral history. Artists use the earth's treasured resources in their body decoration, carvings, weavings, and paintings. Often their images tell of creation ancestors whose epic travels across the land formed its rocks, trees, rivers, mountains, plants, and animals.

Fig. F3–16 **How did this artist use line, shape, and color to create implied texture? If these were areas of real texture, how might they feel?** Rene Robinson (Aboriginal), *Snake Dreaming*, 20th century. Natural pigments on bark. Jennifer Steele/Art Resource.

Try This

Place a piece of paper over a textured surface and hold the paper down firmly. Rub the paper with the flat side of a crayon or piece of chalk to create a rubbing. Find other textures and create additional rubbings. Compare the results.

Computer Option
Explore the illusion of implied texture by using a paint program. With the pencil tool, create a simple still life drawing. Fill the entire page. Select the various objects and fill with different texture effects. How did you choose your textures?

Texture

Texture is the way a surface feels or looks, such as rough, sticky, or prickly. Real textures are those you actually feel when you touch things. Sculptors, architects, and craftspeople use a variety of materials to produce textures in their designs. These textures can range from the gritty feel of sand to the smooth feel of satin.

Artists who work in two-dimensional art forms can create *implied* textures, or the illusion of texture. For example, when an artist paints a picture of a cat, he or she can create the look of soft fur by painting hundreds of tiny fine lines. What kinds of implied texture have you created in paintings or drawings of your own?

Foundation Lesson 3.1

Check Your Understanding

1. What are the elements and principles of design? How are they related?
2. How is an implied line unlike any other type of line?
3. In your own words, explain the difference between positive and negative shapes. Choose an artwork from anywhere in this book as an example.
4. Analyze the color in one of the paintings in this section. Tell what type of color scheme was used. What mood do these colors suggest?

Elements and Principles of Design

41

Computer Option
• Have students select "Electronic Papers" in Dabbler or Painter software, to create implied textures. By using various paint tools and types of "paper" (texture), they can create "rubbings."
• Invite students to visit Web art galleries to find examples of implied texture. Ask students to find the "brushstrokes" or other surface texture that is part of the original painting. Some galleries:
www.artic.edu/aic/collections/
 index.html;
http://artchive.com;
http://www.thinker.org/;
http://www.metalab.unc.edu/wm/paint/;
https://rubens.anu.edu.au/index2.html;
http://sgwww.epfl.ch/berger/

Assess

Check Your Understanding: Answers

1. The elements are line, shape, form, color, value, space, and texture. The principles are balance, unity, variety, emphasis, proportion, pattern, and movement and rhythm. Artists work with the elements to create art. The principles of design have to do with how artists arrange the elements.

2. An implied line is suggested, not actually drawn.

3. The subject is the positive shape, whereas the shape or space around the subject creates the negative shape.

4. Check students' work for an understanding of color.

Close

Ask students to describe each design element and cite an example of that element either in an artwork or in an object. Display students' texture rubbings, and challenge students to identify the textures in one another's art.

Using the Large Reproduction

Compare implied texture with Fig. F3–16 on page 41.

12

Assessment Options

Peer Ask a volunteer to select two artworks in this chapter that seem very different from each other, then describe each work to the class without telling them which work they are describing. Students should use one-sentence clues to describe lines, shape, form, color, value, space, and texture. The rest of the class can then try to guess the work described. Encourage them to give feedback on the accuracy and clarity of the description. Repeat the process with other volunteers.

Prepare

Pacing

One 45-minute period to discuss the art principles

One 45-minute period or more for each Try This

Objectives

- Understand and perceive the principles of design in artworks.
- Create a painting or drawing illustrating symmetrical, asymmetrical, or radial balance.

Vocabulary

principles of design The different ways in which artists combine the elements to achieve a desired effect (balance, unity, variety, emphasis, proportion, pattern, movement and rhythm). For individual definitions, see the glossary on page 312.

Supplies for Engage
- rulers and erasers

National Standards Foundation 3.2

2a Generalize about structures, functions.

2b Employ/analyze effectiveness of organizational structures.

Principles of Design

Balance

Artists use **balance** to give the parts of an artwork equal "visual weight" or interest. The three basic types of visual balance are symmetrical, asymmetrical, and radial. In *symmetrical* balance, the halves of a design are mirror images of each other. Symmetrical balance creates a look of stability and quiet in an artwork.

In *asymmetrical* balance, the halves of a design do not look alike, but they are balanced like a seesaw. For example, a single large shape on the left might balance two smaller shapes on the right. The two sides of the design have the same visual weight, but unlike symmetrical balance, the artwork has a look of action, variety, and change.

In *radial* balance, the parts of a design seem to "radiate" from a central point. The petals of a flower are an example of radial balance. Designs that show radial balance are often symmetrical.

Try This

Choose one form of balance. Create a drawing or painting that illustrates your choice. Compare and contrast your artwork with those of your classmates. How are the artworks the same? In what ways are they different?

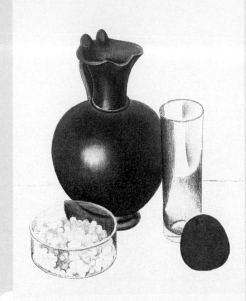

Fig. F3–17 **The large, dark vase in this drawing is balanced by the small, bright apple. Why do you think the artist chose this group of objects?** Charles Sheeler, *Suspended Forms (Still Life)*, c. 1922. Charcoal, chalk, and watercolor, 19" x 15 ¼" (48.2 x 38.7 cm). Bequest of Mrs. G. Gordon Hertslet 123:1972. St. Louis Art Museum.

Computer Option

Explore balance using a drawing or painting program. First, create four geometric shapes. Fill the shapes with colors, values, or patterns. Arrange the shapes on the left half of your document so they do not touch or overlap. Select your entire design. Create a symmetrical design by copying and flipping the selected area horizontally. Save your work. Next, create an asymmetrical design by rearranging the shapes on the right side. Do you need to resize some shapes to balance the new design?

42

Teaching Options

Resources

Teacher's Resource Binder
 Thoughts About Art: F3.2
 A Closer Look: F3.2
 Assessment Master: F3.2
Large Reproduction 8, 14
Overhead Transparency 7, 17
Slides 2, 9, 11, 12

Teaching Through Inquiry

Art Criticism Provide tracing paper and artwork reproductions, and have students trace lines, shapes, and colors that are repeated.

Art Criticism For groups of students, provide artwork reproductions and diagrams of symmetrical, asymmetrical, and radial balance. Ask the groups to discuss how the compositions are balanced, and then to present their findings to the class.

Unity

Unity is the feeling that all parts of a design belong together or work as a team. There are several ways that visual artists can create unity in a design.

- repetition: the use of a shape, color, or other visual element over and over
- dominance: the use of a single shape, color, or other visual element as a major part of the design
- harmony: the combination of colors, textures, or materials that are similar or related

Artists use unity to make a design seem whole. But if an artist uses unity alone, the artwork might be visually boring.

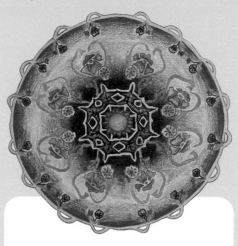

Fig. F3–18 **Repeated shapes help unify this design. Large and small shapes add variety. What kind of balance is shown?** Lyna E. Lacayanga, *Kaleidoscope*, 1999.
Colored pencil, 14" x 14" (35 x 35 cm). T. R. Smedberg Middle School, Sacramento, California.

Variety

Variety adds visual interest to a work of art. Artists create variety by combining elements that contrast, or are different from one another. For example, a painter might draw varying sizes of circles and squares and then paint them in contrasting colors such as violet, yellow, and black. A sculptor might combine metal and feathers in an artwork or simply vary the texture of one material. Architects create variety when they use materials as different as stone, glass, and concrete to create the architectural forms of a building.

Fig. F3–19 **This artist wove different textures to create variety in this wall hanging. In what ways has she created unity?** Lori Kammeraad, *Llama Deux*, 1982.
Tapestry, 72" x 42" (182.9 x 106.7 cm). Courtesy of the artist.

Teach

Engage

To demonstrate balance, have students place a ruler across their finger. Have them add an eraser to one end to discover that a longer section of ruler is needed to balance the added weight. Explain that this is similar to balance in artworks, and that students created symmetrical balance when the same amount of ruler was balanced on each side of their finger; by adding an eraser, they created asymmetrical balance.

Using the Text

Perception After students have read page 42, challenge them to find examples of asymmetrical, symmetrical, and radial balance in other images in this book.

Art Criticism After students have read the section on unity, ask them to look around the classroom and describe where they see repetition, dominance, and harmony. **Ask:** How might you create a more harmonious interior?

Using the Art

Art Criticism Discuss students' answers to the caption question for Fig. F3–19. **Ask:** Where did the artist repeat shapes, colors, and textures? What is the mood of this piece?

Try This

Discuss possible subjects for this art. **Ask:** How could you show the parts of your life that are steady, quiet, and in balance? What parts would you show? Where would you place them? How might you show parts of your life that are mixed up or confused?

Ask students to label the back of their artwork with the type of balance they used.

 Computer Option Guide students to flip the entire, or the top half of, the image vertically, as well as horizontally, to get a radially- and symmetrically-balanced design.

More About...

The ancient Egyptians painted with **watercolor**. But in recent centuries, it was not until Winslow Homer (1836–1910), the famous American artist, used it as an independent medium that it was no longer used just for preparatory sketches. Watercolors contain gum arabic (a water-soluble substance), which binds the pigments to the paper. Most artists apply watercolors in translucent washes, allowing the white of the supporting paper to shine through.

Using the Large Reproduction

8

Use as an example of symmetrical balance, unity, variety, and pattern.

Using the Overhead

7

Use as an example of balance, unity, variety, emphasis, pattern.

Principles of Design

Using the Text

Perception Have students read page 45 and then locate examples of planned and random patterns in the classroom. Suggest that they look for patterns in the floor tiles, the ceiling, their clothing, and even the furniture arrangement.

Using the Art

Perception Use the caption questions for Christine Kidder's *Endangered Hawksbill Turtle* to initiate a discussion about patterns. Encourage students to note the coral patterns in the background. Explain the silkscreen process: a stencil is created on a screen by blocking out the parts of the design that are not to have color; ink is then squeezed through the screen onto fabric or paper.

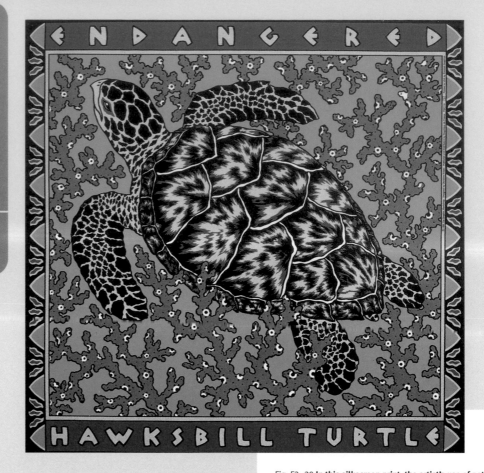

Fig. F3–20 **In this silkscreen print, the artist's use of pattern helps create emphasis. Notice the strong differences between the animal and background patterns. Are the patterns planned or random? Why do you think so?** Christine Kidder, *Endangered Hawksbill Turtle*, 1990. Silkscreen, 25" x 25" (64 x 64 cm). Courtesy of Preston Graphics.

Emphasis

Look at *Endangered Hawksbill Turtle* (Fig. F3–20). What is the first thing you see? The answer is easy: You'll probably say you see the turtle first. Now see if you can explain *why* you noticed it first. Here are some clues.

When artists design an artwork, they use **emphasis** to call attention to the main subject. The size of the subject and where it is placed in the image are two key factors of emphasis. You probably noticed the turtle first because it is larger than the things that surround it. It's also placed in the middle of the image. Sometimes artists create emphasis by arranging other elements in a picture to lead the viewer's eyes to the subject. Or they group certain objects together in the design.

44

Teaching Through Inquiry

Art Production If students have access to film and cameras, have them work in teams to capture close-up images of planned and random patterns in both natural and humanmade environments. Sort into groups and select the best images for a photo essay on pattern.

If cameras are not available, create a series of crayon rubbings of both natural and humanmade surfaces, such as leaves, wood grains, cracks in sidewalks, manhole covers, tile floors, etc. In making the rubbings, a change in color can be used to create emphasis or to call attention to an area. Sort into groups, select the best examples to illustrate emphasis, and both planned and random patterns. Create a display with captions.

Pattern

An artist creates a **pattern** by repeating lines, shapes, or colors in a design. He or she uses patterns to organize the design and to create visual interest. You see patterns every day on wallpaper, fabric, and in many other kinds of art.

Patterns are either planned or random. In a *planned* pattern, the element repeats in a regular or expected way. A *random* pattern is one that happened by chance, such as in a sky filled with small puffy clouds or in the freckles on a person's face. Random patterns are usually more exciting or energetic than planned ones.

Try This

Suggest that students explore possibilities for both planned and random patterns and that they think about how variation in size, position, or color can help to create emphasis.

Fig. F3–21 **Look carefully at this print. How many patterns do you see?** Emily Carr, *Dancing Parrots*, 1997.
Watercolor, ink, 18 x 24" (46 x 61 cm). Turkey Hill Middle School, Lunenburg, Massachusetts.

Try This

Create a stencil or gadget print that shows emphasis and pattern. You might choose a specific subject for your print or create a print that is nonobjective. Think about how you will create emphasis and pattern. Experiment with color and design before you make your final print.

Elements and Principles of Design

45

More About...

Silkscreen printing, or **serigraphy,** primarily was developed in the United States. Artists first create a stencil, attach it to silk, and then force ink through the stencil with a squeegee. The ink only transfers onto the paper in the open areas of the stencil. As with woodblock prints, a separate stencil is necessary for each separate color of a print.

Using the Text

Perception After students have read about proportion on page 46, ask them to press their elbow against their body to notice where it aligns. Encourage students to compare the size of their hands to their face and to their feet.

Perception To illustrate the concept of scale, place a small toy figure next to an everyday object, such as a shoe; or place a piece of fruit in a dollhouse. Ask students to imagine drawing a picture of this. Their viewers might wonder if the apple was extraordinarily big or if the house was extremely small.

Using the Art

Art Criticism Have students study Giacomo Balla's *Dynamism of a Dog on a Leash,* and ask them to use their hands to describe the dog's movement. Remind them of cartoons in which movement is indicated with a series of lines. **Ask:** What might this artist have been trying to show?

Extend

• Direct students to find newspaper cartoons to illustrate several means of showing movement. Then challenge students to use some of these devices to draw their own action.

• So that students understand proportions in the human figure, ask student pairs to take turns drawing each other. Instruct students to measure their model in "heads." **Ask:** How many heads would fit the height of your partner's body? Ask students to determine the number of heads from their model's waist to knees, and then to draw their model, paying attention to the body proportions.

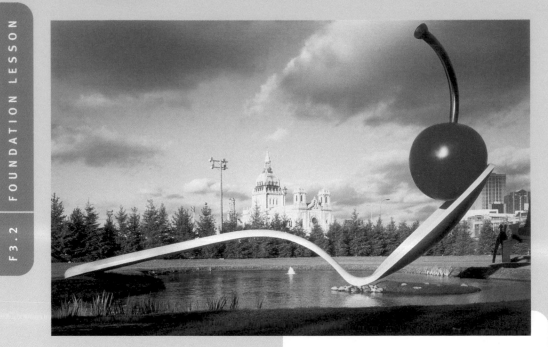

Fig. F3–22 **Artists often change the normal size, scale, or proportion of things to show their importance in artworks. What might the artists be saying about these objects?** Claes Oldenburg and Coosje van Bruggen, *Spoonbridge and Cherry,* 1988. Aluminum painted with polyurethane enamel and stainless steel, 29'6" x 51'6" x 13'6" (9 x 15.7 x 4.1 m). Minneapolis Sculpture Garden, Walker Art Center, Minneapolis. Photograph by Attilio Maranzano. Courtesy of the artists.

Proportion

Proportion is the relationship of size, location, or amount of one thing to another. In art, proportion is mainly associated with the human body. For example, even though your body might be larger, smaller, or shorter than your best friend's, you both share common proportions: Your hips are about halfway between the top of your head and your heels; your knees are halfway between your hips and your feet; and your elbows are about even with your waist.

Scale is the size of one object compared to the size of something else. An artist sometimes uses scale to exaggerate something in an artwork. Look at *Spoonbridge and Cherry* (Fig. F3–22). How do these artists' use of scale make ordinary objects look important?

46

Teaching Through Inquiry

Art Production Ask students to use a famous artist's compositional scheme to express their own ideas.

Art Production Have students use cut paper and stencils to demonstrate their understanding of symmetry and asymmetry.

Art Criticism Challenge students to explain how Jacques Hnizdovsky created emphasis, pattern, rhythm, and movement in *New York Subway*, Fig. F3–15.

More About...

Futurism, Balla's art style, developed from Cubism. Balla and other Futurist artists tried to represent speed and movement artistically.

Movement and Rhythm

Artists often create a sense of action, or **movement,** in their artworks. Artworks that actually move, such as mobiles, are called *kinetic* art. Other forms of art, such as photographs, paintings, and sculpture, may only record the movement of their subjects. Movement in an artwork creates excitement and energy. Artists use movement to communicate an idea or to set a particular mood, such as surprise or humor.

Rhythm is related to both movement and pattern. Artists create rhythm by repeating elements in a particular order. It may be simple and predictable, such as the lines in a sidewalk. Or it may be complex and unexpected, such as the rhythm shown in *Dynamism of a Dog on a Leash* (Fig. F3–23). Artists use rhythm, like pattern, to help organize a design or add visual interest.

Fig. F3–23 **How has this artist captured the rhythmic movements of the dog and its owner?** Giacomo Balla, *Dynamism of a Dog on a Leash*, 1912.
Oil on canvas, 35 3/8" x 43 1/4" (89 x 110 cm). Albright-Knox Art Gallery, Buffalo, New York. Bequest of A. Conger Goodyear and Gift of George F. Goodyear, 1964. © 2000 The Artists Rights Society (ARS), New York/SIAE, Rome.

Sketchbook Connection
Choose a partner and spend some time observing each other's face. What shape is the face? Where are the eyes located in relation to the top of the head and chin? Where are the nose, mouth, and ears located in relation to the eyes and the rest of the face? Sketch your partner's face in as accurate proportion as you can.

Foundation Lesson 3.2

Check Your Understanding
1. Why might a totally unified design be visually boring?
2. Describe some ways that an artist might create emphasis in a design.
3. How does kinetic art differ from other works of art that depict movement?
4. Select a piece of art from this chapter that appeals to you. Describe how the artist used at least two of the art principles in this design.

Elements and Principles of Design

47

Assess

Check Your Understanding: Answers

1. Variety adds interest to a work.

2. Artists might make the subject large, center the subject in the design, arrange other elements so that they lead to the main subject, or group objects to create a center of interest.

3. Kinetic art actually moves.

4. Check students' work for an understanding of how the principles relate to the chosen piece of art.

Close

Conduct a review of the elements and principles of design. Ask small groups of students to present examples of the elements and principles in images from this book. Allow students to sort the class artworks by the type of balance used.

Using the Large Reproduction

Use as an example of movement and rhythm.

14

Using the Overhead

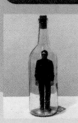

Compare use of proportion and scale with Fig. F3–22.

17

Assessment Options

Teacher Ask students to complete each sentence, using:
symmetrical balance, asymmetrical balance, radial balance, unity, variety, emphasis, proportion, pattern

1. When all parts of a design work as a team, the work has _____.
2. Artists create ____ by combining elements that are different from one another.
3. When two halves of a design appear as mirror images of each other, we say the work has _____.
4. When two sides of a design seem to have the same visual weight, but are very different from one another, we say the work has _____.
5. Designs that have parts organized like the petals of a flower have _____.
6. Artists use ____ to call attention to an important subject or area of an artwork.
7. _____ is the relationship of size of one thing to another.
8. A _____ of repeated elements can be random or planned.

Careers

To help students understand that there are differences between commercial and fine-art photography, display and discuss examples of both. If possible, invite a professional photographer to speak to the class.

Note: The Kodak home page (http://www.kodak.com) is a valuable resource for teachers interested in photography.

Math

Islamic tile designs and the work of Dutch artist M. C. Escher are the most familiar tessellations in art. Display, discuss, and compare examples of tessellations in art. Then direct students to research tessellations on the Internet to discover how to create their own.

Note: Computer-generated tessellations can be made with the CD-ROM *TesselMania Deluxe* (MECC).

Connect to...

Careers

The **photography** profession requires expertise with the elements and principles of design: the success of a photograph depends on the photographer's composition of the image in the camera's viewfinder. For instance, the composition may have asymmetrical or symmetrical balance, and contrasting values, colors, lines, or shapes.

Career options in photography include commercial photography, such as advertising and graphic design; fashion photography; wedding and portrait photography; sports photography; and medical photography. Photojournalism, fine-art photography, videography, or filmmaking are other possibilities.

F3–24 **Wildlife photographer Clayton Fogle combines his love for animals and the outdoors with his artistic profession.** Digital montage courtesy of the artist.

Other Arts

Music

What is music? Are sounds of nature—such as those made by birds, water, and animals —the same as music? How is singing different from speaking? Listen to some music, and make a list of what things about the sounds make them music. Discuss findings with classmates. Can you agree on what makes music?

Music, like art, has design: it is made to express something. If we compare their elements, we might say that a line in art is like a note in music. As a line moves in a certain direction, a note has a certain duration: it goes somewhere in time. Color in art is similar to tone color (or timbre) in music. Musical sounds have "color," which is how we can tell a guitar from a saxophone.

The principles of art can also apply to music. Music is made up of patterns of sound, but composers balance repetition and contrast to create music that has a sense of unity, so it all "hangs together."

Daily Life

F3–25 **What kinds of lines do you see here?** Franz Steiner, *Sunset*, 1999. Watercolor, brush and ink, 22" x 14" (55.8 x 35.6 cm). Central Tree Middle School, Rutland, Massachusetts.

You can easily find examples of the **principles and elements of design** in your daily environment. Try looking for the element of line. Vertical and horizontal lines outline windows, buildings, telephone and lamp poles, signs, and other human-made structures. The painted lines on both sides of a road appear diagonal when they seem to meet in the distance. Tree trunks are often vertical lines, and their branches may be diagonal or curvy lines.

To sharpen your observational skills, chose another element or a principle of design, and look for examples of it throughout a day. Make note of what you find.

Teaching Options

Resources

Teacher's Resource Binder
Using the Web
Interview with an Artist
Teacher Letter

Video Connection

Show the Davis art careers video to give students a real-life look at the career highlighted above.

Other Subjects

Mathematics

Both artists and mathematicians work with the principle of design known as **pattern.** Artists use combinations of lines, colors, and shapes to form repeating designs. Mathematicians are interested in analyzing the symmetry, or balanced proportion, of such patterns. Congruent shapes—shapes that are the same size and shape—make up basic mathematical symmetry.

Mathematicians use types of congruent shapes such as translations, rotations, and reflections to create tessellations—repeating symmetrical patterns without any gaps or overlaps. Can you name an artist who is well known for his expertise in designing tessellations?

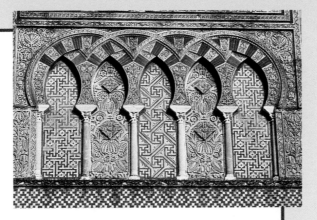

F3–26 **The entire façade of this building is covered in patterns. Can you find some tessellations?** Cordoba, Spain. *Grand Mosque,* 8th–11th century.
West Facade. Courtesy of Davis Art Slides.

Science

The primary colors (red, yellow, and blue) and the secondary colors (green, violet, and orange) appear on the **color wheel** (see page 308) familiar to you and used by artists. However, this color wheel applies only to dyes and pigments, such as paint or other applied color. The color wheel used in photography is different, because **the human eye perceives light differently than it perceives pigment.** For example, a combination of red and green pigments produces brown; combining red and green light produces yellow.

In **optics,** the scientific study of light, the primary colors are red, blue, and green; and the secondary colors are yellow, cyan, and magenta. Who might most need to understand and use the color wheel for light?

F3–27 **When white light passes through a prism, the result is a band of colors called the spectrum.**

Internet Connection
For more activities related to this chapter, go to the Davis website at **www.davis-art.com.**

Science

Direct students to look at the color wheel on page 36. Review that this color wheel applies only to dyes and pigments. **Ask:** A person in what profession would most need to understand the optics color wheel? Why is the optics color wheel important for color photography?

Other Arts

Have students look up art terms from this chapter in a musical dictionary, such as the *Harvard Dictionary of Music.* **Ask:** How are *form, rhythm, shape,* and *texture* defined? Do they have the same meaning in music as they do in art?

Elements and Principles of Design

Internet Resources

Cooper-Hewitt, National Design Museum
http://www.si.edu/ndm/
The collection of this museum contains both historic and contemporary design—from one-of-a-kind to mass-produced objects. The museum's collection encompasses graphic design, applied arts and industrial design, architecture, urban planning, and environmental design.

The Victoria and Albert Museum, London
http://www.vam.ac.uk/
Explore the Victoria and Albert Museum in London, the world's finest museum of the decorative arts. Founded in 1852, the museum's vast collections include sculpture, furniture, fashion and textiles, paintings, silver, glass, ceramics, jewelry, books, prints, and photographs.

Museum Connection

Assist students in writing letters to museums around the world, to find out how their collections are organized. For example, students might ask if objects are grouped by art forms (drawings, paintings, sculptures, and so on), by time period, by theme, or by subject matter.

Talking About Student Art

To help students attend to the formal arrangement of an artwork, have them identify the focal point or center of interest. **Ask:** Where does your eye go first? Why? Invite students to use words they learned in this chapter so as to describe how the artist directed the viewer's attention.

Portfolio Tip

Give students a selected Studio Reflection handout from the Teacher's Resource Binder to use when choosing elements and principles for their work.

Sketchbook Tip

Suggest to students that they design a color wheel to include in their sketchbook. They might also design various color schemes and combinations of complements, split complements, and so on.

Portfolio

F3–28 Sarah Smalley, *Rowboat on the Shore*, 1999. Watercolor, 12" x 18" (30 x 46 cm). Samford Middle School, Auburn, Alabama.

"I got the idea to paint this picture after I saw a picture of a rowboat in the water. I really liked the boat but it had people in it. I decided to put the boat on the shore, add trees and bushes, and take the people out of the boat. I had a lot of fun painting and adding things to the background." **Sarah Smalley**

F3–29 Jessie Bergsma, *California Poppies*, 1997. Oil pastels, 18" x 24" (46 x 61 cm). Fairhaven Middle School, Bellingham, Washington.

"I got the idea because I like rabbits. The easy parts were the body and the hard part was the head." **Spencer Heaton**

F3–30 Spencer Heaton, *Sumi-e Rabbit*, 1998. Ink, 7" x 9" (18 x 23 cm). Fairhaven Middle School, Bellingham, Washington.

"I've loved poppies ever since I was a little girl. Since I started painting, I've loved using opposite colors. I like contrast a lot and tried to use it in this picture as well as balance. It was one of the first times I've ever used pastels, so that was definitely the most difficult part." **Jessie Bergsma**

CD-ROM Connection
To see more student art, check out the Global Pursuit Student Gallery.

Teaching Options

Resources

Teacher's Resource Binder
 Chapter Review F3
 Portfolio Tips
 Write About Art
 Understanding Your Artistic Process
 Analyzing Your Studio Work

CD-ROM Connection

Additional student works related to studio activities in this chapter can be used for inspiration, comparison, or criticism exercises.

Foundation 3 Review

Recall

List the elements and principles of design.

Understand

Describe the difference between the elements and the principles of design.

Apply

Examine Fig. F3–6 (Helen Escobedo, *Coatl [snake]* shown below and on page 35), and identify which elements and principles of design the artist used.

Analyze

From the theme chapters of this book, select reproductions of artworks that illustrate each of the elements and principles of design.

Synthesize

On separate note cards, write the name of each element of design, and put the cards into a hat or bag. Do likewise for the principles of design, but put them into another hat or bag. Without looking, pull out two cards from each hat. Use your four selections as the basis for a realistic or abstract artwork.

Evaluate

Examine one of your favorite artworks—your own or one by another artist. Write a persuasive argument as a song lyric or poem that explains how the artist mastered the elements and principles of design in this piece.

Page 35

For Your Portfolio
From artworks that you have created, choose one that you think shows your understanding of one or more of the elements and principles of design. On a separate sheet of paper, explain how you used the elements and principles to get certain results.

For Your Sketchbook
Study the sketchbook entries that you made during this chapter. Choose one idea, think about it, and develop it in a different way.

Elements and Principles of Design

51

Community Involvement

Make the community aware of the benefits of an education in art. You might begin with school-board members, parents, town-council members and other public officials, local businesspeople, and members of social and civic organizations.

Advocacy

At performing-arts events, display information about the goals of your program and the value of art education.

Foundation 3 Review Answers

Recall

line, shape, form, color, value, space, and texture; balance, unity, variety, emphasis, pattern, proportion, and movement and rhythm

Understand

The elements are the ingredients that artists use in their compositions. The principles are the ways in which artists fit the elements together.

Apply

Elements: square forms; color and value; space; and texture, smooth and ridged. Principles: balance, pattern, movement and rhythm.

Analyze

Check for selections that demonstrate an understanding of these concepts.

Synthesize

Look for an integration and understanding of the selected elements and principles. Display the finished works, and have students discuss which four cards they think the artist pulled from the hats.

Evaluate

Look for students' use of the elements and principles as criteria for supporting their choices. Share and discuss students' responses.

Reteach

Ask students to choose three images from this chapter. For each image, have them write a paragraph in which they identify two elements and two principles of design that the artist used but that are not mentioned in the caption. Instruct students to explain the location of those elements and principles in the work.

Foundation Organizer

9 weeks | 18 weeks | 36 weeks

Foundation 4 Approaches to Art

Foundation 4 Overview
pages 52–53

Foundation Focus

- Understand that asking questions can guide us to better understand and appreciate artworks.
- **4.1** Art History
- **4.2** Art Criticism
- **4.3** Art Production
- **4.4** Aesthetics

National Content Standards

2 Use knowledge of structures and functions.

3 Choose and evaluate subject matter, symbols, and ideas.

4 Uderstand artist in relation to history and cultures.

5 Assess own and others' work.

9 wks	18 wks	36 wks			

2 | 2 | 1

**Foundation 4.1
Art History**
page 54
Pacing: One or more
45-minute periods

Objectives
- Explain the role of art historians in art inquiry.

National Standards
4b Place objects in historical, cultural contexts.

**Try This
Art-historical questions**
page 55

Objectives
- Generate art-historical questions about artworks.

National Standards
5b Analyze contemporary, historical meaning through inquiry.

2 | 2 | 1

**Foundation 4.2
Art Criticism**
page 56
Pacing: One or more
45-minute periods

Objectives
- Explain the role of art critics in art inquiry.

National Standards
2a Generalize about structures, functions.

**Try This
Finding meaning**
page 57

- Generate questions about the meaning of art.

5b Analyze contemporary, historical meaning through inquiry.

2 | 2 | 1

**Foundation 4.3
Art Production**
page 58
Pacing: One or more
45-minute periods

Objectives
- Explain the role of artists in art inquiry.

National Standards
3b Use subjects, themes, symbols that communicate meaning.

**Try This
Report and portrait**
page 59

- Generate questions about the production of artworks.

5c Describe, compare responses to own or other artworks.

Featured Artists

Nancy Burson
Anne Coe
Pieter de Hooch
Felix de Rooy
Jacob Lawrence
Roy Lichtenstein

Charles McQuillen
Joan Mitchell
Marie Louise Vigée-
 Lebrun

Vocabulary

art historian
art critic
artist
aesthetician

Teaching Options

Teaching Through Inquiry
More About…Art history
Using the Large Reproduction
Using the Overhead
Assessment Option

Technology

CD-ROM Connection
 e-Gallery

Resources

Teacher's Resource Binder
 A Closer Look: F4.1
 Assessment Master:
 F4.1

Large Reproduction 9
Overhead Transparency 18
Slides 2, 14

CD-ROM Connection
 Student Gallery

Teacher's Resource Binder
 Thoughts About Art: F4.1

Teaching Options

Teaching Through Inquiry
More About…Art criticism
Using the Large Reproduction
Using the Overhead Transparency
Assessment Option

Technology

CD-ROM Connection
 e-Gallery

Resources

Teacher's Resource Binder
 A Closer Look: F4.2
 Assessment Master:
 F4.2

Large Reproduction 15
Overhead Transparency 6
Slides 4, 15

CD-ROM Connection
 Student Gallery

Teacher's Resource Binder
 Thoughts About Art: F4.2

Teaching Options

Meeting Individual Needs
Teaching Through Inquiry
More About…Art production
Using the Large Reproduction
Using the Overhead
Assessment Option

Technology

CD-ROM Connection
 e-Gallery

Resources

Teacher's Resource Binder
 A Closer Look: F4.3
 Assessment Master:
 F4.3

Large Reproduction 7
Overhead Transparency 10
Slides 16

CD-ROM Connection
 Student Gallery

Teacher's Resource Binder
 Thoughts About Art: F4.3

Foundation Organizer continued

9 weeks	18 weeks	36 weeks		Objectives	National Standards
2	1	1	**Foundation 4.4 Aesthetics** page 60 Pacing: One or more 45-minute periods	• Explain the role of aestheticians in art inquiry.	**5c** Describe, compare responses to own or other artworks.
			Try This Report and portrait page 61	• Generate aesthetics questions about artworks.	**5a** Compare multiple purposes for creating art.

				Objectives	National Standards
•	•	•	**Connect to...** page 62	• Identify and understand ways other disciplines are connected to and informed by the visual arts. • Understand a visual arts career and how it relates to chapter content.	**6** Make connections between disciplines.

				Objectives	National Standards
•	•	•	**Portfolio/Review** page 64	• Learn to look at and comment respectfully on artworks by peers. • Demonstrate understanding of chapter content.	**5** Assess own and others' work.

Teaching Options

Teaching Through Inquiry
More About…Aesthetic inquiry
Using the Large Reprodcution
Using the Overhead
Assessment Option

Technology

CD-ROM Connection
 e-Gallery

Resources

Teacher's Resource Binder
 A Closer Look: F4.4
 Assessment Master:
 F4.4

Large Reproduction 17
Overhead Transparency 2
Slides 17, 18

Computer Option
CD-ROM Connection
 Student Gallery

Teacher's Resource Binder
 Thoughts About Art: F4.4

Teaching Options

Community Involvement
Interdisciplinary Tip

Technology

Internet Connection
Internet Resources
Video Connection
CD-ROM Connection
 e-Gallery

Resources

Teacher's Resource Binder
 Using the Web
 Interview with an Artist
 Teacher Letter

Teaching Options

Advocacy
Family Involvement

Technology

CD-ROM Connection
 Student Gallery

Resources

Teacher's Resource Binder
 Chapter Review F4
 Portfolio Tips
 Write About Art
 Understanding Your Artistic Process
 Analyzing Your Studio Work

Chapter Overview

Foundation 4

Asking questions from the disciplines of art history, art criticism, art production, and aesthetics can guide us in developing and understanding an appreciation of artworks.

Featured Artists

Nancy Burson
Anne Coe
Howard Finster
Pieter de Hooch
Jacob Lawrence
Roy Lichtenstein
Charles McQuillen
Joan Mitchell
Felix de Rooy
Marie Louise Elisabeth Vigée-Lebrun
Edward Weston

Chapter Focus

As people study artworks, they become curious about them. The types of questions usually asked in the study of art may be categorized into art history, art criticism, art production, and aesthetics.

Supplies for Warm-up

- artwork, jewelry, or pottery from another culture

Approaches to Art

Focus

- What do people want to know about art?
- What kinds of questions do people ask about art?

Imagine finding an object that's unlike anything you've ever seen before. You turn the object over in your hands and ask yourself, "What is this? Who made it? How was it made?" Suppose something about the object suggests that it was made a long time ago. You might wonder why the object was important to the people who lived at that time. What did they use it for? How is it different from objects that you normally see or use?

For thousands of years, people have wondered where objects and artworks come from and why they were made. It's human nature to be curious. We can be as curious about the function of an artwork as we are about its meaning. Asking questions about the artwork helps us understand it. The information we learn about the artwork can also teach us something about the times and cultures of our world and where we fit in.

This chapter will introduce you to the kinds of questions people ask about artworks. As you read the chapter, you will see that the questions fall into four categories: art history, art criticism, the making of art itself, and the philosophy of art.

What's Ahead

- **F4.1 Art History**
 Learn how to find the story behind an artwork.
- **F4.2 Art Criticism**
 Explore ways to find the meaning of a work of art.
- **F4.3 Art Production**
 Learn more about yourself as an artist.
- **F4.4 Aesthetics**
 Investigate the larger world of art.

Words to Know

art historian artist
art critic aesthetician

National Standards Foundation 4 Content Standards

2. Use knowledge of structures and functions.

3. Choose and evaluate subject matter, symbols, and ideas.

4. Understand arts in relation to history and cultures.

5. Assess own and others' work.

Teaching Options

Teaching Through Inquiry

Aesthetics Have students work in small groups and discuss their personal responses to each artwork on page 53. Have each group identify the three most positive responses and the three most negative responses expressed in the discussion. After each group reports on the responses, lead the class in making some generalizations about personal preferences when responding to art. Consider how we might expect preferences to change as a result of more experiences with different types of art.

Fig. F4–1 **Look carefully at this painting. Try to imagine how the artist painted it. Notice that the name of the artwork is *Ladybug*. What features of this artwork suggest the idea of a ladybug? Might the artwork actually be about something else? What functions do titles serve?** Joan Mitchell, *Ladybug*, 1957.
Oil on canvas, 77 ⅞" x 108" (197.9 x 274 cm). The Museum of Modern Art, New York. Purchase. Photograph ©2000 The Museum of Modern Art, New York.

Fig. F4–2 **Jacob Lawrence's artworks often show events from African-American history and working life. How could you use information about hammers and other carpentry tools to determine when this artwork was made? Hint: Do you think the look of carpentry tools has changed over time?** Jacob Lawrence, *Cabinet Maker*, 1957.
Casein on paper, 30 ½" x 22 ½" (77.5 x 57 cm). Hirshhorn Museum and Sculpture Garden, Smithsonian Institution, Gift of Joseph H. Hirshhorn, 1966. Photo: Lee Stalsworth.

Fig. F4–3 **This artist used crayon rubbings to make her artwork. What qualities do the rubbings add to the subject?** Jenna Skophammer, *Alien UFO*, 1998.
Crayon, 0 ¼" x 11" (21 x 20 cm). Manson Northwest Webster Community School, Barnum, Iowa.

Fig. F4–4 **To make this artwork, the artist assembled electronic parts. How is this set of parts different from electronic parts you might find on the street? Is it any different?** Howard Finster, *The Model of a Super Power Plant*, 1979.
Assembled and painted electronical television parts, painted metal, 20" x 6 ⅝" x 7 ⅝" (50.8 x 16.9 x 19.4 cm). Gift of Herbert Waide Hemphill, Jr. and Museum purchase made by Ralph Cross Johnson. 1986.65.245. National Museum of American Art, Smithsonian Institution, Washington, DC/Art Resource, NY.

Approaches to Art

53

Chapter Warm-up

Let students examine an artwork from another culture and then develop a list of questions about it. Explain that in this chapter, they will consider questions to guide their study of art.

Using the Text

After students have read the text, discuss what it means to be curious and the difference between curious and nosy. Talk about how young people are sometimes discouraged from asking questions, and why we should value the asking of good questions.

Using the Art

After students study these artworks and answer the caption questions, have them write several questions that they have about each piece. Note that these questions may be from art history, art criticism, art production, and aesthetics.

More About...

Despite its nonobjective quality, **Joan Mitchell** (b. 1926) roots her abstract art in the observable world. She once stated: "My paintings are about a feeling that comes to me from the outside, from landscape." Her fluid, visible brushwork is emblematic of the Abstract Expressionists, also known as Action Painters, who came to the fore in the late 1940s and 1950s.

Prepare

Pacing

One 45-minute period or more

Objectives

- Generate art-historical questions about artworks.
- Explain the role of art historians in art inquiry.

Vocabulary

art historian A person who researches the history of art and then synthesizes the information.

> ### Supplies for Engage
> - a designed, mass-produced object

Teach

Engage

Display the mass-produced object. **Ask:** If people found this a thousand years from now, what might they want to know about it? Would they know what it is and why it was made?

Using the Text

Art History After students have read pages 54 and 55, encourage them to pretend that they are art historians investigating the object from Engage. Lead students in identifying the questions in the text that would be important or necessary to ask.

National Standards Foundation 4.1

4b Place objects in historical, cultural contexts.

5b Analyze contemporary, historical meaning through inquiry.

Art History

The Stories Behind Art

Art history is just what you'd expect: the history of art. **Art historians**—people who study the history of art—want to know where artworks began. They research the cultures from which artworks spring. They learn about the people, the politics, and the economic conditions at the time and place where artworks were made. They try to figure out why artists created artworks and how the artworks are different from others. And finally, when all of their research is done, they piece together the stories of art.

Do you ever wonder where artworks come from or what their story is? If you do, then you have begun investigating their history.

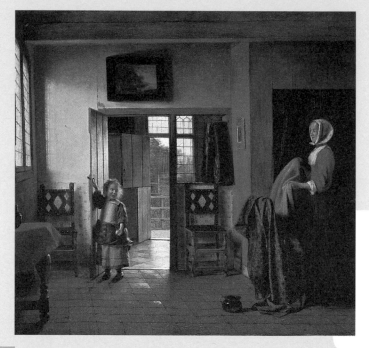

Fig. F4–5 **Dutch painter Pieter de Hooch painted this bedroom scene during his last years in the city of Delft. When you look at this painting, what can you learn about everyday life in mid-1600s Holland?** Pieter de Hooch, *The Bedroom*, c. 1660.
Oil on canvas, 20" x 23 ½" (50.8 x 59.7 cm). The National Gallery of Art, Washington, DC, Widener Collection.

54

Looking at Art

There are certain basic questions that will get you started on the search for an artwork's story.
1. What is the artwork? What is it about? What is its purpose?
2. When and where was it made?
3. Has the artwork always looked like this? Or has it changed somehow over time?

Finding the Story

The next set of questions will help you find out what an artwork meant to the artist and to the people who lived at the time it was made. By asking these questions, you can learn how the artwork reflects the cultural traditions of the time. Your answers will also help place the artwork in history.
1. What was happening in the world when the artwork was made? How is the world different now?

Teaching Options

Resources

Teacher's Resource Binder
 Thoughts About Art: F4.1
 A Closer Look: F4.1
 Assessment Master: F4.1
Large Reproduction 9
Overhead Transparency 18
Slides 2, 14

Teaching Through Inquiry

Art History Ask students to work in groups to search out images of similar objects over a period of decades. Possibilities include telephones, cars, shoes, or gravestones. Direct students to order the objects chronologically and then by style. Have them research issues and events in the periods represented. Finally, ask students to explain how and why the object might have changed.

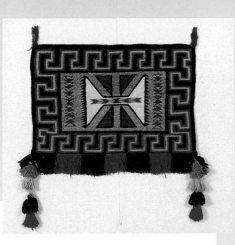

Fig. F4–6 **Many artworks are influenced by family or cultural traditions—customs and beliefs passed down from generation to generation. If you wanted to learn about this traditional artwork, what questions could you ask?** Navajo, *Saddle Blanket*, late 19th century. Germantown yarn, 46" x 37 ½" (116.8 x 95.3 cm). Smithsonian Institution, Washington, DC. National Museum of the American Indian, Matthew M. Cushing Collection. Presented by Mrs. Nellie I.F. Cushing in his memory. Photo by Katherine Fogden.

2. How do the customs and traditions of the artist's family or culture add to the meaning of the artwork?
3. What other kinds of art did people make at that time?

Introducing the Artist

As the story of an artwork unfolds, questions about the artist begin to surface. Some art historians focus their investigations mainly on the life and work of a single artist. Imagine the challenge of discovering something new and interesting about an artist!
1. Who made this artwork?
2. What role did artists play in the community in which this work was made?
3. How does this artist's style compare to the style of other artists during that time?
4. What decisions was the artist faced with as he or she created this artwork?

Fig. F4–7 **Imagine that someone will find this artwork 100 years from now. What clues in the artwork will help the person learn about the artist who made it?** Philip Brooks, *Caged*, 1997. Found object assemblage, 36" x 30" x 30" (91.4 x 76 x 76 cm). Andrew G. Curtin Middle School, Williamsport, Pennsylvania.

You can ask any of these sample questions about a specific artwork or artist. You can also ask similar questions about an entire art period or about the value and use of artworks in general.

See if you can find out what art historians have said about artworks and artists that interest you. Try to learn more about when and where the artworks were created.

Try This

Choose one artwork in this chapter and see what answers to the sample questions you come up with. You don't have to answer all of them. Choose one from each category that interests you most. Do some research at the library or on the Internet. Then, present your findings to the class.

Foundation Lesson 4.1

Check Your Understanding
1. What general topics do art historians focus on in their investigations?
2. How does the work of the art historian help you understand why an artwork looks the way it does?

Approaches to Art

55

Using the Art

Art History Ask students to answer the caption questions for de Hooch's *The Bedroom*. **Ask:** What similarities and differences do you notice between de Hooch's bedroom and your bedroom or another room in your home?

Try This

Suggest to students that they present their answers—with a copy (hand drawing, photocopy, or computer printout) of the artwork—on a poster that they design.

Assess

Check Your Understanding: Answers

1. artworks, cultures, and artists

2. By learning about the background of an artwork, the art historian can explain who made the piece, and why and how it was made.

Close

Remind students that to engage in art historical inquiry, they need to practice skills that include describing the work (what it is about, what its purpose was or is, when and where it was made); explaining if and how the work has changed over time; imagining the work's restoration, if applicable; and gathering information about the artist, the style, and artistic decisions.

More About...

Art history is important:
- as a way of coming to know another time and place.
- to understand the point of view of people of other cultures or other times.
- in appreciating historical preservations as efforts to maintain a community's visual heritage.
- to value art as a realm of human accomplishment.
- to develop artistically, both as artists and as perceivers.

Using the Large Reproduction

9

Compare style and time period with Fig. F4–6.

Using the Overhead

18

Compare materials and time period with Fig. F4–7.

Assessment Options

Teacher Imagine that you have just found an artwork in your barn. No one knows anything about it. You are naturally curious and want to know more. What questions would you have and how might you go about finding answers?

Prepare

Pacing

One 45-minute period or more

Objectives

- Generate questions about the meaning of art.
- Explain the role of art critics in art inquiry.

Vocabulary

art critic A person who expresses a reasoned opinion on any matter concerning art.

Teach

Engage

Ask: Have you ever read a book or listened to music because a friend described it to you? Have you ever read a review of a movie that you had already seen? Did you agree with the review?

Using the Text

Art Criticism Have students discuss answers to the questions in Finding Clues, Making Connections, and Judging Importance.

Using the Art

Art Criticism Have students answer and then discuss the caption questions on pages 56–57. Then ask them to pretend to be an art critic describing one of the works. **Ask:** What would you tell people to look for when viewing this art?

Art Criticism

Searching for Meaning

Art critics want to know what artworks mean. They can help us learn about artworks by describing them and pointing out interesting things to look for. They judge the quality of artworks and suggest why they are valuable or important. Art critics often write about art in newspapers or magazines. Their views can influence the way we look at and think about artworks.

You have already asked questions like an art critic, perhaps without even realizing it. You may have looked at artworks in this book and wondered about their meaning. You have expressed your thoughts and opinions about objects and artworks around you. And you have compared them to other objects or artworks you're familiar with.

Your views may have affected the way your classmates or others think about artworks.

Finding Clues

As an art critic, you need to observe certain things about an artwork before you can begin to think about its possible meaning. Here are some questions that will help get you started.

1. What does the artwork look like?
2. How was it made?
3. How are the parts of the artwork arranged?
4. Does it seem to suggest a mood or feeling? An idea or theme?

Making Connections

Once you understand how the artwork is put together, you can focus more on its meaning and ask questions such as these:

1. What is the artwork about?
2. What message does it send? How does it make me think, feel, or act when I see it?
3. How is the artwork related to events in the artist's life? How is it related to events that happened at the time it was made?

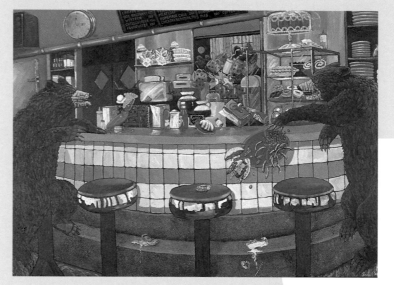

Fig. F4–8 **Art critics have suggested that this artwork pokes fun at the human destruction of nature and animal habitats. What clues do you see in the painting that support this idea?** Anne Coe, *Counter Culture*, 1990.
Acrylic on canvas, 50" x 70" (127 x 177.8 cm). Courtesy of the artist.

Teaching Options

Teaching Through Inquiry

Art Criticism Write standards for judgment on 3" x 5" cards, one per card. Include *representational accuracy, expression of a feeling, communication of an idea, effective use of design elements and principles, technical skill and craftsmanship,* and *originality.* Distribute the cards. Have students debate appropriate standards for judging specific art reproductions. Explain that no single standard is appropriate for judging all artworks, an artwork may be judged by more than one standard, and the choice of appropriate standards for judgment may depend on the interpretation of the artwork.

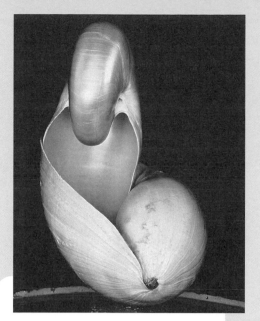

Fig. F4–9 **Art critics say that this photograph is important because it makes us look carefully at natural forms. What do you think?** Edward Weston, *Two Shells*, 1927.
Gelatin silver print, 9 1/2" x 7 1/4" (24 x 18.4 cm). J. Paul Getty Museum, Los Angeles.

Judging Importance

Suppose you have learned enough about the artwork to decide that it is important. Next, you need to support your judgment. Ask yourself:
1. What aspects of the artwork—such as artist, culture, message, or function—make it important? Why?
2. What sets this artwork apart from similar artworks?
3. How is my response to this artwork different from my response to similar artworks?

You can see the kinds of things art critics say about art when you read a review of an art exhibit in your local newspaper. Try to visit the exhibit yourself. Do you agree with what the critic says about it? Why or why not?

Try This

Sometimes, the meaning of a group of artworks by one artist is easier to interpret than the meaning of a single artwork. Choose one artwork in this book that interests you. Then find two or three other artworks by the same artist in other books, magazines, on the Internet, or on CD-ROMs. Use questions from this lesson to find the meaning and importance of the group.

Foundation Lesson 4.2

Check Your Understanding
1. What do art critics learn about artworks?
2. Why, do you think, are art critics important?

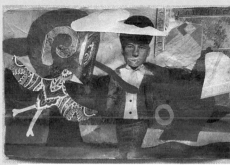

Fig. F4–10 **What elements of this image suggest a park?** Dylan Haynes, *Woman in the Park*, 1999.
Magazine cut-outs, markers, 12" x 18" (30 x 46 cm). Asheville Middle School, Asheville, North Carolina.

Approaches to Art

57

Try This
Students might work in groups to find artworks. Encourage students to interpret the body of work as a whole.

Critical Thinking
Read aloud a review of an art exhibit. **Ask:** What could you expect to find in this exhibit? Would you want to visit the exhibit? Why or why not?

Teaching Tip
Tell students some standards that critics use to judge art: degree of realism, formal order, expressiveness, use, economy of means, significance of content, originality, craftsmanship, strong attraction.

Assess

Check Your Understanding: Answers

1. what artworks mean, how they're made, their messages, how they relate to the period in which they were made, and their importance

2. They inform us about the meaning of artworks and suggest why they are important.

Close

Remind students that to be art critics, they need to practice describing the sensory, formal, technical, and expressive qualities of artworks; offering interpretations; and giving well-supported evaluations by using a variety of standards.

More About...
So that students appreciate the value of the **art criticism** process, encourage them to be curious about the meanings of the artworks they encounter; look for clues in the artworks so as to understand their meanings; appreciate the value of good reasons offered in support of interpretations and evaluations of artworks; and respect alternative views so long as they are backed with reasons.

Using the Large Reproduction

Analyze using questions in Finding Clues to Meaning.

18

Using the Overhead

Compare theme of ecology of planet with Fig. F4–8.

6

Assessment Options

Teacher Imagine that someone said to you, "Art critics are very opinionated people. All they do is tell artists what's wrong with their work. They are always looking for mistakes." From your understanding of art criticism as described in this lesson, what would you say to correct the speaker's perception?

Prepare

Pacing
One 45-minute period, depending on the scope of Try This

Objectives
- Generate questions about the production of artworks.
- Explain the role of artists in art inquiry.

Vocabulary

Teach

Engage
Ask: Have you ever wondered why so many toddlers make marks with crayons on the walls in their homes? Have you ever thought about why adults make marks on paper and call it art? What is this urge that people have to make things with their hands?

Using the Text
Art Production Have students use an artwork of their own to answer this lesson's questions about producing art. Encourage students to do this activity when creating other artworks.

Using the Art
Art Criticism Encourage students to compare Lichtenstein's hard-edge paint style to Vigée-Lebrun's soft, feathery strokes. **Ask:** Which of these two artists would you prefer to paint your portrait?

Art Production

Making Art

Artists all over the world make artworks for decoration, to celebrate important events, and to communicate ideas or feelings. When artists plan a work of art, they think about its purpose and meaning. As they create the work, they explore their ideas and sometimes test the limits of the materials they use. In the end, they create a work that satisfies their personal and social needs, interests, values, or beliefs.

You think like an artist every time you explore the things you can do with pastels, a lump of clay, or any other art material. You might have an idea when you start, or your exploration might lead you to one. When you are finished expressing your idea, you have a work of art that is all your own.

Reflecting on Your Art and Yourself

As you create art, you will begin to realize what art and making art mean to you. Asking questions about your art-making experience will help you uncover that meaning.

1. What artworks are important to me? How do they affect the way I make art?
2. What feelings or ideas do I like to express in my artwork? What does my art say about me?
3. What process do I go through when I make art?

Considering Your Art and the World

When you have a better understanding of your own art, you can think about how it fits into the big picture. Ask yourself:
1. What does my artwork tell others about the place and time in which I live? What special events, people, or things does it suggest?
2. What do my choices of materials and techniques tell others about my world?
3. How is my artwork similar to or different from art that was made in other times and places?

Fig. F4–11 **Roy Lichtenstein is known for creating paintings that resemble comic strips. This artwork sends a message. If you were to create a painting like this, what subject would you choose? What message would you send? Why?** Roy Lichtenstein, *Forget It! Forget Me!*, 1962. Magna and oil on canvas, 80" x 68" (203 x 173 cm). Rose Art Museum, Brandeis University, Waltham, Massachusetts. Gevirtz-Munchin Purchase Fund. ©Estate of Roy Lichtenstein.

58

National Standards Foundation 4.3

3b Use subjects, themes, symbols that communicate meaning.

5c Describe, compare responses to own or other artworks.

Teaching Options

Resources
Teacher's Resource Binder
 Thoughts About Art: F4.3
 A Closer Look: F4.3
 Assessment Master: F4.3
Large Reproduction 7
Overhead Transparency 10
Slides 16

Teaching Through Inquiry
Ask students to research various artists' reasons for making art, where they get their ideas, and their personal standards for determining when their work is finished and whether it is successful. Then have students work in groups to generate a list of criteria for judging whether a work is finished.

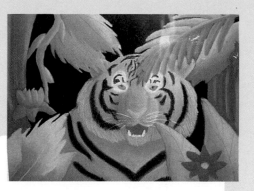

Fig. F4–12 **Look carefully at this drawing. What feeling does it suggest? What feeling would you suggest in a drawing like this?** Melissa Sung, *Tiger*, 1999. Pastels, 17" x 23" (43 x 58 cm). Reading-Fleming Middle School, Flemington, New Jersey.

Comparing Your Art to Other Art

As an artist, you are probably aware of ideas and concerns that other artists have. When you compare your work to theirs, you might see a connection.

1. How is my artwork similar to or different from artworks made by others? How has their work affected my work?
2. If I could create an artwork with another artist, whom would I choose to work with? Why?
3. What materials and techniques have other artists used that I would like to explore? Why?

The next time you create a work of art, ask yourself the questions in this lesson. See what answers you come up with. You'll probably learn something surprising about the artist in you!

Fig. F4–13 **Marie Vigée-Lebrun shows herself as a painter of portraits. If you were going to paint a self-portrait, how would you show yourself?** Marie Louise Elisabeth Vigée-Lebrun, *Self-Portrait of Marie Louise Elisabeth Vigée-Lebrun*, 1791. Oil on canvas, 39" x 31⅞" (99 x 81 cm). Ickworth, (The Bristol Collection) National Trust Photo Library / Angelo Hornak.

Try This

Use the questions in this lesson to interview and write a report about a classmate's art-making experiences. Create a portrait of your classmate to accompany the report. Use what you learn from this experience to interview an artist in your community.

Sketchbook Connection
Plan a work of art that uses materials and techniques you haven't tried before. Talk to people who have used the materials and techniques. Sketch your ideas. When your plan is finished, create the work of art. Then write about your experience. Describe your process and how you feel about the artwork.

Foundation Lesson 4.3

Check Your Understanding
1. What are the main reasons artists make things?
2. What three types of questions do artists typically explore?

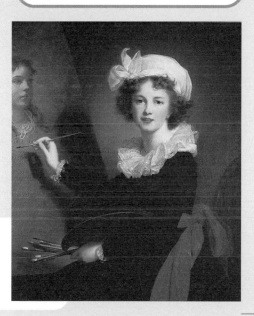

Approaches to Art

59

Try This
For the portrait, encourage students to emphasize the classmate's interests and experience that are highlighted in the written report. Help students identify local artists to interview.

Extend
Tell students that Lichtenstein created parodies of van Gogh, Matisse, and Picasso in his comic-strip style. Ask students to imagine how Lichtenstein might have reinterpreted Vigée-Lebrun's self-portrait. Have them draw Vigée-Lebrun as Lichtenstein might have drawn her.

Assess

Check Your Understanding: Answers

1. for decoration, to celebrate an event, and to communicate an idea or feeling

2. questions about themselves; about their art and the world; and about their art as compared to other art

Close

Remind students that to produce artworks, they need to explore and consider ideas, media, techniques, personal fulfillment and expression, problem solving, and the art of others.

Using the Large Reproduction

Compare with Fig. F4–13.

7

Using the Overhead

Use with questions under Considering Your Art and the World.

10

More About...

So that students can find fulfillment in the **art production** process, encourage them to hold positive attitudes toward art and artists; to be open-minded toward experimentation; to empathize with artists and the process of their work; and to participate in art-related activities.

Assessment Options

Teacher Tell students to imagine that the local school board has questioned why students should spend time making art as part of their education. Students have been invited to provide testimony. **Ask:** Based on your understanding of art production, what would you say to convince board members of the value of art production?

Prepare

Pacing

One or more 45-minute periods

Objectives

- Generate aesthetics questions about artworks.
- Explain the role of aestheticians in art inquiry.

Vocabulary

aesthetician A person who investigates art, how it came to be, why it is made, and how it fits into society.

Teach

Engage

Ask: What do you think of when you hear the word "beauty"? Have you ever thought about why people seem to have very different ideas about what makes something beautiful?

Using the Text

Aesthetics After students have read pages 60–61, have them define *aesthetics* in their own words.

Using the Art

Aesthetics Ask students to imagine that the art in this chapter is in an exhibit. **Ask:** To which piece would you award first place? Which piece do you like the best? (These two are not necessarily the same.) Lead a discussion about what makes some artworks better than others.

Aesthetics

Investigating Art

Aesthetics is the philosophy, or investigation, of art. **Aestheticians** (*es-the-TISH-uns*) can be called art philosophers. They ask questions about why art is made and how it fits into society. They're interested in how artworks came to be.

Every time you wonder about art or beauty, you think like an aesthetician. The questions that come to your mind about art are probably like the questions that aestheticians ask. All you need is a curious mind and probing questions to be an art philosopher yourself.

Thinking About Artworks

At some time or another, you have probably wondered what artworks are. Like an aesthetician, you can ask certain questions that will help you think more carefully.
1. Are all artworks about something?
2. In what ways are artworks special? What makes some artworks better than others?
3. Do artworks have to be beautiful or pretty? Why or why not?
4. What makes one kind of artwork different from another?

Thinking About Artists

As an aesthetician, you might wonder about the people who make art, why they make it, and why some people, but not all, are called artists. You might ask:
1. What do artworks tell us about the people who made them? What do they tell us about the world in which they were made?
2. What do people express through making art? Do artworks always mean what the artist intends them to mean?

Fig. F4–14 **What does this artwork tell you about the artist who made it?** Charles McQuillen, *Ritual III*, 1995.
Clay on tree. Courtesy of the artist.

3. Should there be rules that artists follow to make good artworks?

Thinking About Experiences with Art

When you talk about art, you probably discuss whether you like an artwork or not. And you probably talk about how an artwork makes you feel. These questions will help you dig deeper into your experience with an artwork.
1. How do people know what an artwork means?
2. Is it possible to dislike an artwork and still think it is good?

Teaching Options

Resources

Teacher's Resource Binder
 Thoughts About Art: F4.4
 A Closer Look: F4.4
 Assessment Master: F4.4
Large Reproduction 17
Overhead Transparency 2
Slides 17, 18

Teaching Through Inquiry

Aesthetics Have students write an essay in which they give a definition of *art* and offer reasons to support the definition. Ask students to exchange essays with a partner and try to refine their definition and reasons.

3. How is the experience of looking at an artwork like the experience of looking at a beautiful sunset? Or are these experiences completely different?

4. How do beliefs about art affect the way people look at and explore artworks?

The questions that aestheticians ask do not necessarily investigate a specific artwork. Instead, they investigate the larger world of art in general.

Try This

What makes one kind of art different from another? Break this question down into other questions, such as: What do all paintings have in common? What do all sculptures have in common? What do all photographs have in common? etc. Design and illustrate a book called *Asking Questions About Art.*

Computer Option
Begin with an imported photograph—a still life, landscape, or portrait. Use filters and other effects to transform the photograph into a digital painting. Now find a painting on the Internet or a CD-ROM with a similar subject. Print out copies of each "painting" for discussion. How do computers affect our understanding of different kinds of art?

Foundation Lesson 4.4

Check Your Understanding
1. Why might it be important to have some understanding of art in general?
2. What do aestheticians do?

Fig. F4–15 a and b **How are these images different from snapshot photos of people? What might the artist be saying here?** Nancy Burson with Richard Carling and David Kramlich, *First and Second Beauty Composites:* **a:** Bette Davis, Audrey Hepburn, Grace Kelly, Sophia Loren, Marilyn Monroe, 1982. **b:** Jane Fonda, Jacqueline Bissett, Diane Keaton, Brooke Shields, Meryl Streep, 1982. Computer generated. Courtesy of the Jan Kesner Gallery and the artist.

Approaches to Art

61

Try This
Tell students that their book may be complex (see page 294) or simple (stapled pages of pictures). Students may work in small groups.

Computer Option
Have students discuss the purpose of different kinds of artworks. **Ask:** What is the difference between the purpose of art produced for the Internet and that produced in traditional media?

Assess

Check Your Understanding: Answers

1. Possible answers: to guide art-making decisions; to help interpret visual messages; to appreciate art.

2. Aestheticians ask questions about why art is made and how it fits into society. They are interested in explaining why artworks exist and how they came to be.

Close

Remind students that in order to understand aesthetics, they need to listen to other points of view; learn to make general statements; use language carefully; present and evaluate definitions and positions; and recognize philosophical issues.

More About...

So that students may appreciate the value of **aesthetic inquiry,** encourage them to look at the nature and significance of art and any art-historical or art-criticism assumptions; appreciate the giving and assessing of reasons; and recognize and respect alternative answers so long as they are backed by reasons.

Using the Large Reproduction

Compare with Fig. F4–14 when discussing questions such as "Do artworks have to be beautiful or pretty?" or "Should there be rules to follow?"

17

Using the Overhead

Use to discuss questions in Thinking About Experiences with Art.

2

Assessment Options

Teacher Write a short letter to the National Geographic Society in support of including an aesthetician on an expedition team to investigate a previously unknown cultural group in a remote part of the world. The letter should state what the concerns of an aestheticians would be, what kinds of questions she or he might ask, and why this would be important for the world.

Careers

Compile newspaper or magazine articles or editorials that detail a national or local artistic controversy. **Ask:** Do you think that criticism can be positive? Explain that journalistic art criticism, written for the general public, tends to be positive, largely because critics prefer to write about artwork they like. After initial discussion, have students work in small groups. Give each group a different article to discuss. Instruct each group to take a position, pro or con, on the controversy, and then, in turn, share their opinions with the entire class.

Science

Review the scientific method. **Ask:** How can the scientific approach be applied to an investigation of an artwork? How can artworks be "tested" by inquiry based on careful observation, by research on background information, and by conclusions based on interpretation?

Connect to...

Daily Life

In your day-to-day life, you probably do some of the same things that art critics, historians, aestheticians, and artists do. For instance, have you ever recommended that a friend see a movie that you have seen? **As a critic,** you probably gave your friend some reasons for your recommendation. Have you ever asked an older person to tell you about what life was like at an earlier time? Historians wonder about such things. You act **like a historian** whenever you try to figure out how an unfamiliar object was used when it was new.

Have you, **like an aesthetician,** looked at something that other people called art and wondered why they did so? Whenever you look at one of your own or a friend's artworks and wonder how you can know if it is good or not, you act like an aesthetician. You have probably made or decorated lots of things. Every time you make an artwork, wrap a gift, or make drawings on a notebook, you make decisions **like an artist** does. Try to keep track of the many times in your daily life that you think like an art critic, an art historian, an aesthetician, or an artist.

Other Subjects

Science

F4–16 Sir Isaac Newton, 1642–1727.
©Bettman/Corbis

The scientific method, an approach to scientific study first designed by Isaac Newton in 1687, is a standard way of conducting scientific experiments. It involves the observation of a phenomenon, or event, and the formation of a hypothesis, or theory, about the event. The next steps of the scientific method are experiments to prove the hypothesis, gathering the data, interpreting the results, and drawing conclusions. Now consider the approach taken in art criticism: description, analysis, interpretation, and judgment. What are some similarities between the two approaches?

Language Arts

Think of some stories you learned in language arts. **Narrative artworks** also tell stories. Many artists consider themselves to be storytellers. They use visual rather than written or spoken language to tell their tales. Both kinds of narrative can entertain, inform, or teach the audience or viewer. Stories—whether written, oral, or visual—may have characters, events, action, plot, sequence, and purpose.

Discover these similarities yourself. Choose a narrative artwork from this chapter, and write a summary of the story that you think is told in the image.

Internet Connection
For more activities related to this chapter, go to the Davis website at **www.davis-art.com.**

Teaching Options

Resources

Teacher's Resource Binder
 Using the Web
 Interview with an Artist
 Teacher Letter

Video Connection

Show the Davis art careers video to give students a real-life look at the career highlighted above.

Other Arts

Music/Dance

When you listen to a new piece of music or see a new dance, you naturally compare it to music you have heard or dance you have seen. If it is similar to music or dance you know, you will probably understand it. The less it is like what you know, the more difficulty you will have. Questions to ask about any piece of music or dance are:

- What kind of work is this?
- What is its purpose?
- In what culture was it created?
- How does it reflect that culture?

You could answer some of these questions by listening or watching. For others, you might need to do research. **The questions that you ask about music or dance** might also be the questions that you ask—and answer—about art.

Try it out. Choose an artwork, a piece of music, and a dance video. For each work, write answers to the questions above.

F4–17 **How do you think these instruments might sound? Can you imagine a dance that is likely to be performed to their music?** Turkey, *Costumes of the Court and the City of Constantinople—musicians*, 1720. Bibliotheque Nationale de France, Paris. Giraudon/Art Resource, New York.

Careers

Art critics may have different theories about art, but they all write persuasive arguments to convince us to look at the art ourselves. An art critic might be a newspaper reporter, a scholar who writes for professional journals or textbooks, or an artist who writes about other artists.

Journalistic art criticism, written for the general public, includes reviews of art exhibitions in galleries and museums. Journalistic criticism appears in newspapers and magazines, and on radio and TV. Scholarly art criticism is written for a more specialized art audience and appears in art journals and other texts. Scholarly criticism is usually written by professors or museum curators who have a particular knowledge about a style, period, medium, or artist.

F4–18 **Arlene Raven is an art historian who has published seven books on contemporary art. She has written criticism for a variety of newspapers, magazines, exhibition catalogues, and scholarly journals. She has also taught art and curated exhibitions.** Photo: ©Robert MacDonald.

Language Arts

Have students work in small groups to choose a narrative artwork from this book to present as a dramatic interpretation. Suggest that the chosen work include several characters. Allow students time to plan and practice their presentation, and then have groups take turns dramatizing their artwork for the entire class.

Other Arts

Play "Picking Tea Leaves and Chasing Butterflies" from *Flower Drum and Other Chinese Folk Songs* (Monitor MCD 71420), but do not tell students the title of the piece. Have them complete a worksheet with the four questions in their book. Discuss their answers, and ask students to describe the music's instrumentation, mood, and effect on the listener. Tell students the title of the piece, and ask them to think about the significance of the title as they listen a second time. **Ask:** How does the music reflect the title?

Approaches to Art

Internet Resources

Jacob Lawrence Catalogue Raisonné Project

http://www.jacoblawrence.org/

This online archive and education center provides images and documentation of the entire body of Lawrence's work.

Roy Lichtenstein Foundation

http://www.lichtensteinfoundation.org/

Browse through this site to learn more about the artist's paintings, sculpture, and drawings; also ongoing exhibitions, publications, etc.

Community Involvement

- Have students question local artists about their reasons for making art. Then discuss their findings for similarities and differences.

- To institute an after-school enrichment program, give a series of workshops on a topic of interest to students, family members, and community residents.

Interdisciplinary Tip

To help students see artworks—whether completed or in progress—as functional parts of a culture, discuss them in relation to social, emotional, intellectual, economic, political, and aesthetic issues.

Talking About Student Art

Use the process of art criticism—describing, analyzing, interpreting, and judging—to talk about student artwork. Make the discussion fluid, moving among the four steps.

Portfolio Tip

Use the reproducible worksheets in the Teacher's Resource Binder for portfolio entries. Remind students to date their written reports on art history, criticism, aesthetics, production, and so on.

Sketchbook Tip

Have students set up a time-line page in their sketchbook—for artists, dates, and events or important works—in a format such as this:

Artist	Date	Event or Artwork
1.		
2.		
3.		

Portfolio

"I got this idea from an old calendar. I was going to draw just a flower, but I needed something that would grab on to the flower. I thought a butterfly would be perfect. The hard part of this artwork was making perfect dots so the lines on the butterfly will show up clearly." **Joy Simongkhoun**

F4–19 Joy Simongkhoun, *Butterfly/Pointillism*, 1999. Tempera, 9" x 12" (23 x 30 cm). Fairhaven Middle School, Bellingham, Washington.

"I was thinking about how disoriented I look and feel whenever I wake up late. I feel like my face isn't in one piece. This is why I put the ears on top of the mask. I named the mask's mouth 'plow-mouth' because when I wake up late, I just don't feel like talking much and the plow part of my plow-mouth just absorbs my breakfast (or plows it up)." **Nicole Peter**

F4–20 Dana Edwards, *Sumi-e Painting*, 1999. Ink, brush, 12" x 18" (30 x 46 cm). Horace Mann Middle School, Franklin, Massachusetts.

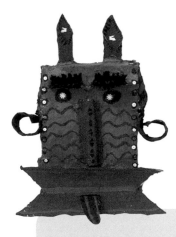

F4–21 Nicole Peter, *Woke Up Late*, 1999. Cardboard, plaster of paris, acrylic paint, 12" x 8" (30 x 20 cm). Copeland Middle School, Rockaway, New Jersey.

CD-ROM Connection
To see more student art, check out the Global Pursuit Student Gallery.

Teaching Options

Resources

Teacher's Resource Binder
Chapter Review F4
Portfolio Tips
Write About Art
Understanding Your Artistic Process
Analyzing Your Studio Work

CD-ROM Connection

Additional student works related to studio activities in this chapter can be used for inspiration, comparison, or criticism exercises.

Foundation 4 Review

Recall

Name the four categories for or approaches to examining art.

Understand

Explain the major differences in the work of an art historian, an art critic, an artist, and an aesthetician.

Apply

Give examples of questions an art historian might ask about Fig. F4–5 (Pieter de Hooch, *The Bedroom*, shown below and on page 54) and try answering them yourself by closely examining the work. Conduct additional research if necessary.

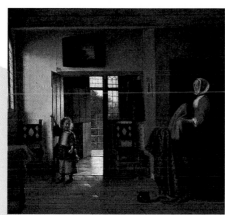

Page 54

For Your Sketchbook
Start a page in your sketchbook on which you write questions that you have about artworks, artists, how to look at art, and how art is made. Add to this list throughout the year.

Analyze

Write a critical review of the images in Foundation 4.2. Then describe and support your selection of the single work you find most successful.

Synthesize

Write an imaginary diary entry as the artist Marie Vigée-Lebrun about what she might have wished to communicate to others in her self-portrait (Fig. F4–13), and the challenges she faced while working.

Evaluate

As an aesthetician, write an essay, based on Fig. F4–14, explaining whether all art has to be beautiful. Defend the use of Vermeer's *The Milkmaid* (Fig. 5–1) as an introduction to Chapter 5's theme of daily life.

For Your Portfolio
To show that you understand how to think like an art historian and like an art critic, choose one artwork from this chapter. Then write a list of questions that an art historian would explore, and a list of questions that an art critic would explore. From each list, pick one question, and research and write the answer. Write the date on your report, and put it, along with the lists of questions, into your portfolio.

Family Involvement

Enlist parents and others in helping to collect reproductions of artworks such as calendars, postcards, and note cards from museum collections.

Advocacy

Set up a Web page for your art program.

Foundation 4 Review Answers

Recall

art history, art criticism, art production, aesthetics

Understand

Art historians look for the stories behind the art and the art's cultural context; art critics search for the meaning of the individual works and judge their quality and importance; artists create the works themselves; aestheticians reflect on philosophical questions about art.

Apply

What does this artwork represent? *(a bedroom scene in an ordinary house in Holland)* What was the work's purpose in its society? *(to record daily life in the seventeenth century)* Where was it made? *(Holland)*

Analyze

Look for support of criteria that demonstrate careful consideration of the art, not simple value judgments or an unsubstantiated "I like/don't like" approach.

Synthesize

Look for an understanding of the artist's possible intent, based on what can be visually discerned in Vigée-Lebrun's painting.

Evaluate

Look for thoughtful consideration and evidence that students have used the actual artwork in their essay.

Reteach

Divide the class into groups of four students, and ask each group to agree on an intriguing image from the chapter. Ask groups to research the piece, and its era and culture. Have each group member take the role of art historian, art critic, artist, or aesthetician and then perform a debate about the work's meaning and importance. Afterward, discuss how each perspective added another layer of understanding.

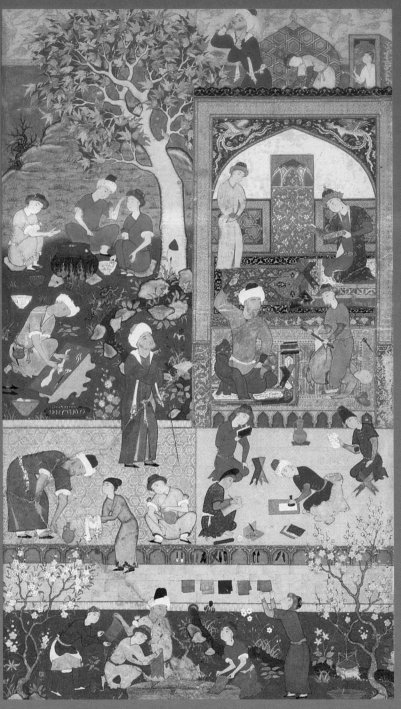

Page 149

Art is a Global Pursuit

What's a neighbor? Not very long ago, your neighbors were just the people who lived next door. Today, because of television and other kinds of communication, almost anyone could be called your neighbor. You can make friends with people who live on the other side of the globe. You can see and learn about ways of life that are nothing like your own. If you were to "travel" around the world via the Internet, videos, and satellite broadcasts, you'd learn about many different religions, holidays, types of food, and lifestyles. You'd see that many people have beliefs and customs that are strange to you. But you'd also begin to see that people have lots of things in common.

One important thing that people everywhere have in common is the desire to make art. Throughout history, people have decorated the things they use and the places where they live and work. They have used the materials around them to make things that beautify their lives. And if you look closely at art from around the globe, you'll see that no matter where they live, people care about similar things.

All over the world, people teach each other what they think it's important to know. They create ways to organize their lives. They gather together to remember and celebrate the past. They respond to nature. Themes like these have been part of people's lives throughout history.

In this part of this book, you'll explore some common themes in art. Look carefully at the artworks on these pages. Then look for these same themes in the artwork around you. Can you find them? Can you see how many "neighbors" you really have?

67

Chapter Organizer

Chapter Focus

Chapter 1
Messages
Chapter 1 Overview
pages 68–69

- **Core** Art helps people communicate stories, lessons, important ideas, and feelings.
- **1.1** Art of the Ancient World
- **1.2** Line and Pattern
- **1.3** Art of Africa
- **1.4** Making a Bas-relief

Chapter National Standards

2 Use knowledge of structures and functions.
4 Understand arts in relation to history and cultures.
5 Assess own and others' work.

9 weeks	18 weeks	36 weeks			

Objectives / National Standards

| 1 | 1 | 1 | **Core Lesson**
Messages in Art
page 70
Pacing: One 45-minute period | • Use examples to explain the statement "Art sends messages."
• Describe artworks' features that convey messages. | **5b** Analyze contemporary, historical meaning through inquiry. |

| | | | **Core Studio**
Creating Your Own Message
page 74 | • Use line and pattern to create a message about contemporary life. | **1a** Select/analyze media, techniques, processes, reflect. |

Objectives / National Standards

| | | 2 | **Art History Lesson 1.1**
Art of the Ancient World
page 76
Pacing: Two 45-minute periods | • Explain how people in ancient times communicated through their art.
• Describe the subject matter in selected artworks of the ancient world. | **4a** Compare artworks of various eras, cultures. |

| | | | **Studio Connection**
page 78 | • Communicate movement and action of the human figure through gesture drawing. | **2b** Employ/analyze effectiveness of organizational structures. |

Objectives / National Standards

| | | 1 | **Elements and Principles Lesson 1.2**
Line and Pattern
page 80
Pacing: One or two 45-minute periods | • Describe qualities of line and pattern in artworks and explain how these elements are used to communicate messages. | **2c** Select, use structures, functions. |

| | | | **Studio Connection**
page 81 | • Use line and pattern to decorate a CD label or book cover that conveys information about the contents. | **2c** Select, use structures, functions. |

Featured Artists

Kenneth B. Haas, III
Käthe Kollwitz
Jacob Lawrence
William Lishman
Sa'di
Rand Shiltz

Chapter Vocabulary

bas-relief
contour lines
cultural meaning
cuneiform
line
narrative
pattern
stele
symbol

Teaching Options

Teaching Through Inquiry
More About…Käthe Kollwitz
More About…Jacob Lawrence
Meeting Individual Needs
Using the Overhead
Using the Large Reproduction

Technology

CD-ROM Connection
 e-Gallery

Resources

Teacher's Resource Binder
 Thoughts About Art:
 1 Core
 A Closer Look: 1 Core
 Find Out More: 1 Core
 Studio Master: 1 Core
 Assessment Master:
 1 Core

Large Reproduction 1
Overhead Transparency 2
Slides 1a, 1b, 1c

Meeting Individual Needs
Teaching Through Inquiry
More About…Why people draw
More About…Blind contour drawing
Assessment Options

CD-ROM Connection
 Student Gallery

Teacher's Resource Binder
 Studio Reflection: 1 Core

Teaching Options

Teaching Through Inquiry
More About…Radiocarbon dating
Using the Overhead

Technology

CD-ROM Connection
 e-Gallery

Resources

Teacher's Resource Binder
 Names to Know: 1.1
 A Closer Look :1.1
 Map: 1.1
 Find Out More: 1.1
 Assessment Master: 1.1

Overhead Transparency 1
Slides 1d

Meeting Individual Needs
Teaching Through Inquiry
More About…Gesture Exercises
Assessment Options

CD-ROM Connection
 Student Gallery

Teacher's Resource Binder
 Check Your Work: 1.1

Teaching Options

Teaching Through Inquiry
Using the Overhead
Assessment Options

Technology

CD-ROM Connection
 e-Gallery

Resources

Teacher's Resource Binder
 Finder Cards: 1.2
 A Closer Look: 1.2
 Find Out More: 1.2
 Assessment Master: 1.2

Overhead Transparency 1

CD-ROM Connection
 Student Gallery

Teacher's Resource Binder
 Check Your Work: 1.2

				Objectives	National Standards
		3	**Global View Lesson 1.3 African Kingdoms** page 82 Pacing: Three 45-minute periods	• Describe how African artworks communicate. • Explain why understanding the purposes, messages, and meanings of African artworks requires information about African cultures.	**4b** Place objects in historical, cultural contexts. **5b** Analyze contemporary, historical meaning through inquiry.
			Studio Connection page 84	• Capture the expressiveness of an action figure by combining found materials in a sculptural form.	**2b** Employ/analyze effectiveness of organizational structures.

				Objectives	National Standards
	2	1	**Studio Lesson 1.4 Making a Bas-Relief** page 86 Pacing: One or two 45-minute periods	• Recognize the qualities and characteristics of clay as a medium for bas-relief. • Apply the ceramic processes of modeling, embossing, and carving to convey a message in relief. • Reflect on one's own purposes and processes of art making.	**5b** Analyze contemporary, historical meaning through inquiry.

				Objectives	National Standards
•	•	•	**Connect to...** page 90	• Identify and understand ways other disciplines are connected to and informed by the visual arts. • Understand a visual arts career and how it relates to chapter content.	**6** Make connections between disciplines.

				Objectives	National Standards
•	•	•	**Portfolio/Review** page 92	• Learn to look at and comment respectfully on artworks by peers. • Demonstrate understanding of chapter content.	**5** Assess own and others' work.

2 Lesson of your choice

Teaching Options

Teaching Through Inquiry
More About...African Art
Using the Large Reproduction

Technology

CD-ROM Connection
e-Gallery

Resources

Teacher's Resource Binder
 A Closer Look: 1.3
 Map: 1.3
 Find Out More: 1.3
 Assessment Master: 1.3

Large Reproduction 2
Slides 1e

Meeting Individual Needs
More About...Sculpture
Assessment Options

CD-ROM Connection
 Student Gallery

Teacher's Resource Binder
 Check Your Work: 1.3

Teaching Options

Meeting Individual Needs
More About...Stelae
Using the Large Reproduction
Studio Collaboration
Teaching Through Inquiry
More About...Relief sculptures
Assessment Options

Technology

CD-ROM Connection
 Student Gallery
Computer Option

Resources

Teacher's Resource Binder
 Studio Master: 1.4
 Studio Reflection: 1.4
 A Closer Look: 1.4
 Find Out More: 1.4

Large Reproduction 2
Slides 1f

Teaching Options

Museum Connection
Community Involvement
Interdisciplinary Planning

Technology

Internet Connection
Internet Resources
Video Connection
CD-ROM Connection
 e-Gallery

Resources

Teacher's Resource Binder
 Using the Web
 Interview with an Artist
 Teacher Letter

Teaching Options

Advocacy
Family Involvement

Technology

CD-ROM Connection
 Student Gallery

Resources

Teacher's Resource Binder
 Chapter Review 1
 Portfolio Tips
 Write About Art
 Understanding Your Artistic Process
 Analyzing Your Studio Work

Chapter Overview

Theme

People around the world and throughout time have found ways to communicate with one another— through messages. Art is a way for people to send messages.

Featured Artists

Kenneth B. Haas, III
Käthe Kollwitz
Jacob Lawrence
William Lishman
Sa'di
Rand Schiltz

Chapter Focus

Art helps people communicate stories, lessons, important ideas, and feelings. This chapter focuses on the art of prehistoric people, the ancient civilizations of Egypt and Mesopotamia, and kingdoms throughout Africa. We consider how artists use line and pattern to communicate lasting messages about their lives.

1 Messages

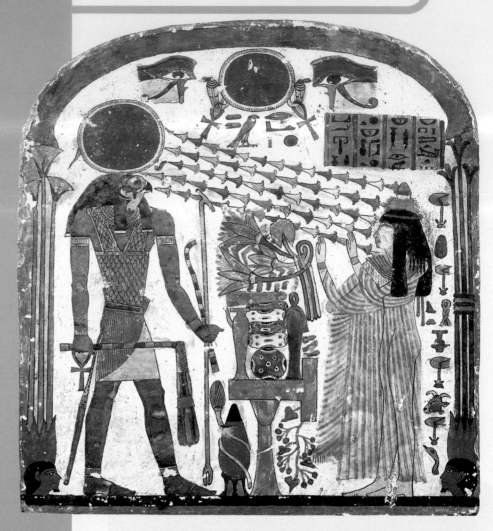

Fig. 1–1 **Carved and painted stone slabs like this one, called a stele** *(STEE-lee)*, **tell of a woman making offerings to the Egyptian sun god Re-Harakhte. The large disk above his head, along with other symbols, identify who he is. The lotus flowers—which represent rays of the sun— lead from Re-Harakhte, over a table filled with offerings, to the woman standing before him.** Lower Egypt (Lybia), 22nd dynasty (950–730 BC.), *Lady Taperet before Re-Harakhte.* Painted stele, Louvre, Paris, France. Girauon/Art Resource, New York.

68

National Standards
Chapter 1
Content Standards

2. Use knowledge of structures and functions.

4. Understand arts in relation to history and cultures.

5. Assess own and others' work.

Teaching Options

Teaching Through Inquiry

Aesthetics Ask students to imagine that a community group has questioned the value of using school time to study ancient Egyptian artworks. The letter to the principal states that we can't understand the artworks' messages, we don't believe in the gods and goddesses, and the artworks do not relate to our lives. To help the principal respond, groups of students can take a position and prepare a statement. Ask groups to share their statement.

More About...

Ancient Egyptian Messages In Fig. 1–1, the falcon-headed sun god Re holds an ankh (a symbol of life) and a flail, which represents Lower Egypt. He also holds a crook, for Upper Egypt, and a scepter, a symbol of power. The cobras around the upper solar disk represent the fiery eye of Re. Re's eyes themselves are symbols of protection. Twined lotus and papyrus blossoms represent Upper and Lower Egypt together.

Focus

- How do we send messages to one another?
- How have people around the world and over time communicated with one another through art?

Like many people, you have probably had the experience of looking at an artwork and asking, "What does it *mean*?" "What is it *about*?" We tend to believe that all artworks are *about* something—that they have some kind of meaning. We assume that whoever made the artwork was trying to communicate something. In some cases, the meaning or message is obvious. At other times, for a variety of reasons, we cannot be sure what the message is.

Imagine how exciting it was to discover the Egyptian artwork shown in Fig. 1–1. When these images were carved and painted on the stone surface, the artist could not have known that thousands of years later, people would find the artwork and wonder about its meaning. The message on this stone stele was not put there for us specifically, yet the painting still holds a message for us. These images—put on the walls of tombs to accompany the dead to an afterlife—tell about life in ancient Egypt. They also say to us, "We were here. This is what we believed. This is what we cared about when we were alive. You can see it in our artworks."

What's Ahead

- **Core Lesson** Examine some of the many ways that art is used to communicate.
- **1.1 Art History Lesson** Discover how people in early times communicated through their art.
- **1.2 Elements & Principles Lesson** See how ancient Egyptians used line and pattern to tell about their lives.
- **1.3 Global View Lesson** Learn how people in Africa send messages through their art.
- **1.4 Studio Lesson** Explore the use of clay to create your own message in relief.

Words to Know

stele	line
symbol	pattern
narrative	cultural meaning
contour lines	bas-relief
cuneiform	

Messages

69

Chapter Warm-up

Have students work in pairs to create and then share a visual way—without words—to communicate the statement "Have a nice day." Discuss similarities and differences among their visual messages, and have students identify those that clearly send the message. Discuss why. Tell students that this chapter focuses on visual communication—specifically, the ways that artworks around the world and over time have helped people send messages to others.

Using the Text

Have students read page 69 to discover what else we might learn from artworks made long ago.

Using the Art

List what students see in the Egyptian stele. Some items will be familiar. *(plant, animal, and human forms)* **Ask:** What items seem most important? Why? *(two figures, because of size; disk and rows of flower forms, because of diagonal placement)* Of the two figures, which seems more powerful? Why? *(the male figure, because of size, upright stance, and the objects of power he is holding)* What do you think is happening in this image? What might this image tell us about life in ancient Egypt? What helps you to think this?

Extend

Ask: Why might we have difficulty in fully understanding the messages of artworks made more than 3,000 years ago? *(Many images had special meaning for people who lived at that time; the meanings have been lost.)*

Graphic Organizer
Chapter 1

1.1 Art History Lesson
Art of the Ancient World
page 76

1.2 Elements & Principles Lesson
Line and Pattern
page 80

Core Lesson
Messages in Art

Core Studio
Creating Your Own Message
page 74

1.3 Global View Lesson
Messages of African Kingdoms
page 82

1.4 Studio Lesson
Making a Bas-Relief
page 86

Prepare

Pacing

One 45-minute period

Objectives

- Use examples to explain the statement "Art sends messages."

- Describe artworks' features that convey messages.

- Use line and pattern to create a message about contemporary life.

Vocabulary

stele An upright slab with sculptured or painted designs or inscriptions.

symbol Something that stands for something else; especially a letter, figure, or sign that represents a real object or idea; for instance, a heart shape is a symbol of love.

narrative Describing something that tells a story.

contour lines Lines that show or describe the edges of forms.

Teach

Engage

Ask: What messages have you sent since the beginning of the day? How did you communicate to others about breakfast, getting to school, or how you were feeling? What form of communication did you use? Explain to students that people often use words to communicate messages. They sometimes use gestures. They also use artworks.

National Standards Core Lesson

5b Analyze contemporary, historical meaning through inquiry.

Messages in Art

Sending Messages

Groups of people who live together need to communicate. At a basic level, we communicate about topics important to our survival: obtaining food, building shelters, and protecting the community. But we humans communicate about much more than these basic needs. We tell stories. We share our dreams for the future and our memories of the past. To communicate all this—to send messages—we use words, gestures, and symbols. A **symbol** is an image that stands for something else, such as the slash within a circle that means "not allowed," or the heart that can stand for love.

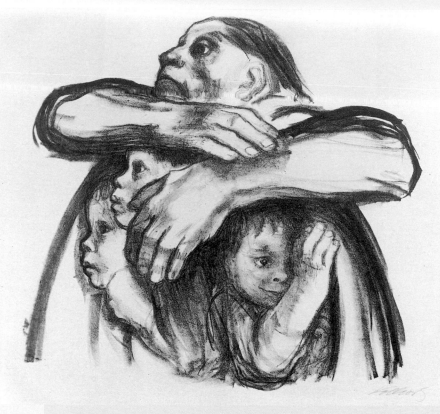

Fig. 1–2 **In her artworks, Käthe Kollwitz tells about the dignity and strength of the poor, the beauty of the human spirit, and the horror of war. This was her last artwork, made following the death of her grandson in World War II.** Käthe Kollwitz, *Seed for Sowing Shall Not Be Ground*, 1942. Lithograph on ivory paper. Private Collection, Courtesy Galerie St. Etienne, New York. © 2000 Artists Rights Society (ARS), New York/VG Bild-Kunst, Bonn.

70

Teaching Options

Resources

Teacher's Resource Binder
 Thoughts About Art: 1 Core
 A Closer Look: 1 Core
 Find Out More: 1 Core
 Studio Master: 1 Core
 Studio Reflection: 1 Core
 Assessment Master: 1 Core
Large Reproduction 1
Overhead Transparency 2
Slides 1a, 1b, 1c

Teaching Through Inquiry

Art History Have students study Figs. 1–3 and 1–4, and then work in small groups to make a chart with four columns: The Artwork; What We Know About It; What We Want to Know; How We Can Find Out More. Ask students to include the title of the artwork; a description of subject matter, materials, techniques, colors, lines, shapes, and other elements; questions about purpose or function; information about the culture or time period. Remind students that **art-historical inquiry** addresses the question "What was the message of the artwork when it was created?"

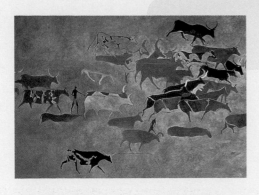

Fig. 1–3 **What can this painting tell us about life in prehistoric times?** *Saharan rock painting of Jabbaren showing early herders driving cattle*, 5500 BC–2000 BC. Phototheque du Musee de l'Homme, Paris.

Receiving Messages

Artworks are like words and gestures: They convey meaning, and people use them to communicate. We don't know what all words and gestures mean from the moment we're born. We learn their meanings gradually, as we grow up. How do we learn how to interpret messages in artworks?

Sometimes understanding what an artwork means is fairly easy. For instance, most viewers can see the compassion and love of a mother for her children in the artwork by Käthe Kollwitz shown in

Fig. 1–2. Do the words "guard" and "protect" come to mind as you study the image?

With other artworks, we might not be as sure about the message. For instance, we cannot fully understand messages left by prehistoric people—those who lived before the time of written records. They made drawings of animals and hunters on cave walls and other rock surfaces. These drawings give us clues about how prehistoric people lived. For example, some rock art tells us about their early hunting methods.

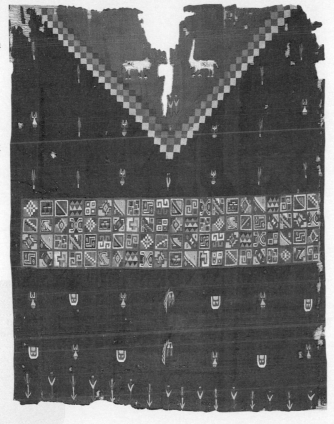

Fig. 1–4 Artworks that show symbols can be more difficult to understand than artworks that show objects we know. Look closely at the symbols in this tunic from Peru. What ideas do they suggest to you? Peru, South Coast, Inca, Early Colonial Period, *Half-Tunic*.
Interlocked tapestry: cotton warps and wool wefts, 37 ½" x 28 ½" (95.3 x 72.5 cm).
©The Cleveland Museum of Art, The Norweb Collection, 1951.393.

Messages

Using the Text

Have students read pages 70 and 71 to learn how people use artworks to send and receive messages. Have students study the three images. **Ask:** Which sends the clearest message? Why? What more would you like to know about the other two images?

Using the Art

Art Criticism Have students make a list of what they see (subject matter) in each image. Direct students to the Käthe Kollwitz lithograph, and have them describe what they see. Discuss the people, their expressions, and how they are grouped in the image. Note the simple, bold lines and the emphasis on arms. **Ask:** How did the artist create different feelings with line and shading?

More About...

Käthe Kollwitz was born in Prussia, into a family that encouraged her art and her concern for political and social causes. She and her physician husband settled in a Berlin working-class neighborhood, near the clinic her husband supervised. There, Kollwitz saw the daily hardships of the poor, and she particularly identified with mothers struggling to protect their children. Many of her artworks capture the grief of women and children whose lives are shattered by the death of loved ones in war. Her great gift was the ability to express—in a few bold, sure strokes— the grief, misery, and agony of victims.

Using the Overhead

Think It Through

Ideas What seems to be the springboard for this message?

Materials What materials were used?

Techniques What did the artist do with them?

Audience Whom is the message for?

Using the Large Reproduction

Talk It Over

Describe What is the subject matter?

Analyze How did the artist change the way things look in real life?

Interpret What feeling or mood is expressed?

Judge Why should people care about this artwork?

Using the Text

Have students read pages 72 and 73. **Ask:** What are some things that people communicate through art? On the board, write the prompt "People make art to communicate . . ." List students' answers.

Aesthetics Have groups of students discuss the question "Does *all* art send a message?" Ask students to support their position, and remind them that they may not reach a consensus. Allow ten minutes for the group discussion, and then have groups present their position. Discuss the positions, adding to two lists on the board, one labeled "Yes, because. . ." and the other, "No, because. . ."

Using the Art

Art Criticism Have students work in small groups to describe all that they see in Jacob Lawrence's *Tombstones.* Provide information about the artist (see More About Jacob Lawrence). Tell students that this painting was part of his Harlem series, based on a New York City area populated by African Americans for much of the twentieth century.

Messages About Our Lives

People make artworks to communicate ideas and goals. Through our art, we tell what is important, what we believe, and how we think people should live. Some art suggests ways to make the world a better place.

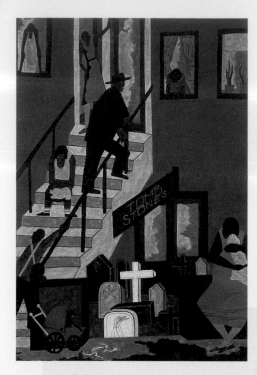

Fig. 1–5 **A single image can sometimes tell a complicated story. What do you think American artist Jacob Lawrence tells?** Jacob Lawrence, *Tombstones*, 1942.
Gouache on paper, 28 ³⁄₄" x 20 ¹⁄₂" (73 x 52.1 cm). Collection of Whitney Museum of American Art, New York. Purchase 43.14.

We often teach our values and beliefs through stories, legends, and myths. An artwork that suggests a story is called a **narrative** artwork. Not all narrative art is made to teach important lessons. Some narrative artworks tell stories to delight or amuse us. Others use images to report actual events. These artworks help document history and send messages to others about who we are and how we live.

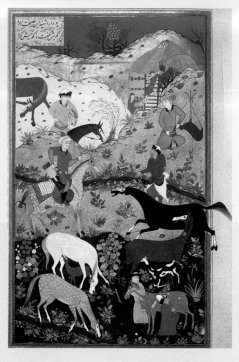

Fig. 1–6 **You can "read" this lively Persian miniature painting much as you would read a written story. The scenes toward the bottom of the painting are closest; those at the top are in the distance. Notice the expressions on the faces of animals and people. What story is told here?** Sa'di, *Bustan (Garden of Perfume): Darius and the Herdsmen,* mid-16th century.
Ink, colors and gold on paper, 11 ¹⁄₂" x 7 ³⁄₄" (29 x 20 cm). The Metropolitan Museum of Art, Frederick C. Hewitt Fund, 1911. (11.134.2) Photograph © 1978 The Metropolitan Museum of Art.

Teaching Options

Meeting Individual Needs

Multiple Intelligences/Linguistic Ask students to choose an image from page 72 or 73 and then "translate" the visual narrative into a written story. Encourage them to use their writing skills to develop pictures in the reader's mind. After students have read the stories to the class, discuss the similarities and differences between telling stories in art and in written form, paying particular attention to what an artwork can do that words cannot, and vice versa.

More About...

Jacob Lawrence was one of the first African-American artists to gain national recognition. His study of art began in an art program in a New York City library. During the 1930s, while working for the Works Progress Administration, Lawrence painted historical themes in "dynamic Cubism," a style of flat shapes of bright colors. Later, he taught at the Pratt Institute and the University of Washington in Seattle.

Telling About Who We Are

People make artworks as a way to dream. We imagine other worlds, other creatures, other lives. Through artworks, we can communicate our visions and fantasies.

From early records of games and toys, we know that humans have always loved to play. Artworks can reveal this playful side of us. When we lightheartedly combine materials to make new forms, we show how we love to experiment.

People do more than experiment with materials. We also explore techniques and processes, such as using computers for new ways to make art. As artists experiment and play with materials and techniques, they seek new ways to send messages. They explore art's potential to communicate with others—both today and in the future. Whether carved into stone or digitized for cyberspace, art sends messages about our lives.

Fig. 1–7 **Rand Schiltz playfully combined forms that, at first glance, seem lighthearted and even silly. Often, however, humorous artworks contain serious messages. What might the message be here?**
Rand Schiltz, *Renovations, Out with the Old, In with the New,* 1991.
Vacuum cast bronze and lacquer, 14" x 11" x 4" (35.5 x 28 x 10.2 cm). Courtesy of the artist. Photo by Jock McDonald

Fig. 1–8 **What kind of fantasy do you see in this picture? If this were a painting instead of a computer-generated image, how might the message be different?** Kenneth B. Haas, III, *Crossroads,* 1999.
Computer-generated image, 17.7" x 13.3" @ 72ppi, Bryce Software. Courtesy of the artist.

Messages

73

Journal Connection

Aesthetics Have students enter some of their thoughts about art in their journal, by answering the prompt "I believe that *all* art (does/does not) send a message because. . ."

Extend

Have students write an essay in which they address the question "What is the message of Jacob Lawrence's *Tombstones*?" Remind students to support their answer.

Teaching Through Inquiry

Art Criticism Have small groups of students choose one image from pages 72 and 73 and then **describe the details** they see. Explain that, like detectives at the scene of a crime, they must pay careful attention to details. Ask them to take an inventory of the image, listing such things as subject matter; materials; techniques; colors, lines, shapes, and other design elements; and organization. Challenge students to be specific, describing color, for instance, as dull, bright, somber, or vibrant. Allow ten minutes for the group work. Discuss findings with the entire class, and ask students to tell what they think is their selected artwork's story and message.

CD-ROM Connection

For more images relating to this theme, see the Global Pursuit CD-ROM.

73

1 CORE LESSON

Supplies

- props (such as sports equipment or cooking utensils)
- 9" x 12" sketch paper or newsprint
- pencils
- felt-tip markers
- 9" x 12" or larger drawing paper

Using the Text

Art Production After students have read the first column on page 74, ask them to create an outline by tracing around an outspread hand. Then have them create a contour line of their hand by looking at it and moving their pencil on the paper, slowly recording every ridge, groove, or edge. Encourage students to look at the form, not the paper. Explain that contour lines describe the shape of an object, and include interior detail. Remind students that they will be using contour lines in their drawings.

Using the Art

After students have read Studio Background, ask them to examine and compare the images on pages 74 and 75 by listing details and noting the use of line and pattern. For instance, students should notice if lines are thick or thin, bold or delicate, horizontal or vertical, stiff or fluid. **Ask:** What ideas and feelings does each kind of line help to express? *(Bold, diagonal lines might suggest strength and confidence; delicate, curved lines might suggest gentleness.)* How do the lines define the edges of forms? Discuss how repeated lines create pattern in each image.

Drawing in the Studio
Creating Your Own Message

In this studio experience, you will use contour lines and pattern to communicate something about life in the twenty-first century.

Contour lines are lines that follow the edges of forms. *Pattern* can be created by repeating lines in a planned way. Imagine that people in the future will "receive" the message you create.

Think of some ways that early artists showed how people lived in the past. Use line and pattern to show people in a present-day scene. You might show an event important to many people, such as astronauts building a space station, or a more common event, such as someone selecting clothing at a mall, playing soccer, or cooking a meal.

Fig. 1–9 **Notice the many different ways this artist used pattern.** Rachel Freeman, *Katelyn's Softball Portrait*, 1999.
Marker, 12" x 18" (30 x 46 cm). Hayfield Secondary School, Alexandria, Virginia.

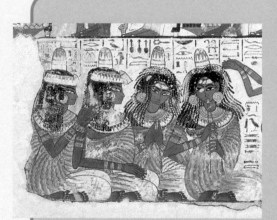

Fig. 1–10 **Contour lines show the forms of these women. Line creates pattern in their robes, jewelry, and wigs.** Egypt, Thebes, 18th Dynasty, *Banquet Scene*, (detail), about 1400 BC.
Wall painting. ©The British Museum.

Studio Background

Messages in Art
Art provides a glimpse of life from around the world and throughout history. It communicates messages from an earlier time.

Artworks that depict people often show them engaged in an activity. Examine the artworks on page 72. Notice how they send messages through the use of line. Notice how the lines in the images in Figs. 1–10 and 1–11 record the edges of forms: arms and legs, garments, musical instruments, and other objects. The artists followed these edges by moving a drawing tool. Look for differences between the length, weight, and thickness of the lines in the images.

Repeated lines can create pattern. Notice the pattern of the garments and jewelry in Fig. 1–10. Patterns can be simple, as in the earrings worn by the musicians, or more complex, as in the garment worn by the Assyrian soldier. Observe how pattern creates variety and interest in the overall composition.

Teaching Options

Meeting Individual Needs

Adaptive Tools Provide students with assorted stamps and prepared contour stencils for creating their scene.

Assistive Technology Have students use drawing or painting software, which allows easy duplication of shapes and lines to make patterns.

More About...

Why people draw: (1) to communicate ideas and feelings; (2) to record objects and events that are important to us; (3) to investigate, study, and question the world that we physically encounter; (4) to collect and keep impressions and ideas; (5) to make visible the world of our imagination.

You Will Need

- props
- sketch paper or newsprint
- pencil
- markers
- drawing paper

Try This

1. Sketch classmates posing in different activities. Practice drawing just the edges of clothing, features, and props. Notice the ripples, creases, and other features of the edges you draw. Exact detail is not important.

2. After you have made several practice drawings, choose an event or activity to show in a finished drawing. What visual message do you want the drawing to send about life in your time?

3. Plan your drawing on a sheet of sketch paper. How many people and poses will you include? What props will add meaning to your message?

4. Try a variety of ways to create pattern with line.

5. Use markers to make your final drawing.

Check Your Work

Share your drawing with a small group of classmates. Take turns describing the main features of each other's artwork. Pay attention to the way each of you used contour lines. Note where and how lines were repeated to create pattern. Discuss what messages about life today would be sent if the drawings are found a hundred years from now.

Sketchbook Connection
Fill several pages of your sketchbook with experiments in line and pattern. Repeat short diagonal lines. Make a series of curved lines in several rows. How can you change each pattern by making bold or delicate lines? Create a very simple line pattern. Then try to make the pattern complicated. Use your patterns to make future drawings more interesting.

Core Lesson 1

Check Your Understanding
1. Use artworks as examples to explain the statement, "Art sends messages."
2. What might an artwork tell about life in the past?
3. What do we mean by "narrative" art?
4. How is a contour line different from an outline?

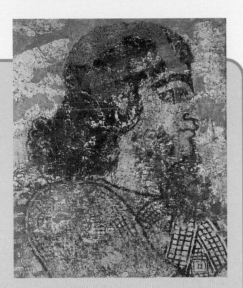

Fig. 1–11 **This fresco was painted for Assyrian King Tiglathpileser II. Notice the way the artist used contour lines to show the soldier's shoulder, profile, and other detail. Line is repeated to create pattern.** Neo-Assyrian, *Head of Man with Beard,* 8th century BC. Fresco from the Palace of Tiglathpileser III at Tell Atimar (Til Barsip), Syria. Giraudon/Art Resource, NY.

Assess

Check Your Work

Ask each student to share his or her artwork in a small groups by carefully describing the main features, especially the use of contour lines and pattern. Remind the class that referring to an artwork's details is important for determining its message about life today.

Check Your Understanding: Answers

1. Answers will vary. Check that students have provided examples.

2. Artworks can tell how people in the past lived and what they thought was important.

3. Narrative art is art that tells or suggests a story.

4. A contour line follows the edges of forms, including interior detail. An outline follows only the outside edges of an object.

Close

Reinforce the importance of careful description for interpreting an artwork's meaning or message, and of identifying information that would help "tell a story" about what the artwork meant at the time it was made. **Ask:** What are at least two different kinds of messages that art can send?

Lead a discussion of students' answers to Check Your Understanding.

Teaching Through Inquiry

Art Criticism Have students take turns describing objects in the room and having others, with their eyes closed, try to guess each object. Explain to students that they will have to find a way to **describe an object** so that someone else can imagine it.

More About...

Blind contour drawing is a way for artists to practice looking at and recording subtle changes in the edges of forms. To make a blind contour drawing, look only at the object, not the paper. Begin, for example, at the top of the drawing surface, with eyes on the uppermost part of the form. Do not lift your pencil from the paper. Follow the edges as you draw, until reaching either the end of the surface or the end of the form. At this point, look at the paper only to position the pencil at the top. Repeat the process, drawing over lines as needed to get from one point to another.

Assessment Options

Peer Provide small groups of students with a postcard reproduction of an artwork, and have group members identify and describe the artwork's features so as to exemplify the ways that artworks send messages: to tell about important ideas and beliefs; to teach lessons; to amuse; to convey facts about actual events; to share visions and fantasies; to show how humans are playful and like to experiment.

Prepare

Pacing

One 45-minute period for art history
One 45-minute period for Studio Connection

Objectives

- Explain how people in ancient times communicated through their art.
- Describe the subject matter in selected artworks of the ancient world.
- Communicate movement and action of the human figure through gesture drawing.

Vocabulary

cuneiform An ancient writing system with characters formed from wedge-shaped elements.

Using the Time Line

Have students calculate the time between events on the time line. **Ask:** How many years passed from the *Hall of Bulls* until the *Pyramid of Cheops* was built? *(12,430 years)* Is the *Pyramid of Cheops* closer in time to us or to artists who painted at Lascaux? *(much closer to us)*

Art of the Ancient World

	3000 BC cuneiform writing	2570 BC Pyramid of Cheops	
Prehistory	Ancient Near East	Ancient Egypt	Greek Classical Period page 102
c. 15,000 BC *Hall of Bulls*, Lascaux	c. 2685 BC *Standard of Ur*	c. 1297 Painted Relief	

Marks with Messages

Have you ever used a stick to scratch lines or other marks into dirt or sand? Do you notice scuff marks made by people walking down a hallway? Humans make marks. Sometimes, we make marks unintentionally, but most of the time, we do so for a purpose.

We might doodle to help us think, or draw a map to show someone where we live. When early humans drew on rock surfaces, painted on tomb walls, or carved huge stones, they did so with a purpose—to communicate.

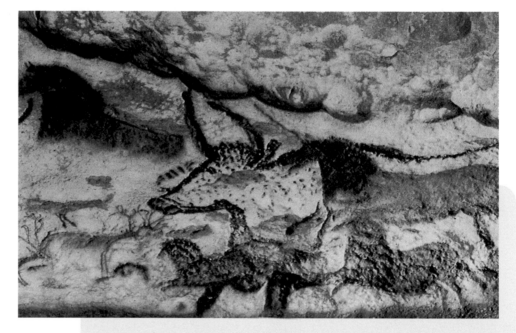

Fig. 1–12 **These cave paintings may have been created to tell stories and to educate children.** Lascaux, *Hall of Bulls*, detail, c. 15,000–13,000 BC, Dordogne, France.
Color photo Hans Hinz.

National Standards
1.1 Art History Lesson

4a Compare artworks of various eras, cultures.

Teaching Options

Resources

Teacher's Resource Binder
 Names to Know: 1.1
 A Closer Look: 1.1
 Map: 1.1
 Find Out More: 1.1
 Check Your Work: 1.1
 Assessment Master: 1.1
Overhead Transparency 1
Slides 1d

Teaching Through Inquiry

Art History Make and display a chart entitled "How People in Early Times Communicated Through Their Art." Include three columns—Prehistoric, Mesopotamian, Egyptian—and make a four-section grid in each column. Down the side, label the four sections: art forms, materials/techniques, subject matter, location of artwork. Help students fill in the grid with information from this chapter's text and Figs. 1–1, 1–3, 1–10, 1–12, 1–13, 1–14, 1–15, 1–16, 1–17. Review and summarize the completed chart, and have students record questions for further research.

Prehistoric Art: Our First Messages

Some of the oldest known images—more than 25,000 years old—are those painted on cave walls or carved into rock. These early messages have been found on every continent. The purpose of these images may have been to communicate hope for a successful hunt, to record events, or to educate children.

Most rock art shows three main subjects: humans, animals, and symbols. In rock painting, people often appear as stick figures with spears. Animals are shown mostly from the side and appear detailed and lifelike. Often, the images fit the surface or shape of the rock. Images sometimes overlap, which suggests that people worked on them at different times.

People used available materials—such as chalk, burned wood, and clay—to create these images. Some of these early artists mixed powdered minerals with animal fat to create colored pigments. They applied these colors with their fingers, moss, or brushes made from fur, feathers, or chewed twigs. They also applied color by blowing it through tubes made of bone.

Art of the Near East: Records of Accomplishment

About 7000 years ago, people began to live in farming communities along fertile river valleys in Mesopotamia (present-day Iraq). Over time, these ancient people began to create art to tell about the power of their rulers. Magnificent palaces and royal tombs were filled with furniture and other artworks. The works were made of wood, gold, silver, gemstones, shells, stone, and clay. Some of these artworks show the rulers as animal gods. Some tell stories of hunts, battles, and ceremonies.

The Mesopotamians also developed a system of writing for keeping records. The earliest examples of writing date to about 3000 BC. This writing—called **cuneiform**—was made up of wedge-shaped symbols pressed into clay tablets.

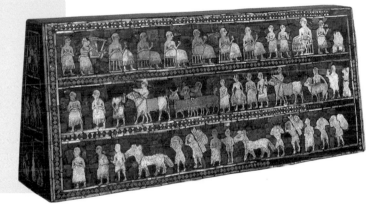

Fig. 1–13 **This is one of the two sides of a mosaic-like panel of shell and colored stones. This side tells a story of peace after a military battle; the other side depicts the battle. Notice that the figures are evenly spaced, and that the king is larger than the other figures he faces.** Sumerian, *Standard of Ur: Peace*, about 2685–2645 BC. Mosaic panel of shell and colored stones, 19" (48 cm) long. Royal Cemetery at Ur. ©The British Museum.

Messages

77

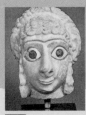

Using the Text

Art Production Have students read page 78. **Ask:** How did Egyptian artists work?

Aesthetics Engage students in a discussion about the pros and cons of following rules in art. **Ask:** Are rules ever good to have for art making? Why? When, if ever, are original ideas important for an artist?

Using the Art

Art Criticism Have students compare Fig. 1–15 to other Egyptian artworks in this chapter (Figs. 1–1, 1–10, and 1–17). **Ask:** How are they similar? How are they different? What is the message of each artwork? How does the composition contribute to the message?

Studio Connection

Have students read the Studio Connection, and then review it with them. Illustrate the Egyptian way of drawing human figures, or provide students with A Closer Look handout on the Egyptian scale of proportion. For contrast, demonstrate gesture drawing next to it.

Arrange desks so that all students have a clear view of the model, and have several models, in turn, assume an action pose for three minutes. Ensure that the models assume different actions. Ask students to use charcoal, colored chalk, or conté crayon to draw each pose on newsprint, manila paper, or colored construction paper. Suggest that they overlap several poses. If students use colored chalk, they may use a different color for each pose. Allow students to draw one action—for which the model poses longer—on a single sheet of paper.

Assess See Teacher's Resource Binder: Check Your Work 1.1.

ART HISTORY LESSON

1.1

Art of Ancient Egypt: Lasting Messages

During a period spanning more than 3000 years, powerful kings called pharaohs ruled the vast kingdoms of ancient Egypt. This civilization grew up along the Nile River, in northeastern Africa. The Egyptian pharaohs built elaborate royal cities and commanded skilled artisans to create artworks. These artworks told important stories about the daily life of the pharaohs.

The earliest Egyptian stone structures, carved monuments, tomb paintings, hieroglyphics (an early form of picture writing), and artifacts of daily life are almost 5000 years old. The region's dry climate has helped preserve them. These objects give us a record of ancient Egyptian life and culture.

The Egyptians believed that their pharaohs were gods who would live after death. Many pharaohs had their tombs built in the form of pyramids. Tombs were filled with furniture, jewelry, and other items that the rulers would need in the afterlife. Wall paintings, relief sculptures, and small models in the tombs tell stories of servants bringing gifts, harvesting crops, and fishing.

For centuries, artists in Egyptian kingdoms used a single set of artistic rules. For example, drawings of people were carefully measured for correct proportions. The human figure was always outlined. Artists were valued for their ability to follow these rules. Being original or spontaneous was not part of an Egyptian artist's role.

Much of Egyptian art is considered timeless. Artists today use many of the same artistic principles that the ancient Egyptian artists used nearly 5000 years ago.

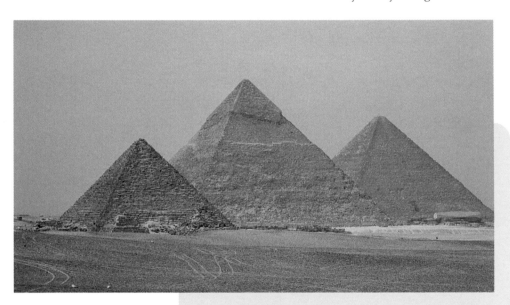

Fig 1-14 **The great pyramids were once covered with smooth stone that reflected sunlight. What kind of message might that convey to someone looking at them from a distance?** Giza, Egypt, *The Pyramids of Mycerinus, Chefren, and Cheops*, built between 2589 and 2350 BC. Limestone. Erich Lessing/Art Resource, NY.

78

Teaching Options

Meeting Individual Needs

English as a Second Language Ask: Who might have been buried beneath the structures in Fig. 1–14? Write the word *pyramid* on the board, and explain that Egyptian kings were buried in these tombs. Have students write *king* and *tomb* in English and in their native language.

Teaching Through Inquiry

Art History Ask: What's Egyptian, what's not, and how can you tell? Have students work in groups to compare Egyptian representations of the human figure with the Mesopotamian figures in Figs. 1–13 and 1–26. Ask students to list Egyptian and Mesopotamian style characteristics and then to note significant differences. If you have reproductions of other Egyptian and Mesopotamian figurative art, have students sort them by style.

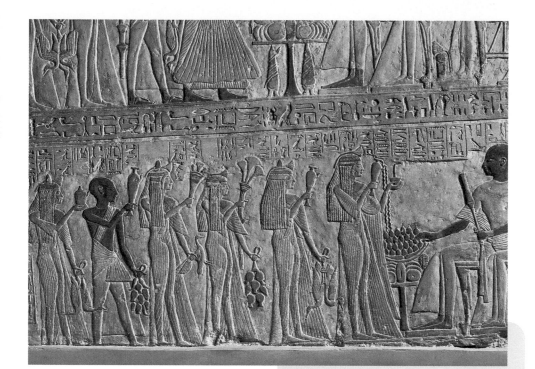

Fig 1–15 **This painted relief reflects the Egyptian artistic rules for showing people. The head, arms, and lower body are shown in profile. The eye and upper torso are shown in a front view.** Egypt, *Ptahmoses, high-ranking official of Memphis receiving offerings from his children,* 19th dynasty.
Painted relief. Museo Archeologico, Florence, Italy. Scala/Art Resource.

Studio Connection

As a contrast to the Egyptian style, try gesture drawing to record human figures in action. Gesture drawings are made with quickly drawn lines that define the basic position and mass of a figure: quick, easy strokes that capture a pose or action. These drawings are not meant to be realistic, but they should communicate the action of the figure.

Draw your friends or classmates quickly as they "freeze" in different action poses for a few moments. Try to capture their essence with just a few lines. Compare your gesture drawings with the Egyptian and an Assyrian contour drawings shown in Figs. 1–10, 1–11, and 1–15. Which method sends more interesting messages?

1.1 Art History

Check Your Understanding

1. What is the main subject matter depicted in most ancient rock art around the world? What might have been some purposes of this art?
2. What stories are told on many of the stone carvings of Mesopotamia?
3. What stories are told on the walls of Egyptian tombs?
4. Why did the Egyptian style of representing the human figure remain constant for thousands of years?

Messages

79

Check Your Understanding: Answers

1. The main subjects are humans, animals, and symbols. The purpose of the art may have been to communicate hope for a successful hunt, record events, or educate children.

2. The Mesopotamian stone carvings tell of hunts, battles, and ceremonies.

3. In images of gift-giving, harvesting, and fishing, the tomb walls tell stories of daily life and culture in ancient Egypt.

4. The Egyptian stylistic rules were thought to be timeless, and the role of the artist did not include spontaneity or originality.

Close

On a world map, point out the two river valleys where the artworks of Egyptian and Mesopotamian civilizations were located. **Ask:** Where else might art have been made in ancient times? *(other great river valleys, in India, China, South America, and so on)*

Remind students that art is a basic human activity, and it has always been used to send messages.

More About...

Gesture Exercises Instruct students to:

- stand while drawing.
- use paper at least 18" x 24".
- use any medium (charcoal or chalk is preferred).
- use large arm movements.
- scan the entire subject before beginning to draw.
- be aware that the hand duplicates the motion of the eye.
- keep their drawing tool in contact with the paper throughout the drawing.
- keep their eye on the subject, only occasionally referring to their paper.
- avoid outlines, and draw through the forms.

Assessment Options

 Teacher Have students write a brief essay that explains how ancient peoples used their art to communicate. Instruct students to describe the subjects and messages in prehistoric, Mesopotamian, and Egyptian artworks.

Self Have students select and mount what they consider to be their best gesture drawing. Ask them to attach a descriptive label that includes a title that communicates the movement or action of the figure and a short statement about why they think their artwork is successful.

1.2 ELEMENTS & PRINCIPLES LESSON

Line and Pattern

If you look carefully at artworks from the earliest times, you can see that line is the oldest and most direct form of communication. **Lines** are marks made by pushing, pulling, or dragging a tool across a surface. To tell about their lives, people from all cultures have used lines to decorate objects and mark surfaces. Sometimes the lines are combined with additional lines and shapes to form **patterns.**

The direction in which lines go and where they are placed can suggest various actions, moods, and space. You can describe a line by the way it looks—straight, curved, or broken, for example. You can also describe lines as being graceful, calm, energetic, and so forth.

Artists use lines to create shapes, textures, and patterns. Egyptian artists used line to divide space and define shapes. Before they applied color, their paintings probably looked like the outline drawings in a coloring book.

Looking at Line

Drawn quickly or slowly, heavily or lightly, line can define space. It can create the illusion of volume and form. One simple line might suggest the belly of a horse, a muscle in a leg, or a fold of cloth. Artists make lines by using a variety of tools and methods. For instance, by using a light pencil line, an artist expresses a feeling different from that of a heavy, painted line.

Looking at Pattern

Artists create patterns by repeating lines, colors, or shapes in an orderly or systematic way. Every pattern involves the repeated use of some basic element. This element can be a dot, a line, or a shape. Large patterned areas tend to hold an artwork together, whereas smaller patterns in only a few areas tend to add interest.

Fig. 1–16 **The thrills of a desert hunt are captured in this scene. Where do you see line? Where do you see pattern?** Egypt, Thebes, *King Tutankhamen after the Hunt,* c. 1352 BC. Photo by Fred J. Maroon.

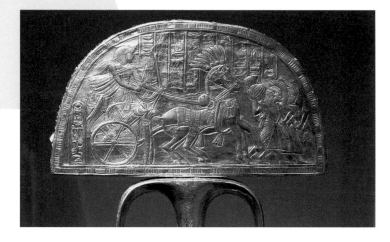

Prepare

Pacing
One or two 45-minute periods

Objectives
- Describe qualities of line and pattern in artworks and explain how these elements are used to communicate messages.
- Use line and pattern to decorate a CD label or book cover that conveys information about the contents.

Vocabulary
line A mark with length and direction created by a point that moves across a surface. Line can vary in length, width, direction, curvature, and color; and can be two-dimensional, three-dimensional, or implied.

pattern A combination of lines, colors, or shapes, repeated over and over in a planned way.

Teach

Engage
Ask students to look around the room for lines and patterns in such everyday items as clothing and furniture. Tell students that this lesson focuses on how artists use line and pattern in their artworks.

National Standards
1.2 Elements and Principles Lesson

2c Select, use structures, functions.

Teaching Options

Resources

Teacher's Resource Binder
- Finder Cards: 1.2
- A Closer Look: 1.2
- Find Out More: 1.2
- Check Your Work: 1.2
- Assessment Master: 1.2
- Overhead Transparency 1

Teaching Through Inquiry

Have students work in small groups to use objective words (*straight, zigzag, curved*) and expressive words (*bold, delicate, calm*) to describe line qualities in three artworks from other lessons. Have each group create a chart with the headings: Artwork, Title, "Look" of Lines, "Feel" of Lines; and then fill in the chart for each artwork. Have students share their findings with the rest of the class.

In Figs. 1–16 and 1–17, Egyptian artists used pattern in a variety of ways. What patterns do you see in these artworks? Identify both a pattern of repeated lines and a repeated flower shape.

Studio Connection
Design a book jacket for your favorite novel or a CD label for the soundtrack from your favorite movie. Use line and pattern to help communicate the important message or theme of the story or movie. Select an element that is important to the plot and repeat it as a border or decorative element in the design. Use markers or colored pencils.

Sketchbook Connection
Fill several pages of your sketchbook with line experiments. Use a range of tools: twigs, feathers, and cardboard edges dipped in ink, markers, brushes, crayons, charcoal, chalk, and pencils of different types. Change the way you work: Draw at arm's length, with two hands, with your eyes closed, and with your drawing tool taped to a yardstick. Think of other ways to experiment. Return to your sketchbook after a few days. Assign a name to each type of line you created.

1.2 Elements & Principles

Check Your Understanding
1. What are some ways that artists create pattern?
2. How do lines function in artworks?

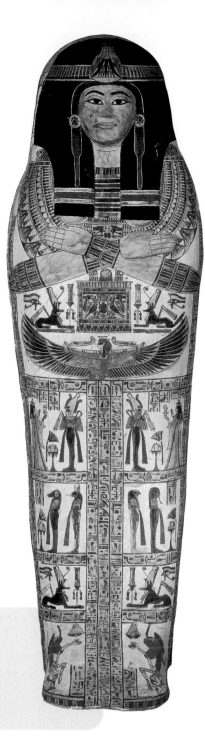

Fig. 1–17 **The outer coffin is decorated with a representation of the chantress and figures of the gods of the underworld. The chantress sang hymns, much as a cantor does in today's churches or synagogues.** Thebes (Egypt), *Outer coffin of Henettawy, Chantress of Amun at Thebes,* 1085–719 BC.
Wood, painted and gessoed, length 79 7/8" (203 cm). The Metropolitan Museum of Art, Rogers Fund, 1925. (25.3.182). Photograph © 1992 The Metropolitan Museum of Art.

Using the Text
Perception Have students read pages 80 and 81. **Ask:** What kinds of lines do you see in the artworks here? Where are lines that divide space? What shapes are outlined? How was line used to create patterns? What other patterns do you see?

Using the Art
Art Criticism Help students describe line qualities, distinguishing between expressive and objective words to do so. **Ask:** Where do you see *graceful* (expressive) and *curved* (objective) lines? *Restful* and *straight*? *Energetic* and *angular*? Which of these words are expressive? Which are objective?

Studio Connection

Demonstrate how to use simple cut-paper shapes as templates for creating patterns; and how to use various lines to divide space and create borders. Have students use newsprint for planning, and drawing paper for their final design.
Assess See Teacher's Resource Binder: Check Your Work 1.2

Assess

Check Your Understanding: Answers

1. by repeating lines, colors, or shapes in orderly or systematic ways

2. Lines are used to create shapes, textures, and patterns; and to divide space and define shapes and forms.

Close

Review how we describe lines by their look (objective qualities) and their feel (expressive qualities). Review ways that lines can be used to make pattern.

Using the Overhead

Write About It

Describe Have students write three or more words that describe the quality of lines.

Analyze Use the overlay, and have students write two or three sentences about how the artist created pattern.

Assessment Options

Teacher Have each student find an advertisement in a magazine or a package design that illustrates an effective use of pattern to help convey a message. Have students write a brief explanation of how the designer used pattern and why the design is effective.

Prepare

Pacing

One 45-minute period to consider text and images

Two 45-minute periods for studio experience

Objectives

- Describe how African artworks communicate.
- Explain why understanding the purposes, messages, and meanings of African artworks requires information about African cultures.
- Capture the expressiveness of an action figure by combining found materials in a sculptural form.

Vocabulary

cultural meaning A meaning that only members of a certain culture can understand.

<div>

Supplies for Engage
- pencils
- lined paper for writing

</div>

Using the Map

Have students look at the drawing of the world, identify which latitude line is the equator, and note where Africa is in relation to the equator and poles. **Ask:** What conclusions can you draw about the climate and its effect on art?

Messages of African Kingdoms

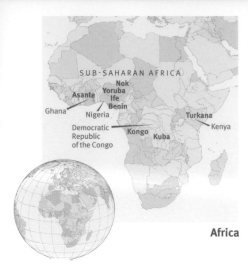

Africa

Forms That Communicate

African peoples create art for special purposes, but we can't always tell what the artwork's purpose is just by looking at it. Some artworks are used in secret rituals and ceremonies. Others are used in public celebrations.

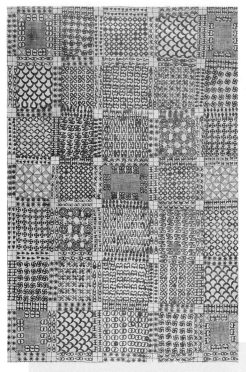

Fig. 1–18 **The designs of African fabrics sometimes have special meaning. The message of this fabric is "good-bye." This hand-stamped cloth is worn at functions for departing guests and at funeral ceremonies.** Asante people, Ghana, *Display Cloth*, late 19th century. Cotton cloth, natural dye, 82 ¾" x 118 ⅞" (210 x 302 cm). Museum purchase, 83-3-8. Photograph by Franko Khoury. National Museum of African Art, Smithsonian Institution, Washington, DC.

The arts of the ancient North African civilization of Egypt were an early influence on Western culture. Sadly, much of the early African artwork south of the equator was destroyed by hot, damp weather and wood-eating insects. By looking at objects and traditions that remain, we can tell that much African art—both past and present—has been created to send messages to spirit worlds or community members.

Artworks from the widespread African kingdoms are made in many different materials and styles. They have many levels of meaning and a variety of uses. Household objects such as spoons and stools, sculptures of figures and animals, jewelry, and textiles are often used to send messages about power, status, hope, good health, and the like. Unless we have learned the **cultural meaning** (meaning that only members of a specific culture can understand) of symbols, and understand what the artwork is used for, we can't receive the messages the artwork sends.

<div>

National Standards
1.3 Global View Lesson

4b Place objects in historical, cultural contexts.

5b Analyze contemporary, historical meaning through inquiry.

</div>

Teaching Options

<div>

Resources

Teacher's Resource Binder
 A Closer Look: 1.3
 Map: 1.3
 Find Out More: 1.3
 Check Your Work: 1.3
 Assessment Master: 1.3
Large Reproduction 2
Slides 1e

</div>

<div>

Teaching Through Inquiry

Display a political map of Africa, and provide images of African art from different cultural groups and regions. Keep a list of the artworks and their region of origin. Give some images to groups of students, and ask them to decide, based on appearance, if they have artworks from the same cultural group or country. Provide them with the location where each artwork was made. Have groups use stick-on notes for descriptive labels for the images. Ask groups to display their images and use yarn to connect the image with the approximate location on the map where it was made. Use the display to generate questions for further research.

</div>

Specially handcrafted objects and costumes might be used to communicate with powerful spirits. Ancestors are an important part of the spirit world.

In many ritual ceremonies, carved wood masks are used as part of a costume. African people might think of a costumed dancer as a messenger for the spirit world. Masks and costumes are used to mark the time when children move into adult life. They might also be used when judging a person accused of a crime. Each situation has its own special ritual. Each ritual makes use of certain types of masks, costumes, and other objects.

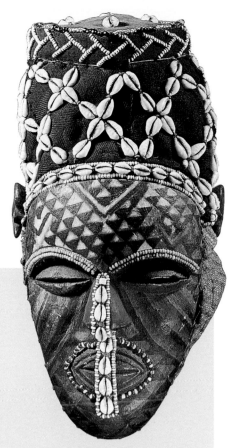

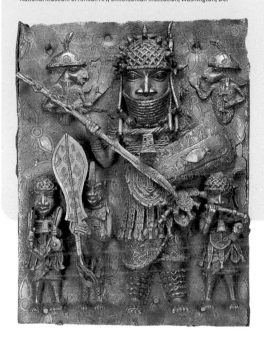

Fig. 1–19 **This bronze relief sculpture once decorated the king's palace in Benin. Plaques like these tell about the achievements of great leaders. What does this plaque tell about royal life in Benin?** Edo peoples, Benin Kingdom, Nigeria, *Plaque*, mid-16th–17th century. Cast copper alloy, 116.8" (46 cm). Purchased with funds provided by the Smithsonian Acquisition Program, 82-5-3. Photograph by Franko Khoury. National Museum of African Art, Smithsonian Institution, Washington, DC.

Fig. 1–20 **When viewing masks in a museum, remember that they were part of a costume and were used in ceremonies that likely included chants, music, and dance. This mask communicates sorrow and was used in a performance that honored deceased members of the group. What do the parallel lines that run from the eyes suggest to you?** Democratic Republic of the Congo; Kongo, Kuba, *Female Mask (Ngady Mwaash)*, 19th century. Wood, cowrie shells, glass beads, paint, raffia cloth, trade cloth, height: 13 3/8" (34 cm). ©Bildarchiv Preussischer Kulturbesitz, Berlin.

Messages

83

Teach

Engage
Distribute pencils and paper, and ask students to complete these sentences: One thing I know about Africa is_____ . I think of _____ when I think of African art. Collect the papers for later use.

Using the Text
Aesthetics Have students read page 82. **Ask:** When an artwork's meaning can be understood only by members of the artist's cultural group, why exhibit the work for others? *(to show craftsmanship and design; to share the artist's culture)*

Using the Art
Art Criticism Have students study the images and read the captions. **Ask:** What messages do these artworks send? How do you know? Discuss the extent to which the messages are clearly evident. *(Without a cultural understanding of the symbols, lines, and patterns in* Display Cloth, *probably no one except the Asante could interpret the message. Without knowing the cultural meaning of the parallel lines under the eyes of the mask, we might miss the message of sorrow. Because of realistic representation, the message of military strength is more obvious in the Benin plaque.)*

More About...

An object in **African art**, its use, and the process of creating it are inseparable. For example, a ritual honoring the forest spirits residing in and around a tree might be performed before the cutting of the tree. The tree might then be secretly brought to a village and carved by an authorized person so that the proper spiritual forces remain in both the wood and the object made from it. The woodcarver might have to observe rules or include certain symbols. After an object is created, it might be presented in a public ceremony or celebration.

Using the Large Reproduction

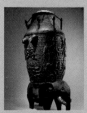

Consider Context

Describe What materials were used to make this?

Attribute What clues do we have about where or by whom this was made?

Understand How could you find out more about how this was used?

Explain How does the symbolism relate to the messages?

Using the Text

Critical Thinking Have students read Meaning Over Time, as well as the image captions. **Ask:** How would you like to see African art presented? What would you want people to know about the objects, and how would you provide that? (For example, the Yoruba headdress was not made for a museum display. Without the complete costume and the dancer's movements, the message is incomplete.)

Using the Art

Art Criticism On the chalkboard, create columns headed: lines, shapes, colors, textures, values. Use descriptive word cards (or lists of descriptive words) to generate a discussion of the artworks in this lesson. As students describe the lines in each artwork, write their words in the appropriate columns. **Ask:** How do these visual qualities contribute to the meaning and message of the artwork?

Studio Connection

Have a variety of materials available: scrap wood, wire, cardboard, paper, and assorted found objects. Assembly will require glue, nails, staplers, and other materials and tools appropriate for joining.

Use these materials to demonstrate several methods of figure sculpture. Encourage students to think about how their sculpture can communicate a message, and assist them in finding appropriate solutions to any construction problems.

Assess See Teacher's Resource Binder: Check Your Work 1.3.

Meaning Over Time

Africa is a continent of diverse cultural and ethnic groups. Because of this, many creative traditions with long histories are represented in African art. About 500 BC, people of the Nok culture created clay sculptures of people and animals. During the 1400s and 1500s, artists of the kingdoms of Benin, in southern Nigeria, and Ife, west of Benin, mastered bronze casting. The bronze works are detailed, well-crafted, and tell us much about the Ife and Benin kingdoms.

Masks and other art forms from Africa were first displayed in Europe during the late 1800s. Beginning in the nineteenth century, African artisans began to produce art objects for trade. These objects were usually replicas of items used in ritual celebrations or other ceremonies. Ceremonial artworks like these influenced such Western artists as Pablo Picasso and Henri Matisse early in the twentieth century. Today, many museums have collections of African art.

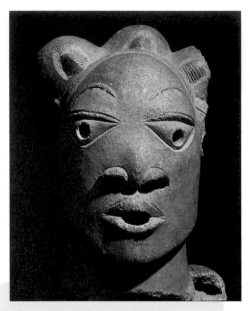

Fig. 1–21 **The oldest sculptures discovered so far in sub-Saharan Africa are figures such as this one, which is about 2000 years old. The figures probably served a religious function, perhaps as personal offerings or as messengers to the dead.** Nok culture, Nigeria. *Terra cotta head from Rafin Kura,* 500 BC – 200 AD.
Frontal View. National Museum, Lagos, Nigeria. Werner Forman/Art Resource, NY.

Studio Connection

Construct a sculpture of a human figure to celebrate a joyous occasion—a sports victory, birthday, special holiday, or even the beginning of summer vacation. Construct your sculpture to be freestanding, perhaps with a flat base. Select materials and use colors that will help to show the feeling that goes along with the event. Use details to create a festive effect. How can you simplify a human figure? How can you make it express happiness or joy? What shapes, color, and symbolic elements can you use to show what you mean?

1.3 Global View

Check Your Understanding
1. How do African artists use artworks to communicate?
2. Why is knowledge about a culture important for understanding the meaning of its artworks?
3. Where and when in Africa was bronze casting mastered?
4. How was twentieth-century European art influenced by African art?

Teaching Options

Meeting Individual Needs

Multiple Intelligences/Bodily-Kinesthetic Ask students to study Fig. 1–22, the Yoruba headdress and read its caption. Ask students to imagine having seen the original dancer wearing this headdress and the rest of the costume. **Ask:** How did the artist arrange the materials so that the headdress enhanced the dancer's movements?

More About...

Sculpture is probably the most widely practiced art form in Africa. Artists work with all four sculptural processes: subtractive carving; and additive constructing, modeling, and casting. Some artists carve wood, whereas others cast bronze, model clay, or construct and assemble fibers and found materials to make both traditional and inventive sculptures.

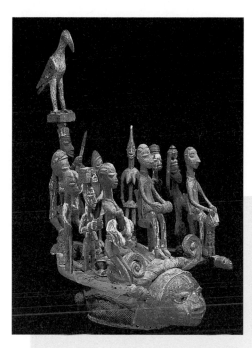

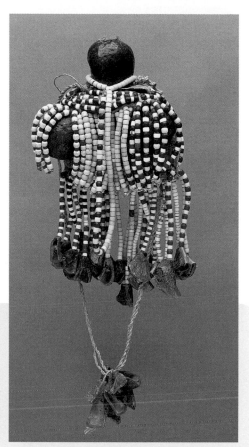

Fig. 1–22 **This headdress is made to be worn with a costume in a dance performance. Such performances can be considered "newspapers" because they make comments on current events and community conditions. What messages do you see?** Yoruba people, Nigeria. *Magbo Headpiece for Oro Society,* first half of 20th century.
Wood, pigment, cloth, iron, metal, foil, mastic, height. 28 5/16" (71.9 cm). Indianapolis Museum of Art, Gift of Mr. and Mrs. Harrison Eiteljorg.

Fig. 1–23 **Small sculptures of human figures from most parts of Africa are commonly labeled as dolls in museum collections. Bead-decorated dolls like this one, made from a gourd, are more than playthings: They communicate a hope to bear children.** Turkana (Kenya), *Doll.*
Gourd, beads, glass, fiber, leather, horn, 10" x 2 1/2" (25.4 x 6.3 cm). Seattle Art Museum, Gift of Katherine White and the Boeing Company. 81.17.1077. Photo by Paul Macapia.

Messages

85

Extend

Give each student a reproducible map of Africa. Ask students to locate regions from which each artwork on pages 82–85 comes. Help students recognize the diversity of cultural groups in Africa. **Ask:** Do you think the artworks on these pages can fairly represent all of African art? Why or why not? Encourage students to use the Internet and the library to research the art of other African cultural groups.

Assess

Check Your Understanding: Answers

1. Answers might include "to communicate with ancestors in the spirit world" or "to celebrate a child becoming an adult."

2. because the true intent comes from knowing the specific cultural meanings of symbols, along with the purpose of the artworks within the culture

3. in Benin and Ife during the 1400s and 1500s

4. Picasso, Matisse, and other European artists were influenced by the shapes, colors, and patterns of ceremonial objects imported from Africa.

Close

Ask again the questions from Engage, and have students respond again in writing. Return the original responses, and have students compare their responses.

Conclude that we often have only general, limited ideas about art from other cultures, and what we must gain is an understanding of cultural meanings.

Assessment Options

Peer Have pairs of students exchange both sets of responses from the opening and closing of the lesson, and instruct them to answer, in writing, the following questions when reading and comparing their classmate's responses: Does the second response show that your partner better understands how African artworks are used to communicate? In what ways? Does the second response show that your partner understands the importance of cultural meaning? How?

Self Have students mount and attach a written description of how their sculpture symbolizes an activity and what expressive qualities it conveys. Ask them also to explain how decisions about the selection and use of materials and design elements contributed to the success of the piece.

85

Prepare

Pacing

One or two 45-minute class periods

Objectives

- Recognize the qualities and characteristics of clay as a medium for bas-relief.
- Apply the ceramic processes of modeling, embossing, and carving to convey a message in relief.
- Reflect on one's own purposes and processes of art making.

Vocabulary

bas-relief A form of sculpture in which portions of the design stand out slightly from a flat background.

Supplies

- pennies
- clay
- cloth-covered boards (about 8 1/2" x 11")
- rolling pins or dowel rods
- wooden slates (1/2" thick), 2 per student
- clay modeling tools or a paper clip and tongue depressor
- plastic wrap

Sculpture in the Studio

Making a Bas-Relief

Sending Your Own Message

Studio Introduction

Have you ever noticed public statues or monuments in your neighborhood or in a nearby town? Why were they made? Who or what do they help you remember? The bas-relief sculptures of ancient kingdoms are similar to our public monuments. They, too, celebrate important events and individuals.

In this studio lesson, you will carve, model, and emboss clay to create your own bas-relief sculpture. Page 88 will tell you how to do it. *Carving* involves scooping out unwanted clay. You can *model* a clay slab by shaping it with your fingers or adding smaller pieces of clay to it. To *emboss* clay, press objects into its surface.

Use these techniques to tell about events in your life, a single event, or a sequence of daily activities. As you plan your sculpture, ask yourself: What will I show? What purpose will it serve? How will I display it?

Studio Background

Messages in Relief

The artworks shown in Figs. 1–24, 1–26, and 1–27 are **bas-relief** sculptures. In a bas-relief, some parts of the design stand out from the background. The people who created these sculptures were highly skilled artists: Their works are greatly detailed and show a feeling of depth, even though they are fairly flat.

Bas-reliefs were often created to help people remember a special accomplishment. They may have recorded a military victory, the opening of a new waterway, or the completion of a large building project. Their dramatic stories, high level of craftsmanship, and size were no doubt intended to impress the general public.

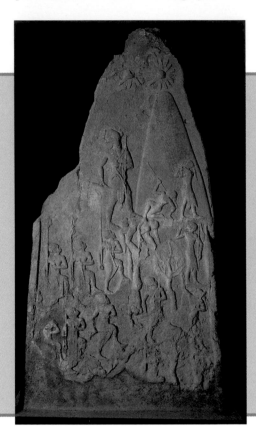

Fig. 1–24 **This stele is a boulder of pink sandstone, six feet high. The natural shape has been altered only slightly. What kinds of lines do you see? What shapes are repeated? What can you see that suggests it commemorates victory in battle?** Akkadian, *The stele of Naram-Sin*, c. 2300–2200 BC. Pink sandstone, 6' 6" (1.98 m) high. Louvre, Paris. Giraudon/Art Resource, New York.

86

National Standards
1.4 Studio Lesson

5b Analyze contemporary, historical meaning through inquiry.

Teaching Options

Resources

Teacher's Resource Binder
 Studio Master: 1.4
 Studio Reflection: 1.4
 A Closer Look: 1.4
 Find Out More: 1.4
 Large Reproduction 2
 Slides 1f

Meeting Individual Needs

Adaptive Materials Students lacking fine motor skills may have difficulty working with clay. Before students start to work, prepare softer clay by adding more water, or provide a softer material such as Model Magic or a sculpting foam.

Figs. 1–25 "Panther" tiles, which feature the school mascot, border the main images of two large murals made by students at the Plymouth Middle School, Maple Grove, Minnesota. See the full image on page 89.
Plymouth Middle School, Maple Grove, Minnesota.

Teach

Engage

Give each student a penny. **Ask:** What makes the words and images on the coin stand out? What parts are higher than others? What parts are lower? How are details created? In addition to its use as money, what other purpose does a penny have? *(commemorates a national leader; sends a message about national identity)* Explain that a penny is a bas-relief sculpture.

Tell students that, in this lesson, they will see how ancient bas-reliefs sent messages, and that they will use bas-relief to communicate their own message.

Using the Text

Art Criticism Have students read the text and captions on pages 86 and 87. **Ask:** How are the sculptures similar to the penny? *(give an impression of depth but are fairly flat; celebrate important people or events)* How are they different? *(larger; show full figures in action; give more information)*

Using the Art

Perception Ask: What parts of the sculptures are raised? What parts are lower than others? How do you think the artists created the images? How does line show the forms? How does line create patterns? What are the different textures in the artworks?

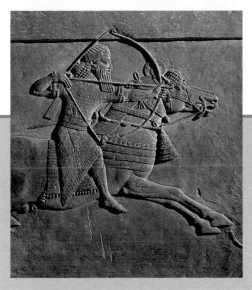

Fig. 1–26 This relief shows a soldier in battle. Notice the detail. How many different patterns do you see? What are they? How could you make these in clay? Assyrian, *Ashurbanipal in battle*, 7th century BC.

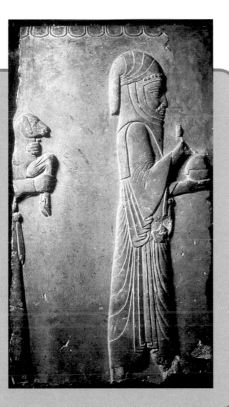

Fig. 1–27 A tribute is a gift or payment that one person gives to another. Notice the object that the man in this relief is holding. Notice the fragment of the person behind him holding a lamb. What story might his artwork tell? Persia (Persepolis), *Tribute Bearer*, 5th or 4th century BC. Limestone, 32 ½" x 19 ½" x 5" (82.5 x 49.5 x 12.7 cm). The Nelson-Atkins Museum of Art, Kansas City, Missouri (Purchase: Nelson Trust).

Messages

87

Using the Large Reproduction

Look Closely What part of this artwork is a bas-relief sculpture? Notice the way this drum is decorated. How would you describe the line and pattern? What qualities of this surface might you use in your bas-relief?

Making Your Bas-Relief

Studio Experience

1. Review the use of clay tools. Demonstrate:

- wedging clay.

- rolling a slab using slats to control thickness.

- cutting shapes with a template.

- making balls and coils.

- embossing a clay surface.

- scratching surfaces/using slip to join parts.

2. Encourage students to explore ways to work with clay: carving into and incising; pinching and modeling.

3. Emphasize the importance of building up layers from the base.

4. Review clean-up procedures, and wrapping a work in progress with plastic for storage.

5. After the first firing, explain to students how they may finish their work: glaze and fire a second time; rub pigment into embossed areas and wipe raised surfaces; coat with clear wax or polymer; paint or stain with acrylic paint or shoe polish.

Idea Generators

Have students brainstorm ideas for their bas-relief. List events they might depict. **Ask:** What format will you use? What details will you include?

Studio Tips

- Remind students that the clay should not be thicker than their thumb. In thicker clay, air bubbles may become trapped, causing the piece to crack during firing. Tell students to hollow out, on the reverse side, any very thick parts of the design.

- Allow the sculpture to dry thoroughly before firing on a cloth-covered board or on a board covered with aluminum foil. If dried on absorbent cardboard, the work may curl.

STUDIO LESSON

1.4

Sculpture in the Studio

Making Your Bas-Relief

You Will Need

- clay
- paper clip
- board covered with cloth
- rolling pin or dowel
- finishing materials
- wooden slats
- clay modeling tools or tongue depressor
- found objects
- finishing materials

Try This

1. Use a rolling pin or dowel to roll out clay into a slab about ½ to 1 inch thick. Cut the slab into the shape you want with a paper clip.

2. Combine carving, embossing, and modeling to create your relief sculpture. Reshape the surface of the slab with your hands and fingers. Apply coils, pellets, and ribbons of clay with slip. Create surface textures by embossing.

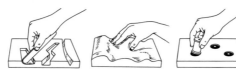

3. As your sculpture begins to take shape, ask yourself: How will the composition fill the space? Which techniques will best show the message? Think about how the high and low areas of the relief create areas of light and dark.

4. When you are satisfied with your work, put it aside to dry evenly and slowly. Your teacher will supervise the kiln firing when the sculptures are dry.

5. Finish your work in one of the following ways:

- Rub neutral pigments or moist dirt into the embossed areas. Before the dirt or pigment dries, wipe the raised surfaces with a moistened rag. Add a protective coat of liquid wax or clear gloss polymer.

- Paint your sculpture with acrylic paint. Use only one color. After the paint is dry, stain it with diluted black acrylic or shoe polish.

Check Your Work

What message did you try to communicate? Were you successful? Were you able to combine modeling, embossing, and carving in a visually pleasing way? Discuss your work with your classmates. As you worked on this project, did you gain any insights into the question of why we make art?

Computer Option
Consider how you might send a message using shapes or symbols only, no words. Using a draw or paint program, design a shape-and-symbol plaque that sends a message. As you develop your design, you may wish to save several versions. Make a printout of the version you think works best. Using markers, add shading for a three-dimensional effect.

Sketchbook Connection
Design a series of coins commemorating important events in your life. Work within a circular format. Consider images for both sides of the coin.

Teaching Options

Studio Collaboration

By planning ahead and coordinating students' work, you can help the class combine their individual efforts into one large mural composition, perhaps one that tells the story of school life.

Teaching Through Inquiry

Art Production Have students make individual contributions to a collaborative sampler of clay embossings that could be used as a teaching reference for future ceramic projects. Give each student enough clay to make a 4" x 4" tile, about 1/2" thick. Each student selects one found object (such as a nail, spool, bolt, or key) and explores textural/surface design possibilities with that object. Fire the tiles and display along with the found objects.

Sketchbook Connection

Suggest to students that they use a compass, jar lids, or other circle templates. Encourage them to accommodate words, images, and patterns in their designs. Ideas might be developed in clay, embossed metal foil, or cardboard relief.

Computer Option

Guide students to use Claris, AppleWorks, or PowerPoint to gather their images into an electronic slide show. Suggest that they choose a sequence of symbols and illustrations that communicates a message. Encourage students to apply embossing effects to letters or shapes by using paint programs (Color It, Paint Shop Pro, Dabbler, Painter, or Photoshop).

Assess

Check Your Work

Have groups of students use the Check Your Work questions to critique the group members' work. **Ask:** What other materials could you use to create a bas-relief sculpture? What are some disadvantages of using clay?

Close

Display the bas-relief sculptures, and have students work in small groups to create labels for the display: one label that tells about each sculpture, another label that explains the process of creating a bas-relief sculpture in clay.

Fig. 1–28 **With the help of their art teacher, 150 students designed and made two large murals, composed of approximately 750 ceramic tiles, for the front entrance of their school. General themes include daily life, friendships, sticking together, equality, peace, connectedness to the world, and unity throughout the school. Images used to show these themes include school materials like the pencil, ruler, computer, books, piano keys, and violin. In addition to working with clay, students stated they had learned teamwork. "You have to do your own part. If you don't finish, it ruins the whole thing. What other people did affected us."** Ceramic, 8' x 8' (2.45 x 2.45 m). Plymouth Middle School, Maple Grove, Minnesota.

Messages

89

More About...

Relief sculptures are classified by the degree of projection from the background surface. The lowest degree of relief is called **crushed relief**. The projection barely exceeds the thickness of a sheet of paper. In **low, or bas, relief** the figures project only slightly. No part is entirely detached from the background. In **high, or deep, relief** the figures project at least half of their natural circumference from the background. Between high and low relief there is middle, or half, relief. There is also hollow relief, or relief in reverse, in which all the carving is within a hollowed-out area below the surface plane.

Assessment Options

Self Ask students to write a short paragraph in which they reflect on the process they used, what they like about their completed sculpture, and what they would change, if anything.

Peer Have students work in small groups to plan a demonstration—to present to a group of younger students—of using clay for a bas-relief. Explain that the purpose of the demonstration is to help other students learn about bas-relief sculpture and discover the qualities and characteristics of clay as a medium for bas-relief.

Careers

Explain that most archeologists bear no resemblance to the movie character Indiana Jones, though that public perception has been prevalent since the first excavations of ancient Egyptian tombs. Instead, archaeologists carefully and painstakingly search for evidence of human culture. **Ask:** What cultures or time periods might require special knowledge of art from an archaeologist? Could someone be a competent archaeologist without knowledge and understanding of art? Why or why not?

Daily Life

Lead a discussion of how billboards, graffiti, and signs on buses relate to Adinkra stamps, Egyptian hieroglyphs, and cuneiform writing.

Mathematics

Collect and display magazine ads or illustrations of people or objects extremely out of proportion to their environment. **Ask:** Which parts of the ads are out of proportion? What kind of message might advertisers send by images of exaggerated proportions? Demonstrate the process of using a grid to enlarge a photograph or postcard. Have students use a photograph from home as the basis for an enlarged drawing or painting.

Connect to...

Daily Life

What do Adinkra stamps, Egyptian hieroglyphs, and cuneiform writing have in common? Whether created on stone, wood, cloth, or clay, these symbols of language and ideas send messages. Although they were once understood by people from a particular culture, we often do not fully understand the meaning of such ancient symbols. For example, think how difficult it would be for someone from the ancient world to understand a pedestrian crossing sign, a red traffic light, or other signs and symbols that we see daily.

Look around your immediate environment for **messages from contemporary culture**. What product brands do you recognize and understand just from their symbol, needing no written language to help you? What messages can you find that are meant to be seen by many people?

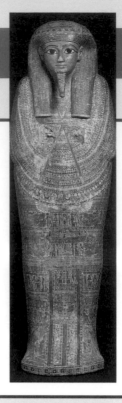

Fig. 1–29 *Coffin of Bakenmut*, detail, Egypt, late 21st–22nd Dynasty. Gessoed and painted sycamore fig wood, 81 ⅛" x 17 ½" (208 x 68 cm). ©The Cleveland Museum of Art, Gift of John Huntington Art and Polytechnic Trust, 1914.561.a-.b

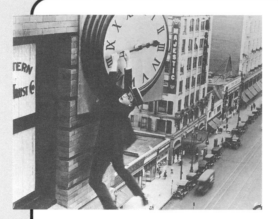

Fig. 1–30 **What music do you imagine playing during this scene?** Harold Lloyd in *Safety Last* (1923 US). The Museum of Modern Art, Film Stills Archive, New York.

Other Arts

Music

Musicians play or sing music for various purposes, depending on the event (what is happening) and the audience (who is listening). Watch a scene from a movie or a TV show. Notice how the film score or the soundtrack communicates danger, fear, sadness, action, bravery, or love. How does the composer use musical elements—such as tempo (speed of the music), rhythm, melody, harmony, choice of instruments, and dynamics (loudness and softness)—to create mood? What messages does the music send? Is the **musical message** ever different from the visual message? What might that tell you?

Teaching Options

Resources

Teacher's Resource Binder
 Using the Web
 Interview with an Artist
 Teacher Letter

Community Involvement

Meet with local newspaper and business leaders to plan a special section of the paper for an advertising competition. Encourage students to design ads, and have community businesspeople judge the ads.

Video Connection

Show the Davis art careers video to give students a real-life look at the career highlighted above.

Other Subjects

Mathematics

How do you think early artists created large paintings with **accurate proportions** on high walls? Like many contemporary muralists, they first created drawings in a size that they could easily handle. Then they added a lined grid on top of the image. Next, they drew a much larger grid on the wall, and then transferred and enlarged the image, block by block. Each block, for instance, might have been three times the size of the original drawing, so the ratio of the smaller to the larger drawing was 1:3. This method guaranteed the desired proportions in the completed wall painting.

Social Studies

Artworks and monuments have both **social and historical significance.** They might symbolize, or stand for, various ideas whose meaning depends on the viewer's social or cultural background. Some works are widely recognized and become part of general cultural knowledge. Artists may take advantage of this situation to "copy" and alter such works. For example, Stonehenge has been recreated in a variety of ways. Some artists have used objects other than monumental stones. Two such works are **Autohenge,** in Ontario, and **Fridgehenge,** in Santa Fe. What messages do the artists of these works send?

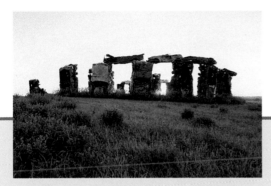

Fig. 1–31 **What does this monument tell about the artist's culture?** William Lishman, *Autohenge*, 1986. Crushed, painted automobiles. Blackstock, Ontario. Photo by W. M. Lishman.

Careers

How do we know how people in ancient cultures lived? The scientists who provide that information are **archaeologists.** But, along with their expertise in science, many archaeologists also have artistic skills, such as the ability to observe carefully, draw, or paint. Such scientists/artists must accurately depict and document historic finds and help interpret messages from the past. Usually specializing in a particular culture, an archaeologist goes on field studies and excavations to search for tools, buildings, weapons, and other evidence of a culture. Often using scientific dating methods, the archaeologist will then interpret the historic sites and artifacts, and thereby give us a picture of the past.

Internet Connection
For more activities related to this chapter, go to the Davis website at **www.davis-art.com.**

Other Arts

Try a musical-message experiment. Show students a movie action scene (such as a car chase) with the sound turned off. **Ask:** What emotions are related to the action? What predictions can you make about the music for this scene? Is it fast or slow? Loud or soft? What instruments would you expect to hear? Play the scene again, but with the sound on. **Ask:** Were your predictions accurate? Does the music reflect any changes in action? What if the natural sounds (squealing tires, racing engines) were present, but no music was included? Try this with a scene in which two characters are conversing. **Ask:** Does the music tell us what they are thinking?

Messages

91

Internet Resources

The British Museum, Department of Egyptian Antiquities

http://www.british-museum.ac.uk/egyptian/index.html

The Egyptian Antiquities department at the British Museum houses works from Predynastic times (c. 4000 BC) to the Coptic period (1100 AD). This site includes extensive information and images.

Also at the British Museum: *Cracking Codes: The Rosetta Stone and Decipherment.* The Rosetta Stone is the remains of a stele in three scripts; hieroglyphic, a cursive form of ancient Egyptian, and ancient Greek.

The Metropolitan Museum of Art

http://www.metmuseum.org

The world-renowned Metropolitan Museum of Art houses a collection of more than three million objects. The site is an excellent one to explore, especially for the Museum's Egyptian and Byzantium collections. A time line of museum objects, highlighted by thumbnail images, is particularly useful.

Interdisciplinary Planning

To support interdisciplinary teaching and learning, meet with fellow teachers on a monthly basis, and provide copies of these "Connect to. . ." pages. Identify cross-disciplinary concepts, and share activities and ideas.

Talking About Student Art

Remind students that careful description of an artwork—perhaps in a way similar to telling someone about it in a phone conversation—is a form of art criticism. Have students work in pairs to describe one another's artworks.

Portfolio Tip

Remind students that their portfolio not only holds artistic production, but also written reflections about their creative process, historical knowledge, critical thinking, and aesthetic understanding.

Sketchbook Tip

Guide students to see that the design of a sketchbook page can help them recall and make sense of information. Suggest to students that they divide a sketchbook page—as a visual organizer—into sections for vocabulary, important questions, things to remember, assignments, and so on. Students might design a special symbol for each section.

Portfolio

"I love rock 'n' roll music. If you have a problem and go listen to the music, your problem will go away, just for that moment."
Jessica Tejeda

Fig. 1–32 **Artwork can communicate what the artist cares about. When asked to design a CD cover, this artist made a list of the things she liked: guitar, head phones, dogs, and pizza. Why do artists use line and pattern to create a frame around their work?** Jessica Tejeda, *Hard Rock*, 1999.
Colored pencils, 8 ½" x 8 ½" (22 x 22 cm). Central Middle School, Galveston, Texas.

Fig. 1–33 **A student artist who has won awards for her poetry included a poem in her sculpture. Words are written on a strip of paper held between two hands she fashioned with plaster. Her message speaks of the conflict and isolation between people of different races.** Natalie Araujo, *Black and White*, 1997.
Mixed media sculpture, 18" x 18" x 18" (46 x 46 x 46 cm). Avery Coonley School, Downers Grove, Illinois.

Fig. 1–34 **A successful gesture drawing will capture the feeling of action or movement. What do you think this figure is doing? (See Studio Connection on page 79.)** William Lara, *Thinking of Someone*, 1992.
Oil stick, 18" x 12" (46 x 30 cm). Sweetwater Middle School, Sweetwater, Texas.

CD-ROM Connection
To see more student art, check out the Global Pursuit Student Gallery.

Teaching Options

Resources

Teacher's Resource Binder
Chapter Review 1
Portfolio Tips
Write About Art
Understanding Your Artistic Process
Analyzing Your Studio Work

CD-ROM Connection

Additional student works related to studio activities in this chapter can be used for inspiration, comparison, or criticism exercises.

Chapter 1 Review

Recall

What is a symbol?

Understand

Explain how artworks send messages.

Apply

Design two dinner plates—one with little or no decoration, and the other with added lines and patterns. Consider the message sent by each, and give your dinnerware an appropriate name.

Analyze

Compare and contrast the use of symbols in two artworks reproduced in this chapter. Identify and describe the artworks and consider how they look, what they represent, and how easy or difficult it is to understand the message they send.

Synthesize

Design a poster that encourages people to appreciate how art has been used as a means of communication around the world and throughout time.

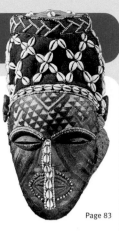

Page 83

Evaluate

Select an artwork from this chapter that you believe is a good example of an artist's use of line or pattern to communicate an important message. (One example is shown above.) Write a short essay in which you describe the artwork and give reasons to justify your selection.

Keeping a Portfolio

A portfolio provides a single place to put your work and keep it in good condition. You may use the work in your portfolio as a reminder of your growth as a maker and viewer of art.

Keeping a Sketchbook

From themes—such as "messages" or "nature"—you might get ideas for artworks. Explore various themes—and try out personal ideas—in your sketchbook.

For Your Portfolio

Choose an artwork that you made during this chapter. On a separate sheet of paper, write the media and techniques you used; how the work sends a message; how you used elements and principles of design to send your message; and why you are or are not satisfied with the work. Include your name and the date, and put your report into your portfolio.

For Your Sketchbook

Keep one or two pages in your sketchbook on which to design symbols for human emotions. Instead of using facial expressions for an emotion, you might, for instance, use line and pattern. Add more such designs to these pages throughout the year.

Family Involvement

For effective communication between school and family, send home newsletters containing reminders and specific information about what students are learning in art.

Advocacy

Create a brochure about your program goals, purposes, rationale, and means by which your program achieves the national, state, and local standards.

Chapter 1 Review Answers

Recall

A symbol is something that stands for something else; especially a letter, figure, or sign that represents a real object or idea.

Understand

Cultural groups assign special meaning to certain images or marks. Artists use those symbols and marks to convey meaning in their artworks. If the viewers know the special meanings, they will understand the message.

Apply

Look for an appropriate relationship between the expressive use of line and pattern and the name given to the dinnerware. For example, dinnerware with a border pattern of delicate wavy lines might appropriately be called "Serenity."

Analyze

Answers will vary. Look for careful description, understanding of how symbols communicate, and awareness of the role of cultural knowledge in interpreting messages.

Synthesize

Look for an understanding of the power of visual images to attract attention and send a persuasive message about a group members' lives (their ideas, goals, beliefs, stories, legends, and myths) and about who they are (their dreams, visions, fantasies, and tendency to experiment).

Evaluate

Look for a detailed description of the artwork and reasons that refer to expressive use of line or pattern.

Reteach

Have students create a bulletin-board display—of maps, time lines, magazine images, and art reproductions—as a way to understand the following ideas:

- People need to and do communicate all the time.
- People worldwide make, and have always made, artworks to help them communicate.

Chapter Organizer

Chapter 2
Identity and Ideals
Chapter 2 Overview
pages 94–95

Chapter Focus

- **Core** Art is a means by which people express individual and group identity, and their beliefs and goals, or ideals.
- 2.1 The Art of Three Empires
- 2.2 Texture and Rhythm
- 2.3 Native North American Art
- 2.4 Drawing Architectural Forms

Chapter National Standards

1 Understand media, techniques, and processes.
2 Use knowledge of structures and functions.
3 Choose and evaluate subject matter, symbols, and ideas.
4 Understand arts in relation to history and cultures.
5 Assess own and others' work.

3 3 3

Objectives

Core Lesson
The Art of Special Groups
page 96
Pacing: Three 45-minute periods

- Explain how artworks can convey information about personal or cultural identity.
- Use examples to explain how the beliefs of a group of people might have an impact on the art they produce.

National Standards

3b Use subjects, themes, symbols that communicate meaning.
5c Describe, compare responses to own or other artworks.

Core Studio
Making a Self-Portrait Sculpture
page 100

- Sculpt a papier-mâché self-portrait that uses symbols to show identity and ideals.

2c Select, use structures, functions.

1

Objectives

Art History Lesson 2.1
The Art of Three Empires
page 102
Pacing: One or two 45-minute periods

- Explain how artworks reflect what was important to the people of ancient Greece, Rome, and Byzantium.
- Compare the identity conveyed in classical sculptures of ancient Greece with realistic sculptures of ancient Rome.

National Standards

4a Compare artworks of various eras, cultures.

Studio Connection
page 104

- Create a two-dimensional building façade to convey information about the identity of those who use the building.

1b Use media/techniques/processes to communicate experiences, ideas.

1

Objectives

Elements and Principles Lesson 2.2
Texture and Rhythm
page 106
Pacing: One or two 45-minute periods

- Describe qualities of texture and rhythm in artworks and explain how these elements are used to unify the composition.

National Standards

2b Employ/analyze effectiveness of organizational structures.

Studio Connection
page 107

- Use texture and rhythm in a paper mosaic to convey a person's identity.

2b Employ/analyze effectiveness of organizational structures.

Featured Artists

Borie, Trumbauer, and
 Zantzinger
Antonio Gaudí
Iktinos and Kallikrates
Jack Mallotte

Frank Memkus
Myron of Athens
Alison Saar
Peter Vandenberge
Kay WalkingStick

Chapter Vocabulary

architectural floor plan
crest
elevation drawing
ideals
identity
mosaic

papier-mâché
rhythm
self-portrait
tesserae
texture
totem

Teaching Options	Technology	Resources	
Meeting Individual Needs Teaching Through Inquiry More About…Ceremonial masks Using the Overhead More About…Golden Age of Byzantine Culture Using the Large Reproduction	CD-ROM Connection e-Gallery	Teacher's Resource Binder Thoughts About Art: 2 Core A Closer Look: 2 Core Find Out More: 2 Core Studio Master: 2 Core Assessment Master: 2 Core	Large Reproduction 3 Overhead Transparency 4 Slides 2a, 2b, 2c
Meeting Individual Needs Teaching Through Inquiry More About…Papier-mâché Assessment Options	CD-ROM Connection Student Gallery	Teacher's Resource Binder Studio Reflection: 2 Core	

Teaching Options	Technology	Resources	
Meeting Individual Needs Teaching Through Inquiry More About…The *Charioteer of Delphi* Using the Overhead	CD-ROM Connection e-Gallery	Teacher's Resource Binder Names to Know 2.1 A Closer Look 2.1 Map 2.1 Find Out More 2.1 Assessment Master 2.1	Overhead Transparency 3 Slides 2d
Teaching Through Inquiry More About…Roman Sculpture More About…Caryatids Assessment Options	CD-ROM Connection Student Gallery	Teacher's Resource Binder Check Your Work: 2.1	

Teaching Options	Technology	Resources	
Teaching Through Inquiry More About…Mosaic Using the Overhead Assessment Options	CD-ROM Connection e-Gallery	Teacher's Resource Binder Finder Cards 2.2 A Closer Look 2.2 Find Out More 2.2 Assessment Master 2.2	Overhead Transparency 3
	CD-ROM Connection Student Gallery	Teacher's Resource Binder Check Your Work: 2.2	

Chapter Organizer continued

9 weeks | 18 weeks | 36 weeks

		3	**Global View Lesson 2.3 Native-American Art** page 108 Pacing: Three 45-minute periods

Objectives

- Understand the unique features of Native American artworks that make possible the identification of the community or region of their production.
- Explain how the identity and ideals of Native Americans are reflected in their artworks.

National Standards

3a Integrate visual, spatial, temporal concepts with content.
4a Compare artworks of various eras, cultures.

Studio Connection page 110

Objectives

- Create a three-dimensional artwork that conveys one's personal identity in the form of an animal.

National Standards

1a Select/analyze media, techniques, processes, reflect.

2	2	**Studio Lesson 2.4 Architectural Drawing** page 112 Pacing: Two 45-minute periods

Objectives

- Explain the difference between architectural floor plans and elevation drawings.
- Create a drawing of a building whose architectural elements reflect ideals and identity.
- Identify architectural features that borrow from the past.

National Standards

1a Select/analyze media, techniques, processes, reflect.
4a Compare artworks of various eras, cultures.

Connect to... page 116

Objectives

- Identify and understand ways other disciplines are connected to and informed by the visual arts.
- Understand a visual arts career and how it relates to chapter content.

National Standards

6 Make connections between disciplines.

Portfolio/Review page 118

Objectives

- Learn to look at and comment respectfully on artworks by peers.
- Demonstrate understanding of chapter content.

National Standards

5 Assess own and others' work.

2 Lesson of your choice

Teaching Options

Teaching Through Inquiry
More About…The Anasazi

Technology

CD-ROM Connection
 e-Gallery

Resources

Teacher's Resource Binder
 A Closer Look: 2.3
 Map: 2.3
 Find Out More: 2.3
 Assessment Master: 2.3

Large Reproduction 4
Slides 2e

Meeting Individual Needs
Teaching Through Inquiry
More About…Traditional Yup'ik masks
Using the Large Reproduction
Assessment Options

CD-ROM Connection
 Student Gallery

Teacher's Resource Binder
 Check Your Work 2.3

Teaching Options

Meeting Individual Needs
Teaching Through Inquiry
More About…Elevations
Studio Collaboration
More About…Drawing tools
Using the Overhead
Assessment Options

Technology

CD-ROM Connection
 Student Gallery
 Computer Option

Resources

Teacher's Resource Binder
 Studio Master: 2.4
 Studio Reflection: 2.4
 A Closer Look: 2.4
 Find Out More: 2.4

Overhead Transparency 3
Slides 2f

Teaching Options

Community Involvement
Museum Connection
Interdisciplinary Tip

Technology

Internet Connection
 Internet Resources
Video Connection
CD-ROM Connection
 e-Gallery

Resources

Teacher's Resource Binder
 Using the Web
 Interview with an Artist
 Teacher Letter
 Venn Diagram

Teaching Options

Advocacy
Family Involvement

Technology

CD-ROM Connection
 Student Gallery

Resources

Teacher's Resource Binder
 Chapter Review 2
 Portfolio Tips
 Write About Art
 Understanding Your Artistic Process
 Analyzing Your Studio Work

Chapter Overview

Theme

Because we all belong to and identify with groups or institutions, we develop some form of social bonding. Art can reflect and preserve the ideals that hold people together.

Featured Artists

Borie, Trumbauer, and Zantzinger
Antonio Gaudí
Iktinos and Kallikrates
Jack Malotte
Frank Memkus
Myron of Athens
Alison Saar
Peter Vandenberge
Kay WalkingStick

Chapter Focus

Art is a means by which people express individual and group identity, and their beliefs and goals, or ideals. This chapter focuses on how Native North American art and the art of ancient Greece, Rome, and Byzantium reflect identity and promote ideals. We consider how artists use texture and rhythm toward these ends.

2 Identity and Ideals

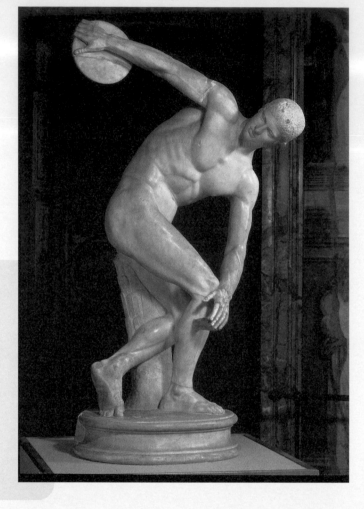

Fig. 2–1 By copying the original Greek *Discus Thrower* by the sculptor Myron, the Romans showed that they greatly admired the Greeks. The body of this athlete shows the strain of throwing a heavy discus, but the face seems calm. How do both the motion of the body and the calm expression reflect important ideals of the ancient Greeks? Myron of Athens, *Discobolus (Discus Thrower).* Roman copy of Greek original (c. 450 BC).
Museo Nazionale Romano delle Terme, Rome, Italy. Scala/Art Resource, New York.

94

National Standards Chapter 2 Content Standards

1. Understand media, techniques, and processes.
2. Use knowledge of structures and functions.
3. Choose and evaluate subject matter, symbols, and ideas.
4. Understand arts in relation to history and cultures.
5. Assess own and others' work.

Teaching Options

Teaching Through Inquiry

Aesthetics Remind students that many Roman artists copied the discus thrower of the Greek sculptor Myron. Have students work in small groups to create a set of classroom **rules about copying**, such as if and when it is acceptable to copy art made by another person; why an artist would want to copy something; what harm is done by copying; how copying can be a good thing; how important it is that every artwork be original or unique. Discuss how students' rules reflect their ideals.

More About...

The Greek sculptor **Myron** cast the original of the *Discobolus* in bronze, but the original has been lost since antiquity. However, from the several Roman marble copies, we can understand why ancient writers praised the realism of his sculptures. In *Discobolus,* Myron stopped action in the middle of a motion sequence, yet maintained the balance and harmony.

Focus

- Why are identity and ideals important parts of life?
- What does art tell us about identity and ideals?

Add up the amount of time that you spend alone in a day. Do you find that most of your time is spent with other people? We tend to live, work, and play together. We live together in households. We pull together to get jobs done. We create games and play sports for fun.

Each of us has an individual **identity**—who we are as a person. When we are young, much of our identity comes from the people who take care of us. As we get older, the groups we belong to also help give us our identity. Groups may be small, like a science club, or large, like a political party. People usually gather in groups because they like to be with others who have similar goals or beliefs. Throughout history and around the world, people have created art that shows and celebrates these similarities.

Members of a group often share **ideals**—a view of what the world and the people in it would be like if they were perfect. What does perfection mean to you? Think of a group you belong to. What is the group trying to do? How does it show its ideals? The *Discus Thrower* (Fig. 2–1) reflects the ideals of people who lived together in ancient Greece. The Greeks believed that the ideal person—one who was perfect in every way— learned to control both mind and body. The ideal mind was calm and not emotional. The ideal body was strong and flexible, with pleasing proportions.

What's Ahead

- **Core Lesson** Examine ways that art reflects identity and promotes ideals.
- **2.1 Art History Lesson** Learn about three Mediterranean empires and how art helped each empire show its ideals and identity.
- **2.2 Elements & Principles Lesson** Focus on ways that artists use texture and rhythm to unify their artworks.
- **2.3 Global View Lesson** Learn how Native-American art promotes identity and helps keep people together in groups.
- **2.4 Studio Lesson** Make drawings of architectural elements that reflect a group's identity.

Words to Know

identity	tesserae
ideals	crest
self-portrait	totem
rhythm	architectural
texture	floor plan
mosaic	elevation drawing

Identity and ideals

Chapter Warm-up

Ask: Why do you wear what you wear? How did you come to wear any one piece of clothing that you have on today? Did you choose it because it says something about who you are and what you care about? Does it represent something you think is important? Does it set you apart from others, or does it help you to blend in with the crowd? Summarize by telling students they will be learning how art, like clothing and jewelry, helps people express their identity and the things they care about.

Using the Text

Have students read the introduction to find out how individual identity and goals are connected to group identity and goals.

Using the Art

Discuss answers to the caption question with *Discobolus*. If necessary, point out that the graceful movement shows control of the body, and the calm expression shows control of the mind.

Graphic Organizer
Chapter 2

2.1 Art History Lesson
The Art of Three Empires
page 102

Core Lesson
The Art of Special Groups

Core Studio
Sculpting Your Identity
page 100

2.3 Global View Lesson
Native North
American Art
page 108

2.2 Elements & Principles Lesson
Texture and Rhythm
page 106

2.4 Studio Lesson
Drawing Architectural
Forms
page 112

Prepare

Pacing

Three 45-minute periods: one to read the text and to build armature; one to add papier-mâché; one to paint

Objectives

• Explain how artworks can tell about personal or cultural identity.

• Use examples to explain how the beliefs of a group of people might have an impact on the art they produce.

• Sculpt a papier-mâché self-portrait that uses symbols to show identity and ideals.

Vocabulary

ideals Views of what the world and the people in it would be like if they were perfect.

identity That which defines who someone is in relation to the groups to which he or she belongs.

self-portrait Any artwork in which an artist shows him- or herself.

Teach

Engage

Ask students to think of an athletic event, and discuss what roles different people play. They should consider not only the players and officials, but also the coaches, cheerleaders, band members, food-service workers, security officials, journalists, and spectators. **Ask:** How does the clothing of these people identify their role?

National Standards Core Lesson

3b Use subjects, themes, symbols that communicate meaning.

5c Describe, compare responses to own or other artworks.

The Art of Special Groups

Art Reflects Identity

Imagine that you are watching an Independence Day parade. Think of groups that march in the parade. What do members of these groups have in common? How do they show that they are a group? Marching bands, war veterans, town clubs, and sports teams, for instance, might show their group identity by their uniforms, floats, or theme songs. Many such groups use symbols to help represent who they are and what they believe.

Artworks can show group identity, too. Some artworks are used in important ceremonies or rituals. Some cultures believe that wearing elaborate costumes or using special objects will help them achieve a goal. The carved wooden mask in Fig. 2–2 was made to be worn in a ceremonial dance held by the Native-American Kwakiutl (*kwah-key-OOT-ul*) of Vancouver Island. The mask was used to remind the group of significant beliefs.

The way artworks look can tell us something about what is important to a group. For example, the clay sculpture in Fig. 2–3 represents an important person in ancient

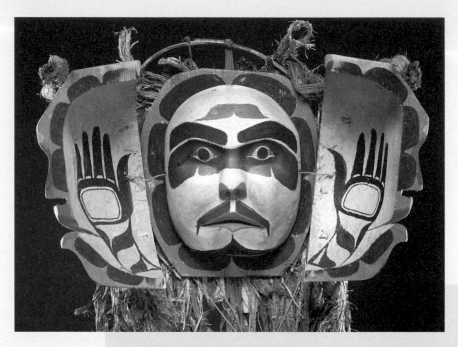

Fig. 2–2 Masks such as this one are for Native-American ceremonies called potlatches. Potlatches are held to distribute property and make marriages and other contracts official. How might this mask show that the wearer belongs to a group? Hopetown, *Mask of Born-to-Be-Head-of-the World*. Wood, reed and undyed cedar bark, rope, 24 ½" x 29 ⅝" x 9 ⅛" (62 x 75 x 23 cm). No. 4577(2). Photo by Lynton Gardiner. Courtesy Department of Library Services, American Museum of Natural History.

96

Teaching Options

Resources

Teacher's Resource Binder
 Thoughts About Art: 2 Core
 A Closer Look: 2 Core
 Find Out More: 2 Core
 Studio Master: 2 Core
 Studio Reflection: 2 Core
 Assessment Master: 2 Core
Large Reproduction 3
Overhead Transparency 4
Slides 2a, 2b, 2c

Meeting Individual Needs

English as a Second Language Ask students to study Fig. 2–3, and discuss how the artist tells us visually that the ruler was an important person. Have students then draw a self-portrait in which they use clothes, objects, surroundings, or a pose to indicate their own importance. Afterward, have students write a paragraph in English about their portraits.

Mayan society. To show their status, Mayan kings, lords, and warriors wore fancy headdresses. The more complex the headdress, the more important the wearer. Think about your own culture. How do people make themselves look important or powerful? How can you tell, for instance, the difference between an ordinary soldier and a general?

Artists can also challenge group members to question their beliefs. When Native-American artist Jack Malotte created *It's Hard to Be Traditional When You're All Plugged In* (Fig. 2–4), he wanted to challenge young people—especially Native Americans—to question the way they live their lives.

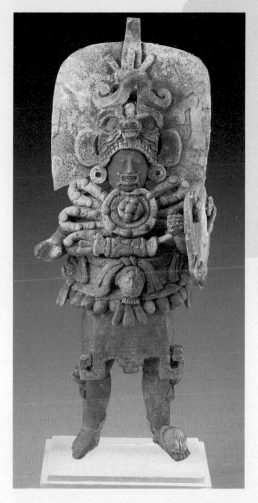

Fig. 2–3 The Mayan ruler represented in this sculpture wears a very complex headdress. What other details in this artwork might suggest this ruler's identity? Mayan, *A Ruler Dressed as Chac-Xib-Chac and the Holmul Dancer*, c. 600–800. Ceramic with traces of paint, 9 3/8" (23.8 cm) high. Kimbell Art Museum, Fort Worth, TX. Photo by Michael Bodycomb.

Fig. 2–4 This artist points out how difficult it can be to hold onto ancient traditions in a modern world. Jack Malotte, *It's Hard to Be Traditional When You're All Plugged In*, 1983. Mixed media, 22" x 30" (55.9 x 76.2 cm). American Indian Contemporary Arts.

Identity and Ideals

97

Using the Text

Have students read pages 96–97. Lead a discussion using the questions asked in the text. Think about your own culture. **Ask:** How do people make themselves look important or powerful? Ask students to think beyond popular culture—have them consider specific cultural groups to which they belong.

Using the Art

Perception Ask: How would each artwork actually feel to the touch? Where are the repeated elements in each artwork? How do the repeated elements lead your eyes around the artwork?

Art Criticism Have students study the Hopetown mask, and point out the inner and the outer mask. **Ask:** How would this mask change the wearer's identity? *(by the wearer's assuming a special role, or identity, in the potlatch ceremony)* What might be the purpose of having two masks in one?

Art Production Have students speculate about how the Mayan figure was constructed. **Ask:** What tools might have been used? What techniques? *(slab, coil, embossing, incising)* How might the artist have gotten ideas for showing identity? *(by observing how people dressed and how certain clothing and accessories symbolized rank or status)*

Teaching Through Inquiry

Art Criticism Ask small groups of students to consider interpretations of Fig. 2–4. (1) Focusing on advertising messages can get in the way of learning about one's cultural heritage; (2) Acquiring computers, TVs, and stereos is a desirable goal for Native Americans; (3) Americans should question their fascination with material goods.

Tell each group to choose the interpretation they think best explains the artwork and to provide reasons. Suggest to students that they consider the title and details in the work. Have groups share their reasons in a group discussion. Remind students that there can be more than one well-supported interpretation of an artwork.

More About...

American Northwest Coast tribes created **ceremonial masks** that represented mythological creatures and spirits. No two masks were alike; each artist carved his own interpretation. The masks were worn by dancers who used cords and hinges to control the opening and closing. The mask above opens to reveal an enclosed face.

Using the Overhead

Think It Through

Ideas What ideas about identity were developed in this mural?

Materials What materials and processes were used?

Techniques How was this made?

Audience Who will see this?

Using the Text

Art Criticism Have students read pages 98 and 99 to understand how symbolism in art can promote a culture's ideals. Discuss students' answers to the caption questions. **Ask:** What is the meaning of each artwork's symbols? How do the symbols portray the beliefs of the culture in which the work was made? *(The red, white, and blue represent America's flag and patriotic beliefs; the silk robe represents the official's status; the cross represents the death of Jesus.)*

Using the Art

Art Criticism Explain that ideals can be presented in artworks in both playful and serious ways. **Ask:** What are the serious and the playful messages in *Whirligig*? What materials were used to create the Chinese robe and the Byzantine cross? Why, do students think, did the artists use such expensive media? *(to convey the emperor's importance and power, and the holiness of the cross)* What might have been the symbolic meaning of the emperor's gift of the expensive cross to the pope? *(a representation of an alliance or an expression of support)*

Art Promotes Ideals

People like to celebrate and display what they believe is important or ideal. Citizens of the United States understand that the red, white, and blue flag with stars and stripes stands for their country. The flag also stands for democracy and the ideals of freedom, responsibility, and loyalty. When artists use this powerful symbol, they expect viewers to recognize a message about American ideals. Study Fig. 2–5, *Whirligig Entitled "America."* Why do you think artist Frank Memkus combined the playfulness of the whirligig with the seriousness represented by the flag?

Ideals are often presented through a culture's customs. Throughout history in China, for example, color, style, and fabric patterns all have special meaning. For official business, men wore a dragon robe like the one in Fig. 2–6, in which several dragons are shown. The dragon, a symbol of authority, is usually associated with the Chinese emperor. Patterns on the robe represent water, clouds, mountains, fire, and grain—all symbols of power and authority.

Most world religions use symbols to remind followers of shared ideals. The cross shown in Fig. 2–7, for example, suggests ideas, values, and goals that are important to Christians.

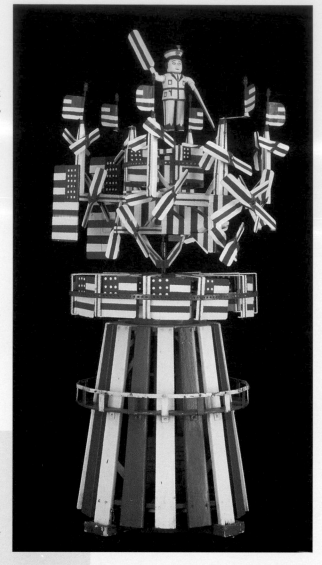

Fig. 2–5 **Imagine you didn't know about United States symbols and ideals. Would you be able to name some American ideas represented by this painted wooden form?** Frank Memkus, *Whirligig Entitled "America,"* 1938/42. Wood and metal, 80 ³/₄" x 29" x 40" (205 x 73.7 x 101.6 cm). Restricted gift of Marshall Field, Mr. and Mrs. Robert A. Kuhicek, Mr. James Raoul Simmons, Mrs. Esther Sparks, Mrs. Frank L. Sulzberger, and the Oak Park-River Forest Associates of the Woman's Board of The Institute of Chicago, 1980.166. Photo by Thomas Cinoman. Photograph copyright 1999, The Art Institute of Chicago, All Rights Reserved.

98

Teaching Options

Teaching Through Inquiry

Art Criticism Tell students that each artwork on pages 98 and 99 sends a message about people's beliefs, such as those about power and authority. Have students work in small groups to complete the following for each artwork: "We believe that this artwork conveys the idea that _____ possesses power and authority, because _____." *(the American citizen; the nineteenth-century Chinese emperor; the Christian God)* Tell students to use what they see in the artwork and what they know about the cultures represented to provide reasons for their position. Have groups share their response.

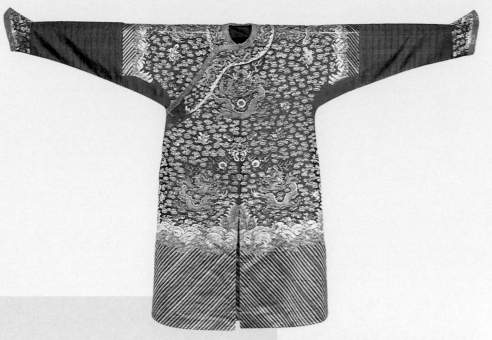

Extend

Have students write an essay about the role of symbols in conveying a culture's identity and ideals in artworks.

Fig. 2–6 The dragon robe was worn for daily official business. Chinese dress codes required a more elaborate robe for important state occasions. Why do you think that the bottom of the sleeve was called a horse-hoof cuff? China, *Dragon Robe*, late 19th century (Quing dynasty).
Embroidery on silk gauze, 53 ½" x 84" (135.9 x 213.4 cm).
Asian Art Museum, San Francisco, The Avery Brundage Collection, 1988.3.

Fig. 2–7 This cross, decorated with gems, was a gift to a sixth-century pope from a Byzantine emperor. A cross—whether made of gems and precious metals or simpler materials—stands for the crucifixion of Christ and is a central symbol of Christian ideals and identity. *Reliquary Cross of Justinian*, Byzantine, 6th century.
Gold. Museum of the Treasury, St. Peter's Basilica, Vatican State. Scala/Art Resource, New York.

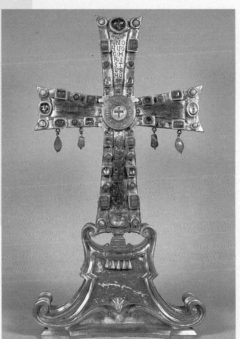

Identity and Ideals

99

The Golden Age of Byzantine Culture—During the reign of Justinian (527–565 AD), Constantinople, with its Eastern influence, dominated world art and politics. Under Justinian, Ravenna became the Byzantine capital in Italy. The inside of Ravenna's San Vitale is covered with glittering mosaics. In the mosaic of Justinian and his court, a church official holds a cross similar to that in Fig. 2–7.

Talk It Over

Describe What lines, shapes, colors, textures do you see? What else do you see?

Analyze How were the parts organized? What is suggested by the arrangement?

Interpret What does this image have to do with identity?

Judge What makes this artwork special?

For more images relating to this theme, see the Global Pursuit CD-ROM.

Supplies

- pencils
- scrap paper
- wire or pipe cleaners
- papier-mâché paste (diluted white glue, wheat paste, wallpaper paste, or acrylic medium)
- containers for paste
- tape
- newspapers
- paper towels or tissues
- modeling tools
- assorted found materials
- acrylic paint, varnish, and paintbrushes (optional)
- wood, Styrofoam, or heavy cardboard for base (optional)
- staples and staple gun (optional)

Using the Text

Art Production After students have read Sculpting Your Identity, have them list groups that they belong to and that are part of their identity. **Ask:** What do you do after school? How could you represent these groups and activities? Encourage students to draw symbols for their groups and activities. **Ask:** How can you emphasize a group's importance? *(by exaggeration)* Have students sketch an idea for their sculpture.

Demonstrate how to create an armature and how to tear 2"-wide newspaper strips, dip them into the paste, and squeegee off the excess.

Sculpture in the Studio
Sculpting Your Identity

You've seen that artworks can show group identity and encourage group ideals, sometimes by using symbols. Think of the groups you belong to that help make up your identity. The family is the first group to which most of us belong. You might also belong to a religious group, a sports team, or a club. What other groups do you belong to?

A **self-portrait** is an artwork you make that shows yourself. **In this studio experience, you will make a papier-mâché self-portrait that uses symbols to tell about who you are and what is important to you.**

Fig. 2–8 **The artist chose a symbol of this person's identity.** Peter Vandenberge, *Hostess*, 1998.
Ceramic, stains, slips, underglazes, 46" x 22" x 13" (116.8 x 55.9 x33 cm). John Natsoulas Gallery, Davis, CA.

You Will Need

- pencil
- scrap paper
- wire or pipe cleaners
- papier-mâché paste
- tape
- newspapers
- paper towels or tissues
- modeling tools
- assorted found materials
- acrylic paint, varnish, and paintbrushes (optional)

Try This

1. Make a list of all the groups to which you belong. Then make a list of your ideals. Draw symbols to represent each item on the lists.

2. Sketch portrait ideas, including poses and where you could include symbols.

3. Build an armature for your sculpture. Bend wire into the pose you desire.

4. Wrap paper tightly on the wire armature. Add rolls or wads of paper towels or tissues for the head, hands and feet, and other special features.

Studio Background

Artworks About People

Art can show what a person looks like on the surface. It can also show deeper characteristics—what the person loves or hates and how he or she feels. A person's identity, including his or her ideals, values, beliefs, and principles, can be shown in different ways. The artist might show the person doing something. Or the person might be shown dressed a certain way. Artists also use facial expression to show emotions.

Meeting Individual Needs

Assistive Technology Provide disposable gloves for students who have skin reactions to commercial wallpaper paste (which usually contains preservatives) or to wheat-flour papier-mâché.

Alternative Materials Substitute soft clay for papier-mâché. Soften ceramic clay by adding more water, or provide a softer modeling material, such as Model Magic or a sculpting foam.

More About...

The Chinese were probably first to use **papier-mâché**. Later, the Persians and Japanese used it for masks and festival objects. During the seventeenth century, the material received the name by which we know it: papier-mâché (French for "chewed paper"). In Victorian England, the papier-mâché industry supplied home furnishings. In colonial America, papier-mâché survived as a craft in boxes, lamps, and plaques. In Mexico today, papier-mâché is used for piñatas, dolls, and masks.

5. Wrap the sculpture with four or five layers of paste-soaked newspaper strips. Add a final layer made from strips of blank newsprint paper.

6. When the sculpture is dry, decorate with paint, yarn, fabric, buttons, and small objects. Include symbols that represent your identity and ideals.

Check Your Work

Display the completed self-portraits and discuss them as a class. How does each self-portrait show identity and ideals? Can you tell which groups the person belongs to based on his or her self-portrait?

Fig. 2–9 Kelly O'Connor, *Field Hockey Girl #10*, 1999. Plaster gauze, over a wire and newspaper armature, and acrylic paint, 12" (30.5 cm) high. Pocono Mountain Intermediate School South, Swiftwater, Pennsylvania.

How did artists Peter Vandenberge (Fig. 2–8) and Alison Saar (Fig. 2–10) give us information about the people they sculpted? Can you guess some groups these people might belong to? What do the materials the artists chose tell us about the people they portrayed?

Both of the sculptures shown here include symbolic objects. Saar and Vandenberge very carefully chose the objects they included in their portrait sculptures. Notice where these objects are placed within the sculptures. What does the placement of the objects tell us about these people?

Sketchbook Connection

Practice drawing the human figure. Ask a friend or family member to pose for you in a standing position. The overall figure should be about seven heads tall. Sketch the basic shapes. When you are pleased with shapes and proportions, you may wish to add details. To practice further, have the model pose in a new position or ask a different person to pose.

Core Lesson 2

Check Your Understanding

1. How might the beliefs of a group of people affect the art they produce? Give examples with your answer.
2. How can an artwork show the status of a person within a community?
3. What can the design of an artwork tell you about the identity of the people who made and used it?
4. How can a papier-mâché sculpture show a person's identity?

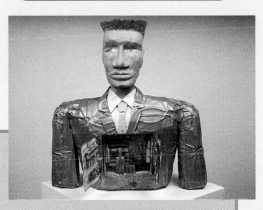

Fig. 2–10 **This contemporary portrait bust has wild orange hair and a green formal suit. What do you think these features might symbolize? Do you think the artist promoted or challenged ideals by including the man's own medicine "chest"?** Alison Saar, *Medicine Man*, 1987. Wood and tin, 27" (68.6 cm) high. Jan Baum Gallery, Los Angeles.

Identity and Ideals

101

Using the Art

Art Criticism Encourage students to compare the two sculptures shown in Studio Background. **Ask:** How did each artist represent the subject's interest and personality? How did each artist abstract or exaggerate features?

Assess

Check Your Work

Have students work in small groups to describe identity features in one another's works. **Ask:** Does the viewer's description match the artist's intended messages? What do these sculptures tell about the time and place of the artists?

Check Your Understanding: Answers

1. People create images of what they believe to be important. If an ideal body is important, they may create a statue such as *Discobolus*; if religion is important, they may create a symbol such as a cross.

2. through the artwork's fine craftsmanship and by depiction of the subject's clothes, home, and possessions, which can convey an illusion of power, status, or importance

3. with whom the people identified, what their status was, what era and location they lived in, what materials were available to them, what their beliefs were, and what was important to them

4. by showing what the subject is interested in, what groups the subject identifies with, what objects he or she uses, and something about his or her emotions

Close

Remind students that they have been studying how ideals and identities can be expressed in art. Review the identity and ideals of the artists represented on pages 94–99. **Ask:** Why are identity and ideals important parts of life?

Teaching Through Inquiry

Aesthetics Remind students that artworks communicate beliefs about what is important. Ask groups of students to use artworks in this lesson, along with objects from their everyday world, to illustrate each of these beliefs:

• A person's most important responsibility is the care of both mind and body.

• What you wear is what counts.

• Take pride in yourself and your heritage.

Have students explain why the artwork illustrates the belief.

Assessment Options

Self Have students create a new identity for *Discobolus,* by designing an outfit that clearly conveys information about personal or cultural identity. Have them attach a statement that tells how the outfit conveys group membership, interests, and social status or rank.

The Art of Three Empires

	448 BC Parthenon begun		1st Century AD *Augustus of Prima Porta*		
Ancient Egypt page 76	Greek Classic Period	Roman Empire		Byzantium	Early Medieval page 128
	c. 478 BC *Charioteer*	72 AD Colosseum begun		11th Century *The Archangel Michael*	

Prepare

Pacing

One or two 45-minute periods

Objectives

- Explain how artworks reflect what was important to the people of ancient Greece, Rome, and Byzantium.

- Compare the identity conveyed in classical sculptures of ancient Greece with realistic sculptures of ancient Rome.

- Create a two-dimensional building façade to convey information about the identity of those who use the building.

Using the Time Line

Point out to students that the time line encompasses both BC and AD dates. **Ask:** How many centuries elapsed between the creation of the *Charioteer* in the Greek classical period and that of *The Archangel Michael* in the Byzantine empire?

Greece, Rome, and Byzantium

While civilizations in Mesopotamia, Egypt, and elsewhere flourished along great river valleys, others were developing along the shores of the Mediterranean Sea. The ideals of Greece, Rome, and Byzantium would have a great influence on art in many parts of the world.

In all areas of their lives, the Greeks tried hard to attain their ideal of the person who was perfect in both body and mind. Their art reflects this ideal.

When Greek culture was at its height, Rome was just a village of straw-roofed huts. The Romans eventually conquered Greece, much of the Mediterranean world, and vast areas beyond. Early Romans admired the Greek ideals of harmony and balance. The Romans copied many examples of Greek art. They also tried to make their art realistic.

In 330 AD, Rome's last important emperor, Constantine, moved the capital east, to Constantinople. Near his death, Constantine became a Christian. His eastern empire was called Byzantium. This new empire embraced Christianity and its ideals.

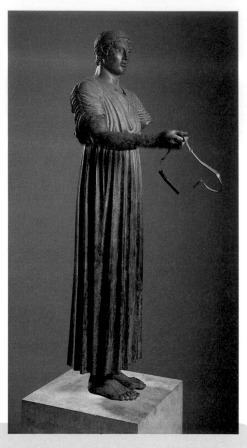

Fig. 2–11 **This sculpture was once part of a grouping with a chariot and horses. Notice the calm pose and facial expression. How does this sculpture reflect Greek ideals?** Greek (Classical), *The Charioteer of Delphi* (side view). Dedicated by Polyzalos of Gela for a victory either in 478 or 474 BC. Bronze, 71" (180 cm) high. Archaeological Museum, Delphi, Greece. Nimatallah/Art Resource, New York.

National Standards
2.1 Art History Lesson

4a Compare artworks of various eras, cultures.

Teaching Options

Resources

Teacher's Resource Binder
- Names to Know: 2.1
- A Closer Look: 2.1
- Map: 2.1
- Find Out More: 2.1
- Check Your Work: 2.1
- Assessment Master: 2.1

Overhead Transparency 3

Slides 2d

Meeting Individual Needs

Multiple Intelligences/Spatial Have students look at Fig. 2–13 while you review what they have read about the Greeks' use of the human body as the basis of architecture. Have students identify each part of the Parthenon façade with a corresponding section (legs, torso, head) of the human body.

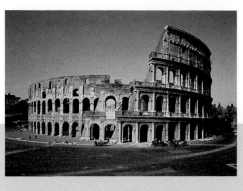

Fig. 2–12 Compare this Roman amphitheater (a kind of arena) to the Greek temple in Fig. 2–13. How does the use of the arch make the Roman example different? What modern structure does this remind you of? *The Colosseum*, 72–80 AD. Rome, Italy. Scala/Art Resource, NY.

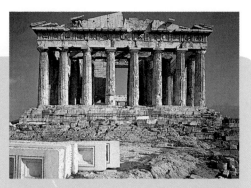

Fig. 2–13 Greek architecture reflects the ideals of order, balance, and proportion. Each part relates to the others harmoniously. Imagine if these columns were placed at greatly varying distances from each other. How would that change this temple? Iktinois and Kallikrates. *West façade of the Parthenon*, Acropolis. Athens, Greece, 448–432 BC. Pentelic marble, 111' x 237' (33.8 x 72.2 m) at base. Scala/Art Resource, New York.

The Greek Search for Perfection

Artists in ancient Greece experimented with different kinds of art. They explored sculpture, painting, mosaics, and architecture. Their goal was to achieve harmony and balance. The Greek idea of beauty was based on perfect proportions and balanced forms.

Greek artists of the sixth and seventh centuries BC created sculptures of the human figure standing in a somewhat stiff pose with one foot forward. By the fifth century BC, the style had changed. Artists showed more natural-looking figures in realistic positions. These artworks are called classical.

Ancient Greek sculptures showed how people moved and looked in real life. They usually did not show people's wrinkles, freckles, or other features that make each person unique. Greek artists were trying to show the perfect person, rather than a specific one. Their art reflects the ideal that Greek people were trying to live up to: a perfect human being, both in body and in mind.

The Greeks used the human body as the basis for their architecture, too. They compared the parts of a building to the parts of the human figure. They noticed the way parts relate to one another, support each other, and work together in harmony. The Greeks wanted their architecture to have perfect balance and ideal proportions, just as the figures in their sculpture and painting did.

Identity and Ideals

103

Teach

Engage

Ask: According to popular media, what is the ideal body type in America? Is anyone really like this? Inform students that even the photographs of the top models are usually airbrushed. Discuss how this compares to the Greeks' search for the ideal in their art.

Using the Text

Perception Have students read page 103. **Ask:** How does *The Charioteer of Delphi* summarize the Greeks' search for perfection? What is the figure doing? *(driving horses)* What kind of movement does this usually require? What is the figure's stance, facial expression, and overall mood?

Using the Art

Perception Have students compare the columns of the Erechtheum (page 105) and the Parthenon (page 103). Note that both buildings are on the Acropolis, in Athens. Have students study the caryatids. **Ask:** What differences do you see among the caryatids? *(Their weight is on different legs.)* Point out that the columns on the Parthenon are not perfectly straight, and challenge students to detect the slight bulge in them.

Teaching Through Inquiry

Art History Have students focus on the *Charioteer of Delphi*, and note that it was originally part of a grouping with a chariot and horses. **Ask:** How might the entire original artwork have appeared? Challenge them to make sketches of the chariot, using what they know about Greek ideals. Encourage them to research chariots, and share their sketches and research with the class. Remind students that art historians must try to imagine how artworks looked when they were created.

More About...

The Charioteer of Delphi probably commemorated a king's victorious chariot race. The charioteer, wearing a headband to keep his hair in place, represents the king's driver. This early bronze casting is one of the few remaining Greek bronzes. It has glass paste eyes and inlaid copper lips and eyelashes. Although the pose and features are rigid and severe, the folds in the cloth, the facial features, and the muscles are natural.

Using the Overhead

Investigate the Past

Describe How does this work look different from when it was first made?

Attribute What clues will help you to identify when and where it was made?

Interpret Could people living when this was made identify with it? Why or why not?

Explain Compare the drapery with the way cloth is shown in *The Charioteer of Delphi*.

3

Using the Text

Art Criticism After students have read page 104, encourage them to compare the faces of the Roman statues to those of *Discobolus*, Fig. 2–1, and the *Charioteer of Delphi*, Fig. 2–11. **Ask:** Would you rather have a Greek or a Roman sculptor carve your portrait? Why?

Aesthetics Explain that people living at different times and places hold different ideas about what is beautiful. Encourage students to consider their own ideas about beauty. **Ask:** Can something with imperfections be beautiful? What examples help support your position? Would you want fashion photographs to include the model's flaws? Why? How are fashion photographs similar to or different from Greek and Roman sculptures?

Using the Art

Art Criticism Ask students to compile a class list of words that describe the Byzantine icon. Challenge students to compare the style of this figure to that of Augustus (Fig. 2–14). *(icon: symbolic; Augustus: realistic)*

Studio Connection

Help students brainstorm subjects for their façade. **Ask:** What type of caryatids might you find on a gym? An artist's studio? A theater?

Assess See Teacher's Resource Binder: Check Your Work 2.1.

Roman Realism

Artists of ancient Rome learned many lessons from the Greeks. But art had different functions in the vast Roman Empire. The Romans wanted the identity of the people in their artworks to be easily recognized. So they created sculptures and paintings of people they knew or wanted to remember.

These artworks showed their rulers, ancestors, and their own peers as they really looked.

For the rulers of the Roman empire, art was also a way to promote their own identity. Likenesses of Roman rulers appeared in sculptures, paintings, and on carved reliefs throughout the empire. Roman artists sometimes made the bodies look perfect to emphasize the perfect qualities of the ruler. But they also showed the ruler's own facial features and expressions. This way, subjects in any part of the empire would know what their ruler looked like.

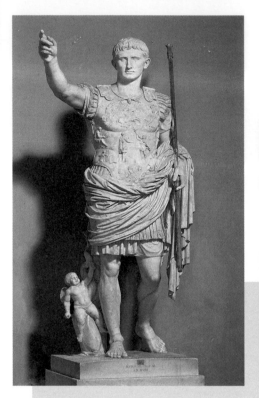

Fig. 2–14 This Roman sculpture looks like earlier Greek examples in its pose and overall proportions. How has this sculptor created a portrait that looks like the ruler himself? How does this differ from the Greek figure in Fig. 2–11? *Augustus of Prima Porta*, Roman Sculpture, Early first century AD.
Vatican Museums, Vatican State. Scala/Art Resource, New York.

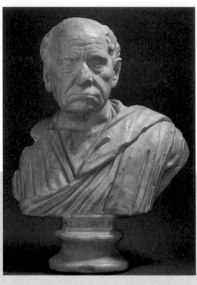

Fig. 2–15 Roman portrait sculptors showed the exact features and details of a person's face. They created a true record of how he or she looked. *The Roman Gentleman*, c.120 AD.
Marble, 17" x 23 5/8" x 10 3/4" (43.2 x 60 x 27.3 cm). Nelson-Atkins Museum of Art, Kansas City (Purchase: Nelson Trust). Photography by Robert Newcombe. ©1999 The Nelson Gallery Foundation. All Reproduction Rights Reserved.

Teaching Through Inquiry

Art History Invite students to imagine that they had journeyed back to the ancient Greek, Roman, and Byzantine empires. The goal of their journey was to discover what was important to the people. Challenge students to create a travelogue of their findings, using the images in this book and in other sources to explain differences in ideals held by the people of these empires. Students may work individually or in small groups and then present their report to the entire class as a script for an upbeat TV travel show.

More About...

Roman Sculpture—In ancient Rome, sculptors often carved large numbers of the same idealized—and headless—male and female body forms. People interested in having a sculpture made of themselves or a loved one could go to a studio and select a marble body from any number of stylized poses. The sculptor would then carve a realistic head of the person and attach it to the body, hiding the seam with a sculpted veil or draped toga.

Byzantine Ideals

After nearly four centuries of peace and prosperity, problems were beginning to appear in the mighty Roman empire. The empire was divided into a western half in Rome and an eastern half centered around what is today the city of Istanbul, Turkey. The strength and power of the empire were no longer certain. People began to look to new ideals for comfort and stability.

The popularity of Christian ideals marked a new age in Western art. People questioned Greek and Roman ideals of the perfect human being, physical beauty, and strength. They began to look to Christian teachings for ideals of how to live.

Much art of this time shows these new spiritual ideals. Artists frequently focused on scenes and figures from holy books. Such artworks reminded people that following these new teachings was the best way to live.

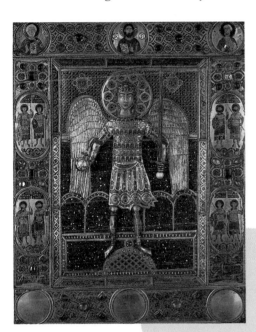

Studio Connection

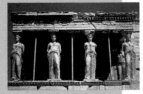

As the detail below shows, the Greeks sometimes used statues of male or female figures as supports for buildings. How are these different from the columns in the Parthenon (Fig. 2–13)? Create a collage of your own building façade (outside front) using human figures as the architectural supports. The people you show in the columns should reflect the identity of the people who will use the building. Photocopy pictures of people. Combine them with pictures of architectural details, such as windows, a roof, or doors. Give your building façade a name, such as *The House of the Football Players.*

2.1 Art History

Check Your Understanding

1. Select one artwork from each of the ancient empires. Tell how each one reflects what was important to the people living at the time.
2. Which sculptures show the identity of the individual more clearly: classical sculptures of ancient Greece or realistic sculptures of ancient Rome?
3. How do the artworks produced by Roman artists reflect their admiration for Greek sculpture?
4. What is a significant difference between the art of the Byzantine and the Roman empires?

Fig. 2–16 Christianity spread quickly throughout the eastern Byzantine empire. Artworks emphasized humanity's relationship to God and used images to tell stories about how to live a Christian life. Can you identify symbols of Christianity in this enameled artwork? *The Archangel Michael with Sword*, Byzantine, 11th century. Gold, enamel, and precious stone. Framed icon. Tesoro San Marco, Venice. Cameraphoto/Art Resource, New York.

Identity and Ideals

Extend

Ask: Why did the Romans feel that clearly identifying the unique features of individuals portrayed in their sculptures was important? *(They valued individual freedom and responsibility, and recognized the importance of the unique character of individual citizens.)*

Assess

Check Your Understanding: Answers

1. Responses should include reference to Greek ideals of beauty, the Roman importance of conveying a realistic identity, and the Byzantine concentration on conveying Christian teachings.

2. Classical sculptures of ancient Greece showed how people moved and looked in real life, but did not include their unique features. Roman sculptures showed people—rulers, ancestors, and peers—as they appeared in life, including their imperfections.

3. Many Roman artists made copies of Greek sculptures.

4. Byzantine art expresses Christian ideals and uses religious subject matter. Roman art expresses the ideals of political rulers and uses realistic images of people.

Close

Have students cite and describe artworks that are examples of Greek perfection, Roman realism, and Byzantine symbolism.

More About...

The **caryatids** carry the weight of a simplified entablature on their heads. The necks are the thinnest part of these figures, and therefore the weakest spot in the support. Each caryatid stands on her inside leg.

Post-modern architect Michael Graves designed—for a Walt Disney Corporation building in Burbank, California—contemporary caryatids in the form of 19-foot-tall statues of the seven dwarfs.

Assessment Options

Teacher Have each student write a conversation among three artists—one from each of the ancient empires. Instruct students to include a discussion of how each artist creates artworks that reflect important ideas of the people.

Prepare

Pacing

One or two 45-minute periods

Objectives

- Describe qualities of texture and rhythm in artworks and explain how these elements are used to unify the composition.
- Use texture and rhythm in a paper mosaic to convey a person's identity.

Vocabulary

rhythm A type of visual or actual movement in an artwork. A principle of design, rhythm is created by repeating visual elements.

texture An element of design; the way a surface feels (actual texture) or how it may look (simulated texture).

mosaic An artwork made by fitting together tesserae.

tesserae Small pieces of glass, tile, stone, paper, or other materials used to make a mosaic.

Teach

Engage

Have students use texture and rhythm finders (index cards with sample textures and rhythms), to find and name textures in clothing, furniture, and building materials in the classroom.

Texture and Rhythm

Look at the people in Fig. 2–18. Who is the most important person in the group? How can you tell? In the Byzantine empire, people thought of Emperor Justinian as very nearly equal to God. Notice the golden halo around his head. The halo breaks the visual **rhythm** of the row of repeated round heads. It calls attention to the emperor. In the benches in Fig. 2–17, visual rhythm is used in another way to bring out a playful mood. In both works, the real **texture** of the mosaics reflects light and creates visual interest.

Looking at Texture

Texture is how a surface feels when you touch it. Every object has its own texture or combination of textures. In art, there are two kinds of textures. *Actual* textures are those you can really feel. For example, the actual textures of glass, stone, and clay feel hard and smooth. *Implied* textures are created textures that only look like actual textures. An artist can paint with smooth watercolors a texture that looks like a soft, fuzzy surface.

Textures can also be described by the way a surface reflects light. A glossy surface has a shiny texture: It reflects light and glistens. A rough surface absorbs light and looks dull.

Artists use different media to create textures and the illusion of textures in artworks. If you wanted to create a heavenly look in your artwork of the emperor and empress, what art media would you choose? Byzantine artists chose a **mosaic,** which was made of cut and assembled **tesserae**—small pieces of colored glass, marble, and stones. They pressed each piece into wet plaster. The mosaic stood out from the wall at a slight angle. The texture helped express Byzantine ideals of what was divine or holy.

In Fig. 2–17, Antonio Gaudí chose to design a fanciful mosaic bench using larger pieces of ceramic tile. He combined a shiny texture with other design elements to create an ideal public space. How might the mood of this park space be changed if the bench were made of wood?

Fig. 2–17 To give this mosaic bench a curved surface, Gaudí broke flat tiles and arranged the pieces to follow the outlines. Where can you see rhythm in his design? Antonio Gaudí, *Güell Park Benches,* 1900–1914. Barcelona, Spain. Courtesy of Davis Art Slides.

National Standards 2.2 Elements and Principles Lesson

2b Employ/analyze effectiveness of organizational structures.

Teaching Options

Resources

Teacher's Resource Binder
Finder Cards: 2.2
A Closer Look: 2.2
Find Out More: 2.2
Check Your Work: 2.2
Assessment Master: 2.2
Overhead Transparency 3

Teaching Through Inquiry

Art Production Have students create a portable display to teach children about **actual and implied textures**. Students might also make implied-texture drawings to accompany the actual textures (a drawing of wood grain might accompany a piece of wood). As students arrange the display, ask them to consider how rhythm can unify the display, and whether a young audience will easily understand the ideas.

Fig. 2–18 **Since Justinian had never been to Ravenna, the mosaic reminded people in Ravenna of his power. The mosaic's glittering texture and gold background suggest a spiritual world. Imagine the effect of light on this mosaic texture. How would the mosaic look different if it were a sunny day? A cloudy day?** Byzantine, *The Court of Justinian*, c. 547.
Mosaic, 8'8" x 12' (2.64 x 3.65 m). S. Vitale, Ravenna, Italy. Scala/Art Resource, NY.

Looking at Rhythm

Feel your heartbeat. Tap your foot to music. You are responding to rhythm. In artworks, rhythms may be created by repeating visual elements. Flowing lines, changes in colors, or spaces between shapes can also create rhythm. Graceful, curving lines might create a flowing rhythm. Sudden changes in colors or shapes might create a jazzy or jumpy rhythm. If an artist carefully plans the rhythms, the artwork can become unified. Rhythms can lead the viewer from one point to another in a visually pleasing way.

Notice the rhythms created by repeating elements in the Byzantine mosaics. Do you sense a rhythm in the way the artist arranged the vertical folds of the gowns and robes? Do you sense a rhythm between the round heads and the spaces between them?

Studio Connection
Create your own mosaic by using an assortment of papers cut or torn into small pieces. Show someone you know in an outfit or clothing that identifies them as belonging to a particular group. Add shiny paper or foil to create a surprise element and to reflect light. Use papers of different thickness and textures to create an interesting, rich surface.

2.2 Elements & Principles

Check Your Understanding
1. How is the texture of the Byzantine mosaic similar to the texture of Gaudí's park bench? How is it different?
2. Explain one way that artists can create rhythm in an artwork.

Identity and Ideals

Using the Text
Art Criticism Have students read pages 106 and 107 and then describe the textures in the two mosaics. **Ask:** What is the purpose of each artwork? Why are tesserae suitable media for the function of each piece?

Using the Art
Perception Have students compare rhythms in the mosaics. Notice those formed by patterns in the tesserae; then, those in the overall design.

Studio Connection

Discuss how to create texture and rhythm in a paper mosaic. Provide students with a wide variety of paper and foils, pencils, glue, and scissors.
Assess See Teacher's Resource Binder: Check Your Work 2.2.

Assess

Check Your Understanding: Answers
1. The textures in both mosaics are smooth along the face of the tiles. The Byzantine tesserae have a regular size and shape; the tesserae in Gaudí's bench have an irregular shape.

2. by repeating visual elements; using various line types; varying colors and shapes

Close
Review the various ways to create rhythm and textures in artworks.

More About...

Mosaic is made by fitting together tesserae—small pieces of stone, colored glass, or other material. Tesserae are set in cement or plaster to form a surface pattern. Several churches in Ravenna, Italy are decorated with outstanding Byzantine mosaics. Broken glass tesserae are positioned with their rough sides exposed to catch and reflect the light. Flat or smooth-surfaced tesserae are also set at angles and varying depths to add brilliant sparkle.

Using the Overhead

Write About It
Describe Have students write two sentences to describe the texture and surface in this artwork.

3

Analyze Use the overlay, and have students write two sentences to tell how the artist created a sense of rhythm in this work.

Assessment Options

Peer Provide small groups with two or three art reproductions. Ask students to place **texture and rhythm finders** on the artworks with the corresponding texture or rhythm. When groups are satisfied with the placements, have members discuss how texture and rhythm are used in each artwork to hold interest and guide the eye around the composition. Pair up the groups. Ask the members of one group to show the other group their placement and to explain how texture and rhythm are used. Have each group critique the other group's placement and suggest changes, if appropriate.

Prepare

Pacing

Three 45-minute periods: one to study Native North American art; one to build sculpture; one to paint, finish, and critique sculpture

Objectives

- Understand the unique features of Native-American artworks that make possible the identification of the community or region of their production.

- Explain how the identity and ideals of Native Americans are reflected in their artworks.

- Create a three-dimensional artwork that conveys one's personal identity in the form of an animal.

Vocabulary

crest An emblem or decoration that shows the identity of a family, tribe, or nation.

totem An object that serves as a symbol of a family, person, idea, or legend.

Using the Map

Have students locate where the pieces of art in this lesson were created. Discuss the characteristics of the areas and how they might have inspired or affected the art.

Native North American Art

Throughout human history, people have moved in groups from one continent to another. These movements are called migrations. North America has had migrations, too. Archaeologists now believe there may have been migrations as far back as 15,000 BC. With the help of modern technology, we continue to learn about and discover the many different peoples who lived in this part of the world.

Ancient and native peoples who migrated to North America did not keep written records. They shared their beliefs and traditions through spoken stories and tales of how life began. Each native group has its own history, language, and beliefs. However, when we compare their artworks, we can see that Native Americans share common ideals and a deep respect for nature.

Native peoples of North America have a long history. They show their identity and ideals through many different kinds of artistic objects. Today, native peoples continue to use traditional themes and techniques for inspiration. Art is the link that helps them hold onto the identity and ideals of their ancestors.

Group Identity: Unique Designs

Early in their settlement of North America, native peoples developed specific shapes, patterns, and designs on their artworks. For example, about 1000–1250 AD, ancient cultures of the American Southwest such as the Anasazi (Fig. 2–19) and Mimbres were creating black-and-white geometric designs and animal forms that are unlike any others. Today, it is often possible to know the identity of a community by looking at its unique designs.

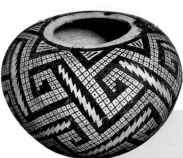

Fig. 2–19 Complex patterns such as the design on this jar were created by painting in black on a white background. How did the artist make the design fit the form of the jar? American, New Mexico, Anasazi people, *Seed Jar*, 1100–1300. Earthenware, black and white pigment, 10 5/8" (27 cm) high, diameter 14 1/2" (36.9cm). Gift of Mr. Edward Harris 175:1981. St. Louis Art Museum.

Native Arts of North America

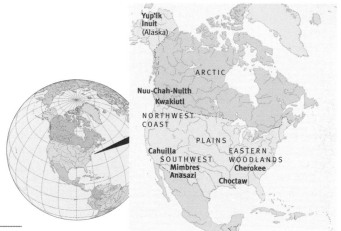

Yup'ik
Inuit
(Alaska)

ARCTIC

Nuu-Chah-Nulth
Kwakiutl

NORTHWEST
COAST

PLAINS

Cahuilla
SOUTHWEST
Mimbres
Anasazi

EASTERN
WOODLANDS
Cherokee

Choctaw

108

Teaching Options

Resources

Teacher's Resource Binder

A Closer Look: 2.3

Map: 2.3

Find Out More: 2.3

Check Your Work: 2.3

Assessment Master: 2.3

Large Reproduction 4

Slides 2e

Teaching Through Inquiry

Art Production Have students select one artwork in the lesson and list the steps they believe the artist took to make it. Instruct students to start by identifying the materials used, and then proceed by considering how the artist prepared the materials, manipulated them, and refined the artwork to complete it. Ask students to make their best guess about any steps they are unsure of, and to think about where they might learn more. Have pairs of students share and discuss their work, and encourage them to help each other find additional information.

Family Identity: Crests and Totems

The Pacific coast of Canada and northern United States is known as the Northwest Coast. Northwest Coast peoples are known for artwork with simple shapes and strong outlines of human and animal forms (Figs. 2–20 and 2–21).

In native Northwest Coast communities, the **crest** is the most important way to show identity. A crest is a grouping of **totems**—animals or imaginary creatures that are the ancestors or special protectors of a family. Only that family has the right to use those crest images in their art.

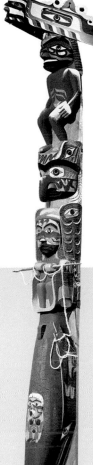

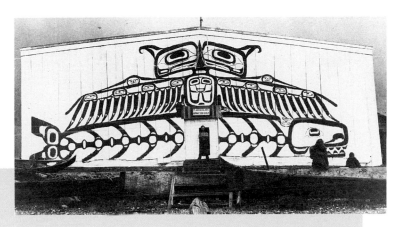

Fig. 2–20 Look closely at this Northwest Coast totem pole. What human or animal forms can you see? Nuu-Chah-Nulth people, Canada, *Totem.* Painted wood. S92-4402. Canadian Museum of Civilization, Quebec.

Fig. 2–21 The façade of this house shows a Northwest Coast family's crest figures. The crest shows a thunderbird (a mythical bird) trying to lift a whale. What effect do you think this large painted image has on visitors? *Kwakiutl Painted House.* Kwakiutl, Alert Bay, British Columbia, Canada, before 1889. Courtesy of the Smithsonian Institution, National Anthropological Archives, Bureau of American Ethnology, neg. no. 49, 486.

Identity and Ideals

109

Engage
Tell students that they will be studying Native-American art. Have them look at the artworks in this lesson—but not read the captions—and challenge them to identify each object.

Using the Text
Perception After students have read pages 108 and 109, ask them to describe the rhythms, textures, and patterns in the Anasazi seed jar. Discuss how the design seems to go with the shape of the pot, and ask students to compare this design to that of the Mimbres bowl (Fig. F1–1 on page 3).

Using the Art
Perception As students study the totem pole and family crest, challenge them to identify animals in each. **Ask:** What characteristics of these animals might a family want to have? Point out the rhythms created by repeated patterns in these designs.

More About...
The "ancient ones," the **Anasazi**, were the prehistoric ancestors of the Pueblo peoples. From about 200 to 1300 AD, their culture developed in the Four Corners region of the United States. They lived in villages in **cliff dwellings** like those at Mesa Verde. About 900 AD, they began to create white pottery decorated with distinctive black geometric designs.

Using the Text

Perception After students have read pages 110 and 111, ask them to describe the references to nature in the mask and basket. *(Both objects use natural materials and contain animal figures.)* Discuss how European influences affected Native-American art.

Using the Art

As students study the Choctaw bandoliers, explain that glass beads were European, not Native American. After Europeans began trading with the Native Americans, they were surprised to discover that the Americans valued glass beads for their symbolism. Native Americans associated crystals, shells, and glass beads with long life, well-being, and success.

Studio Connection

Discuss Northwest Coast crests and totems. With students, generate a list of metaphors to describe themselves. Demonstrate how to begin to combine materials to form an animal, and encourage students to exaggerate features that stress the meaning of their metaphor. Discuss the use of textures and rhythm to enliven their sculptures.

Assess See Teacher's Resource Binder: Check Your Work 2.3.

Extend

Encourage students to research symbols and materials of Native cultures and then create an artwork inspired by the designs.

Ideals of Nature

You have probably noticed that much Native North American art is made of natural materials. Many of these artworks have plants and animals in the designs. This is because Native Americans believe that living in harmony with the natural world is an important ideal. They believe they must form a special relationship with everything in the natural world: animals and plants, the sun and water, earth and sky. They respect natural things and forces. They know they depend on nature and cannot live without it.

Making artworks from natural materials and using designs related to nature help native peoples form this special relationship. They believe they can receive power, strength, protection, and knowledge from the spirits that are part of all natural things.

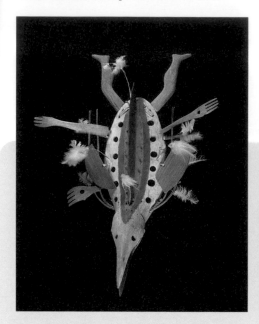

Fig. 2–22 Traditional Yup'ik (also called Eskimo) masks from Alaska were worn during dances or ceremonies. By wearing these masks, the Yup'ik hoped to connect with the spirits found in animals and nature. The spirits would ensure a good hunt or help heal someone who was sick. Yup'ik, *Mask of a diving loon*, before 1892.
Wood, paint, owl feathers, height: 31 ½" (80 cm). Sheldon Jackson Museum, Sitka, Alaska (11.0.11). Photo by Barry McWayne.

Fig. 2–23 From gathering the grasses to creating the designs on this basket, everything is a give-and-take process between human beings and the natural world. Why might someone living in the desert choose a snake design to decorate a basket? Cahuilla, *Basket with rattlesnake design*, California, n.d. 6 ⅜" x 14 ⅛" (17.3 x 35.8 cm). National Museum of the American Indian, Smithsonian Institution. Photo by David Heald. 24.7735.

Teaching Options

Teaching Through Inquiry

Art History For each image in the lesson, have students describe an object from their own or another culture that has a similar purpose. Instruct students to state the object's use and how it reflects either cultural identity or ideals. To help students begin, tell them that they might compare the purpose of the seed jar to that of a cookie jar or other household container. Students may work alone, in pairs, or in small groups.

More About...

The appendages on **traditional Yup'ik masks** identify the spirit and its activity. Often, a mask created for a single use would be buried or burned following the performance.

Fig. 2–24 The arrival of European settlers also brought new materials for artworks. Although glass beads replaced bird or porcupine quills to decorate objects, the designs often remained traditional. Choctaw, *Eskofatshi (beaded Bandoliers)*, Mississippi, c. 1907.
Wool with cloth appliqué, 46 ½" x 3 ¼" (118 x 8.1 cm); 49 ½" x 3 ½" (125.6 x 8.8 cm). National Museum of the American Indian, Smithsonian Institution. Photo by David Heald. 1.8859 and 1.8864.

Fig. 2–25 This artist feels she lives a "double life" as a Native American living in a non-Native society. Why do you think she chose this two-part format for her artwork? Kay WalkingStick, *On the Edge*, 1989.
Acrylic, wax, and oil, 32" x 64" x 3 ½" (81.3 x 162.6 x 8.9 cm). June Kelly Gallery, New York,

Changes in Identity: The Postcontact World

There was another great wave of migration to North America in the early 1600s. The arrival of European settlers greatly altered the lives of native peoples. Often the Native Americans were forced to accept a new way of life with different ideals and values. But some native cultures were able to retain their traditions and ideals. They continued to produce works using age-old techniques and styles.

Today, many contemporary artists still work with traditional techniques and designs. They try to preserve a link with the past. Others choose to work in nontraditional ways, but use their art to reflect their native heritage and identity.

Studio Connection

If you could have a personal mascot or an animal to represent you, what would it be? Think about how animals are used to advertise products or to identify sports teams. Think about phrases such as "wise as an owl," "fast as a rabbit," "clever as a fox," and "busy as a bee." Do any of these describe you? Think of the materials and techniques you might use to make an animal sculpture that would be your identity mascot. Use clay, wood, wire, or cardboard to make your sculpture.

2.3 Global View

Check Your Understanding

1. How does Native-American art promote identity and help keep groups together?
2. How do traditional Native-American artworks reflect the ideals of Native Americans?
3. What special features of Northwest Coast artworks make it easy to tell them from artworks made by Native Americans in the Southwest?
4. How have contemporary Native-American artists dealt with issues of identity in their work?

Identity and Ideals

111

1. Use of unique symbols and patterns in artworks reveals the identity of the people who made them. The symbols and patterns form the link from the people to the identity and ideals of their ancestors.

2. The use of natural materials and the designs with images of plants and animals reflect a belief that living in harmony with the natural world is an important ideal.

3. Both the art forms and the designs are different. The geometric designs on Southwest pottery contrast sharply with the more organic patterns and animal forms of the Northwest Coast family crests.

4. To express their identity, some contemporary artists have chosen to work with traditional techniques and design. Others work in nontraditional ways, but use images that reflect their native heritage and identity.

Close

Refer to the map to review where each piece in this lesson was created. Lead students in describing the distinctive patterns and media of each region. Discuss how Native Americans include references to their identity and ideals in their artworks. **Ask:** How does your own sculpture convey your personal identity?

Meeting Individual Needs

English as a Second Language As students examine Fig. 2–24, tell them that a Choctaw woman created the traditional Native-American designs with European beads and cloth. Explain that language too can reflect a mixing of cultures. Ask students to define words that come from Native-American languages, such as the Algonquin words *Manhattan, raccoon, squash, pecan, skunk,* and *moose.*

Using the Large Reproduction

4

Consider Context

Describe What different materials were used in this piece?

Attribute How would identifying the type of feathers and hide help you to find out more about when and by whom this was made?

Understand How can you find out who might have worn this headdress and when?

Explain What does this headdress have to do with identity, and why might this have been important to the people or person who made it?

Assessment Options

Self Have students choose one art form (such as baskets, pottery, clothing, or architecture) and then find two examples of that art form from Native North American groups. Tell students to use what they know from the text, from additional reading, and from careful description of the artwork to consider how each artwork reflects each group's identity or ideals.

Prepare

Pacing
One 45-minute class period to introduce and begin drawing

One 45-minute class period to draw

Objectives
- Explain the difference between architectural floor plans and elevation drawings.
- Create a drawing of a building in which architectural elements reflect ideals and identity.
- Identify architectural features that borrow from the past.

Vocabulary
architectural floor plan A diagram of a building as seen from above.

elevation drawing A drawing that shows an exterior side of a building or interior wall of a room.

Supplies
- sketchbooks or sketch paper taped to drawing board (stiff cardboard)
- soft lead pencils (#2)
- 9" x 12" graph or drawing paper
- rulers
- fine-tip markers
- camera (optional)

National Standards
2.4 Studio Lesson

1a Select/analyze media, techniques, processes, reflect.

4a Compare artworks of various eras, cultures.

Teaching Options

Architecture in the Studio
Drawing Architectural Forms

Buildings and Identity

Studio Introduction
Imagine that you are designing a sports complex that expresses the identities and ideals of the local athletic teams. How will you represent the teams' identities? How can you express the teams' ideals visually? If you were an architect, you would sketch your ideas, then you would probably draw an **architectural floor plan**—a diagram of an interior part of the complex seen from above. Or you might make an **elevation drawing**—a drawing that shows an interior or exterior side of the complex.

Architectural designs often convey important ideas about the people who will use the building. **In this studio lesson, you will create an elevation drawing of a public building— a school, library, town hall, or the like—in your community.** Pages 114 and 115 will tell you how to do it. The drawing will include visual clues related to the purpose of the building or the kinds of people who use it.

Studio Background

Architecture with Meaning
You have probably seen architecture around your town that looks something like the temples and public buildings of ancient Greece and Rome. Architects who design banks, libraries, and government structures often borrow shapes and forms that were first used by Greek and Roman architects. These features reflect ancient ideas about politics and beauty. They send the message that whatever is inside the building will last forever.

Some cultures use a more personal expression of identity in their architecture. The large plank houses built by Native Americans of the Northwest Coast are an impressive example. Every plank house has an enormous totem pole. The animals and crests on the totem pole declare the family's identity and history. Other features, such as house posts and exterior walls, are also decorated with family symbols.

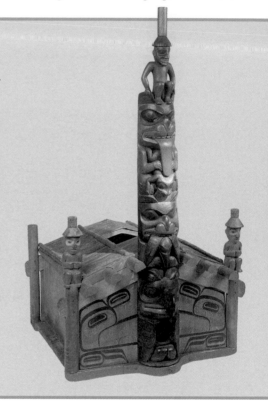

Fig. 2–26 **Plank houses of the Northwest Coast Haida people, which range in size from 20' x 30' (6 x 9 m) to 50' x 60' (15 x 18 m), were designed to house extended families and their slaves. What kinds of animal symbols do you see in the totem pole? What stories might they tell?** *Haida house model,* late 19th century. British Columbia, Canada. Carved and painted wood, 35 ³/₈" x 18 ⁷/₈" x 16 ¹/₂" (90 x 48 x 42 cm). National Museum of the American Indian, Smithsonian Institution. Photo by David Heald. 7.3031.

112

Resources

Teacher's Resource Binder
 Studio Master: 2.4
 Studio Reflection: 2.4
 A Closer Look: 2.4
 Find Out More: 2.4
Overhead Transparency 3
Slides 2f

Meeting Individual Needs

Focusing Ideas Have students bring in photographs (actual photos or ones from magazines or newspapers) of interest to them.

Assistive Technology For making straight lines, provide rulers with handles.

Fig. 2–27 "I picked this house because I like the look of a Colonial house in the country. It reminds me of my house except a little smaller. Making the shingles and windows took a while because of all the lines. I had a fun time making it." Andrew T. Napier, *The Big House*, 1999.
Pencil, pen, 8 ½" x 11" (20 x 28 cm). Antioch Upper Grade School, Antioch, Illinois.

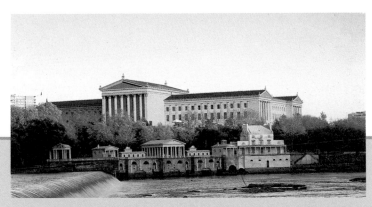

Doric

Ionic

Corinthian

Fig. 2–28 You might think that this building is a well-preserved temple from ancient Greece, but it's actually the Philadelphia Museum of Art. The museum structure is like that of Greek temples built 2500 years ago. Why do you think the architects included features of Greek architecture in the museum design? *Philadelphia Museum of Art*, 1995.
Photo by Graydon Wood, 1990. (D. Winston, H. Armstrong Roberts, Inc.). Riverfront view.

Fig. 2–30 The Greek ideals of elegance and beauty are clearly seen in the evolution of the culture's columns and capitals. How would you describe the differences between the capitals diagrammed here?

Fig. 2–29 Borie, Trumbauer, and Zantzinger, *Philadelphia Museum of Art*, 1912.
Watercolor and graphite. Philadelphia Museum of Art Archives. Photo: Graydon Wood, 1996.

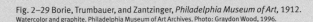

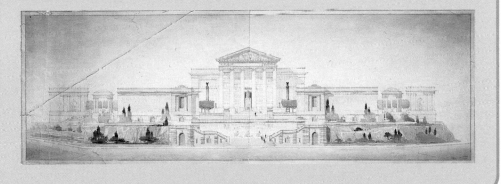

Preparation: If students sketch on paper, tape each sheet to a board. Arrange for students to visit and sketch a public building. Prior to the visit, scout out interesting viewpoints.

Teach

Engage

Ask students to close their eyes and imagine a prominent local building that you name. **Ask:** What do you first "see" when you think of this building? Tell students that they will draw a particular kind of exterior view of a building, called an elevation drawing.

Using the Text

Art Criticism Have students read Studio Background. Explain that the design of the Philadelphia Museum of Art—its columns, porch, and triangular pediment—is based on Greek and Roman temple architecture. **Ask:** What ideals are represented by this design?

Using the Art

Perception Have students compare the shape, materials, and textures of the museum to those of the Haida house model. **Ask:** What features provide clues to the function of each building? *(The museum's classical Greek design suggests classical fine art; the carvings on the Haida house identify the family who lived there.)*

Extend

Challenge students to create posters that illustrate the architectural features of Greek and Roman temples. Invite students to do research in art-history books and on the Internet.

Identity and Ideals

113

Perception Have students look through magazines and books to find examples of **architectural elements** borrowed from ancient Greece and Rome. **Ask:** Why would an architect want to build a structure with features associated with ancient Greece or Rome? What ideas are conveyed in a building's classical architectural details? Have students use their findings to create a guide for designers, to help these artists decide when and why to borrow ideas from classical architecture.

More About...

In architecture, exterior or interior views of a building's vertical planes are called **elevations**. From these drawings, builders can determine measurements and proportions. When making sketches, many artists use a sighting technique to help them determine the proportions. For example, to figure out how large a door would be in relation to the rest of the building, artists look through only one eye and hold their pencil at arm's length. They position it so that one end seems to touch the top of the door and move their thumb on the pencil until it marks the bottom. With this measurement, they can count how many "doors" high the building is.

Architectural Drawing

Studio Experience

1. Discuss the prominent features of the building that the students will draw. Note any classical details, and point out moldings, cornices, and other elements. **Ask:** What does the architecture convey about the purpose of the building?

2. Instruct students to draw in the main building shapes very lightly as they determine the relative proportions of various parts. Encourage them to draw the big shapes before beginning to focus on the details.

3. Students may photograph their views in case they do not complete the drawing and cannot return to the location.

Idea Generators

As students walk around the building, discuss the pros and cons of several different views. After students have selected a view, demonstrate how to sight with a pencil.

Sketchbook Tip

After students have made their doodles, encourage them to expand one of them into an architectural feature. Students may write about what type of building their invented feature might embellish.

Drawing in the Studio

Creating Your Elevation Drawing

You Will Need

- sketchbook
- soft lead pencil (#2)
- eraser
- graph paper or drawing paper
- ruler
- fine-tip marker

Try This

1. Discuss or visit a public building in your community. What clues to the building's identity do you notice? For example, what emblem or design does your school building feature? What does it tell people about the ideals of the school or the school's values?

2. Select a building that interests you. Choose an interior or exterior wall that you think tells something about the building. Make some quick pencil sketches that show the basic features of the wall and how those features work together. Don't worry about drawing straight lines.

3. Estimate the size of the wall and its parts. Then create a scale at which you will draw the wall. For example, ½ inch might equal 1 foot of the wall's length.

4. Using a ruler, draw the wall to scale on graph paper.

5. After you draw the basic shape of the wall, add simple lines that suggest details such as windows, cabinets, decorative elements, and the like. Think about how these architectural details can help show the ideals the building represents.

6. When the elevation drawing is finished, trace over the pencil lines with a fine-tip marker.

Check Your Work

Share your sketches and elevation with a partner or small group, and discuss any challenges you faced. What parts of the drawings are particularly successful? What would you change?

Display all the elevations and discuss ways they do or do not reveal the identity of the buildings portrayed. Which buildings borrow architectural details from the past?

Teaching Options

Studio Collaboration

Students may work together to draw an enlarged view of a building. Explain the importance of using the same scale so that all parts will be in proper proportion. Encourage students to indicate textures on their drawings.

Teaching Through Inquiry

Invite students to identify local buildings that do not seem to follow classical traditions. They might consider a strip mall, gas station, or their own school. **Ask:** What ideals may have guided the design of these structures?

Fig. 2–31 "The hardest part was making the house to scale. The easiest part was the garage. I like the point of view from straight on. It looks different from the usual perspective drawing of a house." Tricia Moore, *My House*, 1999.
Marker, 8 ½" x 11" (22 x 28 cm), Antioch Upper Grade School, Antioch, Illinois.

Sketchbook Connection
Sketching and doodling help artists and designers think visually. Experiment with doodles. Make a sequence of fifteen doodles that start with a simple shape—a circle, square, or triangle. What ideas come to mind as you work with the shape? Which of your doodles could become a design for an architectural feature? Why?

Computer Option
Complete steps 1 through 3 of the **Try This**. For steps 4 and 5, use a drawing program to accurately create the elevation drawing. How can you use the power of the computer to increase the accuracy of your measurements? Use different line weights to show the importance of details

Computer Option
Help students determine the proportions and scale of architectural elements. They may use guides and the electronic ruler to draw windows, doors, and other elements; and they can select, duplicate, and scale elements as needed. Guide students to use the bezegon or bezier tool to create arches and curves. Drawing programs that lend themselves to this studio lesson are ClarisDraw, AppleWorks, Microsoft Works, Canvas, Free-Hand, and Illustrator.
DoodleOpolis at: http://www.onlineclass.com/ Doodle/doodle.html explores space and architecture, and features student work from grades 4 through 12.

Assess

Check Your Work
Encourage small groups of students to show their work to one another and point out successes, challenges, and changes they would make if they were to redo the drawing.

Close
Display the drawings, and ask students to identify architectural features from the past. Review the clues in each building's features that point to that building's function.

More About...
Show students some architectural **drawing tools**, and teach how to measure with an architect's rule and draw with French curves and a flexible curved rod. Explain how arcs can also be useful in dividing a circle into equal segments. Allow a student to explain the use of a protractor, and lead students in thinking of reasons an artist might need to measure angles. Discuss advantages of cork-backed rulers. Demonstrate drawing parallel lines by measuring two points at equal distance from one edge of a paper and connecting them. Finally, demonstrate drawing parallel lines with a T-square.

Using the Overhead
Think It Through

Ideas If you were going to design a detail such as this for a school, what kinds of figures and textures would you include? What part of this artwork is a bas-relief? How would you describe the texture? Could you use any of the qualities of this surface in your elevation drawing?

Assessment Options

Self Ask students to write a description of their drawing in which they note its strengths and suggest ways to improve it.
Teacher Respond to the student's self-assessment; discuss any discrepancies.

Careers

Invite an architect to speak to the class; many local chapters of the American Institute of Architects sponsor speakers and provide educational resources to schools.

Daily Life

Prepare a Venn diagram for use as an overhead transparency (two overlapping circles that fill an 8 1/2" x 11" paper). Label each circle with its figure designation. Have students locate and study the Chinese dragon robe (Fig. 2–0) and Peruvian half-tunic (Fig. 1–4). Project the Venn diagram, and explain that each circle represents one of the artworks, and the overlapping area represents what is common to both artworks. **Ask:** What are the similarities? Where should I write them in the diagram? Encourage elaboration of vocabulary as the discussion proceeds. Write students' comments, if justifiable, in the center section. **Ask:** What are the differences? Where should I write them in the diagram? Write students' comments, if justifiable, in the appropriate circle. As an extension, ask students to use the vocabulary in the diagram for a compare-and-contrast essay.

Connect to...

Other Arts

Theater

In this chapter, you learned that we can examine the art of a past civilization and begin to know **how its people lived and what ideas they shared.** By looking at the visual art of the ancient Greeks, we know that they sought perfection in mind and body. From their plays, we know they believed that the individual had a responsibility to act morally, even if that meant going against society's laws. The Greek playwright Sophocles (c. 496–406 BC) explored this idea in *Antigone*, a play about a young woman who dares to speak up against the cruel actions of Creon, the dictator king. Read the following scene from *Antigone*, and discuss who is right, Antigone or Ismene.

(Antigone and her sister Ismene are discussing their brothers, Eteocles and Polyneices, who have just been killed in battle.)

ANTIGONE: Eteocles is to be entombed with every solemn rite and ceremony to do him honor, but as for Polyneices, King Creon has ordered that none shall bury him or mourn for him. Polyneices must be left to lie unwept and unburied. So King Creon has decreed to all the citizens and to you and to me. The person who disobeys King Creon shall be put to death. Will you join hands with me and share my task?

Fig. 2–32 *Antigone and Ismene.*
Photo courtesy of The Southeast Institute for Education in Theatre, 1992, directed by Kim Wheetley, starring Susan Elder as Antigone and Tara McLeevy as Ismene.

ISMENE: What dangerous enterprise have you in mind?

ANTIGONE: To bury his body! Will you join me?

ISMENE: Would you dare bury him against Creon's law?

ANTIGONE: My brother I will bury, and no one shall say I failed.

ISMENE: You are too bold! King Creon has forbidden it.

ANTIGONE: He has no right to keep me from burying my own brother.

ISMENE: Antigone, please remember that we are not trained to fight. I yield to those who have the authority.

ANTIGONE: I will not attempt to convince you, but I shall bury him. If I have to die for this pure crime, I am content, for I shall rest beside him. But you, if you choose, may scorn the sacred laws of burial that heaven holds in honor.

Adapted from Cullum, Albert (1993). *Greek and Roman Plays for the Intermediate Grades*, Carthage, IL: Fearon Teacher Aides, p.36

Daily Life

With what groups do you identify? How do you show your attachment to these groups? Do you wear certain colors, hats, shoes, or uniforms? What part does peer pressure play in your choice of clothing?

Throughout history and across cultures, clothing has expressed identity and status. Evidence of this is seen in a Chinese *Dragon Robe* (Fig. 2–6), a sculpture of *Augustus of Prima Porta* (Fig. 2–14), or the latest craze in name-brand jeans.

As a class, brainstorm answers to these questions: Why is it important to know when someone is dressed for a special occasion? Should a person's choice of clothing be accepted without question? Why or why not?

Teaching Options

Resources

Teacher's Resource Binder
 Using the Web
 Interview with an Artist
 Teacher Letter
 Venn Diagram

Community Involvement

Hold art-career presentations for students, as part of career day or in weekly installments. Invite local professionals to speak about their training and art-related career.

Video Connection

Show the Davis art careers video to give students a real-life look at the career highlighted above.

Other Subjects

Fig. 2–33 **How is this arch similar to the arches in the Colosseum?** Rome, *Arch of Constantine*, 315 AD. East elevation. Courtesy of Davis Art Slides.

Mathematics

Ancient Roman engineers perfected the use of the **round arch,** a curved architectural element used to span an opening. Arches open up large spaces in walls, let in light, reduce the weight of the walls, and decrease the amount of building material needed. The Romans constructed arches from wedge-shaped pieces of stone that met at an angle perpendicular to the curve of the arch. One of the best surviving examples of the Roman use of the arch is the Colosseum, built in Rome from AD 72 to AD 80 (see page 103). What are some examples of arches in your community? In what kinds of buildings are arches most often used?

Social Studies

Our interpretation of an art object's meaning can be influenced by its classification and presentation. How would your understanding of **a cultural artifact** such as Chinese *Dragon Robe* (Fig. 2–6) be shaped by its presentation in an art museum? Would your interpretation change if instead you saw the work displayed in a natural-history museum? Why do you think it might make a difference?

Who makes the choices about placing objects in museums? What reasons would you consider if you were to decide whether an artifact should be placed in an art museum or in a natural-history museum?

Careers

You may know Thomas Jefferson as the third president of the United States, but did you know that he was also an **architect**? Jefferson incorporated classic ideals about architecture in his design for the University of Virginia. The university structures are similar to many government, university, and museum buildings throughout North America. Since Jefferson's time, an architect's primary role of designing buildings and supervising their construction has changed. Architects' designs must still reflect their clients' ideals. Today, however, the planning and construction of enormous structures requires teams of experts. Architectural firms employ specialists including drafters, modelmakers, and illustrators. These people, in turn, work with engineers, builders, construction companies, landscape architects, and interior designers.

Fig. 2–34 **Elevation drawing of the facade of the rotunda at University of Virginia.**

How might Jefferson feel about contemporary architecture? Would he think that it harmonizes art with nature? Would he want to design a building today?

Internet Connection
For more activities related to this chapter, go to the Davis website at **www.davis-art.com.**

Social Studies

To help students understand that the interpretation of an art object's meaning can be influenced by its classification and presentation, bring a number of objects to class for discussion. Choose objects that are clearly artworks, historic artifacts whose functions may or may not be difficult to determine, and objects of natural origin. Display the objects on a table in front of the class, and encourage students to discuss if each belongs in an art museum, a history museum, or a natural-history museum, explaining reasons for each choice.

Internet Resources

ArtsEdNet

http://www.artsednet.getty.edu

Here, the Getty Education Institute for the Arts offers information on art and artists, an image bank, and suggested activities. Online exhibitions and discussions are regular features of ArtsEdNet.

University of British Columbia Museum of Anthropology

http://www.voice.ca/tourism/moa/anthrop.htm

Art and artifacts in the Museum of Anthropology illustrate the achievements of the First Peoples of the Northwest Coast.

Museum Connection

Encourage students to observe portraits—either at a local gallery or in reproductions—and to create stories about the people portrayed. Instruct students to base their stories on the subject's clothing, facial expression, props, and so on.

Interdisciplinary Tip

Invite colleagues to your classroom to see your art program at work, and share with them any relevant articles and books on art or art education.

Talking About Student Art

Prepare vocabulary word cards to help students talk about the formal arrangement of line, pattern, texture, and rhythm. Have volunteers use appropriate cards to describe the principle or element in a student artwork.

Portfolio Tip

Refer students to Foundation 4, pages 56–57, as a guide for writing about artworks

Sketchbook Tip

Encourage students to take visualized notes, so as to associate visual imagery with language. Demonstrate the use of a stick-person symbol for information about an artist, a group of artists, or a culture, by attaching notes to the appropriate spot on the figure. Notes about ideas are attached to the brain; about words, to the mouth; about actions, to the hands; about feelings, to the heart; about movement, to the feet; and about strengths, to the bicep.

Portfolio

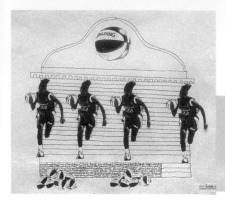

"I decided to do women's basketball because I love basketball and I am a fan; also I like to play it. I like the idea of basketballs as the bushes. I think that looks neat."
Justine Larrabee

Fig. 2–35 Justine Larrabee, *Basketball Dome*, 1999. Magazine cutouts, pen, 18" x 24" (46 x 61 cm). Jordan-Elbridge Middle School, Jordan, New York.

"I have had an interest in komodo dragons for a while. I realized how badly it deserved to be vibrant. So, I made it the most vibrant red I could find. Also, we had to add a prop to it, so I chose an egg. For the sake of science I changed it to a gila monster because I heard they are much more fond of eggs."
Veronika Yermal

Fig. 2–36 Favorite objects or animals, in this case a pet cat, can help establish the identity of a human subject. Jenny Abplanalp, *Self-Portrait with Cat*, 1997. Acrylic, 12" x 18" (30 x 46 cm). Verona Area Middle School, Verona, Wisconsin.

"I did this as an off-shoot of a Frida Kahlo work (the one with the monkey). I was having a hard time with this piece. Painting a self-portrait was something new and complicated. However, I did enjoy this project, which got me interested in painting." **Jenny Abplanalp**

Fig. 2–37 The choice of an unusual animal, decorated with traditional symbols, makes an intriguing mascot. Veronika Yermal, *Epiphany*, 1999. Papier-mâché, wire, tempera, 22" x 24" (56 x 61 cm). Copeland Middle School, Rockaway, New Jersey.

CD-ROM Connection
To see more student art, check out the Global Pursuit Student Gallery.

Teaching Options

Resources

Teacher's Resource Binder
Chapter Review 2
Portfolio Tips
Write About Art
Understanding Your Artistic Process
Analyzing Your Studio Work

CD-ROM Connection

Additional student works related to studio activities in this chapter can be used for inspiration, comparison, or criticism exercises.

Chapter 2 Review

Recall
What did the Greeks believe the ideal or perfect person should be?

Understand
Use examples to explain how artworks reflect identity and promote ideals.

Apply
Identify features of an architectural structure that reflect important ideals of the community in which it is found.

Analyze
Both individuals and groups develop distinctive ways of making things. Compare the masks in Fig. 2–2 (Hopetown, *Mask of Born-to-Be-Head-of-the-World,* below left) and Fig. 2–22 (Yup'ik, *Mask of a diving loon,* below right). Contrast their shapes, patterns, form, and use of materials. Make statements about the distinctive features of each work. Your descriptions should help your classmates to identify other works made by the same group or individual.

Synthesize
Compose a dialogue between two sculptors—one who is from ancient Greece and the other who is from ancient Rome—who are trying to decide how to show, in marble, an ordinary citizen. What would the Greek position be? How would it be different from that of the Roman sculptor?

Evaluate
Identify certain ways of dressing that are currently "in style" for people your age. Make a judgment about which style best shows the ideals that are most important to you. Explain your position.

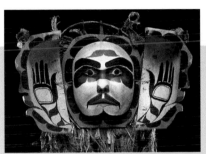

Page 96

Page 110

For Your Sketchbook
On a page in your sketchbook, write a list of words about identity. For instance, you might list words that name or describe anyone's personality, physical appearance, or family and culture. Refer to this list for ideas for future artworks.

For Your Portfolio
Choose an artwork in this book that sends a clear message about identity and ideals. Write a detailed description of the work. Tell what its message is, and how the arrangement of the parts helps to send it. Date your report, and add it to your portfolio.

Family Involvement
Set a positive tone for family-member visits to your classroom. Share your goals for the year, curriculum, discipline plan, daily routines, and procedures. Invite family members to participate in students' art education.

Advocacy
With any display of student art in the school lobby, include statements of goals for art students.

Chapter 2
Review Answers
Recall
The Greeks believed that the ideal person should be perfect in every way: the ideal body should be strong and athletic, and the ideal mind should be calm and not emotional.

Understand
Answers will vary. Possible answers: clothing can express role and status; masks can change or alter identity; ceremonial objects can symbolize power and authority or promote important beliefs.

Apply
Check that students have named architectural features of a specific structure and have explained how they reflect the community's ideals.

Analyze
Look for careful description and identification of distinctive features.

Synthesize
Look for reference to Greek ideals of beauty and to Roman realism.

Evaluate
Look for a clear and appropriate connection between a way of dressing and the student's stated ideals.

Reteach
Invite students to identify popular-culture artworks and objects that express group identity and ideals. *(school colors in a banner, school mascot)* Groups to consider are family, school, community, state, or nation. **Ask:** What visual features of each artwork or object help convey identity or ideals?

Identity and ideals

119

3 Lessons

Chapter Organizer

Chapter 3 Lessons

Chapter 3 Overview
pages 120–121

Chapter Focus

- **Core** Artworks have been used to inspire and to teach important ideas around the world and over time.
- **3.1** Art of the Medieval World
- **3.2** Shape and Balance
- **3.3** The Art of India
- **3.4** Creating a Folded Box of Lessons

Chapter National Standards

1 Understand media, techniques, and processes.
2 Use knowledge of structures and functions.
3 Choose and evaluate subject matter, symbols, and ideas.
4 Understand arts in relation to history and cultures.

2 2 2

**Core Lesson
Looking and Learning**
page 122
Pacing: Two 45-minute periods

Objectives

- Explain how artists use words, images, and symbols to teach important lessons.
- Use examples to explain how artworks can remind people of past events and cultural heritage.

National Standards

3b Use subjects, themes, symbols that communicate meaning.
4a Compare artworks of various eras, cultures.

**Core Studio
Teaching Triptychs**
page 126

- Design an artwork with three sections to teach something important.

1a Select/analyze media, techniques, processes, reflect.

2

**Art History Lesson 3.1
Art of the Medieval World**
page 128
Pacing: Two 45-minute periods

Objectives

- Distinguish between Romanesque and Gothic styles.
- Describe changes in illumination styles over time.

National Standards

4a Compare artworks of various eras, cultures.

Studio Connection
page 130

- Design an illuminated manuscript page with a balanced composition.

2c Select, use structures, functions.

2

**Elements and
Principles Lesson 3.2
Shape and Balance**
page 132
Pacing: Two 45-minute periods

Objectives

- Describe qualities of shape and balance in artworks and explain how they are used to unify a composition.

National Standards

2b Employ/analyze effectiveness of organizational structures.

Studio Connection
page 133

- Arrange positive and negative shapes in a design for a balanced Gothic arch or rose window.

2c Select, use structures, functions.

Featured Artists

Giselbertus
Harold Haydon
Pablo Picasso
Karen Stahlecker
Lydia Stein

Chapter Vocabulary

balance
 symmetrical
 asymmetrical
 radial
Gothic
illuminated manuscript
mural
Romanesque

shape
 organic
 geometric
 positive
 negative
triptych

Teaching Options

Teaching Through Inquiry
More About…Judaic and Islamic religious symbolism
Using the Large Reproduction
Meeting Individual Needs
More About…*Bayeux Tapestry*
More About…*Guernica*
Using the Overhead

Technology

CD-ROM Connection
e-Gallery

Resources

Teacher's Resource Binder
 Thoughts About Art:
 3 Core
 A Closer Look: 3 Core
 Find Out More: 3 Core
 Studio Master: 3 Core
 Assessment Master:
 3 Core

Large Reproduction 5
Overhead Transparency 6
Slides 3a, 3b, 3c

Meeting Individual Needs
Teaching Through Inquiry
More About…The Stavelot Triptych
Assessment Options

CD-ROM Connection
 Student Gallery

Teacher's Resource Binder
 Studio Reflection: 3 Core

Teaching Options

Meeting Individual Needs
Teaching Through Inquiry
Using the Overhead

Technology

CD-ROM Connection
e-Gallery

Resources

Teacher's Resource Binder
 Names to Know: 3.1
 A Closer Look: 3.1
 Map: 3.1
 Find Out More: 3.1
 Assessment Master: 3.1

Overhead Transparency 5
Slides 3d

Teaching Through Inquiry
Assessment Options

CD-ROM Connection
 Student Gallery

Teacher's Resource Binder
 Check Your Work: 3.1

Teaching Options

Teaching Through Inquiry
More About…Stained-glass windows
Using the Overhead
Assessment Options

Technology

CD-ROM Connection
e-Gallery

Resources

Teacher's Resource Binder
 Finder Cards: 3.2
 A Closer Look: 3.2
 Find Out More: 3.2
 Assessment Master: 3.2

Overhead Transparency 5

CD-ROM Connection
 Student Gallery

Teacher's Resource Binder
 Check Your Work: 3.2

9 weeks

18 weeks

36 weeks

				Objectives	**National Standards**
		3	**Global View Lesson 3.3 The Art of India** page 134 Pacing: Three 45-minute class periods	• Describe symbolic features of sculptural images of Buddha, Vishnu, and Siva. • Explain, in general terms, what Indian art reflects and how it is meant to be experienced.	**1b** Use media/techniques/processes to communicate experiences, ideas. **4a** Compare artworks of various eras, cultures.
			Studio Connection page 135	• Create a cut-paper collage, using symbols that teach.	**3b** Use subjects, themes, symbols that communicate meaning.

				Objectives	**National Standards**
	2	**1**	**Studio Lesson 3.4 Creating a Box of Lessons** page 138 Pacing: One to two 45-minute periods	• Apply an understanding of the role of symbols in teaching important lessons in an artwork. • Construct a folded paper box with symbolic decorations. • Use symbols in a meaningful way both to teach and to decorate.	**3a** Integrate visual, spatial, temporal concepts with content.

				Objectives	**National Standards**
•	•	•	**Connect to...** page 142	• Identify and understand ways other disciplines are connected to and informed by the visual arts. • Understand a visual arts career and how it relates to chapter content.	**6** Make connections between disciplines.

				Objectives	**National Standards**
•	•	•	**Portfolio/Review** page 144	• Learn to look at and comment respectfully on artworks by peers. • Demonstrate understanding of chapter content.	**5** Assess own and others' work.

2

Lesson of your choice

Teaching Options

Meeting Individual Needs
Teaching Through Inquiry
More About...Identifying features of Buddha
Using the Large Reproduction

Technology

CD-ROM Connection
e-Gallery

Resources

Teacher's Resource Binder
 A Closer Look: 3.3
 Map: 3.3
 Find Out More: 3.3
 Assessment Master: 3.3

Large Reproduction 6
Slides 3e

Teaching Through Inquiry
More About...Indian art
More About...Islam
Assessment Options

CD-ROM Connection
 Student Gallery

Teacher's Resource Binder
 Check Your Work: 3.3

Teaching Options

Meeting Individual Needs
Teaching Through Inquiry
More About...Judaic Symbolism
More About...Origami
Using the Overhead

Technology

CD-ROM Connection
 Student Gallery
Computer Option

Resources

Teacher's Resource Binder
 Studio Master: 3.4
 Studio Reflection: 3.4
 A Closer Look: 3.4
 Find Out More: 3.4

Overhead Transparency 6
Slides: 3f

Teaching Options

Community Involvement
Interdisciplinary Tip

Technology

Internet Connection
Internet Resources
Video Connection
CD-ROM Connection
 e-Gallery

Resources

Teacher's Resource Binder
 Using the Web
 Interview with an Artist
 Teacher Letter
 Story Map

Teaching Options

Family Involvement
Advocacy

Technology

CD-ROM Connection
 Student Gallery

Resources

Teacher's Resource Binder
 Chapter Review 3
 Portfolio Tips
 Write About Art
 Understanding Your Artistic Process
 Analyzing Your Studio Work

Chapter Overview

Theme

People worldwide seek guidance when making choices in life. Art can teach important lessons for a purposeful life.

Featured Artists

Giselbertus
Harold Haydon
Pablo Picasso
Karen Stahlecker
Lydia Stein

Chapter Focus

This chapter looks at the way artworks have been used to inspire and to teach important ideas around the world and over time. We look to India and medieval Europe for artworks that teach lessons for good living, and also consider how artists use balance, shapes, and symbols to create artworks that teach.

Chapter Warm-up

Draw this symbol Ø on the chalkboard. **Ask:** What does this symbol mean? Discuss where the symbol would be seen, and explain that it guides our actions. Challenge students to name other symbols that influence how we act or move. Tell students that they will study symbols that teach, guide, and inspire.

3 Lessons

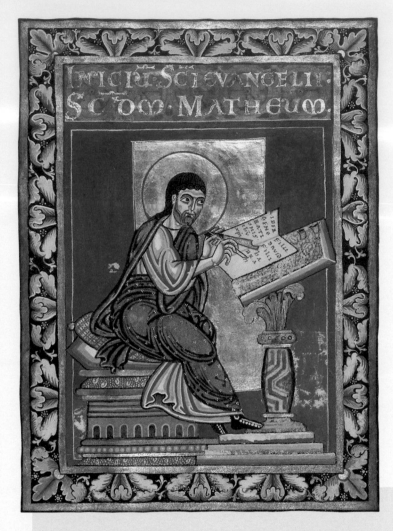

Fig. 3–1 **St. Matthew, shown here with pen in hand, is writing the Gospels—the stories of Christ's teachings and time on earth. How might the artist have wanted this portrait to inspire the viewer?** German (Helmarshausen Abbey), *St. Matthew*, fol. 9v, Gospel Book, c. 1120–40. Tempera colors, gold, and silver on parchment bound between pasteboard covered with brown calf, 9" x 6 ½" (22.8 x 16.4 cm). The J. Paul Getty Museum, Los Angeles.

120

National Standards Chapter 3 Content Standards

1. Understand media, techniques, and processes.

2. Use knowledge of structures and functions.

3. Choose and evaluate subject matter, symbols, and ideas.

4. Understand arts in relation to history and cultures.

Teaching Options

Teaching Through Inquiry

Art Production Bring in children's books, and have students work in small groups to discuss how the illustrations help tell the story. **Ask:** What are the qualities of a good **illustration that teaches**? Would the main idea or lesson be obvious without the words? Ask students to think about stories they have been told for the purpose of teaching a lesson or changing behavior; and about stories, such as a newspaper story about an accident, that were reminders for safe living. Have students make a drawing to teach a lesson originally taught in a story.

More About...

One of the most important medieval art forms was **manuscript illumination**. Cloistered monks and nuns spent their lives copying ancient texts and illustrating them with intricate designs and depictions of the Gospel writers and fanciful animals. Usually, these illuminated parchment pages were bound between elaborately tooled metal covers studded with jewels.

- How can images and symbols inspire us and provide us with guidance?
- How do artists help teach important lessons?

You probably remember being read to as a child. Do you remember a story called "The Little Engine That Could"? It was about a very small train engine struggling to pull a large number of cars up and over a mountain. With determination and while repeating "I think I can, I think I can," the little engine managed to keep going and reach the mountaintop.

The story about the little engine is familiar to millions of children. They like the main character, and they also learn an important lesson for living: Don't give up. When the going gets tough, don't despair; stay focused on your task, and you will make it.

Lessons for living are passed down in all cultures. Parents and other adults use stories to teach children how to live healthy, productive, and meaningful lives. Adults also need lessons for living. Sometimes these lessons are in the form of artworks rather than written stories. For example, the twelfth-century *manuscript illumination* (Fig. 3–1), a hand-painted illustration, was used to teach important religious ideas. In this chapter, you will see how artworks have been created and used for centuries worldwide for teaching important ideas.

What's Ahead

- **Core Lesson** Learn how people worldwide and over time have used art to inspire and teach one another.
- **3.1 Art History Lesson** Discover how people in the Middle Ages learned important lessons through artworks.
- **3.2 Elements & Principles Lesson** Examine the use of shape and balance in artworks designed for teaching.
- **3.3 Global View Lesson** Learn how artworks in India teach about the Buddhist and Hindu religions.
- **3.4 Studio Lesson** Create a paper box that uses symbols to teach classmates about yourself.

Words to Know

mural	shape:
triptych	*organic*
Romanesque	*geometric*
Gothic	*positive*
illuminated	*negative*
manuscript	balance:
	symmetrical
	asymmetrical
	radial

Using the Text

Discuss the questions in Focus. After students have read page 121, ask volunteers to share some of their family's lessons for living.

Using the Art

Art Criticism Ask: What did the artist emphasize? *(eyes, holiness of Matthew by halo around head, pen)* What do you notice about the figure? *(unrealistic anatomy)* What was the artist's message? Was conveying a realistic portrait of St. Matthew the artist's main intent? How does the size of the actual artwork compare to the size of this book?

**Graphic Organizer
Chapter 3**

3.1 Art History Lesson
Art of the Medieval World
page 128

Core Lesson
Understanding Art's Lessons

Core Studio
Teaching Triptychs
page 126

3.3 Global View Lesson
The Art of India
page 134

3.2 Elements & Principles Lesson
Shape and Balance
page 132

3.4 Studio Lesson
Creating a Folded Box of Lessons
page 138

Prepare

Pacing

Two 45-minute periods

Objectives

- Explain how artists use words, images, and symbols to teach important lessons.

- Use examples to explain how artworks can remind people of past events and cultural heritage.

- Design an artwork with three sections to teach something important.

Supplies for Engage

- colored paper: green, red, orange, black, white, brown, and school colors, 1 sheet of each per student

Vocabulary

mural A large painting or artwork, usually designed for and created on a wall or ceiling of a public building.

triptych An altarpiece consisting of three joined panels. Usually, the two outer panels are hinged to close over the central panel.

National Standards Core Lesson

3b Use subjects, themes, symbols that communicate meaning.

4a Compare artworks of various eras, cultures.

Understanding Art's Lessons

Looking and Learning

We all wonder about our place in the world and ask, "Why am I here?" or "What should I do?" We want to know how the world came to be and what life is all about. Family members, teachers, and political and religious leaders help provide answers to these important questions. Artworks can help give us answers, too.

Many of our lessons for living come from customs and ideas passed from one generation to the next. Some lessons are political. They teach people how to live together peacefully. Other lessons are religious. They teach a set of beliefs. Art can help us see and understand these lessons in new ways.

Artists can use words, images, and symbols to help tell others about important teachings, laws, and rules. *Symbols* are signs, letters, or figures that stand for other things. Pictures, simple shapes, and even colors can be symbols. Lessons are often told through artworks that have many symbols. These works are usually placed in public or shared spaces, such as government buildings, where many people can see them and discuss them with others.

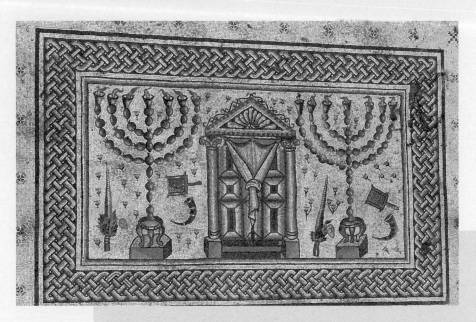

Fig. 3–2 **Carefully designed mosaic floors are often part of ancient Jewish synagogues. This balanced composition of stone and glass cubes shows the front of a temple with its sacred objects arranged on either side. What might you learn about fourth-century Judaism by looking at this design?** *Detail from mosaic pavement from a synagogue at Hammat Tiberias,* 4th century AD.
Photograph: Zev Radovan, Jerusalem.

122

Teaching Options

Resources

Teacher's Resource Binder
 Thoughts About Art: 3 Core
 A Closer Look: 3 Core
 Find Out More: 3 Core
 Studio Master: 3 Core
 Studio Reflection: 3 Core
 Assessment Master: 3 Core
Large Reproduction 5
Overhead Transparency 6
Slides 3a, 3b, 3c

Teaching Through Inquiry

Have students work in small groups to find artwork reproductions or magazine images that they can combine to teach simple **rules for living**. Possible lessons are: never tell a lie; look before you leap; plan ahead; chew with your mouth closed; don't rock the boat. Have each group share their best idea with the class.

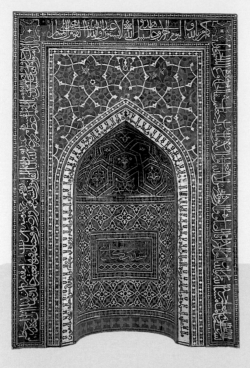

Fig. 3–3 **The walls of the mosque, the Islamic building for worship, are covered with lessons. Geometric patterns and plant shapes are combined with writing that uses the Arabic alphabet. In any mosque, a small space in the wall called the** *mihrab* (*MIH-râb*) **is the most important site. The mihrab points to Mecca, believed to be the holiest of places.** Iranian, *Mihrab of the Medersa Imami, Isfahan,* c. 1354.
Composite body, glazed, sawed to shape and assembled in mosaic, height: 11' 3" (342.9 cm). The Metropolitan Museum of Art, Harris Brisbane Dick Fund, 1939. (39.20) Photograph © 1982 The Metropolitan Museum of Art.

Fig. 3–4 **Artists of the Buddhist religion sculpted many likenesses of their leader. This one shows Buddha's hands in the teaching position.** India, *Seated Buddha Preaching in the First Sermon, Sarnath,* Gupta period, 5th century AD.
Stele, sandstone, 63" (160 cm) high. Archaelogical Museum, Sarnath, Uttar Pradesh, India. Borromeo/Art Resource, NY.

Religious lessons are often displayed in places of worship. The lessons might be shown in small portable paintings, altarpieces, holy books, windows, or on walls and floors. As you learn more about a religion's beliefs, the symbols you see in artworks gain more meaning. The lessons taught through images and symbols are meant to help people achieve a stronger and more lasting religious faith.

The Islamic, Jewish, and Buddhist religions express teachings through the use of artworks, as do other world religions. Study the artworks in Figs. 3–2, 3–3, and 3–4. Do you learn anything about the religions from looking at these works? Are there symbols you can recognize?

Lessons

123

Engage

Hold up green and red papers; then orange and black; red and white; orange and brown; and school colors. **Ask:** What does each of these color combinations represent? Students will probably mention holidays or certain athletic teams. Explain that colors have been used symbolically for centuries.

Using the Text

Have students read pages 122 and 123. **Ask:** What lesson does each artwork teach? How might each artwork be used to teach, to remind, or to inspire?

Using the Art

Perception Ask: What special feature of each artwork sets it apart from the others? What visual qualities do the three artworks have in common?

Art History Ask students to think about what the sculpture of Buddha might have meant to the people who were living at the time it was made. Tell students that looking at the sculpture of Buddha is intended to remind viewers of the wheel of life, one of Buddha's lessons.

More About...

Representations of human and animal forms as religious symbols are common in both Christian and Buddhist worship, whereas **Judaic and Islamic religious symbolism** does not include images of human figures. In Byzantine Jewish communities, mosaic floors in synagogues were popular. Most of the design elements of Islamic ornament are based on plant motifs, which are sometimes intermingled with symbolic, geometric figures.

Using the Large Reproduction

5

Talk It Over

Describe What shapes and symbols do you see?

Analyze How are the sections arranged to tell a story?

Interpret What might these symbols represent? What lessons do they teach?

Judge Why would you want people to see this quilt?

Using the Text

Perception Ask students to note the length of the *Bayeux Tapestry*. Explain that the piece was designed to hang like a frieze around the top of the walls of the cathedral at Bayeux, which was dedicated in 1077. **Ask:** How do the tapestry's dimensions compare to those of the classroom? Would the tapestry fit in this room? How much would be "left over"?

Using the Art

Perception Ask: What do you see in *Guernica*? Call students' attention to the images and symbolism. Picasso indicated that the bull represented "brutality and darkness," but in the midst of all the terror and agony, he included symbols of hope: the arm clutching the lamp evokes the Statue of Liberty; and a flower, symbolic of life and growth, emerges from the broken sword clutched by the dead soldier. Note that Picasso's figures, the gray-black colors, and the texture all echo the newspaper photographs of the massacre.

Art Teaches About Events

Most people look for ways to live together peacefully. They work together to make rules about how to treat one another. They encourage one another to have pride in their history and heritage. Artworks are important sources of information about the past. For instance, the *Bayeux Tapestry* (Fig. 3–5) shows the Norman invasion of England in 1066. The events of the battle are retold in the embroidered images. Artworks such as this teach about events that dramatically changed the lives of the people of the time.

Artworks are a powerful teaching tool that may help us understand how to live together without conflict. Pablo Picasso created *Guernica* (Fig. 3–6) after the 1937 bombing

Fig. 3–5 **We do not know the names of the people who made this amazing artwork, but most embroidery of the time was done by women. This was probably a group effort, with artists and an historian working together. The mural is over 230 feet (70.1 m) long and contains 626 human figures, 731 animals, 376 beasts, and 70 buildings and trees.** *Bayeux Tapestry,* William preparing his troops for combat with English Army. Musée de la Tapisserie, Bayeux, France. Giraudon/Art Resource, New York.

Fig. 3–6 *Guernica*'s **message is not completely about the horror of war. Picasso included Liberty, who, with her lamp, is a symbol of peace and personal freedom. In doing so, what is he suggesting about civilization?** Pablo Picasso, *Guernica.* 1937. Oil on canvas, 11' 5 ½" x 25' 5 ¾" (3.49 x 7.77 m). Museo Nacional Centro de Arte Reina Sofia, Madrid. Photo: Museo Nacional Centro de Arte Reina Sofia Photographic Archive, Madrid. © 2000 Estate of Pablo Picasso/Artists Rights Society (ARS), New York.

Teaching Options

Meeting Individual Needs

Multiple Intelligences/Logical-Mathematical Ask students to examine the *Bayeux Tapestry* and *Guernica* to see how the artists (from different centuries and cultures) told a story about war in a long, rectangular format. **Ask:** How did each artist divide the space to communicate different parts of the story? Are all the sequences, or "frames," in each work about the same width? How does this affect our "reading" of the artwork's narrative?

More About...

Tell students that the *Bayeux Tapestry* is a piece of embroidered linen showing the conquest of England by William the Conqueror, in 1066. The piece depicts the story, from a French viewpoint, of the crossing of the English Channel by the Normans; the Battle of Hastings; and William's coronation. The chain-mail armor, helmets, bows, lances, and battle axes are accurately depicted. Shields bear the crest of the owner.

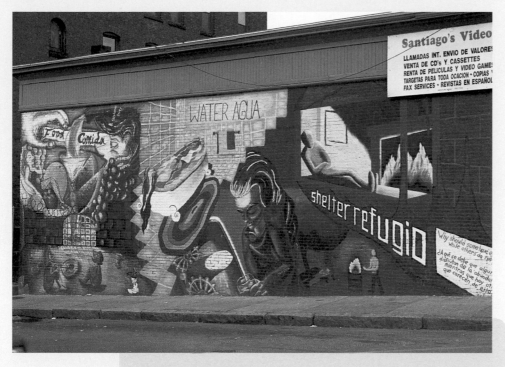

Fig. 3–7 This mural on the side of a market in Worcester, Massachusetts, makes a strong statement about poverty. What is the artist trying to say to her community?
Photo by Tom Fiorelli.

of the Spanish town of that name because he wanted to teach people about the horrors of war. Look carefully at the image. Notice how the positions of the bodies and the expressions on the faces tell of the terrible destruction and pain of the people.

Artworks can perhaps do their best teaching if they are displayed where many people can see them. **Murals**—large artworks usually designed for walls or ceilings—have long been used to present ideas about history and about how to live. Look for murals in government buildings and other public places in your town.

Some city neighborhoods have murals on outdoor walls (see Fig. 3–7, above). The people who live there can see and learn from them daily. If there is a mural near where you live, try to visit it. Look at it carefully. Does the mural tell you about an important event? Does it encourage people to get along with each other? What would you like to show in a mural that everyone could see?

Teaching Through Inquiry

Tell students that Picasso planned for *Guernica* to teach people about the horrors of war. Have students work in small groups to respond to questions. Ask: How did Picasso show the pain and suffering of war? Brutality against defenseless people? Hope amidst despair? The suffering amidst the refusal to recognize it?

More About...

Guernica In January of 1937, the exiled Spanish government commissioned Picasso to create an artwork for their pavilion at the Paris World's Fair. For months, Picasso did nothing on the work; but when Franco's forces bombed Guernica, the ancient Basque capital, the artist painted his emotional response to the horror of bombs that rained destruction on civilians.

Using the Overhead

Think It Through

Ideas What do you think this artist was interested in?

Materials What materials look familiar?

Techniques How can you find out more about how the artist made this?

Audience Do you think the artist had a particular audience in mind? What lesson was being taught, and to whom?

Supplies

- pencils
- 11" x 17" drawing paper or light cardboard
- scissors
- markers, colored pencils
- glue
- magazine cutouts
- computer printouts, gold and silver paint (optional)

Safety Note

Many permanent markers produce toxic fumes. Use only those with the AP, CP, or Health Label approval.

Using the Text

Perception Have students read Studio Background and then study *The Stavelot Triptych*. Tell students that triptychs were used as altarpieces in medieval churches, and that *cloisonné* is French for "partition." Note the tooled copper, and explain that enamels fill shapes created by the thin strips of metal. **Ask:** What symbols can you identify?

Art Production Brainstorm with students some ideas that they might depict. **Ask:** Will you symbolize your ideas? What symbols will you use? How will the triptych shape affect your design?

Demonstrate how to fold paper to form the triptych shape.

When students are almost finished, have them set their work upright and look at it from a distance. **Ask:** Are there places where more lines, color, or value contrasts would improve your work?

3 | CORE STUDIO

Teaching Triptychs

How can you work with the format of a **triptych** (an artwork with three sections) as a creative way to teach something important? **In this studio experience, you will make a foldout booklet or greeting card that teaches a lesson.** You might make images that instruct someone about your religious, political, or social beliefs. You could use symbols to stand for important ideas. Or you might suggest a simple lesson for living, such as not giving up when things seem hopeless. You might choose to show an event—something that happened at home, in your neighborhood, or at school—that you think others can learn from.

You Will Need

- pencil
- drawing paper or light cardboard
- markers
- colored pencils
- glue
- magazine cutouts
- printouts of computer-generated designs (optional)
- gold and silver paint or markers (optional)

Studio Background

About Triptychs

A triptych is an artwork with three sections. It has a central panel and two wings, which are attached with hinges. Some triptychs have architectural elements such as columns, arches, or windows. In the Middle Ages, triptychs showed religious subjects. Some of these triptychs were small enough to be carried by their owners, like portable altars. The images told religious stories and taught key beliefs. As with much medieval art, symbols represented important ideas. They also stood for the identities of saints.

1. Make two folds in a piece of paper to form a central panel and two sides that fold out. If you wish, cut the triptych into a shape that will help teach your lesson.

2. Lightly sketch a plan for what you will show. Will you tell a story? Consider presenting your story in three scenes. Will you use symbols? Symbols might be simplified images of animals, birds, or plants.

3. When you have a plan, outline the shapes with markers. Combine collage and colored-pencil techniques to make each panel rich and colorful.

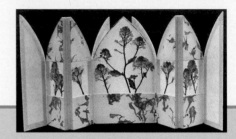

Fig. 3–8 **This one-of-a-kind artist's book was designed to showcase natural materials collected on a nature walk. How is the format like that of medieval portable altars?** Karen Stahlecker, *Golden Shrine*, 1995.
Shaped book with perforated covers, artist's handmade papers, natural materials, 7 1/4" x 4 1/4" x 1 1/3" (18.4 x 10.8 x 3.5 cm), when closed. Photo by K. Stahlecker.

The triptych format can be used to give shape to ideas about family, culture, history, or other important themes. A triptych does not require a religious focus.

Teaching Options

Meeting Individual Needs

Adaptive Materials Draw guidelines where students are to make the creases for the triptych. Have students use a straightedge to make the creases.

Focusing Ideas Rather than having students create their own design, give them topics to choose from. Alternatively, brainstorm with individual students to determine an appropriate and meaningful design.

Adaptive Tools Provide students with assorted stamps and stencils.

More About...

The Stavelot Triptych This Romanesque work depicts events from Emperor Constantine's life in medallions on the outside sections. One depiction is of a legend: the night before his triumph in the battle at the Milvian Bridge, Constantine saw a flaming cross in the sky; the cross was inscribed with words that stated he would win the battle if he fought under the sign of the cross.

Check Your Work

Does your triptych teach about something important to you? Exchange your triptych with a classmate. Each of you should guess what lesson is being taught. Do collage and colored pencil help present powerful messages? Are symbols used effectively?

Fig. 3–9 **This card is folded into thirds and opens from the middle, like a door, to reveal a story that illustrates a lesson. "My artwork is about making an effort. This is a good topic because people should always give it their full effort." How would you illustrate this concept? See page 144 for the solution this student artist created.** Rachel King, *Effort*, 1999. Colored pencils, 8 ¾" x 12" (22 x 30 cm). Yorkville Middle School, Yorkville, Illinois.

Sketchbook Connection
Make a series of sketches to show where you are and what you are doing at various times of the day: before school, in morning class, at lunch, after lunch, and after school. Design a symbol for each activity that will teach someone you don't know about your life.

Core Lesson 3

Check Your Understanding
1. List at least three ways that artworks are used to inspire or teach others.
2. If you were to teach someone about symbols, what are some things you would tell him or her?
3. Choose one image in this lesson and tell how its parts combine to teach a lesson.
4. Describe a social or cultural tradition you are familiar with that teaches a lesson.

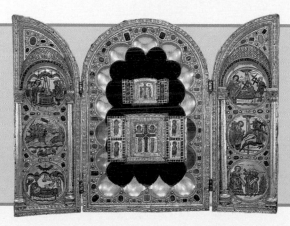

Fig. 3–10 **The two side panels of this triptych depict scenes from the life of Roman Emperor Constantine I. Notice the two triptychs within the larger triptych.** Mosan, *The Stavelot Triptych*, c. 1156–1158. Gold, cloisonné enamel, inlay, 19 1/16" x 26" (48.4 x 66 cm) when open. The Pierpont Morgan Library, New York/Art Resource, New York.

Lessons

127

Using the Art

Perception Ask students to compare the medieval triptych to the contemporary artist's book. **Ask:** In what ways are they alike? *(folding, arched top, self-supporting)* How are they different? *(materials, subjects, textures)*

Assess

Check Your Work
Discuss the questions in the text and how students might make their lesson more understandable.

> **Check Your Understanding: Answers**
>
> **1.** Artists use words, images, and symbols in artworks to teach laws, rules, and religious lessons.
>
> **2.** Symbols are signs, letters, figures, pictures, shapes, and colors that stand for other things. For instance, the depiction of a dove could be a symbol of peace.
>
> **3.** Look for an explanation of how the parts in the image teach a lesson.
>
> **4.** Answers will vary.

Close

Review how images and symbols can teach, inspire, and guide us. Ask students to cite artworks, other than those in Chapter 3, that teach lessons and then to explain the lesson.

Teaching Through Inquiry

Art Production Have students work in groups to compare the artworks on these pages. Ask them to create and complete a chart that addresses these questions for each artwork: (1) Where do you think the artist got the ideas for this artwork? What might have inspired the artist? (2) What materials did the artist use? (3) How did the artist use the materials? What techniques or processes were important in making this artwork? (4) How did the artist use the art elements in arranging the various parts of this artwork? Ask students to share and discuss their findings with the class.

Assessment Options

Peer Have students design a picture postcard with images and symbols to teach an important lesson. Then have pairs of students exchange postcards and explain, in a message on the back of the postcard, how the images and symbols can be interpreted so as to understand the lesson. Have students return the cards to their partner and discuss the interpretation.

CD-ROM Connection

For more images relating to this theme, see the Global Pursuit CD-ROM.

Art of the Medieval World

Prepare

Pacing

Two 45-minute class periods: one to consider text and images; one for Studio Connection

Objectives

- Distinguish between Romanesque and Gothic styles.
- Describe changes in illumination styles over time.
- Design an illuminated manuscript page with a balanced composition.

Vocabulary

Romanesque A style of art and architecture influenced by Roman art, that developed in western Europe during the Middle Ages. Cathedrals had heavy walls, rounded arches, and sculptural decorations.

Gothic A late-medieval European art style, typified by churches with flying buttresses and stained-glass windows.

illuminated manuscript A medieval art form of intricate designs and borders around text.

Using the Time Line

Review with students the sequence of the Early Medieval, Romanesque, and Gothic periods. Suggest that students place Fig. 3–1 on the time line. Within what period does it fall?

| c. 800 | | | 1163 | |
| Book of Kells | | | Notre Dame begun | |

| Byzantium page 102 | Early Medieval | Romanesque | Gothic | Renaissance page 154 |

| | 1130 | 12th Century | |
| | Last Judgment | Chartres stained-glass windows | |

After the decline of the Roman empire in the fifth century, Europe entered a new and difficult era. Migrations of people swept across Europe. This era, called the Middle Ages or Medieval period, lasted nearly 1000 years.

The one stable element during this time was the comfort people found in the teachings of Christianity, Islam, and Judaism. Because most Europeans could not read or write, art continued to be an important way to communicate these lessons.

In early medieval times, art was often small and portable. Books and objects of adornment were easily carried by people on the move. But by the eleventh century, people began to settle in permanent communities or towns. They borrowed Roman art ideas. The style of the art and architecture of this period is called **Romanesque.**

Toward the end of the Middle Ages (from the 1200s through the early 1400s), churches became the center of religious and social activity. The art of this part of the Middle Ages is called **Gothic.** It shows the energy of the growing cities of the time.

Fig. 3–11 **The Gothic period was a time of new approaches in architecture. This Gothic cathedral shows the use of flying buttresses—angled arches held up by pillars—that support the high ceiling inside.** *Notre Dame Cathedral,* exterior, begun 1163. Paris, France.

National Standards
3.1 Art History Lesson

4a Compare artworks of various eras, cultures.

Teaching Options

Resources

Teacher's Resource Binder
 Names to Know: 3.1
 A Closer Look: 3.1
 Map: 3.1
 Find Out More: 3.1
 Check Your Work: 3.1
 Assessment Master: 3.1
Overhead Transparency 5
Slides 3d

Meeting Individual Needs

Gifted and Talented Have students compare the *Chi-rho* to a page of a book they are reading for language arts. **Ask:** What is the difference in their decoration? Why are books today not illuminated as they were in the Middle Ages?

Fig. 3–12 **Notice the geometric design on this illuminated page from an Irish manuscript. Do you see an X and P? This is a symbol for the name of Christ. It is pronounced** *ky-roh*. *Chi-rho* Gospel of St. Matthew, chapter 1 verse 18, Irish (vellum). *Book of Kells*, c. 800.
The Board of Trinity College, Dublin, Ireland/Bridgeman Art Library.

Early Medieval Art

In early medieval times, books played an important role in preserving the lessons of Christianity, Judaism, and Islam. Scribes spent their lifetimes copying sacred manuscripts. Their goal was to preserve the lessons for future generations.

Illuminated Lessons
Scribes copied the sacred texts, and artists, called *illuminators,* illustrated certain parts of the scriptures. On the book pages, illuminators painted scenes with complex geometric patterns, figures, and fantastic animals. Often they added a thin layer of gold to emphasize parts of the image. These illustrated texts, called **illuminated manuscripts,** were carried throughout the lands to teach religious ideas. The art of manuscript illumination was practiced throughout medieval Europe and the Middle East.

Sketchbook Connection
Fill one or more pages of your sketchbook with playful ornamental alphabets. One alphabet might be plant forms, another might be animals or insects, and so on.

Lessons

129

Teach

Engage
Ask: How do you teach someone to read or write? How can you teach without using words?

Using the Text
Aesthetics Tell students that old churches are sometimes converted into restaurants, apartments, and the like. The original form and details of such structures were visual reminders of important lessons for living. **Ask:** When the function and use of a building changes, do the lessons for living also change? What kind of lessons were taught by Gothic and Romanesque art and architecture?

Using the Art
Art History Explain that, in the seventh century, the illumination practice of enlarging the first letter of a text developed into the practice of enlarging a letter to cover an entire page (known as a carpet page). **Ask:** To which illumination practice does the *Chi-rho* belong? What two facts support your answer? *(The* X *and* P *fill the page; the work was made c. 800.)*

Teaching Through Inquiry

Art History Ask students to work in small groups to **compare the** *Chi-rho* **with** *St. Matthew*, Fig. 3–1. **Ask:** What are the distinctive features of each? Give each group a blank time line. Have them copy the information from the lesson's time line and then add the date of each illumination. Lead a class discussion of the ways illuminations have changed over time.

Using the Overhead

Investigate the Past

Describe What is this? What is it made from? What are the important shapes and symbols?

Attribute When was it made? Who might have made it?

Interpret What does this image suggest about how people felt about books?

Explain Why would someone want to cover a book in this way?

5

Art of the Medieval World

Using the Text

Perception Have students read page 130. **Ask:** Which is largest figure in *The Last Judgment*? The smallest? Are they in pain? Are they realistic? What, do you think, was the artist's lesson? Explain that, in medieval symbolism, the most important figures occupy the largest space relative to any other figures; and halos usually mark any holy figures.

Using the Art

Art History Ask if any students know the stories told in the Chartres windows. At the top, the risen Christ is telling one of the women who discovered him not to touch him. The lower circle shows Jesus dying on the cross, flanked on the left by Mary and, on the right, by John. Because the figures are holy, they all have halos. Point out that the colors of dress are symbolic: medieval worshipers were able to recognize religious figures, and thereby recall their stories, by the clothing colors.

Studio Connection

Encourage students to make several pencil sketches and then transfer the most successful, balanced design to drawing paper. Instruct students to outline everything with a fine-tip black waterproof marker, and to add color after the ink has dried. When the paint has dried, they may add details with fine-tip markers, and additional sparkle with gold and silver metallic markers.

Assess See Teacher's Resource Binder: Check Your Work 3.1.

Romanesque Art

The wars from the fifth through the tenth centuries destroyed many buildings in Europe. At the start of a new millennium in the year 1000, there was much building. New stone churches were built in the Romanesque style. For medieval Christians, the church became the center of teaching. Lessons for good living were shown in vivid images on walls and in sculptures.

Lessons Carved in Stone

Artists of the Romanesque period are known for bringing back the Greek and Roman tradition of carving large-scale sculptures. For Christian churches, they often carved scenes to fit in the arched space above church doorways, known as a *tympanum* (Fig. 3–13). These sculptural scenes, as well as other sculptures and paintings in the church interior, used figures and symbols to remind worshipers about their beliefs and the teachings of their faith.

Studio Connection

Illuminations can take the form of decorated letters, border pages, and scenes that include figures. Create an illuminated manuscript page with one or more decorated capital letters. Think of a lesson your page might teach. Look at books and cards with examples of historical and modern illumination and decorative borders. Or study Fig. 3–12 to help you get ideas.

Your illumination might consist of your initials or your favorite saying or poem presented in your best calligraphy. Experiment with different kinds of type: large or small, plain or fancy. Plan your composition carefully.

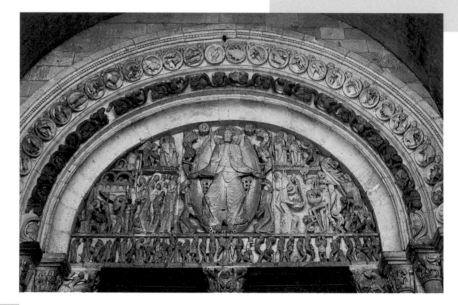

Fig. 3–13 **This tympanum shows Christ weighing people's souls, on the way they have lived their lives. If you believed in this, imagine how you might feel walking under this scene.** Giselbertus, *The Last Judgment*, 1130–1140. West tympanum, St. Lazare. Autun, France.

Teaching Through Inquiry

The construction of Gothic cathedrals with **stained-glass windows** was dependent on large donations of money. In some cases, guilds or organizations representing specific groups of craftsmen donated windows illustrating their professional activities. Wealthy people who donated enough money for windows were rewarded with an image of themselves in a biblical scene. **Ask:** What lesson was taught to the masses of people who saw the image of a wealthy contributor in the company of angels or holy people? What might a donor window have inspired others to do? Consider the previously mentioned practice of showing the work that contributing groups do for a living. Does this teach a different lesson?

Gothic Art

Church-building continued well into the 1300s. Earlier, Romanesque structures had been made of thick stone walls. They had dark interiors with very few windows. For Christians, light symbolized the presence of God, and soon they wanted to fill their churches and cathedrals with light. As a result, architects began to find new ways to open up interior spaces. They developed a new system of architectural supports (Fig. 3–11) that helped them build taller buildings with thinner walls. More importantly, the walls could have many large windows to let in ample amounts of light.

Lessons in Glowing Light

The interiors of Gothic cathedrals were made even more beautiful by the use of stained-glass windows (Figs. 3–14 and 3–16). Rather than clear glass, the windows were made of small pieces of cut colored glass held together with lead. The colors glow like jewels as light passes through them.

Stained-glass windows changed church interiors into glowing places of worship. They also helped continue to teach the churchgoers. In the windows, scenes from the Bible were again depicted and served as visual reminders of how to live a good life.

3.1 Art History

Check Your Understanding
1. What is meant by Romanesque art?
2. Name two differences between Gothic and Romanesque architecture.
3. What is an illuminated manuscript?
4. What special functions did stained-glass windows serve in cathedrals?

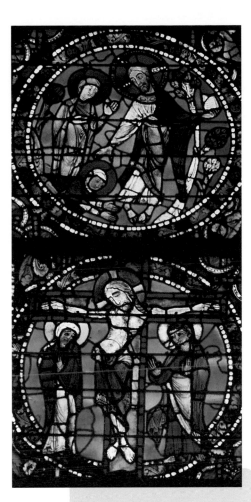

Fig. 3–14 **Gothic church stained-glass windows often depicted scenes from the Bible. These two details show stories from the life of Jesus. How do the colors make you feel?** *Noli me tangere* and *Crucifixion* (detail), Cathedral of Chartres, 12th century.
Stained glass. Photo by Edouard Fiévet.

Extend

One purpose of a high-ceilinged Gothic cathedral was to inspire or motivate people to live their lives with an eye toward heaven. Have students cite a local building that, because of its form and structure, can inspire or motivate people in some way. Ask students to explain their choices.

Assess

Check Your Understanding: Answers

1. Romanesque art was influenced by Roman art, and developed in western Europe during the Middle Ages. Romanesque cathedrals had heavy walls, rounded arches, and sculptural decorations.

2. Romanesque structures had thick stone walls, a dark interior, and very few windows. Gothic buildings were taller with thinner walls and many large windows.

3. an illustrated text that usually taught important lessons

4. Stained-glass windows changed church interiors into glowing places of worship. The scenes depicted in the windows served as reminders of how to live a good life.

Close

Review the differences between Romanesque and Gothic architecture, and ask students to describe an illuminated manuscript. Display the students' illuminated manuscripts, and discuss how theirs differ from medieval ones.

Assessment Options

Teacher Ask students to imagine being a curator of a photography show of Romanesque and Gothic architecture. If possible, provide them with photocopies or reproductions. Have students write an introduction to the show, explaining to viewers the major differences between Romanesque and Gothic styles, and what important things to notice when viewing the photographs.

Teacher Tell students that another part of this show includes examples of illuminated manuscripts. Ask students to write an introduction describing the major changes in illumination styles over time.

3.2 ELEMENTS & PRINCIPLES LESSON

Shape and Balance

Prepare

Pacing

Two 45-minute periods

Objectives

- Describe qualities of shape and balance in artworks and explain how they are used to unify a composition.

- Arrange positive and negative shapes in a design for a balanced Gothic arch or rose window.

Vocabulary

Refer to the glossary for definitions.

Teach

Using the Text

Art History After students read, tell them that shapes used as symbols change from one culture to another. In Christian iconography, the rose is a symbol for Mary. In thirteenth-century France, the rose was a symbol for eternal life. In other belief systems, the rose symbolizes youth, purity, perfection, wholeness, love, rebirth, death, and secrecy.

Using the Art

Perception Ask: Where are the positive shapes in Haydon's *The Path*? What kind of balance did Haydon use?

Critical Thinking

Ask: Why, do you think, did the artists choose to balance the parts of these windows in the way they did?

Looking at Shape

Shape is a design element in two-dimensional artworks. Shapes have height and width but no depth. They can be defined by an outline or area of color. Many artists carefully plan their use of shape to help show a specific idea or teach a lesson. Some artists use shapes as symbols, to add meaning.

Organic shapes are often free-flowing and irregular. Most shapes found in nature are organic. Feathers, leaves, and puddles have organic shapes. **Geometric** shapes are precise and can be mathematically defined. Triangles, circles, rectangles, and squares are geometric shapes. In both of the artworks shown here, artists combined organic shapes and geometric shapes to express important ideas.

There is another way to describe shape. Shapes that you notice are called **positive** shapes. The subjects of artworks—the person in a portrait or the objects shown—are positive shapes. The area around the positive shapes creates **negative** shapes. In the stained-glass window, the shapes made of colored glass are positive shapes. The black area surrounding them is the negative shape. A successful design balances the use of positive and negative shapes.

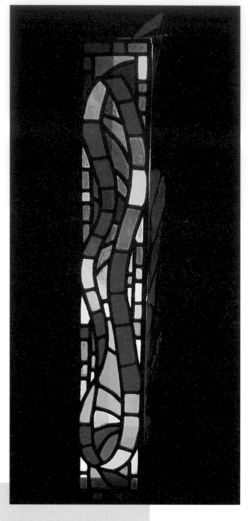

Fig. 3–15 **Notice how this artist arranged different geometric shapes in an organic shape that resembles a ribbon. These shapes of different sizes and colors create a feeling of asymmetrical balance. What might this window symbolize?** Harold Haydon, *The Path*, 1972. Stained-glass window. University of Chicago, Rockefeller Chapel.

132

National Standards 3.2 Elements and Principles Lesson

2b Employ/analyze effectiveness of organizational structures.

Teaching Options

Resources

Teacher's Resource Binder
- Finder Cards: 3.2
- A Closer Look: 3.2
- Find Out More: 3.2
- Check Your Work: 3.2
- Assessment Master: 3.2
- Overhead Transparency 5

Teaching Through Inquiry

Ask students to collect as many varieties of leaves as possible and then group the leaves by the type of balance they most closely exhibit. Have students make outline drawings for a bulletin-board display.

Looking at Balance

Balance holds a design together. Different kinds of balance have different effects on the viewer.

Balance can be **symmetrical** or **asymmetrical**. In many cultures, symmetrical, or formal, balance is used to suggest a feeling of stability or quiet. A design with symmetrical balance looks the same on both sides, like a mirror image. Asymmetrical, or informal, balance is often used to express a feeling of motion or action. An asymmetrical design (Fig. 3–15) does not look the same on both sides. Instead, an area on one side of the design is balanced by a different type of area on the other side.

The Chartres stained-glass window (Fig. 3–16) teaches a religious lesson with the help of **radial** balance, a type of symmetrical balance with parts leading away from or toward a center point. Look at Fig. 3–15, a very different design. What lesson do you think *The Path* teaches?

Studio Connection

Make your own design for a symmetrically balanced Gothic arch or rose window. Draw the positive shapes of the design in pencil on black paper. Cut out these shapes. The remaining parts of the black paper, which will be the negative shapes, will be unbroken and connected. Glue colored tissue pieces behind the cutouts.

3.2 Elements & Principles

Check Your Understanding
1. What is the difference between positive and negative shapes?
2. What type of balance would you use to depict a wild ride at an amusement park? Explain the reason for your decision.

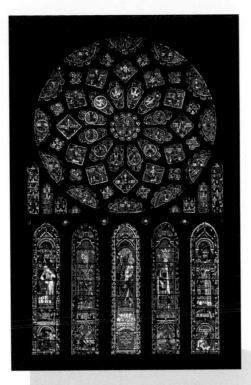

Fig. 3–16 This stained-glass work depicts religious history. Mary holds the Christ Child, enthroned in the center of the radial design and surrounded by doves and angels. Twelve kings and, beyond them, twelve prophets complete the balanced circular design. The tall lancets (pointed arches below the rose window) depict saints and Old Testament figures. How do repeated shapes and colors contribute to the formal sense of balance? *North Transept Rose and Lancet Windows (Melchizedek & Nebuchadnezzar, David & Saul, St. Anne, Solomon & Herod, Aaron & Pharaoh)*, 13th century. Stained glass, 42' (12.8 m) diameter. Chartres Cathedral, France. Scala/Art Resource, New York.

Lessons

133

Studio Connection

Provide students with white copy paper, black construction paper, colored tissue paper, scissors, glue, and chalk (optional, for "lead" lines). Discuss the balanced symmetry of the rose window and lancets.

Assess See Teacher's Resource Binder: Check Your Work 3.2.

Assess

Check Your Understanding: Answers

1. Positive shapes are the subject matter of artworks, such as the shape of a figure or a tree. Negative shapes—such as the empty space around a tree, or between the branches—surround, or trap inside, a positive shape.

2. Answers may vary, although asymmetrical balance would be the likeliest choice, because it tends to suggest motion and action. Accept well-supported answers.

Close

Discuss reasons that shapes in an artwork might, at first glance, seem purely decorative, and reasons that balance might seem only a structural solution to the arrangement of parts. Review how artists can use shapes and balance effectively.

More About...

To create a **stained-glass window**, an artist would draw the design on a large board, set sheets of colored glass over the design, and cut them into the shapes for the window. The artist used lead strips to solder the glass pieces, and sometimes painted details and shading onto the glass. Iron bars and carved stone tracery, which appear as wide dark lines in the window, were used to support the whole window.

Assessment Options

Peer Have students create two different tissue paper collages, using natural shapes such as leaves, fish, etc. They should create one based on the style of Impressionism using atmospheric color ideas, and the other on the style of Post-Impressionism using complementary color schemes. Students then exchange artworks with a peer. Peer reviewers are to write comments, indicating how well the artist showed differences in the way Impressionists and Post-Impressionists used color.

Using the Overhead

Write About It

Describe Have students write a short statement describing the different kinds of shapes in this artwork.

Analyze Using the overlay, have students make a simple sketch of the balanced parts. Then ask them to write a short statement about balance in this artwork.

Prepare

Pacing

Three 45-minute periods: one to consider text and images; two for Studio Connection

Objectives

- Describe symbolic features of sculptural images of Buddha, Vishnu, and Siva.

- Explain, in general terms, what Indian art reflects and how it is meant to be experienced.

- Create a cut-paper collage, using symbols that teach.

Using the Map

Have students discuss the relative size of India on the globe. **Ask:** India is a part of which continent? Why, do you think, is India sometimes called a "sub-continent"?

Teach

Engage

Explain that students will be learning about religious lessons in Indian art. **Ask:** What art have you seen in places of worship? What symbols are used? What lessons are taught?

The Art of India

India is a land of variety and contrasts: from snow-covered mountains to rich valleys and fertile plains. Early peoples lived in this diverse region many thousands of years ago, probably as far back as 30,000 BC. Around 2700 BC, just as the ancient civilization of Egypt was emerging, the earliest Indian culture settled in the area of the Indus River. It is known as the Indus Valley civilization.

Throughout its long history, Indian art has reflected the teachings of its two main religions: Hinduism and Buddhism. Each religion produced its own unique style of sculpture and architecture. Each religion also used a rich variety of distinct symbols to teach followers important lessons.

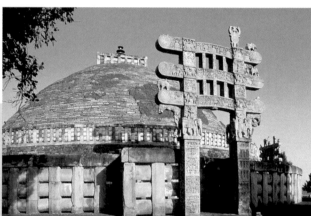

Fig. 3–17 Vishnu, the Hindu god of love and forgiveness, is often associated with playing pranks and games. Here he is shown in animal form, as a lion. India, late Chola period (c. 13th century), *Narasimha: Lion Incarnation of Vishnu.* Bronze, 21 ¾" (55.2 cm) high. ©The Cleveland Museum of Art, 1999, Gift of Dr. Norman Zaworski, 1973.187.

India

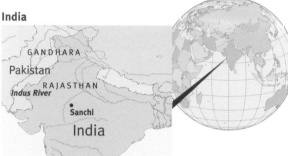

Fig. 3–18 The carvings on this stupa's gateways tell stories from the previous lives of the Buddha. Why do you think these carvings were placed at the entryways to the stupa? How could they help teach lessons? India (Sanchi), east gate, *Great Stupa*, 75–50 BC. ©Adam Woolfitt. All Rights Reserved.

134

Teaching Options

National Standards
3.3 Global View Lesson

1b Use media/techniques/processes to communicate experiences, ideas.

4a Compare artworks of various eras, cultures.

Meeting Individual Needs

English as a Second Language Have students identify the animal in Fig. 3-17. Write the word "lion" on the board. **Ask:** What qualities does a lion have that you also have? Have students draw a self-portrait that includes an animal. Ask them to write the animal's name and the characteristic they share.

Buddha's Lessons

Buddhism is based on the teachings of a holy man known as Buddha, or the "enlightened one." Buddhism first appeared in India in the sixth century BC.

Buddhist art and architecture are meant to help followers reach their own state of enlightenment through meditation, just as the Buddha did. The earliest form of Buddhist architecture is called the *stupa* (STEW-pah). It is a type of rounded burial mound built to honor the Buddha (Fig. 3–18). Stupas may be built up from the ground or carved out of rock. They are often part of a complex of buildings where monks live, and they serve as places for meditation and prayer.

At first, the Buddha was shown in artworks only by a symbol. Sometimes it was a lotus flower, the symbol of purity. Other times it was a wheel, an ancient sun symbol that represented his teachings and the cycle of life. Beginning in the first or second century AD, images of the Buddha appeared. The symbols and gestures shown in the sculptures and reliefs make the image of the Buddha easy to recognize (Fig. 3–19).

Studio Connection

Make a list of your characteristics. What's your astrological sign? What talents do you have? What are your favorite things? Think about yourself as a shape, a color, a line, a flower, an insect, or an animal. Plan a cut-paper collage in the form of a manuscript page with figures and a patterned background. Use colored and textured papers to create a collage that teaches others something about yourself.

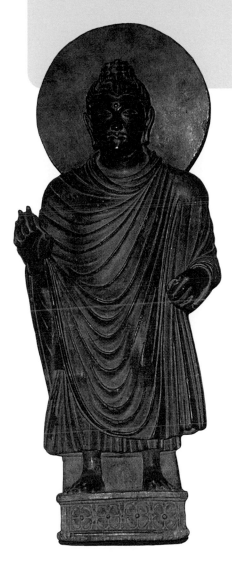

Fig. 3–19 **The Buddha is always shown with certain symbols. He makes hand gestures that are known as *mudras*. This mudra means "fear not." The coil of hair on top of his head is a symbol of *enlightenment*.** India (Gandhara), *Standing Buddha*, 2nd–3rd century AD (Kushan period). Phyllite, 23 ¼" x 13" (59.1 x 33 cm). Asian Art Museum of San Francisco, the Avery Brundage Collection, B60 S132+.

Using the Text

Write the words *stupa, lotus flower,* and *wheel* on the chalkboard. Ask students to read the text to find out what these words have in common, then to define the terms and discuss the symbolism associated with Buddha.

Using the Art

Art History Have students compare *Standing Buddha* with *Charioteer of Delphi*, page 102. **Ask:** What evidence might support the claim that some images of Buddha reflect the spread of Greek artistic ideas? Explain that Greek influences reached India through trade.

Art Criticism Ask students to compare balance, movement, form, and complexity in the sculptures of Buddha and Vishnu.

Studio Connection

Provide scissors, glue, pencils, and a variety of colored and textured papers, including 12" x 18" drawing paper. Discuss the attributes of Buddha, Vishnu, and Siva. **Ask:** If you needed to meet someone who had never seen you, what might you tell the person to look for? Explain to students that colors and special objects can help identify them. Encourage students to be playful in the development of their attributes.

Assess See Teacher's Resource Binder: Check Your Work 3.3.

Teaching Through Inquiry

Art Criticism Have students work in groups to make lists of the symbols associated with Buddha, Siva, and Vishnu. Use information in text and captions, and do further research to find the meanings of symbols.

More About...

There are thirty-two **identifying features of Buddha**; a single Buddha image may have three or four. Some of the features are a halo; a knob on the top of the head (for spiritual knowledge); elongated earlobes (a reference to the heavy jewels Buddha once wore as a prince); a dot between the eyebrows (representing spiritual vision); and distinctive hand gestures, called *mudras*. Buddha is often shown sitting cross-legged under a tree. He is sometimes shown with a third, "all-seeing" eye, and large "all-hearing" ears.

Using the Large Reproduction

6

Consider Context

Describe How is this work organized?

Attribute What clues might help you to identify the culture that produced this artwork?

Understand How would you find out what lesson is being taught?

Explain What will you need to research in order to explain why this work looks the way it does?

Using the Text

Ask students to explain, in their own words, how outside influences affected the art of India during the Mughal period. Then ask if they can name other instances in which art was influenced by another culture. *(Native Americans incorporated materials from Europe; modern artists, such as Picasso, were influenced by African art.)*

Using the Art

Explain to students that images of gods in India are not meant to be likenesses of human beings, nor are they representations of what we see in our own world. In the image world of India, gods are "visible thoughts" about invisible things. **Ask:** How do Vishnu and Siva show leaps of artistic imagination?

3.3 GLOBAL VIEW LESSON

Hindu Lessons

Today, Hinduism is India's oldest religion. It has many different gods, or deities. The three main gods are: Brahma, the Creator; Vishnu, the Preserver; and Siva, the Destroyer. In bronze and stone sculptures and reliefs, artists show these gods in animal or human form. They are shown with symbols that stand for each god's special powers.

For example, Siva (Fig. 3–20) is often shown holding a drum in his back right hand. This symbolizes his power to create and contrasts with the fire in his back left hand, which represents his power to destroy. His inner right hand is raised in a gesture that means "fear not." His inner left arm points to his raised left foot that symbolizes escape from ignorance.

Architecture has also played an important role in the Hindu religion. Elaborate cave temples and square stone temples topped with towers were built as the residences of the gods. Inside, a sculpted image of the temple's god is placed in a sacred space.

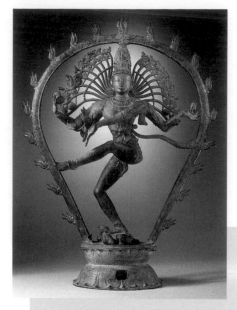

Fig. 3–20 **When the Hindu god Siva is shown dancing, he is called Nataraja, meaning "Lord of the Dance." The moves he makes and objects he holds stand for the rhythm of the universe. What type of balance does this sculpture show?** Indian (Tamil Nadu), *Siva, King of the Dancers, Performing the Nataraja*, c. 950. Copper alloy, 30" x 22 1/2" x 7" (76.2 x 57.1 x 17.8 cm). Los Angeles County Museum of Art, given anonymously. M.75.1.

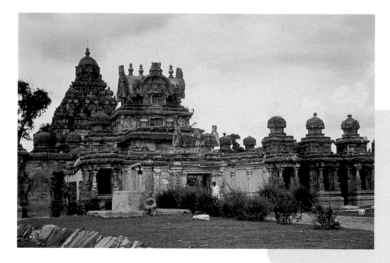

Fig. 3–21 **Like Buddhist stupas, many Hindu temples were carved from rock. Inside, these temples are like caves, which are considered holy places in India. Each part of the building's design and construction is symbolic, based on important religious beliefs.** India (Kanchipuram), *Kailasanatha Temple*, c. 700 AD. Courtesy of Davis Art Slides.

136

Teaching Options

Teaching Through Inquiry

Art History Have students work in groups to prepare a time line of Indian art from the Indus Valley cultures to the present. Assign each group a different time period. Identify major historical and political events and place the artworks in this lesson on the time line. Additional research will be necessary. Display the time line and have each group orally present to the class what they learned about their time period.

More About...

Tell students that most **Indian art** that we see was created for a larger physical setting in India. Stone sculptures, now displayed on separate pedestals, once covered walls of Indian temples and were meant to be seen as part of a larger whole. In India, religious images are meant to be touched, bathed, adorned with clothes and flowers, and offered food. The act of seeing images means reaching out to deities with endearing eyes.

Forces from the Outside

Hinduism and Buddhism have greatly influenced the art of India. Outside forces also affected Indian art styles. One such force was the religion called Islam.

The Influence of Islam
The Islamic religion was founded in Arabia in 622 by the prophet Muhammad. Islam spread into Europe and Africa. It first appeared in northern India in the eighth century. Islam was most powerful in India from the sixteenth until the eighteenth century. This era of Islamic influence is called the Mughal period.

Images of God and people are forbidden in Islamic religious art. Pictures of people and animals are only allowed in stories about everyday life. Figures and scenes from stories appear in small paintings called miniatures. During the Mughal period,

Indian artists used Moslem miniature painting techniques to illustrate books and stories on paper (Fig. 3–22). Until this time, most Indian paintings had been on cave walls. The introduction of paper in the fourteenth century through trade with Arabia opened the way for new ideas. The Mughal empire artists created a unique style of colorful and richly decorated surfaces, intricate patterns, and realistic depictions of figures.

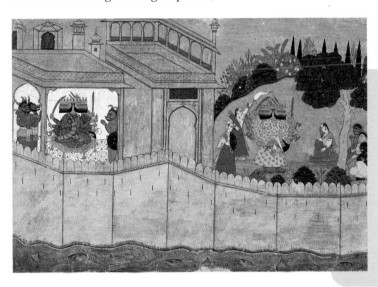

> ### 3.3 Global View
>
> **Check Your Understanding**
> 1. What major religious beliefs influenced the art of India?
> 2. How did the influence of Islam change Indian art?
> 3. How have the symbolic characteristics of Buddha changed over time?
> 4. Describe some of the earliest forms of art in India.

Fig. 3–22 **This manuscript page shows a scene from the great Indian poem, the** *Ramayana.* **It teaches about good and evil, and gives information about the values and ideals of ancient India.** India (Pahari, Guler School), *Sita in the Garden of Lanka,* from the *Ramayana, Epic of Valmaki.* Gold and color on paper, 22" x 31" (55.5 x 79 cm). The Cleveland Museum of Art, Gift of George P. Bickford, 66.143.

Lessons

137

Prepare

Pacing
One or two 45-minute class periods to create and decorate box

Objectives
- Apply an understanding of the role of symbols in teaching important lessons in an artwork.
- Construct a folded paper box with symbolic decorations.
- Use symbols in a meaningful way both to teach and to decorate.

Supplies
- two squares of white drawing or construction paper, 1 piece 8 1/2" x 8 1/2" and 1 piece 8" x 8" (for lid)
- newsprint or scrap paper
- pencil and eraser
- colored markers
- glue
- typewriter bond or copy paper, 8 1/2" x 8 1/2"

Prepare materials: Construct a box as an example of the finished product. Cut the drawing or construction paper and the bond paper into squares with a paper cutter. Save the strips for students to letter their proverbs or advice.

National Standards 3.4 Studio Lesson

3a Integrate visual, spatial, temporal concepts with content.

Creating a Folded Box of Lessons

Teaching with Symbols

Studio Introduction
What do a hexagon, a fork and knife, and the alphabet have in common? They can all be used as symbols to express important information. When seen from a distance, the red hexagon of a stop sign alerts a driver that it's time to slow down. A fork and knife symbolize food. And just imagine how difficult it would be to communicate if we didn't have an alphabet!

Symbols like these help us get along in life. Symbols can also remind us of traditions passed down from generation to generation. Symbols that teach lessons can be found in families, communities, and cultures all over the world.

In this studio lesson, you will fold a box and decorate it with symbols that represent meaningful things in your life. Pages 140 and 141 will tell you how to do it. As you plan your box, think about the kinds of lessons you want to put inside.

Studio Background

Symbols in Time
Religions all over the world share the tradition of teaching. Their artworks often tell stories or incorporate symbols that have special religious meaning. If you look closely at religious artworks, you might see symbols that stand for important lessons or ideas. You may even be surprised to find symbols you didn't know were founded in religion, such as those on the Jewish zodiac table.

Judaism—the Jewish religion—began about the fourteenth century BC. It started as a way of thinking. By the Middle Ages, Jewish philosophy had developed into a full religion. The customs, traditions, and laws of Jewish life influenced a wide variety of ceremonial artworks. Many of these artworks are decorated with special symbols. The Star of David, the universal symbol of Judaism today, came into popular use during the seventeenth–nineteenth centuries AD. It appears on the flag of the state of Israel, in synagogues, and on Jewish ritual objects, such as the mezuzah pictured in Fig. 3–25.

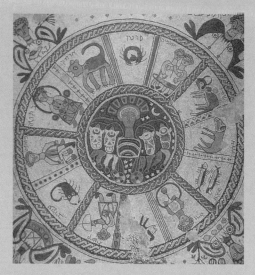

Fig. 3–23 **Through the centuries, the study of astrology has been part of Jewish life. The signs of the zodiac, each labeled in Hebrew, are arranged around the sun in his chariot.** *Zodiac Mosaic Floor,* 3rd–4th century.
Stone mosaic. Synagogue, Beth Alpha, Israel. The Jewish Museum, NY/Art Resource, NY.

138

Resources
Teacher's Resource Binder
 Studio Master: 3.4
 Studio Reflection: 3.4
 A Closer Look: 3.4
 Find Out More: 3.4
 Overhead Transparency 6
 Slides 3f

Meeting Individual Needs
Adaptive Materials Provide boxes for students to decorate. Provide rubber stamps, magazines, newspapers, and so on, for decorating. Students may also bring these items or personal photographs from home.

Fig 3–24 **An interest in fortune telling prompted this student to decorate her box with symbols from a deck of cards. Inside the box are slips of paper that explain traditional meanings of hearts, aces, clubs, and spades.** Abby Reid, *Untitled*, 1999.
Paper, markers, 3 ¼" x 3 ¼" x 1 ⅝" (8 x 8 x 4 cm). Shrewsbury Middle School, Shrewsbury, Massachusetts.

Fig. 3–26 **The Star of David is made up of two triangles. The upward-pointing triangle represents the sun, fire, and masculine energy. The downward-pointing triangle represents the moon, water, and feminine energy. What kind of balance does the Star of David exhibit?** Israel, Jerusalem, *Star of David, Lion Gate*, detail, 1st century AD. Courtesy of Davis Art Slides.

Fig. 3–25 **A mezuzah is a small receptacle containing a tiny scroll, or *shema*, with scripture from the Torah. Traditionally, the mezuzah is positioned by the front door of a Jewish home. Notice the surface decorations.** Galicia, *Mezuzah*, c.1850.
Carved wood, ink on parchment, 26.5 x 5.7 cm, Gift of Dr. Harry G. Friedman. The Jewish Museum, NY/Art Resource, NY.

Lessons

139

Teach

Engage

Draw a hexagon and an inverted triangle on the board. **Ask:** What do these mean? *(traffic sign shapes for "stop" and "caution").* Explain that these are symbols recognized by most people in our culture. Tell students that they will decorate a box with personally meaningful symbols.

Using the Text

Art Criticism Have students read pages 138 and 139 and study the images. Discuss the meaning of their symbols. **Ask:** What is the meaning of someone's wearing of one of these symbols? Does it identify that person with a group of people? What symbols do you wear that identify you with other people?

Using the Art

Perception Call students' attention to the Israeli mosaic. **Ask:** What feature unites this work? *(the border design)* What creates the pattern in the border? *(the repetition of equal shapes)* What other unifying feature did the artist use? *(decorated corners)*

Perception Have students read the caption for the mezuzah. Ask students to identify the symbols.

Teaching Through Inquiry

Art Production Have students work together to plan a series of folded boxes in graduated sizes and coordinated colors. They may make the boxes from large sheets of hand-decorated papers.

More About...

Judaic Symbolism The nine-branched **menorah** is used to celebrate Hanukkah, the eight-day festival of lights. One branch of the candelabrum holds the **shammes** candle, which is used to light each of the remaining eight candles. The holiday was instituted in 165 BC to mark the rededication of the Temple of Jerusalem. Later, the holiday became linked to the miracle of a one-

day supply of sacramental oil that lasted eight days. The **shofar**, a ram's horn used as a wind instrument, is blown on Yom Kippur, the Jewish Day of Atonement, and on Rosh Hashanah, the Jewish New Year. A **lulav**, for the holiday of Sukkoth, is woven leaves of palm, and symbolizes the tents that gave shelter when the Jews wandered in the wilderness after the Exodus.

Creating a Box of Lessons

Studio Experience

1. Show students the box that you made. Discuss the box and ways that students might decorate their own box.

2. Demonstrate how to fold the box and lid.

3. Have students practice the folding with copy paper.

4. Students can use drawing paper or construction paper to make the box and lid.

5. Before students complete their box, encourage them to look at it from different sides and consider what they might add.

Idea Generators

Encourage students to discuss possibilities for symbols to include on their box. **Ask:** What is meaningful to you? What might you use to represent parts of your life? Lead a second discussion about what kinds of lessons or sayings students might write to store inside their box. Encourage students to share different kinds of words they are familiar with: poems, songs, stories, proverbs, and the like.

Sketchbook Tip
Suggest to students that they paste into their sketchbook a variety of magazine or newspaper cutouts of symbols and logos that decorate and give special meaning to familiar objects. Students may use these in future artworks.

Sculpture in the Studio
Creating Your Box of Lessons

You Will Need

- two squares of white drawing or construction paper
- newsprint paper
- pencil and eraser
- colored markers
- typewriter bond

Try This

1. Follow the steps illustrated on the Studio Master to construct a box and lid. Use the smaller sheet of white paper for the bottom of the box and the larger sheet for the lid.

2. After your box is constructed, design three or four symbols that represent meaningful things in your life. For example, what symbols might represent your family, your favorite pastime, a special place, or the like? Sketch your ideas on newsprint paper.

3. When you're happy with your sketches, choose where you want to add the symbols to the box. Carefully decorate the box with colored markers.

4. Your box can be a container for lessons or sayings that mean something to you. You may be fond of some proverbs or truisms, such as, "A penny saved is a penny earned." Write the sayings carefully on small pieces of paper. Place them inside your box.

Check Your Work

In what way does your finished product show your usual quality of work? What new skills or abilities did you demonstrate when you made this artwork? Share your box with classmates. See if they can identify the meaning behind the symbols you created. Ask them if they've learned anything new about you after looking at your box and reading the sayings inside.

Sketchbook Connection
If you look carefully, you will probably notice that symbols are used to decorate jewelry, bumper stickers, hats, coffee mugs, and many other everyday objects. Choose a subject you're interested in, such as nature, sports, music, or the like. Design a symbol that shows what is meaningful to you about that subject.

Computer Option
In a drawing or painting program, design and create the side view of a container that teaches about your life. Choose a geometric or organic shape for the container. The shape you choose should fit your idea of who you are.

Add symbols to show different aspects of your life. What colors will you use? Will you include a lid for your container?

Teaching Options

Teaching Through Inquiry

Art History Have students research the uses and processes for origami, the Japanese art of paper folding. They can create a display that shows the history of this art form and how it is used in Japan and in other places in the world. Students might create their own examples to add to the display.

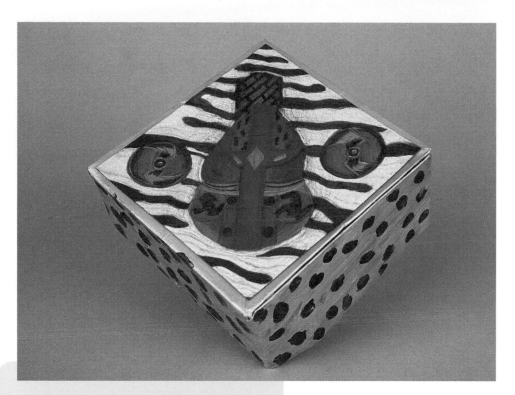

Fig. 3–27 **"My ideas for designing the outside of the box came from looking at many African books. The top is a drawing of a mask surrounded by a zebra skin. The sides are painted like a leopard skin. I imagined the mask to be of an African king. The fur represents the king's robe. I have learned that my heritage has a respect for animals. My box will remind me of the culture I hope to make proud of me someday."** Jonathan Nickerson, *African Me*, 1999.
Paper, colored pencil, acrylic, 4 ½" x 4 ½" x 2 (11.5 x 11.5 x 5 cm). Sweetwater Middle School, Sweetwater, Texas.

Lessons

141

Computer Option

Have students use paint software to create a container shape. Encourage students to shade the container electronically to create a three-dimensional effect. Photoshop and Painter have "lighting effects," which allow for the selection of light sources that shine on an object and provide the illusion of shading and shadows.

Suggest to students that they create the lid separately from the container, placing it on a separate layer (in Painter and Photoshop) or as a separate element in a draw program (Claris, Apple, Microsoft Works). By doing this, students may combine the lid with the container, or try it in different positions.

Assess

Check Your Work

Have student pairs exchange boxes and tell each other what both the box and the inside messages might mean. Encourage students to discuss what they find to be special and effective in their partner's piece. As a class, discuss why practice and careful attention are necessary for successful results.

Close

Have students make two labels for their box: one with their name and one to explain their use of symbols.

More About...

The term *origami* comes from the Japanese words *oru,* meaning "to fold," and *kami,* meaning "paper." With the sixth-century introduction of paper to Japan, the medium became integrated into their culture, from architecture to Shinto rituals. The Japanese passed down their techniques and paper designs from mother to daughter until 1797, when *Senbauru Orikata* (*How to Fold One Thousand Cranes*) was published.

Today, **paper folding** is an art form. Books teach folding techniques and how to create intricate designs; many special and multicolored papers are available; and origami-club Web sites are filled with examples and how-to illustrations.

Using the Overhead

Looking Closer

Ask: How is this surface decorated? How are the shapes balanced? What parts of this design might you use for your folded box?

6

Assessment Options

Peer Have students do research on signs and symbols in several cultures and then design a poster for young learners on what the symbols teach.

Daily Life

With students, make a list of events, both positive and negative, that had nationwide impact during the past year. Have students categorize the events. Discuss how we react to such events when they come to us immediately, through TV or radio broadcasts or via the Internet. Have students use the list and the information from the discussion to answer the questions in their book. **Ask:** What recent event might you want to memorialize? Why? What materials would you use? Would you make a mural, a sculpture, or a Web site? Would you write a poem or a song?

Mathematics

Compile and display several examples of radial symmetry in both natural and human-made objects and artifacts (such as seed pods, flowers, hubcaps, wheels, and kaleidoscopes). Ask students to describe the radial symmetry in each. Have students explain why radial-symmetry designs have infinite lines of symmetry. Provide each student with a compass, ruler, pencil, paper, and colored markers or pencils, and have them create a radial-symmetry design.

Science

Discuss the purposes of gargoyles on Gothic cathedrals. After discussion, direct students to make functional clay gargoyles with both a practical and a symbolic function, as an object to "protect" us from a negative aspect of today's society.

Connect to...

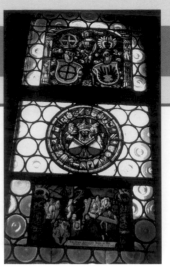

Fig. 3–28 **In the days before electric lights, the brilliance of colors in windows such as this was unprecedented. How do you think such art influenced people to learn?** *Top third of window,* 19th century. Swiss National Museum, Zürich. Photo: H. Ronan.

Careers

Inscribed on the stone of Notre Dame (see pages 128 and 143) is the name of Jehan de Chelles, the master mason responsible for overseeing the building of the cathedral. Under the medieval guild system of training, craftsmen, such as stained-glass artists, moved through three levels—apprenticeship, journeyman, master.

Today, **a stained-glass designer** may have trained at an art school, a university, or a trade school. Stained-glass artists make working "cartoons," or drawings. They then construct windows or other artworks by cutting and placing pieces of glass, and joining them with lead and solder. Many choices of glass are available to contemporary artists. Where do you think the craftsmen of the Middle Ages obtained their glass?

Daily Life

Art records people's lives, from ordinary details to extraordinary events. The *Bayeux Tapestry* (page 124) documents the events of the Battle of Hastings, the Norman invasion of England on October 14, 1066. The battle—between Harold the Great and William the Conqueror for the crown of England—marked the last time that any foreign power conquered the English.

The tapestry is **a visual record of events** before, during, and after the battle. What kinds of contemporary events do we consider worthy to remember and tell? How do we memorialize such historic events? What far-reaching events have made an impact on your life? What memorials can you find in your community, state, and nation?

Other Arts

Theater

Theater may be used in a way similar to that of the visual arts: to teach lessons. The ancient Greeks noted that the purpose of theater was "to teach and to please," and by the Middle Ages, the **morality play** became perhaps the most obvious example of theater that teaches. Through characters who represent different vices and virtues, this type of medieval play was designed to teach the audience about Christian morals.

The most famous morality play, *Everyman,* was written in the fifteenth century. It depicts Everyman's attempt to escape Death through the help of Good Deeds and Knowledge. Everyman, Death, Good Deeds, and Knowledge are represented by individual actors, whose dialogue teaches a lesson. This teaching dialogue is the characteristic form of a morality play.

Teaching Options

Resources

Teacher's Resource Binder
Using the Web
Interview with an Artist
Teacher Letter
Story Map

Community Involvement

Organize an arts resource center for the community for lending student artwork for display at local restaurants and businesses.

Video Connection

 Show the Davis art careers video to give students a real-life look at the career highlighted above.

Other Subjects

Mathematics

The concept of **radial symmetry** is basic to both art and mathematics. Radial symmetry is a type of formal balance in which the elements of a composition move outward like rays from a central axis in a regularly repeating pattern. The elements on either side of a center line—the line of symmetry—mirror each other. Do you think that Chartres Cathedral's rose window, shown on page 133, has radial symmetry? Why or why not?

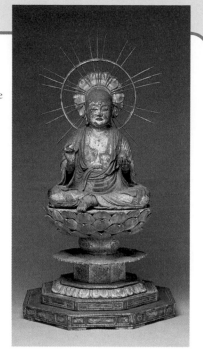

Fig. 3–29 **What center line can you find in this image? Can you find two kinds of symmetry?** Japanese, *Jizo Bosatsu*, 1185–1333.
Wood covered with lacquer and cut gold foil, height: 45 ³/₄" (116.2 cm). The Metropolitan Museum of Art, The Harry G. C. Packard Collection of Asian Art, Gift of Harris G. C. Packard and Purchase, Fletcher, Rogers, Harris Brisbane Dick and Louis V. Bell Funds, Joseph Pulitzer Bequest and the Annenberg Fund, Inc. Gift, 1975. (1975.268.166a-d) Photo: Schecter Lee. ©1986 The Metropolitan Museum of Art.

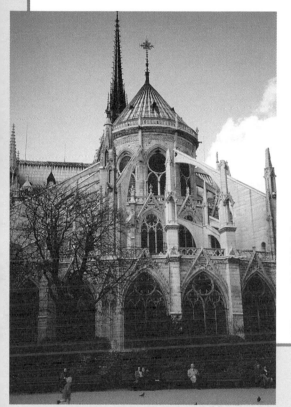

Science

As builders in the Middle Ages experimented with more elaborate ways to decorate cathedrals for the glory of God, they developed an important scientific advancement in **Gothic architecture.** Because the heavy masonry walls of a cathedral could lean outwards and collapse if left unsupported, architects joined masonry columns to the upper walls of the exterior.

Fig. 3–30 **The flying buttresses on Gothic cathedrals were decorated with complex gables and sculptures. Gothic cathedrals were also ornamented with figures of grotesque beasts and humans that taught lessons and served a practical purpose as waterspouts.** *Notre Dame Cathedral*, 1163–1250. Paris, France. Courtesy of Davis Art Slides.

Internet Connection
For more activities related to this chapter, go to the Davis website at **www.davis-art.com.**

Lessons

143

Other Arts

If students are having difficulty understanding either the form and purpose of the morality play or the accompanying activity, ask them to read—or read to them—a selection from *Everyman.* The play is available in most libraries.

Have students work with a partner to make a list of moral decisions that a person might have to make, such as telling the truth or saying no to drugs and cigarettes. From the list, have them choose the idea that interests them most, and then write out the different issues that might influence someone who is trying to make the decision. (For example, if someone is deciding whether to experiment with drugs, some issues that he or she might think about are health, peer pressure, and behavior.) Next, ask students to choose two of the issues and imagine that each issue is a character in a play. **Ask:** What might one character say to the character making the decision so as to influence him or her? Challenge students to write dialogue for the characters in one scene of a morality play. Have volunteers act out the scene for the class. Discuss the performance and the issues.

Internet Resources

The Bayeux Tapestry: The Battle of Hastings 1066

http://battle1066.com/index.html

This site documents an important artwork that has survived from the eleventh century. Individual highlights and the complete tapestry are included. There is a section on tapestry construction.

The Labyrinth: Resources for Medieval Studies

http://www.georgetown.edu/labyrinth/

Everything medieval is here, including manuscripts, music, mythology, maps, fonts that recreate medieval handwriting, a virtual tour of a medieval city, and more.

Interdisciplinary Tip

For both artworks and literature, use story maps in the Teacher's Resource Binder for classifying main ideas with supporting events and information.

Talking About Student Art

Write expressive words such as "mysterious," "sad," "happy," "calm," etc. on cards. Ask students to study a display of student artworks and to place their cards next to appropriate pieces. Discuss students' reasons for their choices.

Portfolio Tip

Remind students that the portfolio is not only a collection of artworks, but also a reflection of all aspects of student learning.

Sketchbook Tip

For their sketchbook ideas, provide students with alphabet books, examples of alphabets, and rubber stamps.

Portfolio

"We studied about France and particularly stained glass in churches. While working on this piece I was thinking about the stained-glass windows that I've seen in churches. The easiest part was coming up with a design. The hardest part was cutting the shapes out and gluing them on." Kristen Lane

Fig. 3–31 **How has this student balanced organic and geometric shapes?** Kristen Lane, *Round Stained-Glass Window*, 1999.
Black construction paper, colored cellophane, 12" (30.5 cm) diameter. Johnakin Middle School, Marion, South Carolina.

Fig. 3–32 **Compare this artwork with the illuminated letter on page 145. Notice how the medieval artist used intricate detail to fill the space around the letter, while this work has more open space. What different effect does each have on the viewer?** Rachel Jackson, *R*, 1999.
Tempera, 9" x 12" (23 x 30.5 cm). Fairhaven Middle School, Bellingham, Washington.

"One girl is making an effort and one is not, and it shows the consequences—in this case bad grades. Then one girl helps the other girl and both come out with good results." **Rachel King**

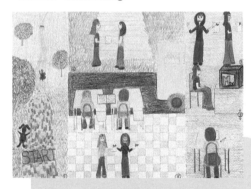

Fig. 3–33 **The inside of this card (the outside is shown on page 127) teaches a lesson.** Rachel King, *Effort*, 1999.
Colored pencil, 8 ¾" x 12" (22 x 30 cm). Yorkville Middle School, Yorkville, Illinois.

CD-ROM Connection
To see more student art, check out the Global Pursuit Student Gallery.

144

Teaching Options

Resources

Teacher's Resource Binder

Chapter Review 3

Portfolio Tips

Write About Art

Understanding Your Artistic Process

Analyzing Your Studio Work

CD-ROM Connection

Additional student works related to studio activities in this chapter can be used for inspiration, comparison, or criticism exercises.

Chapter 3 Review

Chapter 3 Review Answers

Recall

Define "illuminated manuscript" (*example below*) and explain its use to teach important lessons.

Understand

Explain how art can be used to teach people how to live meaningful lives.

Apply

Create an outline drawing as a proposal for a stained-glass window for the school entrance-way that would instruct new students about school life.

Analyze

Compare and contrast the use of symbolic imagery and pattern in Islamic, Christian, Judaic, Hindu, and Buddhist art.

Synthesize

Write a poem about the ways that art can instruct and inspire. Draw upon information in the text and in the captions. Make specific references to the artworks.

Evaluate

Based on what you consider to be the most important artworks in Chapter 3, recommend a foreign-travel tour for your class. Name the artworks you will see, and state why you think it would be important for your class to see them.

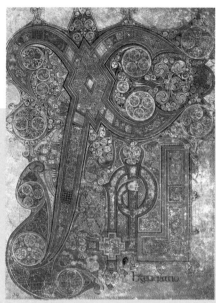

Page 129

For Your Portfolio

From this chapter, choose one artwork that was made before the twentieth century. Write a two-part essay. In the first part, describe the work in detail. In the second part, summarize how the artwork shows or suggests local or world events at the time it was made (you may have to do some additional research). Add your name and date, and put your essay into your portfolio.

For Your Sketchbook

Use some of your sketchbook ideas to develop a decorative alphabet for an alphabet book.

Advocacy

Put together and present a slide show for parent groups and civic organizations.

Family Involvement

Encourage family members to sign up for a block of time to help with classroom activities.

Recall

An illuminated manuscript was a small book with hand-painted illustrations. The book was portable and was used to teach others about religious beliefs and stories with important messages.

Understand

In their artworks, artists can use words, images, and symbols to help teach important lessons, laws, and rules for leading a good life.

Apply

Check students' work for use of symbols, awareness of the audience, and obvious meaning and message.

Analyze

Answers may vary, but generally should indicate that representations of human and animal forms as religious symbols are common in Christian, Hindu, and, to some extent, Buddhist religious art. Judaic and Islamic religious art does not include images of human figures. The depiction of ritual objects in Judaic art is often symbolic.

Synthesize

Look for understanding of how art can teach and inspire, presented in the main ideas in the chapter. Also look for attention to specific artworks and details in the poem's imagery.

Evaluate

Look for a clear understanding of how specific artworks teach lessons for living or serve as reminders of important ideas.

Reteach

- Ask students to find examples of symbols in contemporary society. Have them create a bulletin-board display of the symbols and then identify each. Captions can also refer to the main ideas in the chapter.

- Have students look for examples of ornamental letters and decorative use of words in contemporary advertising. Discuss how, or if, they help to put the point across.

- Organize a display of beautifully illustrated books, and discuss their visual qualities as decorated manuscripts and their effectiveness for teaching important ideas or lessons.

Chapter Organizer

Chapter Focus

Chapter National Standards

Chapter 4
Order and Organization
Chapter 4 Overview
pages 146–147

- **Core** Throughout the world and over time, people have devised ways to create order in their lives. Artworks have organizational systems, each unique to a particular region.
- **4.1** The Art of the Renaissance
- **4.2** Unity and Variety
- **4.3** The Art of China and Korea
- **4.4** Drawing in Perspective

2 Use knowledge of structures and functions.
3 Choose and evaluate subject matter, symbols, and ideas.
4 Understand arts in relation to history and cultures.
5 Assess own and others' work.

3 3 3

Objectives

National Standards

Core Lesson
Organizing Artworks
page 148
Pacing: Three 45-minute periods

- Use examples to explain how artists organize their work with design principles and elements.
- Describe methods used by both Western and non-Western cultures to indicate depth.

2a Generalize about structures, functions.
2b Employ/analyze effectiveness of organizational structures.
4a Compare artworks of various eras, cultures.
5b Analyze contemporary, historical meaning through inquiry.

Core Studio
Organizing a Sculpture
page 152

- Create a Cubist sculpture.

1a Select/analyze media, techniques, processes, reflect.

2

Objectives

National Standards

Art History Lesson 4.1
The Art of the Renaissance
page 154
Pacing: Two 45-minute periods

- Understand what characterized the Renaissance.
- Identify two ways that artists create the illusion of depth in paintings.

3b Use subjects, themes, symbols that communicate meaning.
4b Place objects in historical, cultural contexts.

Studio Connection
page 156

- Create a drawing to show an understanding of Renaissance style.

3b Use subjects, themes, symbols that communicate meaning.

2

Objectives

National Standards

Elements and Principles Lesson 4.2
Unity and Variety
page 158
Pacing: Two 45-minute periods

- Explain how an artist might organize an artwork to create both unity and variety.

2a Generalize about structures, functions.
2b Employ/analyze effectiveness of organizational structures.

Studio Connection
page 159

- Apply principles of unity and variety to an artwork showing people in action.

2c Select, use structures, functions.

Featured Artists

Sofonisba Anguissola
Pieter Brueghel
John Amos Comenius
Albrecht Dürer
Nancy Graves
David Hockney
Leonardo da Vinci
Masaccio
Quentin Matsys

Michelangelo
 Buonarroti
Pablo Picasso
Piero della Francesca
Raphael Sanzio
Mir Sayyid-Ali
George Tooker
Lu Zhi

Chapter Vocabulary

foreground
middle ground
background
porcelain
perspective
vanishing point

unity
variety
horizon line

Teaching Options

Teaching Through Inquiry
More About…David Hockney
Using the Overhead
Meeting Individual Needs
More About…George Tooker
More About…Nancy Graves
Using the Large Reproduction

Technology

CD-ROM Connection
 e-Gallery

Resources

Teacher's Resource Binder
 Thoughts About Art:
 4 Core
 A Closer Look: 4 Core
 Find Out More: 4 Core
 Studio Master: 4 Core
 Assessment Master:
 4 Core

Large Reproduction 7
Overhead Transparency 8
Slides 4a, 4b, 4c

Meeting Individual Needs
Teaching Through Inquiry
More About…Cubism
Assessment Options

CD-ROM Connection
 Student Gallery

Teacher's Resource Binder
 Studio Reflection: 4 Core

Teaching Options

Teaching Through Inquiry
More About…The Renaissance
Using the Overhead

Technology

CD-ROM Connection
 e-Gallery

Resources

Teacher's Resource Binder
 Names to Know: 4.1
 A Closer Look: 4.1
 Map: 4.1
 Find Out More: 4.1
 Assessment Master: 4.1

Overhead Transparency 7
Slides 4d

Meeting Individual Needs
Teaching Through Inquiry
More About…Albrecht Dürer
Assessment Options

CD-ROM Connection
 Student Gallery

Teacher's Resource Binder
 Check Your Work: 4.1

Teaching Options

Teaching Through Inquiry
More About…Sofonisba Anguissola
Using the Overhead
Assessment Options

Technology

CD-ROM Connection
 e-Gallery

Resources

Teacher's Resource Binder
 Finder Cards: 4.2
 A Closer Look: 4.2
 Find Out More: 4.2
 Assessment Master: 4.2

Overhead Transparency 7

CD-ROM Connection
 Student Gallery

Teacher's Resource Binder
 Check Your Work: 4.2

9 weeks | 18 weeks | 36 weeks

2

Objectives

National Standards

Global View Lesson 4.3
The Art of China and
Korea
page 160
Pacing: Two 45-minute
periods

- Explain how the surface decorations of Chinese and Korean vessels are organized.
- Describe the way space is organized in Chinese and Korean landscape paintings.

4a Compare artworks of various eras, cultures.
2c Select, use structures, functions.

Studio Connection
page 162

- Create a landscape painting that uses the Chinese and Korean system for showing distance.

2c Select, use structures, functions.

Objectives

National Standards

1 1

Studio Lesson 4.4
Drawing in Perspective
page 164
Pacing: One or more
45-minute periods

- Explain the principles of linear perspective.
- Identify the location of the horizon line and the vanishing point in clear examples of linear perspective.
- Explore ways to use linear perspective in a drawing.

3a Integrate visual, spatial, temporal concepts with content.

Objectives

National Standards

Connect to...
page 168

- Identify and understand ways other disciplines are connected to and informed by the visual arts.
- Understand a visual arts career and how it relates to chapter content.

6 Make connections between disciplines.

Objectives

National Standards

Portfolio/Review
page 170

- Learn to look at and comment respectfully on artworks by peers.
- Demonstrate understanding of chapter content.

5 Assess own and others' work.

2

Lesson of your choice

Teaching Options

Meeting Individual Needs
Teaching Through Inquiry
More About... Celadon

Technology

CD-ROM Connection
e-Gallery

Resources

Teacher's Resource Binder
 A Closer Look: 4.3
 Map: 4.3
 Find Out More: 4.3
 Check Your Work: 4.3
 Assessment Master: 4.3

Large Reproduction 8
Slides 4e

More About...Handscrolls
Using the Large Reproduction
Assessment Options

CD-ROM Connection
 Student Gallery

Teacher's Resource Binder
 Check Your Work: 4.3

Teaching Options

Meeting Individual Needs
Teaching Through Inquiry
More About... *The School of Athens*
More About...Perspective
Assessment Options

Technology

CD-ROM Connection
 Student Gallery
Computer Option

Resources

Teacher's Resource Binder
 Studio Master: 4.4
 Studio Reflection: 4.4
 A Closer Look: 4.4
 Find Out More: 4.4

Overhead Transparency 8
Slides 4f

Teaching Options

Museum Connection
Community Involvement
Interdisciplinary Tip

Technology

Internet Connection
Internet Resources
Video Connection
CD-ROM Connection
 e-Gallery

Resources

Teacher's Resource Binder
 Using the Web
 Interview with an Artist
 Teacher Letter
 Analogy Map

Teaching Options

Advocacy
Family Involvement

Technology

CD-ROM Connection
 Student Gallery

Resources

Teacher's Resource Binder
 Chapter Review 4
 Portfolio Tips
 Write About Art
 Understanding Your Artistic Process
 Analyzing Your Studio Work

Chapter Overview

Theme
We seek to create order in our world. Art is organized through systems we develop.

Featured Artists
Sofonisba Anguissola
Pieter Brueghel
John Amos Comenius
Albrecht Dürer
Nancy Graves
David Hockney
Leonardo da Vinci
Masaccio
Quentin Matsys
Michelangelo Buonarroti
Pablo Picasso
Piero della Francesca
Raphael Sanzio
Mir Sayyid-Ali
George Tooker
Lu Zhi

Chapter Focus
Throughout the world and over time, people have devised ways to create order in their lives. Artworks have organizational systems, each unique to a particular region. Renaissance artists focused on ways to organize artworks, especially to create the illusion of depth. This chapter highlights how artists in the Western world, as well as those in China and Korea, use unity and variety to organize artworks. Students work with the principles of linear perspective in drawing.

4 Order and Organization

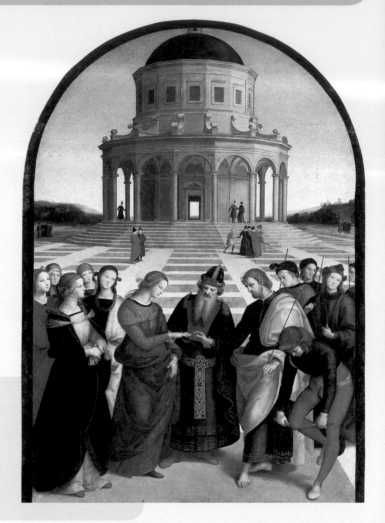

Fig. 4–1 Notice how your eyes move toward the space in the distance, beyond the main characters in the scene. How has the artist created the illusion of depth? Raphael Sanzio, *Marriage of the Virgin*, 1504. Wood panel, 67" x 46" (170 x 118 cm). Pinacoteca di Brera, Milan, Italy. Scala/Art Resource, New York.

146

National Standards
Chapter 4
Content Standards

2. Use knowledge of structures and functions.

3. Choose and evaluate subject matter, symbols, and ideas.

4. Understand arts in relation to history and cultures.

5. Assess own and others' work.

Teaching Options

Teaching Through Inquiry

Perception Invite students to examine the Raphael painting to determine how the artist **organized the main shapes and lines**. Give each student two sheets of tracing paper. On one sheet, have them indicate how the artist established a foreground, middle ground, and background. On the same sheet, have students trace the lines that lead the viewer's eyes into deeper space. On the other sheet, have students trace only the figures. Discuss the actual proximity among the figures and the great differences in their sizes.

More About...

The biographer Vasari wrote of **Raphael** (1483–1520) that he was "so gentle and charitable that even the animals love him." Raphael became a master artist at seventeen. At twenty-six, aided by fifty assistants, he painted frescoes in the Vatican. His art—with its pyramidal compositions, linear perspective, and classical figural poses—epitomizes the High Renaissance style.

Focus

- How does organizing help us in life and in art?
- What are some ways artists organize their work?

Do you line up your socks in the drawer according to their color? Do you have labels on your bookshelves showing where certain types of books belong? Or maybe you're a person who knows where all your possessions are, but you're the *only* person who can find them.

People tend to organize things. Sometimes the organizing system is obvious to others—like a color-coded sock drawer. Other times the system is obvious only to the person who created it. These are extremes. Most of us fall somewhere in the middle. Most people like to have *some* order in their lives. Organization certainly makes life easier. It allows people to focus on what really counts—the life that goes on around and inside all that order.

Art can work in a similar way. Artists have figured out how to organize artworks so that they are easy to view and understand. The organization of an artwork allows viewers to focus on what really counts—the message, meaning, and use that it can have.

Raphael, a great Renaissance artist, organized his painting (Fig. 4–1) so that viewers can see what is going on in all parts of it. The flat surface of the panel was painted so that the scene looks as though it goes back in space. What is happening in the **foreground**, or area that seems closest to you? The **background**, or area farthest away? Where do you think the **middle ground** lies?

What's Ahead

- **Core Lesson** Learn about perspective and other ways that artists organize their artworks.
- **4.1 Art History Lesson** Discover what artists achieved during the time of the Renaissance in Europe.
- **4.2 Elements & Principles Lesson** Focus on ways to create unity and variety in artworks.
- **4.3 Global View Lesson** See how artists in China and Korea have used centuries-old systems to organize their artworks.
- **4.4 Studio Lesson** Explore ways to use perspective in a drawing.

Words to Know

foreground	atmospheric
background	perspective
middle ground	unity
linear perspective	variety
vanishing point	porcelain
patron	horizon line

Order and Organization

147

Chapter Warm-up

Ask students to think of ways that the design of their school building and its furnishings organize their movements and lives. Students might suggest lockers, halls, stripes in the parking lot, the cafeteria line, and the arrangement of desks in the classrooms. **Ask:** What if our school had no systems of organization? What if all students met in one room? What if desks and chairs were scattered randomly? How would this affect the function of the building and your movement through it? Tell students that they will discuss how and why artists and designers create order within their art.

Using the Text

Perception After students have read page 147, discuss their answers to the questions in the last paragraph. **Ask:** Which lines in Raphael's painting help organize the composition? *(those in the pavement and temple)*

Using the Art

Perception Discuss how Raphael grouped and overlapped the figures. **Ask:** How did Raphael make the figures of the wedding party important? *(They are larger, in the foreground, face toward Mary.)*

Extend

Have volunteers assume the roles of the people in the foreground of *Marriage of the Virgin.* Ask each "figure" to describe his or her location while moving back into space, giving details of the walk: what he or she encounters along the way, and how far he or she has to walk.

Graphic Organizer
Chapter 4

CD-ROM Connection

For more images relating to this theme, see the Global Pursuit CD-ROM.

Prepare

Pacing
Three 45-minute periods: one to consider the text and images; one to draw; one to create sculpture

Objectives
- Use examples to explain how artists organize their work with design principles and elements.
- Describe methods used by both Western and non-Western cultures to indicate depth.
- Create a Cubist sculpture.

Vocabulary
foreground Parts of an artwork that appear closest to the viewer.

background Parts of artwork that appear to be in the distance or behind the objects in the foreground.

middle ground Parts of an artwork that appear to be between objects in the foreground and the background.

linear perspective A technique for creating three-dimensional space on a two-dimensional surface.

vanishing point In a perspective drawing, the point on the horizon where parallel lines seem to meet and disappear.

Organizing Artworks

Creating the Illusion of Depth

European artists of the Renaissance were fascinated by linear perspective. **Linear perspective** is a special technique used to show three-dimensional space on a two-dimensional surface. Renaissance artists observed that objects that are far away seem smaller. Artists interested in linear perspective found that parallel lines seem to move away from the viewer and appear to meet at a point on the horizon. You can see this for yourself if you stand in a long hallway and look at the lines formed by the walls at the ceiling and the floor.

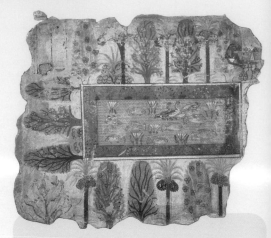

Fig. 4-2 Notice how we look directly down on the pool, whereas we see the plants around the pool from the side. What methods of organizing space has the artist used here? Thebes, XVIIIth dynasty, *Garden with Pond*, c. 1400 BC.
©The British Museum.

Fig. 4–3 David Hockney creates and explores his own system for organizing space. David Hockney, *Merced River Yosemite Valley Sept. 1982*, 1982.
Photographic collage, 52" x 61" (131.1 x 154.9 cm). © David Hockney.

148

Teaching Options

Resources

Teacher's Resource Binder
 Thoughts About Art: 4 Core
 A Closer Look: 4 Core
 Find Out More: 4 Core
 Studio Master: 4 Core
 Studio Reflection: 4 Core
 Assessment Master: 4 Core
Large Reproduction 7
Overhead Transparency 8
Slides 4a, 4b, 4c

Teaching Through Inquiry

Divide the class into six groups. Assign every two groups one of the three images. **Ask:** How did the artist **organize the artwork**? What, do you think, did the artist want to show viewers? How does the organization help present the information? Have the two groups who studied the same image meet and discuss their findings.

Not surprisingly, the point at which parallel lines seem to meet and disappear is called the **vanishing point.** As artists experimented with linear perspective, they found that they could create the illusion of depth with one, two, and even three vanishing points.

There are other ways to organize a flat surface to create the illusion of depth. One way is overlapping. Objects that overlap others seem closer than whatever is covered up. Artists also work with size, color, and placement to help suggest depth. Larger objects seem closer to the viewer than smaller objects. Things look more distant if their colors are dull or their shapes are blurred and less detailed.

Islamic and Persian artists (see Fig. 4–4) created the illusion of depth by "stacking" space. Viewers see things shown in the lower portions of an image as close by. Objects in the upper portions appear farther away.

Some systems of creating perspective are cultural, with all artists in a particular culture following the same rules. This was true with the ancient Egyptians, who set forth principles for drawing human beings

(see page 78). Other systems are personal. Contemporary artist David Hockney has experimented with ways of showing places and people. For instance, he combined many photographs (Fig. 4–3) to show more in two dimensions than a photograph or painting can usually show.

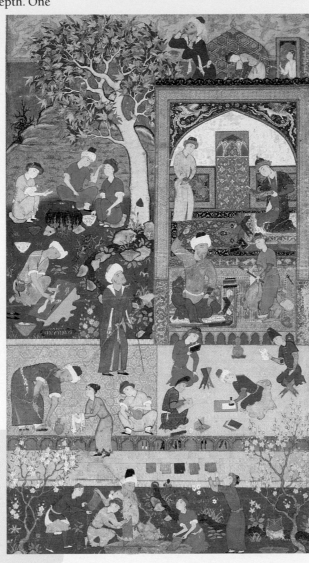

Fig. 4–4 In this scene, space is "stacked." Some activities—such as the students' dyeing and tinting paper—take place in the foreground, at the bottom of the image. The chef prepares noodles outdoors in the distance, at the middle left. A man and boy perform their prayers on the faraway roof. Mir Sayyid-Ali, *A School Scene,* c. 1540. Opaque watercolor, ink, and gold on paper. Arthur M. Sackler Gallery, Smithsonian Institution, Washington, DC. S1986.221.

Order and Organization

Teach

Engage

Ask students to compare the sizes of nearby objects to distant ones in an outdoor view. Point out that distant objects seem smaller, have fewer visible details, and have lighter values. Tell students that they will learn how artists indicate depth.

Using the Text

Perception Have students read pages 148 and 149. **Ask:** How do Raphael's methods of indicating depth compare to those of the artists on these pages? What methods are similar to Raphael's?

Using the Art

Perception Ask: For each work of art shown on these pages, what objects and figures seem closest to the viewer? Which seem farthest away?

More About...

Born and educated in England, **David Hockney** (b. 1937) now resides in southern California. In this collage (Fig. 4–3), he joined photographs taken from varying angles to create a series of works reminiscent of Cubism (not surprisingly, Hockney credits Picasso as a major influence). Hockney's first uses of Polaroids were to organize his paintings, but he consequently discovered that these photomontages are actually more realistic than the way we usually see, because our gaze moves constantly to compile the views.

Using the Overhead

Think It Through

Ideas Why, do you think, did the artist choose this view of a bridge? Do you think the artist was interested in perspective and the illusion of deep space? Why?

8

Materials Are the brushstrokes obvious? How can you tell this is an oil painting?

Techniques What does this image tell you about the way this artist works?

Audience Do you think the artist had an audience in mind when he painted this view?

Using the Text

Art Criticism Have students read page 150, and then discuss their answers to the questions within the text. Encourage students to explain how the use of elements and principles contributes to the organization of each artwork.

Using the Art

Art Criticism Discuss students' answers to the caption questions. **Ask:** What is the mood in each work? Which elements and principles did each artist use to create this mood?

Design as an Organizational Tool

Artists in every culture organize their artworks. They pay attention to how the parts add to the entire work. But artists around the world think about the parts of an artwork in different ways. Within the Western tradition, artists mostly use principles of design (such as unity, pattern, and repetition) to guide their use of the elements of design (such as line, shape, and color).

Notice how the sculptor of the terra-cotta dog with a human face (Fig. 4–7) used a smooth burnished surface to add a unified look to the artwork. Repeating simple rounded forms also adds to this sense of unity. What other principles of design did the artist use?

Nancy Graves organized her sculpture (Fig. 4–6) by repeating similar shapes and forms. Do you see how her use of color adds an element of rhythm? Do your eyes move from part to part? From color to color?

George Tooker used repeated colors, values, and shapes to help unify his painting (Fig. 4–5). Note how all but the central character are wearing drab-colored coats and have a similar form. The red dress and the wearer's worried expression also add contrast to the composition. Many lines point to the woman, including the bars on the revolving gate. The lines add tension and interest. This painting clearly shows how an organizing system can help an artist hold the viewer's interest. Such a system can also help direct the attention of the viewer. With the elements and principles of design as organizational tools, an artist has the power to convey mood and meaning.

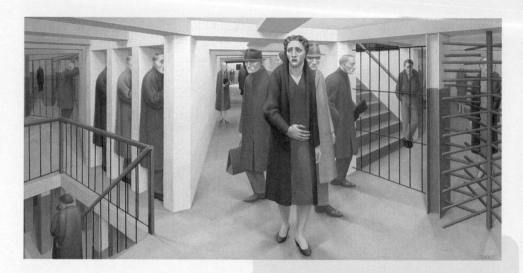

Fig. 4–5 The artist organized all the parts to create a feeling of anxiety in this painting. Lines, forms, and colors are arranged to heighten suspense. Can you determine how he used perspective? George Tooker, *The Subway*, 1950.
Egg tempera on composition board. Collection of Whitney Museum of American Art. Purchased with funds from the Juliana Force Purchase Award. 50.23. Courtesy D.C. Moore Gallery, NY. Photo by Sheldon C. Collins.

150

Teaching Options

Meeting Individual Needs

Gifted and Talented Have students study *The Subway* and the Colima dog and then describe the organization that each artist used. Then challenge students to use the same or a similar subject as that in either artwork—but a different type of organization—to create their own composition. Afterwards, ask what they found most challenging in creating a new organization for an existing work.

More About...

Surrealist painter and printer **George Tooker** (b. 1920) is a Brooklyn native. While studying English literature at Harvard, he decided that he wanted to use art as a tool for social change. He was influenced by Mexican mural painters David Siqueiros and José Orozco.

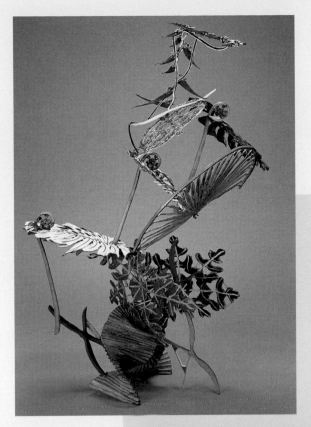

Journal Connection

Assign students to describe the scene in Tooker's *The Subway* from the viewpoint of one of the figures in it. **Ask:** What emotion would the person express? What would the person see?

Extend

Challenge students to find other examples of George Tooker's work in books and on the Internet. **Ask:** How did he make ordinary settings seem ominous?

Fig. 4–6 At first glance, this sculpture may appear so lively as to seem chaotic. Yet the sculptor has organized her work very carefully. How would you describe her use of the principles of unity and balance? Nancy Graves, *Zaga*, 1983. Cast bronze with polychrome chemical patination, 72" x 49" x 32" (182.8 x 124.5 x 81.3 cm). Nelson-Atkins Museum of Art, Kansas City, Missouri (Gift of the Friends of Art). ©1999 The Nelson Gallery Foundation. All Reproduction Rights Reserved. ©Nancy Graves Foundation/Licensed by VAGA, New York, NY.

Fig. 4–7 Sculptures of dogs were common in ancient Mexico. Experts are not certain why some of them wear masks with human faces. Mexico (Colima), *Dog Wearing a Human Face Mask*, 200 BC–AD 500. Ceramic with burnished red and orange slip, 8 1/2" x 15 1/2" x 7" (21.6 x 39.4 x 17.8 cm). Los Angeles County Museum of Art, The Proctor Stafford Collection, Museum Purchase with funds provided by Mr. and Mrs. Allan C. Balch. M.86.296.154.

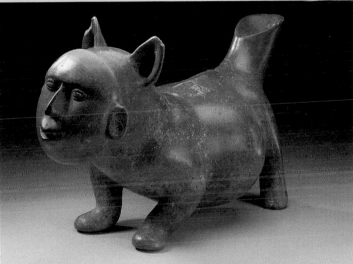

151

Provide students with examples of **commercial packaging**, such as cereal boxes, canned goods, and soft-drink bottles. Display and assign each example a number. Have students work in small groups to answer these questions for each numbered package: How did the artist use line, shape, and/or color to unify the design? How did the artist add interest, or variety? What mood or feeling is conveyed by the design? Why is this mood or feeling appropriate for this particular kind of package? Lead students in a whole-class discussion of their findings.

As a child, **Nancy Graves** (1940–95) spent time at the Berkshire Museum where her father worked. Her bronze sculptures include paleontological, archaeological, and anthropological references to that early learning. Graves made bronze casts of everyday objects and welded the objects together, yet retained each object's original identity.

7

Talk It Over

Describe How is this woman dressed? What details catch your eye?

Analyze How did the artist position the figure?

Interpret What clues besides the title might suggest that this is a noblewoman?

Judge Why is this work important in the history of art?

15

Order and Organization

Supplies

- objects to draw (musical instruments, sports equipment, etc.)
- drawing paper or newsprint, 18" x 24"
- pencils, erasers
- posterboard or cardboard, 22" x 28"
- scissors
- tape or glue
- X-acto knives (optional)
- acrylic paints (optional)

Safety Note

Remind students to be cautious when they use X-acto knives and to keep fingers out of the knife's path. To protect the work surface, have them place cardboard under their work.

Using the Text

Art Criticism After students have read page 152, ask them to explain the quotation about Picasso and Raphael. **Ask:** Does Picasso's painting look like Raphael's *Marriage of the Virgin*? What did each artist show in his work? *(Raphael: indication of great depth realistically; Picasso: several shifting views of the same object)*

Art Production Allow students to select an object to draw. After they sketch it from several viewpoints, ask them to draw and cut out shapes from posterboard. Demonstrate how to cut slits into the pieces and join the shapes together with tape or glue.

Using the Art

Art Criticism Have students compare Picasso's painting and sculpture. **Ask:** How are they alike? How are they different? How did Picasso indicate depth in the painting?

4 CORE STUDIO

Sculpture in the Studio
Organizing a Sculpture

Pablo Picasso first used his system called Cubism in his drawings and paintings (Fig. 4–8). Then, while looking at one of his Cubist paintings, he realized it would only have to be cut up and reassembled to be sculpture. So, Picasso created a kind of sculpture (Fig. 4–9) that had never been seen before. He began cutting simple shapes out of flat pieces of metal and cardboard and assembling them.

In this lesson, you will experiment with Cubist ideas, first by drawing and then in a sculpture. As you work, consider how you are organizing the space in your composition.

You Will Need

- object to draw
- sketch paper
- pencil
- posterboard
- scissors
- tape

Studio Background

Picasso and Cubism

When Pablo Picasso was a young child in the late nineteenth century, people said that he could "draw like Raphael." Picasso continued to draw and explore other art media for more than seventy years. During this time, he experimented with many different ways to organize his artworks. The system for which he is most famous is called Cubism.

Like the Renaissance artists, Picasso wanted to show figures as they really exist in space. But he noted that figures in space are actually seen from many changing viewpoints. Therefore, the Cubist system broke up natural forms into tilting, shifting planes and geometric shapes.

1. Select an object that interests you. Look at the object from many different angles. What features of the object do you think are most important?

2. Sketch the main shapes of the object from different points of view. Draw your object repeatedly until you feel you know it well. Which shapes will you simplify for a sculpture?

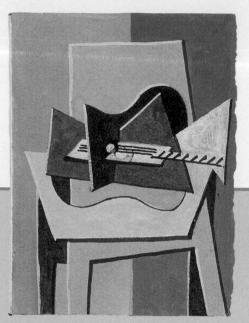

Fig. 4–8 This painting is an example of Cubism. Cubism is an art movement that began when Picasso noticed that forms could be simplified into shapes and shown from more than one point of view. Pablo Picasso, *Guitar on a Table*, 1919. Gouache on paper, 4 9/16" x 3 7/16" (11.6 x 8.7 cm). Musee Picasso, Paris, Dation Picasso. © Photo RMN. ©2000 Estate of Pablo Picasso/Artists Rights Society (ARS), New York.

Teaching Options

Meeting Individual Needs

Alternative Assignment Have students glue a photograph or magazine picture of an object to a posterboard. After the image has dried, instruct students to cut the image into pieces and then glue the pieces back together, slightly overlapping them so as to distort the image.

Teaching Through Inquiry

Art Production Remind students that artists are often inspired by the work of other artists. Ask them to experiment with ways of showing objects or scenes in the world from more than one perspective at the same time. They might use photographs, drawings, or a combination of both. Their artworks might be two-dimensional, or they could take the form of sculpture. Suggest that students share their experiments with one another, asking for comments and suggestions.

3. Draw each of your shape choices separately on posterboard.

4. Cut out each shape. How will they interlock? Cut the slots.

5. Construct your sculpture. Secure the parts with tape.

As a class, discuss each student's sculpture. How were the simplified shapes combined to provide different viewpoints? How have you organized your forms in space? What effect might the work have on the viewer?

Fig. 4–10 "I got the idea for this project because I love to play the guitar. I thought it would be nice to do a simple object that I like. Making and cutting the body was easy. The hardest part was to connect the strings to the guitar and base."
Amanda Sacy, *Strings of Life*, 1999.
Mixed media, 22" x 14" x 6" (56 x 36 x 15 cm). Avery Coonley School, Downers Grove, Illinois.

Sketchbook Connection

Select two or three everyday objects that have simple forms and shapes. Sketch each object from different points of view. Then arrange the objects into a still life. Using your sketches for reference, create a still-life drawing in the Cubist style. Which views of the objects will work best together? Combine views to make the drawing interesting.

Core Lesson 4

Check Your Understanding

1. Use examples to explain two ways an artist can unify an artwork.
2. Show by example how an artist can create the illusion of depth in an artwork.
3. How was the development of Cubism similar to the development of linear perspective?
4. How would you use information in this lesson to support the position that Cubist artworks are well organized?

Fig. 4–9 Before Picasso created this work, all sculpture had been either carved or modeled. Why do you think this new kind of sculpture was called constructed sculpture?
Pablo Picasso, *Guitar*, 1912–13.
Construction of sheet metal and wire, 30 ½" x 13 ¾" x 7 ⅝" (77.5 x 35 x 19.3 cm). Museum of Modern Art, New York. Gift of the artist. Photograph ©2000 The Museum of Modern Art, New York. ©2000 Estate of Pablo Picaso/Artists Rights Society (ARS), NY.

Order and Organization

153

Extend

Challenge students to create a Cubist drawing. Tell them to begin drawing one view of an object, then move to another side and draw what they see. Repeat until they draw the whole object from multiple views.

Assess

Check Your Work

Set up a class exhibit of the sculptures. Have students answer the questions in Check Your Work orally or in writing. **Ask:** How would you change your sculpture if you were to redo it?

Check Your Understanding: Answers

1. Nancy Graves's sculpture is unified by the repetition of shapes and forms. George Tooker unified his painting by repeating colors, values, and shapes. The terra-cotta dog is unified by a harmonious smooth surface and repeated rounded forms.

2. By stacking, overlapping, and using a vanishing point artists can create an illusion of depth. Examples will vary.

3. Cubist and Renaissance artists were interested in showing how figures really exist in space.

4. Students should mention repetition of colors, lines, shapes, and forms to create unity.

Close

Remind students that they have been learning how artists organize their artworks. Review ways to indicate depth on a two-dimensional surface. *(linear perspective; overlapping; the seeming nearness of larger, brighter objects)* Discuss using design to create order. **Ask:** How is your cardboard sculpture Cubistic? *(cut-up and reassembled shapes shown from different viewpoints)*

More About...

Cubism began in 1907, when Pablo Picasso sought new ways to represent real objects on a flat canvas. When we actually see an object, our eyes move and our viewpoint changes; but Cubism provides the viewer with more information about the object than the realistic view. Picasso and Braque further developed Cubism by overlapping several points of view in order to convey an *idea* of an object, rather than a particular view of it. Cubism influenced other artists, including David Hockney, to experiment with abstraction and nonrepresentational art.

Assessment Options

Teacher Have students work in small groups to identify the means that artists use to create a sense of order within their art. Allow each group to select one Western and one non-Western artwork from the Foundation chapters. Ask them to describe how depth is indicated and how design elements and principles were used to organize the composition. Have groups report their findings to the whole class.

Prepare

Pacing

Two 45-minute class periods: one to consider text and images; one for Studio Connection

Objectives

- Understand what characterized the Renaissance.
- Identify two ways that artists create the illusion of depth in paintings.
- Create a drawing to show an understanding of Renaissance style.

Vocabulary

atmospheric perspective The use of pale colors, fuzzy outlines, and minimal details to distinguish background from foreground and middle ground in an artwork.

patron A wealthy or influential supporter of an artist.

Using the Time Line

Encourage students to compare the dates of the Italian Renaissance works and the Northern Renaissance works. **Ask:** Which works were contemporary?

National Standards
4.1 Art History Lesson

3b Use subjects, themes, symbols that communicate meaning.

4b Place objects in historical, cultural contexts.

The Art of the Renaissance

	1498 Michelangelo, *Pietà*		1513 Dürer, *Knight, Death, and Devil*	
Gothic page 128	Renaissance in Italy	Renaissance in Northern Europe		Baroque page 180
	c. 1427 Masaccio, *Tribute Money*	1546–64 Michelangelo, *St. Peter's Dome*	1514 Matsys, *Moneylender*	

As the Middle Ages came to a close in the late 1300s, people in Europe were looking for ways to improve their lives. In Italy, new ideas were being formed about the individual's place in the world. New ways of thinking based on science and inquiry were taking hold.

Individual participation in trade and commerce increased. Towns and cities grew. The middle and upper classes controlled the wealth and government of the cities. They also became **patrons** for local artists by hiring them to create special artworks for their use. Along with the church and royalty, wealthy merchants and bankers provided artists with financial support. Artists paid tribute to their patrons by sometimes including their portraits in religious scenes.

Fifteenth-century artists knew they were living in a special time. They wanted to create their own golden age of art. They called it the Renaissance. The term *renaissance* means "rebirth." It refers to the return to classical ideals of ancient Greece and Rome.

Renaissance scholars, scientists, and artists searched for order in a world that often seemed confused. Many looked to the ancient Greeks and Romans as guides to help them discover the great things that individuals could achieve.

Art: A New Perspective

The Renaissance was a great age for art. Artists used new knowledge about the natural world. They established new theories and systems for drawing. They created special new portraits, landscapes, and religious paintings. Art criticism, art history, and new theories about architecture and linear perspective were written.

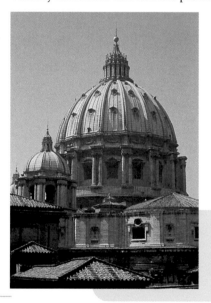

Fig. 4–11 Compare this dome with the Greek Parthenon (Fig. 2–13) and the Roman Colosseum (Fig. 2–12). Can you see the lessons in architecture Michelangelo learned from the ancient Greeks and Romans? Where else have you seen domes such as this one? Michelangelo Buonarroti, *Dome of St. Peter's,* 1546–64.
The Vatican, Rome. Courtesy Davis Art Slides.

154

Teaching Options

Resources

Teacher's Resource Binder
- Names to Know: 4.1
- A Closer Look: 4.1
- Map: 4.1
- Find Out More: 4.1
- Check Your Work: 4.1
- Assessment Master: 4.1
Overhead Transparency 7
Slides 4d

Teaching Through Inquiry

Perception Ask students to create a simple sketch to show how Michelangelo organized the various parts of **St. Peter's dome** to create a sense of unity. Have students show and explain their diagram. **Ask:** What are the basic forms and decorative features? What forms and shapes are repeated? How do lines created by architectural features help to organize the artwork? How does color contribute to the unity?

Through the use of linear perspective, Renaissance artists were able to arrange their works in an orderly way. Linear perspective is a system based on geometry. Linear perspective helps show how the shapes of things seem to change as they recede in space. A scene painted using linear perspective appears orderly to our eyes because it shows how we see things in real life.

To make things seem very far away, artists used pale colors, fuzzy outlines, and almost no details. This technique is called **atmospheric perspective.** It can help give order to an artwork by separating it into distinct sections, such as foreground, middle ground, and background. Artists such as Leonardo da Vinci became masters of this type of perspective.

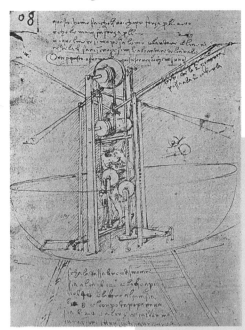

Fig. 4–12 **Like other artists of the Italian Renaissance, Leonardo was interested in many things, including science and technology. His notebook is filled with ideas for inventions as well as nature sketches and studies of human anatomy.** Leonardo da Vinci, *Study of a Flying Machine*, Codex B, folio 80r.
Institut de France, Paris, France. Scala/Art Resource.

Fig. 4–13 **Masaccio was one of the first artists to experiment with different techniques of perspective. Look at the diagonal lines of the building in this fresco. They show linear perspective. The paler colors of hills and mountains are examples of atmospheric perspective.** Masaccio, *The Tribute Money*, c. 1427.
Fresco. Brancacci Chapel, S. Maria del Carmine, Florence, Italy. Scala/Art Resource, New York.

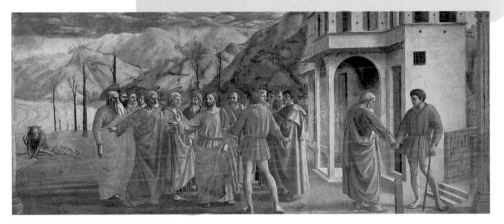

Order and Organization

155

Teach

Engage
Ask: When did Columbus first come to America? Explain that, along with increased exploration at this time, a period of discovery in art and learning—the Renaissance—was occurring in Europe.

Using the Text
Art History After students have read the text, ask small groups to create a graphic organizer of the factors that led to the Renaissance. *(new ideas about individual's place in world; thinking based on science/inquiry; increased trade/commerce; growth of towns, middle and upper classes, and their control of wealth and art patronage)* Discuss the groups' findings.

Using the Art
Art History Ask: How does Leonardo's drawing reflect Renaissance thinking? *(combines science and inquiry with art)*

Art Criticism Tell students the story of the tribute money: a Roman tax collector asks Jesus and his disciples for money; Jesus tells Peter that he will find the money in a fish; Peter slits open a fish, finds money, and pays the tax collector. **Ask:** What figure is repeated in Masaccio's *The Tribute Money*? *(Peter)* How many different events are in this one painting? *(three)* How did Masaccio create linear and atmospheric perspective?

More About...

The art of **the Renaissance** reflected major technical and creative breakthroughs. Artists used new machines and engineering skills to create complicated forms of sculpture and architecture. The development of oil paint, which could be applied to stretched canvas, allowed artists to use a greater range of rich, clear colors and thereby better represent texture and three-dimensional form. As a result, Renaissance paintings have glowing surfaces and textural details.

Using the Overhead

7

Investigate the Past

Describe What is the setting? Who are the people?

Attribute What evidence suggests that this artwork was painted during the Renaissance?

Interpret How could you find out more about what the artist was saying with this work?

Explain Find out which artists Raphael admired, and what artists were influenced by him. Share this information.

Art of the Renaissance

Using the Text

Art Criticism After students have read Sculpture: A Classical Order, encourage them to find evidence of stability and calm in Michelangelo's *Pietà*. Have them finger-trace the triangle formed by Mary's head and Christ's elbow and knees.

Using the Art

Perception Call attention to the details in Matsys's genre painting *The Moneylender and His Wife*. **Ask:** What objects are in this picture? What might they symbolize or tell about the couple? What is the medium of this work? How is this work a contrast to *The Tribute Money* (Fig. 4–13)?

Journal Connection

Ask students to write a description of the scene, objects, and animals in Dürer's *Knight, Death, and Devil* and to tell what the objects suggest about the main subject.

Studio Connection

Provide each student with 9" x 12" drawing paper, a soft pencil, and an eraser. If students draw a self-portrait, suggest that they use a mirror. Review facial proportions: eyes are in the middle of the head; the nose is a little less than halfway to the chin.

Assess See Teacher's Resource Binder: Check Your Work 4.1.

Sculpture: A Classical Order

The work of Michelangelo clearly expresses the Renaissance world. His sculptures and paintings are a mixture of calm and energy. The figures appear serene and balanced, but they also seem filled with life.

Like many artists of his time, Michelangelo studied anatomy. His artworks reveal this new knowledge of the human body. Look at Michelangelo's *Pietà* (Fig. 4–16). Despite the heavy folds of clothing, Michelangelo gives us the sense of a real body underneath. This sculpture is an example of the Renaissance interest in showing the underlying structure of things.

The Renaissance in the North

Like the Italians, northern Renaissance artists wanted their artworks to look real. But while Italian artists focused on the structure of things, artists of the north were more interested in showing their surface, or how they appeared. The new medium of oil paint helped them show richly colored, carefully detailed surfaces.

Often, northern Renaissance artworks are filled with everyday objects. These objects might stand for religious ideas, but they also create a real setting for the scene. Northern artists succeeded in arranging all the different elements into organized compositions. They created a sense of balance and order by using size, color, and placement to draw the eye to areas they wanted to emphasize.

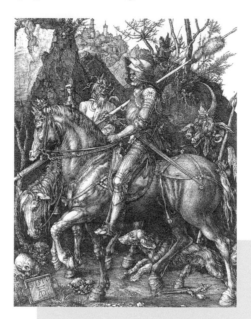

Fig. 4–14 Dürer was skilled at the printmaking medium called *engraving*. From a single copper plate he was able to make hundreds of prints. His prints were then sold throughout Europe. Notice all the details he has included in this print. It is smaller than a piece of notebook paper. Albrecht Dürer, *Knight, Death, and Devil*, 1513. Engraving, 9 ¾" x 7 ⅜" (24.8 x 18.7 cm). Art Resource, New York.

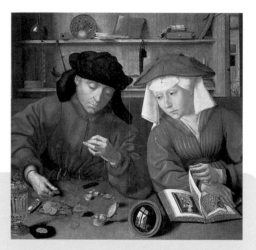

Fig. 4–15 Do you feel as though you're sitting right across from these two people? This artist draws you into the painting by showing the very edge and top of the table. He emphasized the figures by making them large and placing them in the center of the composition. What do you see reflected in the round mirror on the table? Quentin Matsys, *The Moneylender and His Wife*, 1514. Oil on wood, 27 ¾" x 26 ½" (70.5 x 67 cm). Louvre, Paris, France. Erich Lessing/Art Resource, NY.

Teaching Options

Meeting Individual Needs

Multiple Intelligences/Bodily-Kinesthetic Ask: What visual clues did Masaccio use in *The Tribute Money*? *(overlapping, linear and atmospheric perspective)* Ask students to arrange themselves in a group that replicates the gathering in the fresco to see if Masaccio visually communicated a realistic sense of space.

More About...

German artist **Albrecht Dürer** (1471–1528) was the son of a goldsmith. After his art apprenticeship, he learned **printmaking**. In 1494, he made his first pilgrimage to Venice to study Italian artists' methods of drawing human figures. When he returned to Nuremberg, he incorporated these Italian Renaissance techniques into his paintings and engravings.

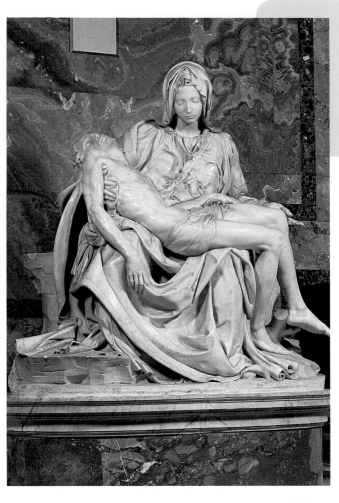

Fig. 4–16 During the Renaissance, the church remained an important patron of the arts. This sculpture was commissioned by a cardinal in the Vatican. Notice the triangular shape made by the arrangement of the figures. How does this overall shape create a feeling of stability and calm? Michelangelo Buonarroti, *Pietà*, 1499.
Marble, height: 5' 6" (1.7 cm). St. Peter's Basilica, Vatican State. Scala/Art Resource, NY.

Studio Connection

Create a portrait of yourself, or someone you know, in a Renaissance setting. Or show a famous Renaissance person in a twenty-first-century setting. Consider the following: What clothing and hair style will you include? What setting will you depict? How will your viewers know what century you have depicted? How will your viewers recognize the subject of your portrait?

Check Your Understanding

1. Explain why the fifteenth and sixteenth centuries in Europe are referred to as the Renaissance.
2. What are two ways Renaissance artists organized their paintings to create an illusion of depth?
3. How did northern Renaissance artists approach the challenge of making artworks look real?
4. How did Italian Renaissance artists approach the same challenge?

Order and Organization

157

Assess

Check Your Understanding: Answers

1. Renaissance means "rebirth." During the Renaissance, scholars, scientists, and artists searched for order in a world that often seemed confused. They returned to the classical ideals of ancient Greece and Rome to guide them in discovering what individuals could achieve.

2. linear and atmospheric perspective

3. They used oil paint to show a variety of colors that could better represent textured surfaces.

4. They used new scientific information, such as anatomy, to structure their works. They used perspective as a system of organizing space.

Close

Review the meaning of *renaissance* and why it appropriately describes the fifteenth and sixteenth centuries in Europe. Ask the class to choose which of their own drawings are most similar to Renaissance art.

Teaching Through Inquiry

Art History Invite students to research some of the **Renaissance artists** and then create a bulletin-board display of their findings.

Perception Ask students to stand in the hallway or look out a window to note **how things look when they are far away**. *(Objects seem hazy, overlapping; lines seem to converge.)* Have students make quick sketches, adding labels or notations, to record what they see.

Assessment Options

 Peer Put students into groups of three. Provide each student with a paper with these headings spaced equally down the page: Renaissance as Rebirth, Perspective, Northern European Renaissance. Have a volunteer in each group select one of the topics and write a short paragraph about it from memory. The other students can review the text. Have the writer pass the page to another group member. This student first reviews the comments of the previous student and provides additional information, if necessary. The student then selects a remaining topic and writes about it. Repeat this procedure for the last topic. Have group members review their answers together, adding or changing parts, as they believe appropriate. Remind students to look for accurate and relevant information about each topic.

Prepare

Pacing

Two 45-minute periods: one to consider text and images; one to create collage

Objectives

- Explain how an artist might organize an artwork to create both unity and variety.
- Apply principles of unity and variety to an artwork showing people in action.

Vocabulary

unity A feeling that all parts of a design work together.

variety The use of lines, shapes, textures, colors, and other elements of design to create interest in an artwork.

Teach

Engage

Introduce the words *unity* and *variety*. **Ask:** If you were to draw a line that shows unity, what kind of line would you draw? Can you draw a line that shows variety?

Using the Text

Art Criticism After students have read the text, help them follow the zigzag path through Brueghel's *Children's Games.* **Ask:** How could you describe this scene? *(topsy-turvy world of disorder and confusion)* If you were part of this village scene,

Unity and Variety

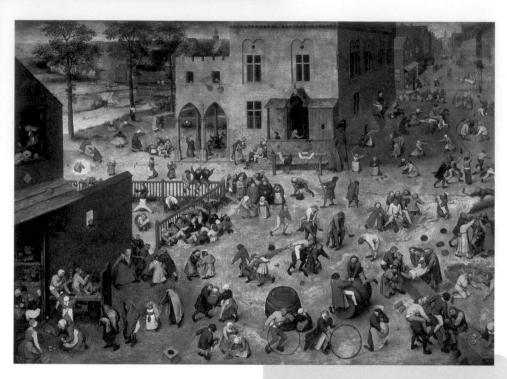

Fig. 4–17 How does Brueghel unify this painting of a town filled with activity? Pieter Brueghel, *Children's Games*, 1559–60.
Oil on wood, 46 ½" x 63 ½" (118 x 161 cm). Kunsthistorisches Museum, Vienna.

Even though consistency and change are opposites, people seem to like both. Too much order can be monotonous. Too little order may seem confusing. This is true in life and in art. By using the design principles of unity and variety, artists can express ideas and capture our interest.

Looking at Unity

Unity is the sense of oneness in a work of art. It is about how parts work together in harmony. In art, unity is often created by:
- repetition: the use of a design element again and again. Notice the repetition of shapes and colors in Figs. 4–17 and 4–18.

- dominance: the use of one major color, shape, or element. What one color unifies Brueghel's work?

- harmony: the comfortable relationship among similar colors, textures, or materials. Notice how both artists carefully chose colors that go well together.

There are other ways to create unity. Some artists show one major element in several different ways throughout the work. The human figure in action, shown in many different poses, would help unify a work.

158

Carefully placed shapes can lead the viewer's eye around the work and create unity. Can you find the zigzag "path" that starts in the lower left corner of Brueghel's panel? It ends in the bottom right. Follow the fence and then the row of trees; next move across the top of the building and back down the open street. Can you see how this "path" helps pull the work together?

Looking at Variety

Variety, unity's opposite, is the use of different or contrasting design elements to make a composition livelier. Artists try to use variety wisely so that the artwork is interesting but not confusing.

Notice how the slight changes in texture and color within the dresses of the three sisters create variety (Fig. 4–18). It can also be created by adding visual surprises, such as unexpected contrasts, exaggerations, or bright colors in a dull-colored area.

Studio Connection
Use markers and cut-paper shapes to show people involved in an activity. You might show close-ups of one person or more. Or you could show many people and poses from afar.

How can you use shapes, colors, lines, or textures to create unity? How will you create variety? If most areas of your composition are filled with lots of shapes and textures, you might add variety by keeping one area very simple.

4.2 Elements & Principles

Check Your Understanding
1. Describe three ways an artist might plan for unity in an artwork.
2. Why might an artist want to create disunity in a work of art? What feelings might such a work cause in its viewers?

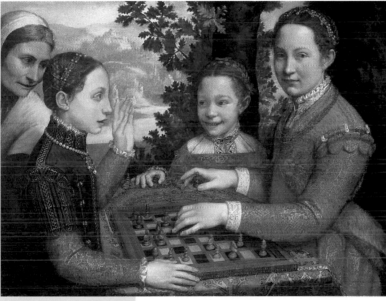

Fig. 4–18 Sofonisba Anguissola was the first famous woman artist in the history of Italian painting. Does she successfully achieve a balance of unity and variety in this work? Why or why not? Sofonisba Anguissola, *Three Sisters Playing Chess*, 1555. Oil on canvas, 28 3/8" x 38 1/4" (72 x 97 cm) MNPM039. Muzeum Narodwe, Poznan, Poland. Photo by Jerzy Nowakowski.

Order and Organization

159

would you have an overall sense of organization? Discuss how Brueghel used the unifying devices of repetition, dominance, and harmony to create order in a disorganized scene.

Using the Art

Art Criticism Ask: Do you think Brueghel and Anguissola used variety wisely in their compositions? Why or why not?

Studio Connection

Have students brainstorm some activities that they might show, and list their suggestions on the board. **Ask:** Which of the figures in your composition will be closest to and farthest from the viewer?

Have students draw and cut the figures, arrange a background of cut-paper shapes, and then add the figures. Students may have the option of cutting figures from magazines. Encourage students to arrange their shapes and figures in different ways before gluing them down.

Assess See Teacher's Resource Binder: Check Your Work 4.2.

Assess

Check Your Understanding: Answers

1. by the use of repetition, dominance, and harmony

2. Answers will vary. An artist might create disunity to surprise viewers or evoke an unsettled feeling.

More About...

Raised in a wealthy family in Cremona, Italy, **Sofonisba Anguissola** (1532–1625) was one of the few women of her time to achieve renown as an artist. She was court painter to Philip II of Spain and is credited for introducing genre into formal portraiture.

Using the Overhead

Write About It

Describe Use perspective overlay, and have students write a statement that tells how the artist organized and unified the space.

7

Analyze Use the unity/variety overlay, and have students write a short statement that tells how the artist introduced variety to a unified composition.

Assessment Options

Teacher Provide each student with an art reproduction (or have students select an artwork in the text), two fine-tip markers, and a piece of tracing paper. Have students trace the major features of the artwork, using one color for the elements that create unity, and another color to indicate how the artist created variety. Ask students to write a short essay that explains how the artist used unity and variety to organize the artwork, and to submit the essay with the tracing paper and the title of the artwork.

Prepare

Pacing

Two 45-minute periods: one to consider text and images; one to paint scroll

Objectives

- Explain how the surface decorations of Chinese and Korean vessels are organized.
- Describe the way space is organized in Chinese and Korean landscape paintings.
- Create a landscape painting that uses the Chinese and Korean system for showing distance.

Vocabulary

porcelain Fine white clay; also, an object made of such clay, which produces a work that is hard, translucent, sonorous, nonporous, and, usually, very thin.

Using the Map

Using the world map on pages 306–307 in conjunction with the maps shown here, ask students to locate China and Korea. Ask volunteers to finger-trace the geographic route that they think brought influences from China to Korea to Japan and on to other parts of Asia. Challenge students to explain why their route makes sense.

National Standards
4.3 Global View Lesson

4a Compare artworks of various eras, cultures.

2c Select, use structures, functions.

The Art of China and Korea

Very often, the peoples of one country influence those of another, either by taking over the country or simply by example. These influences can be seen in the ways people live, how they think, and in the art they create. This is particularly true of the east Asian countries of China and Korea.

The long histories of China and Korea are usually divided into dynasties. China has the longer history, going back some 8000 years. But Korea helped spread China's influence into other parts of east Asia, especially Japan.

The art of both China and Korea spans thousands of years. Chinese ideas and culture greatly influenced Korea, but Korean artists developed their own unique style of art. Artists from both countries have worked in varied media, perfecting their techniques over time. Their works range from ceremonial sculpture and architecture to paintings and everyday objects.

In this lesson, we will look at ceramic and bronze objects, as well as painting, to discover some of the ways Chinese and Korean artists have organized their artworks over time.

China and Korea

Patterned Vessels

Over the centuries, the Chinese have developed unique and elegant forms for their bronze and ceramic vessels.

Chinese artists have decorated these vessels and other objects with designs and patterns that have special meaning to them. Look at the early Chinese bronze vessel in Fig. 4–19. Notice the many different patterns and textures. How was the artist able to create a sense of order on the surface?

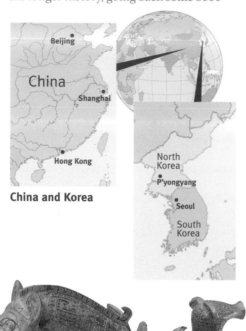

Fig. 4–19 **This vessel was probably used only for ceremonies. Can you see how the overall form of this vessel looks like a bird? The bird's neck and head are the pouring handle. The front of the lid is shaped like a tiger, while the back changes into the face of an owl.** China (Shang Dynasty, c.1600–1045 BC), *Kuang Ceremonial Vessel*, 12th century BC. Bronze, 9 ¼" x 12 ³⁄₁₆" (23.5 x 31.0 cm). Courtesy of the Freer Gallery of Art, Smithsonian Institution, Washington, DC.

160

Teaching Options

Resources

Teacher's Resource Binder
- A Closer Look: 4.3
- Map: 4.3
- Find Out More: 4.3
- Check Your Work: 4.3
- Assessment Master: 4.3

Large Reproduction 8

Slides 4e

Meeting Individual Needs

English as a Second Language Have students look at Fig. 4–21. Write *dragon* on the chalkboard. **Ask:** What is a definition of *dragon*? What do you know about dragons? How did the artist indicate the dragon's fierce power? *(open claws; sharp teeth; surrounding, flamelike linear decoration)*

Fig. 4–21 **The dragon has always been an important element in Chinese designs. It is associated with the sky, rain, and thunder. During the Ming Dynasty, when this jar was made, the dragon represented the emperor.** China, Ming Dynasty (1368–1644), *Pair of Vases*, 1426–35. Porcelain with blue underglaze decoration, 21 ³/₄" x 11 ½" (55.2 x 29.2 cm), The Nelson-Atkins Museum of Art, Kansas City, Missouri (Purchase: Nelson trust).

Fig. 4–20 **This vase shows the Korean inlay technique.** Korea, Koryo Dynasty (918–1392), *Meiping Vase with Crane and Cloud Design*, late 13th–early 14th century. Porcelaneous ware, celadon with inlaid design, 11 ½" (29.2 cm) high. The Metropolitan Museum of Art, Fletcher Fund, 1927 (27.119.11). Photograph ©1987 The Metropolitan Museum of Art.

The Order of Patterns

Designs and patterns cover the surface of many Chinese objects. This is called an *allover pattern*. In artworks, patterns help organize and unify the different parts. The artist of the bronze vessel on page 160 organized the allover pattern into different sections that you can easily see.

Chinese artists have organized their designs in other ways, too. Sometimes the designs were placed only in bands around the vessel's form. The Chinese vase shown above has one such band at the bottom.

Korean ceramics (Fig. 4–20) show the influence of the Chinese. Chinese artists taught the Koreans the techniques of glazing and working with **porcelain** (POR-suh-len), a type of fine white clay. Like the Chinese, Korean artists used allover patterns and bands to organize surface designs. They carved a design into the main clay form and then placed black and white clays in the grooves. This technique, known as *inlay*, was much admired by the Chinese.

Order and Organization

161

Engage

Show students various advertisements or catalogue pages featuring clothing. Have students indicate those they believe are most interesting. Ask them to identify ways that the artist has designed the page to attract and hold their interest. Tell students that they will be looking more closely at ways artists organize artworks to attract and hold a viewer's attention.

Using the Text

Perception Have students read the text and study Fig. 4–19. Point out to them the date of the piece. The Chinese were creating highly sophisticated bronzes thousands of years ago. **Ask:** Does the central section remind you of a bird's wing? Tell students some early bronze vessels are rounded and have three legs. Others have four legs and are square. Still others, like this one, have the overall shape of an animal. Ask students to think about why people might have wanted to have legs on bronze vessels. *(for cooking and placing over a fire)*

Using the Art

Ask: What do the decorative elements on each of the three vessels have in common? *(shapes and patterns from nature)* How are they different? *(Some are realistic; some are imaginary; some are stylized.)*

Teaching Through Inquiry

Art Criticism Have students compose a cinquain to describe and interpret one or more of the vessels. Beginning with one vessel and continuing with others, invite students to create a list of descriptive words. Remind them to consider color, line, shape, and texture. Next, have students generate a list of words (such as *playful* or *scary*) associated with the expressive characteristics of each vessel, beginning with the prompt, "The vessel seems . . ."

Finally, have them list participles (-ing descriptive words, such as *laughing, lunging, grinning,* or *pouring,* for Fig. 4–19) associated with each vessel. A cinquain has five lines: line 1 is a two-syllable noun; line 2 is two two-syllable adjectives; line 3 is three two-syllable participles; line 4 is an eight-syllable simile; and line 5 is a two-syllable noun. Have students share and discuss the cinquains with the entire class.

More About...

A blue-green porcelain pottery first produced in China's Song dynasty (960–1279), **celadon** was copied and modified for centuries. Its crackle glaze, so-called because of its network of small cracks, was challenging to work with. Celadon pottery developed in Korea almost simultaneously. Many Korean works are shaped like the lotus flower and tend toward softer blue-green colors and more ornate decoration.

Using the Text

Have students reread the third paragraph on page 162. Discuss the advantages and disadvantages of copying artworks.

Using the Art

Perception Have students compare the two images. **Ask:** How does the exaggeration of the mountains help increase the sense of order and organization?

Studio Connection

Provide students with 9" x 24" drawing paper, ink or watercolors, bamboo brushes, copy paper, and pencils. Have students look again at Figs. 4–22 and 4–23. Point out and discuss the paths that the artists wanted the viewer's eye to follow, and note how few brushstrokes each artist used. If possible, have students sketch a scene outdoors, or encourage them to think of scenes that they are familiar with, such as what they see on their way to school, out the window, or at a sports field. Write their suggestions on the chalkboard.

Demonstrate using ink or watercolor with an economy of strokes. After students have planned their composition on copy paper and practiced painting or using ink to draw as few strokes as possible, they may paint their scroll on the drawing paper.

Assess See Teacher's Resource Binder: Check Your Work 4.3.

Painted Spaces

Painting has always been an important art form in east Asia. Chinese artists had a long tradition of landscape painting, which they transferred to Korea. But Korean artists treated the subject in their own way. They often added humorous elements or exaggerated certain parts of the landscape.

Early Chinese artists painted on walls or silk, and both materials decay easily over time. These early examples no longer exist today, but they are not really lost. Other Chinese artists have copied them for centuries.

In China, artists copied older artworks they considered perfect. Because of this, Chinese paintings from many different periods in history have a similar look. From past masters, artists learned how to create the scene they wanted to show. But each painter also brought original ideas to the works while learning from the past.

Organizing Space

Chinese and Korean paintings are carefully organized. It is sometimes helpful to imagine taking a walk inside these artworks. On long horizontal paintings (called *handscrolls*), start on the right-hand side. On long vertical paintings (called *hanging scrolls*), start at the bottom. Try to notice

Fig. 4–22 Follow the order of this painting from the rocks and small figure near the bottom through the mountains near the top. Here a large unpainted space forms the middle ground. It represents the wide open space of the river. How does it help link the foreground to the background? Lu Zhi (Ming Dynasty, 1368–1644), *Pulling Oars Under Clearing Autumn Skies* (*"Distant Mountains"*), 1540–1550. Hanging scroll, ink and color on paper, 41 5/8" x 12 1/4" (105.7 x 31.1 cm). W.L. Mead Fund 1953.159. overall. Photograph ©1999, The Art Institute of Chicago. All Rights Reserved.

Teaching Options

Teaching Through Inquiry

Have students select one of the paintings and imagine that they are in the foreground of the scene. Ask them to take a "journey" through the scene, from foreground to background, and write a story of the journey, describing everything they see.

More About...

Handscrolls are gradually unrolled for study from right to left, section by section, and can be viewed only by an individual or a small group. **Hanging scrolls** hang on a wall, and can be viewed from a distance by a larger group of people. **Fan paintings** are painted images on one or both sides of a fan. **Album paintings** are pasted into books, usually on the right-hand page; a passage of relevant calligraphy faces each painting.

where the artist wants you to look first. Perhaps the artist has used changes in value, color, or different kinds of lines to direct your eye. Contrasts in light and dark or colored and uncolored parts can make certain things stand out and draw your attention.

Study a detail from a Korean screen painting (Fig. 4–23). Look at all the things going on: textured trees, calm water, and curving mountains. How did the artist give a sense of order to this composition? Notice how the rounded shapes of the mountains contrast with the jagged shapes of the trees. This contrast helps balance the different parts of the painting and organizes them into a unified composition.

Another way Chinese and Korean painters create a sense of order in their artworks is by arranging objects carefully. Objects in the foreground are usually shown lower in the painting. Objects in the background are shown higher in the work.

Studio Connection

Make a scroll painting that leads your viewer on a "walk" across the surface. Borrow the Chinese and Korean system for showing distance. Think carefully about:
• the path of the journey
• the format (vertical or horizontal)
• colors
Place the closest parts of the scene at the bottom of the painting and the distant parts at the top.

4.3 Global View

Check Your Understanding

1. What are some of the similarities between Chinese and Korean art?
2. Explain how the surface decorations of Chinese and Korean vessels are organized.
3. How does the way that Chinese and Korean artists represent space and distance differ from that of European Renaissance artists?
4. What cultures were most directly influenced by the arts of China and Korea?

Fig. 4–23 **How does the contrast between light and dark unify this work?** Korea (Choson period, late 18th century), *Seven Jewelled Peaks (Ch'ibosan).* Ten-panel screen, ink and color on cloth, 62 ¼" x 172 ½" (158.1 x 438.2 cm). ©The Cleveland Museum of Art, Mr. and Mrs. William H. Marlatt Fund, 1989.6.

Order and Organization

Extend

Invite a local artist into the classroom to demonstrate *sumi-e,* an ancient style of Asian painting with bamboo brushes and an ink stick. Alternatively, show a video about Chinese brush painting.

Assess

Check Your Understanding: Answers

1. glazing techniques, inlay, and allover patterns and bands to organize surface decoration

2. Both use allover patterns and bands to organize surface decorations.

3. Chinese and Korean artists tend to arrange things in rows from foreground to background. Renaissance artists used linear perspective.

4. Japan and other parts of east Asia

Close

Remind students that Chinese or Korean artworks might appear at first as though the surfaces are covered with unrelated designs, figures, and other elements. **Ask:** Does a closer look reveal that the works are very carefully organized? Can you explain how?

Wit and Wisdom

The four treasures of Chinese artists are the ink stick, the ink stone, the bamboo brush, and the paper. They keep these treasures neatly organized in a special box. In a specific order, the artist takes a small portion of the ink stick, dilutes it with water while grinding it on the ink stone, and then applies ink with a bamboo brush.

Using the Large Reproduction

Consider Context

Describe What details seem important? How is the figure positioned?

Attribute What clues might help you to identify when and where this was made?

Understand What does this artwork suggest about attitudes toward ancestors?

Explain What comparisons can you make between this work and the Chinese artworks in this lesson to suggest a cultural attitude toward surface decoration?

Assessment Options

Peer Have each student draw an outline of a vessel and then use spatial divisions and patterns from nature similar to those on the vessels on pages 160 and 161. Have students write and attach a paragraph explaining how they organized decorative elements. Have pairs of students exchange their work and make comments. Invite peer assessors to make suggestions for improvement.

Prepare

Pacing
One or more 45-minute periods

Objectives
- Explain the principles of linear perspective.
- Identify the location of the horizon line and the vanishing point in clear examples of linear perspective.
- Explore ways to use linear perspective in a drawing.

Vocabulary
horizon line A level line where water or land seems to end and the sky seems to begin, usually at the viewer's eye level.

Pre-studio assignment: Have students sketch a view that they see on their way to or from school.

Supplies
- drawing paper, 12" x 18" or 9" x 12"
- pencil and eraser
- ruler
- colored pencils

Teach

Engage
Show and discuss examples of linear perspective.

National Standards 4.4 Studio Lesson
3a Integrate visual, spatial, temporal concepts with content.

Drawing in Perspective

Organizing Sensational Space

Studio Introduction
Have you ever wondered what it might be like to step into a landscape painting? Suddenly, everything in the painting would come alive. What seemed flat would have depth.

Artists can create that sense of wonder when they draw or paint with linear perspective. **In this studio lesson, you will draw a scene in one-point perspective.** Pages 166 and 167 will show you how to do it. Use one-point perspective to add a sense of real life to the picture. Think about other methods of perspective that you can use. (See Studio Background.) Make your scene as inviting to viewers as you can.

Studio Background

Organizing a Picture's Space
For hundreds of years, artists practiced many methods of perspective. Until the Renaissance, the most common methods included overlap, variation of size, placement of subject matter, amount of detail, and use of color (see Organizing Artworks, page 148). While artists of the Renaissance knew these methods well, they wanted to paint with greater realism.

In the early 1400s, artist and architect Filippo Brunelleschi discovered linear perspective. An artist painting or drawing a scene in linear perspective creates a **horizon line**—a level line where the earth seems to end and the sky begins. The horizon line is usually located at eye level. It can be high, low, or in the middle of the artwork, depending on where the artist wants you to see the scene from. Vanishing points are placed on the horizon line.

From the 1400s on, artists could combine linear perspective with other methods of perspective. This helped them achieve realism. The picture surface became an open window that invited the viewer in.

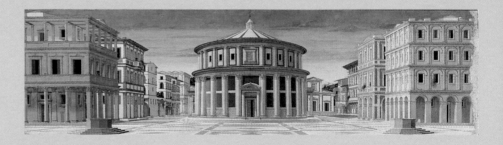

Teaching Options

Resources
Teacher's Resource Binder
- Studio Master: 4.4
- Studio Reflection: 4.4
- A Closer Look: 4.4
- Find Out More: 4.4
- Overhead Transparency 8
- Slides 4f

Meeting Individual Needs
Assistive Technology Students may use computer software to create their image.

Fig. 4–24 In addition to exploring one-point perspective, this student gave thought to which colors would work best to make her drawing more interesting. She made the windows yellow to suggest a time of day: late afternoon just before dark.
Joanna Lim, *A City of Color*, 1999.
Colored pencil, 9" x 12" (29 x 30.5 cm). Samford Middle School, Auburn, Alabama.

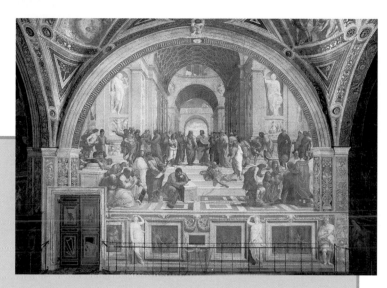

Fig. 4–25 Raphael used architectural features to create linear perspective in this painting. The floor tiles and moldings along the tops of the walls meet at a vanishing point behind the two central figures. He has also created a foreground, middle ground, and background. What do you see in the foreground? What do you see in the background?
Raphael Sanzio, *The School of Athens*, 1509–11.
Stanza della Segnatura, Vatican Palace, Vatican State. Scala/Art Resource, NY.

Fig. 4–26 This cityscape (far left) is an excellent example of linear perspective. The vertical lines of windows, arches, and columns are perpendicular (at right angles) to the horizon line. Horizontal lines are parallel to the horizon line, unless they recede into space. Notice how the roof and foundation lines, building stories, and lines of the pavement meet. Piero della Francesca, *The Ideal City*, 1480.
Galleria Nazionale delle Marche, Urbino, Italy, Scala, Art Resource, NY.

Using the Text

Perception After students have read pages 164 and 165, ask them to imagine walking through the scene in one of the images. **Ask:** How long would it take you to walk from the front to the back of the scene? What in the painting tells us how distant the objects are? Discuss how the artists created a sense of depth. Have students locate the horizon line and vanishing point in each image.

Using the Art

Perception Ask: How did Raphael emphasize the two central figures in *School of Athens*? *(centrally located; everything in the painting leads to them)* Point out the door in the lower right corner. Explain that this is a real door, not part of the painting. Ask students to finger-trace the triangular composition in *The School of Athens* and *The Ideal City*.

Art History Challenge students to list typical Renaissance features in *The School of Athens*. *(classical architecture, sculptures, clothing, subjects; celebration of learning; triangular composition; linear and atmospheric perspective; realistic anatomy)*

Sketchbook Tip
Suggest to students that they cut out magazine or newspaper pictures that are good examples of linear perspective. Have them paste these into their sketchbook for future reference.

165

Teaching Through Inquiry

Project an artwork or photograph with good linear perspective onto a white dry-erase board or a large piece of white paper taped over the board. Invite students to use markers to trace the receding lines in one color, the horizontal lines in another, and the vertical lines in another. Try this with several different artworks.

More About...

While Michelangelo was working on the Sistine Chapel ceiling, Raphael was in the pope's library of the same building, painting frescoes that illustrated the four domains of learning: ***The School of Athens*** represents philosophy. The two central figures are the great classical philosophers Plato, pointing up, and Aristotle, pointing down. As a tribute to Michelangelo, Raphael added his image, the figure in the foreground who is writing and has his head resting on his hand. The portrait of Michelangelo is similar in style to the figures in the Sistine Chapel.

Using the Overhead

8

Looking Closer
Note the way the artist used perspective.
Ask: What are some ways you could introduce curved lines into a linear perspective drawing?

Drawing in Perspective

Studio Experience

1. Display and discuss the sketches that students made to or from school. **Ask:** Which lines converge at vanishing points?

2. Demonstrate drawing a horizon line, vanishing point, and lines that come together at that point.

3. For their drawing, remind students to consider relative size of figures and objects; use lighter, cooler, and duller colors in the background; and step back and check their work as it nears completion. **Ask:** Do you need to add more contrast between objects so that they may be clearly seen? Would texture on some objects add more interest? Are the closer objects brighter or darker than objects farther away?

Idea Generators

Ask: What are some different ways to show depth in a drawing? What kind of imaginative details could you add to make your scene more interesting?

Drawing in the Studio
Drawing Your Scene

You Will Need

- drawing paper
- pencil and eraser
- ruler
- colored pencils

Try This

1. On your way to or from school, find an indoor or outdoor scene that interests you and lends itself to one-point perspective. The scene should have features with lines that clearly come together to a single vanishing point—a tree-lined road, rooftops, railroad tracks, a long hallway, or the like.

2. Study the scene. Where is the horizon line? Which lines in the scene come together to a vanishing point? Sketch the scene to help you remember the linear perspective qualities and details.

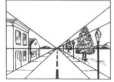

3. When you're at school, begin your drawing. First, draw a light horizon line. Will it be high, low, or in the middle of your paper? Mark a vanishing point on the horizon line. Then use a ruler to add light guides for the lines that come together at the vanishing point.

4. Lightly sketch the main features of the scene. Follow the guidelines as needed to keep the linear perspective.

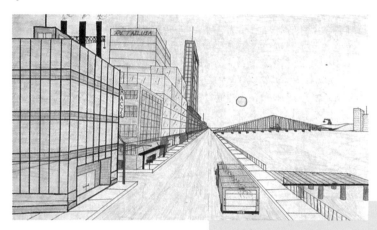

Fig. 4–27 Perspective drawings can be challenging but worth the effort as you see a realistic-looking city grow on paper. "It was very difficult drawing the buildings on the far side of the river. I like it because I worked hard on it." Dan Hartman, *City Life*, 1999.
Colored pencil, 12" x 18" (30.5 x 46 cm). Samford Middle School, Auburn, Alabama.

Teaching Options

Teaching Through Inquiry

Make and distribute photocopies of Raphael's *The School of Athens*. Have students carefully cut out the figures and then paste them on one piece of paper; and cut and then paste the architectural features on another piece. Challenge them to use pencil to extend and restore the lines of the floor, steps, and walls. Display the images, and have students compare them to the original image. Then have students complete these prompts: "Without the people, the architecture seems _____." *(stark, empty, like a tunnel, neat and orderly)*. "Without the architecture, the people seem _____." *(disorganized, lost in space, flat)*

5. When you are happy with your sketch, add color and the details you remember with colored pencils. You may wish to add details from your imagination. As you work, think about other methods of perspective that will help you create the illusion of space. Are objects in the distance smaller than those up close? Do objects overlap? Do they get lighter in color as they recede into space?

6. When you are finished, carefully erase any unwanted guidelines.

Check Your Work

Discuss your drawing with classmates. What was the most difficult challenge you faced when drawing in one-point perspective? How did you solve the problem? See if your classmates can find your horizon line and vanishing point. Can they point out other methods of perspective that you used?

Sketchbook Connection
Sketch the same scene again, but do not use linear perspective this time. Instead, emphasize another method of perspective. When you are finished, compare the two drawings. Write a paragraph or two describing the similarities and differences you notice in the illusion of space shown in each drawing.

Computer Option
Plan a landscape by sketching a basic idea on paper. Then use the "layers" feature in a drawing or painting program. Create and save perspective guidelines in one layer. In a second layer, make your landscape, including trees, fence posts, buildings, or another repeating subject.

Create depth realistically by using size and detail while following your guidelines for placement. Disable the guideline layer occasionally to view your work. When you are happy with your landscape, print the layer without the guidelines.

Order and Organization

167

Computer Option
Demonstrate how to draw guidelines on a background layer (in Photoshop, Adobe Illustrator, MetaCreations Painter, and MicroFrontier Enhance). Students may create their landscape as the document's top layer.

Alternatively, students may use objects as perspective guidelines (in drawing programs such as Microsoft or Apple Works, Claris Draw, or Canvas), which they can lock while drawing the landscape. When students are satisfied with their work, have them unlock and delete the guidelines.

Demonstrate how to scale and to overlap objects to increase the sense of depth; and how to move objects from front to back, up or down the page.

Assess

Check Your Work
Have students, either within a group or as a written assignment, answer the questions in Check Your Work.

Close

Have students create and attach labels to their linear-perspective drawing, with their name, title of the art, and the various methods they used to show depth. Display the drawings.

More About...

After Albrecht Dürer learned **perspective** drawing from Italian artists, he created a grid-based drafting device. He strung wires through a rectangular wooden frame to form a transparent grid. He then drew a corresponding grid on his paper. He studied his subject by looking through each square of the wire grid; then he copied onto his paper exactly what he saw in each square. In this way, he created accurate perspective drawings. (Students can use a similar technique by drawing or photocopying a grid onto transparent acetate. They then draw a similar grid on their paper, look through the transparent grid at their subject, and lightly sketch what they see in each square.)

Assessment Options

Teacher Make photocopies of magazine pictures of room interiors or city streets that have linear perspective. Have students use rulers and colored pencils to find and mark the horizon line and vanishing point, and to connect the receding lines of walls or windows to the vanishing point.

167

Careers

Explain that graphic designers once drew by hand, painted images with airbrushes, used press-on type for text, and made painstaking paste-ups of camera-ready art and text. Today, however, a successful graphic designer must have expert knowledge and skill in computer graphics. Discuss the changing role of graphic artists, and ask students for examples of their work in magazines and on web sites, TV, billboards, clothing, and product packaging.

Daily Life

To help students understand a simple ritual that brings order to the day in many cultures, have volunteers bring in their cereal bowl. Display their bowls next to ceramic bowls—or images of them—with cultural characteristics. Discuss the like and unlike characteristics of the bowls, and have students arrange the bowls by criteria that they develop as a class.

Connect to...

Careers

Graphic designers are artists who bring order and organization to visual communication. Once known as commercial artists, graphic designers are hired by services and industries to provide information that is essential to business success. These artists use the elements and principles of design every day to create memorable advertisements, presentations, books, commercials, displays, web pages, signs, and packaging. Some of their "building blocks" are words (typography), corporate-identity symbols (logos), photography, illustration, and digital special effects.

Fig. 4–28 **Graphic designer David Lai develops web sites and CD-ROMs, writes books on design, and teaches web design. He is now using his organizing skills as chief executive officer of Hello Design in Culver City, California (www.hellodesign.com).** Photo courtesy of the artist.

Daily Life

What kind of a bowl do you use for your breakfast cereal? Perhaps it is made from a type of ceramic clay. **Clay containers** found from the earliest civilizations in China and Korea range from undecorated food vessels of rough earthenware clay to beautifully formed porcelain clay pieces decorated with a variety of brilliant colors. An appealing, ordered simplicity of form and design, and delicate visual scenes of nature's beauty are the traditional characteristics of Asian ceramics.

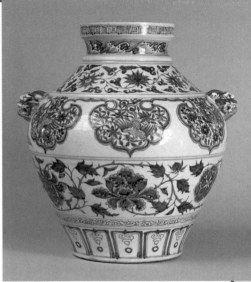

Fig. 4–29 **Look closely at any vessel in your home—see if you can find any similarities to the characteristics of Asian ceramics.** China, Yuan Dynasty (14th century), *Jar.* Porcelain with underglaze blue decoration, 15 1/2" (39.3 cm) high. ©The Cleveland Museum of Art, John L. Severance Fund, 1962.154.

Internet Connection
For more activities related to this chapter, go to the Davis website at **www.davis-art.com.**

Teaching Options

Resources

Teacher's Resource Binder
 Using the Web
 Interview with an Artist
 Teacher Letter
 Analogy Map

Interdisciplinary Tip

Use an Analogy Map from the Teacher's Resource Binder to illustrate similarities and differences between familiar and new interdisciplinary concepts.

Video Connection

 Show the Davis art careers video to give students a real-life look at the career highlighted above.

Other Subjects

Language Arts

Until the mid-1400s, books or manuscripts had to be copied carefully by hand. As a result, they were rare and expensive. Because most people did not know how to read or write at the time, the demand for reading materials was not great. The **invention of the printing press** and movable type changed these circumstances.

Around 1450, Johannes Gutenberg, a German printer, began to print with movable type, in which a mirror image of each letter was carved in relief on a small block of wood. Individual letters were put together to form words; the words filled a page; and the pages made a book.

Social Studies

Have you noticed that few women are identified as artists during the Renaissance? At that time, a **woman with artistic talent** who wanted to become an artist usually had to be from a wealthy family whose position allowed her to receive instruction. Even so, women's training was somewhat limited because they were not allowed to study live male models.

Sofonisba Anguissola, who was encouraged by her aristocratic father to paint and play music (see Fig.4–18 on page 159), showed

Fig. 4–30 John Amos Comenius, *Typographers (Die Buchdruckerey), Orbis Sensualium Pictus*. Nuremburg, 1658, p. 190.
PML 83013 The Pierpont Morgan Library/Art Resource, NY.

artistic talent early in her childhood. Her family's support helped her become the first woman to achieve international fame as a portrait painter. Do you think women today face difficulties in achieving success as artists?

Other Arts

Music

In musical works, **composers organize sounds** to create a melody, the tune that captures our attention and that we perceive as a unit. To the melody, the composer adds harmony, which adds musical "space" to the work and is often performed by instruments other than those playing the melody. If we compare music and art, we might say that harmony is like a painting's perspective: it provides a sense of depth.

Listen to "Courante," a dance piece written by Michael Praetorius in 1612. Notice which instrument plays the melody and what other instruments play the harmony. The piece has two sections, A and B, each of which repeat, so the order can be stated as AABB. What instrument is added during the B section of the piece? When the A section repeats, is the repetition the same as the first, or is there a difference? Which section is longer, A or B?

Social Studies

Describe the Guerrilla Girls, a group of women artists, writers, and performers who have declared themselves the female counterparts to male heroes such as Robin Hood, Batman, and the Lone Ranger. They wear gorilla masks to hide their identity and use humor to provoke discussion and express opinions. Ask students to share their opinions about such efforts.

Note: The Guerrilla Girls' web site is at: http://www.guerrillagirls.com/.

The National Museum of Women in the Arts, which offers teachers' resources, is available at: http://www.nmwa.org/education/educat.htm.

Other Arts

The instruments in "Courante" (available on Pierre Verany 730006) are the oboe, trumpet, trombone, and lute. Bells enter the piece during the B section. Students should notice that the repeat of the A section is slightly different from the first. The B section is longer.

Internet Resources

Exploring Leonardo

http://www.mos.org/sln/Leonardo/LeoHomePage.html

Visit this extensive website to discover more about Leonardo da Vinci's futuristic inventions and use of perspective. Lesson ideas are also to be found here, such as Sketching Gadget Anatomy.

Ho-Am Art Museum

http://www.hoammuseum.org/english/index.html

Browse the collection of more than 15,000 artifacts and artworks belonging to the largest private museum in Korea.

Uffizi Gallery

http://www.uffizi.firenze.it/welcomeE.html

Take a virtual tour of the Uffizi Gallery in Florence, Italy. Enter the gallery and click on the floor maps to discover which artworks are in each room.

Community Involvement

Invite a community design and planning professional (zoning officer, city planner, township supervisor, county commissioner, architect) to talk with students about how the community was designed, how it functions, where problems and needs exist, and what plans are being made for the future.

Talking About Student Art

When discussing the meaning or message of student artworks, remind students to give reasons, and explain to them that there can be more than one plausible interpretation of a particular artwork.

Portfolio Tip

 Refer students to Foundation 4, pages 58–59, when doing a studio analysis of artwork in their portfolio.

Sketchbook Tip

 Challenge students to think of doorways in unique ways and from various viewpoints. **Ask:** Which doorway is the most mysterious? Inviting? Amusing?

Portfolio

"I have been coloring and drawing ever since I was a little kid. I took art this year so I would have a chance to explore different kinds of art." Rebecca Lamb

Fig. 4–32 Linear perspective can help you draw something that looks real, even when it's from your imagination. Can you identify where the two vanishing points are located? Rebecca Lamb, *City of the Future*, 1999.
Colored pencils, pastels, 12" x 18" (30 x 46 cm). Yorkville Middle School, Yorkville, Illinois.

Fig. 4–31 For a celebration honoring important women, this student chose to do a portrait of someone who fought for women's rights in the nineteenth century. Rather than just copy an image from a photograph, the student created a colorful style of her own. For unity, the head is in a strong, central position; creative use of multiple colors adds variety. Lesly Cruz, *Lucy Stone*, 1999.
Pastel on toned paper, 8 ½" x 11" (22 x 28 cm). McGrath School, Worcester, Massachusetts.

Fig. 4–33 This student's use of color provides unity; how has variety been introduced? Katie Atkinson, *River in Desolate Mountains*, 1999.
Acrylic, 12" x 36" (30.5 x 91.5 cm). Johnakin Middle School, Marion, South Carolina.

"I did this artwork when my school studied different cultures this year. We studied China, France, Africa, and then South Carolina. We had to research China and create a Chinese artwork. I chose to do a scroll with washed-out neutral colors." Katie Atkinson

 CD-ROM Connection
To see more student art, check out the Global Pursuit Student Gallery.

Teaching Options

Resources

Teacher's Resource Binder
Chapter Review 4
Portfolio Tips
Write About Art
Understanding Your Artistic Process
Analyzing Your Studio Work

CD-ROM Connection

 Additional student works related to studio activities in this chapter can be used for inspiration, comparison, or criticism exercises.

Chapter 4 Review

Recall

Define "vanishing point" (*example below*).

Understand

Compare the Islamic and Persian way of creating the illusion of depth with the system used by European artists of the Renaissance.

Apply

Use linear perspective to create an orderly view of a futuristic city.

Analyze

Select an artwork in the chapter and explain how the artist organized the parts.

Synthesize

Work with a group of classmates to create a display of the different ways to represent the illusion of depth. To illustrate the display, use reproductions of artworks from several cultures. Add labels to identify the systems that artists have used.

Evaluate

Select an artwork from this chapter in which you think the visual elements are especially well organized and carefully arranged. To justify your choice, refer to specific details such as lines, shapes, and patterns. Tell why their placement is effective in this particular piece.

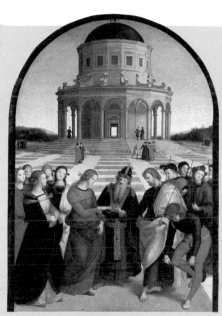

Page 146

For Your Portfolio
Choose one of your works that you believe is well organized. For instance, the work might show the use of unity with variety, or it might have an effective illusion of depth. Write a short review of your portfolio entry: explain how it shows good organization, and what you might change if you were to recreate the work.

For Your Sketchbook
Fill a page with thumbnail sketches of various views through a doorway—from indoors looking out, and from outdoors looking in. Try out different ways to organize your sketches: create the illusion of deep space in some views, and shallow space in other views.

Order and Organization

171

Chapter 4 Review Answers

Recall

the point at which receding parallel lines seem to meet and disappear

Understand

Islamic and Persian artists stacked space: objects in the lower parts of an image are to be perceived as close by; those in the higher parts, as farther away. Renaissance artists used linear perspective, showing faraway objects as smaller, and used receding parallel lines that converge at a vanishing point.

Apply

Check students' work for awareness of vanishing point and diminishing size of objects in the background.

Analyze

Look for appropriate mention of elements and principles of design.

Synthesize

Look for correct labeling and awareness of more than one system.

Evaluate

Look for accurate description of details and appropriate support.

Reteach

Provide students with reproductions of artworks from the Renaissance and from China or Korea. Help them identify repeated elements that unify the compositions. To ensure that students understand how space is organized differently, have them identify the use of perspective, overlapping, and stacking. For each artwork, have students also tell how the artist included variety.

Family Involvement

Invite family members and community groups to help you begin a file of articles about local artists, art history, architectural and other restorations, reviews of area exhibits, and so on. Use the articles to investigate issues about art.

Advocacy

Put together and make copies of an attractive booklet of students' writings about art. Distribute to all administrators and school-board members.

171

Chapter Organizer

Chapter 5 Daily Life
Chapter 5 Overview
pages 172–173

Chapter Focus
- **Core** The objects and events of daily life have been the subject matter of art throughout time and across cultures.
- **5.1** European Art: 1600–1800
- **5.2** Light, Value, and Contrast
- **5.3** The Art of Latin America
- **5.4** Decorating a Container

Chapter National Standards
1 Understand media, techniques, and processes.
2 Use knowledge of structures and functions.
3 Choose and evaluate subject matter, symbols, and ideas.
4 Understand arts in relation to history and cultures.
5 Assess own and others' work.

3 4 3

Core Lesson
Art and Daily LIfe
page 174
Pacing: Three to four
45-minute periods

Objectives
- Use examples to explain how daily objects have both practical and artistic purposes
- Describe, with examples, how artists observe and record daily life.

National Standards
3b Use subjects, themes, symbols that communicate meaning.
5a Compare multiple purposes for creating art.

Core Studio
A Still-Life Painting
page 178

- Paint a still life of everyday objects that have special or symbolic meaning.

2a Generalize about structures, functions.

3

Art History Lesson 5.1
European Art: 1600–1800
page 180
Pacing: Three or four
45-minute class periods

Objectives
- Identify characteristics of Baroque and Rococo styles.
- Understand that genre scenes are images of everyday life.

National Standards
1a Select/analyze media, techniques, processes, reflect.
4a Compare artworks of various eras, cultures.

Studio Connection
page 182

- Create a genre scene by using drawing, painting, and collage.

1b Use media/techniques/processes to communicate experiences, ideas.

1

Elements and Principles Lesson 5.2
Light, Value, and Contrast
page 184
Pacing: One or two
45-minute periods

Objectives
- Recognize and identify value and contrast in artworks.

National Standards
2c Select, use structures, functions.

Studio Connection
page 185

- Use value contrasts to create their own drawing and collage scene of an American-life activity.

2c Select, use structures, functions.

Featured Artists

Germain Boffrand
Jean-Baptiste Simeon
 Chardin
Jaime Colson
Audrey Flack
Ramon Frade
Carmen Lomas Garza
Jan Davidsz de Heem
Hiroshima Kazuo
Judith Leyster
Johann Peter Melchior

Clara Peeters
Amelia Pelaez
Mary Carpenter
 Pickering
Pieter de Hooch
Quiringh Van
 Brekelenkam
Rembrandt van Rijn
Diego Rivera
Diego Velázquez
Johannes Vermeer

Chapter Vocabulary

Baroque
contrast
genre
patron

pre-Columbian
Rococo
still life
value

Teaching Options

Teaching Through Inquiry
Using the Large Reproduction
Using the Overhead
More About…Carmen Lomas Garza

Technology

CD-ROM Connection
 e-Gallery

Resources

Teacher's Resource Binder
 Thoughts About Art:
 5 Core
 A Closer Look: 5 Core
 Find Out More: 5 Core
 Studio Master: 5 Core
 Assessment Master:
 5 Core

Large Reproduction 9
Overhead Transparency 10
Slides 5a, 5b, 5c

Meeting Individual Needs
Teaching Through Inquiry
More About…Audrey Flack
Assessment Options

CD-ROM Connection
 Student Gallery

Teacher's Resource Binder
 Studio Reflection: 5 Core

Teaching Options

Meeting Individual Needs
Teaching Through Inquiry
More About…*Las Meninas*

Technology

CD-ROM Connection
 e-Gallery

Resources

Teacher's Resource Binder
 Names to Know: 5.1
 A Closer Look: 5.1
 Map: 5.1
 Find Out More: 5.1
 Assessment Master: 5.1

Overhead Transparency 9
Slides 5d

Teaching Through Inquiry
More About…Genre scenes
Using the Overhead
Assessment Options

CD-ROM Connection
 Student Gallery

Teacher's Resource Binder
 Check Your Work: 5.1

Teaching Options

Teaching Through Inquiry
Using the Overhead
More About…*Vanitas* painting
Assessment Options

Technology

CD-ROM Connection
 e-Gallery

Resources

Teacher's Resource Binder
 Finder Cards: 5.2
 A Closer Look: 5.2
 Find Out More: 5.2
 Assessment Master: 5.2

Overhead Transparency 9

CD-ROM Connection
 Student Gallery

Teacher's Resource Binder
 Check Your Work: 5.2

Chapter Organizer continued

9 weeks	18 weeks	36 weeks		Objectives	National Standards
		3	**Global View Lesson 5.3 The Art of Latin America** page 186 Pacing: Three 45-minute class periods	• Understand the influence that European conquests of the 1500s had on Latin American art. • Explain how visual qualities influence the moods and feelings in twentieth-century Latin American artworks, such as those by Diego Rivera and Ramon Frade.	**1a** Select/analyze media, techniques, processes, reflect. **4c** Analyze, demonstrate how time and place influence visual characteristics.
			Studio Connection page 188	• Create a genre painting of an outdoor scene by using a mixed-media technique.	**1a** Select/analyze media, techniques, processes, reflect.

				Objectives	National Standards
	4	3	**Studio Lesson 5.4 Decorating a Container** page 190 Pacing: Three or four 45-minute class periods	• Describe details and technical features of functional and decorative objects. • Distinguish between Rococo and pre-Columbian decorative styles. • Embellish a functional container with papier-mâché to express something about daily life.	**3b** Use subjects, themes, symbols that communicate meaning. **4a** Compare artworks of various eras, cultures. **5a** Compare multiple purposes for creating art.

				Objectives	National Standards
•	•	•	**Connect to...** page 194	• Identify and understand ways other disciplines are connected to and informed by the visual arts. • Understand a visual arts career and how it relates to chapter content.	**6** Make connections between disciplines.

				Objectives	National Standards
•	•	•	**Portfolio/Review** page 196	• Learn to look at and comment respectfully on artworks by peers. • Demonstrate understanding of chapter content.	**5** Assess own and others' work.

2 Lesson of your choice

Teaching Options

Teaching Through Inquiry
More About…Ponchos
Using the Large Reproduction

Technology

CD-ROM Connection
e-Gallery

Resources

Teacher's Resource Binder
 A Closer Look: 5.3
 Map: 5.3
 Find Out More: 5.3
 Assessment Master: 5.3

Large Reproduction 10
Slides 5e

Meeting Individual Needs
Teaching Through Inquiry
More About…Diego Rivera
Assessment Options

CD-ROM Connection
 Student Gallery

Teacher's Resource Binder
 Check Your Work: 5.3

Teaching Options

Meeting Individual Needs
Teaching Through Inquiry
Wit and Wisdom
Using the Large Reproduction
Using the Overhead
More About…Papier-mâché
Assessment Options

Technology

CD-ROM Connection
 Student Gallery
 Computer Option

Resources

Teacher's Resource Binder
 Studio Master: 5.4
 Studio Reflection: 5.4
 A Closer Look: 5.4
 Find Out More: 5.4

Large Reproduction 9
Overhead Transparency 10
Slides 5f

Teaching Options

Museum Connection
Community Involvement

Technology

Internet Connection
Internet Resources
Video Connection
CD-ROM Connection
 e-Gallery

Resources

Teacher's Resource Binder
 Using the Web
 Interview with an Artist
 Teacher Letter

Teaching Options

Advocacy
Family Involvement

Technology

CD-ROM Connection
 Student Gallery

Resources

Teacher's Resource Binder
 Chapter Review 5
 Portfolio tips
 Write About Art
 Understanding Your Artistic Process
 Analyzing Your Studio Work

Chapter Overview

Theme

As part of daily life, we produce and consume; we work and we play. Art can enter and reflect these daily-life activities.

Featured Artists

Germain Boffrand
Jean-Baptiste Simeon Chardin
Jaime Colson
Audrey Flack
Ramon Frade
Carmen Lomas Garza
Jan Davidsz de Heem
Pieter de Hooch
Hiroshima Kazuo
Judith Leyster
Johann Peter Melchior
Clara Peeters
Amelia Pelaez
Mary Carpenter Pickering
Quinringh van Brekelenkam
Rembrandt van Rijn
Diego Rivera
Diego Velázquez
Jan Johannes Vermeer

Chapter Focus

The objects and events of daily life have been the subject matter of art throughout time and across cultures. In this chapter, we focus on European Baroque and Rococo artworks, as well as artworks from Latin America, to see how artists depict realistic scenes of everyday life. We consider the design and use of objects, and their embellishment. We look at value and contrast in artworks.

172

5 Daily Life

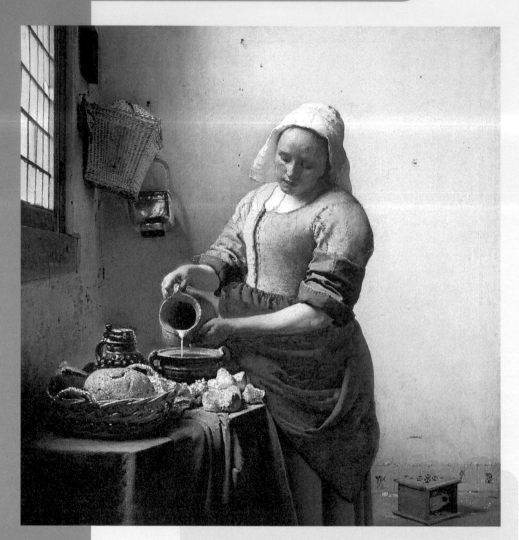

Fig. 5–1 **Vermeer shows a quiet scene from daily life and allows us to see that our everyday actions have a special beauty.** Jan Johannes Vermeer, *The Milkmaid*, c. 1658. Oil on canvas, 18" x 16 ⅛" (45.5 x 41 cm). Purchased from the heirs of Jonkheer P.H. Six van Vromade, Amsterdam, 1908, with aid from the Rembrandt Society. Rijksmuseum, Amsterdam.

National Standards Chapter 5 Content Standards

1. Understand media, techniques, and processes.
2. Use knowledge of structures and functions.
3. Choose and evaluate subject matter, symbols, and ideas.
4. Understand arts in relation to history and cultures.
5. Assess own and others' work.

Teaching Options

Teaching Through Inquiry

People keep track of and share the **details of their daily life** through conversation, journal writing, and illustrations. Have students work in groups to think of other ways (such as Internet chat rooms, TV talk shows, autobiographies, photographs, and home videos). Ask groups to share their ideas with the class.

More About...

Jan Vermeer (1632–75) was an art dealer and master Delft painter. Only thirty-four paintings have been attributed to him, and many of these are small interiors of daily-life activity, usually featuring one or two people side-lit from a nearby window. Vermeer probably used a *camera obscura* to cast an image of his composition on a facing surface. He could then trace the image.

Focus

- Why do people keep records of their everyday life?
- How do artists show daily life and create everyday objects?

Lots of people keep a journal or diary to record what they do each day. Do you? Many people now use cameras—either still or video—to record daily life and special events. Keeping such records is important, and people have been doing so for centuries. Even in an ancient village in Egypt, archaeologists have found small rocks carved with descriptions of daily-life events. They are like journals from another time and place.

If you were to travel around the world, you would find that people do many of the same basic things. We rest, prepare food, and eat. We work and we play. But where we rest or work and what we eat may differ from place to place.

We might spend our free time in many different ways. But whatever our daily activities, art plays a role. Most of the objects we use daily were designed and crafted by people. Look around you now. Note the objects that resulted from someone's plan or creation. Artists have also found daily-life objects and events to be important subject matter for artworks. So the way we work and play and the things we have in our homes and workplaces have also found their way into paintings and sculptures.

What's Ahead

- **Core Lesson** Learn how art enters and reflects our daily lives.
- **5.1 Art History Lesson** Discover how Baroque and Rococo artists showed scenes and objects from daily life.
- **5.2 Elements & Principles Lesson** Explore ways artists use value and contrast to make everyday scenes look real.
- **5.3 Global View Lesson** Learn how daily life is reflected in the art of Latin America, past and present.
- **5.4 Studio Lesson** Decorate an everyday container.

Words to Know

still life	value
Baroque	contrast
Rococo	pre-Columbian
genre	

Fig. 5–2 **Workers in ancient Egypt who built Nefertari's tomb recorded their daily activities on these small limestone chunks.** *Limestone Flakes.* Photo by J. Hyde.

Daily Life

173

Chapter Warm-up

To introduce students to the idea that we like to remember daily-life events, ask them to tell the ways that their family records these activities.

Artists often design commonly used objects. For a collection of objects such as spoons, scissors, ballpoint pens, or felt-tip markers, discuss how their design suits our daily needs.

Using the Text

Ask students to compare the use of the limestone flakes from Egypt with how we record daily-life events today.

Using the Art

Ask: What is happening in this painting? Do you think that this is a special event or an everyday one? Why? How is the activity both like and unlike what happens in your home?

Ask: How did Vermeer make pouring milk an important, graceful gesture? Notice that the subject is softly lit from the window, silhouetting the woman's form against the bare wall. X rays of the painting show that, at one time, an object had been painted on the wall above the maid's head. Discuss how the simplicity of the final background focuses attention on the milkmaid. Point out value contrasts, particularly the woman's outline against the light wall and the white milk against the darker pitcher.

More About...

Tens of thousands of **inscribed limestone flakes**, found in an Egyptian workers' village, tell about work and leisure activities. Lawsuits, personal relationships, and religious thoughts were also inscribed on these stone journals.

Graphic Organizer
Chapter 5

5.1 Art History Lesson
European Art: 1600–1750
page 180

Core Lesson
Art and Daily Life

Core Studio
A Still-Life Painting
page 178

5.3 Global View Lesson
The Art of Latin America
page 186

5.2 Elements & Principles Lesson
Light, Value, and Contrast
page 184

5.4 Studio Lesson
Decorating a Container
page 190

Prepare

Pacing

One 45-minute period for core introduction and drawing

Two or three 45-minute periods for studio painting

Objectives

- Use examples to explain how daily-life objects have both practical and artistic purposes.
- Describe, with examples, how artists observe and record daily life.
- Paint a still life of everyday objects that have special or symbolic meaning.

Vocabulary

still life Art based on an arrangement of objects.

Teach

Engage

Challenge students to find something in the room that was not made or designed by an artist. **Ask:** What does this say about the importance of art in daily life?

National Standards

3b Use subjects, themes, symbols that communicate meaning.

5a Compare multiple purposes for creating art.

Art and Daily Life

Artistic Objects

Even when daily life is difficult, people care about having beauty around them. They carefully design objects to help them with their work and play. Crafted tools, containers for storing and serving food, and clothing and blankets for staying warm are all created with care. In cultures worldwide and throughout time, functional objects for daily use have been decorated with traditional patterns and symbols.

Prehistoric people probably used oil lamps to light the caves where they created wall paintings. These early oil lamps (Fig. 5–3) were practical, but they were also decorated.

Useful objects are usually made from materials that are easy to find nearby. Have you ever made something useful from materials around you? Have you seen wind-catchers made from plastic soda containers? Can you imagine how an artist might use empty cans to make a toy (Fig. 5–6)?

Fig. 5–3 **From the earliest times, people have decorated objects. Note the decoration on this lamp used to light caves.** Lascaux, *Decorated lamp*, 15,000–13,000 BC.
Musée des Antiquities Nationale, St. Germaine-en-Laye, France. Photo © RMN, Jean Schormans.

Fig. 5–4 **Look closely at all the parts of this basket. How do you think it was made? Why might someone take such care to create a fish trap?** Hiroshima Kazuo, *Fishtrap Basket*, 1986.
Bamboo, rope, metal wire, and synthetic string, 20 1/8" x 20 1/8" x 20 1/8" (51 x 51 x 51 cm). National Museum of Natural History Collections, Smithsonian Institution.

174

Teaching Options

Teaching Through Inquiry

Art Criticism Have students find examples of objects in their homes and community that have the same function as the objects shown here (lamp, basket, quilt, and toy). **Ask:** What materials are used? How are they decorated? Have small groups or the entire class choose one function and find as many visual examples as possible, throughout time and across cultures. Have students group the images of objects according to the types of decoration and then label them with descriptions of the decoration.

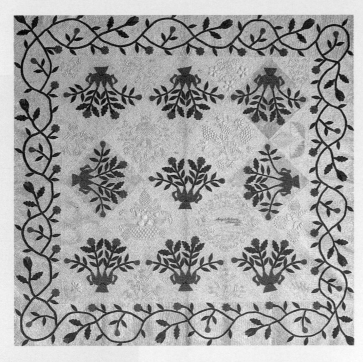

Fig. 5–5 **Mary Carpenter made the top part of this quilt when she was only thirteen. Do you think her sole interest was in making something that would keep her warm?** Mary Carpenter Pickering, *Quilt appliquéd with fruit and flowers,* 1850–54. Cotton fabric, 89 ⅛" x 89 ¼" (226.4 x 226.7 cm). National Museum of American History.

Fig. 5–6 **Daily objects can be recycled to create new forms. Here, a milk can is turned into a toy.** South Africa (Johannesburg), *Deux Chevaux (Toy Car),* 1994. Johannesburg, South Africa. Nestle concentrated milk can. Collection of the International Folk Art Foundation, Museum of International Folk Art, Santa Fe. Photo: John Bigelow Taylor, NYC.

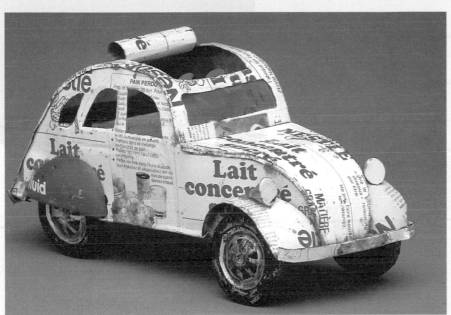

Daily Life

175

Using the Text

Art History Ask students to read the first paragraph on page 174 and then study the prehistoric lamp from a Lascaux cave in central France. The lamp, whose bowl was used for the burning of animal fat, was found near 15,000-year-old murals of bulls, bison, and horses. **Ask:** What new insight does this lamp give you into what life was like 15,000 years ago? Have you ever imagined that objects this old would have been decorated?

Perception Ask students to discuss the craftsmanship necessary to make each object shown here.

Art Criticism Have each student write one or two words that describe each object's form. Compile a list of descriptions.

Using the Art

Perception Ask students to compare the four artworks. **Ask:** What materials were used? Where might each artist have found the materials? *(reeds for fish trap probably grew nearby; stone for lamp was likely from the local area; quilt cloth was from scraps; toy car was made from a recycled milk can)* What was the function of each piece?

Compile a list of similarly crafted objects from students' homes and community.

Using the Large Reproduction

9

Talk It Over

Describe What are the people doing, where are they, and how are they dressed?

Analyze What is the first thing you noticed? How did the artist direct your attention to certain areas?

Interpret What does the artist tell you about the way people lived?

Judge What is special or important about this artwork?

Using the Overhead

10

Think It Through

Ideas What images and ideas might have been important to this artist?

Materials What materials did the artist use?

Techniques How is the artwork formed?

Audience For whom or for what daily-life purpose might this artwork have been made?

175

Using the Text

Art Criticism After students read this material, ask what the three paintings have in common. Students will probably note that people are engaged in some activity.

Divide the class into cooperative-learning groups of four students. Assign each group to study one of these paintings, answer the following questions, and report findings to the class.

Ask:

• In what activity is the group involved?

• What are the people holding in their hands?

• How many people are in the painting? How do these figures interact? Are they overlapped or separated by space? How many groups are shown? Which direction do most of the figures face? How does this focus your attention?

• What is the most important part of the picture?

• Describe the setting or location. What do furniture and wall decorations tell about these people?

Using the Art

Art History Both *The Milkmaid* (page 172), and *The Tailor's Workshop* were painted by seventeenth-century Dutch artists. **Ask:** How are the paintings alike? If students do not say when these were made, ask what clues within the pictures suggest that they were painted in the 1600s. *(dress, setting, painting style)*

Daily-Life Events

Lots of different events make up your daily life. You sometimes gather with friends and family. Perhaps you dance or sing. You play games. Many people also work hard every day. On your way home today, notice the people at work. What are they doing? How are they working? Are they alone or are they working with others? Do they use special equipment? Must they dress in a special way? How might they feel about their work?

Artists notice how people work and play together and alone. Sometimes artists make daily life the subject matter of their artworks. For example, Carmen Lomas Garza likes to show the ways that people in families and communities get together. In her work showing a family get-together for making tamales (Fig. 5–7), we see people working together on an important activity. She also shows us the steps of the process.

Most adults, no matter where they live, spend much of their time working to make a living. Some people find their work satisfying and enjoyable. Others spend years just putting up with a daily struggle. Look closely at a Dutch artist's view of a tailor's shop (Fig. 5–9). What do you think the artist wanted you to know about this kind of work?

Free time is another important part of daily life. The special atmosphere created by people relaxing often appeals to artists. In Jaime Colson's painting (Fig. 5–8), notice the poses of the people. What has the artist done to help show an easy-going atmosphere?

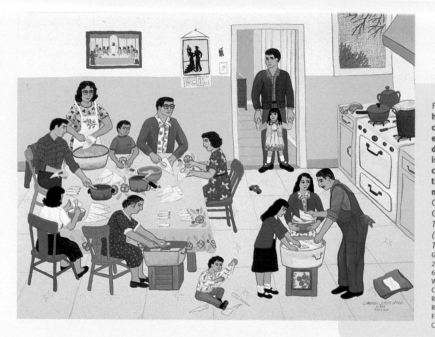

Fig. 5–7 **We see here that families can work together to get a job done. From what is shown here, can you describe the process of making tamales?** Carmen Lomas Garza, *La Tamalada (Making Tamales)*, 1984. Gouache painting, 20" x 27" (50.8 x 68.6 cm). Photo: Wolfgang Dietze. Collection of Leonila Ramirez, Don Ramon's Restaurant, San Francisco, California. Courtesy of the artist.

Teaching Options

Teaching Through Inquiry

Art Production Ask students to find examples in newspapers and magazines of contemporary life around the world. The images should show people involved in daily-life events such as those shown here: family or group gatherings, leisure-time activities, work. Challenge students to use the images, along with those in this book, to generate ideas for an original artwork. Once students have chosen an activity and a setting, ask them to draw upon their own experience to create the artwork. Display artworks after students have grouped them by daily-life activity.

Art History Have students research the making of tamales, the merengue, and seventeenth-century tailoring. Then ask them to use their research to re-examine the paintings here so as to determine what the artists chose to include and exclude. **Ask:** Which artwork tells the most about the subject?

Aesthetics To record daily-life events, must an artist include every detail? Why or why not?

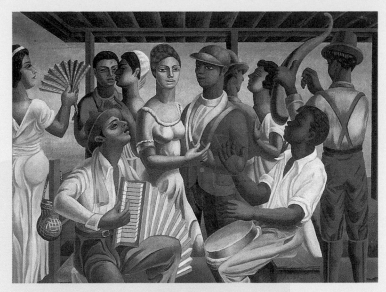

Fig. 5–8 **Artists often show the many ways we spend our free time. Jaime Colson, from the Dominican Republic, showed people dancing the merengue.** Jaime Colson, *Merengue*, 1937.
Tempera on board. Museo Juan Jose Bellapart, Santo Domingo, Dominican Republic.

Fig. 5–9 **In this painting, the artist provided a glimpse of work in seventeenth-century Holland. What clues reveal that the setting is a tailor's shop?** Quinringh Gerritsz van Brekelenkam, *The Tailor's Workshop*, 1661.
Canvas, 26" x 20⅞" (66 x 53 cm). Rijksmuseum, Amsterdam.

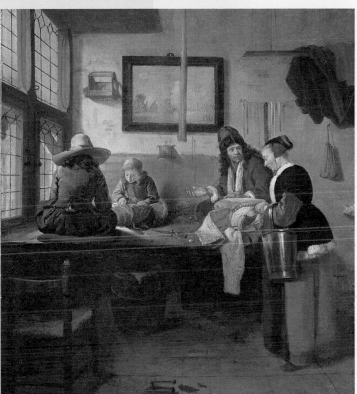

Daily Life

177

Art Criticism Encourage students to compare the three paintings and notice how the design elements and principles help convey the artist's message about the activity.

- Describe the mood in each work.
- Which seems stiffest, with the most straight lines? Which has the most curved and flowing lines?
- Which has the brightest colors?
- Which has the greatest contrast in value?

Extend

Assign groups of students to write a dialogue of what the subjects in one of these paintings might be saying to one another. Ask groups to perform the dialogues.

More About...

Carmen Lomas Garza is a Mexican-American artist who lives in San Francisco. Her very personal paintings portray the life she led while growing up in Kingsville, Texas. She describes the painting in Fig. 5–7 as follows: "This is a scene from my parents' kitchen. Everybody is making tamales. My grandfather is wearing blue overalls and a blue shirt. I'm right next to him with my sister Margie. We're helping to soak the dried leaves from the corn. My mother is spreading the cornmeal dough on the leaves and my aunt and uncle are spreading meat on the dough. My grandmother is lining up the rolled and folded tamales ready for cooking. In some families just the women make tamales, but in our family everybody helps."

CD-ROM Connection

For more images relating to this theme, see the Global Pursuit CD-ROM.

Supplies

- objects from daily life
- flashlight or gooseneck lamp, 1 per setup
- 12" x 18" heavy drawing paper
- soft pencils, erasers
- tempera paint, assorted colors
- paintbrushes
- water in containers

Safety Note
Have students unplug the lamps when they are not in use. Remind students not to look into the light as they work.

Using the Text

Art History Ask students to read Studio Background and the captions. Discuss the meaning of *still life*. **Ask:** Which objects in Fig. 5–10 would be exotic in Holland? *(lemon, parrot)* What might the life cycle of a lemon symbolize? *(birth, life, death of people)* Explain that Fig. 5–11 is an example of twentieth-century photo-realism.

Art Production Rearrange objects to show spacing possibilities. Move the light source to vary shadow effects. Demonstrate mixing tints and shades. Have students practice the painting of one simple form, such as a ball, to show shadows and highlights.

Using the Art

Perception Ask: What is the light source in Fig. 5–11? Where are the shadows? Point out light, dark, and middle values; discuss how the objects fill the canvas, noting the overlapping.

Painting in the Studio
A Still-Life Painting

In this studio experience you will create your own still-life painting of objects from your daily life. Think about objects you collect or like to arrange. Why are they important to you? Do they tell something about who you are? Choose objects that have special meaning to you or that might symbolize something else, like the flowers and fruits in early Dutch paintings.

You Will Need

- paper
- pencils
- tempera paint
- brushes

Studio Background

Paintings of Everyday Objects
Since early times, artists have drawn and painted groups of ordinary objects. In seventeenth-century Holland, artists began to use the term **still life** for paintings in which objects were most important. Dutch artists used food, flowers, and precious objects as symbols to caution people to live good lives. For example, because the beauty of flowers or fruit does not last long, Dutch artists used them in paintings. They wanted to remind people that their lives were also short.

Try This

1. Arrange your objects in several different ways. Think about how your arrangement can express something about your daily life. Choose the arrangement you like the best.

2. If you can control the lighting, direct the light in a way that creates shadows that you like.

3. Sketch your arrangement. Draw the main forms first. Then add the smaller ones.

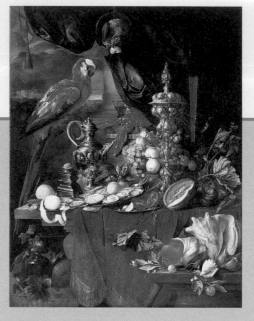

Fig. 5–10 **This painting was made at a time when Dutch merchants were traveling to faraway lands. They often brought back new and unusual foods and objects. The artist arranged a collection of such objects. He also used them symbolically. Can you see any objects that might stand for an idea?** Jan Davidsz de Heem, *A Still Life with Parrots*, late 1640s. Oil on canvas, 59 ¼" x 46 ¼" (150.5 x 117.5 cm). Bequest of John Ringling, Collection of the John and Mable Ringling Museum of Art, the State Art Museum of Florida.

Teaching Options

Meeting Individual Needs

English as a Second Language After discussing the images on pages 178–179, ask students to draw an object from home that is both useful and beautiful (such as an elaborate picture frame, fancy serving dish, fine basket, decorated clock). Have them write a few sentences in English on their drawing, describing the piece's function and why they think it is attractive.

Adaptive Materials In addition to paint, make crayons or markers available.

Focusing Ideas Prepare a still life with two or three simple objects ahead of time.

More About...

Audrey Flack produces both paintings and sculptures. Her still-life paintings make poetic statements about life's beauty and tragedy, and about the good—and the evil—that people can do. Like the Dutch vanitas painters, Flack uses objects as symbols. In this painting, she reminds viewers that life, like the plastic parrot, can be both beautiful and artificial.

4. Paint your composition. Mix and use tints and shades. As you paint, pay careful attention to where light and dark areas are in your arrangement.

Check Your Work

Talk with your classmates about your artworks. Try to use at least five adjectives to describe the qualities of light you see in them. What makes each composition work well? How does the use of light make the objects look? Do they look important? Mysterious? Cheerful? Discuss whatever personal or symbolic meaning the objects seem to have to the artist.

Fig. 5–12 **This student composed a simple still life featuring a bowl of rice, her favorite food. "Rice, mmmm! It is so tasty dressed in soy sauce; even better, butter. Rice can have so many flavors, why wouldn't you like it?"** Abby Reid, *Bowl of Rice*, 1999.
Tempera, 20" x 30" (51 x 76 cm). Shrewsbury Middle School, Shrewsbury, Massachusetts.

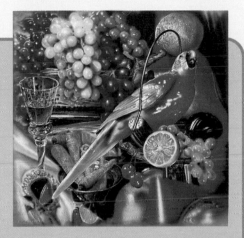

Fig. 5–11 **This painting was made about 300 years after the de Heem still life, yet its message is similar. Plastics were not commonly used until the early twentieth century. Why would a plastic parrot live forever?** Audrey Flack, *Parrots Live Forever*, 1978.
Oil over acrylic on canvas, 83" x 83" (210.8 x 210.8 cm). Courtesy of the Louis K. Meisel Gallery, New York.

Sketchbook Connection
Arrange some fruits, such as apples and oranges. Look closely at the organic forms. Make a series of drawings that capture the colors and textures of the surfaces. Next cut each fruit in half and arrange the halves. Examine the shapes, patterns, and textures on the inside. Make a series of drawings of the inside surfaces.

Core Lesson 5

Check Your Understanding
1. What are some ways that art enters our daily lives?
2. What can a still life painting tell about daily life?
3. What do we mean when we say that Dutch artists used objects as symbols?
4. How are artists observers of life?

Daily Life

179

Sketchbook Tip
Suggest to students that they draw natural objects from different viewpoints.

Assess

Check Your Work

Ask students to step back and view their work, noting value contrasts. **Ask:** Are you satisfied with the overlapping and spacing? Do you want to add or remove any objects? Can you identify each object? Where is the light source? Allow students to revise their work.

Check Your Understanding: Answers

1. through the design and decoration of objects we use every day

2. It can show objects and settings from daily life. When objects are used symbolically, they can send a message about how to live a good life.

3. The objects and their characteristics represented, or stood for, deeper meanings, truths, or lessons.

4. Artists notice how people work and play, and use these activities as subject matter for their art.

Close

Review ways that artists' works make reference to everyday life. Ask for an example (from this book) of a prehistoric, carefully crafted and designed object. *(Fig. 5–3, lamp)* **Ask:** What especially well-designed, everyday utensil or tool do you use? What painting of an ordinary scene especially appealed to you? Why?

After students have written answers to Check Your Understanding, lead a discussion of their answers.

Teaching Through Inquiry

Art Criticism Tell students that critics have said that in her paintings, Audrey Flack releases the voices of objects. Ask students to look at Flack's painting in this lesson and to support or challenge this position. **Ask:** Could the same be said of the work of de Heem?

Assessment Options

Peer Provide students with four objects. For each object, have them write its practical purpose and then provide evidence that the object has an artistic purpose. Have each student check another student's work to see that parts or features for practical purposes and those for artistic purposes are identified.

Teacher Ask students to select an artwork from a previous chapter and write about how the artist recorded daily life. Have students describe the subject matter, tell what is happening, and explain how the artist organized the elements in the scene.

Prepare

Pacing

One 45-minute period for art history

Two or three 45-minute periods for Studio Connection

Objectives

- Identify characteristics of Baroque and Rococo styles.
- Understand that genre scenes are images of everyday life.
- Create a genre scene by using drawing, painting, and collage.

Vocabulary

Baroque An art style and period marked by rich colors and dramatic contrasts of light and shade.

Rococo An eighteenth-century art style marked by delicate colors, airy playfulness, and graceful movement.

genre Subjects and scenes from everyday life.

Supplies for Engage

- triumphal Baroque musical selection: instrumental by Handel or Vivaldi (ask music teacher for suggestions)
- tape or CD player

National Standards
5.1 Art History Lesson

1a Select/analyze media, techniques, processes, reflect.

4a Compare artworks of various eras, cultures.

European Art: 1600–1750

	1656 Velázquez, *Las Meninas*		1732 Hôtel de Soubise, Paris	
Renaissance page 154	**Baroque**		**Rococo**	Neoclassicism page 206
	c. 1650 Rembrandt, *View of Amsterdam*	1658 de Hooch, *Courtyard of a House*	c. 1755 *Soup Tureen*	

Around 1600, exciting changes were taking place in the art world. Artists throughout Europe were competing to paint works of art for people who wanted them.

To please their patrons, artists created fancy works that were full of drama and energy. Artists searched for dramatic ways to show familiar subjects: portraits, still lifes, and scenes of everyday life. Tastes were changing. A bold new art style was formed.

This new art style is called **Baroque.** It began in Italy, but artists throughout Europe liked its power and drama. They used rich textures to add realism. Diagonal lines helped them express movement. Often, Baroque artworks are dramatically lit, like a theater stage. Bright-colored figures or objects emerge from a dim background.

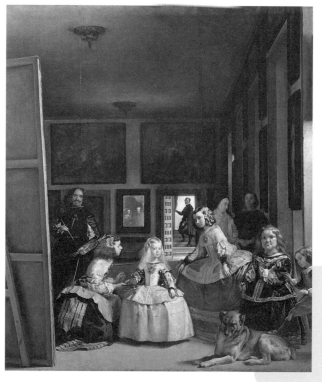

Some words that describe the Baroque style are *grandiose, emotional,* and *exuberant.*

In the 1700s, artists in France took Baroque drama and grandeur one step further. They developed the witty and playful **Rococo** style. Rococo artists used contrast, texture, and movement in their art and architecture. Rococo artists wanted to create a light and airy feeling. Their paintings had shimmering highlights and textures. Their pastel-colored sculptures appeared delicate and fragile.

Fig. 5–13 **Notice how Velázquez used light in this painting of himself, the princess of the Spanish royal court, and her ladies-in-waiting. What direction does the natural light come from? How does this add drama and contrast to the figures?** Diego Velázquez, *Las Meninas (The Maids of Honor),* 1656. Oil on canvas, 10' 7" x 9' ¹/₂" (3.23 x 2.76 m). Derechos Reservados ©Museo Nacional Del Prado, Madrid.

180

Teaching Options

Resources

Teacher's Resource Binder

- Names to Know: 5.1
- A Closer Look: 5.1
- Map: 5.1
- Find Out More: 5.1
- Check Your Work: 5.1
- Assessment Master: 5.1

Overhead Transparency 9

Slides 5d

Meeting Individual Needs

Multiple Intelligences/Musical Have students review the information on pages 180–181. Then play examples of Baroque music (Bach, Handel, Scarlatti) while they imagine themselves in the painting of the royal family (Fig. 5–13) and the grand Parisian hotel (Fig. 5–15). **Ask:** How do both the music and the artwork fit the description of the Baroque period as grandiose, emotional, and exuberant?

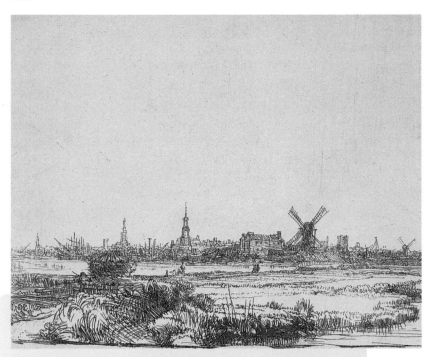

Fig. 5–14 **Prints, especially those showing landscapes, were inexpensive and very popular with the Dutch middle class. Dutch landscape artists such as Rembrandt created realistic scenes of the towns and countryside they saw around them.** Rembrandt van Rijn, *View of Amsterdam*, c. 1650. Rijksmuseum, Amsterdam.

Fig. 5–15 **Rococo architecture was generally lighter and more graceful than the earlier Baroque style. How does this kind of architecture make you feel?** Germain Boffrand, *Salon de la Princesse*, Hotel de Soubise, Paris, begun 1732. Scala/Art Resource, NY.

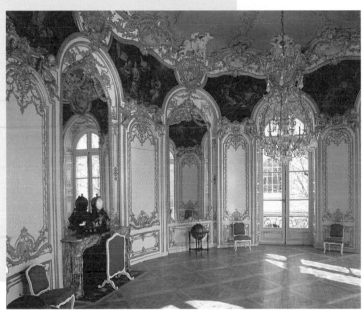

Daily Life

181

Using the Time Line

Ask students to choose one date on the time line and investigate what daily life was like for ordinary people in France, Spain, or Holland at that time.

Teach

Engage

Open this section with some triumphal Baroque music. Explain that the Baroque and Rococo periods occurred during an exciting, optimistic time in Europe. Art was high-spirited, and featured movement and drama.

Using the Text

Have students read page 180. **Ask:** Based on the descriptions of Baroque and Rococo, in which period would you place *Las Meninas*? In which would you place *Salon de la Princesse*? (They should do this without reading the captions.)

Using the Art

Focus on *Las Meninas*. Point out the characteristically Baroque dramatic contrasts of light and dark. Have students answer caption questions.

Tell students that this is a picture of everyday life in the palace of King Philip IV of Spain. Velázquez, who stands behind a huge canvas, is painting a royal portrait. **Ask:** Where are the king and queen standing? *(where the viewer is)*

Teaching Through Inquiry

Use the Rembrandt print and the Rococo architectural interior. Have students work in small groups to write a dialogue between a person who lives in the Rembrandt scene and a person who regularly uses the Rococo interior space. The dialogue should reveal how each person spends a typical day. Caution students to pay attention to and describe each setting. Encourage them to research each period and culture to make sure their situations are authentic.

More About...

Las Meninas has been called the world's best painting. Here, the painter is at work in his studio, which has been invaded by the Princess Margarita with her attendant maids, a dwarf, and a dog. At the far end of the room, a figure looks back as he goes up the stairs beyond an open door. Beside this figure are the framed images, perhaps a mirror reflection, of the king and queen of Spain, who are having their portrait painted, and are presumably standing where the viewer of the painting would be standing.

Velázquez lived and worked in the Spanish court for most of his life and wished to be considered part of the nobility. The red cross on his chest is a symbol of the Order of Santiago, one of Spain's most exclusive knightly orders.

Using the Text

Art History Ask students to read Everyday Splendors and answer the caption question for Fig. 5–18. Lead students in imagining the table setting where this soup tureen would have been found. **Ask:** Why might French patrons have wanted such highly decorated objects?

Using the Art

Aesthetics Have students compare the Rococo soup tureen with other everyday objects in this chapter, by noting surface textures, decoration, coloring, utility, and ornamentation. Ask them to choose one of the objects for their own home and to explain their choice.

Art Criticism Point out that both *Game of Tric-Trac* and *Courtyard of a House in Delft* are *genre* paintings. Review the meaning of *genre,* and discuss setting and mood in the paintings. Have students describe similar scenes from their own life.

Ask students to compare the light—source, lightest and darkest values, mood—in the paintings.

Critical Thinking

Have students look at the soup tureen (Fig. 5–18) and Vermeer's *Milkmaid* (Fig. 5–1). **Ask:** Do you think the milkmaid would use a tureen like this in her own home? Why or why not?

Studio Connection

Have students review this chapter's paintings of people in everyday scenes, which might remind them of similar scenes in their own life that they could depict. Ask students to use pencil or markers to draw such a scene on heavy drawing paper or poster board. Then have them glue on cut-paper textures and add tempera or acrylic paint.

Assess See Teacher's Resource Binder: Check Your Work 5.1.

Extend

Encourage students to research other Dutch Baroque genre scenes, such as those by Judith Leyster, Jan Steen, and Jan Vermeer.

A Glimpse of Daily Life

We know a lot about daily life in seventeenth-century Holland thanks to the visual record the artists and patrons have left behind. Dutch artists were experiencing an exciting time. The middle class in Holland was growing. As people became wealthier, more and more of them were able to buy artworks to decorate their homes. Art was no longer just for the rich and powerful. Almost anyone could buy it.

For their homes, Dutch people wanted art that reminded them of their everyday, comfortable world. This made artists focus on landscapes or on images of everyday life, called **genre** scenes, as their subjects. Artists such as Judith Leyster (Fig. 5–17) and

Pieter de Hooch (Fig. 5–16) became known for their paintings of people and places in Holland. These genre scenes showed ordinary people enjoying their free time. The Dutch saw themselves, their lives, and their activities reflected in these artworks.

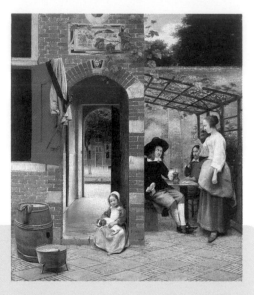

Fig. 5–16 **Dutch Baroque artists had a specific audience in mind when they created their artworks. Why do you think this painting would have appealed to the country's new middle class?** Pieter de Hooch, *Courtyard of a House in Delft*, 1658. Canvas laid down on panel, 26 ⁵⁄₈" x 22 ⁵⁄₈" (67.8 x 57.5 cm). Private collection. Courtesy Noortman Ltd.

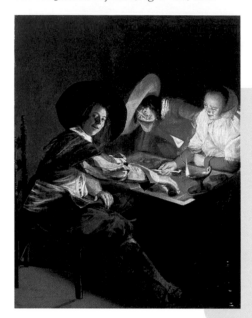

Fig. 5–17 **This interior genre scene shows an ordinary Dutch family enjoying themselves at a popular game, similar to backgammon.** Judith Leyster, *Game of Tric-Trac*. Oil on panel, 16" x 12 ¼" (40.7 x 31.1 cm). Worcester Art Museum, Worcester, Massachusetts. Gift of Robert and Mary S. Cushman.

Teaching Options

Teaching Through Inquiry

Write the statements below on the board, and direct students to study Figs. 5–1, 5–9, 5–14, 5–16, 5–17, 5–20. Have them work in small groups to decide which statements were most likely to have been made by seventeenth-century Dutch citizens. By identifying the accurate statements, students can formalize a response to this question: What did artworks like those by Dutch artists in this chapter mean to the people of seventeenth-century Holland?

We enjoy the comfort of our homes.

Most of us live in poverty.

We enjoy pictures on our walls.

We do not decorate our homes.

We can afford to buy art.

Art is only for churches and royalty.

We like images of religious idols.

We like pictures of familiar, real things.

Everyday Splendors

Rococo artists took the lessons of Baroque art to new heights. They decided to trade Baroque heaviness and seriousness for wit and whimsy. Rococo art reflected the tastes of the wealthy upper class of French society. French patrons valued elegance and wit. They wanted whimsical artworks that showed them enjoying their leisure time.

Soon these patrons wanted furniture, statues, and other household decorations in the Rococo style. Even everyday objects—salt shakers, clocks, dishware—showed the frills and charm of this new style. Look at the everyday object used to serve soup in Fig. 5–18. What does it tell you about life in eighteenth-century France?

Studio Connection

Combine drawing, painting, and collage to create an interior scene from everyday life. Use perspective and overlapping to show foreground, middle ground, and background. Think about how you might use a light source, color, and value for dramatic effects.

To add interest to your scene, create a series of crayon rubbings. Cut shapes from these rubbings. You might also combine them with magazine cutouts to add pattern and detail to some surfaces.

5.1 Art History

Check Your Understanding

1. How was the use of art in seventeenth-century Holland different from that in other parts of Europe at the time?
2. What are the characteristics of Baroque art?
3. What kind of daily life was depicted in Rococo art?
4. How is the art of Spanish court artist Velázquez similar to and different from the art of Dutch painters of this time?

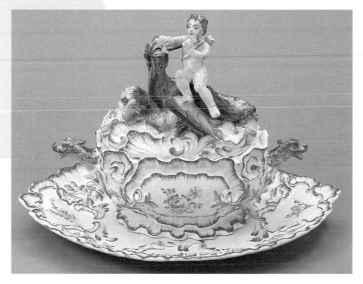

Fig. 5–18 **The Rococo style appeared in all kinds of objects. What do you think it would be like to serve soup from this tureen?** *Soup Tureen, Cover, and Stand,* c. 1755.
Faience with enamel decoration, 11 ⁷/₈" x 14" x 17 ⁷/₈" (30.1 x 35.5 x 45.4 cm).
Sceaux Pottery and Porcelain Manufactory, France. Nelson-Atkins Museum of Art, Kansas City, Missouri (Purchase: Nelson Trust). Photography by E.G. Schempf. ©1999. The Nelson Gallery Foundation. All Reproduction Rights Reserved.

Daily Life

183

Assess

Check Your Understanding: Answers

1. Art was used to decorate the homes of ordinary, middle-class people.

2. grandiose, emotional, and exuberant style; rich texture; dramatic light

3. the leisure time and playful activities of the wealthy upper classes

4. The art of both deals with daily-life events, often in dramatically lit and carefully composed settings. However, the subjects are people of different classes, and the Dutch settings are less grand.

Close

Direct students to select a Baroque or Rococo artwork and explain how it is typical of its period. Students may do this in a group, or they may write their explanation.

More About...

Genre is a term used in art history and art criticism for artworks depicting **scenes from daily life**. The term is applicable to the art of any place or time, but most commonly refers to subject matter made popular by seventeenth-century Dutch artists. A genre painting might depict a domestic interior or a rural or village street scene.

Using the Overhead

Investigate the Past

Describe
What objects do you see? How are they arranged?

9

Attribute What helps you identify this artwork as Baroque?

Interpret What might people have liked about this artwork when it was made?

Explain How might earlier still-life artists have influenced this artist?

Assessment Options

Peer Ask each student to write words that describe the Baroque style *(grandiose, emotional, exuberant),* and words that describe the Rococo style *(witty, playful, delicate).* Challenge students to find images in magazines—of fashions, room interiors, or architecture—that each set of words describes. Have groups work to select the best examples of "the look of Rococo" and "the look of Baroque." Have students share and evaluate reasons for their choices.

Prepare

Pacing

One or two 45-minute class periods

Objectives

- Recognize and identify value and contrast in artworks.

- Use value contrasts to create their own drawing and collage scene of an American-life activity.

Vocabulary

value The range of light and dark in a color or tone.

contrast A difference between two design elements.

Teach

Using the Text

Have students read and discuss the text and captions. Shine a light on a volunteer's face from different directions and distances. Encourage students to describe how shadows and moods change as a result.

Using the Art

Perception Ask students to identify the light source in each painting; guide them to locate the light, dark, and middle values. **Ask:** Where are the greatest value contrasts? When you squint, what do you see first? Note that the center of interest usually has the greatest value contrast.

Light, Value, and Contrast

We need light to see what is around us. The artists of the works shown on these pages lived in a time before the invention of the electric light bulb. They painted objects from their daily lives lit only by the sun or by lanterns. The objects in these paintings have deep shadows and strong highlights. Using the language of art, we say these paintings show contrast between dark and light values. This contrast helps make the items look three-dimensional, as if they exist in space.

Looking at Value

Value is the range of light and dark in a color. The artists of these works carefully chose light and dark values of paint. They used these values to make the objects seem real to viewers. They used dark values of paint to make the shadows that provide a sense of depth. They painted the lightest values in the areas facing the source of light. Can you identify the direction light comes from in each painting?

Shading is a gradual change in value. It is used to show the shift from dark areas to light ones. Notice how Clara Peeters used shading to show the round forms of fruit in her painting (Fig. 5–20). Gradual changes in value can give the sense of a misty atmosphere or a mood of calmness or quiet. More sudden changes in value create a strong contrast between very light areas and areas of deep shadow, as in Rembrandt's *Side of Beef* (Fig. 5–21).

Fig. 5–19 **How would you describe the artist's use of contrast in this work?** Jean-Baptiste Simeon Chardin, *The Silver Goblet*, c. 1760.
Louvre, Paris, France. Giraudon/Art Resource, NY.

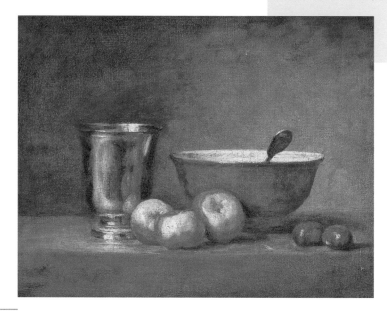

184

National Standards
5.2 Elements and Principles Lesson

2c Select, use structures, functions.

Teaching Options

Resources

Teacher's Resource Binder
 Finder Cards: 5.2
 A Closer Look: 5.2
 Find Out More: 5.2
 Check Your Work: 5.2
 Assessment Master: 5.2
Overhead Transparency 9

Using the Overhead

Write It Down

Describe Have students write three or more words to describe the elements of light, value, and contrast in this artwork.

9

Analyze Have students write two or three sentences about how the artist used light, value, and contrast to organize this artwork.

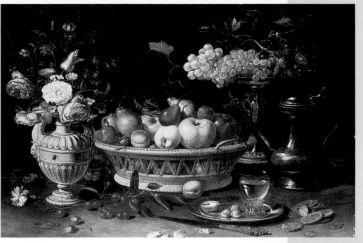

Fig. 5–20 **People in seventeenth-century Holland enjoyed decorating their homes with artworks of objects and scenes they saw every day. Where did this artist use the most contrast in her work?** Clara Peeters, *Still Life with Nuts and Fruit*, after 1620. ©Ashmolean Museum, Oxford.

Fig. 5–21 **Would you want to decorate your home with this painting? What do you think interested the artist about this scene?** Rembrandt van Rijn, *Side of Beef*, 1655. Oil on canvas, 37" x 27 ⅛" (94 x 69 cm). Louvre, Paris. Giraudon/Art Resource, NY.

Art History Point out the exotic fruits in Peeters's painting: these were available in Holland at the time, either from world trade or from cultivation in the country's greenhouses. The artist's patrons recognized the symbolic meanings of the objects, which were to remind them of their mortality.

Looking at Contrast

Contrast is a great difference between two things. A contrast in values creates a noticeable difference between light and dark in a composition. This design principle allows artists to add excitement or drama to their work, as we can see in these paintings of daily life. Often, the area of an artwork with the greatest contrast captures our attention first.

Value is only one element artists can contrast in their work. Peeters and Chardin (Fig. 5–19) used color contrast in their paintings. Rembrandt contrasted the smooth texture of meat and muscle in the animal carcass with the rough wood and stone of the building. Can you find other examples of contrast in these three works?

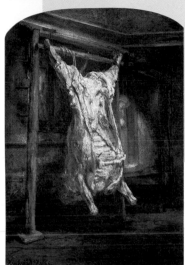

5.2 Elements & Principles

Check Your Understanding
1. How do value and shading help artists make objects look more realistic?
2. How might the artworks on these pages look different if a strong spotlight had been used to illuminate the objects in each?

Studio Connection
Use pencil or charcoal to make a careful drawing of an everyday object. Locate the light source. Notice where the light creates highlights and shadows on the object. Experiment with shading. Apply pressure to the pencil or charcoal to create dark values. Use less pressure to create light values.

Daily Life

185

Studio Connection

Provide still-life objects, such as tools or sports equipment; and encourage students to concentrate on the contrast of light and dark. Suggest ways to blend values (using fingers, tissue) and create lighter areas with an eraser.

Assess See Teacher's Resource Binder: Check Your Work 5.2.

Assess

Check Your Understanding: Answers

1. Highlights, shadows, and contrast help make items look three-dimensional, as if they exist in space.

2. Items would have stronger shadows, darker values, brighter highlights, and greater contrast.

Close

Review the terms that describe value *(light, dark)* and contrast *(sharp, gradual)*. Ask students to think about the value and contrast controls on a TV. **Ask:** How do changes in value and contrast affect your viewing?

Teaching Through Inquiry

For the three images in this lesson, write the following two lists on the board.

Descriptors of light, value, contrast:
• extreme contrast in values
• gradual changes in value
• contrast in texture
• bright highlights
• deep, dark shadows

Descriptors of feelings:
calm, quiet, serene, mysterious, eerie, scary, exuberant, fancy, simple, energetic, dramatic

Have students use the words from the lists—or their own words—to complete this prompt for each artwork: In (title of painting), (name of the artist) used (choose descriptors of light, value, contrast) to create a feeling of (choose one or more descriptors of feelings).

More About...

The Latin *vanitas* means "worthlessness." In a **vanitas painting**, still-life objects such as wilting flowers, candles, hourglasses, and skulls symbolize the quick passage of life. Coins and jewels refer to the futility of wealth, and empty vessels suggest life's emptiness. During the seventeenth century, vanitas paintings were popular Dutch themes.

Assessment Options

Teacher Find examples of the use of light, value, and contrast in contemporary advertising. Have each student make a booklet of images and descriptive words for them, or have groups make a display.

Prepare

Pacing

Three 45-minute class periods—one to consider images and two for studio experience

Objectives

- Understand the influence that European conquests of the 1500s had on Latin American art.
- Explain how visual qualities influence the moods and feelings in twentieth-century Latin American artworks, such as those by Diego Rivera and Ramon Frade.
- Create a genre painting of an outdoor scene by using a mixed-media technique.

Vocabulary

pre-Columbian Relating to the culture of Mesoamerica and South America before the arrival of European settlers.

> ### Supplies for Engage
> - Latin American music and food

Using the Map

Emphasize that Latin America includes Mexico, the Caribbean islands, and Central and South America. Have students read the captions to discover where each work was made and then to locate the artist's home on the map.

The Art of Latin America

Artists of Latin America have always been interested in decorating objects they use every day. They often show scenes of their daily life, activities, and work.

You may be wondering: Where is Latin America? Latin America is really a term that groups together many different countries on two continents: Mexico, countries in South America and Central America, and the Caribbean islands. The history of each of these countries is very different. But they all share one important historical event. All these countries were taken over by European settlers in the 1500s.

In the next pages, you will see examples of Latin American art from ancient to modern times. The art of these countries is varied and diverse, just like the countries themselves. But all these artworks provide valuable clues about the daily life of the people.

Fig. 5–22 **This Cuban artist often painted interior scenes and still lifes of fruits. The strong black outlines and bright-colored shapes look like the stained-glass windows in old-fashioned Cuban homes.** Amelia Pelaez, *Still Life*, 1942. Gouache and watercolor, 29 7/8" x 28 3/8" (75.7 x 72 cm). ©Christie's Images, Ltd, 1999.

186

> ### National Standards
> ### 5.3 Global View Lesson
>
> **1a** Select/analyze media, techniques, processes, reflect.
>
> **4c** Analyze, demonstrate how time and place influence visual characteristics.

Teaching Options

> ### Resources
>
> Teacher's Resource Binder
> A Closer Look: 5.3
> Map: 5.3
> Find Out More: 5.3
> Check Your Work: 5.3
> Assessment Master: 5.3
> Large Reproduction 10
> Slides 5e

> ### Teaching Through Inquiry
>
> **Art History** Ask students to imagine that they can call an 800 number to verify the style of a work (the characteristics of artworks that are consistent with those of others made by a particular person, or in a particular place or time). To obtain the name of an artwork's style, callers must observe it carefully and describe it in complete detail (size, shape, color, pattern, texture, subject matter, and so on). For each artwork on pages 186–189, what information would students need to make this call?

Pre-Columbian Art

Many civilizations were flourishing in the Americas long before the arrival of Europeans. We call the art these cultures made before the arrival of European settlers **pre-Columbian**, meaning "before Columbus." This art was created without influences from Europe. After the settlers arrived, the style and content of much of this art changed.

Clues to Daily Life

People of these early cultures are known for the many kinds of objects they decorated. They painted pottery, carved stone calendars, formed metal vessels, and wove colorful patterned textiles. Each culture became skillful at working with certain art materials. They used these materials to craft everyday and ceremonial objects.

Art was part of people's everyday lives. They decorated the objects they wore with human and animal designs. These designs reminded them of nature and their gods, which were important to their survival.

Unfortunately, when some European settlers arrived, they destroyed many objects the native cultures had produced. Those made of gold, silver, and other precious metals were most often destroyed. But many examples have been uncovered from tombs or found in the ruins of ancient cities. These objects allow us a glimpse into daily life in these ancient cultures.

Fig. 5-23 **An ancient Mayan ceremonial ball game was popular subject matter for sculptures such as this one. Why do you think the Maya wanted to make artworks showing this game?** Mayan, *Model of a Ball Game*. Pottery, 6 ½" x 14 ½" x 10 ⅝" (16.5 x 36.8 x 27 cm). Worcester Art Museum, Worcester, Massachusetts. Gift of Mr. and Mrs. Aldus Chapin Higgins. Photo ©Worcester Art Museum.

Fig. 5–24 **Pre-Columbian cultures in Peru are known for their textiles, including ponchos (a kind of cape) and tapestries. Like many Peruvian textiles, this one was buried in the desert and has been preserved in perfect condition. Find the cats that make up part of this poncho's design. Do you think cats were important to this culture?** Peru, Paracas, *Poncho*, 300–100 BC. Wool embroidery on cotton, 30" x 23 ⅝" (76 x 60 cm). 24:1956. St. Louis Art Museum.

Daily Life

187

Using the Text

Art Criticism After the class reads A Celebration of the Worker and the captions, discuss answers to the caption questions.

Using the Art

Art Criticism As students study the paintings on these pages, **ask**: what is the common theme? *(people working)* **Ask**: How did the artists make the workers important? *(by painting the figures large and filling the scene with their bodies)* Note value contrasts in each work, and how the artist used contrasts to focus attention on the main subject. **Ask**: What does each subject hold? What is each subject wearing? What is in the background of each painting?

Art History Mexican artist Diego Rivera was most famous for huge murals in which he organized hundreds of images of workers into compositions similar to Aztec paintings. Tell students that Rivera was a Cubist painter in Paris before returning to his homeland. **Ask**: What influence of Cubism do you see in the form of this figure? *(It has been simplified and flattened.)*

Studio Connection

 Have students look again at Fig. 5–25, *Our Daily Bread*. Point out that it shows a figure working outdoors. **Ask**: What is in the background and foreground? Explain to students that they will create a genre painting or drawing of people in an outdoor setting. Make a list of student suggestions of activities they might draw.

Modern Latin American Art

After centuries of European rule, the countries of Latin America eventually gained their freedom. Some Latin American artists decided to return to the themes and images from their past. They wanted to show a connection with their nearly forgotten native heritage.

A Celebration of the Worker

Like pre-Columbian art, modern Latin American art also gives us clues about everyday life. But modern artists seem to be sending us a different message about the

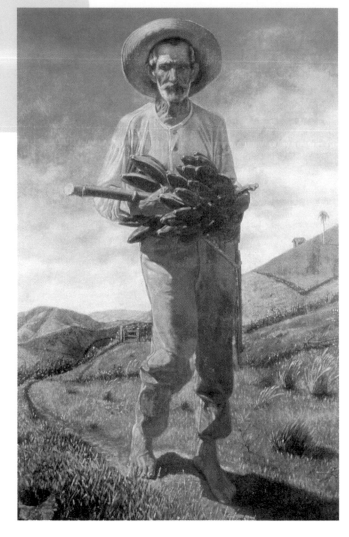

Fig. 5–25 **This work is a criticism of the difficult labor many people had to face in the artist's homeland of Puerto Rico. Why do you think he gave this painting showing a man carrying bananas the title *Our Daily Bread*?** Ramon Frade, *Our Daily Bread*, c. 1905. Puerto Rico. Institute de Cultura Puertoriquans, Galeria Botello, Hato Ray, PR. Photo by John Betancourt.

Teaching Options

Meeting Individual Needs

Gifted and Talented/Multiple Intelligences-Linguistic Ask students to review the text and images on pages 188–189. Then have them read newspaper or journal articles about the plight of workers anywhere. Challenge students to communicate the information in an artwork.

More About...

In his murals, Mexican painter **Diego Rivera** (1886–1957) featured workers and their plight. Although he was active in the Communist Party, he was expelled from it when he accepted commissions from American industrialists. Because he included a portrait of Lenin in his mural for Rockefeller Center, his sponsors had the entire work destroyed. Rivera was married to painter Frida Kahlo.

daily life around them. These artists often focused on the life of the worker, showing scenes of daily household chores or farm work. They showed the hard labor of people who worked the land. They pointed out how such workers helped their country prosper. Through their celebration of the worker, modern Latin American artists hope to make others aware of the often overlooked value and dignity of work.

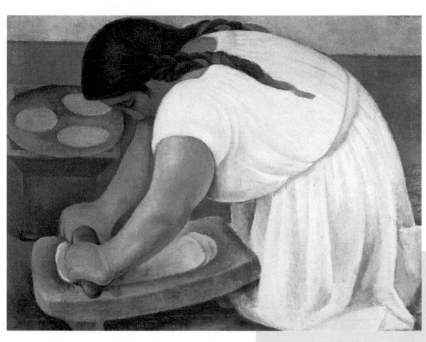

Fig. 5–26 **Diego Rivera wanted to present native Mexicans with dignity and show their everyday lives. How has he shown that grinding corn is hard work?** Diego Rivera, *Woman Grinding Maize*, 1924.
Mexico. Museo Nacional de Arte, Mexico City CNCA-INBA

Studio Connection

Scenes of everyday life, or genre paintings, often show people in their homes. Outdoor genre scenes might show life in the city, in the suburbs, or on a farm.

For your genre painting, choose an outdoor scene of people at work or play. Think of your favorite weekend activity, one of the outdoor chores you do, or a recess game at school. Try using a mixed-media technique. For example, you might use oil pastels with collage and tempera paints. What other combinations are possible? Which one is best for your subject?

5.3 Global View

Check Your Understanding
1. What major event occurred in Latin America in the early 1500s?
2. What do we call the art made by Latin American cultures before the arrival of Christopher Columbus and European settlers?
3. Name two kinds of objects for which early Latin American cultures are known.
4. Why have some modern Latin American artists chosen to show workers in their artworks?

Daily Life

189

Have students draw with pencil on heavy drawing paper or illustration board, 9" x 12" or larger. They may use oil pastels, tempera, and collage, as suggested, or you may give them a choice of media.

Assess See Teacher's Resource Binder: Check Your Work 5.3.

Extend

Students may want to learn more about Rivera's murals on public buildings in the U.S. and Mexico City. After viewing Rivera's murals, students may paint their own mural on a wall or a 4' x 8' sheet of plywood or Masonite.

Assess

Check Your Understanding: Answers

1. Latin America was conquered by Europeans.

2. pre-Columbian art

3. It showed the influence of European art.

4. the life of workers, with their daily tasks; the value and dignity of work

Close

Review what pre-Columbian art is and where it was made. Ask students to name two twentieth-century Latin American artists. Have them answer questions in Check Your Understanding, and then review the answers in a class discussion.

Teaching Through Inquiry

Art Criticism Have students work in pairs or small groups and imagine that they are to provide visual images for two political candidates. One candidate promises to improve working conditions, and she needs images that show work as humbling, humiliating, and wearisome. The other candidate believes that working conditions are fine, and he needs images that show the pride in, and dignity of, work.

The students' challenge is to verbally convince both candidates that the works by Frade and Rivera are well-suited to their campaign. This requires being able to see that the same artworks can be interpreted in very different ways. To justify their interpretation, have students point to evidence in each work.

Aesthetics Review the reasons given for the different interpretations in the previous exercise. **Ask:** Were some interpretations better supported than others? Why? Can an interpretation be absolutely wrong? Lead a discussion in which students speculate about the characteristics of good interpretations.

Assessment Options

Teacher Ask students to note the artworks in this lesson that were made before 1500 and those that were made later. Have students identify several ways that the pre-1500 artworks are unlike European artworks, and the ways that the post-1500 pieces are like European artworks.

STUDIO LESSON

5.4

Prepare

Pacing

Three or four 45-minute class periods: one to introduce and build armature, one to papier-mâché, one to paint, and one to add final touches

Objectives

- Describe details and features of functional and decorative objects.
- Distinguish between Rococo and pre-Columbian decorative styles.
- Embellish a functional container with papier-mâché to express something about daily life.

Supplies

- wheat paste: mix water with powder, stirring constantly until thick and creamy; store up to several days in covered containers; thin with water as necessary
- alternative to wheat paste: diluted white school glue (dries faster)
- clear acrylic or varnish, to protect tempera-painted forms

Safety Note

Commercial wallpaper paste may contain chemicals that are harmful to skin.

National Standards 5.4 Studio Lesson

3b Use subjects, themes, symbols that communicate meaning.

4a Compare artworks of various eras, cultures.

5a Compare multiple purposes for creating art.

Decorating a Container

Adding Meaning to Daily Life

Studio Introduction

Picture your favorite drinking glass, lunchbox, or other container that you use every day. How is it decorated? Is it painted with a design? Were decorations added to its surface? Is the form itself decorative?

Now think about other things you see in your daily life: furniture, lamps, linens, dinnerware. Cultures all over the world decorate objects like these. Many objects are simply patterned, while others appear complicated and overdone. Some are not decorated at all.

In this studio lesson, you will decorate an everyday container. Pages 192 and 193 will tell you how to do it. The features and decorations you add to the container should express something about your daily life.

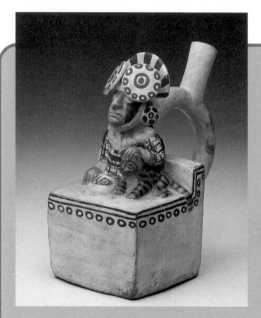

Fig. 5–27 **Stirrup vessels have a hollow handle and spout through which liquid is poured. Many take the form of an animal or human head and are painted with colored clay slips. What might the forms and decorations you see on this vessel represent? What main shapes do you see?** Peru (Mochica culture), *Stirrup Vessel representing seated ruler with pampas cat*, 250–550 AD. Ceramic, 7 5/8" x 7 1/2" (19.4 x 19.1 cm). Kate S. Buckingham Endowment, 1955.2281. Photograph ©1999 The Art Institute of Chicago, All Rights Reserved.

Studio Background

Decorating for Daily Life

The Rococo art style, which started in eighteenth-century France, is known for its extreme amount of detail. Porcelain pieces (Figs. 5–29 and 5–30) from this period are highly decorated and playful. You might think that Rococo artists "went overboard" with intricate detail, but the ornate style was an expression of a new lighthearted spirit in Europe.

Pre-Columbian vessels and sculpture contrast sharply with the delicate forms and pastel colors of Rococo objects. Pottery from the pre-Columbian period (Fig. 5–27) is fairly plain and is decorated with simple, often geometric, shapes that resemble symbols. Its colors are usually soft and dull. Most pre-Columbian objects that have lasted to the present had ceremonial uses. They generally have a more serious tone than Rococo objects.

Teaching Options

Resources

Teacher's Resource Binder
- Studio Master: 5.4
- Studio Reflection: 5.4
- A Closer Look: 5.4
- Find Out More: 5.4
- Large Reproduction 9
- Overhead Transparency 10
- Slides 5f

Meeting Individual Needs

Adaptive Materials Provide large containers. Soften ceramic clay by adding more water, or provide a softer material, such as Model Magic or a sculpting foam.

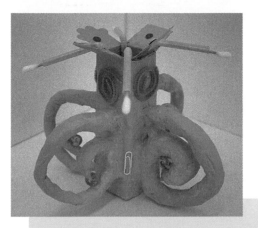

Fig. 5–28 **"Creating a Rococo style container was a real challenge at first. Then I was inspired! An origami gift box was perfect for the project. Papier-mâché gave the basic form a whole new look."** Claire Whang, *Rococo Container*, 1999.
Papier-mâché, acrylic, found objects, 7" x 9" x 9" (18 x 23 x 23 cm). Plum Grove Junior High School, Rolling Meadows, Illinois.

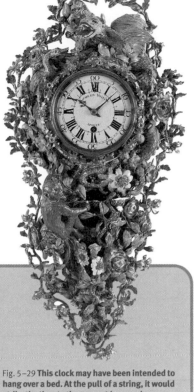

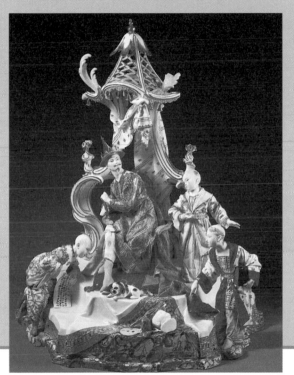

Fig. 5–29 **This clock may have been intended to hang over a bed. At the pull of a string, it would strike the time to the nearest hour and a quarter. How would you describe the textures you see in the clock's decoration?** Movement made by Charles Voisin and Chantilly manufactory, *Wall Clock*, c. 1740.
Soft-paste porcelain, enameled metal, gilt-bronze, and glass. 29 ¹/₂" x 14" x 4 ³/₈" (74.9 x 35.6 x 11.1 cm).
The J. Paul Getty Museum, Los Angeles.

Fig. 5–30 **This Rococo sculpture was a table centerpiece. How is this centerpiece different from one you might find in your own home? How many patterns can you find?** Johann Peter Melchior (modeled by), *The Audience of the Chinese Emperor*, c. 1766.
Hard-paste porcelain, height: 15 ⁷/₈" (40.3 cm). The Metropolitan Museum of Art, Gift of R. Thornton Wilson, in memory of Florence Ellsworth Wilson, 1950. (50.211.217) Photo © 1990 The Metropolitan Museum of Art

Daily Life

191

Teach

Engage

Ask: What about a person's special mug or cup helps identify the owner? Tell students that they will design a container that has something to do with their life.

Using the Text

Call students' attention to the adjectives that describe Rococo objects (*playful, ornate*) and pre-Columbian (*serious, plain*) objects. **Ask:** How might objects be made both plain and playful, or ornate and serious? Have you ever seen such objects? Where? How could you change ordinary objects in this classroom to be plain and playful, or ornate and serious?

Using the Art

Tell each student to write two adjectives to describe the Rococo clock and two different adjectives for the pre-Columbian vessel. Compile the words into two lists on the board. Have students compare the two styles. **Ask:** Which style would be more appropriate on a container that describes your life?

Critical Thinking

Ask: What do we mean when we say that someone "got carried away" when decorating a house? *(that the person didn't know when to stop decorating)* How could we explain that some people might have the opposite opinion of the house? *(People have different ideas about what is beautiful.)*

Teaching Through Inquiry

Aesthetics Have students work in small groups to discuss the following: When does decoration get in the way of the function of an object? Can something ever be too decorative? What are some examples? Ask each group to list their major points and any additional questions, and to share their findings with the rest of the class.

Wit and Wisdom

The term **Rococo** was not always used positively to describe a style of art; originally, it was used negatively to describe a style that was excessively ornate. With changes in taste, Rococo's connotation became more positive. Decorative art that was once viewed as excessively ornate was later valued for its coherence and consistency.

Using the Large Reproduction

9

Look Closely

Context Have students describe how the objects in this room are decorated. **Ask:** What similarities do you see between these objects and other objects shown in this chapter?

Decorating a Container

Studio Experience

Have students complete the following steps:

1. Study the shape of your container. Does the shape remind you of anything?

2. Cut out cardboard shapes for extensions such as handles; tape to the main form.

3. Tear newspaper into 1"-to-2"-wide strips.

4. Dip each strip into wheat paste. Squeegee off excess between two fingers.

5. Spread the strip on the form, smoothing out bumps.

6. Cover the form and extensions with five layers. Add a layer of paper towels as a final, smooth surface.

7. Allow to dry overnight or for several days.

8. Paint large areas of color first. Use a finer brush for details.

9. Glue on found objects and textures.

10. Sign the bottom of your container.

Idea Generators

Ask: What are your interests? Do you have a favorite sports team or music group? What do you do after school?

Studio Tips

• Have several students share one large container of wheat paste or glue.

• To promote drying, store forms in a well-ventilated area.

Computer Option
Do a preliminary search, and then have students do an Internet search with the key words "cyber pet," "virtual pet," and "Net Pet." Ask students to choose a virtual pet and become familiar with its habits and routines. **Ask:** How can you improve the design of your pet dish? Would it work better if it were larger? Taller? How could you improve the pet's environment as a whole? Have students use paint software to create a potential environment for the pet.

Sculpture in the Studio
Decorating Your Container

You Will Need
- sketch paper
- pencils
- container
- cardboard
- newspaper
- scissors
- tape
- wheat paste
- paints
- brushes
- found objects
- glue

Try This

1. Discuss the artworks shown in this lesson. How do the decorations on the clock, centerpiece, and stirrup vessel reflect the ideas or interests of each culture? Which decorative style appeals to you more? Why? How might you use features from that style to decorate your own everyday container?

2. Look at your container. What kinds of decorative features and decorations can you add that will express something about your life? Sketch your ideas.

3. Using the container as your base, build an armature onto which you will apply papier-mâché. Tape features made from cutout cardboard or wads of newspaper securely to the container.

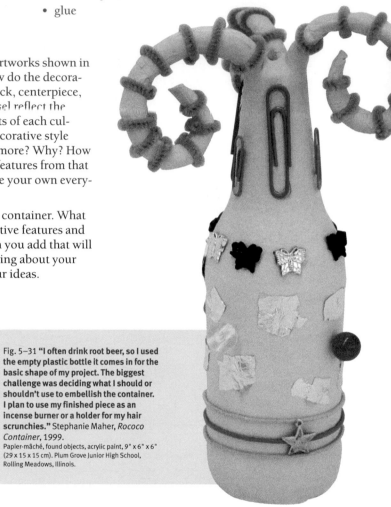

Fig. 5–31 **"I often drink root beer, so I used the empty plastic bottle it comes in for the basic shape of my project. The biggest challenge was deciding what I should or shouldn't use to embellish the container. I plan to use my finished piece as an incense burner or a holder for my hair scrunchies."** Stephanie Maher, *Rococo Container*, 1999.
Papier-mâché, found objects, acrylic paint, 9" x 6" x 6" (29 x 15 x 15 cm). Plum Grove Junior High School, Rolling Meadows, Illinois.

Teaching Options

Teaching Through Inquiry

Art Production Students may work in groups to create a set of containers around a unifying theme, such as a school subject or positions on a ball team.

Using the Overhead

Think It Through

Ideas What images and ideas might have been important to this artist? Do you see similarities between this object and another object shown in this lesson?

Materials What materials did the artist use?

10

Techniques How was the artwork formed?

Audience For whom or what purpose might this artwork have been made?

4. When all the parts are in place, cover the whole form with five or six layers of papier-mâché. Make sure that each layer is smooth and even. Let the work dry completely.

5. Paint your container. Choose a color scheme that best fits your daily life. When the paint is dry, decorate the container with buttons, sequins, beads, ribbons, foil, tissue papers, or other found objects.

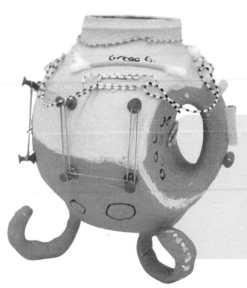

Check Your Work

Identify the best features of your work. What do your decorations say about your culture or your daily life? Why is the decorative style you chose appropriate for your container? Is this a container you could use every day? Why or why not?

Sketchbook Connection
Sketch an ordinary object—a telephone, vegetable peeler, remote control, or the like—that you see or use every day but never really paid attention to. When you are finished, write a brief paragraph describing something new that you learned about the object while sketching it.

Computer Option
Design a "virtual" pet's food or water dish. Decorate with fanciful details such as a pedestal, handles, or mirrors. Add as much detail as possible. What kind of a pet will use the dish? For example, a pet with a long neck could reach high up off the floor. How can you use pattern, color, and contrast to embellish the dish?

Fig. 5–52 "One of my interests is baseball, so when I was looking for a ready-made container, I chose a plastic mug I had saved that was in the shape of a baseball. I was surprised to see that I could use something like rubber bands and push pins to create a decorative repeated pattern that I really liked. My Rococo-style container will make a neat pencil holder for my desk at home."
Greg Greener, *Rococo Container*, 1999.
Papier-mâché, found objects, acrylic paint, 8" x 6" x 6" (20 x 15 x 15 cm). Plum Grove Junior High School, Rolling Meadows, Illinois.

Daily Life

193

Extend
Students may research pre-Columbian calendars (circular carved stones) and then create their own calendar based on important events in their life.

Sketchbook Tip
Encourage students to incorporate written comments on the same page as their drawings. Discuss various ways to organize words and images in an orderly, yet creative and pleasing way.

Assess

Check Your Work
Encourage students to look at their container from all angles. **Ask:** Is the container completely covered with paint? Would it be more interesting with more textures? What message does it send about you or your interests? How might you make your message clearer?

Close

Display students' containers. Encourage them to explain what they were trying to show. **Ask:** Does everyone understand the message? What changes could be made to make the meaning clearer? Which containers seem to be in a Rococo style? Which are more like pre-Columbian art?

More About...
The use of **papier-mâché** can be traced back to the second century. The skills developed by the Chinese, in the form of objects such as papier-mâché warrior's helmets, spread eastward to Japan and westward to Europe. Papier-mâché became an important medium in the Rococo style. It was used for elaborate decorative details on ceilings and walls, and to form ornate furniture and objets d'art. Papier-mâché can transform mundane, disposable household materials into lavish and festive objets d'art.

Assessment Options

Teacher Borrow six or eight patterns of silverware or miscellaneous coffee cups in assorted patterns—from very simple to very ornate. Display the objects, and number each one. Ask students to rank them from the most simple to the most ornate. Have them write a short description of each object.

Teacher Prepare a handout with the outline of two cylindrical containers. Ask students to use colored pencils to decorate one in the Rococo style and the other in the pre-Columbian style. Have them write a short description of each.

Careers

Ask students which products they most often see in television and magazines. No doubt, automobile commercials and ads will be included in students' responses. To demonstrate the significant impact of automotive design on consumers, have students bring in magazine ads that depict new cars. Display the ads and have students compare and contrast the merits of design. List specific design characteristics as students note them. Then ask students to choose their favorites and share the reasons for their choices. Direct student attention back to the list of design characteristics and ask students to refer to the list as they design a new car as a drawing or painting.

Mathematics

Review with students that the early Maya, a people who lived in what today are parts of Central America, developed both sophisticated calendars and an advanced number system. In their number system, used to carry out their calendric and astronomical calculations, a few simple symbols could be used in varying combinations to express numbers. In this system, a dot had the numerical value of one, a bar stood for five, and a shell-shaped symbol represented zero. The written numbers were read from bottom to top in vertical columns. It is believed that the Maya were the earliest people to use the numerical concept of zero. Ask students to discuss why the concept of zero was so difficult yet so important. What evidence of the concept of zero can students see in daily life now?

Connect to...

Careers

What products do you constantly see advertised on TV? Automobile commercials appear frequently, advertising the latest designs and features. Some ads even include computer-generated images that detail the design blueprint of a car. Automobiles are one type of product developed by industrial or product designers. Look around the classroom for ordinary objects that were designed to be both useful and attractive.

Product designers work in every manufacturing industry, usually in collaboration with a design team. They must be creative, aware of their specific audience and style trends, and knowledgeable

Fig. 5–33 **Product designers often sketch their ideas. Some sculpt foam models. This sketch for a camera design is the work of José Pérez.**
Courtesy Kodak.

about manufacturing processes and materials. Product designers might work with samplemakers to create presentation models. They often use computer-aided industrial design (CAID) systems to make working drawings.

Other Arts

Theater

At first glance, Velázquez's painting *Las Meninas* (Fig. 5–13) looks realistic. But look closely, and you will notice that the painter carefully manipulated elements such as light to show the subject in a certain way. Playwrights do something similar with **dramatic dialogue.**

Often, a conversation among the characters in a play seems very realistic, as though it could happen in real life. But, if you listen closely, you will hear a difference. The dialogue does not wander off topic, as with many real-life conversations. Also, the characters use very few words to express their ideas. Many playwrights carefully structure the dialogue to "highlight" certain ideas.

Fig. 5–34 **Tennessee Williams uses realistic dialogue in the play *The Glass Menagerie.***
Photo courtesy of The Southeast Institute for Education in Theatre, directed by Kim Wheetley, 1992, starring Susan Elder as Laura and Julia Martin as Amanda.

Teaching Options

Resources

Teacher's Resource Binder
 Using the Web
 Interview with an Artist
 Teacher Letter

Video Connection

Show the Davis art careers video to give students a real-life look at the career highlighted above.

Museum Connection

Arrange for a member of the local or regional historical society to talk with your students about the design and use of ordinary objects from the past.

Other Subjects

Mathematics

We all need to keep track of time, but how were ancient peoples able to do so? The early Maya—who lived in what today are parts of Mexico, Honduras, Guatemala, Belize, and El Salvador—developed sophisticated **calendars** and an advanced number system. They kept track of the solar and lunar years, eclipses, and the cycles of visible planets.

In their number system, used for astronomical and calendar-related calculations, they used a few simple symbols in varying combinations to express numbers: a dot had the numerical value of 1; a bar stood for 5; and a shell-shaped symbol represented 0. The written numbers were read from bottom to top, in vertical columns. The Maya are one of the first people to have a numerical symbol for zero.

Fig. 5–35 **Do you hang a calendar on your wall? Where might these stone calendars have been located?** Pre-Columbian Maya, *Calendar disk*, c. 200 BC–1521 AD. Chiapas, Mexico. Courtesy of Davis Art Slides.

Physical Education

Before the arrival of Columbus in North America, the Maya played a **ball game** that was taken quite seriously. It was played on a large outdoor court framed by two parallel stone walls. The walls sloped at the bottom so that a ball in play would bounce upward and remain airborne.

The game was played as two opposing teams, facing each other from opposite sides of the court, tried to score points by sending a hard rubber ball through a stone hoop.

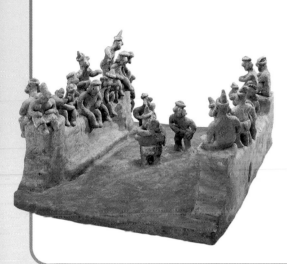

Fig. 5–36 **To make their game balls bouncy, Mayans added juice from morning glory vines to the latex. Is their game similar to any games you play?** Mayan, *Model of a Ball Game.* Pottery, 6 ½" x 14 ½" x 10 ⅝" (16.5 x 36.8 x 27 cm). Worcester Art Museum, Worcester, Massachusetts. Gift of Mr. and Mrs. Aldus Chapin Higgins. Photo ©Worcester Art Museum.

Internet Connection For more activities related to this chapter, go to the Davis website at **www.davis-art.com.**

Physical Education

Describe to students the ball game played by the early Maya. It was played on a large, open court framed by two parallel stone walls. The walls were built with a low slope at the bottom so that a ball in play would bounce upward to keep it airborne. The object of the game was to score points by sending a hard rubber ball through a stone hoop, much like a contemporary basketball hoop. Ask students to compare and contrast the procedures and rules of this game with basketball. Remind them that basketball players, at least, are not in danger of losing their heads.

Other Arts

For students to experience a real-life example, have them try the following: Tape-record a five-minute conversation with a friend about a specific topic. (Be sure your friend knows that you are recording the conversation!) Speak naturally, and try not to edit your conversation because it is being taped.

Listen to the tape, and count how many times the conversation wandered off topic. Write out two minutes of the taped conversation. Then edit the written conversation so that the same ideas are expressed in fewer words, but still appear true to life.

Daily Life

195

Internet Resources

Diego Rivera Virtual Museum
http://www.diegorivera.com/diego_home_eng.html
Available in both Spanish and English versions, this extensive website highlights the artwork and life of the celebrated Mexican muralist Diego Rivera.

Museum of Modern Art
http://www.moma.org/
The Museum of Modern Art in New York City houses the world's first curatorial department devoted to architecture and design, established in 1932. The design collection contains more than 3,000 everyday objects that are both functional and well-designed, including furniture, tableware, tools, sports cars, and even a helicopter.

Community Involvement

Organize a community-wide investigation of the history of local architecture. Include parents, homeowners, realtors, bankers, Chamber of Commerce members, etc. Create a display with photographs, commentary, and a time line. Possible locations for the display are the community library, bank, or other business.

Talking About Student Art

Whenever you lead a discussion about student artworks, ask the student artist to first listen to what others have to say. After the class has discussed the work, the student artist can then respond to their comments and talk about artistic intentions.

Portfolio Tip

 To help in the planning for additions to their portfolio, help students to reflect on idea generation and their choices of subject matter.

Sketchbook Tip

 Discuss the idea of thematic border designs. Show examples of stationery, placemats, wallpaper, etc.

Portfolio

"I was thinking of a playful and imaginative room where I could feel free and easy. See a cuddly stuffed animal on my bed and my art books on the chest of drawers. Smell my sweet flowers. Listen to my radio or call me on the phone. Oops, I forgot to hang up my blue jean jacket." **Stephanie Kreider**

Fig. 5–37 **A room created from the imagination can look realistic when it includes details from daily life.** Stephanie Kreider, *Bed Room*, 1999. Mixed, collage, 18" x 24" (46 x 61 cm). Laurel Nokomis School, Nokomis, Florida.

"The easier part is drawing the pre-sketch or outline, because you get a picture of what the final piece is going to look like. Gradation and value are more difficult. It is hard to make a pencil blend from dark to light. I think that my artwork looks the best when I try my hardest to put in a lot of detail." **Kaelin Burge**

Fig. 5–39 **When drawing a common object in your daily life, you may notice details you never saw before.** Kaelin Burge, *Sketchbook*, 1999. Pencil, ink, colored pencil, 8" x 11" (20 x 28 cm). T. R. Smedberg Middle School, Sacramento, California.

Fig. 5–38 **Genre paintings (scenes of everyday life) capture the interest in ordinary moments. This student chose to portray a friend getting ready for a dance lesson.** Lindsay Voss, *Portrait of Classmate: Becky*, 1999. Oil pastel, 12" x 18" (30 x 46 cm). Verona Area Middle School, Verona, Wisconsin.

"It was important to me that Becky looked like Becky, so I worked especially hard on that part." **Lindsay Voss**

 CD-ROM Connection
To see more student art, check out the Global Pursuit Student Gallery.

Teaching Options

Resources

Teacher's Resource Binder
 Chapter Review 5
 Portfolio Tips
 Write About Art
 Understanding Your Artistic Process
 Analyzing Your Studio Work

CD-ROM Connection

 Additional student works related to studio activities in this chapter can be used for inspiration, comparison, or criticism exercises.

Chapter 5 Review

Recall

Identify two general ways in which art is connected to our daily life.

Understand

Summarize the major difference between Baroque and Rococo styles. Note the degree to which each deals with daily-life activities.

Apply

Use what you have learned about Latin American cultures as a starting point for finding out more about their art. Plan a bulletin-board display to inform others in your school about this artistic tradition.

Analyze

Compare the ways artists presented in this chapter have used light, value, and contrast in genre scenes of daily-life activities. Note which artists used the brightest colors, the darkest colors, the strongest light, and the darkest shadows.

Synthesize

Transform a simple, everyday object—such as a picture frame—into an artwork in the Rococo style.

Evaluate

Defend the use of Vermeer's *The Milkmaid* (Fig. 5–1, shown below and on page 172) as an introduction to Chapter 5's theme of daily life.

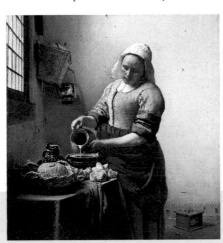

Page 172

For Your Portfolio

Create two portfolio artworks with the theme of daily life. Make one work—such as a bicycle—provide an obvious function in a daily-life activity. Make the other artwork show a daily-life activity that you enjoy, such as playing sports or reading. Use the artworks in this chapter for ideas.

Write a short explanation of how the chapter artworks influenced your two artworks. Put your name and date on your artworks, and add them to your portfolio. (If your work is three-dimensional, provide a mounted photograph of it.)

For Your Sketchbook

Design an attractive border on a sketchbook page where you can write your thoughts or make sketches about ways that art enters your daily life. Add to the page from time to time, and use your ideas for future artworks.

Advocacy

Have students create posters for display in the community and at local businesses that focus attention on the importance of art in daily life. Use the theme "Artists Among Us," and feature objects that we would not have without artists and designers.

Family Involvement

Invite parents and others to loan everyday objects that are well-designed, such as quilts, baskets, dinnerware, or hand tools. The objects may be contemporary or antique. Parents can assist in creating a display in a secured case, complete with labels and a catalogue with a brief description of each object. The exhibition title might be "Designed for Daily Life."

Chapter 5 Review Answers

Recall

In the artistic objects we use for daily purposes; in the artworks that have daily life scenes and events as subject matter.

Understand

Baroque shows familiar subjects and scenes from everyday life of both royalty and ordinary people with dramatic light and contrast. Rococo shows the leisure life of wealthy and upper-class society in a lighthearted manner, with ornate objects, and pastel colors.

Apply

Look for a connection between students' displays and the major ideas presented in Lesson 5.3.

Analyze

Answers will vary. Look for appropriate identification and understanding of light, value, and contrast.

Synthesize

Look for ornate and elaborate decoration and use of pastel colors.

Evaluate

The subject matter is clearly a depiction of a person engaged in a daily-life activity, one of two ways that art is used in connection with daily life. It also shows simple objects that are functionally designed and are used in our daily life.

Reteach

Have students go through magazines and find pictures of people engaged in daily-life activities. Also look for pictures of carefully designed objects used in daily living. Have students tell how these contemporary images are similar to and different from the images featured in this chapter.

6 Place

Chapter Organizer

Chapter 6 Place

Chapter 6 Overview
pages 198–199

- **Core** Throughout time and around the world, people have used art to show the special qualities of places.
- **6.1** European Art: 1800–1900
- **6.2** Space and Emphasis
- **6.3** Isolated in Place: Oceanic Art
- **6.4** Stitching an Artwork

Chapter National Standards

1 Understand media, techniques, and processes.
2 Use knowledge of structures and functions.
3 Choose and evaluate subject matter, symbols, and ideas.
4 Understand arts in relation to history and cultures.
5 Assess own and others' work.
6 Make connections between disciplines.

Objectives

Core Lesson
Telling About Places
page 200
Pacing: Two or more
45-minute periods

- Identify ways that people use places, and explain why places are important.
- Compare and analyze the ways that artists have depicted places in artworks.

National Standards

1b Use media/techniques/processes to communicate experiences, ideas.
5b Analyze contemporary, historical meaning through inquiry.
6a Compare characteristics of art forms.

Core Studio
Creating A Place for Thought
page 204

- Use clay to create a three-dimensional artwork of a calm, peaceful place.

1a Select/analyze media, techniques, processes, reflect.

Objectives

Art History Lesson 6.1
European Art: 1800–1900
page 206
Pacing: Two 45-minute periods

- Consider the influences upon artists, and their interests and pursuits, in the late eighteenth and early nineteenth centuries.
- Differentiate the style characteristics of Neoclassicism, Romanticism, and Realism.

National Standards

1b Use media/techniques/processes to communicate experiences, ideas.
4a Compare artworks of various eras, cultures.
5b Analyze contemporary, historical meaning through inquiry.

Studio Connection
page 208

- Express, in a painting, the mood and feeling of a special place.

2c Select, use structures, functions.

Objectives

Elements and Principles Lesson 6.2
Space and Emphasis
page 210
Pacing: Two 45-minute periods

- Explain ways to create the illusion of space and distance and to achieve emphasis in two-dimensional art.

National Standards

2b Employ/analyze effectiveness of organizational structures.

Studio Connection
page 211

- Use mixed media to depict an imaginary place using emphasis to create deep space.

2b Employ/analyze effectiveness of organizational structures.

9 weeks	18 weeks	36 weeks			
2	2	2	Core Lesson / Core Studio		
		2	Art History Lesson 6.1		
		2	Elements and Principles Lesson 6.2		

Featured Artists

Gianlorenzo Bernini
 and Ercole Ferrata
Rosa Bonheur
Canaletto (Giovanni
 Antonio Canale)
John Constable
Honoré Daumier
Jacques-Louis David
Eugène Delacroix
Caspar David Friedrich
Angelica Kauffmann
Jean-François Millet

Bruce Nabagcyo
Joe Nalo
Faith Ringgold
Jeffrey Samuels
Keith Kaapa Tjangala
Maria Teokolai
Ismalia Traoré
Barbara Watler
Joseph Mallord William
 Turner
Ch'iu Ying

Chapter Vocabulary

Neoclassicism
Romanticism
Realism
space
emphasis
positive space

negative space
implied space
center of interest
fiber artist
appliqué

Teaching Options

Teaching Through Inquiry
More About...John Constable
Using the Large Reproduction
Meeting Individual Needs
More About...Faith Ringgold
Using the Overhead

Technology

CD-ROM Connection
 e-Gallery

Resources

Teacher's Resource Binder
 Thoughts About Art:
 6 Core
 A Closer Look: 6 Core
 Find Out More: 6 Core
 Studio Master: 6 Core
 Assessment Master:
 6 Core

Large Reproduction 11
Overhead Transparency 12
Slides 6a, 6b, 6c

Meeting Individual Needs
Teaching Through Inquiry
More About...Clay
Assessment Options

CD-ROM Connection
 Student Gallery

Teacher's Resource Binder
 Studio Reflection: 6 Core

Teaching Options

Teaching Through Inquiry
More About...*Pliny the Younger*
Using the Overhead
More About...Jacques-Louis David

Technology

CD-ROM Connection
 e-Gallery

Resources

Teacher's Resource Binder
 Names to Know: 6.1
 A Closer Look: 6.1
 Map: 6.1
 Find Out More: 6.1
 Assessment Master: 6.1

Overhead Transparency 11
Slides 6d

Meeting Individual Needs
Teaching Through Inquiry
More About...Honoré Daumier
Assessment Options

CD-ROM Connection
 Student Gallery

Teacher's Resource Binder
 Check Your Work: 6.1

Teaching Options

Teaching Through Inquiry
More About...Casper Friedrich
Using the Overhead
Assessment Options

Technology

CD-ROM Connection
 e-Gallery

Resources

Teacher's Resource Binder
 Finder Cards: 6.2
 A Closer Look: 6.2
 Find Out More: 6.2
 Assessment Master: 6.2

Overhead Transparency 11

CD-ROM Connection
 Student Gallery

Teacher's Resource Binder
 Check Your Work: 6.2

Chapter Organizer continued

Objectives	**National Standards**

2

Global View Lesson 6.3 Oceanic Art
page 212
Pacing: Two 45-minute periods

- Understand how artists in Oceania use natural materials in their artworks.
- Explain how the art of Oceania is connected to place.

3a Integrate visual, spatial, temporal concepts with content.
4a Compare artworks of various eras, cultures.
4c Analyze, demonstrate how time and place influence visual characteristics.

Studio Connection
page 214

- Design a map of a special place, using motifs.

1b Use media/techniques/processes to communicate experiences, ideas.

Objectives	**National Standards**

4 4

Studio Lesson 6.4 Stitching an Artwork
page 216
Pacing: Four 45-minute periods

- Identify a variety of stitching techniques.
- Understand how the traditional technique of stitching can be an expressive art form.
- Create an image of a magical or dreamlike place, using stitchery.

1b Use media/techniques/processes to communicate experiences, ideas.
5a Compare multiple purposes for creating art.

Objectives	**National Standards**

• • •

Connect to...
page 220

- Identify and understand ways other disciplines are connected to and informed by the visual arts.
- Understand a visual arts career and how it relates to chapter content.

6 Make connections between disciplines.

Objectives	**National Standards**

• • •

Portfolio/Review
page 222

- Learn to look at and comment respectfully on artworks by peers.
- Demonstrate understanding of chapter content.

5 Assess own and others' work.

2 Lesson of your choice

Teaching Options

Teaching Through Inquiry
More About…Oceania
More About…The Maori
Using the Large Reproduction

Technology

CD-ROM Connection
e-Gallery

Resources

Teacher's Resource Binder
 A Closer Look: 6.3
 Map: 6.3
 Find Out More: 6.3
 Assessment Master: 6.3

Large Reproduction 12
Slides 6e

Meeting Individual Needs
Teaching Through Inquiry
More About…Aborigines
Assessment Options

CD-ROM Connection
 Student Gallery

Teacher's Resource Binder
 Check Your Work: 6.3

Teaching Options

Meeting Individual Needs
Teaching Through Inquiry
More About…Quilting
Using the Overhead
More About…Fiber artists
Assessment Options

Technology

CD-ROM Connection
 Student Gallery
 Computer Option

Resources

Teacher's Resource Binder
 Studio Master: 6.4
 Studio Reflection: 6.4
 A Closer Look: 6.4
 Find Out More: 6.4

Overhead Transparency 12
Slides 6f

Teaching Options

Community Involvement
Interdisciplinary Planning

Technology

Internet Connection
Resources
Video Connection
CD-ROM Connection
 e-Gallery

Resources

Teacher's Resource Binder
 Using the Web
 Interview with an Artist
 Teacher Letter

Teaching Options

Family Involvement

Technology

CD-ROM Connection
 Student Gallery

Resources

Teacher's Resource Binder
 Chapter Review 6
 Portfolio Tips
 Write About Art
 Understanding Your Artistic Process
 Analyzing Your Studio Work

Chapter Overview

Theme

Most of us have a special, important place. Artworks can serve as reminders of places and tell us about their meaning.

Featured Artists

Gianlorenzo Bernini and Ercole Ferrata
Rosa Bonheur
Canaletto (Giovanni Antonio Canale)
John Constable
Honoré Daumier
Jacques-Louis David
Eugène Delacroix
Caspar David Friedrich
Angelica Kauffmann
Jean-François Millet
Bruce Nabageyo
Joe Nalo
Faith Ringgold
Jeffrey Samuels
Keith Kaapa Tjangala
Maria Teokolai
Ismalia Traoré
Barbara W. Watler
Joseph Mallord William Turner
Ch'iu Ying

Chapter Focus

Throughout time and around the world, people have used art to show the special qualities of places. This was especially evident in the Western art styles of Neoclassicism, Romanticism, and Realism. Some of the art of Oceania is also about special places. Through manipulation of space and emphasis, artists can give special meaning to the places they depict in their artworks. In this chapter, students will use stitchery to create a dream-like place.

6 Place

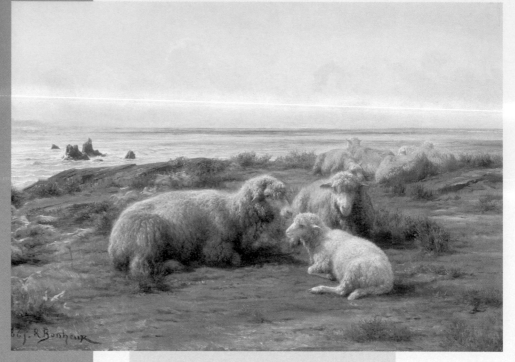

Fig. 6–1 This artist saw beauty in a scene of sheep resting beside the ocean. How would you describe the mood of this painting? Rosa Bonheur, *Sheep by the Sea*, 1869.
Oil on cradled panel, 12 ¾" x 18" (32 x 45.7 cm). Gift of Wallace and Wilhelmina Holladay. The National Museum of Women in the Arts.

198

National Standards Chapter 6 Content Standards

1. Understand media, techniques, and processes.

2. Use knowledge of structures and functions.

3. Choose and evaluate subject matter, symbols, and ideas.

4. Understand arts in relation to history and cultures.

5. Assess own and others' work.

6. Make connections between disciplines.

Teaching Options

Teaching Through Inquiry

Art Production Explain that people often use the term "landmark" to designate important places or positions. Discuss the landmarks in your community. Then have students work in small groups to design a community map of important landmarks.

Focus

- Why are special places important in people's lives?
- What can artworks tell about places and their meaning?

Is there a place you go when you want to be alone? Most of us have that kind of place—our room, a spot under a tree, or our neighborhood. We also have places for certain activities, such as places for working, playing, shopping, or learning. Places—and a sense of place—are important to us. We want to know where we are, and we usually like to feel comfortable.

Because we can remember places, we can "return" to them in our minds. We do this especially for places that have special meaning for us. We may wish to remember where important things happened, such as learning to read or winning a basketball game. Places are also important to groups of people. A community might remember some of its history with a marker or plaque. The marker could tell what happened, who was there, and why the place is important.

All over the world, at many different times in history, individuals, groups, and whole nations have used art to show that certain places are special. Artist Rosa Bonheur looked around her world and saw beauty in ordinary settings (Fig. 6–1). What beautiful places do you know?

What's Ahead

- **Core Lesson** Discover various ways that artists show places in their art.
- **6.1 Art History Lesson** Learn about the Western art styles of Neoclassicism, Romanticism, and Realism.
- **6.2 Elements & Principles Lesson** Consider how artists use space and emphasis when showing a place.
- **6.3 Global View Lesson** Learn how Oceanic artists have included places in their artworks.
- **6.4 Studio Lesson** Use stitchery to create an image of a dream-like place.

Words to Know

document	negative space
Neoclassicism	implied space
Romanticism	center of interest
Realism	motif
emphasis	fiber artist
positive space	appliqué

Place

199

Chapter Warm-up

Ask students to describe their room or another personal space to the class or a small group. **Ask:** What is on the walls, the ceiling, and the floor? Is there a view? What have you done to make this space your own? Explain that artists often use their personal places and things as subjects for their art.

Using the Text

After students have read page 199, discuss special places in their home, school, and community.

Using the Art

Have students look at Bonheur's *Sheep by the Sea.* **Ask:** What is special about this place? Beyond repeating the title, what more can you say to describe what you see?

More About...

Rosa Bonheur (1822–99) is viewed as one of the best-known painters of animals. As a child, she kept animals, including a goat, in her family's apartment; as an adult, she owned exotic animals. She visited animal markets and slaughterhouses to make studies of animals' muscle and skeletal structure. To avoid being conspicuous in these places, she dressed as a man (with the permission of the police). Bonheur was a colorful, independent, and outspoken woman—and the first woman to receive the Grand Cross of the Legion of Honour. Her works became very popular.

Graphic Organizer Chapter 6

6.1 Art History Lesson European Art: 1750–1875 page 206

Core Lesson Telling About Places

Core Studio Creating a Place for Thought page 204

6.3 Global View Lesson Isolated in Place: Oceanic Art page 212

6.2 Elements & Principles Lesson Space and Emphasis page 210

6.4 Studio Lesson Stitching an Artwork page 216

Prepare

Pacing

Two or more 45-minute periods: one to consider place in art; one or more to create 3-D clay place

Objectives

- Identify ways that people use places, and explain why places are important.

- Compare and analyze the ways that artists have depicted places in artworks.

- Use clay to create a three-dimensional artwork of a calm, peaceful place.

Vocabulary

document To record, in an artwork, how a place looks at a particular moment.

Teach

Engage

Display a collection of postcards or travel posters. **Ask:** What visual qualities make these places appealing? What is inviting about these places? Tell students that this lesson is about how art tells about and helps us remember special places.

Telling About Places

Places to Notice

People often see the same places again and again, and they become familiar with the plan of these places. When you enter a place, pay attention to its design. How does the structure remind you of what the place is used for? How does the design of a church, for instance, match its purpose? Look at the mosque in Fig. 6–3. What feeling do you get from this place?

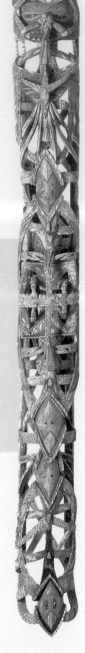

Fig. 6–2 This beautifully carved pole was made to stand in a special place. It was created as a memorial to a deceased person. Why might the artist have painted the animals and faces in different colors? Niu Ailand People, Melanesia (New Ireland), *Memorial Pole*, early 20th century.
Wood, fiber, operculum, vegetable paste, and paint, 98 $^{7}/_{16}$" x 9 $^{7}/_{8}$" x 5 $^{15}/_{16}$" (240 x 25 x 15 cm). Gift of Morton D. May, 60:1977. St. Louis Art Museum.

Fig. 6–3 This mosque is an important place to the people of Djénné, Mali, in West Africa. They come here to worship, to shop, to learn, and to socialize. Every spring, the citizens work for weeks to replaster the surface to protect it from the summer rains. Ismaila Traoré, *The weekly market at the Great Mosque of Djénné*, 1906–07. Adobe. Mali, West Africa. Photo by Rob van Wendel de Joode.

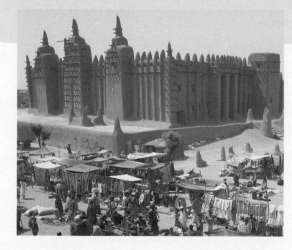

National Standards Core Lesson

1b Use media/techniques/processes to communicate experiences, ideas.

5b Analyze contemporary, historical meaning through inquiry.

6a Compare characteristics of art forms.

Teaching Options

Resources

Teacher's Resource Binder
 Thoughts About Art: 6 Core
 A Closer Look: 6 Core
 Find Out More: 6 Core
 Studio Master: 6 Core
 Studio Reflection: 6 Core
 Assessment Master: 6 Core
Large Reproduction 11
Overhead Transparency 12
Slides 6a, 6b, 6c

Teaching Through Inquiry

Aesthetics Ask students to imagine that they are on an international planning board, and must make decisions about **beautification and preservation of special places** worldwide. One of the committee's goals is to see that people notice and respond positively to places. An international paint company wants to paint the Great Mosque of Djénné with colorful arabesques and geometric patterns, and to paint the house pole with fluorescent colors. **Ask:** What arguments could you use in support of the paint company's plans? What arguments could you use in opposition?

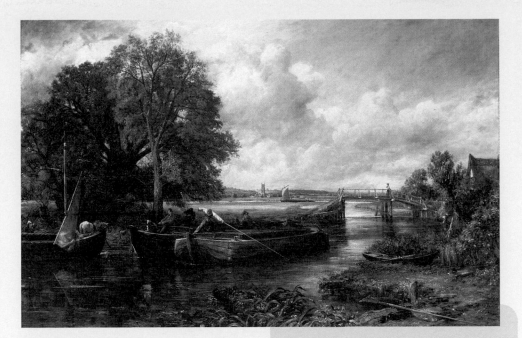

Fig. 6–4 Constable painted a landscape near his home in Suffolk, England. From his painting, we learn how things looked in the past. How might this view look different today? John Constable, *View on the Stour near Dedham*, 1822.
Oil on canvas, 20 ⅛" x 29 ¼" (51 x 74 cm). The Huntington Library, Art Collections and Botanical Gardens, San Marino, California/SuperStock.

Artworks are sometimes created to mark a place. Entryways can tell visitors that they are crossing into a special place. Carefully designed gardens and grounds add beauty to the building they surround. The Maori people of New Zealand use art to add to the significance of their buildings. They carve and decorate wood poles and beams like the one shown in Fig. 6–2.

Artists make artworks to show us places. They might illustrate places from the past that actually existed. They might show imagined places that we wish were real. They might even show places that we are glad do not exist—places that frighten us.

When you look at an artwork that shows a place, think about what the artist might have wanted you to experience. Are you drawn to the place, wishing you could visit it? Does the place have qualities that could not possibly be found in real life? Was the artwork created mainly to **document**, or record, how a place looks? In Fig. 6–4, for example, artist John Constable recorded the Stour River's appearance in 1822.

Place

201

Using the Text

Art Production Discuss the statement on page 201 about places that we are glad do not exist, such as places that frighten us. Ask students to draw a picture of such a place.

Using the Art

Art Criticism Ask students to imagine that Figs. 6–3 and 6–4 are each an image on a postcard imprinted with the message "Wish you were here." **Ask:** What qualities in each image capture your attention? What does each tell you about the kind of experience you might have if you visited this place?

More About...

A painter not rewarded with success in his lifetime, **John Constable** (1776–1837) would sketch outdoors and then work on the final paintings in his studio. His art was generally misunderstood and did not meet the expectations of the common people, who wanted dramatic and theatrical effects; or of the art-world critics, who wanted images in the classical tradition. Constable provided neither, wanting only to capture the reality of a specific place—the feel and smell of nature. Public taste eventually changed, and people took pleasure in his work—city dwellers were reminded of an idyllic, rural lifestyle that was disappearing with the industrial age.

Using the Large Reproduction

Talk It Over

Describe What do you see here?

Analyze How are the different parts of this piece arranged?

11

Interpret How does this represent the theme of place?

Judge Is this an important artwork for people to see? Why?

Using the Text

Perception Have students read page 202. **Ask:** What seems real and what seems imaginary about each image on these pages? Which is the most real? The most magical? Why?

Using the Art

Art Criticism Ask: What did each artist do to make each place especially memorable?

Perception Ask students to compare the images' viewpoints. **Ask:** Where is the viewer? How did each artist indicate distance?

Art History Tell students that St. Mark's Square today is just as popular a tourist destination as it was in the eighteenth century, when British tourists commissioned Canaletto to paint this scene and others in Venice. These splendid souvenirs were the predecessors of today's tourist postcards. Ask students if they have ever bought a postcard or photographed a place that they wanted to remember.

Places to Remember

Artworks can show us how things looked in the past. They can also show how a place was used. Canaletto did this in his painting of St. Mark's Plaza (Fig. 6–5). If we focus on how people used places in the past, we can see that some purposes haven't changed much. The shopping malls of today may look different from eighteenth-century Italian plazas, but they do serve similar purposes for large groups of people.

Artworks can also show us places that are important to the artist as an individual.

Faith Ringgold created a story quilt (Fig. 6–6) about a place she called "Tar Beach." She shows that this rooftop is a magical place where everyday troubles aren't allowed to enter. Do you think this is a real or imagined place? What evidence did the artist provide that supports your opinion?

Artists show some places because the places—and the stories about them—are special to whole communities. In Fig. 6–7, Joe Nalo tells such a tale. The legend is already familiar to the people of this island, but Nalo's art gives the community a new way to see the story.

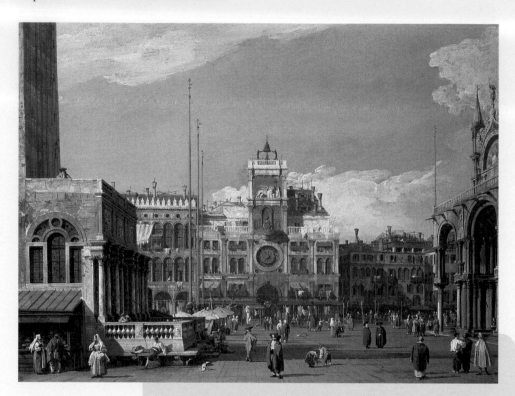

Fig. 6–5 Even today, St. Mark's Plaza in Venice is a place people gather to socialize, rest, shop, and feed the birds. Which details in Canaletto's painting tell us how this important place looked in the past? Giovanni Antonio Canale, called Canaletto, *The Clock Tower in the Piazza San Marco*, c. 1728–30.
Oil on canvas, 20 ¹/₂" x 27 ³/₈" (52.1 x 69.6 cm). The Nelson-Atkins Museum of Art, Kansas City, Missouri (Purchase: Nelson Trust). ©1999 The Nelson Gallery Foundation. All Reproduction Rights Reserved.

202

Teaching Options

Meeting Individual Needs

Multiple Intelligences/Spatial Ask students to "take a walk" through any of the images on pages 202–203. Have them move slowly through the composition, describing what they see, as though they were on a tour. Finally, have students write and illustrate a travel brochure to entice and inform vacationers.

More About...

Using a traditional African-American art form as the basis for her vivid paintings, **Faith Ringgold** often adds text that focuses on activist issues such as feminism and civil rights. She grew up in Harlem, taught art in New York City public schools for eighteen years, and is now a senior professor at the University of California at San Diego.

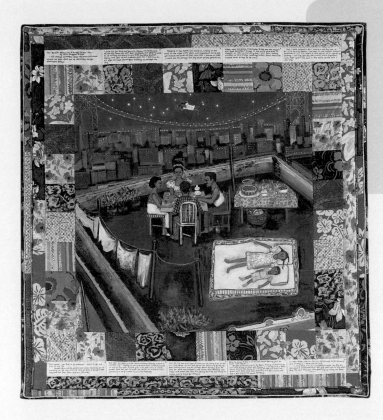

Fig. 6–6 The rooftop of a city apartment building can be a special place. What feeling does the artist give us about this place? How do we know it is a special place to her? Faith Ringgold, *Tar Beach*, 1988.
Acrylic paint on canvas bordered with printed and painted quilted and pieced cloth, 74 5/8" x 68 1/2" (189.5 x 174 cm). Solomon R. Guggenheim Museum of Art, New York. Gift, Mr. and Mrs. Gus and Judith Lieber, 1988. Photograph by David Heald ©The Solomon R. Guggenheim Foundation, New York. (FN 88.3620)

Extend

Art Production Bring in and discuss illustrated children's books that create special places. Have cooperative-learning groups work to illustrate a children's book that features a place.

Fig. 6–7 This composition tells about the origin of Leip Island, in Papua New Guinea. Without being familiar with the legend, can you identify what is important to people from this island? Joe Nalo, *The Legend of Leip Island*, 1993.
Oil on canvas, 59" x 78 3/4" (150 x 200 cm). Collection: Museum für Völkerkunde, Frankfurt am Main. Photograph: Hugh Stevenson.

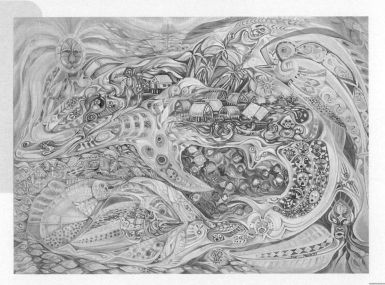

Place

203

Teaching Through Inquiry

Art Production Have students focus on Joe Nalo's *The Legend of Leip Island*, and remind them that the painting tells the origin of a place. Have students research the history of their community and create a group artwork in a way visually similar to Nalo's.

Aesthetics Ask: To record a special place for people to remember, must an artist include every detail? Why or why not?

Using the Overhead

12

Think It Through

Ideas What does this image have to do with the theme of place?

Materials What materials were used?

Techniques What techniques were combined?

Audience Should this be worn daily, or should it be permanently displayed?

CD-ROM Connection

For more images relating to this theme, see the Global Pursuit CD-ROM.

Supplies

- cloth, heavy canvas or burlap
- work board
- clay, either self-drying or ceramic, at least 1 lb/student
- slip (watered-down clay)
- paintbrush
- two sticks of equal thickness, such as lattice
- rolling pin
- clay tools or a knife and fork

Using the Text

Have students read Studio Background and discuss how the places in the images might be desirable places to be alone.

Art Production After students have read the first two paragraphs on page 204, lead a discussion about calm, peaceful places where they can think. **Ask:** Is your place inside or out? What surrounds you in this place? What objects are there? What textures?

Have students roll out a 1/2"-thick slab of clay, using the rolling pin on the two sticks to ensure a consistent thickness. If their artworks are to be fired, have students hollow out forms that are thicker than their thumb. Demonstrate techniques for creating a variety of textures by pressing objects into the clay. Let sculptures dry slowly in a well-ventilated place. Bisque-fire the ceramic clay pieces.

Using the Art

Perception As students study the jade landscape, Fig. 6–9, encourage them to imagine walking through these forms. **Ask:** What spaces would you walk through?

Sketchbook Tip

Suggest that students select a square-foot place in the natural environment and make a series of close-up observational drawings of the special features of the place.

Sculpture in the Studio

Creating a Place for Thought

Imagine a place you can go to relax and think deep thoughts. The place might be a room, a park, a garden, or a spot surrounded by trees. It can be a real or made-up place.

What would you like to show others about this place? **In this lesson you will use clay to create a three-dimensional artwork of your calm, peaceful place.** Think about how you might use space to make the place seem more peaceful. What will you emphasize in your work?

Fig. 6–8 "I picked this location because I went on a boat before and found it relaxing. I did the color in the project like it would look in nature. I found this calming because you can listen to nature without being interrupted." Nicolle Pacanowski, *Untitled*, 1999.
Clay, 5 ½" x 7" x 1 ¼" (14 x 18 x 3 cm). Daniel Boone Middle School, Birdsboro, Pennsylvania.

You Will Need

- square of cloth
- work board
- clay
- slip
- paintbrush
- two sticks and a rolling pin
- clay tools or a knife and fork

Try This

1. Start by making a clay slab for the base. Place a cloth flat on your work board or table. Put your clay on the cloth and place a flat stick on each side of the clay. Press a rolling pin down on the center of the clay, letting it rest on top of the sticks. Roll back and forth until the clay is flat. Use a table knife to trim the edges into the shape you want.

2. Think about the best way to create your environment. Will you build up the sides with additional slabs? Will you add coils, balls, or modeled forms?

Studio Background

Peaceful Places in Art

Why do you think it is valuable to have a place to go for time alone? Most people seem to need such a place. Gazebos, benches shaded by trees, and rock outcroppings are examples of such places. Public gardens are known as special places where people can sit quietly and enjoy their surroundings. Can you think of others?

Some artists show these places in their work so that we can enjoy them without actually visiting. We can imagine being there as we view the work. Traditional Chinese landscape painters were skilled at creating a visual path for viewers to follow through a beautiful natural area. Look at the works in Figs. 6–9 and 6–10 to see how calm, peaceful places have been created by two Chinese artists.

204

Teaching Through Inquiry

Art Criticism On the chalkboard, write two lists of words elicited from students: **expressive words** (such as *peaceful, calm, inviting, crowded, busy, energetic, quiet, restful, mysterious, haunting*) and **descriptive words** (such as *realistic, bright, dark, colorful, vertical, horizontal, framed, deep space, unusual*).

For the artworks by Bonheur, Constable, Ringgold, Canaletto, Nalo, and Ch'iu Ying, have students complete this prompt: "(Name of artist) depicted a place that is (one or more expressive words). The artist did this by making the work (one or more descriptive words)." Discuss students' answers.

3. To join two pieces of clay, always score their surfaces and use slip. How might you create negative space in your environment? Can you leave open space between forms? Can you carve holes or other shapes in the clay?

4. Will you show people in your environment? How can you use textures and small details to add emphasis to parts of your quiet place? As you work, remember that clay will shrink slightly when it dries.

Check Your Work

Compare your artwork with that of your classmates. What features did you include to suggest a quiet place? What are the effects of the positive and negative spaces in everyone's work? How are parts of the peaceful places emphasized?

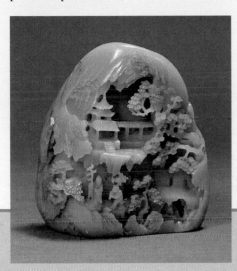

Fig. 6–9 **A Chinese artist created this place. Can you see the positive and negative space? What areas did the artist emphasize?** China, Qing Dynasty, Qianlong period (1736–95), *Mountain Landscape*, 18th century. Jade, 6 ⁷/₈" (17.5 cm). ©Cleveland Museum of Art, Gift of the Misses Alice and Nellie Morris, 1941.594.

Core Lesson 6

Check Your Understanding
1. Why are places important to people?
2. Name two ways that people use places.
3. What are two reasons artists have depicted places?
4. Give an example of a place especially designed to serve human purposes.

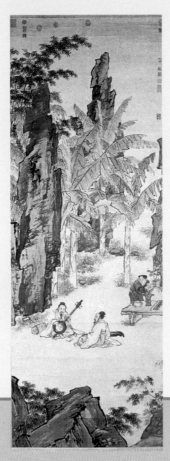

Fig. 6–10 **Where can you see negative space here? How does it help emphasize the figures?** Ch'iu Ying, *Passing a Summer Day Beneath Banana Palms.* Section of a hanging scroll (cropped at top and bottom). Ink and colors on paper, 39" (99 cm). National Palace Museum, Taipei, Taiwan, Republic of China.

Place

205

Extend

After students' self-hardening clay artworks have dried or the ceramic-clay artworks have been bisque-fired, students may decorate either kind of work with acrylic paints, or glaze ceramic-clay work instead of painting it.

Assess

Check Your Work

Call attention to the way students have created an environment with a foreground, middle ground, and background. Discuss examples of good craftsmanship.

Check Your Understanding: Answers

1. Places have special meanings, such as where something important occurred.

2. as places for comfort, gatherings, work, play, and contemplation

3. to commemorate or memorialize a special place; to reveal the beauty of a place; to tell the story of a place

4. Answers may vary. Possible answer: a shopping mall.

Close

Lead a discussion about the significance of place and remind students of some different ways artists have chosen to show places.

Meeting Individual Needs

Adaptive Materials Provide soft clay or a modeling compound.

Focusing Ideas Brainstorm with students, or provide them with ideas for their place.

More About...

Clay is a fine-grained material similar to mud—yet when combined with water, it becomes plastic enough to be formed and keep its shape. It can be hardened by heat (fire).

Long ago, the soft rock where clay originates was worn away by erosion: water and ice changed the material, and carried it to new locations. As the clay moved and settled, minerals were lost and new ones added. That's why there are different kinds of clay found all over the world.

Assessment Options

Peer Have students brainstorm uses of places. Have pairs of students select one use and then design a poster to show places designed for that use. Have students use magazine images or photocopies and attach captions that explain why the places are important. Have the class generate a list of criteria for evaluating the posters. Each student's work is then evaluated by three classmates, using the criteria the class has agreed upon.

Prepare

Pacing

Two 45-minute periods: one to consider European art and sketch picture; one to paint

Objectives

- Consider the influences upon artists, and their interests and pursuits, in the late eighteenth and early nineteenth centuries.
- Differentiate the style characteristics of Neoclassicism, Romanticism, and Realism.
- Express, in a painting, the mood and feeling of a special place.

Vocabulary

Neoclassicism A style of art based on interest in the ideals of ancient Greek and Roman art. Artists used these ideals to express ideas about beauty, courage, sacrifice, and love of country.

Romanticism A style of art that developed as a reaction to Neoclassicism. Themes focused on dramatic action, exotic settings, adventures, imaginary events, faraway places, and strong feelings.

Realism A style of art that shows places, events, people, or objects as the eye sees them.

Using the Time Line

Have students point out the overlap in time among the periods shown.

206

European Art: 1750–1875

| Rococo page 180 | **1784** David, *Oath of the Horatii* Neoclassicism **1785** Kauffmann, *Pliny the Younger* | Romanticism **1860** Delacroix, *Horses* | **1857** Millet, *The Gleaners* Realism **c. 1863** Daumier, *Third Class Carriage* | Impressionism page 232 |

The nineteenth century was a time of different political and social points of view in Europe. Revolutions gave rise to new governments. Ideas were changing in many societies.

The art of this period reflected these differing views. Lighthearted Rococo art was replaced by three new, more serious art styles. Each style was a reaction to the one before it. Each was inspired by a different place in history and the world.

The first style was called **Neoclassicism.** Like artists of the Renaissance, Neoclassical artists looked to the classical Greek and Roman past as models for their art. Their calm, carefully organized paintings, sculpture, and architecture reminded people of the Greek and Roman ideals of order and harmony.

Some artists rejected the strict rules of Neoclassicism and began an art style called **Romanticism.** These artists were interested in medieval times and distant places such as Africa and the Orient.

Toward the mid-1800s, artists of the style known as **Realism** did not want their artworks to show faraway places or times. They thought art should be about the places and things they saw every day.

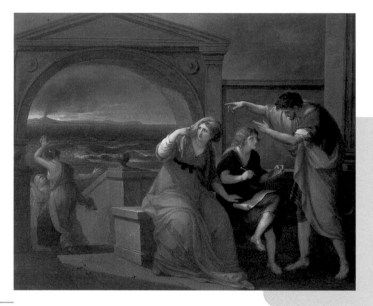

Fig. 6–11 This is an example of a history painting, or a painting that shows an event from history, mythology, or the Bible. Why, do you think, were the event and place shown in this painting a popular subject for Neoclassical artworks? Angelica Kauffmann, *Pliny the Younger and His Mother at Misenum,* AD 79. Oil on canvas, 3' 4 ¹/₂" x 4' 2 ¹/₂" (103 x 128 cm). The Art Museum, Princeton University. Museum purchase, gift of Franklin H. Kissner. Photo Credit: Clem Fiori. ©2000 Artist Rights Society (ARS), New York/VG Bild-Kunst, Bonn.

206

Teaching Options

Resources

Teacher's Resource Binder
- Names to Know: 6.1
- A Closer Look: 6.1
- Map: 6.1
- Find Out More: 6.1
- Check Your Work: 6.1
- Assessment Master: 6.1

Overhead Transparency 11

Slides 6d

Teaching Through Inquiry

Art Criticism Inform students that David was once imprisoned for rebelling against the king of France. Ask students to point to visual evidence in Fig. 6–12 to support the claim that David tried to inspire a sense of duty among the people of France to participate in the revolution.

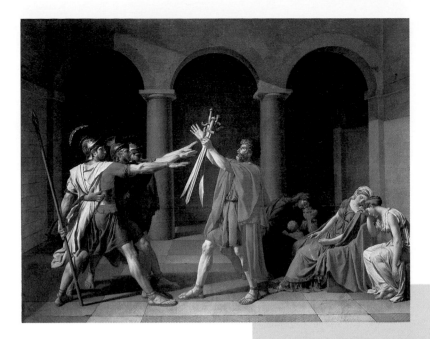

Fig. 6–12 Notice the classical setting and the way the figures appear frozen in action, almost like sculptures. The darkened background and highlighted figures make the painting look like a dramatically lit stage. How does this use of light and dark compare to the Baroque example in Fig. 5–13, *Las Meninas?* Jacques-Louis David, *Oath of the Horatii*, 1784–85. Oil on canvas, 129 ¹¹/₁₂" x 167 ⁵/₁₆" (330 x 425 cm). Louvre, Paris, France. Erich Lessing/Art Resource, New York.

Neoclassicism

Why did artists once again become interested in the classical past? In 1738, there was a great discovery: The ancient Roman cities of Pompeii (*pom-PAY*) and Herculaneum (*her-kew-LAY-nee-um*) were found. The two cities had been destroyed by the volcano, Mount Vesuvius, in 79 AD. They were perfectly preserved under layers of volcanic ash. This new source of information on life in ancient Roman times inspired many artists.

Places of the Past

Artists began to base their paintings on ancient places. They often painted scenes of Roman ruins. Some showed people from their own time in a classical setting of arches and columns. Some artists, like Angelica Kauffmann, even chose the eruption of Mount Vesuvius as the subject for artworks (Fig. 6–11).

Artist Jacques-Louis David wanted his paintings to teach a lesson. In *Oath of the Horatii* (Fig. 6–12), he chose the story of the heroism and patriotism of the Horatius brothers of ancient Rome. In this time of revolutions and rebellions, David hoped his paintings would inspire patriotism and a sense of duty among the people of France.

Place

207

Teach

Engage

Have students recall the Statue of Liberty. **Ask:** What does Liberty wear? *(toga)* Why would sculptors dress their subjects in the clothes of ancient Greece? Note that Figs. 6–11 and 6–12 show classical subjects in classical dress.

Using the Text

Art History After students have read page 206, ask them to define, in their own words, *Neoclassicism, Romanticism,* and *Realism.*

Using the Art

Art Criticism Ask students to point out classical Roman features in *Oath of the Horatii*. *(architecture, dress, story)* Tell students that *Oath of the Horatii* is based on a story of conflict between love and patriotism: the Horatii brothers were chosen to defend Rome; even though one of their sisters was engaged to one of the enemy, the three brothers took an oath, on the raised swords held by their father, to defeat the enemy or die for Rome.

More About...

Pliny the Younger and His Mother at Misenum is a good example of the late-eighteenth-century interest in the classical art and architecture of Greece and Rome. The work not only refers to a historical place, but also to a historic event in Italy, the eruption of Mount Vesuvius in 79 AD. Interest in all things Roman was sparked by the 1738 excavation of the two cities—Pompeii and Herculaneum—buried by the eruption. Framed within a setting of pediments and arches, figures in Roman dress observe the eruption.

Using the Overhead

11

Investigate the Past

Describe What is shown in this scene? How closely did the artist pay attention to details?

Attribute Based on what you have seen and read about in this lesson, to what style period would you attribute this?

Interpret How is this artwork about the theme of place?

Explain Knowing more about Courbet's life might help you identify the artists he admired and how his work came to look the way it does. You might also discover what artists he influenced.

More About...

Jacques-Louis David once said that his trip to Rome in 1775 made him feel as though he "had been operated on for cataracts." He avidly drew every sculpture and architectural ruin he encountered. Many art historians say that the Neoclassical style was started by David.

Using the Text

Art Criticism Have students read pages 208 and 209. **Ask:** What type of settings did Romantic artists and Realist artists usually paint? *(Romantic: faraway places; Realist: everyday places)* If you were a Romantic artist, what modern-day scenes would you paint? What contemporary scenes would you paint if you were a Realist artist?

Art Criticism Discuss students' answers to the questions in Everyday Places, about *The Third Class Carriage.*

Using the Art

Perception Ask students to describe the brushstrokes and texture of *Horses Coming Out of the Sea.* Have students compare this texture to that of *Oath of the Horatii* (Fig. 6–12).

Perception Have students study *The Gleaners* and then describe the scene. **Ask:** What is Millet's message? How does he feel about his subjects, the peasant women? Why, do you think, are copies of this painting often shown at Thanksgiving?

Studio Connection

Suggest to students that they combine observations of human-made places with elements of both natural and built environments to express the mood of the place.

Assess See Teacher's Resource Binder: Check Your Work 6.1.

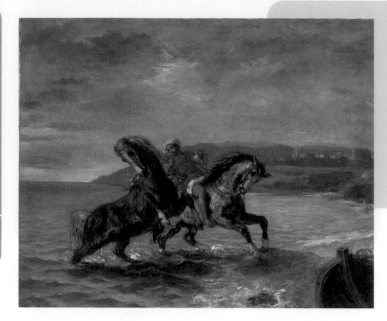

Fig. 6–13 What feeling does the use of color and brush-strokes create in this painting of a place in northern Africa? Compare this arrangement of a figure and horses with the arrangement of figures in David's painting (Fig. 6–12). Do you see how both groups form a similar overall shape? How are the two groups different? Eugène Delacroix, *Horses Coming Out of the Sea*, 1860. Oil on canvas, 20 ¼" x 24 ¼" (5.4 x 61.5 cm). The Phillips Collection, Washington, DC. (0486).

Romanticism

In the nineteenth century, "romances" were medieval stories of heroism and bravery. Maybe you have read about King Arthur and his knights or the search for the Holy Grail. Romantic artists were inspired by these tales of adventure. They rejected the ordered style of Neoclassicism in favor of a style filled with emotion.

Faraway Places

For the Romantics, feeling was everything. Neoclassical artists concentrated on line and careful brushwork, but Romantic artists applied color with wilder, more active brushstrokes. They wanted you to look at a painting and actually *feel* the emotion of the scene. They chose stormy seas, faraway beaches, and dangerous battlefields as settings for their works.

French Romantic painter Eugène Delacroix visited countries in northern Africa and made many watercolor sketches during his travels. When he returned home, he made paintings of the new and exciting people, architecture, and colors he had seen (Fig. 6–13).

Realism

Showing people, places, and things realistically has always been important in Western art. But the realism of the nineteenth century was different from that of other times. Artists in this new movement insisted on showing only things they had seen in real life. They believed that a good painting could come only from patiently observing reality.

208

Teaching Options

Meeting Individual Needs

Gifted and Talented Have students identify how and why artists used references to the past in their works in Figs. 6–11 and 6–12. Next, have students locate and sketch local buildings whose styles evoke a historical time or place. *(Classical columns on a government building might recall the glory of ancient Greece.)* Have students write an essay that explains the architect's reasons for evoking that time or place.

More About...

Honoré Daumier was one of the most original and profound oil painters of figures, yet his public reputation during his lifetime was based on his caricatures and cartoons that were published in journals. His cartoons poked fun at all kinds of situations, but most often, his targets were politics and social injustice.

Everyday Places

Scenes of people working in the countryside or going about their daily lives were the favorite subjects of the Realists (Fig. 6–15). The Realists believed their artworks recorded simple ways of life that were quickly disappearing as new technologies took over.

Some Realists, such as Honoré Daumier, used their art to point out the faults of modern society. In *The Third Class Carriage* (Fig. 6–14), Daumier places us, the viewers, in the poor section of a horse-drawn bus. Notice how the poor family is separated from the wealthier passengers by the back of the seat. What do you think Daumier was trying to say about modern life in the city?

6.1 Art History

Check Your Understanding
1. What inspired the style known as Neoclassicism?
2. What interested artists in the Romantic movement?
3. How was the new Realism of the nineteenth century different from realistic representation in previous centuries?
4. What are three different ways that artists in the nineteenth century thought about places?

Studio Connection
How can you express the idea of a secret place, an exciting place, a romantic place, or maybe even a frightening place in a painting? Decide whether to show a city place, a country place, or somewhere in between. Paint the largest forms first. Think about the brushstrokes that will help show the mood of the place. Then choose different size brushes, and practice your brushstrokes on newsprint. Do your final painting on white paper.

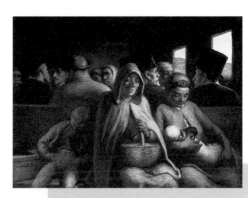

Fig. 6–14 Daumier created several versions of this scene. He chose city life as the subject of his artworks. Honoré Daumier, *The Third Class Carriage*, c. 1863–65. Oil on canvas, 25 ¾ x 35 ½" (65.4 x 90.2 cm). National Gallery of Canada, Ottawa. Purchased 1946.

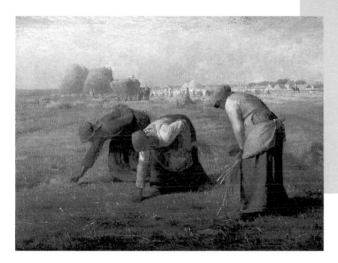

Fig. 6–15 Gleaners are farmworkers who pick up the seeds left behind after a harvest. What kind of mood did Millet create for this scene? Jean-François Millet, *The Gleaners*, 1857. Oil on canvas, 33" x 44" (83.8 x 111.8 cm). Musée d'Orsay ©Photo RMN.

Place

209

Assess

Check Your Understanding: Answers

1. the art, architecture, and democratic ideals of Greece and Rome

2. medieval times and stories of heroism and bravery; the excitement of distant places such as Africa and the Orient

3. The new Realism called for the depiction of things that artists had actually seen. The artists felt that good painting could come only from patiently observing reality.

4. Some studied everyday places; some imagined faraway places; and some remembered places of the past.

Close

On the chalkboard, write these headings: Neoclassicism, Romanticism, Realism. Ask students to list a characteristic and a favorite subject of each style, under its name. Have them cite an artist for each style.

Teaching Through Inquiry

Art History Ask students to look at the works by Delacroix, Millet, and Daumier, on pages 208 and 209. **Ask:** If these were the only works you had ever seen by these artists, what distinctive features in each work would help you identify other works by the artist? Help students make generalizations about subject matter, use of color, and brushstroke.

Assessment Options

Teacher Have students work with a small brush and watercolors to do three stylistically different paintings of natural forms—such as rocks, pebbles, shells, leaves, and flowers—in a natural place. Have students demonstrate their understanding of Neoclassicism, Romanticism, and Realism by creating a painting in each style.

209

Space and Emphasis

Space and Emphasis

Prepare

Pacing

Two 45-minute periods: one to consider text and images, and to paint; one to cut and glue collage

Objectives

- Explain ways to create the illusion of space and distance and to achieve emphasis in two-dimensional art.
- Use mixed media to depict an imaginary place using emphasis to create deep space.

Vocabulary

space

emphasis

positive space

negative space

implied space

center of interest

See the Glossary for definitions.

Teach

Using the Text

Have students read pages 210 and 211 and then define, in their own words, *positive space, negative space, implied space, emphasis,* and *center of interest.*

Using the Art

Art Criticism Ask: How did the artist fill the space in each image? How did each artist create the illusion of space? What is emphasized?

Space can be three-dimensional: buildings and sculptures take up space. It can also be two-dimensional: a painted canvas can show space in many ways. You can look at any space from different places and angles, from inside or outside, in bright light and in shadow.

Regardless of your viewpoint, there will always be something that you notice first about an artwork. **Emphasis** gives importance to part of a work. It makes you notice one part or element before all the others.

Looking at Space

Artists refer to a space as **positive** (the object itself) or **negative** (the area surrounding the object). As they plan the spaces in their work, artists decide whether each area in the artwork will be filled (positive space) or empty (negative space).

You create space by the way you place objects or shapes. In three-dimensional art, artists organize space by carefully placing solid forms. They also plan negative spaces, which are between and around the forms. In two-dimensional art, artists organize space by the placement of shapes.

Implied space is the illusion, or appearance, of three-dimensional space in a two-dimensional artwork. On a flat surface, artists create the illusion of space by overlapping, shading, placement, size, sharpness of focus or detail, and linear perspective (see pages 40 and 148).

Note how Friedrich created the illusion of deep space in Fig. 6–16. The ships seem to get smaller as they move away from shore. There are more details in the foreground figures than in those farther away. Friedrich helps us experience the vastness of the seascape by giving the sky so much space.

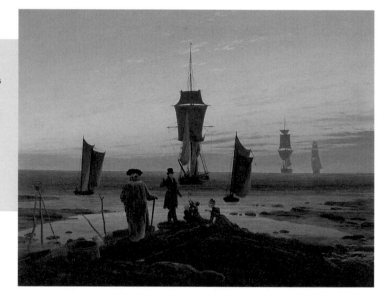

Fig. 6–16 German artist Caspar David Friedrich had deeply personal experiences with the sea and perhaps saw the coast as a place for thought. Can you locate this painting's center of interest? Caspar David Friedrich, *Periods of Life (Lebensstufen),* c. 1834. Oil on canvas, 28 ¾" x 37 ⅛" (73 x 94 cm). Museum der Bildenden Kuenste, Leipzig, Germany. Erich Lessing/Art Resource, NY.

National Standards 6.2 Elements and Principles Lesson

2b Employ/analyze effectiveness of organizational structures.

Teaching Options

Resources

Teacher's Resource Binder

 Finder Cards: 6.2

 A Closer Look: 6.2

 Find Out More: 6.2

 Check Your Work: 6.2

 Assessment Master: 6.2

 Overhead Transparency 11

Teaching Through Inquiry

Encourage students to imagine that they are on a committee to **select one artwork** for a waiting room for passengers about to take an ocean cruise. Half the committee members want to use *Periods of Life,* and half want to use *The Shipwreck.* **Ask:** Which would you support? Why?

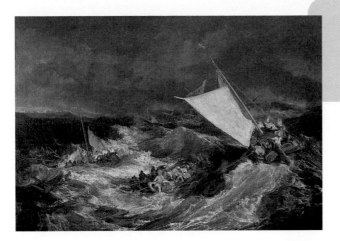

Fig. 6–17 How would you describe this artist's use of space? Did he show a short distance or a great distance? How can you tell? Joseph Mallord William Turner, *The Shipwreck*, 1805.
Oil on canvas, 6 ³/₄" x 9 ¹/₂" (17.1 x 24.2 cm). Clore Collection, The Tate Gallery, London/Art Resource, NY.

Looking at Emphasis

You can create emphasis by planning a work so that some features are more dominant, or stronger, than others. Viewers usually notice the dominant feature first. What do you notice first in Turner's painting (Fig. 6–17)? How did Turner draw attention to the people trying to survive a catastrophic shipwreck?

A bright patch of color in a painting with many dull colors can create emphasis. A repeated element can also create emphasis. For example, look at the shapes of people in Turner's work. Other ways to create emphasis include size and placement. The most important element—the subject of the work—might be larger than other elements. It might be placed near the center of the work or be given a lot of space.

When an area is strongly emphasized, artists say it is the **center of interest** in a work. The center of interest is not always the middle (physical center) of the work. It can be anywhere the dominant element shows up—top, side, or bottom.

Why, do you think, might an artist pay attention to emphasis when showing a particular place?

6.2 Elements & Principles

Check Your Understanding
1. What are some ways to create the illusion of space and distance in two-dimensional art?
2. What are some ways to achieve emphasis in two-dimensional art?

Studio Connection
Think of an imaginary place to depict, and then use emphasis to show deep space. What part or feature of the work do you want viewers to notice first? Experiment with different color combinations of watercolors or pastels.

You might create a colorful and dramatic evening sky and then blend colors to show gradual changes. Use two pieces of construction paper (a dark value and a middle value) and experiment with cut silhouettes. Use the silhouettes to create a middle ground and foreground.

Place

211

Studio Connection

Provide paints or pastels, pencils, brushes, heavy drawing or watercolor paper, assorted colors of construction paper, scissors, and glue. Demonstrate blending watercolors or pastels to create a sky; and how to use construction paper to create an illusion of space.

Lead students in remembering imaginary spaces from literature or movies. **Ask:** Will your place be in the city or in the country? Peaceful or in turmoil? Day or night? What will you emphasize? How will you create emphasis?

Assess See Teacher's Resource Binder: Check Your Work 6.2.

Assess

Check Your Understanding: Answers

1. overlapping, shading, placement, size, sharpness of focus or detail, linear perspective

2. making some features more dominant than others, repeating elements, contrasting colors, creating a center of interest

Close

Have students discuss whether Turner's and Friedrich's uses of emphasis aided their depiction of space.

Prepare

Pacing

Two 45-minute periods: one to consider text and images; one to print maps

Objectives

- Understand how artists in Oceania use natural materials in their artworks.

- Explain how the art of Oceania is connected to place.

- Design a map of a special place using motifs.

Vocabulary

motif Repeated design elements, which may create a pattern.

Using the Map

Use the map on this page in conjunction with the world map on pages 306–307. **Ask:** Where is Oceania? How far away from continents other than Australia are the various islands of Oceania? What does this distance suggest about the artworks of Oceania? What does the number of islands in Oceania suggest about its art?

Isolated in Place: Oceanic Art

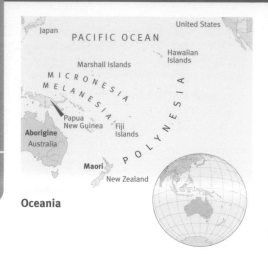

Oceania

Can you find Oceania on a map? Oceania is the name we give to a large area in the Pacific Ocean that contains thousands of islands. Many of the islands are grouped into one of three regions: Micronesia, Polynesia, or Melanesia. Within those regions are countries such as New Zealand and Papua New Guinea. The Hawaiian islands are part of Oceania, too. Oceania is a cultural name, not a political name. This means that the people of this huge area of islands share many similarities, even though they may be from different countries.

Fig. 6–18 Oceanic peoples have a long tradition of teaching and practicing ocean navigation. This map made of sticks shows how to travel to a place by tracking wave formations and patterns created by the ocean water bouncing off of the islands. Marshall Islands, Micronesia, *Stick Chart.*
Wood and shell. Peabody Museum of Art, Salem, Massachusetts. Photo by Jeffrey Dykes.

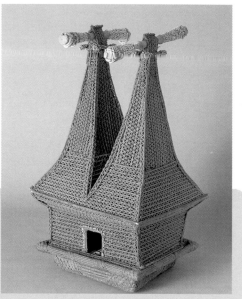

Fig. 6–19 This model for a miniature temple is woven from sennet, a local plant fiber in the Fiji Islands. Small idols, often made of ivory, are placed in the miniature temples as an offering to the spirits. Why do you think this model has two spires? Fiji Islands, Melanesia, *Double Spired Temple Model.*
Sennet, 43 ½" (110.5 cm). Peabody Museum of Art, Salem, Massachusetts. Photo by Jeffrey Dykes.

National Standards 6.3 Global View Lesson

3a Integrate visual, spatial, temporal concepts with content.

4a Compare artworks of various eras, cultures.

4c Analyze, demonstrate how time and place influence visual characteristics.

Teaching Options

Resources

Teacher's Resource Binder

 A Closer Look: 6.3

 Map: 6.3

 Find Out More: 6.3

 Check Your Work: 6.3

 Assessment Master: 6.3

Large Reproduction 12

Slides 6e

Teaching Through Inquiry

Art History Have students study each image on pages 212–215, and take note of where the artworks were created. Ask them to now imagine that they have been adrift on a raft in the South Pacific. Upon reaching shore, they encounter an artwork. Based on the style of the artwork, they must identify where they have landed.

Have students work in pairs and take turns describing one work in the lesson, in general terms (such as many dots placed close together, warm earth tones, and delicate outlines). The other student tries to guess what island or region this artwork is from.

The ocean forms a natural barrier around the islands of Oceania. There are people on these islands who have had very little contact with other cultures, although some parts of Oceania have been settled for more than 40,000 years. Being isolated has allowed the people to keep their cultural and artistic traditions. Many Oceanic peoples, especially those living far from cities and towns, still practice traditional ways of making art.

Oceanic art is usually created to be used in everyday life or for special ceremonies. Artists use local natural materials such as raffia, barkcloth, shells, and feathers in their work.

Some traditional art forms are wood carving, tattooing, maskmaking, and weaving. Many of these art forms show complicated repeated patterns and curving designs. These designs often reflect the animals and plants of the region. The designs also relate to the region's spiritual beliefs. In many Oceanic cultures, ancestor spirits are believed to rule the land and sea. People make offerings to these spirits, and their art shows the spirits in special places.

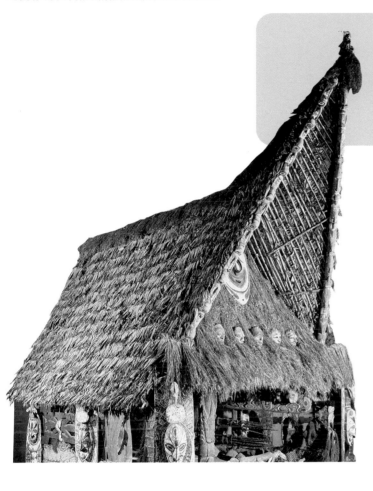

Fig. 6–20 Some native peoples of New Guinea build highly decorated houses for ceremonies. The inside of the house is a sacred space, open to only the initiated. New Guinea, *Hut of Spirits*. Museom Missionario Etnologico, Vatican Museums, Vatican State. Scala/Art Resource.

Place

213

Teach

Using the Text

Art Criticism Have students read pages 212 and 213 and then recall the natural and local materials used by artists in Oceania. Discuss how the subject matter in the art reflects place.

Perception Ask: What features did the artist emphasize in Fig. 6–20? How would you describe the space?

Using the Art

Aesthetics Discuss *Stick Chart*, Fig. 6–18, and then have students complete these prompts: "The ways that *Stick Chart* is like sculpture are____. The ways that *Stick Chart* is not like sculpture are____." Discuss why, or under what conditions, a map might be considered an artwork.

Extend

Art Production Challenge students to create a portrait or mask of one of their ancestors, in a style similar to that of a mask shown in Fig. 6–20. Encourage students to exaggerate their relative's real or imagined features.

More About...

Among the thousands of islands of **Oceania** is Polynesia, a vast triangle, about 5,000 miles on each side, with angles at New Zealand, Hawaii, and Easter Island. Tahiti, in the Society Islands, marks the geographic hub of Polynesia. Melanesia, an area about 3,000 miles long, includes Papua New Guinea, the Solomon Islands, and Fiji. Micronesia includes many small islands north of Melanesia and east of the Philippines.

More About...

The **Maori**, ethnic Polynesians who arrived in New Zealand by canoe around 800 AD, now represent about nine percent of New Zealand's population.

Using the Large Reproduction

Consider Context

Describe What materials were used to make this?

Attribute What clues do we have about where or by whom this was made?

Understand How could you find out more about how this was used?

Explain Finding out about the symbolism could help you understand messages in this work.

12

Using the Text

Art Criticism Have students read pages 214 and 215. **Ask:** If you were to meet a friend in a museum gallery of Aboriginal artworks, and your friend had no idea of what Aboriginal art looks like, what features and qualities would you tell him or her to look for in the artworks, so as to find you?

Art Production Ask: If you were going to create a painting in the style of Aboriginal art, what would you do?

Using the Art

Perception Ask: What qualities do these artworks have that are different from those in any other artworks in this chapter?

Studio Connection

Have available stencils or found objects (buttons, thread spools, seed pods) 18" x 24" brown or white craft or drawing paper, tempera paints, and paper towels. Demonstrate printing with the found objects or stencils. **Ask:** What motifs will you use? What will they symbolize?

Assess See Teacher's Resource Binder: Check Your Work 6.3.

Dreamtime Places

The Aborigines are Australia's most ancient peoples. They use a sense of place in their art in a very special way.

Much Aboriginal art is based on a belief in what is called Dreamtime. Dreamtime is thought to be a time of creation. Giant animals with great power arose from the earth and wandered the land, shaping and changing it as they went. These animal spirits and their journeys have inspired many customs and artworks. The shapes and patterns of some Aboriginal artwork might remind you of maps. The works show you the special places where Dreamtime spirits have been.

The twentieth century was a time of great change for the Aborigines. After European settlers came to Australia in the late nineteenth century, the Aborigines tried to keep their land, their customs, and their traditions. They showed their feelings about the land through artwork.

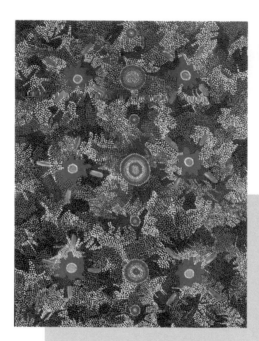

Fig. 6–21 Watering holes are very important in the dry land of Australia. Do think watering holes are shown in this painting? Can you find animal shapes in this Dreamtime scene? Keith Kaapa Tjangala, *Witchetty drub dreaming*, 20th century. Acrylic on canvas. Aboriginal Artists Agency, Sydney, Australia. Jennifer Steele/Art Resource, NY.

Fig. 6–22 The repeated shape of the Australian continent reflects this Aboriginal artist's connection to place. What might the artist be saying about his land? What does he think about change? Jeffrey Samuels, *This Changing Continent of Australia*, 1984. Oil on composition board, 73 5/8" x 48 7/8" (187 x 124 cm). Art Gallery of New South Wales, Sydney.

214

Teaching Options

Meeting Individual Needs

English as a Second Language Discuss how *Stick Chart* (Fig. 6–18) served as a map. Have students locate, on a map or globe, their original homeland (or that of their ancestors) and then identify where they live now. Ask students to create a "map"—with three-dimensional objects or with collage—that shows their or their relatives' migration route.

More About...

Aborigines, the original inhabitants of Australia and Tasmania, came from Asia some 40,000 years ago. Today, they represent about one percent of Australia's population. In the 1930s, the Australian government created Aboriginal reservations in central and northern Australia. In recent years, the Aborigines have actively campaigned to reclaim the sacred lands they lost to European immigrants.

Today, Aboriginal artists still stay connected with the land and the spirit world through their paintings. Traditionally, these paintings are made on barkcloth, a wood fiber that is beaten instead of woven. The artists often use bright colors and **motifs,** or repeated elements that create a pattern. Barkcloth paintings often seem to show a view from high up in the air. Their patterns symbolize the sacred connection between people and the land.

6.3 Global View

Check Your Understanding
1. What belief is much of Australian Aboriginal art based on?
2. What do the patterns in Aboriginal barkcloth paintings symbolize?
3. What is the main purpose of Oceanic art?
4. What kinds of materials are used by artists in Oceania?

Studio Connection
Use stencils or found objects to print a map of a place that is special to you. Choose motifs to stand for certain locations. Invent a way to show typical travel routes between areas within your place. Make your map both informative and interesting to look at. Try different ways of repeating the basic motif. Motifs can lock together or form alternating patterns. Some motifs can be diagonally stepped (dropped) to create complex patterns in several directions.

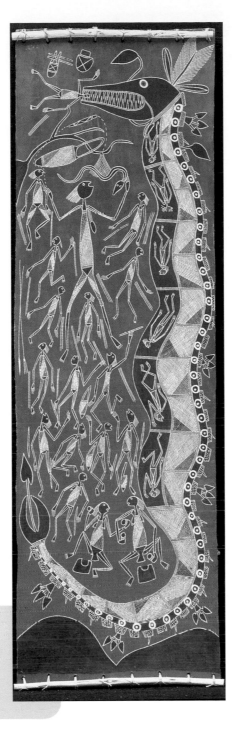

Fig. 6 23 This painting is done in a traditional style on barkcloth. The serpent is shown swallowing people whom she will transform into features of the land. What do you think the water lilies on the serpent's back mean? Bruce Nabageyo, *Ngaylod, The Rainbow Serpent at Gabari,* 1989.
Natural pigments on eucalyptus bark, 59 1/8" x 16" (150.1 x 40.4 cm). National Gallery of Australia, Canberra.

Place

215

Assess

Check Your Understanding: Answers

1. Dreamtime

2. the sacred connection between people and the land

3. Oceanic art is usually created for use in everyday life or for special ceremonies.

4. raffia, bark, shells, feathers

Close

Review Oceania's location and how its location has affected the art of its people. **Ask:** How can you recognize Aboriginal art?

Teaching Through Inquiry

Aesthetics Have students work in pairs or small groups to imagine that they are in the business of designing T-shirts for the Australian tourist industry. One group of businesspeople wants to reproduce the designs of Aboriginal barkcloth paintings. Another group opposes the **use of sacred images** for commercial purposes. Have students list three reasons why the use of the images would be appropriate, and three reasons why their use would not be appropriate. Discuss students' reasons.

Assessment Options

Teacher Ask students to imagine that they are going on a trip to Oceania to interview artists about the materials and processes they use. To prepare for the trip, they must do some research. **Ask:** What kinds of art books on materials and techniques would you check out of the library to prepare for this trip? What questions would you want to ask to find out how their work is connected to where the artists live?

Prepare

Pacing

Four 45-minute periods: one to consider text and art, and to draw design; three to complete the artwork

Objectives

- Identify various stitching techniques.
- Understand how traditional stitching can be an expressive art form.
- Create an image of a magical or dream-like place, using stitchery.

Vocabulary

fiber artist One who creates artworks with cloth, yarns, threads, etc.

appliqué A process of stitching and/or gluing cloth to a background.

Supplies

- sketch paper, 12" x 18"
- pencils, scissors
- tracing paper
- straight pins or tape
- large-eye sewing needle
- loosely-woven background fabric, 12" x 18"
- yarns and threads
- cloth scraps, a variety, for appliqué and practice
- decorative materials
- dowels, 13" and 19"
- white glue or hot glue
- embroidery hoops (optional)

National Standards 6.4 Studio Lesson

1b Use media/techniques/processes to communicate experiences, ideas.

5a Compare multiple purposes for creating art.

216

Fiber Arts in the Studio
Stitching an Artwork

Dream-like Places

Studio Introduction

If someone asked you to create an image of a magical place, what would you show? An exotic landscape? A mountain range on another planet? A city of the future? Perhaps you have actually visited a place that seemed magical to you or remember such a place from a dream you once had.

Now imagine that your only art materials are scraps of cloth, thread, yarn, and a few buttons or beads. What would you do? You would have to think like a **fiber artist**—an artist who creates artworks with cloth, yarns, threads, and other materials. You could cut shapes from fabric and **appliqué**, or sew them onto, a fabric background. You could create details with decorative stitches. You might even sew the buttons or beads onto the artwork.

Artists can express their feelings about places in stitched artworks just as they can in paintings and other forms of art. **In this studio experience, you will create a stitched wall hanging that shows a dream-like place.** Pages 218–219 will tell you how to do it. You might choose to show a place that seems ordinary in real life, but create the image with magical or dream-like qualities. Or you might create a dream-like place that is entirely imaginary.

Studio Background

Creative Quilts

When you hear the word *quilt*, you probably think of a patchwork bedspread. Its colorful fabrics and shapes add feelings of comfort and cheer to a room. But do you know that many cultures create quilts for reasons that go way beyond the bed? They make

Fig. 6–24 When she was first invited to Carlsbad Caverns, Barbara Watler was reluctant to go because she doesn't like very small places. Finally, she gave in and loved the visit. She created this quilt several weeks after the experience. How did she turn what could have been a terrifying place for her into one that is dream-like and inviting? Barbara W. Watler, *Cavern Gardens*, 1996.
Mixed thread painting and mixed fabrics, machine stitched and appliquéd, 24" x 16" (61 x 40.6 cm). Courtesy of the artist. Photo by Gerhard Heidersberger.

216

Teaching Options

Resources

Teacher's Resource Binder
 Studio Master: 6.4
 Studio Reflection: 6.4
 A Closer Look: 6.4
 Find Out More: 6.4
 Overhead Transparency 12
 Slides 6f

Meeting Individual Needs

Adaptive Materials Provide fabric paints or markers suitable for decorating cloth. Supply cut fabric pieces and materials.

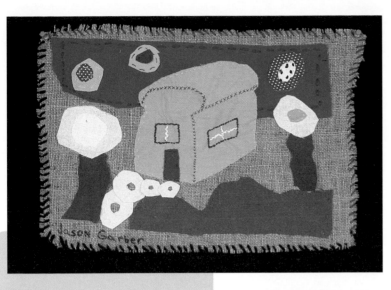

Fig. 6–25 "While I was planning my art project, I was thinking about the Simpsons where they eat so many donuts. Then I thought of many breakfast items. The difficulty with the cloth is getting the needle in the right spot and getting the yarn through the cloth." Jason Garber, *Eat Me*, 1999. Fabric, yarn, thread, 12 x 19" (30 x 48 cm). Yorkville Middle School, Yorkville, Illinois.

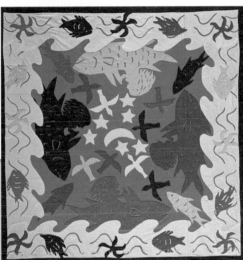

quilts for ceremonies, for weather insulation, and for honoring people. In certain cultures, people spread them on the ground before they sit. Quilt designs can represent ideas about marriage and freedom. And they can tell stories.

The materials used to make quilts can also go beyond what you might expect. In addition to scraps of colorful cloth, many of today's quiltmakers use threads and yarns of all textures and colors. They use ribbon, beads, paper, buttons, lace, mirrors, silk flowers—anything that can be stitched to the cloth. Artists who use such surprising materials have turned the traditional craft of quiltmaking into an expressive form of art.

Fig. 6–26 Women in the Cook Islands of Polynesia work together to create patchwork quilts. The quilts are often used in ceremonies. The designs usually show flowers, birds, fish, and other wildlife seen on and around the islands. Does the place you see here seem realistic or dream-like? Why? Maria Ieokolai and others, Cook Islands, *Ina and the Shark*, c. 1990. Tivaevae (ceremonial cloth), 101" x 97" (257 x 247 cm). Collection of the Museum of New Zealand Te Papa Tongarewa, Wellington, New Zealand, B.24769. Photo by Alan Marchant.

Place

217

Pre-Studio Assignment: Assign students to collect decorative items—buttons, sequins, lace, beads, braid, club patches, jewelry—to include in their stitchery.

Teach

Engage

Ask students to remember quilts that they have seen. **Ask:** What did they look like? What was their use? Who made them? Have students look at the images of quilts, and note how they are shapes of fabric stitched together. Usually, the quilts are padding or have some other kind of backing. Guide students to see that some of these quilts are decorative, and not bed coverings.

Using the Text

Art Criticism Have students describe the difference between quilting and appliqué methods of creating a stitched artwork.

Using the Art

Perception Ask: What place does each image represent? What are the predominant colors? Where are the negative and the positive spaces in each image? What is the center of interest? How did the artist emphasize it?

Sketchbook Tip
Encourage students to go to a favorite place and write in their sketchbook their thoughts about the place, and then make a series of simple drawings to describe the place.

Teaching Through Inquiry

Have students prepare questions to ask a family member or someone in the community about his or her **personal involvement with stitchery or needlework**. Students may need to do library research. If necessary, guide students to understand that the purpose of the interview is to find out how the skills were acquired, where the person learned the skills, what the person likes about this work, the kinds of decisions the person makes, and what the person thinks his or her best work is. Encourage students to consider documenting the interview with photographs and making a presentation to the class.

More About...

Quilting became popular during the Middle Ages, as knights needed quilted coats and hoods to wear under their armor.

Using the Overhead

12

Think It Through

Ideas Where do you think the artist got his idea? What does this image have to do with the theme of place? Does it have any qualities of a dream-like place?

Materials What materials were combined in this artwork? What ideas for materials can you get from this piece?

Techniques What kinds of stitching were used? What ideas do they give you for your own work?

Audience Whom do you think this work was made for?

Stitching an Artwork

Studio Experience

1. Demonstrate some of the stitches illustrated on page 218.

2. Display the fabrics and collected decorative items, and arrange some of them together to give students ideas.

3. Tell students that they may trace the large shapes of their design onto tracing paper, to use for patterns. They can then pin or tape the tracing-paper patterns to their fabric and cut the fabric and the tracing paper together. Before students do any stitching, suggest that they arrange the fabric shapes on the background fabric and pin or tape them in place.

Idea Generators

Brainstorm with students about what a dream-like place might look like. List their suggestions on the board. **Ask:** What dream-like possibilities might the fabrics and decorative items suggest? How will you emphasize a center of interest? How will you indicate space?

Studio Tip
Encourage students to experiment with different types of stitches, and explain that embroidery hoops will hold the fabric flat as they sew.

STUDIO LESSON

6.4

Fiber Arts in the Studio
Stitching Your Dream-like Place

You Will Need

- sketch paper and pencil
- sewing needle
- background fabric
- yarn and thread
- cloth scraps
- scissors
- decorative materials
- dowels
- white glue

Safety Note
To avoid cuts and jabs, handle sharp objects, such as needles and scissors, very carefully. When you are finished with the sharp objects, return them to your teacher or put them away in a safe place. Do not leave them unattended on desks, chairs, or the floor.

Types of Stitches

Running plain Satin Chain Blanket

Threaded Outline Cross Feather

Try This

1. Choose a format for your artwork. Will it be horizontal or vertical?

2. Sketch a design that shows an inviting dream-like place. Will you show an imaginary place? Or will you show a real place that has magical qualities? Sketch the main shapes first. Remember that you will be creating your place from fabric. Keep the design simple.

3. Cut the main shapes of your design from fabric scraps, and stitch them to the background.

4. Using thread and yarn, stitch other shapes and details onto the appliquéd parts and background of the artwork. Try a variety of thread and yarn colors and textures. Which stitches will work best in your design? Can you create any new stitches? Leave some parts of the background blank.

5. Sew decorations onto the artwork wherever you want them.

Teaching Options

Teaching Through Inquiry

Art Production Ask students to locate individuals in their families or neighborhoods who do needlework. Ask them to interview these individuals about how they learned their craft and if any traditions have been passed down from one generation to another. Suggest that they tape record their interviews and encourage them to ask about stories that individuals remember about learning their needlework skills. Have them take notes about the basic materials used for various stitchery and needlework projects. Require students to have the individual teach them one new skill to demonstrate to the class. Suggest they document their interviews with photographs.

6. When you are finished with your stitching, turn the art-work over. Carefully apply white glue along the length of a long dowel. Lay the glued side of the dowel along the top edge of the back of the artwork.

Apply another line of glue to the exposed length of dowel. Carefully roll the dowel, with background fabric attached, until the dowel is wrapped tightly with fabric. The fabric should be glued securely to the dowel.

7. Repeat the gluing process on the bottom edge of the artwork. When the glue has dried, tie a yarn hanger onto the ends of the top dowel.

Check Your Work

Discuss your artwork with classmates. What challenges did you face when you designed the artwork? Does the place you show look dream-like and inviting? How did you use stitches, shapes, colors, and decorations to create the look? How did you choose which stitches and materials to use?

Sketchbook Connection
Many cloth designs and stitched artworks show simplified patterns and figures from nature. Go outside and sketch some plant matter—leaves, flowers, trees, and the like—on a few pages of your sketchbook. Then create a simplified shape to represent each subject.

Computer Connection
Create a dreamlike place in a drawing, painting, or image-editing program. Obtain images of textiles by scanning, photographing with a digital camera, or from a CD-ROM or Internet collection. Choose several to work with. Using cut and paste features, make a digital version of appliqué. Save different versions; print your best one in color.

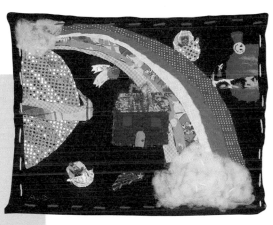

Fig. 6–27 "In science we are studying the solar system. Days later, my art teacher told us about this complicated art project coming up. As I opened my sketch pad, I was thinking of different ideas. First, I thought of a forest idea, but I couldn't think of enough good things to make a composition. I finally had a interesting thought! I could make an imaginative solar system. Soon, I had so many ideas pop into my head that I had to take a lot of them out." Ashley Dieter, *Imagination Space*, 1999.
Fabric, 12" x 19" (30 x 48 cm). Yorkville Middle School, Yorkville, Illinois.

Place

219

Computer Option
Guide students to research quilts and stitchery on the Internet with key words such as *appliqué, quilts, stitchery, needlecraft,* and *fiber arts.* To help students create their own composite images, discuss the kind of imagery they can create with a draw program and with a paint program. **Ask:** Which program would be better for creating soft, dream-like effects? What tools might you use to create the effects? Encourage students to soften their images by working with transparency and using paint-blending modes.

Assess

Check Your Work

Ask: Even though you may have some plain, unstitched areas, does your wall hanging look complete? Did you make effective use of the background areas? Did you use a variety of stitches? Where is the best place to display your work?

Close

Have students make and attach a label with their name and a descriptive title for their stitchery. Before displaying students' completed artworks, discuss how the art should be arranged—by similar subjects, by colors, or by materials.

More About...

Contemporary **fiber artists** weave, stitch, and knot both natural and synthetic fibers. Their work often becomes a kind of three-dimensional sculpture or relief. Fiber arts developed out of necessity; the earliest clothing of fur and hides was often joined with patterned stitches. With the development of the loom, probably during the fifth century BC, woven fabrics soon followed. The ancient Egyptians wove linen cloth, and the Chinese, around 2,000 BC, learned to unwind silkworm cocoon threads and weave them into silk. During the Middle Ages, embroidery reached its height—women created ornate, religious hangings and clothing. The power loom, invented in 1785, made possible a plentiful supply of fabrics.

Assessment Options

Teacher Have students do additional research on stitchery and needlework. They may use the library and supplement their information by conducting interviews in the community. Have students prepare a classroom display called "Stitched in Time," in which they include photocopies or actual stitchery, each labeled with a description of the types of stitches and materials used.

Careers

Ask students to identify any large sculptures or murals they have seen in public places in the community. Discuss why the reactions to public art can be controversial, and what questions are often raised in response to public art. **Ask:** Does the artist, the patron or sponsor, or the general public have the right to determine how the artwork will look? Does the artist have a responsibility to the people who will see the artwork? What are some reasons that a public sculpture might be erected?

Science

Tell students that adobe architecture presently shelters about 1.5 billion people in arid climates around the world. Have students make adobe bricks: Mix dry dirt with straw and water until the mixture holds together. Tightly pack the adobe into a rectangular wooden form about 3" tall, 12" long, and 8" wide. Set the form in the sun, remove it from the frame, and allow it to dry further. When students have finished, ask them to determine how many bricks would have to be formed to build a small house.

Connect to...

Careers

Are there public sculptures or murals in your community? What special places or people do they honor? Are they historic or contemporary? Artists who create such works might be sculptors who produce three-dimensional forms or muralists who work with paint or mosaic tiles. Both are public artists: they plan their art for display in public places, such as parks, buildings, or roadsides.

Many public artists make works that are site-specific—designed to fit or memorialize a specific space. **Public artists** purposely create art with a public audience in mind, often

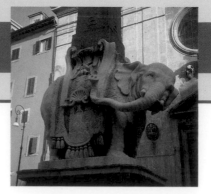

Fig. 6–28 **Public artists are knowledgeable about the durability and weather resistance of their materials. This elephant supports an Egyptian obelisk from the 6th century BC.** Gianlorenzo Bernini and Ercole Ferrata, 1667. Piazza della Minerva, Rome, Italy. Photo: H. Ronan.

expressing social or political ideas in their work. For large public-art projects, the artists often hire assistants or apprentices.

Other Arts

Music

If you created a **"musical picture" of a favorite place,** how would it sound? What instruments could depict this place? Would the tempo be fast or slow? Would you choose loud or soft dynamics? Would the rhythm be smooth or bouncy?

Composers sometimes write music about places they have visited or would like to visit. George Gershwin wrote *An American in Paris,* one of his best-known works for orchestra, after living in Paris for several months. The music realistically depicts the bustling sidewalks and noisy taxicabs of that city. Gustav Holst, however, never visited the subjects of his masterpiece, *The Planets.* He combined his fascination with astronomy, rich imagination, and musical skills to create this well-known orchestral work.

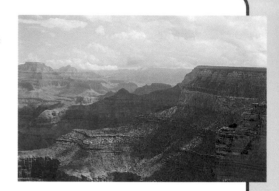

Fig. 6–29 **Ferde Grofé, who got his idea for *Grand Canyon Suite* as he stood on the canyon rim in 1922, represents in the composition the awesome sights and sounds of the national landmark.** Grand Canyon. Photo by H. Ronan.

Internet Connection
For more activities related to this chapter, go to the Davis website at **www.davis-art.com.**

Teaching Options

Resources

Teacher's Resource Binder
 Using the Web
 Interview with an Artist
 Teacher Letter

Video Connection

Show the Davis art careers video to give students a real-life look at the career highlighted above.

Community Involvement

• Work with a civic leader or realtor to find an available vacant lot or open area that students can transform. To call attention to the role that art can play in changing a place, students may create a temporary sculpture or other artwork that they can later remove without damage to the property.

• Call students' attention to any local monuments, memorials, or signage marking special places. Have students make a photographic documentary of these places.

Other Subjects

Science

Adobe structures are made from a mud-and-straw mixture that is formed into bricks or built up into solid walls and then coated with mud plaster. **Adobe design** is folk architecture: it developed from the use of natural building materials available in a particular place; in this case, a desert environment like the Southwest United States and parts of Africa, India, and Saudi Arabia.

Adobe buildings are simple, economical, and thermally efficient in hot, dry climates. Walls up to two feet thick, along with small window and door openings provide insulation, which keeps the indoor temperature fairly constant. The nature of adobe as a building material limits its design characteristics.

Geography

What tools do we use to help us find our way from one place to another? **Maps** of many kinds have helped people find their way to where they want to go. What concepts must we understand in order to "read" these visual images? Knowledge of measurement, scale and proportion, compass directions, and longitude and latitude is necessary for the careful interpretation of maps.

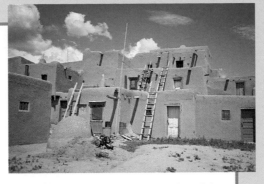

Fig. 6–30 **Adobe forms are simple, organic, and rounded, and are often molded by hand. See page 200 for another type of adobe architecture.** Taos Pueblo, New Mexico. Photo by H. Ronan.

How do you think that future technological advances will affect maps and how we use them? Already, we can go online to locate a detailed map to many addresses. The Global Positioning System, which can tell us exactly where we are on the earth, is available in hand-held receivers and is also offered in some cars. What mapping tools do you think the future might bring?

Daily Life

We generally attach meaning—perhaps joyful or sad—to special places that we use for either **personal or public contemplation.** What places are important to you? Your bedroom? A particular place where you meet your friends? A church or synagogue that you attend? What are some reasons that these places are meaningful to you?

What public places have people commemorated as special? In recent times, public memorials have become more common, as people leave flowers, candles, photographs, and other items to show respect and to honor those who have died. What memorials are found in your community?

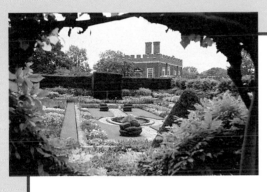

Fig. 6–31 **Imagine having this garden as your back yard—what would you do there?** Hampton Court, *William and Mary Gardens.* London, England. Courtesy of Davis Art Slides.

Geography

Ask: What skills are needed to read a road map, a world map, or a globe? How do mapmakers keep up with changes in political borders? Are illustrated maps easier to understand than maps that are not illustrated? Why might ancient maps have historic and artistic value? Explain that locating and printing detailed maps of home addresses is now possible through online research. Have students depict their own neighborhood as an illustrated map, using research materials from the Internet or other sources.

Other Arts

Have students describe features common to each musical composition and an artwork that depicts the same place (Paris, the Grand Canyon, any of the planets). Recordings of *An American in Paris* (George Gershwin), *Grand Canyon Suite* (Ferde Grofé) and *The Planets* (Gustav Holst) are available in most libraries.

Place

221

Internet Resources

The Art Gallery of New South Wales

http://www.artgallery.nsw.gov.au/about/index.html

The Collection of Aboriginal Art and Torres Strait Islander Art includes a wide range of artworks from historic bark paintings to contemporary sculptures.

Save Outdoor Sculpture! (SOS!)

http:// www.heritagepreservation.org

Save Outdoor Sculpture! is an effort to document, repair, and preserve public monuments and outdoor sculpture in the United States. Inventories on the site detail public art from every state. There are also interactive activities.

Teaching About Architecture and Art

http://www.artsednet.getty.edu/ArtsEdNet/Resources/Maps/Sites/index.html

World cultural heritage places are featured in detail on this site.

Interdisciplinary Planning

Use appropriate narratives, journals, stories, biographies, and autobiographies to enrich the study of art.

Talking About Student Art

After discussing the meaning of a student artwork, summarize students' various interpretations, and create a continuum, placing the most plausible interpretation at one end and the least plausible at the other. Invite students to place the remaining interpretations along the continuum, providing reasons for their decisions.

Portfolio Tip

Encourage students to use the following criteria for written reports for their portfolio: an introduction that sets the stage and captures the reader's interest; detailed ideas; clear explanations; and expressive language.

Sketchbook Tip

Remind students that their sketchbook is a place for brainstorming ideas to work toward creative solutions to problems.

Portfolio

"We were picking out old magazine clippings and designs for a painting when I found a photograph in a book. I loved it so much, I decided to paint it. The blending of the sky was easy, but the trees and branches were hard with their very fine lines. I like the upside-down sky in the water the most." **Julie Gunnin**

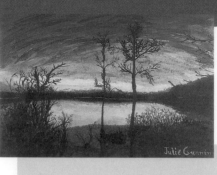

Fig. 6–32 How does time of day affect the mood of a piece? Julie Gunnin, *Sunset*, 1999. Acrylic, 12" x 18" (30 x 46 cm). Johnakin Middle School, Marion, South Carolina.

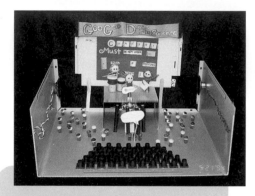

Fig. 6–33 Over the summer, two students went to a concert and decided to use their experience as inspiration for this sculpture. Using small parts, the students created the impression of a large space. What does the artwork tell us about this place? Indu Anand and Jamie Lee Breedlove, *Goo Goo Dolls in Concert*, 1999. Sculpture made from computer parts, 17" x 17" x 7" (43 x 43 x 18 cm). Avery Coonley School, Downers Grove, Illinois.

Fig. 6–34 Use of color in this artwork adds emphasis to foreground, middle ground, and background. Kendra Mooney, *Vacation Time*, 1999. Mixed-media collage with tissue paper and magazine photos, 12" x 18" (30.5 x 46 cm). Asheville Middle School, Asheville, North Carolina.

"I got the idea for my collage by putting in things that I would like to do in my spare time—like go see places on a vacation. I put in a lot that deals with water, because I like going to places where I can swim." **Kendra Mooney**

CD-ROM Connection
To see more student art, check out the Global Pursuit Student Gallery.

Teaching Options

Resources

Teacher's Resource Binder
Chapter Review 6
Portfolio Tips
Write About Art
Understanding Your Artistic Process
Analyzing Your Studio Work

CD-ROM Connection

Additional student works related to studio activities in this chapter can be used for inspiration, comparison, or criticism exercises.

Chapter 6 Review

Recall

Name the three major art styles in Western art in the nineteenth century, and describe how each dealt with the idea of place.

Understand

Explain how a painting of a landscape or seascape can convey moods or feelings.

Apply

Create two pastel drawings, each based on careful observation of a place, so that each expresses a mood or feeling very different from the other.

Analyze

Compare and contrast the navigational map (*Stick Chart*, Fig. 6–18) and the ancestral map of the land (*Witchetty drub dreaming*, Fig.6–21, both shown at right) with maps used by boaters and drivers. Consider how shapes, lines, and colors are used to help people "read" the maps.

Synthesize

Write a conversation that might have taken place between Angelica Kauffmann (Fig. 6–11) and Rosa Bonheur (Fig. 6–1) while looking at the work of Delacroix (Fig. 6–13). They are to express their ideas about how to represent places.

Evaluate

Recommend what should be written on a gallery information card to explain and to justify why the works by John Constable (Fig. 6–4) and Faith Ringgold (Fig. 6–6) have been displayed together as the only two works in a gallery. Include suggestions for what viewers might seek when comparing these two works.

Page 212

For Your Portfolio

Look at the images in each chapter's Global View lesson, and choose one work that interests you. Research the place where the artwork was made, and then prepare a written report. Include a description of the area's geography, climate, natural resources, cultural beliefs, and so on; and provide a map of the area. Add a paragraph that describes what characteristics of the region are shown in the artwork.

For Your Sketchbook

Do a series of sketches of the same place, changing the center of interest in each view.

Page 214

Place

223

Chapter 6 Review Answers

Recall

Neoclassicism looked to places in the past. Romanticism looked to exotic and faraway places. Realism showed places and things that artists see every day.

Understand

Artists can use colors, shapes, lines, and textures in expressive ways to make rolling hills or ocean waves convey moods, for instance, that are calm, frightening, or cheerful. Artists can also use space and emphasis on different features to express moods or feelings.

Apply

Look for careful depictions of a place so as to create two different moods.

Analyze

Shapes, lines, and colors provide useful information in all cases. They show ways of travel, borders, special places or centers of interest, and natural formations. As students consider contrast, answers might include: our nautical and road maps depend upon names and numbers, while the Oceanic examples used only visual symbols; our maps are mass-produced; our maps include much detailed information.

Synthesize

Look for an understanding of the subject matter, style, and approach to the work of all three artists.

Evaluate

Look for indications that each artist's work shows a place and its special characteristics. Viewers might look for evidence that each place depicted is from memory or observation.

Reteach

Have students choose a place and do a drawing of it to fit one of these categories: artists depict places from the past; artists show the unique characteristics of places they have seen; artists depict romantic or fantasy places. Have students present their artworks, and ask the class to decide in which group each work should be displayed.

Family Involvement

Take the class on a "field trip" to a place of students' choice—perhaps Tokyo, Istanbul, or Paris—to see artworks and experience the culture. Ask family members to collect appropriate materials from travel agencies and the Internet, and to help students research various aspects of the destination. On the day of the trip, have students give "tours" of the art and cultural sites.

Advocacy

Set up an exhibition of student artwork, including statements of learning goals and objectives, in the school board's meeting room.

223

Chapter Organizer

Chapter Focus

Chapter National Standards

**Chapter 7
Nature**

Chapter 7 Overview
pages 224–225

- **Core** Artists are inspired by and use natural forms and materials. Through their art, they observe and record the natural world.
- **7.1** European Art: 1875–1900
- **7.2** Color
- **7.3** The Art of Japan
- **7.4** Making a Paper Relief Sculpture

1 Understand media, techniques, and processes.
2 Use knowledge of structures and functions.
3 Choose and evaluate subject matter, symbols, and ideas.
4 Understand arts in relation to history and cultures.
5 Assess own and others' work.

Objectives	**National Standards**

4 **4** **4**

**Core Lesson
Art Connects With
Nature**
page 226
Pacing: Four 45-minute periods

- Identify ways that artists have been inspired by nature.
- Explain, by using specific examples, how artists have used materials from nature.

1b Use media/techniques/processes to communicate experiences, ideas.
3b Use subjects, themes, symbols that communicate meaning.
5a Compare multiple purposes for creating art.

**Core Studio
Nature in Relief**
page 230

- Make a relief print of a subject from the natural world.

2b Employ/analyze effectiveness of organizational structures.

2

Objectives	**National Standards**

**Art History Lesson 7.1
European Art:
1875–1900**
page 232
Pacing: Two 45-minute periods

- Explain what interested and inspired Impressionist painters. Give examples.
- Understand significant differences between Impressionism and Post-Impressionism.

1b Use media/techniques/processes to communicate experiences, ideas.
2c Select, use structures, functions.
4a Compare artworks of various eras, cultures.

Studio Connection
page 234

- Interpret a nature scene in two ways, by varying colors and brushstrokes.

1b Use media/techniques/processes to communicate experiences, ideas.

1

Objectives	**National Standards**

**Elements and
Principles Lesson 7.2
Color**
page 236
Pacing: One 45-minute class period

- Perceive and describe the changing colors in nature and in artworks.

1b Use media/techniques/processes to communicate experiences, ideas.
2a Generalize about structures, functions.
2c Select, use structures, functions.
4a Compare artworks of various eras, cultures.

Studio Connection
page 237

- Create a monoprint of a natural object, using more than one color.

2c Select, use structures, functions.

Featured Artists

Basil Besler
Mary Cassatt
Paul Cézanne
Ron Chespak
Edgar Degas
Nin'ami Dohachi
Kitaoka Fumio
Paul Gauguin

Ando Hiroshige
Katsushika Hokusai
Sen'ei Ikenobo
Maria Sibylla Merian
Claude Monet
Thomas Moran
Berthe Morisot
Okakoto

Dennis Ortakales
Pierre-Auguste Renoir
Georges Seurat
Tamayara Sotatsu and
 Hon'ami Koetsu
Vincent van Gogh
Frank Lloyd Wright

Chapter Vocabulary

simplified
relief print
Impressionism

Post-Impressionism
atmospheric color
complementary

Teaching Options

Teaching Through Inquiry
More About...Maria Sibylla Merian
Using the Large Reproduction
Using the Overhead
Meeting Individual Needs
More About...*Fallingwater*

Technology

CD-ROM Connection
 e-Gallery

Resources

Teacher's Resource Binder
 Thoughts About Art:
 7 Core
 A Closer Look: 7 Core
 Find Out More: 7 Core
 Studio Master: 7 Core
 Assessment Master:
 7 Core

Large Reproduction 13
Overhead Transparency 14
Slides 7a, 7b, 7c

Meeting Individual Needs
Teaching Through Inquiry
More About...Katsushika Hokusai
Wit and Wisdom
Assessment Option

CD-ROM Connection
 Student Gallery

Teacher's Resource Binder
 Studio Reflection: 7 Core

Teaching Options

Teaching Through Inquiry
More About...Impressionism
Using the Overhead

Technology

CD-ROM Connection
 e-Gallery

Resources

Teacher's Resource Binder
 Names to Know: 7.1
 A Closer Look: 7.1
 Map: 7.1
 Find Out More: 7.1
 Assessment Master: 7.1

Overhead Transparency 13
Slides 8d

Meeting Individual Needs
Teaching Through Inquiry
Wit and Wisdom
Assessment Options

CD-ROM Connection
 Student Gallery

Teacher's Resource Binder
 Check Your Work: 7.1

Teaching Options

Teaching Through Inquiry
Using the Overhead
Assessment Options

Technology

CD-ROM Connection
 e-Gallery

Resources

Teacher's Resource Binder
 Finder Cards: 7.2
 A Closer Look: 7.2
 Find Out More: 7.2
 Assessment Master: 7.2

Overhead Transparency 13

CD-ROM Connection
 Student Gallery

Teacher's Resource Binder
 Check Your Work: 7.2

Chapter Organizer continued

9 weeks	18 weeks	36 weeks

Objectives National Standards

2 (36 weeks)

Global View Lesson 7.3
The Art of Japan
page 238
Pacing: Two 45-minute
class periods

Objectives
- Describe ways that nature and the environment are important subjects in Japanese art.
- Give examples of how natural materials are used in Japanese art.

National Standards
- **1b** Use media/techniques/processes to communicate experiences, ideas.
- **4b** Place objects in historical, cultural contexts.
- **4c** Analyze, demonstrate how time and place influence visual characteristics.
- **5c** Describe, compare responses to own or other artworks.

Studio Connection
page 240

Objectives
- Create a ceramic vessel based on close observation of a natural form.

National Standards
- **1b** Use media/techniques/processes to communicate experiences, ideas.

2 (18 weeks) **2** (36 weeks)

Studio Lesson 7.4
Making a Paper Relief
Sculpture
page 242
Pacing: Two 45-minute
periods

Objectives
- Understand the potential of paper for creating three-dimensional forms.
- Create a relief sculpture of natural forms, using a variety of paper-sculpture techniques.

National Standards
- **1b** Use media/techniques/processes to communicate experiences, ideas.
- **3a** Integrate visual, spatial, temporal concepts with content.

Connect to...
page 246

Objectives
- Identify and understand ways other disciplines are connected to and informed by the visual arts.
- Understand a visual arts career and how it relates to chapter content.

National Standards
- **6** Make connections between disciplines.

Portfolio/Review
page 248

Objectives
- Learn to look at and comment respectfully on artworks by peers.
- Demonstrate understanding of chapter content.

National Standards
- **5** Assess own and others' work.

2 (18 weeks) Lesson of your choice

Teaching Options

Teaching Through Inquiry
More About...Golden Pavilion
Using the Large Reproduction

Technology

CD-ROM Connection
e-Gallery

Resources

Teacher's Resource Binder
A Closer Look: 7.3
Map: 7.3
Find Out More: 7.3
Assessment Master: 7.3

Large Reproduction 14
Slides 8e

Meeting Individual Needs
More About...Katsushika Hokusai, Ando Hiroshige
Assessment Options

CD-ROM Connection
Student Gallery

Teacher's Resource Binder
Check Your Work: 7.3

Teaching Options

Teaching Through Inquiry
More About...Free-standing relief
More About...Ron Chespak
Using the Large Reproduction
Meeting Individual Needs
Studio Collaboration
More About...Paper sculptures
Assessment Options

Technology

CD-ROM Connection
Student Gallery
Computer Option

Resources

Teacher's Resource Binder
Studio Master: 7.4
Studio Reflection: 7.4
A Closer Look: 7.4
Find Out More: 7.4

Large Reproduction 14
Slides 8f

Teaching Options

Community Involvement
Curriculum Connection

Technology

Internet Connection
Internet Resources
Video Connection
CD-ROM Connection
e-Gallery

Resources

Teacher's Resource Binder
Using the Web
Interview with an Artist
Teacher Letter

Teaching Options

Advocacy
Family Involvement

Technology

CD-ROM Connection
Student Gallery

Resources

Teacher's Resource Binder
Chapter Review 7
Portfolio Tips
Write About Art
Understanding Your Artistic Process
Analyzing Your Studio Work

Chapter Overview

Theme

We all depend on natural resources and seek to understand the natural forces that affect our lives. Artists are inspired by and use natural forms and materials. Through their art, they observe and record the natural world.

Featured Artists

Basil Besler
Mary Cassatt
Paul Cézanne
Ron Chespak
Edgar Degas
Nin'ami Dohachi
Kitaoka Fumio
Paul Gauguin
Ando Hiroshige
Katsushika Hokusai
Sen'ei Ikenobo
Maria Sibylla Merian
Claude Monet
Thomas Moran
Berthe Morisot
Okakoto
Dennis Ortakales
Pierre-Auguste Renoir
Georges Seurat
Tamayara Sotatsu and Hon'ami Koetsu
Vincent van Gogh
Frank Lloyd Wright

Chapter Focus

We are all connected to nature. Nature affects our lives. This chapter looks at the way artists have been inspired by nature subjects and natural materials; how the Impressionists and Post-Impressionists used color in both natural and expressive ways; and how the art of Japan focuses on nature. Students explore the potential of

7 Nature

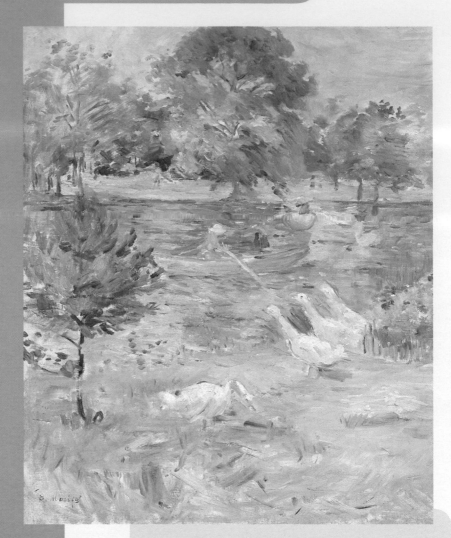

Fig. 7–1 **How does this artwork encourage the viewer to feel close to nature?**
Berthe Morisot, *Girl in a Boat with Geese*, c. 1889.
Oil on canvas, 25 ³/₄" x 21 ¹/₂" (65 x 54.6 cm). Ailsa Mellon Bruce Collection, Photograph © 1999 Board of Trustees, National Gallery of Art, Washington, DC.

224

National Standards Chapter 7 Content Standards

1. Understand media, techniques, and processes.

2. Use knowledge of structures and functions.

3. Choose and evaluate subject matter, symbols, and ideas.

4. Understand arts in relation to history and cultures.

5. Assess own and others' work.

Teaching Options

Teaching Through Inquiry

Ask students to choose one of these interpretations and point to specific evidence in Fig. 7–1 to support their choice:

- This painting is about enjoying nature. The artist captured the colors and textures of the natural surroundings, as well as a delightful moment of connecting with small, hungry creatures.

- This painting is about city parks that are being overrun by destructive wildlife. The artist distorted the colors and showed the destructiveness of animals.

More About...

Berthe Morisot (1841–95) was the granddaughter of the Rococo artist Fragonard and was brought up in a highly cultured atmosphere. She was the pupil of Corot, and was greatly influenced by the work of Manet. She specialized in gentle domestic scenes and painted with a delicate, feathery technique. She was a champion of Impressionist ideals and exhibited in almost all of the major Impressionist exhibitions.

Focus

- In what ways are humans strongly connected to nature?
- How do artists show nature, and use materials from nature, in their works?

How does nature affect your life? Do you notice it only when it keeps you from doing something you enjoy—like when it's too rainy to play basketball outside or a big storm knocks out the electricity and you can't watch TV? Or do you sometimes look at the sky and see shapes in the clouds? Do you notice the patterns on the ground beneath a leafy tree?

Whether you realize it or not, you are connected to nature. Soil, water, and growing things allow you to survive. The buildings you live in are made of materials from nature. And nature's power is still greater than the power of human beings. Humans can't stop tornadoes, prevent earthquakes, or turn back floodwaters. We depend on nature, and we often can't control it.

People throughout time and across cultures have been awed by the natural world. They have been frightened by storms and volcanoes. They also have been inspired and comforted by the beauty of sunsets, trees, and waterfalls.

Our lives have always been linked to nature. So has our art. Artists depend on nature to provide the materials for art. They also study natural patterns and scenes to use as subject matter for their artworks, as you can see in Fig. 7–1. The history of art-making is full of examples of how humans have observed and interpreted the natural world.

What's Ahead

- **Core Lesson** Discover how artists have used nature subjects and materials.
- **7.1 Art History Lesson** Learn how some late nineteenth-century artists painted their impressions of nature.
- **7.2 Elements & Principles Lesson** Focus on how artists use color to create mood.
- **7.3 Global View Lesson** Explore how nature is included in the art of Japan.
- **7.4 Studio Lesson** Create natural forms out of paper.

Words to Know

simplified	Post-Impressionism
relief print	atmospheric color
Impressionism	complementary

paper for creating a three-dimensional sculpture based on natural forms.

Chapter Warm-up

Ask: How has nature affected you today? Did you dress differently, run faster, or slow down because of the weather? Tell students that they will study how artists use aspects of nature as subjects and create art from natural materials.

Using the Text

Perception After students have read page 225, have a volunteer give the day's weather report for Morisot's *Girl in a Boat with Geese*. **Ask:** What are the natural features in Morisot's painting? *(geese, trees, sky, clouds, water, sky)* How does this painting make you feel about being in nature? If this scene occurred in a violent storm, how might the people in the boat feel? Remind students that both the beauty and the violence of nature have been depicted in artworks.

Using the Art

Art Criticism Call students' attention to *Girl in a Boat with Geese*. **Ask:** What are the colors in the sky? In the trees? The water? What do you think Morisot was most interested in showing in this painting?

Extend

Encourage students to paint the scene in *Girl in a Boat with Geese* as it might appear in different weather conditions. **Ask:** How will the colors change?

225

Graphic Organizer
Chapter 7

7.1 Art History Lesson
European Art: 1875–1900
page 232

7.2 Elements & Principles Lesson
Color
page 236

Core Lesson
Art Connects with Nature

Core Studio
Nature in Relief
page 230

7.3 Global View Lesson
The Art of Japan
page 238

7.4 Studio Lesson
Making a Paper Relief Sculpture
page 242

Prepare

Pacing

Four 45-minute periods: one to consider text and art; one to draw nature objects; one to carve block; one to print

Objectives

- Identify ways that artists have been inspired by nature.
- Explain, by using specific examples, how artists have used materials from nature.
- Make a relief print of a subject from the natural world.

Vocabulary

simplify Create in less detail than that in the original object; to highlight areas and to reduce the complex to its most basic elements.

relief print A print created by a printing process in which ink is placed on the raised portions of the block or plate.

Supplies for Engage

- nature objects such as shells, rocks, fossils, leaves, driftwood, seed pods, pinecones, cactus, potted plants

Art Connects with Nature

Inspired by the Natural World

Have you ever collected seashells, rocks, fossils, or leaves? Artists are attracted to these natural forms.

Sometimes, artists make natural forms part of larger compositions. Other times, the forms serve as the main subject of an artwork. Before photography was invented, people relied on artists to record the details of plants, animals, and natural features throughout the world (Fig. 7–2).

Artists are not always interested in showing all of nature's details. Instead, they choose to show the feelings or moods that natural scenes inspire. They use color and other elements to show nature's expressions. Their artworks may appear close up, showing carefully studied details, or at a distance, as if the artist is standing back in awe (Fig. 7–4).

Some artists return to the same scene over and over. Each time, they try to see it in a new way or capture it in a different light.

Impressionist painters, such as Berthe Morisot (see Fig. 7–1), were fascinated with the effect of light on color. They studied the color changes they saw during a single day.

Look around your home. Can you find shapes or decorations that are borrowed from nature? Look for plant shapes in fabric and china patterns and on eating utensils. **Simplified** plant, animal, and insect shapes—shapes that are not as detailed as the actual object— are part of furniture and architectural designs in many cultures worldwide (Fig. 7–3).

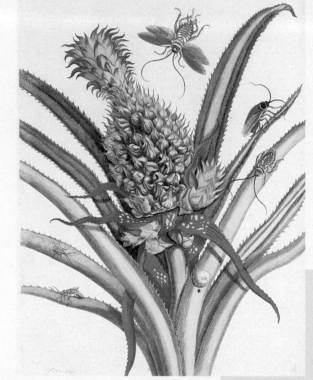

Fig. 7–2 Engravings like this one showed people what plants and insects looked like. How might the invention of photography have affected artists who worked in this style? Maria Sibylla Merian, *Plate 2 from Dissertation in Insect Generations and Metamorphosis in Surinam*, second edition, 1719. Hand-colored engraving, approximately 12 ¾" x 9 ¾" (32.4 x 24.8 cm). The National Museum of Women in the Arts.

National Standards Core Lesson

1b Use media/techniques/processes to communicate experiences, ideas.

3b Use subjects, themes, symbols that communicate meaning.

5a Compare multiple purposes for creating art.

Teaching Options

Resources

Teacher's Resource Binder
 Thoughts About Art: 7 Core
 A Closer Look: 7 Core
 Find Out More: 7 Core
 Studio Master: 7 Core
 Studio Reflection: 7 Core
 Assessment Master: 7 Core
Large Reproduction 13
Overhead Transparency 14
Slides 7a, 7b, 7c

Teaching Through Inquiry

Art Criticism Have students work in groups to identify everyday items with shapes or decorations that are **borrowed from nature**. Make a collection of the actual objects, or use magazine visuals/photocopies of images so that students can sort them into the following groups: (1) accurate representation (Merian's drawing is scientifically accurate); (2) expression of a feeling; (wilting flower to express sadness); (3) stylization to fit design purposes (stylized bird fits the shape of the storage jar); (4) symbolic communication of a message (a dove with an olive branch communicates a message of peace).

Fig. 7–3 People around the world use simplified natural forms as decoration. In what other way does this artwork connect humans with nature? Zuni Pueblo (New Mexico), *Olla (Storage Jar)*, 1850–75.
Painted earthenware, 9 ½" x 11 ½" (24.1 x 29.2 cm). The Nelson-Atkins Museum of Art, Kansas City, Missouri (Gift of Mrs. Frank Paxton in memory of Frank Paxton, Sr.). Photography by Robert Newcombe. ©1999 The Nelson Gallery Foundation. All Reproduction Rights Reserved.

Fig. 7–4 How did this artist use color and light to create a dramatic vision of the natural world? Thomas Moran, *Grand Canyon*, 1912.
Oil on artist's composition board, 15 ¹⁵⁄₁₆" x 23 ¹⁵⁄₁₆" (40.4 x 60.8 cm). The Nelson-Atkins Museum of Art, Kansas City, Missouri (Bequest of Katherine Harvey). Photography by Robert Newcombe. ©1999 The Nelson Gallery Foundation. All Reproduction Rights Reserved.

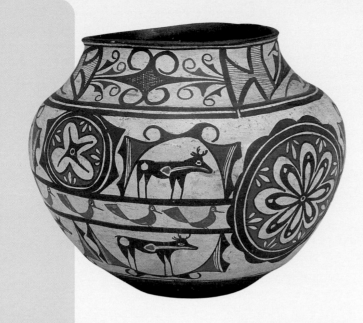

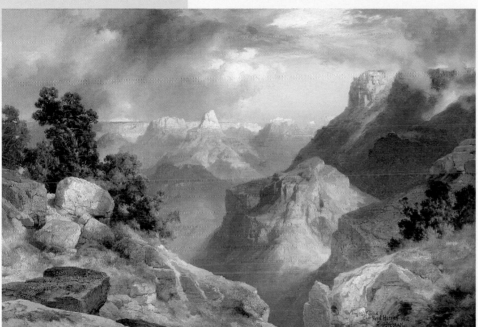

Nature

227

Teach

Engage

Display the nature objects, and encourage students to explain why people collect these. Explain that artists are attracted to these natural forms. Have students select objects that particularly appeal to them.

Using the Text

Art Criticism Have students read page 226. **Ask:** What natural features were Impressionist painters like Morisot trying to capture? *(light)* How did Moran paint light in *Grand Canyon*? How did Morisot paint it in *Girl in a Boat with Geese*? What is the texture of the brushstrokes in each painting? What was each artist's message?

Using the Art

Art Criticism How did Maria Sibylla Merian and the Zuni potter (Fig. 7–3) interpret nature differently? How did the purpose of each artwork influence how the artist depicted nature objects?

More About...

Maria Sibylla Merian (1647–1717) is best known for her scientifically accurate and delicately colored drawings of insects and butterflies. In 1699, Merian journeyed to Suriname, in South America, where she spent two years studying insect life cycles and habitats. Her accurate engravings, published in 1705, were not only important scientific documents, but also beautiful works of art.

Using the Large Reproduction

13

Talk It Over

Describe What elements from nature do you see? What lines, shapes, colors, and textures do you see?

Analyze How were the parts organized? What is suggested by the close-up view?

Interpret How might the artist have wanted viewers to think about nature?

Judge What sets this work apart from other Impressionist works you have seen?

Using the Overhead

Think It Through

Ideas What must have inspired this artist?

Materials What materials did the artist use?

14

Techniques How was this image created?

Audience Whom do you think this work would appeal to?

Using the Text

Perception Have students read page 228. **Ask:** From what natural materials is each artwork made?

Art Criticism Ask: What parts of Fallingwater are made from manufactured materials? *(cement balconies and overhangs)* How did Frank Lloyd Wright make this building seem a part of the natural landscape? *(He used local, natural materials and repeated the shape of the rocks in the balconies.)*

Art Materials from Nature

People have always created artworks from materials such as clay, wood, and fiber. It is sometimes hard to tell that an artwork is made of natural materials, however. When you look at a ceramic vase, for example, you might not believe that it began as a lump of clay in the earth. In other artworks, such as a marble sculpture, the natural materials are easier to recognize.

Artists might shape natural objects to create small works, as when they use plant reeds to make a basket. Or they might shape nature on a large scale, as in the design and creation of a public garden (Fig. 7–5). Architect Frank Lloyd Wright combined a waterfall with rock outcroppings and other natural materials to create a home that was an artwork (Fig. 7–7).

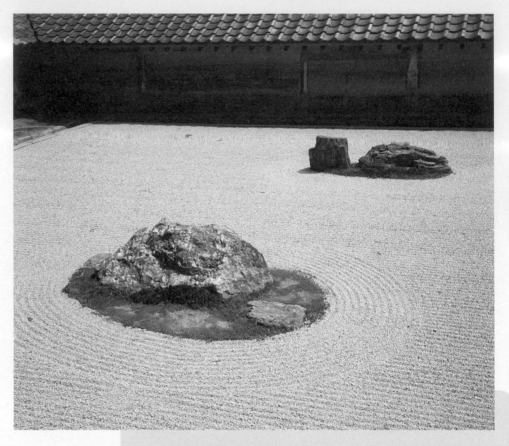

Fig. 7–5 **Artists carefully arranged rocks and sand to create this peaceful garden.** Soami, *Zen Stone Garden*, symbolizing sea and islands. Muromachi period (founded 1473). Ryoan-ji Temple, Kyoto, Japan. SEF/Art Resource, NY.

228

Teaching Options

Meeting Individual Needs

Gifted and Talented/Multiple Intelligences-Naturalistic Have students compare Merian's engraving (Fig. 7–2) to something similar depicted in a scientific text. **Ask:** What is the difference between Merian's depiction of the subject and the presentation of the same subject in a textbook meant solely for teaching? *(composition, use of color)* Have students research Merian's travels to record Suriname wildlife in the late seventeenth century.

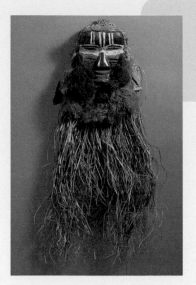

Fig. 7–6 **Can you easily see the natural materials used to create this mask? The geometric design painted on the face, known as the leopard pattern, was also inspired by nature.** Kran culture (Liberia), *Mask Dance*, 20th century. Painted wood, raffia, and fabric, 12" x 8" (30.5 x 20.3 cm). Collection of the University of Central Florida Art Gallery, Orlando, Florida.

Using the Art

Perception Ask students to describe the textures and patterns in the Liberian mask. Point out how the combination of natural materials, the carved wooden face, and the raffia makes the mask visually engaging.

Extend

Have students research Zen gardens to learn about Japanese reverence for nature. Students may then use sand and pebbles to create their own miniature rock garden in a small box.

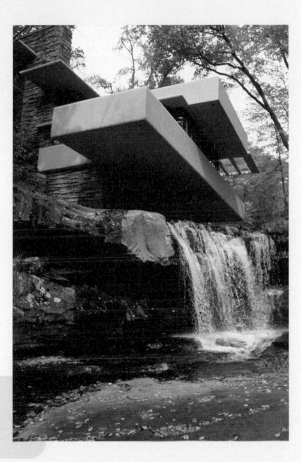

Fig. 7–7 **In this architectural work, which materials are provided by nature? Which are human-made?** Frank Lloyd Wright, *Fallingwater (Kaufmann House)*, 1936. Bear Run, Pennsylvania. Ezra Stoller © Esto. All rights reserved.

Nature

Teaching Through Inquiry

Aesthetics Ask students to consider the variety of ways that **the look of natural materials** is reproduced artificially (as in silk flowers, imitation leather, and Formica wood grain). Discuss the advantages and disadvantages of these imitations of nature.

More About...

Fallingwater, designed in 1936 for Pittsburgh department-store owner Edgar J. Kaufmann and his family, is one of Frank Lloyd Wright's most acclaimed buildings. The waterfall had been the family's favorite picnic and swimming site before they commissioned Wright to build their vacation home. They were surprised when Wright wanted to position the house *over* the falls instead of in a spot from which they could view the falls. Wright integrated his design with nature by cantilevering reinforced concrete balconies over the stream. Fallingwater is now a museum.

CD-ROM Connection

For more images relating to this theme, see the Global Pursuit CD-ROM.

Supplies

- nature objects
- pencils
- paper, typing or copy
- linoleum blocks, 4" x 6"
- linoleum cutters
- print papers, various kinds
- water-soluble block-printing ink
- brayers
- safety blocks or bench hooks
- cookie sheets or trays
- large spoon (optional)
- carbon paper (optional)

Safety Note
Warn students never to put their fingers in front of the linoleum cutters when using them. Have students use a safety block or bench hook. To reduce the likelihood of accidents, provide a soft, easier-to-carve linoleum.

Using the Text

Art Production After students have read the text, review the steps for making a relief print. **Ask:** What do the Japanese prints suggest about the process of making a relief print?

Have students sketch with pencil on copy paper, and then select one design to develop into a print. Remind students that the drawing on the block will be the reverse of the print. They may use carbon paper to transfer their drawing, or they may lay the drawing facedown on the linoleum and rub.

Demonstrate rolling the ink on the inking slab (cookie sheet or tray), and rubbing the paper. Remind students to set the linoleum block on newspapers before inking. Encourage students to experiment by making prints on different papers, using two colors, and printing more than one print on a sheet.

Printmaking in the Studio
Nature in Relief

Printmaking is the process of transferring an image from one surface to another. **In this lesson, you will make a relief print of a subject from the natural world.** You might show a natural object, or you might create an entire nature scene. Whatever you choose, you may simplify the shapes.

You Will Need

- sketch paper
- pencil
- linoleum block
- linoleum cutting tools
- bench hook
- carbon paper
- printing ink
- brayer
- drawing paper

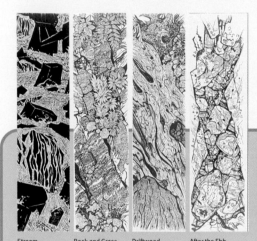

Stream Rock and Grass Driftwood After the Ebb

Fig. 7–8 In these very large woodcut prints, the artist used powerful lines and bold black-and-white shapes. The close-up images of nature appear as abstract designs. Kitaoka Fumio, *Woodcuts,* 1984–85.
Ink on paper, each 78 ³/₄" x 19 ¹/₄" (199.9 x 48.9 cm). Arthur M. Sackler Gallery, Smithsonian Institution, Washington, DC. S1986.530.

230

Safety Note
To avoid cuts, use extreme care when using linoleum tools!

Try This

1. Sketch your design. Think of ways to simplify the shapes of your subject.

2. Use carbon paper to transfer your design onto the linoleum block. With your pencil, lightly fill in areas on the block that you want to print in color.

3. Cut away the areas you do not want to print. These areas will be white on the print itself.

4. Ink the block. Using the brayer, apply a thin, even coat of color to the raised areas of your design.

5. Carefully place your printing paper on the block. Press or rub the paper with your hand. Begin at the center and work toward the edges, rubbing the whole surface gently but firmly.

Studio Background

The Japanese Woodcut
A **relief print** is made from a raised surface that receives ink. The Japanese woodcuts you see here are examples of relief prints.

Japanese woodcut printing was first developed in 1744. The process was usually a collaboration of the artist, engraver, and printer. First, the artist created a brush drawing on transparent paper. The engraver then pasted the drawing to a block of wood and carved the outlines of the drawing. He or she made as many prints of the block as the number of colors chosen for the final print. On each copy, the

Teaching Options

Meeting Individual Needs

Adaptive Materials To make carving easier, have students heat the linoleum with a blow dryer. Alternatively, students may inscribe their nature design on a flat piece of a Styrofoam™ tray.

More About...

Japanese artist **Katsushika Hokusai** (1760–1849) is known for his **ukiyo-e** ("the art of the floating world") prints of everyday life and nature scenes. Hokusai created sets of prints, like *The Various Provinces,* as souvenirs for travelers.

6. Pull the print by slowly peeling it away from the block.

Check Your Work

Examine your completed artwork, along with your classmates' works. Are shapes, lines, and other elements clearly defined? Discuss the ways that nature is shown in the artworks. Do any show nature in a dramatic or expressive way?

Core Lesson 7

Check Your Understanding

1. Name two ways that artists can include objects from nature in their work.
2. Why were careful drawings from nature important in the past?
3. How might an artist convey moods or feelings in an image of nature?
4. What is a relief print?

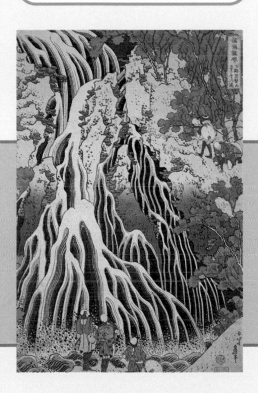

Fig. 7–10 **Simple shapes and expressive lines illustrate a moonfish, native to Hawaii.** Zeenie Preston, *Fish*, 1999.
Two-color block print, 4" x 6" (10 x 15 cm). Colony Middle School, Palmer, Alaska.

Sketchbook Connection

Practice simplifying natural shapes. First draw the natural shape you see—leaf, shell, branch, animal. Then draw it again, but this time leave out some lines in detailed areas. Draw it a third time, leaving out even more detail. Try drawing the shape with straight lines only. As you draw, decide which lines are absolutely necessary. What happens when you make those lines thicker? Try making both heavy outlines and solid shapes (called silhouettes).

engraver marked areas that would appear in one of the colors. Then he or she cut one block per color. Finally, the printer applied an ink color to each of the blocks and pulled the print one color at a time.

Fig. 7–9 **How did the artist simplify the shapes of the falling water, trees, and rock formations? By emphasizing the color and shape of the waterfalls, he showed their dramatic power.** Katsushika Hokusai, *Kirifuri Waterfall at Mt. Kurokami, Shimozuke Province*, Series: *The Various Provinces*, c. 1831.
Color woodblock print, 14 ⅝" x 9 ⅝" (37.2 x 24.5 cm). Nelson-Atkins Museum of Art, Kansas City, Missouri (Purchase: Nelson Trust). © 1999 The Nelson Gallery Foundation. All Reproduction Rights Reserved.

Nature

231

Using the Art

Art Criticism Point out how the artists of the images simplified the shapes of falling water and rocks.
Ask: What appeals to you in Kitaoka Fumio's prints? Do you think they should be shown together in a series, or separately? Why?

Assess

Check Your Work

Have students use poster board or mat board to mount or mat their prints. Lead a discussion of their art.

Check Your Understanding: Answers

1. by making nature the subject of an artwork; by using objects from nature as the materials for an artwork

2. Before the invention of photography, these drawings provided records and information about how things looked.

3. by use of color, by compositions that appear either close up or far away

4. an image that has been transferred to paper or another surface from a raised, inked surface such as a linoleum block

Close

Review ways that artists have been inspired by nature. Ask students to use examples to explain how artists have used materials from nature.

Teaching Through Inquiry

Art Criticism Have students study Figs. 7–8 and 7–9. **Ask:** How are the prints the same? How are they different? How did each artist use lines and shapes to represent natural objects? How did he create texture? What do these prints say about Japan?

Assessment Options

Peer Have students work in groups to prepare visual displays of the ways that artists have interpreted nature, and the ways that they have used materials from nature. Discuss the criteria for the displays, inviting students to offer suggestions. For example, to show scientific interpretations of nature, students could display works by Merian; for intimate views, works by Morisot; for idealized views, works by Moran. To show the use of natural materials, students could display images of objects for practical and those for ceremonial use. Ask students to label their displays, and have pairs of groups use the criteria to assess each other's displays.

Wit and Wisdom

Kitaoka Fumio painted more than 30,000 designs, or about two works per day, during his long artistic life. He felt that "[p]erfect beauty can be found even in the appearance of pebbles on the roadside and in the pattern of the veins of nameless weeds. It enriches my soul. Nature, including all human beings, is god to me."

231

Prepare

Pacing

Two 45-minute periods: one to consider text and plan paintings; one to create paintings

Objectives

- Explain what interested and inspired Impressionist painters. Give examples.
- Understand significant differences between Impressionism and Post-Impressionism.
- Interpret a nature scene in two ways, by varying colors and brush-strokes.

Vocabulary

Impressionism A style of painting that emphasizes views of subjects at a particular moment and the effects of sunlight on color.

Post-Impressionism An art style developed as a reaction to Impressionism. Post-Impressionists focused on organized compositions with a strong sense of design.

Using the Time Line

Point out to students that as their view of European art draws closer to the modern era, the styles of art change with greater rapidity and overlap with greater frequency. **Ask:** What is the time span between Figs. 7–13 and 7–16?

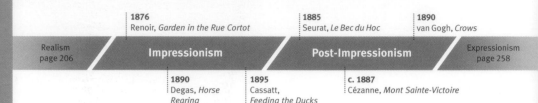

European Art: 1875–1900

1876 Renoir, *Garden in the Rue Cortot*

1885 Seurat, *Le Bec du Hoc*

1890 van Gogh, *Crows*

Realism page 206 | **Impressionism** | **Post-Impressionism** | Expressionism page 258

1890 Degas, *Horse Rearing*

1895 Cassatt, *Feeding the Ducks*

c. 1887 Cézanne, *Mont Sainte-Victoire*

As you learned in the last chapter, the first decades of the 1800s were filled with political revolutions. People struggled for more just systems of government. By the second half of the century, another type of revolution—the Industrial Revolution—was also changing societies. Cities were growing. Exciting inventions and new technologies were changing the way people lived and worked. It was the beginning of modern life.

In this time of great social and technological change, there were also revolutions in art. French artists created two new art styles: **Impressionism** and **Post-Impressionism**.

Why were artists of these two groups so revolutionary? Like many artists throughout history, the Impressionists and Post-Impressionists were inspired by nature and the world around them. They were also learning about exciting new influences and technologies. They created new ways of painting. For them, it was not enough to make things look real on a flat canvas. Instead, they were interested in color and the way it affects how we see and feel about things. They felt that true colors could only be seen outdoors, in nature.

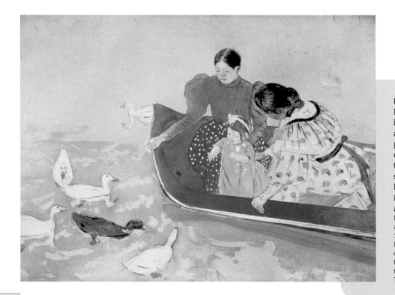

Fig. 7–11 **Many Impressionist artists were inspired by non-European art—especially Japanese prints—and the new medium of photography. How does this print resemble a snapshot? Compare it to the print by Hiroshige in Fig. 7–22.** Mary Cassatt, *Feeding the Ducks*, 1895. Drypoint, soft ground etching, and aquatint printed in colors, 11 $^{11}/_{16}$" x 15 $^{3}/_{4}$" (29.7 x 40 cm). The Metropolitan Museum of Art, Bequest of Mrs. H. O. Havemeyer, 1929. The H. O. Havemeyer Collection (29.107.100). Photograph © 1980 The Metropolitan Museum of Art.

232

National Standards
7.1 Art History Lesson

1b Use media/techniques/processes to communicate experiences, ideas.

2c Select, use structures, functions.

4a Compare artworks of various eras, cultures.

Resources

Teacher's Resource Binder

 Names to Know: 7.1

 A Closer Look: 7.1

 Map: 7.1

 Find Out More: 7.1

 Check Your Work: 7.1

 Assessment Master: 7.1

Overhead Transparency 13

Slides 8d

Teaching Through Inquiry

Art Criticism Ask students to imagine that they are members of a save-the-environment club and are seeking an image to use to represent the club's concerns. Have pairs of students select an image from the chapter and write a proposal to use that image for the club. Encourage students to consider the club's interests and how the artwork's appearance and message are consistent with them.

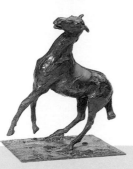

Fig. 7–12 In addition to painting and printmaking, Edgar Degas also made sculptures. How has he captured the movement of the horse? Edgar Degas, *Horse Rearing*, c. 1890. Bronze. Musée d'Orsay ©Photo RMN.

Fig. 7–13 What details do you think Renoir left out of this scene? What colors might you expect if this scene had been painted on a cloudy, rainy day? Pierre-Auguste Renoir, *The Garden in the Rue Cortot*, Montmarte, 1876. Oil on canvas, 59 ³/₄" x 38 ³/₈" (151.8 x 97.5 cm). Carnegie Museum of Art, Pittsburgh; Acquired through the generosity of Mrs. Alan M. Scaife, 65.35. Photography by Peter Harholdt.

Impressionism

The Impressionists hoped their artworks would give an impression of what a natural scene looked like at one moment in time. They wanted to capture a split second, when you look at something quickly and then it changes. Painter Claude Monet even named some of his paintings *Impression*. An art critic saw one and made up the term "impressionism." This is how the art style got its name.

The Colors of Nature

Many Impressionists loved nature and were interested in landscapes and natural objects. They painted outdoors, studying the way colors in nature change in different kinds of light. Working outside helped the Impressionists understand how light affects the way we see things.

Look at the painting by Renoir in Fig. 7–13. Imagine you are the artist painting this garden outdoors. You must work fast to record the colors and light. Like Renoir and the other Impressionists, you might leave out details as you race to capture the scene before everything changes again. As you look quickly from your canvas back to the scene, you use short, fast brushstrokes. When you look at shadows, you notice they are made of many different colors—purples and dark blues. You see that areas in sunlight have the brightest colors—yellows, greens, and reds. And this is what you paint.

The Impressionists' quick brushstrokes blurred the outlines of objects. Shapes seem to merge together. The small strokes of color make their artworks shimmer and sparkle. As you look closely at Impressionist artworks, you will see brushstrokes of different colors placed next to each other. The Impressionists knew that, at a distance, people's eyes would mix the colors.

Nature

233

Teach

Engage

Have students look at Figs. 7–1, 7–11, and 7–13. **Ask:** Based on these paintings, what words might describe Impressionism?

Using the Text

Art History After students have read the text, refer them to the Neoclassical works in Figs. 6–11 and 6–12. **Ask:** Since the Impressionists rebelled against works such as these, what, do you think, were the Impressionists trying to do? What differences do you see in the subject matter, brushstrokes, setting, and color of these two styles?

Using the Art

Art History Ask: What do you think viewers thought of these artworks at the time they were created? Remind students that the critics of Impressionism felt that the works were too much of a departure from traditional, realistic paintings, but that, eventually, the works won critical acceptance and popularity. Suggest to students that they research the role of late-nineteenth-century art critics.

Critical Thinking

Ask: If quick, energetic, and highly visible brushstrokes are qualities of an Impressionist painting, what, do you think, would be the qualities of an Impressionist sculpture?

More About...

Although **Impressionism** is a style name for painting, some late-nineteenth-century, three-dimensional art was also Impressionist. Impressionist sculptors worked quickly in wax or clay, making models that seem to freeze a movement or expression. Sometimes, the artists even left the shimmering surfaces and rough grooves of fingerprints in the wax or clay models. As a result, the cast bronze work often looks energetic without being smooth.

Using the Overhead

Investigate the Past

Describe What is dominant in this scene? What details might be overlooked?

Attribute How does the way this work was painted suggest when it was made?

Interpret Did the artist give the viewer a positive, pleasant view of nature? Why do you think this is—or is not—so?

Explain How can you find out why late-nineteenth-century artists were so interested in nature?

13

Using the Text

Art History After students have read the text, have them explain, in their own words, the major differences between Impressionism and Post-Impressionism.

Using the Art

Perception Ask students to compare the colors and brushstrokes in each artwork. Point out that the paint on van Gogh's *Crows in the Wheatfields* is very thick. **Ask:** What is the mood or feeling of each artwork?

Studio Connection

Provide each student with two sheets of 10" x 15" illustration board or heavy drawing paper, tempera or acrylic paint, brushes, water containers, and a pencil.

Demonstrate a traditional method for painting an environment: First paint the large, background areas, such as the sky and very distant objects. Use white to make light, dull background colors; bluish hues and few details help suggest distant space. In the middle ground, use brighter colors but ones related to those in the background. Finally, mix brighter, darker, and warmer colors for the foreground. Add details to the nearest sections.

Assess See Teacher's Resource Binder: Check Your Work 7.1.

Extend

Assign pairs of students to research the life and art of an Impressionist or Post-Impressionist painter. Then have them create a poster featuring copies of the artist's works and interesting facts about his or her life. Have students arrange the posters in chronological order by each artist's birth date. Have them note and discuss the artists whose lives and work overlapped in time.

Post-Impressionism

Not all artists agreed with the Impressionists' ideas about painting. The Post-Impressionists were a group of artists who felt that Impressionist artworks were too unplanned. They were not interested in trying to capture the momentary effects of light on objects. Instead, they focused on arranging objects into an organized composition. They wanted their artworks to have a strong sense of design.

Color and Composition

The Post-Impressionists used color to help give order to their paintings of nature. Each artist in the group developed a unique way of working with color.

Look at a painting by Georges Seurat (Fig. 7–14), for example. You might think its dabs of color and shimmering light look just like an Impressionist artwork. But notice how each part—the sky, water, and cliff—is carefully painted. Seurat placed thousands of small dots of color very close together. Edges—although not sharp—are clearly defined. Do you see how the placement of the dark and light colors also helps show the form of the cliff?

Paul Cézanne also used color to build up form. Look at *Mont Sainte-Victoire* (Fig. 7–15). Cézanne placed flat patches of color side by side. Some of the patches are dark values, and others are light. Do you see how the light and dark values help show the form of the mountain?

Some Post-Impressionist artists used color to express feelings. In *Crows in the Wheatfields* (Fig. 7–16), Vincent van Gogh did not show the changing colors of nature. Rather, he chose to paint the landscape using the most intense colors—dark blues and bright yellows and oranges. Notice how he created long lines of color on the canvas. What do these brushstrokes and colors tell you about van Gogh's feelings toward nature?

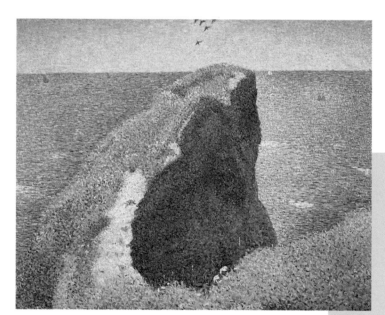

Fig. 7–14 **This scene of nature shows a seascape. Notice how Seurat carefully placed the large shape of the cliff in the center of the composition. Do you think an Impressionist artist would have chosen this placement?** Georges Seurat, *Le Bec du Hoc at Grand Champ*, 1885.
Oil on canvas, 25" x 32" (64 x 81 cm). The Tate Gallery, London. Photo by John Webb. Art Resource, NY.

Teaching Options

Meeting Individual Needs

English as a Second Language/Multiple Intelligences-Naturalistic Have students examine all the paintings in the lesson and then list, in English, the natural elements (ducks, trees, flowers, fields, and so on) in these works that were created more than one hundred years ago. Ask students to list the natural elements in their own surroundings, and then to create a drawing that reflects this present-day environment.

Wit and Wisdom

The Impressionists were committed to painting *en plein air* ("in the open air")—starting and finishing a picture outdoors, in front of the subject. This often presented difficulties: on wet and windy days, they had to weigh their easels down with large stones and mix paints under their raincoat or some other protection; when they worked too slowly and the light changed, they were forced to adapt their paintings or start over.

7.1 Art History

Check Your Understanding

1. What interested and inspired Impressionist painters?
2. How did the term Impressionism come to be used?
3. Name two important characteristics of Post-Impressionist art.
4. How did Post-Impressionists' use of color differ from the Impressionists' use of color?

Studio Connection

Create two different paintings of one of your favorite scenes from nature. Choose different brushstrokes for each painting. You might choose fast, short strokes, carefully placed dots of color, flat patches of color, or swirling strokes. Use one kind of brushstroke to show the scene on a sunny day. Use another kind of brushstroke to show the scene on a cloudy day. Think about the colors you will use to show the weather and the type of light during that season.

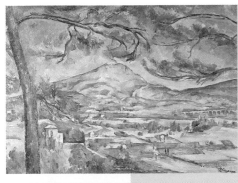

Fig. 7–15 Does there seem to be a light source in this scene? Would you say that this artist tried to capture a particular season or time of day? Paul Cézanne, *Mont Sainte-Victoire*, c. 1887.
Oil on canvas, 26 ¼" x 36 ⅜" (66.8 x 92.3 cm). Courtauld Gallery, London.

Fig. 7–16 Like the Impressionists, Vincent van Gogh created many paintings of the same scene from nature. Notice how he used warm colors in the field and cool colors in the sky. How does this color combination make you feel? Vincent van Gogh, *Crows in the Wheatfields*, 1890.
Oil on canvas, 19 ⅞" x 40 ⅝" (50.4 x 103 cm). Amsterdam, Van Gogh Museum (Vincent van Gogh Foundation).

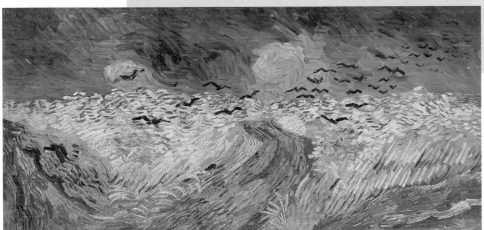

Nature

235

Assess

Check Your Understanding: Answers

1. nature and the world around them, the influences of Japanese prints, the technology of photography

2. An art critic made up the term after seeing a work by Monet, who had titled the painting *Impression*.

3. the use of color to express feelings, and to build up form; the arrangement of objects into an organized composition; strong design

4. Post-Impressionists used color to help give order to their compositions and to build up form. The Impressionists used color to better understand the way light changes the appearances of things in nature.

Close

Use the lesson images to review the characteristics of Impressionism and Post-Impressionism. Have students identify the artists who painted in these styles. **Ask:** What interested and inspired these painters? Have students explain how their own artworks were influenced by the work of these Impressionists and Post-Impressionists.

Teaching Through Inquiry

Aesthetics Explain that much of what we know about Vincent van Gogh comes from more than 600 letters that the artist and his brother wrote to each other. In his letters, van Gogh wrote of his ideas about art: "Instead of trying to reproduce what I see before me, I use color in a completely arbitrary way to express myself powerfully." Discuss van Gogh's statement, and then have students write a letter to a friend, in which they express their ideas about art and their own artworks.

Assessment Options

Teacher Have students work in small groups to create a dialogue that might have occurred between Impressionist and Post-Impressionist artists. Tell students that the artists should discuss and question one another about how they work with color, select subject matter, use brushstrokes, and express feelings. Instruct students to have their artists refer to artworks in this lesson. Have each group reiterate for the class the key points of their dialogue.

Prepare

Pacing
One 45-minute class period

Objectives
- Perceive and describe the changing colors in nature and in artworks.
- Create a monoprint of a natural object, using more than one color.

Vocabulary
atmospheric color The variable color of an object; the change in the object's color is a result of the changing color of sunlight.

complementary Describing colors that are directly opposite each other on the color wheel, such as red and green, blue and orange, and violet and yellow.

Teach

Engage
Create a display of paint manufacturers' samples, and call attention to the color names that are related to nature.

Using the Text
Art Criticism Have students recall from their reading, the words used to describe color, and list these on the board. **Ask:** What words from the list describe the colors in these paintings?

236

ELEMENTS & PRINCIPLES LESSON

7.2

Color

Color forms the background of our daily lives. A color can be bright and intense, light and pastel, or dark and dull. Some artists feel that color is the most important element they work with. Artists must know how colors work together. They learn to mix the colors they need to create certain moods, or feelings, in their artworks.

Looking at Color in Nature

You have probably noticed that the colors of objects in nature can change in different light. Perhaps walking on a sunny summer afternoon, you have seen bright green trees. As the sun sets, the trees may look almost dark blue or purple. Colors in nature change as the light changes. We call these changeable colors **atmospheric color.**

Impressionist artists, like Claude Monet, were interested in atmospheric color. They often painted the same subject at different times of day or in different seasons. They might show the scene in the misty light of

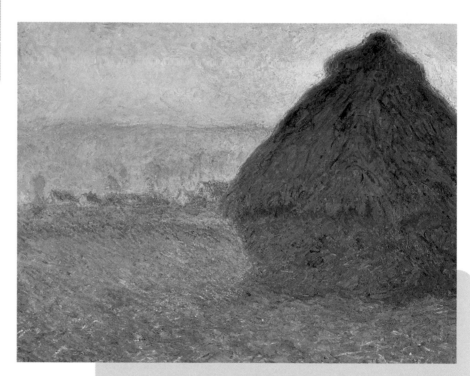

Fig. 7–17 **Warm and cool colors help create this painting's mood. How would the painting be different if it had been painted in the early morning?** Claude Monet, *Grainstack (Sunset)*, 1891. Oil on canvas, 28 ⁷⁄₈" x 36 ¹⁄₂" (73.3 x 92.6 cm). Juliana Cheney Edwards Collection. Courtesy of the Museum of Fine Arts, Boston.

National Standards 7.2 Elements and Principles Lesson
1b Use media/techniques/processes to communicate experiences, ideas.
2a Generalize about structures, functions.
2c Select, use structures, functions.
4a Compare artworks of various eras, cultures.

Teaching Options

Resources
Teacher's Resource Binder
 Finder Cards: 7.2
 A Closer Look: 7.2
 Find Out More: 7.2
 Check Your Work: 7.2
 Assessment Master: 7.2
 Overhead Transparency 13

Using the Overhead
Write About It
Describe Have students write two or three sentences about how the artist used color to convey a mood or feeling.

13

Analyze Use the overlay, and ask students to write a short paragraph describing the colors in this artwork.

dawn, on a sunshine-filled afternoon, or in the gloom of a winter twilight.

Study an example of one of Monet's favorite subjects, haystacks in a field (Fig. 7–17). Notice the bright, intense colors. Even the shadows are painted with bright colors, mostly light greens and blues. Look especially at the triangular shape of the haystack against the sky. The warm colors—yellow, orange, and red—capture the warmth of the setting sun.

Now look at a painting by Post-Impressionist artist Paul Gauguin (Fig. 7–18). Why is the mood of this painting so different from Monet's? Gauguin chose mostly dark colors for his painting. He also chose shades of green and red to create a **complementary** color scheme. (Complementary colors are across from each other on the color wheel. See pages 36 and 38.)

Complementary colors can help create contrast in an artwork. Do you see how the reddish and orange shapes stand out against the green shapes? Gauguin did not want to show how light changed the haystacks. Instead, he wanted to create a sense of order in his composition. He used contrasting colors to make the forms easy to see.

7.2 Elements & Principles

Check Your Understanding
1. Why does the local color of an object change throughout the day?
2. What was one influence on the Impressionists' use of color?

Studio Connection
Many artists show the changing colors of nature in their artworks. They often use color to create different moods.

Create a monoprint of a natural object. A monoprint is a single image made by painting onto a metal, glass, or plastic printing plate. Paper is pressed against the plate to create the print. Choose two or three colors that help create a mood.

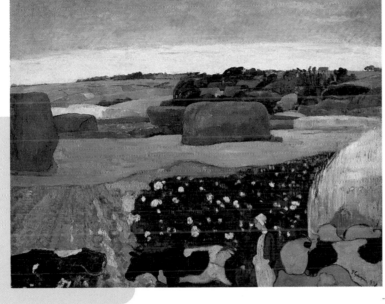

Fig. 7–18 The dark colors in this painting create a serious mood. Compare this sky to the one painted by Monet. What colors might the artist have used in each? Paul Gauguin, *Haystacks in Brittany*, 1890. Oil on canvas, 29 ¹⁄₄" x 36 ⁷⁄₈" (74 x 93.7 cm). Gift of the W. Averell Harriman Foundation in memory of Marie N. Harriman. Photograph © 1999 Board of Trustees, National Gallery of Art, Washington, DC.

Nature

237

Using the Art
Perception Have students compare the shapes and colors of the haystacks in the two artworks.

Studio Connection

Provide students with natural objects, 9" x 12" drawing paper, tempera paint or water-soluble printing ink, brushes, and a printing plate (plastic or Formica, or a cookie sheet—one per student).

Discuss the color variations of the objects. Demonstrate a method of multicolor monoprinting (described in Teaching Through Inquiry, below). Emphasize mixing colors and experimenting with different colors to create various moods. Guide students to work quickly; if the paint or ink dries, it will not transfer to the paper.

Assess See Teacher's Resource Binder: Check Your Work 7.2.

Assess

Check Your Understanding: Answers

1. Changes in sunlight over the course of a day affect changes in the color of an object.

2. atmospheric color, the changing colors in nature

Close

Have students mount prints on colored paper and attach a label (name and title). Display prints, and have students describe the artworks' colors and the feelings they create.

Teaching Through Inquiry

Art Production Encourage students to experiment with multicolor monoprinting. Each method requires a smooth, nonabsorbent surface.

Method 1. Roll out an even layer of ink. Draw directly into the ink with tools (toothpick, pencil eraser, cotton swab, comb). Place paper over the design, and rub evenly but lightly with your hand. Pull the print. Clean the surface, and ink it with a second color. Continue as with the first color. Repeat for additional colors. Allow the print to dry slightly between each printing.

Method 2. Paint with tempera, starting with light colors. Keep the painted areas wet. Place paper over the painted image and rub. Pull the print. Repeat for additional colors. Experiment with drying time between prints.

Method 3. Roll a thin, even layer of ink. Place paper over the inked surface, but do not rub. Draw an image on the paper. Lift the paper: the side facing the ink is the monoprint. Repeat for additional colors, but use a different drawing tool each time.

Assessment Options

Peer Have students use organic shapes to create two tissue-paper collages. Instruct students to make one Impressionist collage, using atmospheric color; and to make one Post-Impressionist collage, using complementary-color schemes. Have students meet in pairs to assess each other's artworks, noting the extent to which each correctly included stylistic characteristics and use of color.

Prepare

Pacing

Two 45-minute class periods: one to consider text and images; one for studio experience

Objectives

- Describe ways that nature and the environment are important subjects in Japanese art.
- Give examples of how natural materials are used in Japanese art.
- Create a ceramic vessel based on close observation of a natural form.

Using the Map

Inform students that calligraphy and Buddhism were brought from China and became part of Japanese culture. **Ask:** What do you see on this map that might indicate the way in which this influence was brought to Japan?

The Art of Japan

Simplicity, elegance, and love of nature—all are found in the art of Japan. The Japanese worshiped nature gods at Shinto shrines long before Buddhism was introduced to their culture. Shinto gods are thought to occupy places in nature, such as trees, waterfalls, and rocks. They are also believed to inhabit animals. The earliest Shinto shrines used as their main hall not a building, but a mountain or forest.

Buddhism came from China in the sixth century AD. Shinto and Buddhist beliefs exist peacefully side by side. Shinto shrines and Buddhist temples and monasteries are found throughout Japan. The world's oldest wooden structures, dating from the early eighth century, are found at the Buddhist temple of Horyu-Ji in Kyoto.

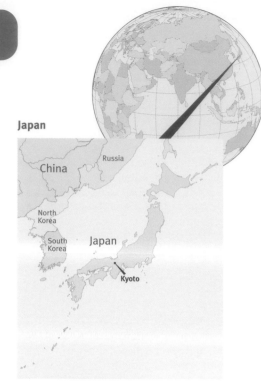

Japan

Russia

China

North Korea

South Korea

Japan

Kyoto

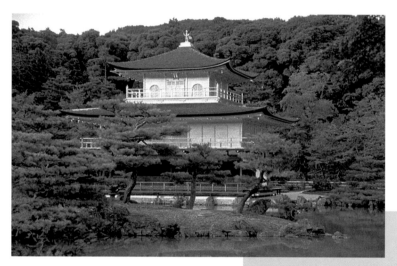

Fig. 7–19 How does this building blend harmoniously with its environment? *Golden Pavilion (Kinkaku-ji)*. Kyoto, 1398. Photo by W. Wade.

Teaching Options

National Standards
7.3 Global View Lesson

1b Use media/techniques/processes to communicate experiences, ideas.

4b Place objects in historical, cultural contexts.

4c Analyze, demonstrate how time and place influence visual characteristics.

5c Describe, compare responses to own or other artworks.

Resources

Teacher's Resource Binder
 A Closer Look: 7.3
 Map: 7.3
 Find Out More: 7.3
 Check Your Work: 7.3
 Assessment Master: 7.3
Large Reproduction 14
Slides 8e

Teaching Through Inquiry

Art History Invite students to create an exhibit about the differences between **Japanese and Chinese** traditional **architecture.** Instruct students to focus their research, and the exhibit, on how the two types of architecture reflect and embody ideas about nature.

Japanese architecture ranges from castles and palaces to the simple home with room spaces created by sliding screens. Architecture includes not only the building itself, but the natural landscape and gardens around the building. The *Golden Pavilion* (Fig. 7–19) served as both a residence and temple. It is a harmonious combination of several cultures and styles.

The Buddhist religion inspired many traditional arts, such as the tea ceremony, ink painting and calligraphy, flower arranging, and garden design. Many people study these art forms for private reflection or meditation. They think about the natural world as they improve their artistic skills. This practice is thought to lead to a healthy, balanced life.

Natural Subjects

Nature and the environment are very important in Japanese art. Landscapes, plants, and animals are often used as subject matter. Many Japanese artists are skilled at simplifying natural forms. For example, study how water is represented in the folding screen (Fig. 7–20). How would you describe the way water is shown here? What other natural features have been simplified?

In the nineteenth century, Japanese artists developed the process of multicolored woodcuts, which became very popular. Hundreds of prints, showing scenes from nature and everyday life, were made from the inked blocks. Hiroshige, Hokusai, Utamaro, and Harunobu are among the masters of multicolor woodcut printing (Fig. 7–22).

Fig. 7–20 Japanese paintings were usually done on scrolls or screens. They often were made with calligraphic brushstrokes. How has this artist combined elegance and simplicity to show a scene from nature? Japan, *The River Bridge at Uji*, Momoyama period (1568–1614). Ink, color, and gold on paper. Six-fold screens, 64 ½" x 133 ¼" (171.4 x 338.4 cm). The Nelson-Atkins Museum of Art, Kansas City, Missouri (Purchase: Nelson Trust).

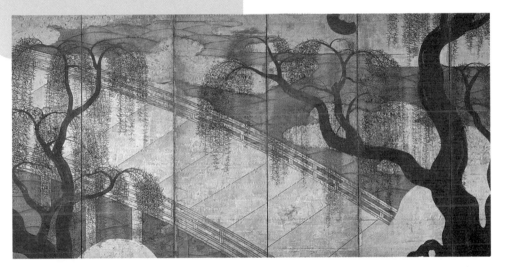

Nature

239

Teach

Engage

On the chalkboard, write: *simplicity, elegance, love of nature.* Either display Japanese art reproductions, or have students look at the images in this lesson.

Ask: How do these artworks fit these words?

Using the Text

Aesthetics Have students read pages 238 and 239. **Ask:** What guiding principles or ideals do you think the artists followed? If necessary, give students this prompt: "Artworks should create____ for the viewer because____. Artworks should include____because____." **Ask:** How would a Japanese artist complete the sentences?

Using the Art

Have students study *The River Bridge at Uji.* Point out the careful study and contemplation of nature necessary to have created this art. Discuss how few brushstrokes the artist used, and have students answer the caption question.

More About...

The gilded **Golden Pavilion** of Kyoto is an outstanding example of Japanese architecture from the Muromachi period (1334–1573). Originally, a nobleman's villa was on the site, but in 1358, a shogun inherited the estate and built the pavilion. After his death, the building was converted into Rokuonji Temple, a three-story reliquary hall. The structure burned several times, most recently in 1950, but each time was restored to its original design.

Using the Large Reproduction

14

Consider Context

Describe What aspects of nature are shown here?

Attribute What visual evidence suggests where and by whom this artwork was made?

Understand How does this work show a respect for nature?

Explain Knowing more about the tradition of printmaking in Japan might help you to explain the cultural importance of this work.

Using the Text

Perception After students have read the text and captions, ask them to identify the natural materials used and/or depicted in these artworks. **Ask:** Which work best uses the material as a part of the design?

Using the Art

Ask: What is the weather in and the mood of Hiroshige's print?

Studio Connection

 Provide students with natural objects (shells, lilies, artichokes, pinecones), ceramic or air-hardening clay (1 lb per student), clay tools, and water or slip.

Demonstrate how to create a pinch pot. Insert both thumbs into a fist-sized ball of clay, and press down until you have a base about 1/2" thick. Pinch and squeeze the clay to open up the ball. Keep turning the ball in your hands until the bottom and sides are even in thickness. Gently tap the base on the table to flatten the base.

Tell students to use slip or water to join clay pieces. After ceramic clay has been bisque-fired, students may glaze or paint their vessel. If they used air-hardening clay, they may paint it with acrylic paints.

Assess See Teacher's Resource Binder: Check Your Work 7.3.

Natural Materials

Japanese artists have traditionally used natural materials. The beauty of the material becomes part of the design. For example, wooden sculptures or structures are often unpainted.

In garden design, natural materials are especially important. Gardens may include trees or other plants, water, sand, stones, a wooden tea house, shrine, or bridge. See Fig. 7–5 (page 228) for an example of a Japanese garden.

Ceramic arts in Japan have traditionally been an important focus. Special handmade bowls are needed for the tea ceremony, and vases are required for ikebana—the art of flower arranging (Fig. 7–21). Influenced by early Korean ceramic arts, the Japanese designs are usually inspired by nature.

Studio Connection

 Choose a natural form, such as an artichoke, seashell, or water lily. Create a ceramic vessel based on your close observation of this natural form. Try the pinch pot method. Focus on the details of your selected object as you decorate and finish your vessel. Coils, thin slabs, and small balls of clay can be pressed onto the basic vessel for petals, leaves, or vines.

7.3 Global View

Check Your Understanding
1. What do Shinto shrines have to do with nature?
2. What kinds of Japanese art traditions are inspired by Buddhism?
3. Name two famous printmakers in Japan.
4. How do Japanese artists take advantage of the qualities of natural materials in their work?

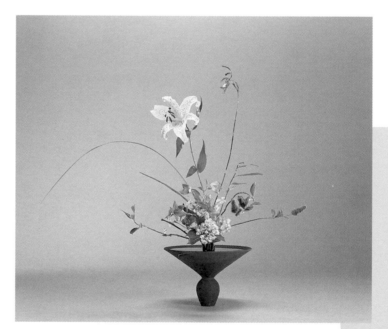

Fig. 7–21 **For hundreds of years, only Buddhist priests, royalty, and samurai were taught ikebana. Eventually, this traditional art form became accessible to all. Besides using natural materials, how might this art relate to nature?** Sen'ei Ikenobo, 45th generation Ikenobo Headmaster, *Rikka style Ikebana arrangement,* 1999.
Lily, oncidium orchid, miscanthus grass, willow leaf spirea, Japanese balloon flower, and hydrangea. Courtesy of Ikenobo Society of Floral Art, Japan.

240

Teaching Options

Meeting Individual Needs

Gifted and Talented After students review the text and images on pages 240 and 241, explain that Australian Aborigines have traditionally created abstracted images of nature, a practice that is key to their art and spiritual beliefs. Have students find examples of Aboriginal art and compare how the artists treated nature with how the Japanese artists treated nature in these images.

More About...

Along with **Katsushika Hokusai**, **Ando Hiroshige** (1797–1858) popularized Japanese landscapes by including everyday scenes in his nature studies. When Impressionists discovered Japanese prints, in the late 1800s, Hiroshige's work provided them with a new vision of nature. In 1832, Hiroshige issued a series of prints featuring fifty-three stations of the recently completed Tokaido highway. Soon after this, he completed the series "Eight Views of Omi Province."

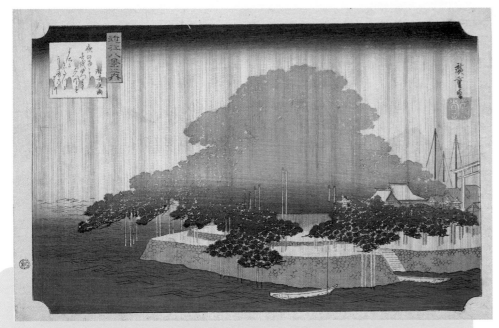

Fig. 7–22 **Printmaking was a way to bring nature scenes into the homes of many people. Woodcut prints of familiar landmarks were popular as gifts. What does the artist say about nature in this work?** Ando Hiroshige, *Evening Rain on the Karasaki Pine*, 19th century. From the series "Eight Views of Omi Province." Woodblock print, 10 ¼" x 15" (26 x 38 cm). The Metropolitan Museum of Art, H. O. Havemeyer Collection, Bequest of Mrs. H. O. Havemeyer, 1929. (JP 1874). Photograph © 1983 The Metropolitan Museum of Art.

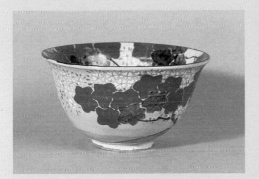

Fig. 7–23 **This bowl was created for use in a tea ceremony. The special ceremony of making and drinking tea was first developed by Zen Buddhist monks as a form of contemplation.** Nin'ami Dohachi, *Footed Bowl*, Edo Period (1615–1867). Kyoto ware, porcelaneous stoneware, with underglaze iron-oxide and overglaze enamel decoration, 3 ⅝" x 6 ½" (9.2 x 16.5 cm) diameter. The Nelson-Atkins Museum of Art, Kansas City, Missouri (Gift of Mr. W. M. Ittmann Jr. in honor of Mrs. George H. Bunting Jr.).

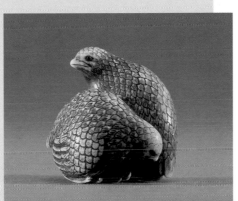

Fig. 7–24 **Netsuke are small carved objects used to fasten a pouch or purse to one's kimono sash.** Okakoto, *Two Quail*, late 18th–early 19th century. Ivory, 1 ⅜" (3.2 cm) wide. Los Angeles County Museum of Art, Gift of Mrs. G. W. Mead. M.59.35.24

Nature

241

Extend

Have students research prints by Hiroshige or Hokusai, and create a print of their own in the artist's style. Make a display of their work and reproductions of Japanese prints from the Internet, CDs, books, or calendars.

Assess

Check Your Understanding: Answers

1. The Japanese worshiped nature gods at Shinto shrines; a natural formation, such as a mountain or a forest, served as the main hall of the earliest Shinto shrines.

2. the tea ceremony, ink painting and calligraphy, flower arranging, garden design

3. Hiroshige, Hokusai, Utamaro, Harunobu

4. They might leave wooden sculptures and structures unpainted; they include wooden shrines, bridges, and teahouses in garden designs; they use ceramic clay to create objects inspired by nature.

Close

Review the ways that nature is important in Japanese art. Ask students to cite examples in this book of the use of natural materials and the use of nature as the subject in Japanese art.

Assessment Options

Teacher Have students arrange collected dried grasses, leaves, and stems on a flat surface; cover the arrangement with a sheet of newsprint; and do a series of crayon rubbings. Have students then study the series and select a small area or detail to enlarge. Instruct students to draw that detail on a Styrofoam™ tray, incise the drawing lines with round-tip wooden sticks of different thicknesses, cover the flat surface of the tray with tempera paint, and make a print. Have students write and attach to their print a short paragraph in which they compare their work to Japanese art. Guide students to focus on the use of natural materials and the importance of nature as subject matter. Have students display their work. Assess the extent to which students demonstrated an understanding of Japanese art.

Prepare

Pacing

Two 45-minute periods: one to consider art and text, and to sketch; one to cut and glue sculpture

Objectives

- Understand the potential of paper for creating three-dimensional forms
- Create a relief sculpture of natural forms using a variety of paper-sculpture techniques.

Supplies

- paper, any kind or size, 1 sheet per student
- nature books and photographs, natural objects, toy animals
- sketch paper, 11" x 14"
- pencils
- glue
- scissors
- construction paper, assorted colors
- lightweight cardboard, 11" x 14"
- paper clips or removable tape
- envelopes

National Standards 7.4 Studio Lesson

1b Use media/techniques/processes to communicate experiences, ideas.

3a Integrate visual, spatial, temporal concepts with content.

Making a Paper Relief Sculpture

Forms in Nature

Studio Introduction

When was the last time you made a newspaper hat? A gum-wrapper chain? A house of cards? Or a paper airplane? When you made these things, you probably didn't realize that you were practicing some paper-sculpture techniques.

Curling, folding, crumpling, and slitting are just some of the ways to turn ordinary paper into a jungle of wild animals or a garden paradise. Sculptors who work with paper make amazing and beautiful three-dimensional forms. When they put the forms together, they can create fantastic artworks!

In this lesson, you will create three-dimensional forms from paper. Pages 244–245 will tell you how to do it. Then you will assemble the forms to make a relief sculpture. Choose any object or scene from nature for your subject.

Studio Background

Paper in Art

Paper is all around us. We use it to write on and to wrap things. We feel its many textures and thicknesses in books and magazines. It fills our homes, schools, and offices. For thousands of years, paper has been an important part of daily life. It has also made its mark in the world of art.

From its earliest time, paper has provided artists with a surface for drawing, painting, and printing pictures. In the early 1900s, paper's role in art expanded into collage and sculpture. Artists invented new ways to express themselves with paper. Many were inspired by the traditional paper-folding and paper-cutting techniques they saw in Europe and Asia. Today, artists create exciting sculptural forms just by cutting, folding, scratching, tearing, piercing, bending, punching, rumpling, gluing, and decorating paper.

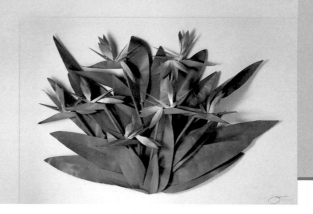

Fig. 7–25 **Notice how this artist simplified the forms of exotic flowers. What paper-sculpture techniques do you see here? Why might the artist have also chosen to simplify the color scheme?** Ron Chespak, *Birds of Paradise*, 1997.
Paper sculpture, 70" x 44" x 8" (177.8 x 111.8 x 20.3 cm).
Courtesy of the artist.

Teaching Options

Resources

Teacher's Resource Binder
- Studio Master: 7.4
- Studio Reflection: 7.4
- A Closer Look: 7.4
- Find Out More: 7.4
- Large Reproduction 14
- Slides 8f

Teaching Through Inquiry

Art Production Have students compare the paper sculptures on these pages. Ask them to use the diagrams on page 244 to identify the techniques used in each piece. Challenge students to select and reproduce a small feature or detail in one of the works.

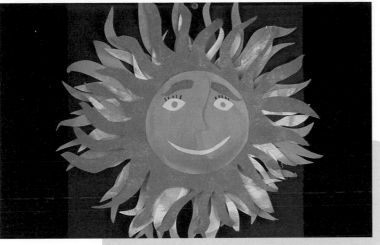

Fig. 7–26 **Can you determine how these student artists manipulated their paper? The face was made from a cone—what other forms do you see?** Danielle M. DeMars and Brittany Leftwich, *Sun Shine*, 1999. Construction paper, sponge paint, 12" x 12" (30.5 x 30.5 cm). William Byrd Middle School, Vinton, Virginia.

The next time you pick up a letter or open a box of cereal, think about the paper that was used to make it. Then look at the paper with the eyes of an artist. What could you do with it?

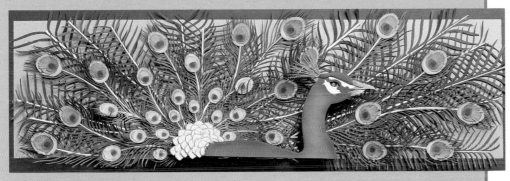

Fig. 7–27 **How has this artist created texture? Is it real texture or implied texture?** Dennis Ortakales, *Peacock*, 1998. Paper sculpture, 10" x 35" x 4" (25.4 x 89 x 10 cm). Courtesy of the artist.

Nature

243

Teach

Engage

Give each student a piece of paper, and explain that paper is essentially two-dimensional. Challenge students to transform their paper into a three-dimensional form. (They may wad, fold, roll, or curl it.)

Using the Text

Have students read Studio Background. Ask them to name at least twenty uses of paper.

Using the Art

Perception Ask: What medium are these sculptures? What colors were used in each sculpture? How do these colors contribute to the mood or feeling of the piece? Explain that these are relief sculptures designed to be viewed from the front. **Ask:** How can you tell that they have depth? How does light create a sense of depth? Which forms are in front, and which are in the back? **Ask:** How, do you think, did Ron Chespak create the blooms in *Birds of Paradise*? Which techniques did Dennis Ortakales use to create the feathers in *Peacock*?

More About...

All types of papers may be sculpted, but larger sculptures usually require thicker papers, for support. Artists begin most **free-standing relief** sculptures from basic shapes, such as cylinders, cubes, cones, or pyramids. The play of light and shadow, created by bending and folding paper into various planes on the surface, creates an illusion of depth.

More About...

Ron Chespak (b. 1960), a California artist, has created cut-paper reliefs that have been featured on magazine covers, in advertisements, and in *The Whimsical Verse of Olly-O*, a children's book by Molly James.

Using the Large Reproduction

14

Think It Through

Ideas What ideas can you get from this, or other close-up views of nature, for your own work?

Materials How would this image be different if it had been made out of cut-paper shapes?

Techniques What paper-sculpture techniques could be used to render a view like this?

Audience When you make art, think about who your audience will be.

Paper Relief Sculpture

Studio Experience

Demonstrate the paper-sculpture techniques, and, when students are ready, lead them in cutting, folding, scoring, and bending their shapes. They may work in groups of four to six to share construction paper.

Idea Generators

Have students look at nature photographs that include plants, animals, and landforms, and at actual nature objects and realistic toy animals. Discuss ways to combine these subjects in a composition. **Ask:** Which forms will you put in the background? In the foreground?

Computer Option

Have students use HyperStudio, a multimedia program that imitates a stack of cards. Each card (page) offers links that allow for jumps to anywhere else in the stack. For example, students can use HyperCard's tools on Card One to "paint" an afternoon-to-night scene, and then duplicate and modify the scene for Card Two (by making the colors darker, lowering the sun in the sky, and so on). Students can work with subsequent cards to simulate the nearing of nighttime, and can backtrack to add a bird or other subject matter to duplicate and modify as the scene progresses. HyperStudio allows for both flip-book and path animation (moving an object along a path).

Alternatively, students may simulate animation by using a slide-show program such as Claris, Apple Works, or PowerPoint. Students can duplicate objects and move them gradually on the page, from slide to slide. By running the slide show at its fastest speed, the objects appear to be moving.

Sculpture in the Studio

Making Your Paper Relief Sculpture

You Will Need

- sketch paper and pencil
- colored construction paper
- lightweight cardboard
- scissors
- tools for scoring
- white glue
- paper clips or removable tape

Try This

1. Choose a subject from nature that interests you. You might consider animals, trees, flowers, the ocean, or mountains. How might you create a paper relief sculpture of your subject?

2. Sketch your ideas. Simplify the shapes and forms of your subject. Will you use geometric shapes and forms, or organic shapes and forms?

3. Practice the paper-sculpture techniques shown in the diagrams. Try scoring and bending straight and curved lines. Compare the results. Experiment with other techniques, such as tearing and twisting paper. Come up with ideas of your own. Which techniques will work best for your sculpture? Think about the colors and forms that will create the effect you want.

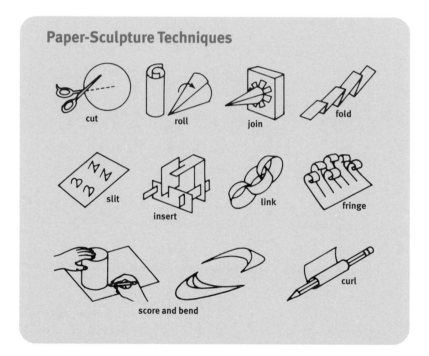

Paper-Sculpture Techniques

cut roll join fold

slit insert link fringe

score and bend curl

Teaching Options

Meeting Individual Needs

Adaptive Materials Provide students with sculpted paper.

Alternative Assignment Assign more experienced students to teach students who need assistance.

Focusing Ideas Brainstorm ideas with students, or provide students with several options and have them choose one.

Studio Collaboration

 Have students create a paper-relief sculpture of a large-scale natural environment to fill a display case or a corner of the classroom.

4. When you are finished shaping the forms for your sculpture, carefully arrange the parts on a piece of lightweight cardboard. Change and rearrange the forms so all parts fit together well.

5. When you are happy with your arrangement, glue the forms in place. Use paper clips to hold the forms in place until the glue dries.

Check Your Work

Explain to classmates why the forms you chose work best for your subject. How many different paper-sculpture techniques did you use to create the forms? How clearly does your sculpture represent nature?

Sketchbook Connection

Creating close-up sketches of plants and other forms in nature is a good way to learn about the subject. Take your sketchbook outside and choose a quiet spot to sit. Find a leaf, flower, or other natural object that interests you. Make some sketches of it. Draw large to fill the page. Include as many small details and textures as you can.

Computer Option

Think about the constant changes in nature. In a paint or multimedia program, create a scene that shows a change such as a flower blooming, an animal growing, or the sky changing at sunset. Use color, values, placement, and special effects to give your design a 3D feeling.

Sketchbook Tip

Encourage students to make close-up drawings of natural forms by choosing a small part of the object and then drawing it large. Instruct students that their drawings will look convincing if they include many details and textures.

Assess

Check Your Work

The effect of light and shade is an important factor in your completed sculpture. **Ask:** Did you plan for the interplay of light and shadow? What do you consider to be the best way to display and view your work?

Close

Create a display of the students' reliefs. **Ask:** What techniques were used to create three dimensions? What nature forms can you identify in the sculptures?

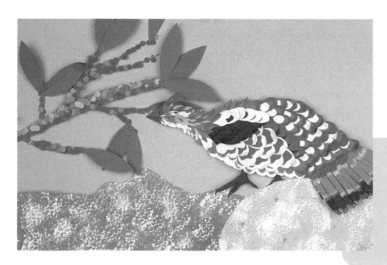

Fig. 7–28 **How did the artist use paper to show the variety of the natural world?**
N. Elizabeth Kite, *Feathers*, 1999. Construction paper, sponge paint, 11" x 17" (28 x 43 cm). William Byrd Middle School, Vinton, Virginia.

Nature

Teaching Through Inquiry

Aesthetics Ask students to make a list of the many ways that paper functions in their daily lives. Consider ways in which paper is: (1) a material valued mostly as a surface to be covered; (2) a material valued mostly as a cover for something else; (3) a material valued mostly for its own sake. Also list and collect examples of paper that is valued for each of the following qualities: strength, fragility, opaqueness, translucence, transparency, flatness, smoothness, texture. Suggest that students create a display with poetic labels to illustrate the aesthetic qualities of paper.

More About...

The earliest known **paper sculptures** were made in China about 2,000 years ago. Later, in seventh-century China, huge paper figures were constructed for the purpose of driving away evil spirits. Paper sculpture now serves the practical purposes of teaching art and design, making architectural models, constructing department-store displays, advertising, and even book-illustrating (pop-up books are a form of paper sculpture).

Assessment Options

Teacher Have students work in small groups to create a visual aid for children, of paper-sculpture techniques. Encourage students to create actual examples of each technique from the book, and then to display them. Assess according to how well students demonstrate their understanding of the potential uses of paper for creating three-dimensional forms.

Careers

In the early days of global exploration, explorers were accompanied by artists, who recorded previously unknown or unfamiliar natural objects and living things. Despite the invention of photography, the need for scientific drawings and paintings has not been eliminated. Drawings can highlight particular details, show more than one view at a time, record how something looks on the inside, or combine objects that would never be found together in life. A number of contemporary botanical illustrators and artist/naturalists have their own Web sites with examples of their work. Search the Internet to locate such artists. You might simply show students their web pages, or arrange for artists to participate in an online dialogue with the class.

Daily Life

Invite students who have visited a national park to share their experiences, focusing especially on the wilderness areas of the park. Explain that efforts to preserve the parks often clash with the desires of visitors. For example, at Grand Canyon National Park, cars are no longer allowed on many of the roads; tourists must take natural-gas-powered buses to see most of the rim vistas. In other parks, bears who had come too close to tourists have been relocated to more isolated areas. Encourage students to discuss these issues and suggest solutions for preserving our national parks.

Connect to...

Careers

In a science textbook, you can find illustrations that depict scientific concepts, natural objects, and living things. These images are created by science illustrators, artists with special skills in one or more areas of science.

Science illustrators must have a strong scientific curiosity and a keen interest in both art and science. They might specialize in one of the science domains: life science, physical science, and earth and space science. For instance, an artist who specializes in life science might create medical or botanical illustrations.

Science illustrators use a variety of media and techniques, and often work closely with doctors and scientists to create accurate drawings and paintings for textbooks, field guides, and other science-based publications. No matter what their field of study, all science illustrators must be expert at seeing detail and drawing accurately what they observe.

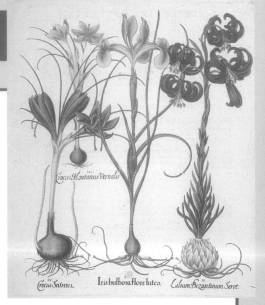

Fig. 7–29 **What are some reasons that scientific illustrations, instead of photographs, are used in publications?**
Basil Besler, *Crocus Sativu, Bulbosa Flora Luteo, Lilium Bizantinum Serot*, 1613.
Colored engraving, 18 7/8" x 15 3/4" (47.9 x 40 cm). Philadelphia Museum of Art, Purchased: Harrison Fund.

Other Arts

Music

As with many artworks, the natural world is a frequent subject in musical works. The direct **representation of animals or natural events** (wind, water, storms) in music is known as imitation. For instance, a composer might use the full range of orchestral sounds to present the dramatic effect—the musical imitation—of a storm.

Listen to three compositions that depict storms: the storm section from Rossini's *William Tell Overture*; the fourth movement of Beethoven's *Sixth Symphony*; "Cloudburst" from Grofé's *Grand Canyon Suite*. How are these pieces similar in the way they represent storms? How do they differ? How did the composers use instruments, dynamics (volume), tempo, rhythm, and harmony to represent storms? Which piece do you think is the most effective? Why?

Internet Connection
For more activities related to this chapter, go to the Davis website at **www.davis-art.com.**

Teaching Options

Resources

Teacher's Resource Binder
Using the Web
Interview with an Artist
Teacher Letter

Video Connection

Show the Davis art careers video to give students a real-life look at the career highlighted above.

Community Involvement

Arrange with a local park official or naturalist to allow students to use natural materials to create a sculpture with an environmental purpose. Students might create a nesting or feeding station for birds or other small animals, a wind sock, or an aesthetically pleasing recycling container.

Other Subjects

Language Arts

One of the most important forms of traditional Japanese poetry is linked to nature. **Haiku** is a thoughtful, unrhymed poem that expresses an essential quality or spirit of the natural world. Well-written haiku contrasts elements such as movement and stillness, or change and stability.

Haiku usually has a particular season and focus on fully appreciating the present moment. A haiku has seventeen syllables in three short lines. How could you learn to write haiku? What natural subjects would you choose to interpret in your haiku?

Fig. 7–30 **The words of a poem are combined with skillful calligraphic brushstrokes in this work about nature.** Tamaraya Sotatsu and Hon'ami Koetsu, *Poem-Card (Shikishi)*, 1606.
Gold, silver, and ink on paper, 52" x 17" (132.1 x 43.2 cm). ©The Cleveland Museum of Art, John L. Severence Fund, 1987.60.

Mathematics

Symmetrical balance is a concept shared by math, science, and art. Symmetrical, or bilateral, balance is produced by the repetition of the same shapes or forms on opposite sides of a center dividing line. Examples of symmetrical balance can be found in nature, especially in living things that have a backbone; or, in mathematical terms, a line of symmetry.

Fig. 7–31 **Can you identify six living creatures that are symmetrically balanced?** Michael Colucci, *Digital Tortoise*, 1998.
Computer graphic, 8" x 8" (20.3 x 20.3 cm). Haverford High School, Havertown, Pennsylvania.

Daily Life

Do you fully experience nature in your everyday life? Each day, are you inside a climate-controlled building in which the windows can't be opened? Do you shop and go to movies inside a mall? Would you rather stay inside—watching TV or playing computer games—or go outside and play sports or explore nature?

Even though we depend on the natural environment, we can easily let ourselves become removed from it. Thomas Moran's extraordinary paintings of Yellowstone and the Grand Canyon (page 227) were crucial in convincing the United States Congress to establish and preserve the areas as national parks. What are some ways to encourage people to better appreciate and enjoy the natural world?

Mathematics

To demonstrate that symmetrical balance is produced by the repetition of the same shapes or forms on opposite sides of a center dividing line (the mathematical line of symmetry), guide students to write a cinquain. (A cinquain has five lines: line 1 is a two-syllable noun; line 2 is two two-syllable adjectives; line 3 is three two-syllable participles; line 4 is an eight-syllable simile; and line 5 is a two-syllable noun.) First create a cinquain with the class, using an image from this book as the subject. Then have each student choose an artwork based on the natural world and write a cinquain about it. Display the cinquains.

Language Arts

Haiku, a traditional form of Japanese poetry, is an unrhymed poem that expresses an essential quality or spirit of the natural world. Haiku usually suggest a particular season of the year and focus on fully appreciating the present moment. English-written haiku have seventeen syllables in three lines. Explain haiku structure (line 1: five syllables; line 2: seven syllables; line 3: five syllables), and write a haiku with the class, using an image from this book as the subject. Then have each student choose an artwork based on the natural world and write a haiku about it.

Nature

247

Internet Resources

American Museum of Natural History
http://www.amnh.org/
Use this site to inspire students about the natural world, or check out art-related special features.

Mary Cassatt, WebMuseum, Paris
http://sunsite.icm.edu.pl/wm/paint/auth/cassatt/
This site offers biographical information and links about Mary Cassatt.

National Museum of Natural History
http://www.mnh.si.edu/
The seven scientific departments of the National Museum of Natural History offer comprehensive collections and research information online.

Curriculum Connection

Social Studies Help students identify Japanese-American artists whose work is exhibited in the United States today. **Ask:** To what extent do these artists draw upon, or make reference to, their Japanese heritage in their work?

Science Have students investigate the physics of color by holding a prism in a white light to separate the rays into a spectrum. Encourage students to note the order of the colors.

Chapter 7
Portfolio & Review

Talking About Student Art

Remind students that judgments about artworks are informed opinions—those made by considering an artwork's details, expressive characteristics, and thematic messages.

Portfolio Tip

Ask students to find descriptive and expressive words to use when writing peer reviews. Suggest they use a dictionary and thesaurus to help find appropriate words.

Sketchbook Tips

• Encourage students to look through their sketchbook occasionally and make notes and comments about the materials and techniques they have used, and ways they achieved certain effects.

• Have students list a number of familiar places; and the seasons, times of day, kinds of weather, and all the details they can imagine for each place. Encourage students to begin a series of sketches based on this information.

Portfolio

"I enjoyed making this because I liked the cool designs that showed up. This project was easy to make and it did not take a long time to finish it." **Tory Velardo**

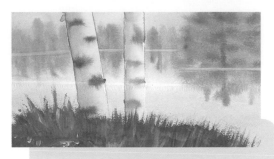

Fig. 7–33 How has this student used color to express her impressions of nature? How would you describe her style? Kaitlin Carleton, *Birch*, 1999.
Watercolor, 7 ½" x 13" (19 x 33 cm). Bird Middle School, Walpole, Massachusetts.

Fig. 7–32 **Students experimented with different contrasting colors to see which would work best together.** Tory Velardo, *Untitled*, 1999.
Printing ink, cardboard, 18" x 24" (46 x 61 cm). Copeland Middle School, Rockaway, New Jersey.

CD-ROM Connection
To see more student art, check out the Global Pursuit Student Gallery.

"I kept thinking that I needed just enough details to make the teapot stand out, but not so many that it would make the teapot become too wild." **Amanda Hill**

Fig. 7–34 **In choosing an object from nature for her clay vessel, this student thought about how the shape of the rose would complement the shape of the teapot.** Amanda Hill, *The Rose Teapot*, 1999.
Clay, 6" x 6" x 5" (15 x 15 x 12 cm). Atlanta International School, Atlanta, Georgia.

248

Teaching Options

Resources

Teacher's Resource Binder
 Chapter Review 7
 Portfolio Tips
 Write About Art
 Understanding Your Artistic Process
 Analyzing Your Studio Work

CD-ROM Connection

Additional student works related to studio activities in this chapter can be used for inspiration, comparison, or criticism exercises.

Chapter 7 Review

Recall

What are two ways that humans connect with nature through art?

Understand

Use examples to explain how the Impressionists used color and light to interpret nature (*example below*).

Apply

Produce a small painting of three apples using the pointillist technique to visually mix the three primary colors.

Analyze

Compare and contrast Japanese and Impressionist interpretations of nature in the artworks in this chapter.

Synthesize

Create a poster showing different interpretations of nature in artworks from around the world. Refer to the core lesson and its development of the theme "nature" as you plan your work.

Evaluate

Recommend three artworks from this chapter that you think everyone should revisit from time to time as reminders of the beauty of the natural world. Give reasons for your selections.

Page 236

For Your Portfolio
Create an artwork especially for your portfolio, based on the theme of nature. Exchange your artwork with a peer, and write a critique of your peer's work. Describe the work, and interpret its meaning, making connections between the details and the work's message about nature. Explain how the artwork is successful. You might also offer suggestions for improvement, with reasons or questions. Exchange critiques, and write a response. Put the response, critique, and artwork into your portfolio.

For Your Sketchbook
Select one object from nature. Draw the object in several different ways, with various media and colors, from different views and in different light.

Nature

249

Family Involvement

Invite family members to assist you in collecting reproductions of artworks.

Advocacy

For distribution to community leaders, have students design flyers that illustrate how the study of art prepares students for careers in the community, by teaching independent thought, working cooperatively, and considering human achievement in global terms.

Chapter 7 Review Answers
Recall

Artists find inspiration and subject matter for their work in the natural world. They also use materials from nature in their artworks.

Understand

Artists like Morisot, Monet, and Renoir used bright, pure colors and placed them next to each other with quick brushstrokes, allowing the eye to "mix" the colors on the canvas. The Impressionists painted outdoors to capture the way light affects the appearance of things at different times of day.

Apply

Look for the application of small dots of primary colors very close to each other, and an understanding of the visual mixing of primary colors to create secondary colors.

Analyze

The Japanese artists used controlled, fluid lines and subtle colors to show natural forms as simplified and flat shapes. The Impressionists used quick brushstrokes and dabs of bright colors that resulted in vaguely defined shapes.

Synthesize

Look for use of artworks inspired by nature and made with natural materials, from a range of cultures.

Evaluate

Answers will vary. Check that reasons appropriately support answers.

Reteach

Discuss the different ways that artists respond to nature: by careful observation of detail, by use of color to show a mood, or by simplifying natural forms into shapes and patterns. Have students find examples in the book or in other art reproductions.

Chapter Organizer

9 weeks | **18 weeks** | **36 weeks**

Chapter Focus

Chapter National Standards

Chapter 8 Continuity and Change
Chapter 8 Overview
pages 250–251

- **Core** Art often honors or is a continuation of tradition; it also sometimes represents a change in tradition.
- **8.1** European Art: 1900–1950
- **8.2** Shape and Form
- **8.3** The Art of Southeast Asia
- **8.4** Creating a Montage

1. Understand media, techniques, and processes.
2. Use knowledge of structures and functions.
3. Choose and evaluate subject matter, symbols, and ideas.
4. Understand arts in relation to history and cultures.
5. Assess own and others' work.

Objectives

National Standards

9 weeks: 3 **18 weeks:** 3 **36 weeks:** 3

**Core Lesson
Continuity and Change
In the Art World**
page 252
Pacing: Three 45-minute periods

- Use examples to explain what is meant by artistic tradition.
- Demonstrate an understanding of how traditions change over time.

1a Select/analyze media, techniques, processes, reflect.
4c Analyze, demonstrate how time and place influence visual characteristics.
5b Analyze contemporary, historical meaning through inquiry.

**Core Studio
Making an Assemblage**
page 256

- Create a nontraditional sculpture with a traditional subject or purpose.

1a Select/analyze media, techniques, processes, reflect.

Objectives

National Standards

36 weeks: 2

**Art History Lesson 8.1
European Art:
1900–1950**
page 258
Pacing: Two 45-minute periods

- Explain how some art in the early twentieth century built on the Impressionist painting tradition.
- Use examples to describe how art in the early twentieth century changed and broke with artistic traditions.

1b Use media/techniques/processes to communicate experiences, ideas.
4a Compare artworks of various eras, cultures.

Studio Connection
page 260

- Create a painting with a technique borrowed from the Surrealist tradition.

1b Use media/techniques/processes to communicate experiences, ideas.

Objectives

National Standards

36 weeks: 1

**Elements and
Principles Lesson 8.2
Shape and Form**
page 262
Pacing: One or two 45-minute periods

- Compare and contrast the use of shape and form in selected artworks.

2b Employ/analyze effectiveness of organizational structures.

Studio Connection
page 263

- Demonstrate an understanding of shape and form by creating a collage.

2b Employ/analyze effectiveness of organizational structures.

Featured Artists

Affandi
Eugène Atget
Herbert Bayer
Romare Bearden
Constantin Brancusi
Georgette Chen
Salvador Dali

Sonia Terk Delaunay
André Derain
Max Ernst
Barbara Hepworth
Hannah Höch
Henri Matisse
L. Metzelaar

Charles Christian Nahl
Louise Nevelson
Georgia O'Keeffe
Pablo Picasso
Augusta Savage
Leo Sewell
Frank Lloyd Wright

Chapter Vocabulary

assemblage
additive process
Expressionism
Fauves
Surrealists
Abstract

Cubism
nonobjective
form
representational
montage

Teaching Options

Teaching Through Inquiry
More About...Traditional methods for creating sculpture
Using the Large Reproduction
Meeting Individual Needs
More About...The Navajo
Using the Overhead

Technology

CD-ROM Connection
e-Gallery

Resources

Teacher's Resource Binder
Thoughts About Art:
8 Core
A Closer Look: 8 Core
Find Out More: 8 Core
Studio Master: 8 Core
Assessment Master:
8 Core

Large Reproduction 15
Overhead Transparency 16
Slides 8a, 8b, 8c

Meeting Individual Needs
Teaching Through Inquiry
More About...Assemblages
More About...Nevelson's sculpture
Assessment Options

CD-ROM Connection
Student Gallery

Teacher's Resource Binder
Studio Reflection: 8 Core

Teaching Options

Teaching Through Inquiry
More About...The Expressionists
More About...The Fauves
Using the Overhead

Technology

CD-ROM Connection
e-Gallery

Resources

Teacher's Resource Binder
Names to Know: 8.1
A Closer Look: 8.1
Map: 8.1
Find Out More: 8.1
Assessment Master: 8.1

Overhead Transparency 15
Slides 8d

Meeting Individual Needs
Teaching Through Inquiry
More About...Decalcomania
Assessment Options

CD-ROM Connection
Student Gallery

Teacher's Resource Binder
Check Your Work: 8.1

Teaching Options

Teaching Through Inquiry
More About...Dame Barbara Hepworth
Using the Overhead
Assessment Options

Technology

CD-ROM Connection
e-Gallery

Resources

Teacher's Resource Binder
Finder Cards: 8.2
A Closer Look: 8.2
Find Out More: 8.2
Assessment Master: 8.2

Overhead Transparency 15

CD-ROM Connection
Student Gallery

Teacher's Resource Binder
Check Your Work: 8.2

Chapter Organizer continued

		2

Objectives

**Global View Lesson 8.3
The Art of Southeast Asia**
page 264
Pacing: Two 45-minute periods

- Describe at least two traditional Southeast Asian art forms.
- Explain, using examples, how Southeast Asian art reflects traditions borrowed from other places.

National Standards

4a Compare artworks of various eras, cultures.
4c Analyze, demonstrate how time and place influence visual characteristics.

Studio Connection
page 266

- Create a paper batik with an overall pattern.

2c Select, use structures, functions.

(18 weeks: 1 36 weeks: 1)

Objectives

**Studio Lesson 8.4
Creating a Montage**
page 268
Pacing: One or two 45-minute periods

- Explain why photography can be an effective medium for the expression of ideas and feelings.
- Create a montage to convey ideas about continuity and change in a family or cultural tradition.
- Place the art of montage in historical time frame.

National Standards

1a Select/analyze media, techniques, processes, reflect.
2b Employ/analyze effectiveness of organizational structures.
3a Integrate visual, spatial, temporal concepts with content.

Objectives

Connect to...
page 272

- Identify and understand ways other disciplines are connected to and informed by the visual arts.
- Understand a visual arts career and how it relates to chapter content.

National Standards

6 Make connections between disciplines.

Objectives

Portfolio/Review
page 274

- Learn to look at and comment respectfully on artworks by peers.
- Demonstrate understanding of chapter content.

National Standards

5 Assess own and others' work.

2 Lesson of your choice

Teaching Options

Teaching Through Inquiry
More About...Indonesian shadow-puppets
Using the Large Reproduction

Technology

CD-ROM Connection
e-Gallery

Resources

Teacher's Resource Binder
 A Closer Look: 8.3
 Map: 8.3
 Find Out More: 8.3
 Assessment Master: 8.3

Large Reproduction 16
Slides 8e

Meeting Individual Needs
Teaching Through Inquiry
More About...Batik
Assessment Options

CD-ROM Connection
 Student Gallery

Teacher's Resource Binder
 Check Your Work: 8.3

Teaching Options

Teaching Through Inquiry
More About...Hannah Höch
More About...Romare Bearden
Meeting Individual Needs
Studio Collaboration
More About...Collage
Assessment Options

Technology

CD-ROM Connection
 Student Gallery
Computer Option

Resources

Teacher's Resource Binder
 Studio Master: 8.4
 Studio Reflection: 8.4
 A Closer Look: 8.4
 Find Out More: 8.4

Slides 8f

Teaching Options

Community Involvement
Interdisciplinary Planning

Technology

Internet Connection
Internet Resources
Video Connection
CD-ROM Connection
 e-Gallery

Resources

Teacher's Resource Binder
 Using the Web
 Interview with an Artist
 Teacher Letter

Teaching Options

Advocacy
Family Involvement

Technology

CD-ROM Connection
 Student Gallery

Resources

Teacher's Resource Binder
 Chapter Review 8
 Portfolio Tips
 Write About Art
 Understanding Your Artistic Process
 Analyzing Your Studio Work

Chapter Overview

Theme

We all conform to and sometimes change traditions in our lives. Art often honors or is a continuation of tradition; it also sometimes represents a change in tradition.

Featured Artists

Affandi
Eugène Atget
Herbert Bayer
Romare Bearden
Constantin Brancusi
Georgette Chen
Salvador Dali
Sonia Terk Delaunay
André Derain
Max Ernst
Barbara Hepworth
Hannah Höch
Henri Matisse
L. Metzelaar
Charles Christian Nahl
Louise Nevelson
Georgia O'Keeffe
Pablo Picasso
Augusta Savage
Leo Sewell
Frank Lloyd Wright

Chapter Focus

This chapter focuses on the function of tradition in artworks—those made within a tradition, those that borrow traditions from other artists or places, and those that break with tradition. Students will see that the twentieth century was a time for rapid changes in Western art traditions; how shape and form can be

8

Continuity and Change

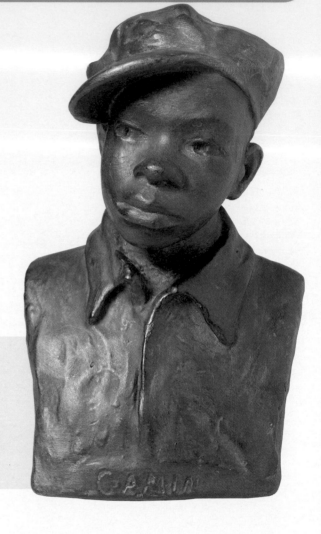

Fig. 8–1 With this sculpture, the artist broke with the portrait tradition in Western art. The boy, modeled after her nephew, was meant to represent other homeless children of the Depression in the United States. Augusta Savage, *Gamin*, c. 1930.
Painted plaster, 16 ½" (41.9 cm) high.
National Museum of American Art, Smithsonian Institution, Washington, DC.

250

National Standards Chapter 8 Content Standards

1. Understand media, techniques, and processes.

2. Use knowledge of structures and functions.

3. Choose and evaluate subject matter, symbols, and ideas.

4. Understand arts in relation to history and cultures.

5. Assess own and others' work.

Teaching Options

Teaching Through Inquiry

Art Production Have students work in pairs to help each other review artworks they have made throughout the year, in terms of continuity and change of subject matter, materials, or techniques. **Ask:** What influenced the continuity in your artworks? Where did you get your ideas about art production? What influenced the changes in your artworks? Have students write a paragraph to describe continuity and change in each other's artworks.

More About...

Augusta Savage (b. 1892) had an early interest in art, but her family did not encourage her. She did model a group of figures from clay given to her by a local potter; she entered the work in a county fair, where she won a special prize. Thus encouraged, she moved to New York City. During the 1930s, she was known in Harlem as a sculptor, art teacher, and community-art-program director.

Focus

- How can traditions both continue and change?
- What are some artistic traditions and how do they change?

Do you celebrate a certain holiday or a special date year after year? How do you celebrate? Do you always do the same things or eat the same foods? Are the same family members and friends present? Most people celebrate at least one holiday as part of a group, in a traditional way, year after year. You maintain *continuity* by carrying on traditions and following holiday customs.

Artists in every culture throughout the world also carry on traditions. European artists have created still lifes using oil paint since the medium was first developed before the fifteenth century. African sculptors have carved masks out of wood since before recorded history.

Think again about your holiday tradition. Would you agree that, from year to year, your celebrations are never exactly the same? Perhaps someone has a new home, and the gathering is moving there. Perhaps a baby was born since last year or maybe someone died. So while there is continuity, there is also *change*.

Artistic traditions can also change. For centuries, artists sculpted bronze portraits of royalty, famous people, or the well-to-do. Augusta Savage made the sculpture in Fig. 8–1 during the Depression. She broke with a portraiture tradition by sculpting an ordinary boy in bronze.

What's Ahead

- **Core Lesson** Discover how traditions in art continue and change.
- **8.1 Art History Lesson** Learn about the rapid changes in Western art traditions in the early twentieth century.
- **8.2 Elements & Principles Lesson** Focus on the use of simplified shape and form in art.
- **8.3 Global View Lesson** Find out about continuity and change in the arts of Southeast Asia.
- **8.4 Studio Lesson** Create a montage, an art form related to collage.

Words to Know

assemblage	additive process
Expressionism	nonobjective
Fauves	form
Surrealists	representational
Abstract art	montage
Cubism	

Continuity and Change

251

used in artworks; and how traditions have been continued, borrowed, and changed in the art of Southeast Asia. Students make a photomontage to highlight continuity and change in their own family or cultural tradition.

Chapter Warm-up

Ask students to describe the traditions of any annual family celebration. **Ask:** How have these traditions changed in the last few years? Explain that art, like traditions, goes through change.

Using the Text

Art Criticism After students have read page 251, have them compare Savage's *Gamin* to Michelangelo's *Pietà*, on page 157. **Ask:** How is the subject matter of this statue different from Michelangelo's? *(Pietà: important religious figures; Gamin: ordinary person)* How does *Gamin* represent a break with tradition? *(Artists had traditionally sculpted bronze portraits of royalty or the famous or rich.)*

Using the Art

Perception Have students study Savage's *Gamin.* **Ask:** What do you know about this subject?

Extend

Have students draw a family or other people engaged in a cultural tradition. **Ask:** What symbols and food will you feature? What decorations are especially important to the people? Who will be there? How will you represent each person—by what particular features, dress, or objects? Are any words or music important to this event? How will you show that?

Graphic Organizer
Chapter 8

CD-ROM Connection

For more images relating to this theme, see the Global Pursuit CD-ROM.

Prepare

Pacing

Three 45-minute periods: one to consider text and art; two to sketch, assemble, and paint sculpture

Objectives

- Use examples to explain what is meant by artistic tradition.
- Demonstrate an understanding of how traditions change over time.
- Create a nontraditional sculpture with a traditional subject or purpose.

Vocabulary

assemblage A three-dimensional artwork made by combining objects.

additive process A method of adding or building up materials to create a form.

8 CORE LESSON

Continuity and Change in the Art World

Types of Traditions

Some art traditions are shared by most cultures around the world. For example, nearly every culture decorates objects that are used every day. But cultural groups also have their own special artistic traditions. Here's one that you may know about: skateboard decoration. Most skateboarders decorate the bottom of their skateboards. This makes each skateboard unique, even though they have similar designs.

There are many different types of traditions in art. The media, or materials, used for artworks are one kind of tradition. For example, oil paint is a material traditionally used on canvas. Materials are often related to places, because they depend on available local resources. For instance, African sculptors traditionally carve the wood from trees grown near their village.

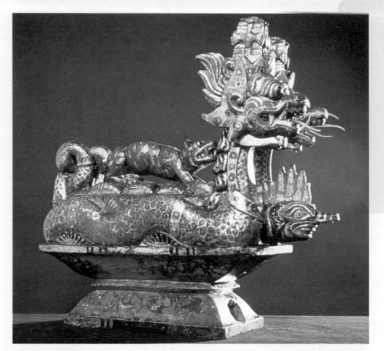

Fig. 8–2 This box was made for a traditional purpose—to hold a symbol of a god. The design also is traditional, telling a legend of the island of Bali sitting on an underworld turtle held between the coils of two serpents. How would understanding the culture of Bali help you to understand this artwork? Bali, *Wahana (miniature vehicle for a votive figure),* 20th century. Wood, pigments, gold leaf, fish glue medium, lacquer, 19 1/8" x 19 1/4" x 8 5/8" (48.5 x 49 x 22 cm). Australian Museum/Nature Focus.

252

National Standards Core Lesson

1a Select/analyze media, techniques, processes, reflect.

4c Analyze, demonstrate how time and place influence visual characteristics.

5b Analyze contemporary, historical meaning through inquiry.

Teaching Options

Resources

Teacher's Resource Binder
 Thoughts About Art: 8 Core
 A Closer Look: 8 Core
 Find Out More: 8 Core
 Studio Master: 8 Core
 Studio Reflection: 8 Core
 Assessment Master: 8 Core
Large Reproduction 15
Overhead Transparency 16
Slides 8a, 8b, 8c

Teaching Through Inquiry

Art History Have students work in groups to **identify the traditions** of certain artworks. Provide each group with an art reproduction. Ask students to identify media, purpose, subject matter, and art forms. Have students find, from various sources, two or more other artworks that represent traditions shown in their image. Have groups share their findings with the class.

An artwork's purpose might also be traditional: to decorate, to teach, to use in a ceremony or celebration, to show power, to record a historical event, or to tell a story. An artwork can have more than one traditional purpose. The Balinese box (Fig. 8–2), for example, is part of a storytelling tradition as well as a ceremonial tradition.

The subject matter of art can be traditional. You have seen some examples in previous chapters: nature in Japanese art, beauty and harmony in classical Greek art, and Christianity in early medieval art.

Certain art forms are considered traditional. Drawing, painting, and sculpture are very old traditions in art. Carved-wood sculpture in Africa (Fig. 8–3) is an art form handed down from one generation to the next. Older, experienced sculptors teach it to younger apprentices.

Each art form has its own customs and traditions. A painting might follow the tradition of landscape or still life (Fig. 8–4). A sculpture might follow the tradition of monuments or portraits.

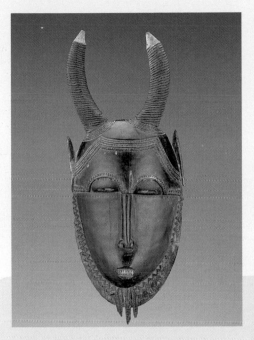

Fig. 8–3 Carving sculpture from wood is one of the oldest artistic traditions in Africa. What sculpture traditions have you been taught? Yaure peoples, Ivory Coast, *Mask*, early 20th century.
Wood and pigment, 14 ³/₄" (37.5 cm). Museum purchase, 91-21-1. National Museum of African Art, Smithsonian Institution, Washington, DC.

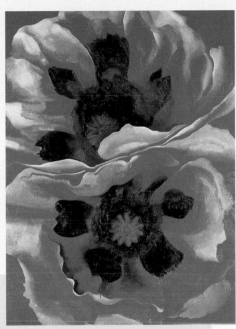

Fig. 8–4 Does this painting seem traditional to you? Why or why not? Georgia O'Keeffe used a traditional art form and showed traditional subject matter. But the way she chose to show the flowers was not traditional. Her new style used simplified flower shapes that filled the canvas. Georgia O'Keeffe, *Oriental Poppies*, 1928.
Oil on canvas, 30" x 40 ¹/₈" (76.2 x 101.9 cm). Collection Frederick R. Weisman Art Museum at the University of Minnesota, Museum purchase. ©2000 The Georgia O'Keeffe Foundation/Artists Rights Society (ARS), New York.

Teach

Engage

Ask: What thing can you name that most of you have, and that you have decorated to make uniquely your own? *(notebook cover, locker interior)* How have you personalized it?

Using the Text

Art Criticism Have students read the text and captions. **Ask:** For what purpose was each artwork created? What tradition does each represent?

Using the Art

Art History African mask carvers follow traditional ways of depicting their subjects. **Ask:** What features were exaggerated in this mask? In what ways was a human face abstracted or changed? Refer students to another Ivory Coast mask, on page 3, and have them compare the two pieces.

Continuity and Change

253

More About...

The **traditional methods for creating sculpture** are carving, modeling, constructing, and casting. Carving is a subtractive process because the artist cuts into and takes away material. Modeling, constructing, and casting are additive processes. In modeling, sculptors shape and build up a form with clay, wax, or other soft materials. In constructing, artists combine materials. In casting, artists use a sculpted form to make a mold into which they pour liquid material, which then hardens. The first step in casting is often the modeling process.

Using the Large Reproduction

15

Talk It Over

Describe What materials were used to make this artwork? What details are important?

Analyze What did the artist do to attract your attention to certain areas?

Interpret What does this artwork have to do with continuity and change?

Judge What impresses you the most about this piece? Why?

Using the Text

Art History Have students read pages 254 and 255. **Ask:** What three ways can art traditions change? How does each artwork illustrate one of these ways of change?

Using the Art

Assign students to research sculptures by Brancusi. Have each student bring to class a copy of one of his sculptures, line them up chronologically, and note how he gradually simplified his subjects until the human head became an egg.

Perception Ask students to describe the shapes and forms in each artwork. Have them compare the shapes in the rug to those in the sculpture. *(angular; round)*

Art Criticism Have students compare Brancusi's sculpture to Savage's *Gamin* (Fig. 8–1) and to the African mask (Fig. 8–3). **Ask:** Which work does the Brancusi piece resemble more? Although Brancusi did break with traditional sculpture, what might he have borrowed from the tradition of the African mask? *(simplified forms)*

Breaking, Borrowing, and Building on Traditions

Traditions in art change over time. Artists develop new interests. They learn new ideas from others. They come upon new technologies, tools, materials, or processes. A painter might start using a software program instead of watercolors to create his or her landscapes. Let's look at three ways that change occurs in art.

Artists sometimes decide to *break with tradition.* Constantin Brancusi (Fig. 8–5) made sculpture out of marble, an ancient tradition. Yet he broke with tradition by not sculpting realistic portraits out of the marble. For over twenty years, Brancusi explored the egg-shaped form shown here. In some ways, he created his own lasting tradition.

Change also occurs when artists *borrow traditions.* You have seen how the Impressionist painters borrowed ways of

Fig. 8–5 Brancusi made sculpture out of marble, a tradition that dates to ancient times. How did he break tradition with his work? Constantin Brancusi, *Mlle. Pogany (III)*, 1931.
White marble, base of limestone and oak, 17" x 7 ½" x 10 ½" (43.3 x 19 x 26.6 cm). Philadelphia Museum of Art: The Louise and Walter Arensberg Collection, 1950. Photo: Graydon Wood, 1994. ©2000 Artists Rights Society (ARS), New York/ADAGP, Paris.

Fig. 8–6 How did Wright borrow from the Mayan tradition for this design? Frank Lloyd Wright, *Ennis-Brown House*, 1924.
Photo by H. Ronan.

Teaching Options

Meeting Individual Needs

English as a Second Language
Have students bring in an object that they feel represents their heritage and then explain, in English, how it is part of their family's tradition. Next, have students draw an object that is similar, visually or in terms of function, from another culture, to see how a tradition can change from culture to culture.

Teaching Through Inquiry

Have the class create two posters: one to demonstrate visually what Mayan traditions Wright borrowed for the design of the Ennis-Brown House; and one to show how Brancusi broke with sculpture traditions in works such as *Mlle. Pogany (III)*. Have students research examples of Mayan artworks and traditional sculptures.

organizing their compositions from the Japanese woodcut tradition (see page 230). The *Ennis-Brown House* (Fig. 8–6) shows a style borrowed from a Mayan architectural tradition. Although these examples are relatively recent, cultures have borrowed traditions from one another since the earliest times.

In addition to breaking or borrowing traditions, artists might *build on traditions*. Refer to the story quilt *Tar Beach* (Fig. 6–6 on page 203) by Faith Ringgold. Ringgold was inspired by traditional quilt patterns and the stories they suggest. She made the

story the focus in her quilt, actually writing and illustrating the story on fabric.

Since the seventeenth century, Navajo weavers made blankets to be worn while traveling. Then, in the late nineteenth century, traders who came to the Southwest found that they could sell the blankets as rugs. The Navajo weavers built on their tradition in response to a change in their world (Fig. 8–7).

When you study an artwork, think about what traditions might be part of it. Does the artwork break with, borrow from, or build on a tradition? Are there other ways that art traditions can change?

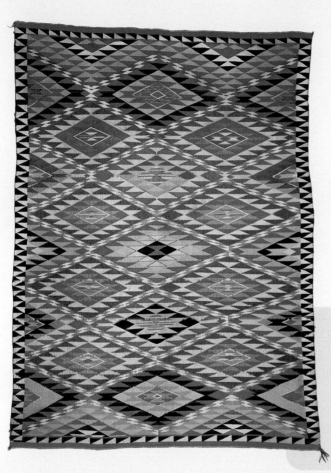

Fig. 8–7 Traders brought new pigments and yarn to Navajo artists, which allowed them to build on the tradition of weaving. A rug like this is called a Germantown, named after the Pennsylvania town where the yarns were produced. Navajo, *Germantown "eye-dazzler" rug*, c. 1880–90.
Extremely rare split yarn, two, three, and four ply, 72" x 50" (182.9 x 127 cm). Courtesy of Museum of Northern Arizona Photo Archives, E3176.

Continuity and Change

255

Aesthetics Have students discuss their ideas about continuing to work within a certain tradition versus breaking with tradition. **Ask:** Should all artworks continue traditions? Why or why not? What are the advantages of working within traditions? What are the advantages of breaking with traditions? Have students consider the issue from the perspective of artists as well as viewers.

Extend

Allow students to create two clay portraits—one realistic, and the other simplified, as exemplified by Brancusi's sculpture and the Ivory Coast mask.

More About...

The Navajo, when they were nomadic, had been skilled basket weavers. By the 1500s, however, they settled in the American Southwest, near **the Pueblo**, who raised and wove cotton. From the Pueblo, the Navajo probably learned to weave cotton cloth on upright looms. After the Spanish introduced sheep to the region, the Navajo became shepherds and began to weave wool. The Europeans also brought red aniline dye, which the Pueblo and the Navajo

added to the traditional plant dyes in their designs.

In the early twentieth century, as tourists began visiting the Southwest, railway agents encouraged weavers to modify their traditional designs—by using more colors and wool, instead of cotton—to produce salable and easily transportable souvenirs. The traditional use for Navajo weavings (apparel) changed due to trade (to rugs and wall hangings).

Using the Overhead

Think It Through

Ideas What details might suggest that this artist got ideas by looking at the art of other cultures?

Materials What materials can you identify?

Techniques How, do you think, was this made?

Audience For whom or for what purpose might this artwork have been made?

16

255

Supplies

- found objects (cardboard scraps, plastics, wood, metal, wire)
- bonding materials (adhesives, wire, hammers)
- sketch paper
- pencils
- tempera or acrylic paint and brushes (optional)
- tools (hammer, screwdriver, wire cutters, wrench)

Pre-Studio Assignment: Several days before the studio experience, assign students to bring in interesting "junk" for their assemblage.

Safety Note
Avoid glues with toxic fumes. Even odorless adhesives should be used only in well-ventilated areas. Warn students to be careful when using hot glue.

Using the Text

Art Production Show students all the sides of one of the found objects. **Ask:** What could this be turned into? What would happen if you added another piece? Would it resemble an animal?

Demonstrate joining objects with nails, glue, or wire. As students are completing their sculpture, encourage them to view it from several sides to see if they should add anything or if they want to paint it with acrylics or tempera.

Using the Art

Art Criticism Ask students to study Sewell's and Nevelson's sculptures. **Ask:** What objects can you identify in each sculpture? How are the two sculptures alike? How are they different?

Studio Tip

Guide students to wipe away excess glue before it dries; and, if they use nails, to plan their location and angle before hammering: nails that are too large, or that are nailed too near the end of a piece, may split the material.

Making an Assemblage

Building on a Sculptural Tradition

In this studio lesson, you will make a different kind of sculpture. An **assemblage**—also called "junk sculpture"—is a combination of found objects that form a sculpted artwork. You may choose either a traditional subject (such as a person or a group of animals) or a traditional purpose (such as to honor a person or show humor).

Begin collecting materials well in advance. Any object you are able to combine by gluing, tying, or otherwise joining could be part of your assemblage.

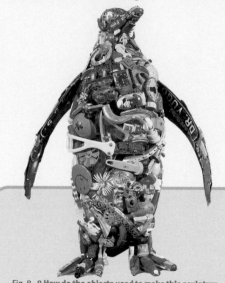

Fig. 8–8 **How do the objects used to make this sculpture change its meaning? How is it different from a traditionally carved or modeled penguin?** Leo Sewell, *Penguin*, 1979. Assemblage-reclaimed objects, 31" x 20" x 9" (79 x 51 x 23 cm). Courtesy of the artist.

You Will Need

- sketch paper
- pencil
- found objects
- bonding materials (glue, nails, screws, bolts, wire)
- tempera paint
- paintbrush
- tools (hammer, screwdriver, wire cutters, wrench)

Try This

1. Sketch some ideas before you begin your assemblage. Think about the possible meanings of the objects you have collected. Will your sculpture have a traditional purpose? Or will your artwork show a traditional subject?

2. When your design is finished, arrange the collected objects. Move them around to get the effect you want. Look at the arrangement from several angles.

3. Begin your final assemblage with one or two larger pieces. Add smaller forms to these. Try several positions for each form before you attach it.

Studio Background

Assemblage sculpture is an **additive process**, which means that materials are added or built up to create a form. Assemblages were made popular by twentieth-century artists such as Louise Nevelson (Fig. 8–9). They are usually organized around a theme or idea. Often, the materials themselves suggest the idea. Sometimes, the artist joins the same kind of objects—such as wooden chair legs. Other times, a

Teaching Options

Meeting Individual Needs

Adaptive Materials Supply sculpture objects (cardboard tubes, boxes, egg cartons, Styrofoam™).

Teaching Through Inquiry

Art Production Have students work out a plan for collecting and organizing found materials for use in sculpture and assemblages as an ongoing project for the school. Consider various ways to publicize needs and types of materials desired; categorizing, labeling, and storing by type, size, color, shape, etc. In their discussions, have students make lists of the various ways that specific found materials might be used. The lists they create could be displayed in the classroom or used as labels on storage bins.

4. As your work takes shape, look at it again from several angles. Are there details you can add that will contribute to its traditional purpose or subject? Will you paint these details or create them with additional materials?

5. Allow any glue to dry before painting your assemblage, if you wish to paint it.

Fig. 8–10 **This found-object sculpture was made from old computer parts. A clever play on words, spelled out with keyboard parts, puts a new twist on an age-old problem. Co-artist Berger says, "The artwork represents a crucial message to American teens and gets people thinking about drinking and driving."** Elizabeth Berger and Sarah Gallagher, *Drunk Driving Crashes More Than Just Hard Drives*, 1999. Computer parts, 20" x 17" x 15" (51 x 43 x 31 cm), The Avery Coonley School, Downers Grove, Illinois.

combination of objects is used—such as chair legs and plastic sunglasses.

An assemblage might be made of ordinary materials—scraps of cardboard, wood, metal, or plastic—that are also in the form of objects, such as tubes, old machine parts, or foam plastic egg cartons.

Check Your Work

Display your finished sculpture along with your classmates' sculptures. Note the similarities and differences. Discuss how the objects help show each sculpture's overall theme or idea.

Sketchbook Connection
Sketching ideas for two-dimensional artworks can be easier than sketching them for three-dimensional ones. Practice sketching three-dimensional groups of objects. Set them up on a square table. Make four different sketches, one from each side of the table. How is each sketch different? How might this help you construct a sculpture?

Core Lesson 8

Check Your Understanding
1. What do we mean by artistic tradition?
2. Name three types of artistic traditions.
3. If someone borrows an artistic tradition, what does that person do?
4. How might tourism affect artistic tradition?

Fig. 8–9 **Where can you see pieces of furniture in this assemblage? The artist also used pieces of wood from old buildings.** Louise Nevelson, *Sky Cathedral*, 1958. Wood, painted black, 101 1/2" x 133 1/2" x 20" (260 x 339.1 x 50.8 cm). George B. and Jenny Mathews Fund, 1970:1. Albright Knox Gallery, Buffalo, New York. ©2000 Estate of Louise Nevelson/Artists Rights Society (ARS), New York.

Continuity and Change

257

Assess

Check Your Work
Have students write and attach a label with their name and the title of the work. Display the art, and encourage students to note the similarities and differences among the sculptures. **Ask:** How do the objects add to the theme of each sculpture?

Check Your Understanding: Answers

1. the continuation of an area of art throughout time, in a particular group or culture

2. media or techniques, purpose, subject matter, art form

3. The person incorporates the media or techniques, purpose, subject matter, or art form of someone else or another group into his or her own artworks.

4. Artists in a tourist spot may wish to create artworks that tourists are interested in purchasing. To sell their artworks, the artists might break with the artistic traditions of their group, culture, or locale.

Close

Review the types of art traditions. Have students name an artwork in this chapter and explain how it is part of an artistic tradition. Ask what is traditional and what is nontraditional about the sculptures that they created.

More About...
Picasso was one of the first artists to create many **assemblages**. In 1914, he developed ideas from his Cubist collages into three-dimensional sculptures. His passion for found objects played an important role in his sculpture and, eventually, in much of twentieth-century art. French painter Jean Dubuffet is credited with coining the term *assemblage* during the 1950s.

More About...
Nevelson's large abstract **sculpture** was one of many pieces for the exhibition "Moon Garden + One," based on a theme of an imaginary night sky.

Assessment Options
 Teacher Provide small groups of students with collections (or photographs) of ordinary objects (such as a collection of flowerpots, pitchers, handbags, chairs, needlework, baskets, sneakers, or skateboards) that span several years—or decades. (Students may have their own collections to share.) Ask students to place the objects in chronological order. Have each group display their collection and write a guide for it, identifying the traditions that the objects continued and the traditions that the objects changed. Note the extent to which students understand tradition and the way it continued or changed.

Prepare

Pacing

Two 45-minute periods: one to consider text and art; one to paint

Objectives

- Explain how some art in the early twentieth century built on the Impressionist painting tradition.
- Use examples to describe how art in the early twentieth century changed and broke with artistic traditions.
- Create a painting with a technique borrowed from the Surrealist tradition.

Vocabulary

Expressionism A style of art which began in Germany. Expressionist artworks show strong mood or feeling.

Fauves A group of painters who used brilliant colors and bold exaggerations.

Surrealists A style of art in which dreams, fantasy, and the human mind were sources of ideas for artists. Surrealist works can be representational or abstract.

Abstract Art that is based on a subject; but the artist simplifes, leaves out, or rearranges elements so the subject may not be recognizable.

Cubism A style in which subject matter is broken into geometric shapes and forms, then reassembled into an abstract composition.

nonobjective Artwork that does not have recognizable subject matter. Also known as nonrepresentational.

National Standards 8.1 Art History Lesson

1b Use media/techniques/processes to communicate experiences, ideas.

4a Compare artworks of various eras, cultures.

European Art: 1900–1950

	c. 1895 Atget, *Cours d'Amoy*		1914 Delaunay, *Electric Prisms*		1931 Dali, *Persistence of Memory*	
Post-Impressionism page 232	Expressionism	Cubism	Surrealism	Abstract Expressionism page 284		
	1906 Derain, *Turning Road*		1921 Picasso, *Three Musicians*		1944 Ernst, *The King*	

The early twentieth century was a time of rapid change. There were great inventions, including the airplane, the car, and the television. There were also great changes in business and industry as more people moved to the city to work and live.

Art was also changing rapidly. Photography was an important new art form. Artists were trying to create their own unique styles. Some artists built on earlier artistic styles. Others experimented with traditional art materials and subjects. Still other artists tried to break completely with the past.

The artworks on these pages are a few examples of the many styles that developed from 1900 to 1950. They show the continuity of past traditions as well as the great changes taking place in the art world.

Building on Traditions

The artists of the Impressionist and Post-Impressionist movements greatly influenced early twentieth-century artists.

Expressionism

The term **Expressionism** refers to artists in the early twentieth century who used color and line with great feeling. Their main goal was to show feelings such as sorrow, joy, or fear in their artworks.

Many Expressionist artists formed groups to share ideas and techniques. One group was known as the **Fauves** (*fohv*). *Fauve* is a French word that means "wild beast." These artists got their name from the wild, intense colors they chose.

The Fauves liked the way the Impressionists broke down natural forms

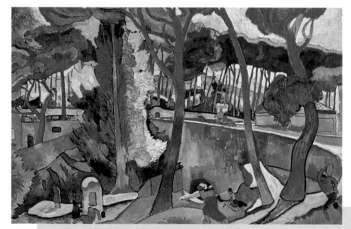

Fig. 8–11 What mood is created by the unusual colors in this work? André Derain, *Turning Road, L'Estaque*, 1906. Oil on canvas, 51" x 76 ³⁄₄" (129.5 x 195 cm). Museum of Fine Arts, Houston; Gift of Audrey Jones Beck. ©2000 Artists Rights Society (ARS), New York/ADAGP, Paris.

Teaching Options

Resources

Teacher's Resource Binder
- Names to Know: 8.1
- A Closer Look: 8.1
- Map: 8.1
- Find Out More: 8.1
- Check Your Work: 8.1
- Assessment Master: 8.1
- Overhead Transparency 15
- Slides 8d

Teaching Through Inquiry

Art History Have each student compare and contrast Derain's *Turning Road* with Renoir's *The Garden in Rue Cortot,* Monmarte, on page 233, by creating a poster to show how the Derain painting both continues and breaks with the Renoir's Impressionist tradition. Encourage students to begin by listing the similarities and differences. They may then enlarge or sketch the two images for the poster, and relate corresponding sections in the artworks by connecting them with lines.

into different colored brushstrokes. They admired the Post-Impressionists' expressive use of color and line. Compare *Turning Road, L'Estaque* (Fig. 8–11) by André Derain with the Post-Impressionist painting by Gauguin in Fig. 7–18, on page 237. Notice how both artworks have clear shapes and a strong composition. But Derain used wild, bright colors.

Changing Traditions

Many early twentieth-century artists were interested in finding new ways to show traditional subjects such as portraits, landscapes, or still lifes. Many turned to their dreams and imaginations for inspiration. These artists were called Surrealists.

Surrealism

Fantasy art can be found in works by the classical Greeks, medieval artists, and artists of the Northern Renaissance. The **Surrealists** experimented with new ways to create fantastic artworks. In Fig. 8–12, Max Ernst used bronze to create a sculpture of large chess pieces. Bronze was usually used to create portraits. By choosing surprising subject matter, Ernst made people think about the question, "What is art?"

Surrealist painters created compositions full of things that don't seem to go together. In Fig. 8–13, Salvador Dali made objects in his painting *look* real. But Dali upset the tradition of realistic painting. He showed things that are not from real life. What kind of message about change do you think Dali was sending?

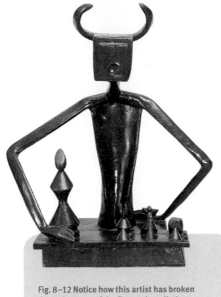

Fig. 8–12 Notice how this artist has broken down the parts of the figures into distinct geometric forms. Where do you see exaggeration in this artwork? Max Ernst, *The King Playing with the Queen*, 1944. Bronze (cast 1954, from original plaster), height: 38 ½" (97.8 cm), at base 18 ¾" x 20 ½" (47.7 x 52.1 cm). The Museum of Modern Art, New York. Gift of D. and J. de Menil. Photograph ©2000 The Museum of Modern Art, New York. ©2000 Artists Rights Society (ARS), New York/ADAGP, Paris.

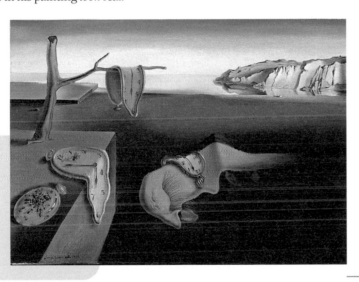

Fig. 8–13 Why do you think the artist chose to show this scene in a realistic way? How does this add to the strange quality of this work? Salvador Dali, *The Persistence of Memory*, 1931. Oil on canvas, 9 ½" x 13" (24.1 x 33 cm). The Museum of Modern Art, New York. Given anonymously. Photograph ©2000 The Museum of Modern Art, New York. ©2000 Artists Rights Society (ARS), New York.

Continuity and Change

259

Using the Time Line

As students study the time line, **ask:** What were some important events from 1895 to 1945 in Europe? *(World War I, the start of World War II)* How might these events have affected the course of art during this period? *(the upheavals encouraged change everywhere, including in art)*

Teach

Engage

Lead students in imagining the early 1900s. Horses and trains provided most transportation. There were few telephones and no television. **Ask:** How, do you think, did inventions in transportation and communications affect artists?

Using the Text

Art Criticism Have students read pages 258 and 259. **Ask:** Why is Ernst's sculpture considered Surreal?

Using the Art

Perception Direct students' attention to Fig. 8–13, and have them describe the objects. **Ask:** What seems real? Unreal? What is the feeling or mood? How does the sense of deep space contribute to the mood?

Using the Overhead

Investigate the Past

Describe Is this a realistic representation? What did the artist do to change the way something really looks?

Attribute What qualities in this work might help you identify other artworks by this artist?

Interpret How could you find out more about what this artwork meant to people in the first half of the twentieth century?

Explain Knowing more about this artist and his body of work might help explain why his work is an important part of twentieth-century art.

259

European Art: 1900–1950

Using the Text

Art History Have students read page 260 and then look at Fig. 7–15, on page 235, to see how Cézanne simplified forms. **Ask:** What influence from Cézanne is seen in Picasso's *Three Musicians*? Tell students that Picasso was also influenced by African masks. Have students look at Fig. 7–6, on page 229. **Ask:** What are the African influences in *Three Musicians*?

Using the Art

Aesthetics Remind students that they have learned that artworks send messages. **Ask:** Can an artwork such as *Electric Prisms* (Fig. 8–16) send a message if it does not show anything recognizable? How might the title relate to the inventions of the early 1900s? How do the colors in this painting compare to color schemes on page 38?

Studio Connection

Provide students with liquid acrylic or tempera paint, two sheets of 12" x 18" drawing or manila paper (per student), spoons, and brushes. Small groups of students may share paint and spoons.

Demonstrate the decalcomania technique. As students create their own painting, encourage them to experiment with colors and shapes.

Assess See Teacher's Resource Binder: Check Your Work 8.1.

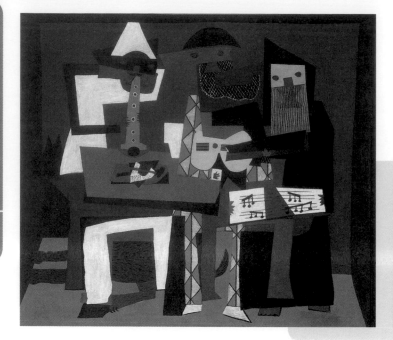

Fig. 8–14 Can you find the musicians and their instruments? If you did not know the title of this painting, how could you tell what it is about? Pablo Picasso, *Three Musicians*, Fontainebleu, summer 1921. Oil on canvas, 6' 7" x 7' 3 ¾" (200.7 x 222.9 cm). The Museum of Modern Art, New York. Mrs. Simon Guggenheim Fund. Photograph ©2000 The Museum of Modern Art, New York. ©2000 Estate of Pablo Picasso/Artists Rights Society (ARS), New York.

A New Tradition

Abstract art was invented by early twentieth-century artists. These artists built on earlier art traditions, but also made an important break with the past. They felt that art did not always need to show subjects that you could easily recognize.

Cubism

Early Abstract artists were influenced by the Post-Impressionist Paul Cézanne. They were interested in Cézanne's idea that everything can be broken down into three basic geometric forms: the cylinder, sphere, and cone. **Cubism** was an Abstract art style that developed from this idea. The Cubists broke down objects and the space around them into different shapes. They then rearranged the shapes into a composition. The new arrangement of shapes sometimes makes it hard to recognize the original subject matter of the artwork.

Study the Cubist painting by Pablo Picasso (Fig. 8–14). Do you see how the artist broke down the faces and bodies of the figures into colored circles, rectangles, and triangles?

Some Cubist artists created **nonobjective** art—art that has no recognizable subject matter. In Fig. 8–16, Sonia Terk Delaunay chose connecting disks of bright colors as her subject.

8.1 Art History

Check Your Understanding
1. What were the major concerns of artists in the early part of the twentieth century?
2. Use examples to support or reject the statement, "Artists of the early twentieth century didn't pay attention to the art of the past."
3. Explain, using examples, how Surrealist artists broke with tradition.
4. What were some influences on early twentieth-century art?

Teaching Options

Meeting Individual Needs

Gifted and Talented Have students compare the images on pages 208 and 209 to those on pages 260 and 261. **Ask:** What changes occurred in the way artists represented the world? Did the trend move toward or away from greater realism? Have students compare their findings to trends in today's art, by selecting images in current art journals. **Ask:** Based on your findings, what predictions can you make about what art will look like a century from now?

More About...

Surrealist artists, especially Max Ernst, used the **decalcomania** technique to create unexpected forms as the basis for paintings. Psychologists later adopted the technique to produce the Rorschach test, which analyzes a person's interpretation of ink blots so as to determine emotional and intellectual functioning.

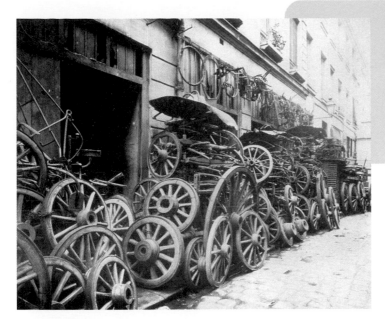

Fig. 8–15 Photography became an exciting new art form in the early twentieth century. Where do you see unity and variety in this photograph? Eugène Atget, *Cours d'Amoy 12, Place de la Bastille*, c. 1895. Aristotype, 7 ⅛" x 8 ¼" (18 x 21 cm). Chicago, formerly the Exchange National Bank Collection.

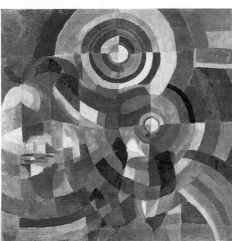

Fig. 8–16 What do you think this artwork is about? Sonia Terk Delaunay, *Electric Prisms*, 1914. Oil on canvas, 93 ¾" x 90 ¾" (238 x 251 cm). Collections Mnam/Cci–Centre Georges Pompidou. ©L & M Services B.V. Amsterdam 9911.6. Photo: Phototheque des collections du Mnam/Cci.

Studio Connection

Surrealist artists liked to experiment with artworks that are random, or unplanned. They created a technique called *decalcomania* (DEE-cal-coh-MAY-nee-ah). Try out the decalcomania technique to create a painting from your imagination. Choose a color scheme (warm, cool, analogous, and so on). Mix several colors of tempera or acrylic paint. With a spoon or stick, place a small amount of each color on two sheets of damp paper. Place the painted side of each sheet face-to-face. Lightly press and rub several areas, then slowly pull the papers apart. What unusual shapes and colors have formed? Use a brush or other tools to change each painting slightly if you wish. Let some of the random shapes and colors remain as part of the final painting.

Continuity and Change

261

Assess

Check Your Understanding: Answers

1. Some were trying to create their own unique styles; some built on earlier artistic styles, especially Impressionism and Post-Impressionism; others experimented with new ways of working with traditional art materials and subjects; and still others tried to break completely with the past.

2. Answers will vary. Students should demonstrate an understanding that artists did pay attention to the past, even if that meant that they would build upon an earlier tradition, change it, or completely break with it.

3. Like Max Ernst, they used traditional materials in unexpected and often shocking ways. Surrealists also created compositions of things that were not usually seen together or showed things that were not part of real life in very realistic settings.

4. Answers may vary. Possible answer: The work of the Impressionists, especially the breaking down of natural forms into different colored brushstrokes, influenced the Fauves. The tradition of realism influenced Surrealists such as Dali, even though he changed tradition by painting things that could not exist.

Close

Have students select one painting to display. Allow them to point out fortunate "accidents" in their work and classify their art as objective, abstract, or nonobjective. **Ask:** Why would you or would you not use the decalcomania technique again?

Teaching Through Inquiry

Art History/Aesthetics Have students find and read three **different art-historical accounts** about an artist whose work is shown in this lesson. Encourage students to note what the writers say about important events in the artist's life, what other artists or styles influenced the artist, how the artist's work is different from the influences, and why the artist's work is important. Students may find that the accounts differ. Hold a class discussion. **Ask:** Why, do you think, do art-historical accounts sometimes differ? Since the accounts sometimes differ, should we ignore them? What can a reader gain from reading more than one account?

Assessment Options

Peer Have groups of students write a TV script for "Continuity and Change in Art of the Early Twentieth Century," in which they demonstrate how some artists built upon the tradition of Impressionism, whereas others changed and also broke with earlier artistic traditions. Instruct students to include Expressionism, Surrealism, and Cubism. Look for the use of appropriate examples, as well as the ideas presented in the text. Suggest that they have pairs of groups evaluate each other's scripts.

Prepare

Pacing

One or two 45-minute periods to consider text and art, and to make shaded collage

Objectives

• Compare and contrast the use of shape and form in selected artworks.

• Demonstrate an understanding of shape and form by creating a collage.

Vocabulary

form Any three-dimensional object. A form can be measured from top to bottom (height), side to side (width), and front to back (depth).

representational Artwork that depicts objects or scenes similar to how they look in real life.

Teach

Using the Text

Art Criticism Have students read the text and then identify organic and geometric shapes and forms in the images. **Ask:** What is the difference between two- and three-dimensional shapes and forms?

Using the Art

Art Criticism Ask: How were the shapes and forms in these artworks created without drawn lines? Which work has only flat shapes? *(Matisse)* Which has an illusion of form? *(Bayer)* Which was made of three-dimensional forms? *(Hepworth)*

National Standards 8.2 Elements and Principles Lesson

2b Employ/analyze effectiveness of organizational structures.

Shape and Form

If someone asked you to draw a shape, what would you draw? A square? A circle? Or would you draw an irregular shape? Artists can use geometric shapes and organic shapes in their compositions. They can also use positive shapes and negative shapes (see Looking at Shape, page 132).

Can you think of ways to show a shape without drawing a line around it? In *Sorrows of the King* (Fig. 8–17), Matisse has used color, value, and texture to make shapes.

If you add depth to a shape, you have a **form.** A form has height, width, and depth. It can be simple or complex. A pear has a simple form. The form of a tree is complex and made up of many parts. Just as shapes can be geometric or organic, forms can be categorized this way. And just as shapes can be positive and negative, so can forms.

Barbara Hepworth's sculpture (Fig. 8–18) is made up of two main forms. You can see smaller forms in each of the forms. Are the forms organic or geometric? Hepworth changed a sculptural tradition. She was one of the first artists to explore positive and negative forms in Abstract sculpture.

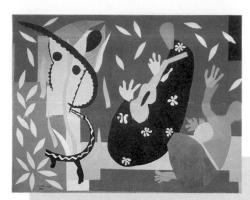

Fig. 8–17 Matisse painted sheets of paper and then cut the sheets into shapes for his collages. He called this process "cutting the color out alive." Henri Matisse, *Sorrows of the King*, 1952.
Collections Mnam/Cci–Centre Georges Pompidou. Photo: Phototheque des collections du Mnam/Cci. ©2000 Succession H. Matisse, Paris/Artist Rights Society (ARS), New York.

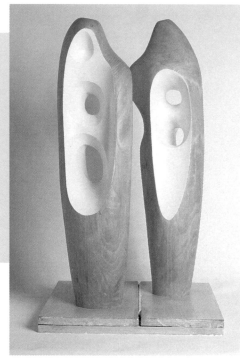

Fig. 8–18 Did the artist just want to experiment with forms? What might these side-by-side forms symbolize? Barbara Hepworth, *Two Figures*, 1947–48.
Elm wood with white paint, 40" x 23" x 23" (101.6 x 58 x 58 cm). Collection Frederick R. Weisman Art Museum at the University of Minnesota. Gift of John Rood Sculpture Collection.

262

Teaching Options

Resources

Teacher's Resource Binder
Finder Cards: 8.2
A Closer Look: 8.2
Find Out More: 8.2
Check Your Work: 8.2
Assessment Master: 8.2
Overhead Transparency 15

Teaching Through Inquiry

Art Production Provide students with a collection of simple objects from the artroom, and have them draw and cut out a simple (recognizable) shape to correspond to each object. Point out the guitar, flowers, and figures in the Matisse as examples. To extend the assignment, have students create two shapes for each object and then shade one of them to create an illusion of form. Have students store their shapes in an envelope in their sketchbooks for future use.

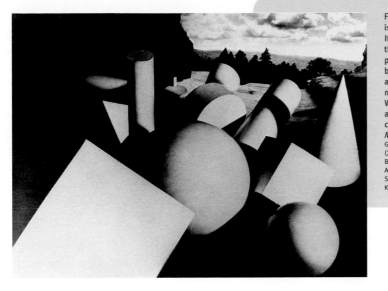

Fig. 8–19 A metamorphosis is a specific kind of change. It is often associated with the stages a caterpillar passes through as it becomes a butterfly. Is there a part of this artwork that might be called traditional? What is the artist saying about continuity and change? Herbert Bayer, *Metamorphosis*, 1936. Gelatin silver print, 9 ¹³/₁₆" x 13 ½" (24.9 x 34 cm). Courtesy Herbert Bayer Collection and Archive, Denver Art Museum. ©2000 Artists Rights Society (ARS), New York/ UG Bild-Kunst, Bonn.

Showing Forms in Two Dimensions

If you were asked to draw or paint a cube on a flat piece of paper, how would you do it? Would you use perspective lines? If you didn't want to use lines, would you change the flat shapes by shading them?

In a two-dimensional artwork, an artist may simply wish to show the shapes of objects. Or the artist may wish to create the illusion of three-dimensional form. Perspective and other devices can give the illusion of depth (see Creating the Illusion of Depth, page 148). The illusion of depth can also be created by adding shading to the flat shape of an object.

Study Fig. 8–19, *Metamorphosis*. It is a two-dimensional artwork. Yet, we can easily see the geometric shapes as three-dimensional forms. That is because of the shading on each form. There are other ways the artist creates the illusion of depth. How many can you find?

Studio Connection

Make a collage by gluing cut or torn paper, fabrics, or other flat materials to a background. Create the illusion of depth by adding shading to shapes. Your collage can be **representational** (showing a subject, such as a still life, portrait, or landscape). Or it can be **nonobjective** (showing no subject). Use both geometric and organic shapes. Add shading with markers. When you are finished, look at your artwork. Which shapes look the most like three-dimensional forms?

8.2 Elements & Principles

Check Your Understanding
1. Select two two-dimensional artworks from this chapter. Tell how each artist used shape and created the illusion of form. How have the artists used shape and form in similar ways? In different ways?
2. Select a three-dimensional artwork from this chapter and describe the forms as simple or complex, geometric or organic.

Continuity and Change

263

Studio Connection

Provide students with 12" x 18" construction or drawing paper, assorted smaller papers, glue, scissors, and pencils or markers. Demonstrate using a marker or pencil to shade.

Assess See Teacher's Resource Binder: Check Your Work 8.2.

Assess

Check Your Understanding: Answers

1. Answers will vary. Look for an accurate description of shapes; an understanding of perspective and shading to create the illusion of form.

2. Answers will vary. Look for accurate descriptions.

Close

Ask a volunteer to read dictionary definitions for *shape* and *form* to the class. Discuss the different meanings in relationship to art. Provide sentences such as: *A circle is a shape. The dancer is in good shape. The dancer has good form. Painting is an art form. He sent a form letter. A sphere is a form.* Emphasize the distinctions between these terms; stress the importance of clarity when using the terms.

More About...

English sculptor **Dame Barbara Hepworth** (1903–75) learned to carve stone in Italy, when she was on scholarship. Over time, she simplified her sculptures into nonobjective forms and became a leader in introducing abstract art to Britain. Her memorial to Dag Hammarskjöld stands at the United Nations in New York City.

Using the Overhead

Write About It

Describe Have students write a statement to describe the shape and form of this image.

Analyze Use the overlay, and have students describe how the individual parts form a whole.

15

Assessment Options

Teacher Set up a still life of three-dimensional forms. Provide students with scissors, black crayons, and construction paper. Ask them to interpret the still life in three ways: (1) create a design by rendering the 3-D forms as flat (cut-out) shapes; (2) create a design by focusing on the negative spaces between the objects; and (3) use black crayon and paper to render the still life as an arrangement of 3-D forms.

Prepare

Pacing

Two 45-minute periods: one to consider text and art; one to make batik

Objectives

- Describe at least two traditional Southeast Asian art forms.

- Explain, using examples, how Southeast Asian art reflects traditions borrowed from other places.

- Create a paper batik with an overall pattern.

Using the Map

Have students locate Cambodia, Vietnam, Thailand, and Indonesia. Explain that this area is Southeast Asia. **Ask:** How might the proximity of China and India have affected Southeast Asia's art? Use a globe to point out latitude lines. **Ask:** Within what latitudes is Southeast Asia? What, do you think, is the climate of Southeast Asia? *(hot and humid)* How might this affect the art? *(Plant and animal materials decay quickly.)*

The Art of Southeast Asia

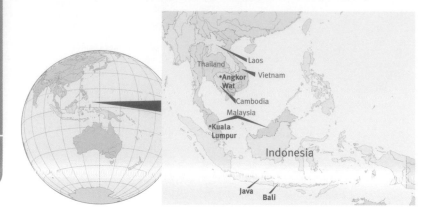

Southeast Asia is made up of many different countries and islands. Some countries are on the continent of Asia, and they include Thailand, Vietnam, and Cambodia. Indonesia, another part of Southeast Asia, is made up of thousands of islands that stretch from Asia almost to Australia.

So far in this book, you have studied the Asian countries of India, China, Korea, and Japan. As you have learned, these countries often shared ideas, cultures, and art styles. Southeast Asian countries have also been influenced by the people and cultures around them. In this lesson, you will see how artists in these countries used such influences to create a unique and special kind of art in Southeast Asia.

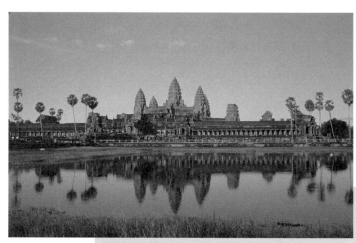

Fig. 8–20 This shrine was built in Angkor, the capital city of the Khmer empire. Look back at the Hindu Temple, Fig. 3–21. What similarities do you see between Southeast Asian and Indian architecture? *Angkor Wat*, 12th century, Cambodia.
©Leo Touchet. All Rights Reserved.

264

National Standards
8.3 Global View Lesson

4a Compare artworks of various eras, cultures.

4c Analyze, demonstrate how time and place influence visual characteristics.

Teaching Options

Resources

Teacher's Resource Binder
- A Closer Look: 8.3
- Map: 8.3
- Find Out More: 8.3
- Check Your Work: 8.3
- Assessment Master: 8.3

Large Reproduction 16

Slides 8e

Teaching Through Inquiry

Art History Have cooperative-learning groups research types of **Indonesian shadow puppets** and their purposes. Tell students to be prepared to explain how, over time, Indonesian puppet theater has continued, borrowed from, and broken with tradition. As a class, discuss students' findings, and then draw conclusions about the **role of tradition** in Indonesian puppet theater.

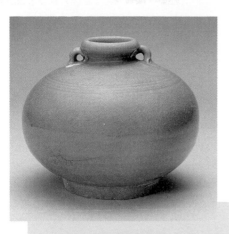

Fig. 8–21 This jar shows how Chinese pottery techniques influenced artists in Thailand. Si Satchanalai, *Coconut Oil Jar*, 14th–mid-16th century.
Stoneware, height: 5⁹⁄₁₆" (14.2 cm), diameter: 6⁷⁄₈" (17.5 cm). Asian Art Museum of San Francisco, The Avery Brundage Collection, The James and Elaine Connell Collection of Thai Ceramics, 1989.34.69.

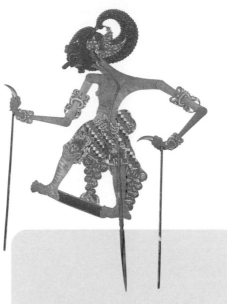

Fig. 8–22 Notice all the cutout parts and painted details on this puppet. Why would an artist add such details and decoration to something that is seen only in shadow? Java, Indonesia, *Wajang purwa shadow puppet: Bima, the Brave Giant*, late 19th–early 20th century.
Painted and gilded leather, 27³⁄₈" x 14¹⁄₄" (69.5 x 36 cm). Gift of the museum in 1947 by Mr. G. Tillman Jr. London. Tropenmuseum, Amsterdam.

Early Traditions

Southeast Asia was most influenced by India and China. Probably as early as the first century, Southeast Asian cultures borrowed and changed many Indian and Chinese ideas to fit their own ways of life. Southeast Asian artists also admired Indian and Chinese art styles. They used them to create unique traditions in art that continue today.

Religious sculpture and architecture became important art forms in Southeast Asia. The sculptures were made of stone or bronze. They have rounded forms and curving lines. Most sculptures showed gods from the Buddhist and Hindu religions. They were kept in religious *shrines* (sacred places).

In 1150, a king began building one of the largest shrines in Southeast Asia. The king was from the Khmer empire that ruled Cambodia. He built a national shrine called a *wat*. This shrine, shown in Fig. 8–20, is

known as Angkor Wat. The buildings of the temple are covered with carved decorations showing figures and animals.

Lasting Art Forms

The islands of Indonesia also have special art forms. Today, many artworks are made in the same way as when they were first created centuries ago.

Making puppets has been popular on the Indonesian island of Java for at least 1000 years. The puppet shown in Fig. 8–22 is a Javanese shadow puppet. It is flat and has moveable arms. In a show with shadow puppets, the audience is in front of a screen. Behind the screen, a puppeteer uses rods to move the puppet in front of a light. The audience sees only the puppet's shadow.

Continuity and Change

265

265

Teach

Engage

Discuss with students what they know about Vietnam, Cambodia, Indonesia, and Thailand. Encourage students of Southeast Asian heritage to share their knowledge; or show a video about the area's culture, or a large reproduction of Southeast Asian art.

Using the Text

Art History Have students read the introduction and Early Traditions. **Ask:** What two cultures influenced Southeast Asian art? Refer students to pages 134–137 and 160–163 to see art of India and China. Have students compare the lines and detail of the puppet (Fig. 8–22) to those of the sculpture (Fig. 3–20) and the dragon on the porcelain jar in Fig. 4–21.

Using the Art

Aesthetics Tell students that Angkor Wat was built in the twelfth century as a Hindu temple. Abandoned after a war, it was covered by a dense jungle for almost 700 years. **Ask:** If you had been among the group of French explorers who found this structure in 1861, why might you have thought that this was a special place?

More About...

The shadow puppets of Wayang, the **Indonesian shadow-puppet** theater, are flat, leather puppets (*wayang kulit*) or 3-dimensional rod puppets (*wayang golek*). With a coconut-husk lamp as the light source, the puppets are silhouetted against a translucent white screen, and are manipulated with rods by the *dalang*, the puppeteer who tells the story. The dalang is accompanied by a gamelan orchestra and, occasionally, by a singer. Performances include poetic narration, clowning and slapstick, commentary on current affairs, and struggles between good and evil.

Using the Large Reproduction

16

Consider Context

Describe What shapes and forms do you see? How are they organized?

Attribute What clues might help you to identify the culture that produced this artwork? What qualities does it have in common with other images in this lesson?

Understand How can you find out how people might have responded to this artwork at the time it was made?

Explain Knowing about outside influences in Southeast Asia provides clues as to why this artwork looks the way it does.

The Art of Southeast Asia

Using the Text

Art History Have students read page 266. **Ask:** How did Southeast Asian art change in the twentieth century? How did it remain the same?

Using the Art

Art Production As students study the batik, explain the process of applying wax to the cloth, dying it, applying more wax, and redying. The lightest color is usually that of the cloth; the darker dyes are the last colors to be applied. **Ask:** What do you think is the color of the cloth? The color of the last dye bath?

Studio Connection

Provide students with pencils; 12" x 18" heavy drawing or manila paper; crayons or melted wax (broken candles, crayons, or paraffin); sticks, cotton swabs, or expendable brushes; and watercolor or thinned tempera paint.

Students may melt wax in a disposable aluminum pan set in water in an electric skillet. If students use melted crayons, have them separate colors in disposable muffin tins, or use an electric wax melter, available from art-supply stores. **Safety Note: Never heat wax directly over a fire or heat source.**

Suggest to students that they draw several motifs in pencil before beginning their pattern, and that they decide whether they will use organic or geometric shapes. Demonstrate melting the wax or making heavy crayon lines and then painting over with a contrasting color of thinned tempera paint or heavy watercolor. Encourage students to use several colors of crayon and washes.

Assess See Teacher's Resource Binder: Check Your Work 8.3.

Indonesian artists have also created special ways of decorating cloth. They developed a technique called *batik* (Fig. 8–23). To create a batik, artists use melted wax to paint a design on a piece of cloth. They dip the cloth into colored dye. The wax protects the cloth from the dye. When the cloth dries, the waxed design stands out against the colored background. Indonesian artists have created many traditional designs and patterns for their batiks. Some have special meaning.

Changes in Modern Times

Artists in Southeast Asia have been exposed to art styles from Europe since the seventeenth century. But for centuries, traditional techniques and art forms remained the most important.

In the twentieth century, some Southeast Asian artists began to experiment with modern European art trends. Many studied in European art schools. Modern art styles have changed the way some Southeast Asian artworks look. But many Southeast Asian artists have tried to maintain their own special art by showing traditional subjects and themes.

Fig. 8–23 This is called a Javanese fairy tale batik. It tells the story of Cinderella. How did the artist tell the story without using words? L. Metzelaar, *Woman's Sarong in batik canting technique*, early 20th century. Cotton, 41" x 86 ⅝" (104 x 220 cm). Tropenmuseum, Amsterdam.

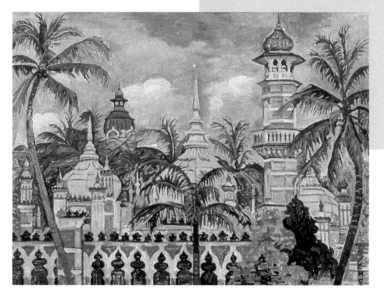

Fig. 8–24 Many contemporary artists show the unique environment of Southeast Asia. What visual clues did the artist include to help tell what her special surroundings looked like? Georgette Chen, *Mosque in Kuala Lumpur*, 1957. Oil on canvas, 28 ¾" 36 ¼" (73 x 92 cm). Singapore. Collection of the Singapore Art Museum.

Meeting Individual Needs

Multiple Intelligences/Intrapersonal and Bodily-Kinesthetic Ask students to imagine they are a dalang, or shadow artist, using the puppet in Fig. 8–22 in the ancient Indonesian art of shadow play, the unique combination of ritual, lesson, and entertainment. **Ask:** How might it feel to manipulate the puppet parts to bring the shadow to life?

Teaching Through Inquiry

Art Criticism Have students work in small groups to prepare presentations on how Figs. 8–24 and 8–25 borrow from European traditions. For each painting, have students identify subject matter, medium, and stylistic characteristics, such as the use of brushstrokes and color; and also tell how these paintings suggest their origin, and how they reflect European art. Tell students to present examples of European art to highlight their points.

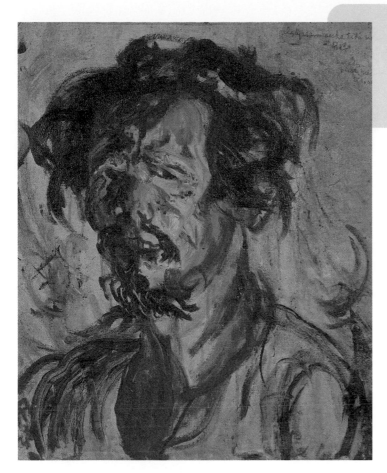

Fig. 8–25 This Indonesian artist's use of color has been compared to the Fauves. How would you describe his brushstrokes? Affandi, *Self-portrait*, 1948. Oil on canvas, 24 ¼" x 21" (61.5 x 53.5 cm). Tropenmuseum, Amsterdam.

Extend

Have students create shadow puppets and give a short performance, borrowing from the Indonesian puppet form of articulated arms supported with rods, as well as the tradition of telling stories. Then have students change the tradition by using the art form to tell traditional stories from their own culture.

Assess

Check Your Understanding: Answers

1. Students may describe pottery, shadow puppets, stone sculpture, shrines, and batik.

2. Students may explain the pottery technique of allover pattern, from China; sculpture of Hindu and Buddhist gods, from India; shrines with carved decorations, from India; and modern art styles, from Europe.

3. by focusing on traditional subjects and themes, using traditional designs and patterns in their work, and continuing the practice of traditional art forms such as puppetry and batik

4. batik

Close

Review traditional Southeast Asian art forms. Ask students to identify examples in the book and then explain how Southeast Asian art reflects Chinese, Indian, and European traditions.

Studio Connection

Design a paper batik with a continuous, overall pattern. Select a simple motif to repeat, making slight changes in each unit as it is repeated. Apply heavy crayon or brush melted wax over the sketched lines before applying a dark watercolor or thin tempera paint wash. You can use more than one color of wax crayon and more than one color of wash.

8.3 Global View

Check Your Understanding

1. Describe two traditional art forms of Southeast Asia.
2. Explain, using examples, how art in Southeast Asia has borrowed traditions from other places.
3. How have today's Southeast Asian artists maintained continuity with the past?
4. What method of decorating cloth was developed in Indonesia?

Continuity and Change

267

More About...

The traditional process of **batik** involves using a tjanting (copper cup with spout on a bamboo handle) to apply hot wax in patterns onto cloth. When the cloth is dipped into dye, the wax acts as a resist, so the wax-coated areas remain the color of the cloth. After this process has been repeated to create complex designs, the wax is either ironed or boiled out of the cloth. Batik takes on its distinctive crackles or thin lines throughout the design when the wax cracks as it is immersed in dye.

Assessment Options

Teacher Have each student create a booklet for use by fourth graders, to learn about continuity and change in Southeast Asian art. Instruct students to include at least two traditional Southeast Asian art forms and to explain how the art reflects both borrowed and adapted traditions.

Prepare

Pacing
One or two 45-minute periods

Objectives
- Explain why photography can be an effective medium for the expression of ideas and feelings.
- Create a montage to convey ideas about continuity and change in a family or cultural tradition.
- Place the art of montage in its historical time frame.

Vocabulary
montage A collage that combines photographs with other flat materials, often to express ideas.

Pre-Studio Assignment: Have students collect photographs, or photocopies of them, to use in their montage.

Supplies
- scissors and glue
- 12" x 18" tag board
- envelopes
- assortment of papers (wallpaper, gift-wrap, construction)
- your own montage of a family tradition (optional)

National Standards 8.4 Studio Lesson

1a Select/analyze media, techniques, processes, reflect.

2b Employ/analyze effectiveness of organizational structures.

3a Integrate visual, spatial, temporal concepts with content.

STUDIO LESSON 8.4

Collage in the Studio
Creating a Montage

Art with Power

Studio Introduction
When you see a large photograph in a newspaper, magazine, or someone's photo album, do you take a closer look? Photographs can have a powerful effect on people. Photos can show just about anything—nature, buildings, and even artworks such as those in this book—but they most often show people. Photographs capture a real moment in time, which can make them especially moving or emotional. Think about photographs you've seen of people involved in a natural disaster or a celebration. How did they make you feel?

Artists know that photographs can affect the way people feel. Some artists use photographs to create a **montage**—a collage that combines photographs or parts of them with other flat materials. Montages often express ideas about life.

In this studio lesson, you will create a montage that shows continuity and change in a family or cultural tradition. Pages 270–271 will show you how to do it. Look carefully at photographs you see in newspapers and magazines. How do they relate to your life? How might you use them in your work?

Fig. 8–26 The artist mixed politics with an interest in images of women in her artworks. Repeated curves add grace. Contrasts of light and dark create a sense of power and drama. What do you think the artist was trying to say? Hannah Höch, *Priestess*, c. 1920.
Collage on cardboard, 13" x 9" (33 x 22.9 cm). ©Christie's Images, Ltd, 1999. ©2000 Artists Rights Society (ARS), New York/VG Bild-Kunst, Bonn.

Studio Background

Collage: A Change of Expression
In the early 1900s, collage was a new form of expression. Artists could create exciting images by tearing, cutting, and pasting different papers and fabrics onto a flat background. Collage also added a new element to paintings. As artists experimented with collage materials, many began to use photographs. Montage became a popular technique that remains popular today.

Through their artworks, montage artists often make statements about current events, politics, or their society. People feel they can understand these artworks because they include photographs from the everyday world. As a result, montage artworks can sometimes make a stronger impression on people than paintings.

268

Teaching Options

Resources
Teacher's Resource Binder
- Studio Master: 8.4
- Studio Reflection: 8.4
- A Closer Look: 8.4
- Find Out More: 8.4
- Slides 8f

Teaching Through Inquiry
Aesthetics Ask: What parts of **photography** make it different from drawing or painting? Do photographs always communicate the truth? Why or why not? Why, do you think, do people tend to believe what they see in a photograph? Make sure that students provide good reasons for their positions. **Ask:** What more might you need to know in order to make a strong case for your position? Where could you find that information?

Fig. 8–27 In this collage, a student explores and expresses her viewpoint on the impact of computers. "No matter how far technology takes us, we will always need a human touch." Kate Riegle-Van West, *A Human Touch*, 1999. Collage, montage, 12" x 18" (30.5 x 46 cm). Metcalf School, Normal, Illinois.

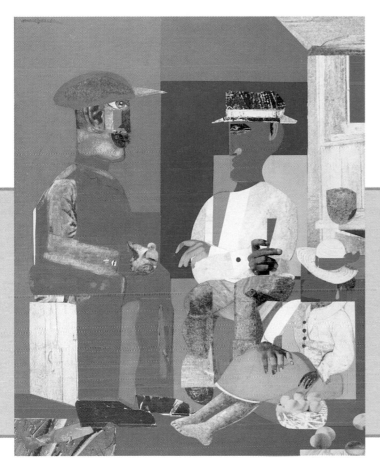

Fig. 8–28 Romare Bearden is considered one of America's greatest collage artists. He often combines collage with painted areas. Which parts of this image are made from photographs? How, do you think, did the artist decide where to use photographs and where to use paint? Romare Bearden, *Eastern Barn*, 1968. Collage of glue, lacquer, oil, and paper, 55 ½" x 44" (141 x 112 cm). Collection of Whitney Museum of American Art. Purchase. Photo by Peter Accettola, NY. ©Romare Bearden Foundation/Licensed by VAGA, New York, NY.

Continuity and Change

269

Teach

Engage

Discuss how magazine photographs get our attention. Have students find an image that reflects a family or cultural tradition, such as a photograph of food, clothes, or scenery. Then have students find an image that seems to break a tradition, such as a new kind of car, hairstyle, architecture, or recipe. Tell students that they will create a collage that shows how a tradition has changed. If you have made a montage, explain its meaning to the class.

Using the Text

Art Criticism Have students read page 268. **Ask:** When was collage developed as an art form? When was each of these collages created? Have students compare the relative scale of the combined images in *Priestess*. Note that the huge candles in front of the figure indicate depth.

Using the Art

Art History Ask: What is similar about *Priestess* and the statue of Siva (Fig. 3–20)? *(multiple arms, flames, facial expression)*

Perception Ask: What are the traditions in Bearden's *Eastern Barn*? How did Bearden use shape to emphasize the central figures?

Art Criticism Have students compare *Eastern Barn* to Picasso's *Guitar on a Table* (Fig. 4–8). **Ask:** What similarities do you see in style? *(simplification of forms, multiple views in one subject)*

More About...

German painter and graphic artist **Hannah Höch** (1889–1978) was associated with the Berlin Dada group, and was one of the first artists to work with photomontage techniques. Combining hundreds of photographs clipped from popular magazines, she bitterly attacked the Weimar Republic's politics and society.

More About...

African-American artist **Romare Bearden** (1914–88) was born in Charlotte, North Carolina, and raised in New York's Harlem, where he developed a passion for jazz. He received a mathematics degree from Columbia University and studied philosophy and art history in Paris. Although he painted, he never had a formal education in producing art. During the 1960s, he became famous for his large collages of newspaper and magazine photographs depicting the struggles of blacks in American society.

Studio Experience

Have students look at Bearden's montage to see how he combined photographs with colored shapes. Encourage students to create background shapes with colored and printed papers, and to experiment with several arrangements before gluing.

Idea Generators

Brainstorm with students about traditions in our culture. **Ask:** How does the mass media picture these traditions? How do people change traditions? What background shapes and colors will you use to show a tradition? How will you use shapes and colors to suggest change? How will the background show how you feel?

Sketchbook Tip
Encourage students to cut out photographs routinely, to use as resources for their artworks, and to save them in an envelope (either manufactured or created from folded and taped paper) glued to a sketchbook page.

STUDIO LESSON 8.4

Collage in the Studio
Creating Your Montage

You Will Need

- photographs
- wallpaper samples
- gift wrap
- construction paper
- scissors
- tagboard
- glue

Try This

1. Think of ideas for your montage. What tradition or traditions can you show that are still practiced in your culture today? These will express continuity. What ideas break away from the tradition? These will express change. How can you show the way you feel about these concepts?

2. Look for photographs that illustrate the main ideas of your montage.

3. Create background shapes and details with assorted colored and printed papers. Try cutting some shapes with scissors. Tear the edges of others for a different effect.

4. Arrange your pieces on tagboard. Try several arrangements. When you are satisfied with the composition, glue the pieces in place.

Check Your Work

Discuss your work with others in the class. How have you expressed the theme of continuity and change in the tradition you chose? What feelings have you shown in your composition?

Computer Option
Create a montage that shows cultural traditions and change. You might focus on your own culture or another that interests you. Think about what you want to show. People? Artifacts? Buildings? Words? Find images and import to a paint or image-editing program. Combine with color backgrounds, type, and effects.

Sketchbook Connection
Develop the habit of cutting out photographs to use in future collages or to get ideas for other artworks. You may find photos in magazines, newspapers, or advertisements. Save personal snapshots, too! If you find a photograph in a book, make a photocopy of it for your files. Keep your collection in your sketchbook, perhaps in an envelope attached to a page.

270

Teaching Options

Meeting Individual Needs

Alternative Assignment Explain that montages can express imagination, hopes, and dreams. Have students use the same materials to show how their hopes and dreams have changed throughout their life.

Assistive Technology Have students scan personal photographs or magazine cutouts and, once they have uploaded the images, manipulate them into a digital photomontage.

Studio Collaboration

Students may work together to create a photomontage about school traditions, showing how they show continuity and change.

Fig. 8–29 The negative impact of changes to the environment is represented in this collage. The artist explains, "Every living creature on this planet is part of an impressive pyramid, each species with its own cube or block. When we kill off one species of frogs, there will be more bugs, which in turn means the death of many plants, which means the death of any animals who survive off those plants, until the whole pyramid crumbles with the loss of those cubes." Sithru Gamage, *If Our Planet Had a Voice*, 1999. Montage, markers, 12" x 18" (30.5 x 46 cm). Metcalf School, Normal, Illinois.

 Computer Option
Guide students to select royalty-free images from the Web and save and import them to an image-editing document in Photoshop, Color It, Dabbler, Painter, Claris, or AppleWorks paint. Encourage students to use the Internet to research their selected culture and historical artworks or artists representative of the culture.

Assess

Check Your Work

Have students answer the questions in Check Your Work. **Ask:** Were you successful in expressing a theme about tradition and change? If you were to create another collage, what would you do differently? Have students select collages that are especially effective at conveying ideas or feelings. **Ask:** What specific emotion or idea is expressed? Question the artist to see if he or she agrees with the viewers.

Close

Direct students to title their works to help viewers understand the meaning. Have students display the art according to what traditions are featured.

Teaching Through Inquiry

Tell students that Bearden said that he painted "the life of my people as I know it, passionately and dispassionately as Breughel." Challenge students to compare Bearden's view of everyday life to Brueghel's. Refer students to *Children's Games,* Fig. 4–17, page 158, and encourage them to research more works by both artists to develop a comparison of their themes and subjects.

More About...

The word *collage* comes from the French *colle,* for "glue." While Picasso and Braque experimented with Cubism, they developed collage techniques of adding bits of newspaper and wallpaper to their paintings. Later, Dada and Surrealist artists became interested in the part that the unconscious played during the creation of a collage.

Assessment Options

 Peer Have students write an artist's statement, in which they tell what ideas they were trying to communicate in their photomontage, and how the use of photographs (versus any other medium) contributed to the overall meaning. Have student pairs exchange artworks and statements, view the artwork, read the statement, and write a paragraph to the student artist. Instruct peers to identify the ways in which the artwork succeeds in communicating what the artist intended; to provide suggestions for improvement; and to write a well-supported statement agreeing or disagreeing with the artist's ideas about the use of photography.

Careers

Discuss with students the recent, tremendous changes in how animation films are made. Explain that until only a short time ago, to show action in an animated film, artists had to create, sequentially arrange, and photograph individually painted "cells." Invite students to compare digital animation with traditional animation. To help students think critically about the art and craft of animation, provide and discuss reviews of animated films.

Daily Life

Collect and display examples of different kinds of photography, and ask students to discuss the uses and purposes of photography in their lives. Have students make a photocopy of a family photograph or download a historic photograph from the Internet and use it as a basis for a collage about their own or a fictitious family history.

Connect to...

Careers

What was the first animated movie you ever saw? Just in your lifetime, animated film production has undergone tremendous change. These changes created a demand for new skills from **animation artists.** Originally, all animated films were created by photographing individually painted "cells" to show action (similar to making a "flip" book).

Technological advances in computer-generated imagery have created a need for animation artists with a particular blend of originality, artistic talent, and computer mastery. If you are interested in a career in animation, you can find academic programs in cities such as Los Angeles and New York.

Fig. 8–30 "I am a creative director and I art-direct the animators. I mostly do the drawings and design the digital sets, then give those designs to the animators to build digitally. The drawings over my board are examples of scenes that I designed for the Spiderman film that we produced for Universal Studios' Islands of Adventure in Orlando." —Kent Mikalsen.
Digital image courtesy of the artist.

Other Arts

Music

Like artworks, many musical compositions demonstrate **continuity and change.** Some remain popular over time and represent cultural traditions; others are altered to reflect change, perhaps in tastes or technology. In music, the adaptation, or arrangement, of an existing composition might feature a variation in instrumentation, style, or vocals. Although a musician receives credit for an arrangement, the original composer continues to own the composition.

To learn how a composition can change over time, listen to an original musical piece and to an arrangement of it. In the arrangement, you'll hear how the original—a more traditional piece—was changed to sound more contemporary.

After listening to the original and to an arrangement of a selection such as "A Boy Like That," answer these questions:
1. How are the pieces alike? How are they different?
2. Discuss the ways that you can tell one piece is more contemporary than the other.
3. What changes make the arrangement sound more contemporary?
4. How was the style changed from that of a Broadway musical to that of contemporary rock piece?

Internet Connection
For more activities related to this chapter, go to the Davis website at **www.davis-art.com.**

Teaching Options

Resources

Teacher's Resource Binder
Using the Web
Interview with an Artist
Teacher Letter

Video Connection

Show the Davis art careers video to give students a real-life look at the career highlighted above.

Community Involvement

Plan a working field trip to an assisted-living facility, where students may work with residents to create an intergenerational mural on the theme "The Way Things Are and the Way They Used to Be." Before the trip, encourage students to write informal questions to ask the residents, and to think of strategies for engaging the residents in making decisions and creating the mural.

Other Subjects

Mathematics

How have the tools for performing mathematical **calculations** changed over time? Early mathematical devices were the abacus, for counting with beads that slide along rods or grooves; the ruler, a straightedge for measuring; the protractor, for measuring angles; and the compass, for making circles and measuring distances.

More recent instruments are the slide rule, a ruler with a sliding center section, for making quick calculations; the individual electronic calculator; and the personal computer. How, do you suppose, has the study of mathematics been affected by these tools? How could you find out?

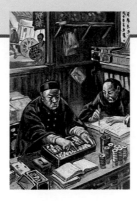

Fig. 8–31 **If you were to draw a modern Chinese person making or using a calculator, how might your artwork look different from this?** *Chinese Merchant Making Calculator.*
©Baldwin H. Ward & Kathryn C. Ward/Corbis.

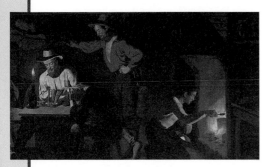

Fig. 8–32 **What impact does artificial lighting have on artists or photographers?** Charles Christian Nahl, *Saturday Night at the Mines* (detail), 1856.
Oil on canvas, 120" x 192" (345.5 x 530.9 cm). Iris & B. Gerald Cantor Center of Visual Arts at Stanford University, Palo Alto, CA, Stanford Family Collections, 12083.

Social Studies

Technological advances often produce significant cultural change. One important advancement that we take for granted today is artificial lighting. Before the development of oil, gas, and electric lamps, the only light available after dark came from candles and indoor fires. Consequently, people tended to go to sleep at nightfall and to wake at sunrise.

In the late 1800s, the development and availability of the incandescent lamp produced a dramatic effect: with artificial lighting, people could produce a likeness of natural daylight at any hour. How would your life be different if there were no electric lights?

Mathematics

Assemble, display, and discuss with students different kinds of mathematical instruments, such as an abacus, a ruler, a protractor, a pair of compasses, a slide rule, and a handheld calculator. Ask students to identify the instruments they recognize, and invite them to speculate on the uses of the ones unknown.

Other Arts

A recording of the original Broadway cast version of "A Boy Like That" is from Sony Music, 60724; a contemporary rock version is from BMG/RCA Victor, 62707.

Daily Life

How do you photographically record family and friends? Do you take pictures frequently? Do you photograph only special events? Do you use a point-and-shoot camera or a digital or video camera? When you have film processed, do you ask for color prints? A CD-ROM? How do you display your photographs?

Though the interest in **photographic images** has continued since the invention of photography, processing has changed dramatically. Early processes were too expensive for widespread use, so photography was not generally used to record daily events. Most people might have been photographed only a few times in their life, on special occasions.

Advances in photography now allow us to print photographs on objects such as coffee mugs, T-shirts, and mouse pads. What advances in photography do you think might occur in your lifetime?

Continuity and Change

273

Internet Resources

Any1CanFly

http://www.artincontext.com/artist/ringgold/

This site has images of Faith Ringgold's art, information about her life and work, and more.

National Museum of African Art

http://www.si.edu/organiza/museums/africart/nmafa.htm

Experience online tours of current exhibitions as well as the permanent collection.

Picasso Museum

http://www.musexpo.com/english/picasso/index.html

Tour the Paris museum dedicated to Pablo Picasso.

Interdisciplinary Planning

With social-studies colleagues, plan ways to establish a historical baseline, such as a condensed chronology, for the study of art. Artworks, artifacts, technologies, commerce, events, customs, languages, and environments are all intricately formed, maintained, changed, and connected within a system that is integrated rather than isolated.

Talking About Student Art

Engage students in a discussion about judging the merits of their own and others' artworks. **Ask:** What criteria should you use? Should you use the same criteria for every artwork? How do you decide?

Portfolio Tip

 Continue to remind students that the portfolio is a place to develop—not master—self-reflection, critical thinking, responsibility for learning, and organizational skills.

Sketchbook Tips

 • Have students study and then draw both simple and complex geometric and organic shapes and forms in their environment. Challenge them to shade some shapes to create the illusion of form.

• Encourage students to think of their sketchbook contents as process, not product, and to use it as a place to seek possible solutions, not perfect answers.

Portfolio

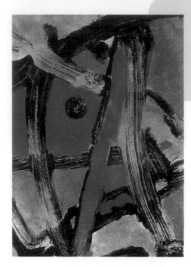

Fig. 8–33 For this monoprint, the student prepared his paper by smearing it with baby powder (to make it smooth). Then he rubbed it with pastel shavings. He then painted an expressive line on a slick surface with black ink. By pressing the paper down gently, then peeling it up, a surprise abstract design was formed. Dustin Bennett, *Untitled*, 1997.
Ink, pastel, 17" x 23" (43 x 58 cm). Sweetwater Middle School, Sweetwater, Texas.

"Using lots of different colors makes it stand out more." Randy K. Krleg

Fig. 8–34 Young students commonly draw a mountain as a plain, pointed triangular shape. This Alaskan student lives in a town surrounded by mountains, and was encouraged by his art teacher to change the way he looked at them. By studying the contours and details of mountains, he created a more realistic image. Randy K. Krieg, *Untitled*, 1999.
Batik on cotton, 13" x 9" (33 x 23 cm). Colony Middle School, Palmer, Alaska.

Fig. 8–35 This student used simplified organic shapes to create a still life. Geometric shapes were used in the background. Black marker shading is added to give the shapes an illusion of depth and form. Use of vibrant colors helps change common objects into abstracted shapes. Julian Wade, *Untitled*, 1999.
Collage, markers, 9" x 12" (23 x 30.5 cm). Forest Grove Middle School, Worcester, Massachusetts.

 CD-ROM Connection
To see more student art, check out the Global Pursuit Student Gallery.

Teaching Options

Resources

Teacher's Resource Binder
 Chapter Review 8
 Portfolio Tips
 Write About Art
 Understanding Your Artistic Process
 Analyzing Your Studio Work

CD-ROM Connection

Additional student works related to studio activities in this chapter can be used for inspiration, comparison, or criticism exercises.

Chapter 8 Review

Recall

Give three examples of ways that artists can use tradition in their approach to art making. *(example below)*

Understand

Explain the differences between Expressionism, Surrealism, and Cubism.

Apply

Use photocopies of a magazine photo to demonstrate how Cubist artists might have approached their work.

Analyze

Classify the artworks in this chapter into two groups: those which represent continuity and those which represent change. Identify specific features to explain your choices.

Synthesize

Research the history of product design or graphic design. For product design, focus on objects that you use daily (such as a telephone). For graphic design, focus on packaging that promotes products you use daily (such as salt). Prepare a display, on the theme of continuity and change, based on your research.

Evaluate

Select and rank three artworks from this chapter that you think should be in a twentieth-century art hall of fame. Justify your number one choice.

For Your Portfolio

Keep your portfolio in good order. Once in a while, check the contents, and choose what to keep in your portfolio and what to remove. Check that each entry is well presented and identified with your name, date, and title of work. Protect each entry with newsprint or tissue paper.

For Your Sketchbook

Think about your portfolio artworks in terms of continuity and change. What subjects or themes do you continue to explore throughout your artworks? Do you use the same colors or types of line? Decide what has changed the most in your work over time. Use a page for your sketchbook to describe your findings.

Page 265

Continuity and Change

275

Advocacy

For a field trip to a local museum or artist's studio, invite school administrators and school-board members to accompany the class—not to chaperone, but to participate.

Family Involvement

Invite family members to assist you in planning a school or community art exhibit that includes examples of student writing (criticism, historical investigation, production analysis, reflections about philosophical issues, and so on).

Chapter 8 Review Answers

Recall

They can borrow, break with, or build on traditions.

Understand

Expressionist artists often used bright colors and energetic lines to express strong feelings, such as joy, sorrow, or fear. Surrealists used the element of surprise and images not ordinarily seen together to create dream-like and fantasy worlds. The Cubists broke down objects and the space around them into different shapes; they then rearranged shapes to show multiple views of the objects.

Apply

Look for multiple views, the breaking down of parts into geometric shapes, and a rearrangement of shapes.

Analyze

Answers may vary. Possible answer: continuity—the symbolism of the dragon in Fig 8–2 or the realistic representation in Fig. 8–1; change—unrealistic representation of human form in Fig. 8–5 and the unusual use of materials for sculpture in Figs. 8–8 or 8–9.

Synthesize

Look for appropriate categorization of objects.

Evaluate

Look for the use of appropriate justification for choices.

Reteach

Collect several illustrated books on traditional crafts, such as quilting, Ukrainian eggs, weaving, pottery, or glass blowing. Have students work in small groups to study the books for examples of how the craft tradition has continued and examples of how it has changed. Ask students to share their findings with the class.

Chapter Organizer

9 weeks | 18 weeks | 36 weeks

Chapter 9 Possibilities

Chapter 9 Overview
pages 276–277

- **Core** Contemporary artists worldwide explore and expand the concept of art, seeking what is possible.
- **9.1** Art Since 1950
- **9.2** Proportion and Scale
- **9.3** Global Possibilities
- **9.4** Making a Book

1 Understand media, techniques, and processes.
2 Use knowledge of structures and functions.
3 Choose and evaluate subject matter, symbols, and ideas.
4 Understand arts in relation to history and cultures.
5 Assess own and others' work.

3 | 3 | 3

Objectives

National Standards

**Core Lesson
Expanding the
Possibilities of Art**
page 278
Pacing: Three 45-minute
periods

- Use examples to explain how artists in the later part of the twentieth century attempted to expand the definition of art.
- Explain how developments in technology have provided artists with new ways to create art.

1b Use media/techniques/processes to communicate experiences, ideas.
4c Analyze, demonstrate how time and place influence visual characteristics.
5b Analyze contemporary, historical meaning through inquiry.

**Core Studio
Making a
Painting/Sculpture**
page 282

- Create an artwork that explores the boundaries of painting and sculpture.

1b Use media/techniques/processes to communicate experiences, ideas.

1

Objectives

National Standards

**Art History Lesson 9.1
Art Since 1950**
page 284
Pacing: One or two
45-minute periods

- Identify three important art movements in the last half of the twentieth century.
- Explain how artists in the late twentieth century explored the possibilities of new techniques and materials.

3a Integrate visual, spatial, temporal concepts with content.
4a Compare artworks of various eras, cultures.

Studio Connection
page 286

- Create a small-scale model of a sculpture for a public place.

1b Use media/techniques/processes to communicate experiences, ideas.

1

Objectives

National Standards

**Elements and
Principles Lesson 9.2
Proportion and Scale**
page 288
Pacing: One 45-minute
class period

- Explain how artists use scale and proportion to convey ideas and achieve effects in their artworks.

2a Generalize about structures, functions.
2c Select, use structures, functions.

Studio Connection
page 289

- Create a portrait caricature by exaggerating proportion and scale.

1b Use media/techniques/processes to communicate experiences, ideas.

Featured Artists

Bronwyn Bancroft
Jennifer Bartlett
Jim Borgman
Nek Chand
Christo and Jeanne-Claude
D.A.S.T. (Danae Stratou,
 Alexandra Stratou, and
 Stella Constantinides)
Helen Frankenthaler
Andy Goldsworthy
Red Grooms

Yolanda Gutierrez
Inga Hunter
Maria Izquierdo
J. Michael James
Lee Krasner
Jean Kropper
Roy Lichtenstein
Antonio Martorell
Jae Hyun Park
Martin Puryear
Nancy Rubins

Miriam Schapiro
Kenny Scharf
Shahzia Sikander
Jaune Quick-to-See Smith
Franca Sonnino
Frank Stella
Claire Van Vilet
Paul Wallot
Zerihun Yetmgeta

Chapter Vocabulary

installation art
earthworks
maquette
proportion
scale
caricature
scroll
concertina
fan

Teaching Options

Teaching Through Inquiry
More About...Jennifer Bartlett
Using the Large Reproducion
Meeting Individual Needs
More About...Andy Goldsworthy
Using the Overhead

Technology

CD-ROM Connection
 e-Gallery

Resources

Teacher's Resource Binder
 Thoughts About Art:
 9 Core
 A Closer Look: 9 Core
 Find Out More: 9 Core
 Studio Master: 9 Core
 Assessment Master:
 9 Core

Large Reproduction 17
Overhead Transparency 18
Slides 9a, 9b, 9c

Meeting Individual Needs
More About...Miriam Schapiro
Assessment Options

CD-ROM Connection
 Student Gallery

Teacher's Resource Binder
 Studio Reflection: 9 Core

Teaching Options

Teaching Through Inquiry
More About...Abstract Expressionism
More About...Pop artists
Using the Overhead

Technology

CD-ROM Connection
 e-Gallery

Resources

Teacher's Resource Binder
 Names to Know: 9.1
 A Closer Look: 9.1
 Map: 9.1
 Find Out More: 9.1
 Assessment Master: 9.1

Overhead Transparency 17
Slides 9d

Meeting Individual Needs
Teaching Through Inquiry
More About...Site-specific sculpture
Assessment Options

CD-ROM Connection
 Student Gallery

Teacher's Resource Binder
 Check Your Work: 9.1

Teaching Options

Teaching Through Inquiry
More About...Red Grooms
Using the Overhead
Assessment Options

Technology

CD-ROM Connection
 e-Gallery

Resources

Teacher's Resource Binder
 Finder Cards: 9.2
 A Closer Look: 9.2
 Find Out More: 9.2
 Assessment Master: 9.2

Overhead Transparency 17

CD-ROM Connection
 Student Gallery

Teacher's Resource Binder
 Check Your Work: 9.2

Chapter Organizer continued

9 weeks	18 weeks	36 weeks		Objectives	National Standards
		1	**Global View Lesson 9.3 Global Possibilities** page 290 Pacing: One or two 45-minute periods	• Explain, with examples, some possibilities that contemporary artists around the globe are pursuing. • Identify elements in contemporary artworks from around the world that reflect a connection to cultural heritage	**4a** Compare artworks of various eras, cultures. **5c** Describe, compare responses to own or other artworks.
			Studio Connection page 291	• Refer to cultural heritage in an artwork that explores possibilities with media and technique.	**3b** Use subjects, themes, symbols that communicate meaning.

				Objectives	National Standards
	6	6	**Studio Lesson 9.4 Making a Book** page 294 Pacing: Six 45-minute periods	• Generate ideas for exploring the possibilities of a book. • Generate ideas for a book's subject. • Create a book that focuses on a subject and explores the possibilities of a book.	**1b** Use media/techniques/processes to communicate experiences, ideas.

				Objectives	National Standards
•	•	•	**Connect to...** page 298	• Identify and understand ways other disciplines are connected to and informed by the visual arts. • Understand a visual arts career and how it relates to chapter content.	**6** Make connections between disciplines.

				Objectives	National Standards
•	•	•	**Portfolio/Review** page 300	• Learn to look at and comment respectfully on artworks by peers. • Demonstrate understanding of chapter content.	**5** Assess own and others' work.

2 Lesson of your choice

Teaching Options

Meeting Individual Needs
Teaching Through Inquiry
More About… Jaune Quick-to-See Smith
More About…Zerihun Yetmgeta

Technology

CD-ROM Connection
e-Gallery

Resources

Teacher's Resource Binder
 A Closer Look: 9.3
 Map: 9.3
 Find Out More: 9.3
 Assessment Master: 9.3

Large Reproduction: 18
Slides: 9e

Teaching Through Inquiry
Using the Large Reproduction
Assessment Options

CD-ROM Connection
Student Gallery

Teacher's Resource Binder
 Check Your Work: 9.3

Teaching Options

Teaching Through Inquiry
More About…Scrolls
Meeting Individual Needs
Studio Collaboration
More About…Concertina books
Assessment Options

Technology

CD-ROM Connection
 Student Gallery
Computer Option

Resources

Teacher's Resource Binder
 Studio Master: 9.4
 Studio Reflection: 9.4
 A Closer Look: 9.4
 Find Out More: 9.4

Slides: 9f

Teaching Options

Community Involvement
Museum Connection

Technology

Internet Connection
Internet Resources
Video Connection
CD-ROM Connection
 e-Gallery

Resources

Teacher's Resource Binder
 Using the Web
 Interview with an Artist
 Teacher Letter

Teaching Options

Advocacy
Family Involvement

Technology

CD-ROM Connection
 Student Gallery

Resources

Teacher's Resource Binder
 Chapter Review 9
 Portfolio Tips
 Write About Art
 Understanding Your Artistic Process
 Analyzing Your Studio Work

Chapter Overview

Theme

All of us have the capacity to anticipate the future. Art provides visions of new worlds and new ways.

Featured Artists

Bronwyn Bancroft
Jennifer Bartlett
Jim Borgman
Nek Chand
Christo and Jeanne-Claude
D.A.S.T. (Danae Stratou, Alexandra Stratou, and Stella Constantinides)
Helen Frankenthaler
Andy Goldsworthy
Red Grooms
Yolanda Guiterrez
Inga Hunter
Maria Izquierdo
J. Michael James
Lee Krasner
Jean Kropper
Roy Lichtenstein
Antonio Martorell
Jae Hyun Park
Martin Puryear
Nancy Rubins
Miriam Schapiro
Kenny Scharf
Shahzia Sikander
Jaune Quick-to-See Smith
Franca Sonnino
Frank Stella
Claire Van Vilet
Paul Wallot
Zerihun Yetmgeta

9 Possibilities

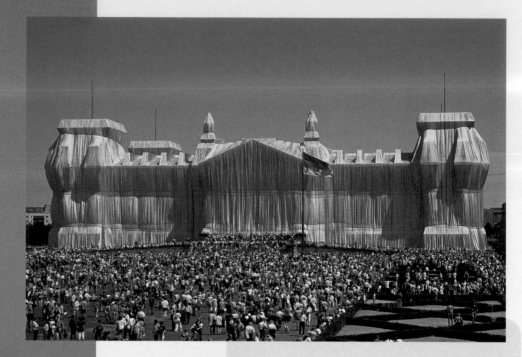

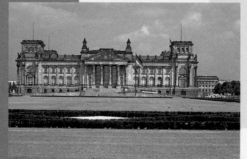

Fig. 9–1a Sometimes, it takes many years to achieve an artistic goal. How is this artwork like the Parthenon (Fig. 2–13, page 103)? How is it different? Christo and Jeanne-Claude, *Wrapped Reichstag*, Berlin, 1971–95. Silver polypropylene fabric, blue polypropylene rope. © Christo 1995. Photo: Wolfgang Volz.

Fig. 9–1b Paul Wallot, architect, *Reichstag (Parliament)*, 1884–94. From the west. Burned 1933, destroyed 1945, restored 1958–72. Photo: Oliver Radford, 1991.

276

National Standards
Chapter 9
Content Standards

1. Understand media, techniques, and processes.
2. Use knowledge of structures and functions.
3. Choose and evaluate subject matter, symbols, and ideas.
4. Understand arts in relation to history and cultures.
5. Assess own and others' work.

Teaching Options

Teaching Through Inquiry

Have students **review the artworks** in the previous theme chapters. From each chapter, have them select one artwork and imagine the challenge faced by the artist. **Ask:** How might the creators of these works have completed the question "Is it possible to . . . ?" Students may work alone or in small groups, and then share their findings with the class.

More About...

By 1958, Bulgarian-born artist **Christo** (Javacheff) (b. 1935) was wrapping small objects to emphasize their form, but he soon began working on a larger scale, eventually wrapping buildings. The "temporary transformative acts" of Christo and his wife, **Jeanne-Claude**, include surrounding eleven islands in Miami's Biscayne Bay with pink plastic. In 1991, they oversaw the installation of 1,760 six-meter-tall yellow umbrellas in the hills north of Los Angeles, and 1,340 blue umbrellas outside of Tokyo.

Focus

- Why is it important to ask what is possible?
- How do artists make new ideas tangible?

Have you ever done something that you thought might not be possible? Perhaps you completed a five-mile race or hit a grand-slam home run. Maybe you sang a solo or painted the walls and ceiling of a room. We often amaze ourselves by what we can accomplish. Most of our accomplishments begin with a simple question: "Is this possible?"

Someone once asked, "Is it possible to create a machine that will fly?" More recently, someone asked, "Is it possible to get to Mars?" Our history is one of responses to questions about what is possible.

We ask "Is it possible?" in all disciplines, including art. People who made images on cave walls asked this question. So did those who built enormous temples and cathedrals, created linear perspective, carved objects out of trees, and put oil paint into tubes and went outdoors to paint. All these artists probably wondered whether they could do what they dreamed of doing.

In the last half of the twentieth century, artists explored more possibilities than ever before. Communication became almost instant. New materials, techniques, and ways of reaching viewers became available. For example, Christo and Jeanne-Claude (Fig. 9–1a) used industrial fabrics and ropes for their wrapping projects. In what ways might their work and the work of other contemporary artists change people's ideas about art?

What's Ahead

- **Core Lesson** Discover how contemporary artists have expanded the concept of art.
- **9.1 Art History Lesson** Learn about art developments since 1950.
- **9.2 Elements & Principles Lesson** Explore possibilities through looking at proportion and scale in artworks.
- **9.3 Global View Lesson** Focus on the art of contemporary artists worldwide.
- **9.4 Studio Lesson** Make an artwork that helps expand the definition of a book.

Words to Know

installation art	caricature
earthworks	scroll
maquette	fan
proportion	concertina
scale	

Possibilities

277

Graphic Organizer
Chapter 9

9.1 Art History Lesson
Art Since 1950
page 284

Core Lesson
Expanding the
Possibilities of Art

9.3 Global View Lesson
Global Possibilities
page 290

9.2 Elements & Principles Lesson
Proportion and Scale
page 288

Core Studio
Making a
Painting/Sculpture
page 282

9.4 Studio Lesson
Making a Book
page 294

Chapter Focus

This chapter looks at the ways that contemporary artists worldwide have explored and expanded the concept of art, seeking what is possible; and at some of the Western art movements that have developed since 1950. Students will see how proportion and scale are used in artworks to achieve certain effects, and will create an artwork in which they, too, explore the boundaries of traditional art forms.

Chapter Warm-up

Ask: What inventions or projects seem—or once did seem—amazing to you? What might you like to do that right now doesn't seem possible?

Using the Text

Art History After students have read page 277, ask them to consider Christo and Jeanne-Claude's *Wrapped Reichstag*. Tell students that twenty-four years passed from the artists' first thoughts of wrapping the Reichstag, until the work was completed. In that time, they had to secure permission, raise funds, manufacture materials, and organize people to do the work. **Ask:** How many people do you think took part in this project? If approached, would you have chosen to participate when the project was just an idea? Why or why not? Now ask students to respond to the first question in the text.

Using the Art

Aesthetics Show students a wrapped package or product. **Ask:** Why are things wrapped? *(to keep what is inside a surprise, to protect, to separate)* **Ask:** How does wrapping a building change its meaning? Why, do you think, did Christo and Jeanne-Claude wrap the Reichstag? Is this art? Why or why not?

Extend

Ask students to research other projects by Christo and Jeanne-Claude, and then discuss the community involvement and environmental impact of those projects. Challenge students to design, draw, and explain a temporary change for a local structure.

Prepare

Pacing

Three 45-minute periods: one to consider text and art; one to construct sculpture; one to paint sculpture

Objectives

- Use examples to explain how artists in the later part of the twentieth century attempted to expand the definition of art.
- Explain how developments in technology have provided artists with new ways to create art.
- Create an artwork that explores the boundaries of painting and sculpture.

Vocabulary

installation art Art created for a particular, and usually large, site.

earthworks Artworks designed for particular outdoor places.

Teach

Engage

Select an object on the wall, such as a fire extinguisher or pencil sharpener. (You might tell students about a museum curator who once said that if a fire extinguisher were hung in a museum, people would look at it.) **Ask:** Is this art? Why or why not? Develop a class list of students' criteria for something to be considered art.

Expanding the Possibilities of Art

Artists in the twentieth century wanted people to help them answer the question "What is art?" As this question became familiar to people throughout the world, artists explored the possibilities of answering it. They experimented with subject matter, media, point of view, size, location, and other traditionally defined art concepts.

A Twist on the Traditional

How many ways could art change? Artists thought about all different art forms and media. They began to see vast possibilities for moving beyond familiar traditions. Painters changed the shape and size of their canvases. They designed huge paintings to fill the walls of a gallery. They experimented with ways of applying paint—pouring, dripping, and spraying paint became accepted techniques.

Sculptors expanded the ideas traditionally associated with their art form. They assembled found objects such as televisions, automobiles, umbrellas, and furniture. They constructed sculpture out of new and unusual materials such as industrial steel, plastic, and neon lights. Artists looked around, saw what was happening, and asked, "What else is possible?"

Fig. 9–2 How does Bartlett's work push the boundaries of what we traditionally consider a painting? Jennifer Bartlett, *Sea Wall* (detail), 1985. Oil on 3 canvases, 84" x 369" (213.4 x 937.3 cm); houses and boats: wood and paint; sea wall: poured concrete and CorTen steel. Collection of artist.

278

Teaching Options

Teaching Through Inquiry

Aesthetics Remind students that a prevailing question explored by contemporary artists is **"What is art?"** Tell students that philosophers have long pondered another question: **"What makes something beautiful?"** Have students consider their position regarding whether any or all of the artworks on these pages are beautiful. **Ask:** Which artwork comes closest to your idea of beauty? Which is furthest away? Have students discuss their answers, first in small groups and then with the entire class. Monitor the discussion so that students provide reasons for their position.

Fig. 9–3 The artist suspended mattresses—rolled, tied, and decorated with mashed cakes—from the ceiling. Why might some people think that her work is about the lack of permanence in our society? Nancy Rubins, *Mattresses and Cakes*, 1993. 250 mattresses and cakes. Paul Kasmin Gallery, NY, New York.

Using the Text

Art Criticism After students have read A Twist on the Traditional, discuss how artists changed traditional painting. Discuss how Bartlett's *Sea Wall* pushes the boundaries of traditional painting. Have students read New Approaches, New Materials. **Ask:** What were the new approaches and new materials used in these artworks?

Using the Art

Art Criticism Ask: How well does the interpretation in the caption for *Mattresses and Cakes* fit the artwork? What are some other interpretations? What message might the artwork send? Would the artwork have a different meaning if the mattresses and cakes were not *actual* mattresses and cakes?

Aesthetics After students have studied *Infinite Condors*, explain that an artist may repeat a motif in a computer image by copying and pasting it. **Ask:** How can this computer-art technique change art? *(Repeating a motif hundreds of times is simplified by computer technology.)* How would you feel about a pencil drawing with a detail drawn hundreds of times, and a computer drawing with a similar repetition?

New Approaches, New Materials

Artists played with what viewers expected to see. Don't you expect a painting to hang on the wall? Jennifer Bartlett and other artists made paintings that seem to spill from the wall onto the floor (Fig. 9–2). Don't you expect a sculpture to stand on a floor or pedestal? Nancy Rubins (Fig. 9–3) and other artists made sculptures that hung from the ceiling.

Advances in electronic media led artists to use video, lasers, and computer technology

Fig. 9–4 This artist used computer technology to create a condor moving on-screen. Each feather looks exactly like the parent bird. If you zoom in, you find that the feathers on these "feathers" also look just like the parent bird. And so do the feathers on the feathers on the feathers! J. Michael James, *Infinite Condors*, 1994. Digital image, still frame from animation of 3-D computer graphic sculpture. Courtesy of the 911 Gallery, Newtwonville, Massachusetts.

in their art. Instead of making traditionally silent, motionless art, more artists began to use sound, light, movement, interactive components, and other high-tech features in their work. Some contemporary artists explored the potential of computers, creating new and unusual artworks (Fig. 9–4).

Possibilities

279

More About...

Jennifer Bartlett (b. 1941), who studied art at Mills College and Yale, was initially influenced by Abstract Expressionism. However, in 1969, she began painting a series of grids, at first on canvas, then on steel plates. During the 1980s, she painted huge seascapes and landscapes. She turned motifs from these paintings into sculpture, and displayed sculpture and painting together as an artwork. By this combining of sculpture and paintings, she changed viewers' expectations about art and sculpture, and about scale and space.

Using the Large Reproduction

Talk It Over

Describe What is this? What materials did the artist use?

17

Analyze How did the artist explore the possibilities of materials? How are the parts arranged?

Interpret What statement did the artist make?

Judge What is important about this artist's work?

Using the Text

Aesthetics Have students read pages 280 and 281. Then ask students to take and defend one of these two positions: (1) Goldsworthy's art is the actual manipulation of natural objects. Unlike most other artworks, his artworks are temporary. A photograph—like any photograph that shows something that existed at one time—is the only documentation of the artwork. (2) Goldsworthy's art is the photograph he takes of manipulated natural materials. The natural materials provide the set-up for the photograph, much like any photograph that is purposefully "staged," like a formal portrait.

Using the Art

Perception Have students describe Martorell's installation and compare its size to that of the artroom. Encourage students to imagine walking through this art.

Critical Thinking

Some of Goldsworthy's projects are permanent, such as the hundred traditional drystone sheep corrals that he and local "wallers" are rebuilding in Cumbria. However, instead of just rebuilding the corrals, they are changing them by inserting boulders into traditional construction. Goldsworthy believes that "[y]ou must have something new in a landscape as well as something old." Do you agree or disagree with his statement? Why or why not?

New Audiences

Along with asking the questions "What is art?" and "How can art change?" artists asked: "Who is art created for?" They began to look beyond the traditional art market toward a broader audience for their work. Some wanted the art viewer to be part of the artwork itself. This idea led to new kinds of experiences with art.

Fig. 9–5 This installation combines various art forms and media. It deals with political and personal identity issues of Caribbean island cultures. Antonio Martorell, *Blanca Snow in Puerto Rico*, 1997. 15' x 12' (4.6 x 3.7 m). Courtesy Hostos Center for the Arts & Culture. Photo by Frank Gimpaya.

280

Teaching Options

Meeting Individual Needs

Multiple Intelligences/Bodily-Kinesthetic On the chalkboard, list what students think might have been the challenges that Christo and Jeanne-Claude faced in wrapping the Reichstag (Fig. 9–1). Stack a number of large cardboard boxes in a varied configuration, and challenge students to wrap them completely and neatly with a bolt of cloth and string. Then ask students to compare the challenges they faced with the ones they thought Christo and Jeanne-Claude might have faced.

Teaching Through Inquiry

Art Production Tell students that the use of new materials or sites for artworks is one way to answer the question **"Is it possible?"** Another way is to show what is possible, by making an artwork, for instance, that depicts a scene where people care for and respect one another. On a large chart, write: Is It Possible? Have students brainstorm to create a list of things they would like to see in the world. Then allow students to create an artwork that proposes an idea from the list.

New Art for Sites, New Sites for Art

Technology-based ways of creating art have resulted in new places for art and new ways of exhibiting it. For example, **installation art**—art created for a particular site—often requires a large space in which to be displayed. Instead of a traditional gallery space, an installation might be shown in a converted factory. The art might include sounds or projected images. Viewers might be asked to participate and alter the art.

In *Blanca Snow in Puerto Rico* (Fig. 9–5), Antonio Martorell presented an installation. He wanted to create a dialogue among the viewers. At the exhibit's opening the audience

was given play money to "bid" for sections of the island. Suddenly, in a moment totally unplanned, people began tossing the money from the balcony until the air resembled a snowstorm. Do you think this kind of art made a lasting impression on the viewer? Why or why not?

When an installation has been taken down, only photographs or videos remain to show us what it looked like. Twentieth-century artists challenged the idea that artworks must be permanent. They explored the possibility of creating works that don't last. They looked for new definitions of public art and saw the Internet as a place to display—and create—art. What kinds of audiences can today's artists reach?

Contemporary artists might show their work outdoors, sometimes in urban areas or in places that are difficult to visit. Once outdoors, artists need to consider the way an artwork will respond to or fit in with the natural elements. Andy Goldsworthy creates artworks with natural materials outdoors and then photographs them (Fig. 9–6). After he leaves the site, he allows natural forces to determine what happens to his work.

Like Goldsworthy, other artists have created artworks that celebrate and otherwise bring attention to the natural environment. Artworks designed for particular outdoor places in nature are called **earthworks.** Like installation art, some earthworks depend on photographs or videos to allow audiences to view them.

Fig. 9–6 After Goldsworthy's sculptured forms are left alone and nature has run its course, only photographic documents remain. Which do you think is more important: the original work or the photograph? Why do you think so? Andy Goldsworthy, *The coldest I have ever known in Britain/as early/worked all day/reconstructed icicles around a tree/finished late afternoon/catching sunlight, Glenn Marlin Falls, Dumfriesshire, 28 december 1995,* 1995. Cibachrome print, 23" x 19" (58 x 48.3 cm) square. Galerie Lelong, New York, New York. Courtesy of Private Collector, New York.

Possibilities

281

Extend

Explain that the making of earthworks began during the late 1960s and early 1970s in conjunction with the growth of environmental awareness. Have students research other earthworks that use natural materials to alter the environment, such as Robert Smithson's *Spiral Jetty,* in the Great Salt Lake, Utah; Michael Heizer's *Double Negative,* in Nevada; or Walter de Maria's *Mile-Long Drawing,* in the Mojave Desert. Students may find earthworks that introduced manufactured materials into the natural environment, such as Michael Heizer's *Complex One,* Maya Lin's *Vietnam Veterans' Memorial Wall,* Nancy Holt's *Sun Tunnels,* or Christo and Jeanne-Claude's *Wrapped Coast.*

More About...

British artist **Andy Goldsworthy** (b. 1956) has used local natural materials to create temporary outdoor sculptures worldwide. He has woven grasses, piled stones in the sea and let waves knock them down, and shaped an icicle around a tree.

Using the Overhead

Think It Through

Ideas What is the big idea here? Do you think the artist was inspired by the materials? Why or why not?

Materials What materials can you identify?

Techniques How did the artist work with his materials?

Audience Do you think this artwork might have popular appeal? Why or why not?

CD-ROM Connection

For more images relating to this theme, see the Global Pursuit CD-ROM.

Possibilities

Supplies

- sketch paper
- pencils
- scissors or X-acto knives
- cardboard or foamcore
- glue and tape
- found objects
- tempera paints and brushes

Safety Note

Warn students to exercise extreme care when using X-acto knives, and to protect the work surface with scrap cardboard. For safety, provide only sharp blades.

Using the Text

Art Production Explain to students that they will create an artwork that has qualities of both sculpture and painting. Suggest making a painting with just a few parts extending from its surface, or, like a relief sculpture, with many extensions. Discuss possibilities for creating a nonobjective sculpture like Stella's, or including recognizable subjects, as in *Anna and David*. Demonstrate cutting, folding, bending, and joining cardboard to create three-dimensional forms.

Using the Art

Art Criticism Ask students to compare Stella's and Schapiro's artworks. **Ask:** Which is more abstract? Which is more three-dimensional? Is Schapiro's a sculpture or a painting? Do paintings have to be rectangular and flat? What is the movement in each piece? Lead students in imagining how they might bend cardboard shapes to create a sculpture similar to Stella's.

Assess

Check Your Work

Have students arrange a display of their sculptures—from those more like sculptures to those more like paintings. **Ask:** Do some pieces blur

Mixed Media in the Studio

Making a Painting/Sculpture

Exploring Possibilities

Both Frank Stella and Miriam Schapiro (see below) pushed the possibilities of traditional painting into different directions. Each artist also blurred the line between sculpture and painting by making the canvases into forms.

In this studio exercise, you will use cardboard and paint to make an artwork that explores the boundaries between sculpture and painting.

You Will Need

- sketch paper and pencil
- cardboard or foamcore
- scissors or X-acto knife
- glue and tape
- found objects
- tempera paints and brushes

Fig. 9–7 What is a painting? Describe the ways that this artwork fits your definition of a painting. Frank Stella, *The Chase, Second Day*, 1989. Mixed media, 101" x 229" x 50" (256.5 x 581.6 x 127 cm). Photograph by Steven Sloman. ©2000 Frank Stella/Artist Rights Society (ARS), New York.

Safety Note

Use extreme caution when using sharp tools to prevent cuts and accidents.

Try This

1. First decide what you want to explore with your artwork. Like Frank Stella, you may wish to focus on shapes and forms alone. Or like Miriam Schapiro, you may wish to convey a message about something you think is important.

2. Sketch your ideas. Decide what forms you will use. Will you make a painting that also seems to be a sculpture? Or a sculpture that also seems to be a painting?

Studio Background

Breaking Boundaries

In the late 1950s, Abstract artist **Frank Stella** painted huge geometric canvases with simple shapes, colors, and lines. In the 1970s, he began to "explode" his paintings into three dimensions. He used aluminum and Fiberglas™ to make multilayered organic forms and swirls. We usually think of Stella's works as paintings. But because they jut out from the wall or stand on the floor, we may also think of them as sculpture.

Miriam Schapiro shaped her paintings into recognizable forms such as hearts, fans, and houses. Throughout her career, she explored the roles, artistic work, and symbols associated with women. She

Teaching Options

Meeting Individual Needs

Focusing Ideas To aid their understanding of abstract work such as Stella's, discuss and then have students create both an abstract and a symbolic sculpture. Ask students to explain the difference between their sculptures.

Adaptive Materials Cut the materials beforehand, or assist students in the cutting.

3. Cut and join your forms. Will you use slots and tabs to connect various pieces? Or will you use tape and glue?

4. Paint your artwork when you are sure it is stable. If you wish, add found objects or other materials to help show your meaning.

Fig. 9–8 Three students worked together to make this impressive work that measures over four feet long and hangs on the wall. Thinking about a major earthquake in Taiwan and the effect it had on the people living there, these students used their artwork to express the destruction of such an event. Nick Hampton, Rebakah Mitchell, Alexander Moyers Marcon, *Earthquake*, 1999. Tempera, 33" x 52" (84 x 132 cm). Mount Nittany Middle School, State College, Pennsylvania.

Check Your Work

Arrange the artworks most like sculptures in one area and those most like paintings in another area. Discuss the artworks with your classmates. Decide which ones are mostly about form and which ones represent an idea or message.

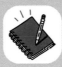

Sketchbook Connection

Plan two additional artworks. In each one, try to blur the boundaries between two art forms. For example, consider printmaking and weaving, sculpture and jewelry-making, or graphic design and painting. Think about traditional and new approaches to each art form. Explore the possibilities.

Core Lesson 9

Check Your Understanding

1. In what ways was the twentieth century a time of exploring new possibilities in art?
2. Use two examples to tell how new technology has influenced contemporary artworks.
3. How have some contemporary artists challenged the expectations of their viewers?
4. How does *The Chase* (Fig. 9–7) blur the line between painting and sculpture?

put doilies, handkerchiefs, and quilt pieces traditionally made by them into her paintings. Simple human figures, often posed for dancing, also appeared. Her artwork *Anna and David* (Fig. 9–9) looks like a huge colored-paper cutout. Unlike Stella's forms, which move into and through space, this sculptural form is relatively flat—very much like a painting.

Fig. 9–9 Why would passersby consider this artwork a sculpture? What might cause them to think of it as a painting? Miriam Schapiro, *Anna and David*, 1987. Stainless steel and aluminum, 35 " x 39" x 9" (88.9 x 78.7 x 22.9 cm). Courtesy Bernice Steinbaum Gallery, Miami, Florida.

Possibilities

283

the boundaries between painting and sculpture more than others? How could any unstable sculptures have been made more stable?

Check Your Understanding: Answers

1. Artists tried to answer "What is art?" by experimenting with subject matter, media, point of view, size, and location.

2. Answers may vary. Sample answer: Computer technology allowed J. Michael James to create *Infinite Condors;* photography allowed Andy Goldsworthy to create *Icicle Tree*.

3. Answers may vary. Sample answer: Bartlett and Stella challenged the expectation that paintings are rectangular and hang flat against a wall; by hanging her sculpture from the ceiling, Rubins challenged the expectation that sculpture stands on the floor or a pedestal.

4. *The Chase* makes use of shape, color, and line, yet also moves in space and stands on the floor.

Close

Ask students to use examples to explain how late-twentieth-century artists attempted to expand possibilities in art. Discuss technological developments that have provided artists with new ways to create art. **Ask:** Have you expanded your perceptions of what art is?

More About...

Miriam Schapiro's 35' figures in *Anna and David* continue her work that explores the relationships between men and women. Many of her artworks celebrate the creative abilities of women and point out that, for centuries, women have not been encouraged to pursue their creative potential. Schapiro often uses theatrical devices and characters—such as stages, dancers, and puppets—to highlight the roles that society has forced women and men to play. In this artwork, she presented a joyous and hopeful interpretation of what might be possible when men and women are equal partners. As cutouts, the figures refer to the paper dolls that young girls traditionally used for pretending "grown-up" life situations.

Assessment Options

Self Have students create an **installation** that demonstrates their understanding of how artists in the late twentieth century attempted to expand the definition of art. Instruct students to include evidence of the impact of technology. Stress that their installation is *not* to be the same as a museum exhibition, but it should provide explanatory information for the viewers. Help students identify a school area (such as in a multipurpose room, or an entrance area) where they could construct the installation.

Have each student submit a written reflection about how the installation does or does not demonstrate his or her understanding of developments in late-twentieth-century art.

Prepare

Pacing
One or two 45-minute periods

Objectives
- Identify three important art movements in the last half of the twentieth century.
- Explain how artists in the late twentieth century explored the possibilities of new techniques and materials.
- Create a small-scale model of a sculpture for a public place.

Vocabulary
maquette A model of a larger sculpture.

Supplies for Engage
- watercolors, brushes
- heavy paper, 9" x 12"
- water in containers
- paper towels, sponges

Using the Time Line
Have students find Pablo Picasso's life dates. Using the time lines on page 258 and on this page, ask students to determine which art styles were current during Picasso's lifetime. Point out that the time lines mention only a few of the art movements that developed in modern times. Suggest that students research other movements.

National Standards
9.1 Art History Lesson
3a Integrate visual, spatial, temporal concepts with content.
4a Compare artworks of various eras, cultures.

Art Since 1950

		1959 Krasner, *The Bull*		1965 Lichtenstein, *Little Big Painting*	1985 Puryear, *Old Mole*	
Surrealism page 259	Abstract Expressionism	Color Field	Pop Art			?
		1962 Frankenthaler, *Rock Pond*		1985 Scharf, *Opulado Teeveona*	1997 D.AST., *Desert Breath*	

Most of the art movements you have studied in this book began in Europe. By the 1950s, though, New York had become the new art center of the world. Art styles began in the United States and spread throughout the world.

American artists brought new possibilities to their artworks. Like the artists of the early 1900s, they worked in many different styles and created a variety of art movements. Some artists experimented with exciting materials no one had used before. Other artists used traditional materials in new ways.

Today, artists continue to challenge what is possible in art. They search for ways to change people's ideas about art. They challenge how we see things and what we think of them. Their explorations create new kinds of art and make us wonder, "What's next?"

New Possibilities in Painting

By the 1950s, artists were asking themselves, "What new things are possible in creating a painting?" Now that painters no longer had to show realistic scenes, they looked for other ways to change what people thought of as a "painting." Many tried using the traditional medium of paint in new ways. Others searched for new ways to show traditional subject matter.

Abstract Expressionism
Abstract Expressionist artists tried different ways of painting. Some dripped, poured, or splashed paint on a canvas. They concentrated

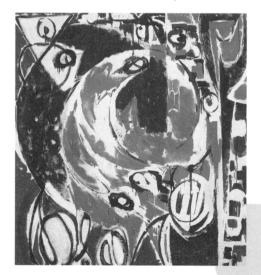

Fig. 9–10 Why do you think Abstract Expressionism was also called "action painting"? Lee Krasner, *The Bull*, 1959. Oil on canvas, 77" x 70" (195.6 x 177.8 cm). Photograph courtesy of the Robert Miller Gallery, New York. ©2000 Pollack-Krasner Foundation/Artists Rights Society (ARS), New York.

284

Teaching Options

Resources
Teacher's Resource Binder
 Names to Know: 9.1
 A Closer Look: 9.1
 Map: 9.1
 Find Out More: 9.1
 Check Your Work: 9.1
 Assessment Master: 9.1
Overhead Transparency 17
Slides 9d

Teaching Through Inquiry
Art Production/Art History Ask students to select one of the artists whose work is shown on these pages, and to create a list of four questions they would like to ask the artist. Then encourage students to do research in order to provide plausible answers. Have students defend their answers with information about the artist.

on the action of creating a brushstroke. Look at the work in Fig. 9–10 by Lee Krasner, an Abstract Expressionist painter. Can you see some of the brushstrokes she used? Imagine you are the artist creating this large painting (it is over six feet tall). You would need to use long, sweeping strokes to cross the canvas. You would probably choose a large brush—maybe even the kind used for painting a house—to create the brushstrokes you see in Krasner's painting.

Color Field

Another group of artists also experimented with new ways to put paint on a canvas. The Color Field painters allowed paint to soak and seep into the canvas. In Fig. 9–11, Helen Frankenthaler poured paint onto the canvas and created fields, or shapes, of color. She used an idea from nature—a pond—for her painting. Then she simplified the scene to only large shapes of color.

Pop Art

Some artists wanted to change what artworks could show. Some of their subjects were soup cans, soda bottles, or other everyday objects. Because their subjects came from popular ("pop") culture, their movement was called Pop Art.

Pop artists worked in many different styles. Roy Lichtenstein created paintings that looked like comic strips. Look at his work in Fig. 9–12. Can a brushstroke be a subject for a painting? How has this artist, and other Pop artists, opened up the possibilities for a painting?

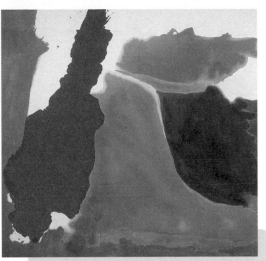

Fig. 9–11 This artist lets paint seep into the canvas. What kind of shapes has she created with this technique? Helen Frankenthaler, *Rock Pond*, 1962.
Acrylic on canvas, 80" x 82" (203 x 208 cm). The Edwin and Virginia Irwin Memorial. ©Cincinnati Art Museum.

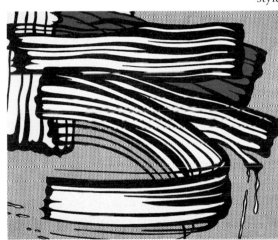

Fig. 9–12 Compare this work to Fig. 9–10. Would you call this artwork an "action painting"? Why or why not? Roy Lichtenstein, *Little Big Painting*, 1965.
Oil and magna on canvas, 68" x 80" (172.7 x 203 cm). Whitney Museum of American Art, New York. Purchased with funds from the friends of the Whitney Museum of American Art. © Estate of Roy Lichtenstein.

Possibilities

285

Teach

Engage

Instruct students to draw a small organic shape and carefully paint it; dip a paper towel or sponge into a container of watercolor, squeeze it onto their paper, and spatter paint on their paper. Discuss these three processes. Explain that some artists revolutionized ideas about art by using these techniques.

Using the Text

Art History Have students read the text to discover which late-twentieth-century artists used techniques similar to those that students used in Engage. Encourage students to explain why the names Abstract Expressionism, Color Field, and Pop Art accurately describe these styles.

Using the Art

Lead students in comparing *The Bull* with *Little Big Painting*. Discuss answers to the caption question for Fig. 9–12. Explain that Lichtenstein painted his big brushstroke with tiny brushstrokes.

Extend

Assign students to research an Abstract Expressionist, Color Field painter, or Pop artist and then depict a chair or other object in the artist's style.

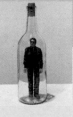

17

Using the Text

Art Criticism Ask students to read the ways indicated in the text that artists used nontraditional materials in sculpture. Ask them to respond to the final question in the text.

Using the Art

Art Criticism Ask students to recall other assemblages that they have studied. Have them compare Scharf's work with *Penguin* (Fig. 8–8). **Ask:** How are they alike? What was each artist's message? Note that the artists used found objects in different ways.

Art Criticism Have students pretend that they are curating an exhibit that features Puryear's *Old Mole* and a similar sculpture from Chapter 8. **Ask:** What sculpture from Chapter 8 would you choose? Why?

Studio Connection

Provide students with a choice of materials to construct their maquette: cardboard, wood scraps, foamcore, found objects, clay, wire, sand, rocks, twigs, glue, nails, hammers, aluminum foil, acrylic paint, brushes. Remind students of local sculptures, and refer them to Escobedo's *Coatl* (Fig. F3–6). **Ask:** Where would you locate your sculpture? What would be its purpose? Would people be able to climb on it? What will be the scale of your maquette?

Assess See Teacher's Resource Binder: Check Your Work 9.1.

New Possibilities in Sculpture

Twentieth-century sculptors have also explored the possibilities of new techniques, materials, and places for their works. They have taken the art form of sculpture in new directions.

Some sculptors have used traditional materials in new ways. In Fig. 9–13, Martin Puryear used wood to create an abstract sculpture. Other artists, such as Kenny Scharf, combined different materials in one sculpture. In Fig. 9–14, Scharf chose unusual materials to make into a sculpture: a TV set, toys, and jewelry. At first, a sculpture made of television sets was new and shocking. Today, many artists use them in their work. Why do you think they have become a common art material?

Four artists worked together to create the artwork you see in Fig. 9–15, *Desert Breath*. The artists moved sand to create cone-shaped hills and holes in an Egyptian desert. This artwork is not meant to last. It is meant to change, and even disappear, as the desert winds blow over it. What do you think are possible materials for future artworks?

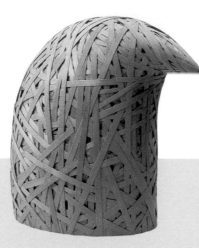

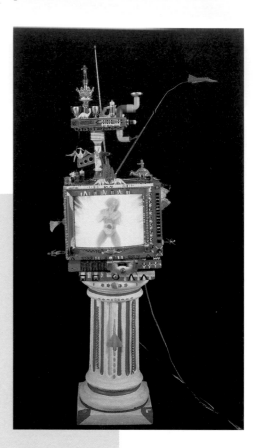

Fig. 9–13 Perhaps this sculpture reminds you of a mole, as the title suggests, or a bird's beak, or maybe something else. The artist used a simple abstract form to suggest many possible meanings. Martin Puryear, *Old Mole*, 1985.
Red cedar, 61" x 61" (154.9 x 154.9 cm); diameter: 34" (86 cm). Philadelphia Museum of Art: Purchased with gifts (by exchange) of Samuel S. White III and Vera White, and Mr. and Mrs. Charles C. G. Chaplin and with funds contributed by Marion Boulton Stroud, Mr. and Mrs. Robert Kardon, Mr. and Mrs. Dennis Alter, and Mrs. H. Gates Lloyd.

Fig. 9–14 This artist feels art should be fun. What other materials could he have used to make a "fun" sculpture? Kenny Scharf, *Opulado Teeveona*, 1985.
Acrylic, jewels, toys on Sony trinitron TV with plastic pedestal, 56" x 17" x 16" (142 x 43.2 x 40.6 cm). Courtesy Tony Shafrazi Gallery, New York. Photo by Ivan Dalla Tana. Copyright Kenny Scharf. ©2000 Kenny Scharf/Artists Rights Society (ARS), New York.

Teaching Options

Meeting Individual Needs

English as a Second Language and Multiple Intelligences/Musical and Linguistic Challenge students to use their body (clapping hands, slapping thighs, tapping toes, clicking tongues, and so on) to create sounds that express the energy in Krasner's *The Bull*. Have students also write a brief poem in English to convey the painting's energy.

Teaching Through Inquiry

Art Criticism Ask students to imagine that they are part of a group with the responsibility of selecting an artist to create a sculpture for the school. The artists of the three artworks shown on pages 286 and 287 are the finalists. **Ask:** Which artist would you select? Why? Encourage students to consider the interests and needs of the school community and the type of artworks these artists would likely propose.

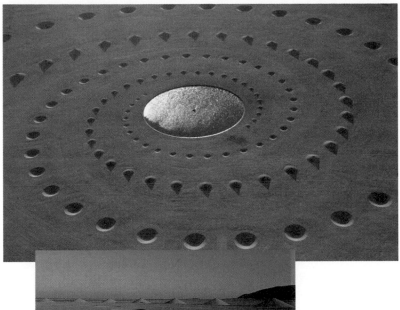

Fig. 9–15 What does this artwork's title make you think of? What happens when you blow on a pile of sand? D.A.ST. Arteam: Danae Stratou, Alexandra Stratou, and Stella Constantinides, *Desert Breath*, 1997. Sand and water, 1,214' (370 m) diameter. Located: Red Sea, Egypt. Courtesy D.A.ST. Arteam.

Studio Connection

Sculptures for public places are often selected by holding a competition. The sponsors of the project invite artists to submit their ideas for the sculpture. Many artists prepare a **maquette**, a small-scale model of what their final sculpture will look like.

Imagine that you are a sculptor hoping to win a competition for a work that reflects new directions in sculpture. Create a maquette of your sculpture designed for a public place. A maquette can be made of any material that suggests how the final sculpture will look. For example, if your sculpture were made of metal sheets, you might use cardboard for your maquette.

9.1 Art History

Check Your Understanding

1. How did many painters in the last half of the twentieth century try to change what people thought of as "painting"?
2. Identify and distinguish among three important art movements of the last half of the twentieth century.
3. How did some sculptors of the last half of the twentieth century explore the possibilities of materials for sculpture?
4. Why do you think there have been so many styles of art in the last half of the twentieth century?

Possibilities

287

Extend

Assign students to create a painting showing how their completed sculpture would look if it were built. Have them include figures and the surrounding landscape.

Assess

Check Your Understanding: Answers

1. Many tried using the traditional medium of paint in new ways. Others searched for new ways to show traditional subject matter.

2. Abstract Expressionists used energetic brushstrokes and unrecognizable subject matter. Color Field painters experimented with paint soaking into canvas. Pop Artists drew upon popular culture for subject matter.

3. Some used traditional materials in new ways; some combined different materials in one sculpture; and others used materials that would not last.

4. Answers will vary. Students might list changes in technology and faster communication so that artists quickly learned about one another's artworks.

Close

Review with students the important art movements in the last half of the twentieth century. **Ask:** What examples can you give to show how these artists explored new techniques and materials for their artworks? How do your maquettes for public sculptures show twentieth-century influences?

More About...

Site-specific or **sited sculpture** is designed for a specific place. Maya Lin's *Vietnam Veterans' Memorial Wall,* in Washington, DC, and Isamu Noguchi's sculpture gardens at Yale University and Costa Mesa, California, are examples of site-specific sculpture.

Assessment Options

Peer On the chalkboard, write the lesson's first and second objectives. Tell students that they will write an essay to show that they have met the objectives. Instruct students to explain this statement: "In the last half of the twentieth century, artists explored possibilities of materials, techniques, and places for their artworks." Have students exchange their essay with a peer. Have the peer assessor refer to the objectives and use the following prompts to respond to the essay: "The part I like best is __ because __. The part I am not clear about is __ because __. Please tell me more about __.You might want to __."

287

9.1 | ART HISTORY LESSON

Prepare

Pacing
One 45-minute class period

Objectives
- Explain how artists use scale and proportion to convey ideas and achieve effects in their artworks.
- Create a portrait caricature by exaggerating proportion and scale.

Vocabulary
proportion The relation in size of one part to the whole.

scale The size of an object compared to what it is expected to be.

caricature A depiction that exaggerates features of a subject.

Teach

Using the Text
Art Criticism Have students read the text to learn the difference between proportion and scale. **Ask:** Where have you heard these words before? *(answers will vary but might include "scale models" or "proportioned to fit" clothing.)* Discuss different uses of the words.

Using the Art
Perception Ask: What do you see in Fig. 9–16? What seems too large or too small?

Art Criticism Ask: How might changing scale in an artwork add meaning?

National Standards
9.2 Elements and Principles Lesson

2a Generalize about structures, functions.

2c Select, use structures, functions.

Proportion and Scale

There are many ways to answer the question "What is possible in art?" Artists in the twentieth century developed some answers by experimenting with proportion and scale. They invented ways to transform our relationship with space.

Some Pop artists asked, "What if I make a colossal monument out of an ordinary object?" Artists such as Red Grooms (Fig. 9–16) and Nek Chand (Fig. 9–17) seem to be asking, "How can I create humor or surprise by presenting unexpected scale and proportion?"

Using the language of art, we can talk simply about proportion and scale. We say artworks are life-size, monumental (much larger than life-size), or miniature (very small).

Looking at Proportion

Proportion refers to how a part of something relates to the whole. Our sense of proportion in art comes from the human body. Proportions can be normal and reflect what we see around us. They can also be exaggerated and distorted.

Look at Nek Chand's sculptures (Fig. 9–17). Which figures are proportioned differently than an actual human body? Which ones have the most exaggerated proportions?

Fig. 9–16 Red Grooms combines the styles of Pop Art and Expressionism. This scene is part of a large work about New York City. How does his choice of sizes affect your sense of scale? What are some clues to its humorous intent? Red Grooms, *The Woolworth Building From Ruckus Manhattan* (detail), 1975–76.
Mixed media, 17' x 14' x 15' (5.2 x 4.3 x 4.6 m). Courtesy of the Marlborough Gallery, New York. Photograph by Richard L. Plaut, Jr. ©2000 Red Grooms/Artists Rights Society (ARS), New York.

288

Teaching Options

Resources
Teacher's Resource Binder
Finder Cards: 9.2
A Closer Look: 9.2
Find Out More: 9.2
Check Your Work: 9.2
Assessment Master: 9.2
Overhead Transparency 17

Teaching Through Inquiry
Have students create "monuments" with ordinary objects (such as a paper clip, shoe, eyeglasses, eraser) to see how **changes in scale** can communicate different meanings. Provide wooden blocks or tin cans to serve as pedestals, and have students imagine that their monument, at full size, is in a public space. **Ask:** What is commemorated or celebrated by this monument? Have students give a title to their imagined, full-size monument so as to convey the new meaning that results from the change in scale.

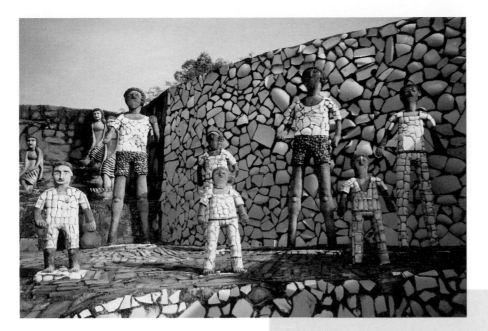

Looking at Scale

Scale is the size of an object compared to what you expect it to be. You do not expect to see a toothbrush bigger than a bed.

In *The Woolworth Building From Ruckus Manhattan* (Fig. 9–16), Red Grooms has presented the building's entrance in monumental scale as compared to its surroundings. Artists often change the normal size, scale, or proportion of things to show their importance.

9.2 Elements & Principles

Check Your Understanding
1. What does proportion refer to?
2. Why might you change the scale of something?

Fig. 9–17 These figures are one small part of a sculpted environment that occupies more than twenty-five acres. *Rock Garden* includes fountains, waterfalls, and giant arches with swings to ride on. Considered an "outsider" artist because he lacks formal training, Nek Chand created his artworks from stones and discarded industrial materials. How do these figures make you feel? Nek Chand, *Rock Garden at Chandigarh*, 1983–1995. Concrete, broken tile and other items, stone, and brick. Photo by Carl Lindquist.

Studio Connection
By "stretching" the possibilities of portraits, artists create **caricatures** —exaggerations— of people, animals, or objects. Draw a portrait caricature of yourself or a famous person. First exaggerate the proportions of the whole shape of head and hair. Then draw the most prominent feature or features, exaggerating the proportions. If the eyes look small in reality, make them very small in the caricature. If the chin is wide, make it very wide. See page 300, Portfolio, for an example of a caricature drawn by a student.

Possibilities

289

Point out to students that in Figs. 1–24 and 3–13, the scale of figures was changed to indicate their importance.

Studio Connection

Provide students with one or two sheets of 9" x 12" drawing paper, pencils, erasers, markers, photographs of celebrities, and mirrors for students who draw themselves (optional). Show students examples of caricatures, and discuss how artists distorted and exaggerated features to add meaning. **Ask:** What features can you exaggerate? What distinctive features will others recognize? Demonstrate drawing a caricature. Guide students to sketch their caricature lightly in pencil and then to darken their drawing with pencil or markers.

Assess See Teacher's Resource Binder: Check Your Work 9.2.

Assess

Check Your Understanding: Answers
1. Proportion refers to how a part of something relates to the whole.
2. to show importance or to create a new meaning

Close

Review how and why artists use scale and proportion. **Ask:** What messages did you create in your caricature? How did you change proportion and scale?

More About...

Red Grooms (b. 1937) grew up in Nashville, where he developed a love for art and theater. He attended several art schools. In 1976—with a team of artists, mechanics, carpenters, and electricians—he completed his "masterpiece of urban folk art," *Ruckus Manhattan,* a 6,400-square-foot walk-through environment.

Using the Overhead

Write About It

Describe Have students write a statement about how the artist manipulated proportion and scale.

17

Analyze Have students write a statement about the effect that the manipulation of proportion and scale has upon the viewer.

Assessment Options

Peer Have small groups of students look through the textbook to find three artworks, other than those on pages 288–289, in which scale and proportion are exaggerated. For each artwork, have students list the effects of exaggerated proportion and scale. Have pairs of groups explain their findings and then evaluate how well the assigned task was completed. Instruct groups to offer suggestions for improvement.

9.3 GLOBAL VIEW LESSON

Global Possibilities

You have probably heard the phrase, "The possibilities are endless." This is particularly true in today's world. Lots of possibilities can be a good thing. You can make any kind of art and use many different materials. But sometimes, you might feel that there are too many possibilities. You might wonder where to begin, where to look for inspiration, or what materials to use.

Artists throughout the world have also been faced with these challenges. As you have learned in this book, artists look for ways to send messages, communicate ideas, teach lessons, and connect with nature. Sometimes, their artworks show a link with the past; other times, they break free from it. But each time, artists explore new possibilities for creating art that is meaningful to their lives and to ours.

Notice the variety of artworks by living artists from around the world on these pages. As you look at the artworks, think of what you have learned about art so far. How do some of these artists connect to past art traditions? What new techniques have they used? What possibilities do you think they are exploring?

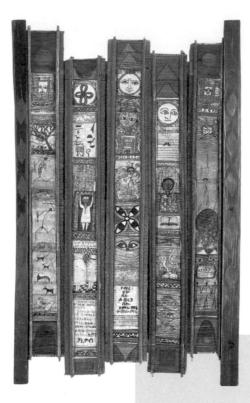

Studio Connection

Each person has a cultural heritage. Your heritage may go back to one of the cultures shown in this chapter or discussed elsewhere in the book. It may have roots in Europe, Africa, North America, or a combination of several cultures. Perhaps you have learned about your cultural heritage from the people you live with.

Create a work of art in any medium you have already worked with in this book. Your challenge is to explore new possibilities with the medium. In this work, try to express something about your cultural heritage. Research the artistic traditions of your cultural heritage. Play with the past as you envision possibilities for the future.

Fig. 9–18 What patterns and images do you see in this artwork? Look back to Chapter 1, Lesson 3. Do you see similar images in the artworks on these pages?
Zerihun Yetmgeta, *Scale of Civilization*, Ethiopia, 1988. Mixed media on wooden looms, 39 ³/₈" x 24 ³/₈" (100 x 62 cm). Inv. 90-312 959, Staatliches Museum fur Volkerkunde, Munich.

Prepare

Pacing
One or two 45-minute periods

Objectives
- Explain, with examples, some possibilities that contemporary artists around the globe are pursuing.
- Identify elements in contemporary artworks from around the world that reflect a connection to cultural heritage.
- Refer to cultural heritage in an artwork that explores possibilities with media and technique.

Teach

Engage
Have students determine the nationality of the artists whose work is portrayed in Figs. 9–18 through 9–23. They may use the guide on page 303. Then have them locate the artists' countries of origin on the world map (pages 306–307). Emphasize to students the variety of art being produced throughout the world.

Using the Text
Art Criticism After students have read the text, have them answer the questions in the third paragraph. Ask students to cite specific artworks to support their ideas.

National Standards
9.3 Global View Lesson

4a Compare artworks of various eras, cultures.

5c Describe, compare responses to own or other artworks.

Teaching Options

Resources

Teacher's Resource Binder
A Closer Look: 9.3
Map: 9.3
Find Out More: 9.3
Check Your Work: 9.3
Assessment Master: 9.3
Large Reproduction 18
Slides 9e

Meeting Individual Needs

Gifted and Talented Have students discuss how Jaune Quick-to-See Smith's *Tree of Life* reflects something of her Native-American heritage. Then have students draw their own "landscapes of the mind" that communicate ideas about their own cultural background.

Fig. 9–19 Why do you think the artist chose animal bones for her artwork? Does her choice of media show a break with past traditions? Yolanda Guiterrez, *Umbral (Threshold)*, Mexico, 1992. Cow jaw bones and wood, installation of variable dimensions: 26 elements of 3 $^{15}/_{16}$" x 23 $^{5}/_{8}$" x 11 $^{7}/_{8}$" (10 x 60 x 30 cm) each. Galerie Yvonamor Palix, Paris.

Fig. 9–20 This artist calls her paintings "landscapes of the mind." How is she exploring new possibilities for showing a landscape? Jaune Quick-to-See Smith, *Tree of Life*, 1994. Oil, collage, mixed media, 60" x 100" (152 x 254 cm). Courtesy of the artist and the Jan Cicero Gallery.

Using the Art

Art History Have students locate areas of *Scale of Civilization* that remind them of African art. *(mask, images from ancient rock carvings, bold geometric patterns associated with African textiles)*

Studio Connection

 Provide students with pencils; sketch paper; a collection of prints and books with art from other cultures (or access to the Internet); and media with which students have had experience in previous lessons.

Ask: Where is your family from? What decorative objects are in your or your relatives' homes? How could you show traditional subjects in a contemporary way? How could you show modern images from your American culture in ways that highlight your heritage?

Encourage students to study art from their cultural heritage, take notes, sketch, select a medium that will best express their message, and then create their art.

Assess See Teacher's Resource Binder: Check Your Work 9.3.

Possiblities

291

Art Criticism Have students work in small groups to consider Figs. 9–18 and 9–20. Ask students to review Lessons 1.3 and 2.3 (pages 82 and 108), to determine how the contemporary artists show a link to their heritage. **Ask:** How are these newer artworks similar in form and function to those of the past? How are they different? Have groups discuss their answers with the entire class.

Jaune Quick-to-See Smith (b. 1940) combines her Salish, French-Cree, and Shoshone heritages in an Expressionistic style to create environmental awareness and messages of social justice. Smith considers her work a bridge between Native-American culture and European art traditions. In her childhood, Smith encountered discrimination when students were punished for speaking a language other than English. As a teenager, she dreamed of becoming an artist, but was discouraged by counselors. Eventually, she graduated from college, and adopted the name Quick-to-See from her Shoshone great-grandmother; her first name, Jaune, (French for "yellow") is a link to her French-Cree ancestry.

Seventeen years of military rule and artistic repression began in Ethiopia in 1974, with the overthrow of Emperor Haile Selassie. Many artists fled, but **Zerihun Yetmgeta** stayed in his homeland. Although he appreciates his Ethiopian heritage and African identity, he considers himself a citizen of the world and often travels to other countries.

Global Possibilities

Using the Text

Art Criticism As students study Figs. 9–19 and 9–22, ask them to compare these to other artworks in earlier lessons of this chapter. **Ask:** How did these artists, like other contemporary artists, stretch the possibilities of art? *(used nontraditional materials in unconventional ways)* Encourage students to compare the idea, site, scale, permanence, and materials of *Toward Unknown Energy* to those in *Desert Breath* (Fig. 9–15).

Using the Art

Art Criticism Have students discuss the caption questions for Bancroft's *Cycle of Life Cape*. To aid their discussion, tell them that Bancroft is a member of the Australian Aborigine Bundjalung people, and is an active advocate of Aborigine rights and culture. She is known for her painting, textile designs, and children's book illustrations.

Extend

Have students write a report about the art of their cultural heritage, in which they include drawings, photocopies, or printouts of symbols and images from their tradition; and an explanation of which elements have become part of American culture.

Fig. 9–21 This artist combines traditions of India, her native country, with ideas about life in America. She has explored new approaches to the traditional Indian art of miniature painting. Shahzia Sikander, *Ready to Leave Series II*, 1997. Vegetable and watercolors on handmade paper, 7 ³/₄" x 6 ¹/₄" (19.7 x 15.9 cm). Collection of Richard and Lois Plehn, New York. Courtesy of Hosfelt Gallery and the artist.

Fig. 9–22 How has this artist explored the possibilities of new spaces for artworks? How does his choice of a site help him communicate something about place? Jae Hyun Park, *Toward Unknown Energy*, 1998. Resin, hempen cloth, and pigments, 85" x 66" x 27" (215.9 x 167.6 x 68.6 cm). Represented by CS Fine Art, Montrose, CA.

Teaching Options

Teaching Through Inquiry

Art History For each image in the lesson, have students determine whether and how someone might know that the artwork is contemporary. **Ask:** Does one of the artworks seem more contemporary than the others? Why?

Art Criticism Have students write an interpretation of one artwork in this chapter so as to give the reader an understanding and appreciation of the piece. Tell students to include a description of the artwork and its message. Upon completion, have students exchange their essay with another student. Invite pairs of students to discuss their interpretations.

Fig. 9–23 Do the patterns on this cape remind you of any examples of Oceanic art you studied in Chapter 6? What message do you think this artist was trying to send?
Bronwyn Bancroft, *Cycle of Life Cape*, 1987.
Australian Museum/Nature Focus. Photo by Carol Bento.

9.3 Global View

Check Your Understanding
1. What big issues do artists all over the world seem to be concerned with?
2. What is meant by international style?
3. Why is preservation of artistic heritage important?
4. How can people approach art with an open mind?

Possibilities

293

Assess

Check Your Understanding: Answers

1. Artists are concerned with the problems of where to begin, where to look for inspiration, and what materials to use. Artists also look for new ways to send messages, communicate ideas, teach lessons, and connect with nature.

2. With advances in communication, artists know more about the look of artworks from around the world, as well as the concerns of artists worldwide. As artists are increasingly influenced by others, their style becomes similar, resulting in an international style.

3. Answers will vary.

4. Answers will vary.

Close

Ask students to describe some art by contemporary artists from several cultural traditions, and to identify elements that reflect a connection to cultural heritage. **Ask:** How did you incorporate your cultural heritage into your artwork?

Using the Large Reproduction

Consider Context

Describe What details do you see in this artwork?

Attribute Might the images and details give you some clues about the heritage of the artist?

Understand What social issues seem to concern this artist? What might this work be suggesting about possibilities?

Explain Researching past events might help to indicate what inspired this artist.

Assessment Options

 Teacher Present to students these goals for teaching art from a global perspective: to learn about Southeast Asian art, students make a shadow puppet; to learn about Korean art, students make a clay vessel with an allover pattern; to learn about Native-American art, students make a tepee; to learn about African art, students make a carved wooden mask. **Ask:** In what ways are these appropriate goals? What suggestions for improvement would you make? Look for evidence that students understand that the art projects provide a limited view of the art of each area, and that they fail to consider the new possibilities that contemporary artists are exploring in their artworks.

293

Prepare

Pacing

Six 45-minute periods: one to consider book styles, one to draw story board, two to design pages, one to assemble book, one to assess

Objectives

- Generate ideas for exploring the possibilities of a book.
- Generate ideas for a book's subject.
- Create a book that focuses on a subject and explores the possibilities of a book.

Vocabulary

scroll An early book format consisting of a long strip of paper or other material, written or drawn upon and rolled for storage.

fan A book with pages loosely bound at one end. Any mix of pages may be viewed, depending upon how the book is held.

concertina A type of book made from a continuous length of paper folded accordion-style.

Sculpture in the Studio

Making a Book

Create the Unexpected

Studio Introduction

When you hear the word "book," what do you think of? You probably think of the kind that's bound with front and back covers. But imagine seeing a book that unrolls as one sheet of paper. Or one that opens like an accordion or a hand-held fan. Or one that is designed simply as an artwork: a sculpture, painting, or collage. All these can be thought of as books, too.

In this lesson, you will break the bounds of what you think of as a book. Pages 296–297 will show you how to do it. You will see several ways to make a book. Then you will choose a format—scroll, concertina, or fan—and create a book of your own.

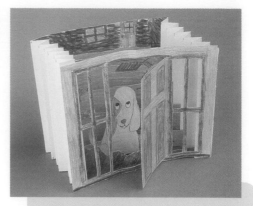

Fig. 9–24 A concertina tunnel book can contain many layers, like a little stage. Windows and an open door invite the viewer to look inside. "I got the idea for the book I made by staring at my dogs as they begged for food. When I was in the process of making my book, I was thinking how bad it looked, but now that it's done, I love it!" Amy Baumbach, *Who's at My Door*, 1999. Colored pencil, 7" x 9" (18 x 23 cm). Camel's Hump Middle School, Richmond, Vermont.

Studio Background

Pushing the Bounds of Books

While the kind of book you're familiar with is seen most often on library shelves, there are other older forms of books that are still in use today.

A **scroll** is a long strip of paper or other material that can be written or drawn on and then rolled up. A rod attached to one or both ends of the scroll makes use and storage easy.

A **fan** is made like a hand-held fan. Its pages—usually strips of paper—are loosely bound at one end. With a fan, you can see any of the pages or a combination of them at one time. The order of the pages is not important.

A simple **concertina** can also be made from a long strip of paper. Only this time, the paper is folded accordion style to create the pages. Because the con-

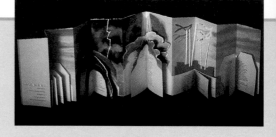

Fig. 9–25 This artist has sewn booklets made from different papers into a concertina book. Notice how each booklet is a different size and shape. Claire Van Vliet, *Dido and Aeneas*, 1989. Handmade paper, 14 ⁵⁄₈" x 70 ³⁄₄" x 1" (37.1 x 179.7 x 2.5 cm), when closed. Paper made at MacGregor/Vinzani, Maine. Courtesy of the artist.

certina is a continuous strip, you can show a single continuous idea on all of the pages or individual ideas on single pages.

National Standards
9.4 Studio Lesson

1b Use media/techniques/processes to communicate experiences, ideas.

Resources

Teacher's Resource Binder
- Studio Master: 9.4
- Studio Reflection: 9.4
- A Closer Look: 9.4
- Find Out More: 9.4

Slides 9f

Teaching Through Inquiry

Aesthetics Before, during, or after they make their own books, have small groups of students complete these prompts: "Something is a book if it __. Something is *not* a book if it __." **Ask:** What *must* something have in order to be considered a book?

Possibilities and Ideas

Scroll
- Create a handscroll to be unrolled and viewed a little at a time. Or create a hanging scroll to be viewed all at once.
- A scroll can be horizontal or vertical, wide or narrow.
- Wrap the ends of a scroll sheet around sticks or twigs, dowels, spools, crayons, straws, or other rod-shaped objects.
- Tie the rolled-up scroll with a cord. Or create a container for it from a film canister, cardboard tube, bottle, or empty flashlight.

Fan
- Make each page a different shape.
- Add different borders to each page.
- Try making a hole in the middle of the pages for a double fan. Or create an irregular fan shape by making a hole a little higher on each page than the previous page.
- Bind the pages together with a nut and bolt, a colored ribbon, a pipe cleaner, a key ring, or some other imaginative object.

Concertina
- Glue several folded sheets together end-to-end for a long concertina.
- Add pockets to the page panels and fill them with pictures, leaves, secret messages, whatever you can think of. Write special words on the panels.
- Gather together several sheets of paper and fold them in half. Stitch the little "booklets" into the concertina folds.
- Fold a narrow concertina for a spine. Attach single pages to the panels created by the folds.

Fig. 9–26 In this scroll, the artist shows us the history and rituals from an imaginary world. Notice how there do not appear to be any words. What art techniques has the artist used to create the images? Inga Hunter, *Imperium Scroll*, 1994. Collage on canvas with a case; etching, woodblock, and linoleum prints; paint and mixed media, 5 1/8" x 39 3/8" (13 x 100 cm). Courtesy of the artist.

Fig. 9–27 Each of these fan books has a distinct theme. Will your fan book have a theme? Or will it break the bounds of theme? Jean Kropper, 1999. Left: *Faces of the World*; Right: *Go Fish*. Left: Collage and beads, 6 1/4" x 2 3/4" (15.9 x 7 cm). Right: Collage, paint chip samples, and beads, 4 3/4" x 1 3/4" (10.8 x 4.5 cm). Courtesy of the artist.

Possibilities

295

More About...

Scrolls—parchment, papyrus, or paper strips joined together into a continuous roll—were common in ancient Greece, Rome, Egypt, Asia, and the Middle East. Each end of the scroll was attached to a stick, around which the scroll was wrapped. A scroll was usually held in the left hand and unrolled horizontally. In cultures that read from right to left, the reader would wind the scroll onto the right stick. Some scrolls were designed to be read from top to bottom. Illustrations were drawn on the back of these scrolls so that an audience in front of the reader could view them. Ancient scrolls were stored in boxes.

Supplies
- papers and fabrics
- paint, markers, pencils
- craft materials (yarn, string, ribbons, sequins, glitter, beads)
- binding materials and tools (awl, large needle, thread, hole punch)
- scissors
- glue, tape, stapler
- found objects (optional)

Pre-Studio Assignment: Encourage students to collect wallpaper, wrapping paper, foils, colored papers, and cardboard.

Supplies for Engage
- examples of fan, concertina, and scroll books
- children's books with unusual bindings or shapes

Teach

Engage
Show students examples of unusual book formats. Tell students that books do not have to be bound rectangles, and that they will create books that stretch their ideas about what books can be.

Using the Text
Have students read pages 294 and 295 and then select one type of book, review the list of possibilities, and make sketches for each idea in the list. Have small "brainstorming" groups share their sketches and try to extend the possibilities with ideas that they generated while sketching or talking with others.

Using the Art
Art Criticism Have students study Figs. 9–25, 9–26, and 9–29. **Ask:** Are these books? How are they like traditional books? How are they different?

Making a Book

Studio Experience

1. Tell students who are making a scroll to mark the end(s) of the scroll to allow space to attach the rods; wrap the end of the paper around the rod and mark where the edge of the paper meets the paper's drawing surface. They should leave blank the area from the mark to the end of the paper.

2. Explain how to expand a concertina with multiple folded sheets, each with a lip for attaching the next section. Instruct students to make covers about 1/2" larger than the pages, for a finished look.

Idea Generators

Ask: What might your book be about? Who will read your book? Will it be for children, a special friend, for yourself? Will your book tell one story, or will it be a collection of facts, images, or memorabilia?

Sketchbook Tip
If possible, show some storyboards to students before they do the Sketchbook Connection. In comic strips, they can see how artists create stories and action in each frame, as well as from one frame to the next.

Sculpture in the Studio
Making Your Book

You Will Need

- papers and fabrics
- art media and tools
- crafts materials
- small found objects
- binding materials and tools
- scissors
- glue
- tape
- stapler

Try This

1. Think of a subject for your book. You can make a book about nature, history, fantasy, alphabets, numbers, stars and planets, a story, dreams, poetry, photographs, religion, culture, anything you want.

2. Choose a format for your book: scroll, concertina, or fan. Which format will show your subject the best? How can you break the bounds of the format?

scroll concertina fan

3. Sketch your ideas. Think of your book as an artwork. Make it as creative and surprising as you can! How big or small will it be? Will it be tall and thin or short and wide? How will the pages be shaped? What will you show on each page? What will your book cover or scroll container look like?

4. As you plan your book, think about materials. What kind, color, and texture of paper will you use? Will you use the same paper on every page or will each be different? Will you tear or cut the edges? What will you make the cover with? What will you bind the book with?

5. When you're happy with your design, start making your book. Carefully create each page or scroll section. Design a cover or container that fits the subject.

6. Bind and finish your book.

Check Your Work

Get together with a few classmates, exchange books, and spend some time looking through them. Then talk about each book separately. How do the subject and design surprise the reader? For example, a book might be designed to open in a unique way, or its words or images might appear in an unexpected order.

Sketchbook Connection
When artists plan an illustrated story or a film, they often create a *storyboard*—a sequence of pictures and words that becomes a "map" for the finished piece. Think of a story you're familiar with or make one up. Create a storyboard that can then become the plan for a book.

Computer Option
Make an animated scroll using multimedia software. Your extraordinary scroll might unroll to reveal pictures, words, and sounds. Think of ways to surprise the viewers of your animated scroll. Who will see your scroll? What possibilities exist?

Teaching Options

Meeting Individual Needs

Adaptive Materials Display different styles of books, and allow students to choose from these formats.

Studio Collaboration

Have groups of students work to create a book. Instruct each group to decide on the book's content, form, and final use. Suggest to students that they donate their books to a local shelter, senior center, or daycare facility.

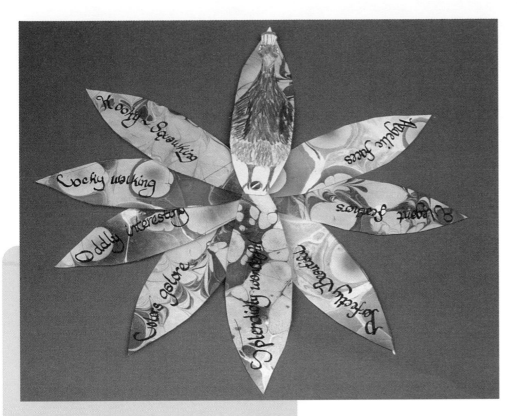

Fig. 9–28 Unusual shapes, calligraphy, and a circular format make this fan book a creative departure from the ordinary. Words that describe the peacock, such as "cocky walking" and "elegant feathers," are written on each tailfeather.
Amanda Hebert, *Peacocks*, 1999.
Marblized paper, colored pencil, calligraphy ink, 9" (23 cm) long, closed. Camel's Hump Middle School, Richmond, Vermont.

Fig. 9–29 Why would you consider this object to be a book? How is it different from a traditional book?
Franca Sonnino, *Sefarim*, 1997.
Cotton, thread, and wire, 11 3/4" x 11 3/4" x 3 1/2" (30 x 30 x 9 cm). Courtesy of the artist.

Possibilities

Computer Option

Hyperstudio allows for scrolling text boxes. If this or other animation software is not available, use any word-processing program to create a "moving message." Have students type only the first letter of the first word of their message; on a new line, below the first letter, repeat that letter and add the second letter; on the next line, repeat the first two letters and add the third letter. Instruct students to continue until three or four words show. Now start slowly removing characters from the beginning of the original word until the desired effect is achieved. To view, spread the rows of text vertically (double-spaced). Close the document window so that only one line of text shows, and scroll down the document—the words will appear to move. Guide students to see that they can repeat and reposition a series of characters as they add to their document, and that they can add surprise words or shapes.

Assess

Check Your Work

Have small groups of students exchange books so that several students read each book. **Ask:** Do the readers understand the message of each book? How could the author make the message clearer? Who would enjoy each book? What does each reader like best about the book?

Close

Ask students if their ideas have changed about what makes a book a book.

More About...

A concertina is the name not only for a type of book, but also for a hexagonal, portable musical instrument with reed organs. Similar to an accordion but smaller, the concertina became popular in Great Britain during the 1800s. **Concertina books** are based on this instrument's accordion folds.

Assessment Options

 Peer Have students place the completed books on a continuum—from artworks that seem *most* like what we normally think of as a book, to artworks that seem *least* like what we normally think of as a book. Next, have students discuss each book, indicating the features that show how it explores the possibilities of a book. For each book, have students ask one question about its subject, and have them suggest ways the book might be improved, if appropriate. As an alternative to the discussion, have each student write comments for each book on a 3" x 5" card. Return the cards to the student artist of each book.

Careers

Invite a curator from a local museum to speak to students about his or her responsibilities and plans for technological implementations at the museum. If possible, arrange a "backstage" tour at the museum, with the curator as the guide.

Daily Life

To encourage students to think about what computer-driven technologies may develop in the future, have students sketch and describe in writing computer-related products they would most like to have in the next ten years.

Connect to...

Daily Life

What was your first experience with a computer? Perhaps it was the use of an early version of a hand-held game or a TV remote control. The technological advances in just your lifetime have been tremendous and speedy, possibly catching your parents off-guard and looking to you for help.

How many **computer devices** do you think you see or use in your daily life? Make a list of those you notice throughout one day. Since many of us take computers for granted, you might be surprised by some of your findings. Remember to include wireless telephones, all

Fig. 9–30 Jim Borgman, *Cincinnati Enquirer* ©1998. Reprinted with special permission of King Features Syndicate.

kinds of remote controls, CD and tape players, clocks, ATMs, and automatic thermostats. Which of these could you least live without? What new possibilities of computer use might be achieved in your future?

Other Arts

Theater

Similar to visual artists' asking "Is it possible?" **theater artists ask "What if …?"** To get an idea for a play, a playwright might ask "What if …?": What if a visually impaired woman overheard the planning of a crime? What if the guests started disappearing from a weekend party?

Actors might ask "What if…?" to figure out how to portray a particular character: What if this character used his hands a lot while talking? What if this character had a funny skip as she walked? By asking "What if …?", theater artists explore possibilities from which they can make artistic choices.

For a scene in a play, create at least three possible story lines by asking a "What if …" question. Write each idea on a separate slip of paper. Put your slips of paper into a bag along with those of your classmates.

Working in groups of four, pick a paper from the bag, and create a scene based on that idea. Take time to plan the scene so that it has a clear beginning, middle, and end. Rehearse the scene several times.

Perform the scene, and ask classmates to complete the original "What if…" question.

Fig. 9–31 These students are improvising a scene from a Cherokee legend. What might be the "What if …" question behind this scene?
Photo courtesy of Carol Cain, Westside Magnet School, LaGrange, Georgia, 1999.

298

Teaching Options

Resources

Teacher's Resource Binder
Using the Web
Interview with an Artist
Teacher Letter

Video Connection

Show the Davis art careers video to give students a real-life look at the career highlighted above.

Community Involvement

For a community or senior center, plan an intergenerational art show with the theme "Possibilities: Working Together Through Art"—with works from several generations of artists alongside student works. Involve students in identifying people in the community to participate in the exhibition. Have students curate the exhibition and prepare labels based on interviews with the artists.

Other Subjects

Language Arts

You can buy **books in electronic form** and then read them on a personal or hand-held computer. Some people think that reading a book on an electronic device will eventually eliminate reading the old-fashioned way, from words printed on bound-together sheets of paper. What do you think will happen? Do you think you would miss reading a book that you can hold?

Science

Did you know that the age of the oldest people now living is about the same as that of the oldest people who lived 1000 years ago? How could that be possible? Due to better nutrition and health care, more people live longer than did people in the past, but the maximum life expectancy for humans remains between 100 and 110 years. What developments do you think will increase life expectancy?

Genetic engineering may offer the possibility of **extending the human life span.** What ethical, religious, and legal problems might this bring?

Fig. 9–32 Maria Izquierdo, *Retrato de Mujer*, 1944.
Watercolor on paper, 20" x 14" (50.7 x 35.5 cm). ©Christie's Images, Ltd, 1999.

Careers

Rapidly advancing computer technologies are creating new possibilities for **museum curators.** Generally, curators are art historians, experts in a particular period or style of art who do scholarly research and writing. They also make recommendations for the purchase of artworks, develop traveling exhibitions, and stay informed of developments in their area of expertise. Because of technology, however, curators must now expand these skills to apply to the Internet. What specific skills do you think museum curators now need to stay current with technology?

Internet Connection
For more activities related to this chapter, go to the Davis website at **www.davis-art.com.**

Language Arts

Ask: Have you ever read a book on-screen? What are the advantages of this way of reading? What are the benefits of reading a book the old-fashioned way? Have students discuss and support with reasons whether they think the practice of reading a book on a computer will eventually eliminate the reading of words printed on paper.

Other Arts

While students are working on their scenes, monitor the groups for understanding and focus. Stress the importance of rehearsing the scene, rather than just talking about it, so as to give a solid performance. After groups have shared their work, ask the audience to critique the scenes. **Ask:** What one moment in the scene worked particularly well? What choices made that moment effective? What meaning did you get from that moment?

Possibilities

299

Internet Resources

Christo and Jeanne-Claude
www.beakman.com/christo/
This fascinating site includes many images of the diverse projects these artists have worked on and are currently working on; also plenty of background information.

Dia Center for the Arts
www.diacenter.org/
Check out artists' Web projects, environmental art, earthworks, and installations, along with contemporary works using more traditional art forms.

Modern Art Museum of Fort Worth
http://www.mamfw.org/menu.htm
Search the collections and view the special exhibitions that focus on modern and contemporary art.

Museum Connection

Invite a museum representative to discuss possible uses of technology in museums of the future. Ask students to prepare questions about new directions in museum planning and to offer suggestions for these museums.

Talking About Student Art

For small-group peer discussions about an exhibit of students' work, have each student write three questions about their own work. The questions should be related in some way to the viewer's perception of the work. Have students share with the rest of the class what they learned from the discussions.

Portfolio Tip

To help students see that growth can be tracked chronologically, encourage them to look for evidence of how their skills, attitudes, and understandings of themes have changed over the course of the year.

Sketchbook Tips

• Have students sketch plans for combining other visual art forms into artworks. Suggest that they label materials and make notes about how they would join the forms.

• Review the value of sketchbooks and journals as research tools, and encourage students to add to their sketchbook beyond the school year.

Portfolio

"I learned that my heritage is very different from others. I looked at some African designs before picking the boy. I painted him like myself. I wanted my pot to mean that my kingdom at night is very calm and motionless." **Jonathan Nickerson**

Fig. 9–33 This student used traditional pot-making techniques to make a statement about his heritage. Jonathan Nickerson, *My Peaceful Kingdom*, 1999.
Low-fired clay, painted with acrylic and sealed with a medium gloss polymer, 5" x 4" (13 x 10 cm). Sweetwater Middle School, Sweetwater, Texas.

Fig. 9–34 When planning a maquette sculpture for a public place, this student thought of a dragon. He pictured it "in a mini golf course. It is supposed to be one of the obstacles for the holes." Josh Gross, *Dragon*, 1999.
Clay, acrylic paint, 8" (20 cm) long x 3.5" (9 cm) tall. Plymouth Middle School, Plymouth, Minnesota.

CD-ROM Connection
To see more student art, check out the Global Pursuit Student Gallery.

"We were to study a student's face and look for one major characteristic. When I drew my caricature, I was supposed to make that feature stand out. I liked using my sense of humor in drawing. But creating caricatures isn't so easy because you have to be sensitive to the feelings of the person you are drawing." **Elizabeth Miles**

Fig. 9–35 Elizabeth Miles, *Untitled*, 1999.
Marker, colored pencil, 12" x 18" (30 x 46 cm). Avery Coonley School, Downers Grove, Illinois.

Teaching Options

Resources

Teacher's Resource Binder
 Chapter Review 9
 Portfolio Tips
 Write About Art
 Understanding Your Artistic Process
 Analyzing Your Studio Work

CD-ROM Connection

Additional student works related to studio activities in this chapter can be used for inspiration, comparison, or criticism exercises.

Chapter 9 Review

Recall

What are two ways that sculptors explored possibilities in the last half of the twentieth century? *(example below)*

Understand

Explain how the impact of mass communication in our global village has affected the look of art around the world at the end of the twentieth century.

Apply

Use a small, discarded, ordinary object—such as a paper clip, old spoon, golf ball, toy car—as the basis for a public sculpture. Alter the object in some way, mount it on a base, and display it within a diorama to give a sense of the new proportion and scale.

Analyze

Make a collection of editorial cartoons from newspapers and magazines. Analyze how the artists have manipulated proportion and scale to make their points.

Synthesize

Compose a poem, or rap, about the many different art styles that emerged in the last half of the twentieth century. Do research on several styles, identifying a major artist and characteristics of each style. Present your research findings through rhyme.

Evaluate

Pose the advantages and disadvantages of the globalization of art styles around the world from two perspectives: 1) We all live in a global village and readily move across cultural boundaries. 2) Every culture is unique and cultural traditions should be preserved.

Page 286

For Your Portfolio

By studying your portfolio entries, you can see your growing ability to create artworks. To see your improvement in presenting meaningful themes, choose four portfolio artworks from among the theme chapters (1–9). For each piece, write a paragraph that explains why the piece is a good example of focus on a theme.

For Your Sketchbook

Study the artworks in each chapter's Global View lesson. On a page in your sketchbook, draw a simple object, such as an apple, in the style of each global area.

Advocacy

For interdisciplinary learning about the value of art in society, ask language-arts teachers and computer specialists to assist students in preparing a presentation using Powerpoint or similar software. Present the program to community groups.

Family Involvement

Involve family members in helping you collect creative junk—usable discards, from the home and the workplace, that can be used in the art program. To aid their search, send home a list of possibilities.

Chapter 9
Review Answers
Recall

They experimented with new materials, such as industrial materials, and new ways of displaying their work, such as installations and earthworks.

Understand

Artists learned quickly how other artists were using materials and techniques to make art. Artwork from around the world began to look more and more alike.

Apply

Check that students understand that changes in scale and proportion will alter the meaning of artwork.

Analyze

Check students' work for an understanding of the use and purpose of exaggeration, distortion, and the like.

Synthesize

Look for an understanding of specific styles, appropriate associations, and correct terminology.

Evaluate

(1) Advantage: The art from any geographical area can easily be understood by people around the globe. Disadvantage: The potential exists for losing a sense of tradition and cultural diversity. (2) Advantage: People can retain pride in their heritage. Disadvantage: Art doesn't reflect global changes and modernization.

Reteach

Have students interview members of the school or local community about changes they have seen in their lifetime that they never dreamed possible (such as the Internet, TV, cell phones, space exploration, and jet travel). Have students use selected quotations from the interviews in a technological presentation (multimedia, video, photo-essay) titled "Possibilities."

Possibilities

301

Acknowledgments

We wish to thank the many people who were involved in the preparation of this book. First of all, we wish to acknowledge the many artists and their representatives who provided both permission and transparencies of their artworks. Particular thanks for extra effort go to Michael Slade at Art Resource, The Asian Art Museum, Roberto Prcela at The Cleveland Museum of Art, Anne Coe, Kenneth Haas, Charles McQuillen, Paul Nagano, Claes Oldenburg/Coosje Van Bruggen Studio, Bonnie Cullen at The Seattle Art Museum, and Bernice Steinbaum.

For her contributions to the Curriculum and Internet Connections, we wish to thank Nancy Walkup. For contributing connections to the performing arts, we thank Ann Rowson, Kathy Blum, and Lee Harris of the Southeast Institute for Education in the Arts. We offer special thanks for the invaluable research assistance provided by Kutztown University students Amy Bloom, Karen Stanford, and Joel Train and the staff at Kutztown University Library. Abby Remer's and Donna Pauler's writing and advice were greatly appreciated. Sharon Seim, Judy Drake, Kaye Passmore and Jaci Hanson were among the program's earliest reviewers, and offered invaluable suggestions. We also wish to acknowledge the thoughtful and dynamic contributions made to the Teacher's Edition by Kaye Passmore.

We owe an enormous debt to the editorial team at Davis Publications for their careful reading and suggestions for the text, their arduous work in photo and image research and acquisition, and their genuine spirit of goodwill throughout the entire process of producing this program. Specifically, we mention Colleen Strang, Jane Reed, Mary Ellen Wilson, Nancy Burnett, and Nancy Bedau. Carol Harley, our consistently upbeat "point person" on the project, provided thoughtful and substantive assistance and support.

Our editors, Claire Golding and Helen Ronan, carefully guided the creation of the program, faithfully attending to both its overall direction and the endless stream of details that emerged en route to its completion. We thank them for their trust and good faith in our work and for the spirit of teamwork they endorsed and consistently demonstrated.

For his trust in us, his vision and enthusiasm for the project, and for his willingness to move in new directions, we thank Wyatt Wade, President of Davis Publications.

Although neither of us has had the privilege of being her student in any formal setting, we owe our grounding in the theory and practice of art education to the scholarship of Laura Chapman. She has been both mentor and friend to each of us throughout the years and especially in this project. We thank her for her loyal support and for providing us the opportunity to continue her work in art curriculum development in this program.

We offer sincere thanks to the hundreds of art teachers who have inspired us throughout the years with their good thinking and creative teaching. We also acknowledge our colleagues at Kutztown University, Penn State University, Ohio State University and other institutions who have contributed to our understanding of teaching and learning.

Finally, we wish to thank our families, especially Adrienne Katter and Deborah Sieger, who have provided loving support and balance in our lives during the preparation of this book.

Eldon Katter
Marilyn Stewart

Educational Consultants
Numerous teachers and their students contributed artworks and writing to this book, often working within very tight timeframes. Davis Publications and the authors extend sincere thanks to:

Louisa Brown, Atlanta International School, Atlanta, Georgia
Monica Brown, Laurel Nokomis School, Nokomis, Florida
Doris Cormier, Turkey Hill Middle School, Lunenburg, Massachusetts
Cappie Dobyns, Sweetwater Middle School, Sweetwater, Texas
Reginald Fatherly, Andrew G. Curtin Middle School, Williamsport, Pennsylvania
Donna Foeldvari, Reading-Fleming Middle School, Flemington, New Jersey
Diane Fogler, Copeland Middle School, Rockaway, New Jersey
Carolyn Freese, Yorkville Middle School, Yorkville, Illinois
Cathy Gersich, Fairhaven Middle School, Bellingham, Washington
Connie Heavey, Plum Grove Junior High School, Rolling Meadows, Illinois
Mary Ann Horton, Camel's Hump Middle School, Richmond, Vermont
Craig Kaufman, Andrew G. Curtin Middle School, Williamsport, Pennsylvania
Darya Kuruna, McGrath School, Worcester, Massachusetts
Karen Lintner, Mount Nittany Middle School, State College, Pennsylvania
Betsy Logan, Samford Middle School, Auburn, Alabama

Publisher:
Wyatt Wade

Editorial Directors:
Claire Mowbray Golding, Helen Ronan

Editorial/Production Team:
Nancy Burnett, Carol Harley, Mary Ellen Wilson

Editorial Assistance:
Laura Alavosus, Frank Hubert, Victoria Hughes, David Payne, Lynn Simon

Illustration:
Susan Christy-Pallo, Stephen Schudlich

Artist Guide

Sallye Mahan-Cox, Hayfield Secondary School, Alexandria, Virginia
Patti Mann, T. R. Smedberg Middle School, Sacramento, California
Deborah A. Myers, Colony Middle School, Palmer, Alaska
Gary Paul, Horace Mann Middle School, Franklin, Massachusetts
Lorraine Pflaumer, Thomas Metcalf School, Normal, Illinois
Sandy Ray, Johnakin Middle School, Marion, South Carolina
Amy Richard, Daniel Boone Middle School, Birdsboro, Pennsylvania
Connie Richards, William Byrd Middle School, Vinton, Virginia
Katherine Richards, Bird Middle School, Walpole, Massachusetts
Susan Rushin, Pocono Mountain Intermediate School South, Swiftwater, Pennsylvania
Roger Shule, Antioch Upper Grade, Antioch, Illinois
Betsy Menson Sio, Jordan-Elbridge Middle School, Jordan, New York
Karen Skophammer, Manson Northwest Webster Community School, Barnum, Iowa
Evelyn Sonnichsen, Plymouth Middle School, Maple Grove, Minnesota
Ann Titus, Central Middle School, Galveston, Texas
Sindee Viano, Avery Coonley School, Downers Grove, Illinois
Karen Watson-Newlin, Verona Area Middle School, Verona, Wisconsin
Shirley W. Whitesides, Asheville Middle School, Asheville, North Carolina
Frankie Worrell, Johnakin Middle School, Marion, South Carolina

Photo Acquisitions:
Colleen Strang, Jane Reed, The Visual Connection, Mary Ellen Wilson, Rebecca Benjamin

Student Work Acquisitions:
Nancy Bedau

Design:
Douglass Scott, Cara Joslin, WGBH Design

Manufacturing:
Georgiana Rock, April Dawley

Affandi (ah-FAHN-dee) Indonesia, 1907–1991
Anasazi culture (ah-nah-SAH-zee) US
Anguissola, Sofonisba (ahn-gwee-SOH-lah, so-fahn-EES-bah) Italy, 1527-1625
Anthemius of Tralles (an-tem-ee-us of TRA-less) Turkey, c.474–c.534
Asante culture (ah-sahn-tee) Ghana
Atget, Eugène (aht-zhay, oo-zhen) France, 1857–1927
Aztec culture (AZ-tek) Mexico
Balla, Giacomo (BAHL-lah, JAH-ko-mo) Italy, 1871–1958
Bancroft, Bronwyn (BANG-kroft, BRAHN-win) Australia, b. 1968
Bartlett, Jennifer US, 1941
Bayer, Herbert (BUY-ur, HUR-burt) Austria, 1900–1985
Bearden, Romare (BEER-dun, ro-MAIR) US, 1912–1988
Benin culture (beh-NEEN) Nigeria
Bernini, Gianlorenzo (bair-NEE-nee, jon-loe-REN-zoh) Italy, 1598–1680
Besler, Basil (BAYZ-ler, BAH-zel) Germany, 1561–1629
Bete culture (be-tay) Ivory Coast
Boffrand, Germain (BOHF-frahnd, zher-men) France, 1667–1754
Bonheur, Rosa (bon-ER, roh-zah) France, 1822–1899
Brancusi, Constantin (BRAN-koo-zee, KON-stahn-teen) Rumania, 1876–1956
Bravo, Claudio (BRAH-vo, KLAU-dee-o) Chile, b.1936
Bruegel, Pieter (BRUE-gul, PEE-tehr) Flanders, c.1525–1569
Burson, Nancy US, b.1948
Cahuilla culture (ke-WEE-ah) California, US
Canal, Giovanni Antonio (known as Canaletto) (kah-NAHL, jo-VAHN-nee ahn-TON-yo) Italy, 1697–1768
Cassatt, Mary (kuh-SAT, MAIR-ee) US, 1844–1926
Cézanne, Paul (say-ZAHN, pol) France, 1839–1906
Chagall, Marc (sha-GAHL, mark) Russia, 1887–1985
Chand, Nek (tchand, nek) India, 21st century
Chapman, Neil US, b.1930
Chardin, Jean-Baptiste Siméon (shar-DA, zhahn-bah-TEEST see-may-OHN) France, 1699–1779

Chen, Georgette (tchen, jor-JET) Singapore, 1907–1993
Cherokee culture (CHER-eh-kee) US
Chespak, Ron US, b.1960
Choctaw culture (chahk-taw) US
Christo and Jeanne-Claude (KREES-toh, ZHUN-klohd) Bulgaria and Morocco, both b.1935
Coe, Anne US, b.1949
Colima culture (ko-lee-ma) Mexico
Constable, John England, 1776–1837
Courbet, Gustave (koor-BAY, GUEWS-tahv) France, 1819–1877
Dali, Salvador (DAH-lee, SAHL-vah-dor) Spain, 1904–1989
Dan culture Ivory Coast, Liberia
D.A.ST. (Danae Stratou, b.1964; Alexandra Stratou, Stella Constantinides) Greece, 21st century
Daumier, Honoré (DOHM-yay, OH-no-ray) France, 1808–1879
David, Jaques-Louis (da-veed, zhak-loo-ee) France, 1748–1825
Degas, Edgar (deh-gah, ed-gahr) France, 1834–1917
Delacroix, Eugène (deh-lah-krwa, oo-zhen) France, 1798–1860
Delaunay, Sonia Terk (deh-lo-nay, SON-yah terk) France, 1885–1979
Derain, André (deh-ra, ahn-dray) France, 1880–1954
Dohachi, Ninnami (doe-ha-chee, nin-na-mee) Japan, 1783–1855
Dürer, Albrecht (DUR-er AHL-brekt) Germany, 1471–1528
Edo culture (eh-DO) Nigeria
Ernst, Max (airnst, mahks) Germany, 1891–1976
Escobedo, Helen (es-ko-VAY-tho, ay-LEN) Mexico, b.1936
Ferrata, Ercole (fair-RA-ta, AIR-ko-lay) Italy, 1610–1686
Finster, Howard US, b.1916
Flack, Audrey US, b.1931
Fogle, Clayton US, b.1956
Frade, Ramon (FRA-day, RA-mohn) Puerto Rico, 1875–1954
Frankenthaler, Helen (FRANG-kun-thah-lur, HEL-un) US, b.1928
Friedrich, Caspar David (FREED-rik, KAS-par DA-vit) Germany, 1774–1840
Fumio, Kitaoka (foo-me-oh, kee-tah-oh-ka) Japan, b.1918
Garza, Carmen Lomas (GAR-tha, CAR-men LO-mahs) US, b. 1948
Gaudi, Antonio (gow-dee, an-toh-nee-o) Spain, 1852–1916

Gauguin, Paul (go-GAN, pol) France, 1848–1903

Giselbertus (zhis-ul-BER-tus) France, 12th century

Goldsworthy, Andy England, b.1956

Graves, Nancy US, 1940-1995

Grofé, Ferde (Ferdinand Rudolph von Grofé) (GRO-fay, FAIR-day) US, 1892–1972

Grooms, Red US, b. 1937

Groover, Jan (GRU-vur, jan) US, b.1943

Gutiérrez, Yolanda (goo-tee-AIR-rez, yo-LAHN-da) Mexico, b.1970

Haas, III, Kenneth B. (hahs, ken-nuth) US, b.1954

Haida culture (hi-deh) British Columbia, Canada

Hammons, David US, b.1943

Harunobu, Suzuki (har-roo-NO-boo, soo-zoo-kee) Japan, 1725–1770

Haydon, Harold US, 1909–1994

Heem, Jan Davidsz de (haym, yahn DAH-vits deh) Holland, 1606–1684

Hepworth, Barbara England, 1903–1975

Hiroshige, Ando (hee-ro-shee-gay, ahn-do) Japan, 1797–1858

Hnizdovsky, Jacques (hniz-DOFF-ski, zhak) US, b.1915

Höch, Hannah (hoek, HAHN-nah) Germany, 1889–1978

Hockney, David England, b.1937

Hokusai, Katsushika (ho-koo-sy, kaht-soo-shee-kah) Japan, 1760–1849

Holst, Gustav (holst, GOO-stahf) England, 1874–1934

Hooch, Pieter de (hoak, PEE-tehr duh) Holland, 1629–1684

Hopper, Edward US, 1882–1967

Hunter, Inga (HUN-ter, ING-ga) Africa, b.1938

Ife culture (EE-fay) Nigeria

Ikenobo, Sen'ei (ee-ken-o-bo, sen-a-yee) Japan, b.1933

Iktinus (ICK-tih-nus) Greece, active 450–420 BC

Inca culture (ING-keh) Peru

Ingres, Jean-Auguste-Dominique (aingr, zhahn-oh-goost-doe-mee-neek) France, 1780–1867

Isidorus of Miletus (iz-i-dor-us of mi-LAY-tus) Turkey, died c.540

Izquierdo, Maria (ees-KYER-doe, ma-REE-ah) Mexico, 1902–1955

James, J. Michael US, b.1946

Jefferson, Thomas US, 1743–1826

Kahlo, Frida (KAH-lo, FREE-dah) Mexico, 1907–1954

Kallikrates (ka-LI-cra-tees) Greece, 5th century BC

Kammeraad, Lori US, b. 1955

Kauffmann, Angelica (KAWF-mahn, an-GAY-le-kah) Switzerland, 1741–1807

Kazuo, Hiroshima (ka-zoo-oh, he-ro-she-ma) Japan, b.1919

Kelly, Ellsworth (KEL-ee, ELZ-wurth) US, b.1923

Kidder, Christine US, b. 1963

Koetsu, Honami (ko-way-tzu, ho-nah-mee) Japan, 1558–1637

Kollwitz, Käthe (KOHL-vits, KAY-teh) Germany, 1867–1945

Kongo culture (kahn-go) Congo Republic, Democratic Republic of the Congo, Angola

Krahn culture (krahn) Liberia

Krasner, Lee (KRAZ-nur, lee) US, 1908–1984

Kropper, Jean US, 21st century

Kruger, Barbara (KROO-ger, BAHR-bu-ruh) US, b.1945

Kuba culture (koo-bah) Democratic Republic of the Congo

Kwakiutl culture (KWAH-kee-oo-tel) Canada

Lackow, Andy US, b. 1953

Lawrence, Jacob US, b.1917

Leonardo da Vinci (lay-oh-NAR-doh dah VIN-chee) Italy, 1452–1519

Leyster, Judith (LY-stir, YOO-deet) Holland, 1609–1660

Lichtenstein, Roy (LICK-ten-stine, roy) US, 1923–1997

MacDonald-Wright, Stanton US, 1890–1973

Maori culture (mou-ree) New Zealand

Martorell, Antonio (mahr-toh-REL, ahn-TON-yo) Puerto Rico, b.1939

Masaccio (ma-ZAHT-cho) Italy, 1401–c.1428

Matisse, Henri (mah-TEESS, ahn-REE) France, 1869–1954

Maya (my-ah) Mexico

McQuillen, Charles US, b. 1962

Melchior, Johann Peter (mel-kee-or, yo-han pay-ter) Germany, 1747–1825

Memkus, Frank US, 1895–1965

Mendez, Leopoldo (MEN-des, lay-o-POL-do) Mexico, 1902–1969

Merian, Maria Sibylla (MAY-ree-ahn, mah-REE-ah SEE-be-lah) Germany, 1647–1717

Metsys, Quentin (met-seese, KWEN-tin) Netherlands, c.1465–1530

Metzelaar, L. (met-ze-lair) Indonesia, 20th century

Michelangelo Buonarroti (mee-kel-AN-jay-loh bwo-na-ROH-tee) Italy, 1475–1564

Mies van der Rohe, Ludwig (mees van der ROAH, LOOD-vig) Germany, 1886–1969

Millet, Jean-François (mee-lay, zhahn-fran-swah) France, 1814–1875

Mimbres people (mim-brayz) New Mexico

Mitchell, Joan US, 1926–1992

Moche culture (mo-kay) Peru

Monet, Claude (moh-nay, kload) France, 1840–1926

Moran, Thomas (muh-RAN, TOM-us) US, 1837–1926

Morisot, Berthe (mo-ree-zoh, bert) France, 1841–1895

Myron (MY-ron) Greece, 5th century BC

Nabageyo, Bruce (na-ba-ge-yo) Australia, b.1949

Nahl, Charles Christian US, 1818–1878

Nalo, Joe (na-lo) Papua New Guinea, 21st century

Natzler, Gertrude and Otto (NATZ-lur, ger-trood, ot-toh) Austria–US, 1908–1971 (Gertrude), b.1908 (Otto)

Navajo culture (NAV-ah-ho) Southwestern US

Nevelson, Louise (NEV-ul-sun, loo-EEZ) Russia, 1899–1988

Ninsei, Nonomura (nin-say, no-no-mura) Japan, died 1695

Nok culture (noek) Nigeria

Nuu-Chah-Nulth culture (nu-cha-nuhlth) Canada

Okakoto (oh-ka-ko-toh) Japan, early 19th century

O'Keeffe, Georgia US, 1887–1986

Oldenburg, Claes (OLD-en-burg, klayss) Sweden, b. 1929

Ortakales, Denise (or-ta-KA-less) US, b. 1958

Paracas culture (pah-ROCK-us) Peru

Park, Jau Hyun (park, jow-hyun) Korea, b.1960

Patrick, Alice US, 21st century

Peeters, Clara (PAY-turs, KLAH-rah) Flanders, 1594–1657

Pei, I.M. (pay) China, b.1917

Peláez, Amelia (pay-LAH-es, ah-MEH-yah) Cuba, 1897–1968

Picasso, Pablo (pee-KAHS-so, PAHV-lo) France, 1881–1973

Pickering, Mary Carpenter US, 1831–1900

Piero della Francesca (PYAY-roh DEL-lah fran-CHES-kah) Italy, c.1410–1492

Popova, Liubov (puh-PO-vuh, lyu-BOF) Russia, 1889–1924

Praetorius, Michael (pray-TOR-ius, mic-HI-el) Germany, 1571–1621

Puryear, Martin (PUR-yeer, MAHR-tin) US, b.1941

Raphael (RA-fah-ell) Italy, 1483–1520

Rembrandt van Rijn (REM-brant van rhine) Netherlands, 1606–1669

Renoir, Pierre-Auguste (ren-wahr, pyer oh-goost) France, 1841–1919

Ringgold, Faith US, b.1934

Rivera, Diego (re-VAY-rah, dee-AY-go) Mexico, 1886–1957

Robinson, Rene Australia, b. early 1960s

Rossini, Gioacchino (roes-SI-ni, jo-AHK-ki-no) Italy, 1792–1868

Rubins, Nancy US, 20th century

Saar, Alison (sahr, AL-e-sun) US, b.1956

Samuels, Jeffrey Australia, 20th century

Savage, Augusta US, 1892–1962

Sayyid-Ali, Mir (sai-yid-ali, meer) Persia, active c.1525–1543

Schapiro, Miriam (shuh-PEER-oh, MEER-ee-um) US/ Canada, b.1923

Scharf, Kenny (sharf, KEN-nee) US, b.1958

Schiltz, Rand (shiltz, rand) US, b. 1950

Seurat, Georges (ser-rah, zhorzh) France, 1859–1891

Sewell, Leo (SOO-ull, LEE-oh) US, b.1945

Sheeler, Charles US, 1883–1965

Sikander, Shahzia (see-kan-der, sha-zia) Pakistan, b. 1969

Smith, Jaune Quick-to-See (smith, zhoan kwik-too-see) US, b.1940

Soami (so-ah-mi) Japan, c.1485–1525

Sonnino, Franca (sohn-NEE-no, frahn-ka) Italy, 21st century

Sotatsu, Tawaraya (so-tat-su, ta-wa-ra-ya) Japan, active 1620s–1640s

Stahlecker, Karen US, b. 1954

Stella, Frank US, b.1936

Storm, Howard US, b. 1946

Teokolai, Maria (TAYO-ko-li, mah-ree-a) New Zealand, 21st century

Tjangala, Keith Kaapa (jan-ga-la) Australia, 21st century

Tooker, George US, b.1920

Toulouse-Lautrec, Henri de (too-looz low-trek, ahn-ree deh) France, 1864–1901

Turkana culture (tur-KA-na) Kenya

Turner, J.M.W. England, 1775–1850

Utamaro, Kitagawa (oo-ta-ma-roh, kih-ta-ga-wa) Japan, 1753–1806

Van Brekelenkam, Quirijn (fahn BREK-len-kahm, kee-rhine) Netherlands, 1620–1669

Van Bruggen, Coosje (fahn bruhk-ken, coo-sia) Netherlands, b. 1942

Vandenberge, Peter (VAN-den-berg) US, b. 1939

van Gogh, Vincent (vahn GO, VIN-sent) Holland, 1853–1890

Van Vliet, Claire (vahn vleet, clair) US, b.1933

Velázquez, Diego (vay-LAHS-kess, dee-AY-go) Spain, 1590–1660

Vermeer, Jan (ver-MAIR, yahn) Holland, 1632–1675

Vigee-Lebrun, Marie Elizabeth (vee-zhay leh-brun, mah-ree ay-lee-sah-bet) France, 1755–1842

Voisin, Charles (vwah-ZEN, sharl) France, 1685–1761

von Brusky, Sonia (von BRU-ski) Brazil, 21st century

WalkingStick, Kay US, b.1935

Waring, Laura Wheeler US, 1887–1948

Watler, Barbara W. US, b.1932

Weston, Edward US, 1886–1958

Winsor, Jackie Canada, b.1941

Wright, Frank Lloyd US, 1867–1959

Yaure peoples (yaw-ray) Ivory Coast

Yepa, Filepe (YAY-pah, fee-lee-PAH) Jemez Pueblo, New Mexico, early 20th century

Yetmgeta, Zerihun (YET-m-geta, ZEHR-hun) Ethiopia, b. 1941

Ying, Ch'iu (ying, chee-yoo) China, c.1510–1551

Yoruba culture (YOH-roo-bah) Nigeria

Yu'pik (Inuit) **culture** (YOO-pik) US and Siberia

Zhi, Lu (she, loo) China, 1496–1576

Zuni (zoo-nee) New Mexico

World Map

The best way to see what the world looks like is to look at a globe. The problem of showing the round earth on a flat surface has challenged mapmakers for centuries. This map is called a Robinson projection. It is designed to show the earth in one piece, while maintaining the shape of the land and size relationships as much as possible. However, any world map has distortions.

This map is also called a *political* map. It shows the names and boundaries of countries as they existed at the time the map was made. Political maps change as new countries develop.

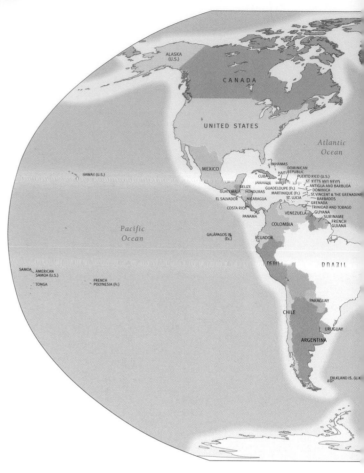

Key to Abbreviations

ALB.	Albania
AUS.	Austria
B.-H.	Bosnia-Hercegovina
BELG.	Belgium
CRO.	Croatia
CZ. REP.	Czech Republic
EQ. GUINEA	Equatorial Guinea
HUNG.	Hungary
LEB.	Lebanon
LITH.	Lithuania
LUX.	Luxembourg
MAC.	Macedonia
NETH.	Netherlands
RUS.	Russia
SLOV.	Slovenia
SLVK.	Slovakia
SWITZ.	Switzerland
YUGO.	Yugoslavia

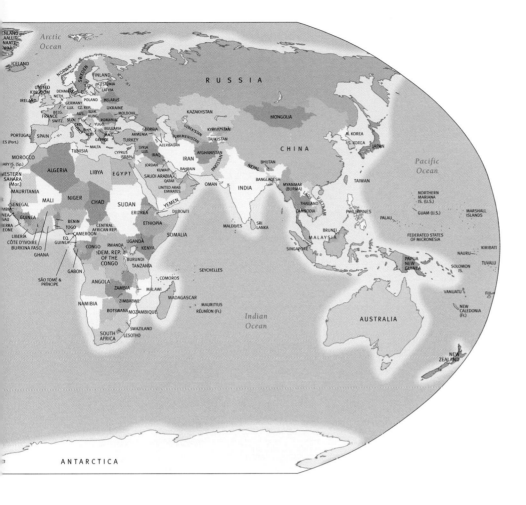

Color Wheel

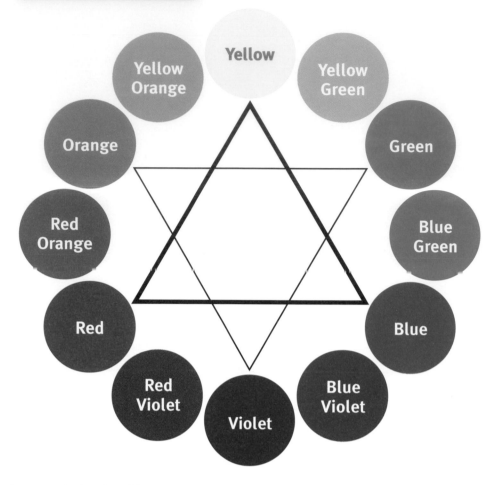

For easy study, the colors of the spectrum are usually arranged in a circle called a **color wheel**. Red, yellow, and blue are the three **primary colors** or hues. All other hues are made by mixing different amounts of these three colors.

If you mix any two primary colors, you will produce one of the three **secondary colors**. From experience, you probably know that red and blue make violet, red and yellow make orange, and blue and yellow make green. These are the three secondary colors.

The color wheel also shows six **intermediate colors**. You can create these by mixing a primary color with a neighboring secondary color. For example, yellow (a primary color) mixed with orange (a secondary color) creates yellow-orange (an intermediate color). Mixing the primary and secondary colors creates the six intermediate colors shown. Mixing different amounts of these colors produces an unlimited number of hues.

Bibliography

Aesthetics

Grimshaw, Caroline. *Connections: Art.* Chicago, IL: World Book, 1996.

Magee, Brian. *The Story of Philosophy.* NY: DK Publishing, 1998.

Varnedoe, Kirk. *A Fine Disregard: What Makes Modern Art Modern.* NY: Harry N. Abrams, Inc., 1994.

Weate, Jeremy. *A Young Person's Guide to Philosophy.* NY: DK Publishing, 1998.

Art Criticism

Antoine, Veronique. *Artists Face to Face.* Hauppauge, NY: Barron's, 1996.

Cumming, Robert. *Annotated Art.* NY: DK Publishing, 1998.

Franc, Helen M. *An Invitation to See: 150 Works from the Museum of Modern Art.* NY: Harry N. Abrams, Inc., 1996.

Greenberg, Jan and Sandra Jordan. *The American Eye.* NY: Delacorte, 1995.

---------------. *The Painter's Eye.* NY: Delacorte, 1991.

---------------. *The Sculptor's Eye.* NY: Delacorte, 1993.

Richardson, Joy. *Looking at Pictures: An Introduction to Art for Young People.* NY: Harry N. Abrams, Inc., 1997.

Rosenfeld, Lucy Davidson. *Reading Pictures: Self-Teaching Activities in Art.* Portland, ME: J. Weston Walch, 1991.

Roukes, Nicholas. *Humor in Art: A Celebration of Visual Wit.* Worcester, MA: Davis Publications, 1997.

Welton, Jude. *Looking at Paintings.* NY: DK Publishing, 1994.

Yenawine, Philip. *How to Look at Modern Art.* NY: Harry N. Abrams, Inc., 1991.

Art History
General

Barron's Art Handbook Series. *How to Recognize Styles.* Hauppauge, NY: Barron's, 1997.

Belloli, Andrea. *Exploring World Art.* Los Angeles, CA: The J. Paul Getty Museum, 1999.

D'Alelio, Jane. *I Know That Building.* Washington, DC: The Preservation Press, 1989.

Gebhardt, Volker. *The History of Art.* Hauppauge, NY: Barron's, 1998.

Hauffe, Thomas. *Design.* Hauppauge, NY: Barron's, 1996.

Janson, H.W. and Anthony F. Janson. *History of Art for Young People.* NY: Harry N. Abrams, Inc., 1997.

Remer, Abby. *Pioneering Spirits: The Life and Times of Remarkable Women Artists in Western History.* Worcester, MA: Davis Publications, 1997.

Stevenson, Neil. *Annotated Guides: Architecture.* NY: DK Publishing, 1997.

Thiele, Carmela. *Sculpture.* Hauppauge, NY: Barron's, 1996.

Wilkinson, Philip and Paolo Donati. *Amazing Buildings.* NY: DK Publishing, 1993.

Ancient World

Corbishley, Mike. *What Do We Know About Prehistoric People.* NY: Peter Bedrick Books, 1994.

Cork, Barbara and Struan Reid. *The Usborne Young Scientist: Archaeology.* London: Usborne Press, 1991.

Crosher, Judith. *Ancient Egypt.* NY: Viking, 1993.

Fleming, Stuart. *The Egyptians.* NY: New Discovery, 1992.

Giblin, James Cross. *The Riddle of the Rosetta Stone.* NY: Thomas Y. Crowell, 1990.

Haslam, Andrew, and Alexandra Parsons. *Make It Work: Ancient Egypt.* NY: Thomsom Learning, 1995.

Millard, Anne. *Pyramids.* NY: Kingfisher, 1996.

Morley, Jacqueline, Mark Bergin, and John Hames. *An Egyptian Pyramid.* NY: Peter Bedrick Books, 1991.

Powell, Jilliam. *Ancient Art.* NY: Thomsom Learning, 1994.

Classical World

Avi-Yonah, Michael. *Piece by Piece! Mosaics of the Ancient World.* Minneapolis, MN: Runestone Press, 1993.

Bardi, Piero. *The Atlas of the Classical World.* NY: Peter Bedrick Books, 1997.

Bruce-Mitford, Miranda. *Illustrated Book of Signs & Symbols.* NY: DK Publishing, 1996.

Chelepi, Chris. *Growing Up in Ancient Greece.* NY: Troll Associates, 1994.

Cohen, Daniel. *Ancient Greece.* NY: Doubleday, 1990.

Corbishley, Mike. *Ancient Rome.* NY: Facts on File, 1989.

Corbishley, Mike. *Growing Up in Ancient Rome.* NY: Troll Associates, 1993.

Hicks, Peter. *The Romans.* NY: Thomson Learning, 1993.

Loverance, Rowena and Wood. *Ancient Greece.* NY: Viking, 1993.

MacDonald, Fiona. *A Greek Temple.* NY: Peter Bedrick Books, 1992.

McCaughrean, G. *Greek Myths.* NY: Margaret McElderry Books, 1992.

Roberts, Morgan J. *Classical Deities and Heroes.* NY: Friedman Group, 1994.

Wilkinson, Philip. *Illustrated Dictionary of Mythology.* NY: DK Publishing, 1998.

Williams, Susan. *The Greeks.* NY: Thomson Learning, 1993.

The Middle Ages

Cairns, Trevor. *The Middle Ages.* NY: Cambridge University Press, 1989.

Caselli, Giovanni. *The Middle Ages.* NY: Peter Bedrick Books, 1993.

Chrisp, Peter. *Look Into the Past: The Normans.* NY: Thomson Learning, 1995.

Corrain, Lucia. *Giotto and Medieval Art.* NY: Peter Bedrick Books, 1995.

Howarth, Sarah. *What Do We Know About the Middle Ages.* NY: Peter Bedrick Books, 1995.

MacDonald, Fiona. *A Medieval Cathedral.* NY: Peter Bedrick Books, 1994.

Mason, Antony. *If You Were There in Medieval Times.* NY: Simon & Schuster, 1996.

Robertson, Bruce. *Marguerite Makes a Book.* Los Angeles, CA: The J. Paul Getty Museum, 1999.

Renaissance

Corrain, Lucia. *Masters of Art: The Art of the Renaissance.* NY: Peter Bedrick Books, 1997.

Di Cagno, Gabriella et al. *Michelangelo.* NY: Peter Bedrick Books, 1996.

Dufour, Alessia Devitini. *Bosch.* ArtBook Series. NY: DK Publishing, 1999.

Fritz, Jean, Katherine Paterson, et. al. *The World in 1492.* NY: Henry Holt & Co., 1992.

Giorgi, Rosa. *Caravagio.* ArtBook Series. NY: DK Publishing, 1999.

Harris, Nathaniel. *Renaissance Art.* NY: Thomson Learning, 1994.

Herbert, Janis. *Leonardo da Vinci for Kids.* Chicago: Chicago Review Press, 1998.

Howarth, Sarah. *Renaissance People.* Brookfield, CT: Millbrook Press, 1992.

---------------. *Renaissance Places.* Brookfield, CT: Millbrook Press, 1992.

Leonardo da Vinci. ArtBook Series. NY: DK Publishing, 1999.

McLanathan, Richard. *First Impressions: Leonardo da Vinci.* NY: Harry N. Abrams, Inc., 1990.

---------------. *First Impressions: Michelangelo.* NY: Harry N. Abrams, Inc., 1993.

Medo, Claudio. *Three Masters of the Renaissance: Leonardo, Michelangelo, Raphael.* Hauppauge, NY: Barron's, 1999.

Milande, Veronique. *Michelangelo and His Times*. NY: Henry Holt & Co., 1995.

Muhlberger, Richard. *What Makes a Leonardo a Leonardo?* NY: Viking, 1994.

---------------. *What Makes a Raphael a Raphael?* NY: Viking, 1993.

Murray, Peter and Linda. *The Art of the Renaissance*. NY: Thames and Hudson, 1985.

Piero della Francesca. ArtBook Series. NY: DK Publishing, 1999.

Richmond, Robin. *Introducing Michelangelo*. Boston, MA: Little, Brown, 1992.

Romei, Francesca. *Leonardo da Vinci*. NY: Peter Bedrick Books, 1994.

Spence, David. *Michelangelo and the Renaissance*. Hauppauge, NY: Barron's, 1998.

Stanley, Diane. *Leonardo da Vinci*. NY: William Morrow, 1996.

Wood, Tim. *The Renaissance*. NY: Viking, 1993.

Wright, Susan. *The Renaissance*. NY: Tiger Books International, 1997.

Zuffi, Stefano. *Dürer*. ArtBook Series. NY: DK Publishing, 1999.

Zuffi, Stefano and Sylvia Tombesi-Walton. *Titian*. ArtBook Series. NY: DK Publishing, 1999.

Baroque and Rococo

Barron's Art Handbooks. *Baroque Painting*. Hauppague, NY: Barron's, 1998.

Bonafoux, Pascal. *A Weekend with Rembrandt*. NY: Rizzoli, 1991.

Jacobsen, Karen. *The Netherlands*. Chicago, IL: Children's Press, 1992.

Muhlberger, Richard. *What Makes a Goya a Goya?* NY: Viking, 1994.

---------------. *What Makes a Rembrandt a Rembrandt?* NY: Viking, 1993.

Pescio, Claudio. *Rembrandt and Seventeenth-Century Holland*. NY: Peter Bedrick Books, 1996.

Rodari, Florian. *A Weekend with Velázquez*. NY: Rizzoli, 1993.

Schwartz, Gary. *First Impressions: Rembrandt*. NY: Harry N. Abrams, Inc., 1992.

Spence, David. *Rembrandt and Dutch Portraiture*. Hauppauge, NY: Barron's, 1998.

Velázquez. ArtBook Series. NY: DK Publishing, 1999.

Vermeer. ArtBook Series. NY: DK Publishing, 1999.

Wright, Patricia. *Goya*. NY: DK Publishing, 1993.

Zuffi, Stefano. *Rembrandt*. ArtBook Series. NY: DK Publishing, 1999.

Neoclassicism, Romanticism, Realism

Friedrich. ArtBook Series. NY: DK Publishing, 1999.

Goya. Eyewitness Books. NY: DK Publishing, 1999.

Rapelli, Paola. *Goya*. ArtBook Series. NY: DK Publishing, 1999.

Impressionism & Post-Impressionism

Barron's Art Handbooks. *Impressionism*. Hauppauge, NY: Barron's, 1997.

Bernard, Bruce. *Van Gogh*. Eyewitness Books. NY: DK Publishing, 1999.

Borghesi, Silvia. *Cézanne*. ArtBook Series. NY: DK Publishing, 1999.

Crepaldi, Gabriele. *Gauguin*. ArtBook Series. NY: DK Publishing, 1999.

---------------. *Matisse*. ArtBook Series. NY: DK Publishing, 1999.

Kandinsky. ArtBook Series. NY: DK Publishing, 1999.

Monet. Eyewitness Books. NY: DK Publishing, 1999.

Muhlberger, Richard. *What Makes a Cassatt a Cassatt?* NY: Viking, 1994.

---------------. *What Makes a Degas a Degas?* NY: Viking, 1993.

---------------. *What Makes a Monet a Monet?* NY: Viking, 1993.

---------------. *What Makes a van Gogh a van Gogh?* NY: Viking, 1993.

Pescio, Claudio. *Masters of Art: Van Gogh*. NY: Peter Bedrick Books, 1996.

Rapelli, Paola. *Monet*. ArtBook Series. NY: DK Publishing, 1999.

Sagner-Duchting, Karin. *Monet at Giverny*. NY: Neueis Publishing, 1994.

Skira-Venturi, Rosabianca. *A Weekend with Degas*. NY: Rizzoli, 1991.

---------------. *A Weekend with van Gogh*. NY: Rizzoli, 1994.

Spence, David. *Cézanne*. Hauppague, NY: Barron's, 1998.

---------------. *Degas*. Hauppague, NY: Barron's, 1998.

---------------. *Gauguin*. Hauppague, NY: Barron's, 1998.

---------------. *Manet: A New Realism*. Hauppague, NY: Barron's, 1998.

---------------. *Monet and Impressionism*. Hauppague, NY: Barron's, 1998.

---------------. *Renoir*. Hauppague, NY: Barron's, 1998.

---------------. *Van Gogh: Art and Emotions*. Hauppague, NY: Barron's, 1998.

Torterolo, Anna. *Van Gogh*. ArtBook Series. NY: Dk Publishing, 1999.

Turner, Robyn Montana. *Mary Cassatt*. Boston, MA: Little, Brown, 1992.

Waldron, Ann. *Claude Monet*. NY: Harry N. Abrams, Inc., 1991.

Welton, Jude. *Impressionism*. NY: DK Publishing, 1993.

Wright, Patricia. *Manet*. Eyewitness Books. NY: DK Publishing, 1999.

20th Century

Antoine, Veronique. *Picasso: A Day in His Studio*. NY: Chelsea House, 1993.

Beardsley, John. *First Impressions: Pablo Picasso*. NY: Harry N. Abrams, Inc., 1991.

Cain, Michael. *Louise Nevelson*. NY: Chelsea House, 1990.

Children's History of the 20th Century. NY: DK Publishing, 1999.

Faerna, Jose Maria, ed. *Great Modern Masters: Matisse*. NY: Harry N. Abrams, Inc., 1994.

Faerna, Jose Maria, ed. *Great Modern Masters: Picasso*. NY: Harry N. Abrams, Inc., 1994.

Gherman, Beverly. *Georgia O'Keeffe: The Wideness and Wonder of Her World*. NY: Simon & Schuster, 1994.

Greenberg, Jan and Sandra Jordan. *Chuck Close Up Close*. NY: DK Publishing, 1998.

Heslewood, Juliet. *Introducing Picasso*. Boston, MA: Little, Brown, 1993.

Paxman, Jeremy. *20th Century Day by Day*. NY: DK Publishing, 1991.

Ridley, Pauline. *Modern Art*. NY: Thomson Learning, 1995.

Rodari, Florian. *A Weekend with Matisse*. NY: Rizolli, 1992.

---------------. *A Weekend with Picasso*. NY: Rizolli, 1991.

Spence, David. *Picasso: Breaking the Rules of Art*. Hauppauge, NY: Barron's, 1998.

Tambini, Michael. *The Look of the Century*. NY: DK Publishing, 1996.

Turner, Robyn Montana. *Georgia O'Keeffe*. Boston, MA: Little, Brown, 1991.

Woolf, Felicity. *Picture This Century: An Introduction to Twentieth-Century Art*. NY: Doubleday, 1993.

United States

Howard, Nancy Shroyer. *Jacob Lawrence: American Scenes, American Struggles*. Worcester, MA: Davis Publications, 1996.

---------------. *William Sidney Mount: Painter of Rural America*. Worcester, MA: Davis Publications, 1994.

Panese, Edith. *American Highlights: United States History in Notable Works of Art*. NY: Harry N. Abrams, Inc., 1993.

Sullivan, Charles, ed. *African-American Literature and Art for Young People*. NY: Harry N. Abrams, Inc., 1991.

---------------. *Here Is My Kingdom: Hispanic-American Literature and Art for Young People*. NY: Harry N. Abrams, Inc., 1994.

---------------. *Imaginary Gardens: American Poetry and Art for Young People*. NY: Harry N. Abrams, Inc., 1989.

Native American

Burby, Liza N. *The Pueblo Indians*. NY: Chelsea House, 1994.

D'Alleva, Anne. *Native American Arts and Culture*. Worcester, MA: Davis Publications, 1993.

Dewey, Jennifer Owings. *Stories on Stone*. Boston, MA: Little, Brown, 1996.

Garborino, Merwyn S. *The Seminole*. NY: Chelsea House, 1989.

Gibson, Robert O. *The Chumash*. NY: Chelsea House, 1991.

Graymont, Barbara, *The Iroquois*. NY: Chelsea House, 1988.

Griffin-Pierce, Trudy. *The Encyclopedia of Native America*. NY: Viking, 1995.

Hakim, Joy. *The First Americans*. NY: Oxford University Press, 1993.

Howard, Nancy Shroyer. *Helen Cordero and the Storytellers of Cochiti Pueblo*. Worcester, MA: Davis Publications, 1995.

Jensen, Vicki. *Carving a Totem Pole*. NY: Henry Holt & Co., 1996.

Littlechild, George. *This Land is My Land*. Emeryville, CA: Children's Book Press, 1993.

Moore, Reavis. *Native Artists of North America*. Santa Fe, NM: John Muir Publications, 1993.

Perdue, Theda. *The Cherokee*. NY: Chelsea House, 1989.

Remer, Abby. *Discovering Native American Art*. Worcester, MA: Davis Publications, 1996.

Sneve, Virginia Driving Hawk. *The Cherokees*. NY: Holiday House, 1996.

Art of Global Cultures
General

Bowker, John. *World Religions*. NY: DK Publishing, 1997.

Eyewitness World Atlas. DK Publishing (CD ROM)

Wilkinson, Philip. *Illustrated Dictionary of Religions*. NY: DK Publishing, 1999.

World Reference Atlas. NY: DK Publishing, 1998.

Africa

Ayo, Yvonne. *Africa*. NY: Alfred A. Knopf, 1995.

Bohannan, Paul and Philip Curtin. *Africa and Africans*. Prospect Heights, IL: Waveland Press, 1995.

Chanda, Jacqueline. *African Arts and Culture*. Worcester, MA: Davis Publications, 1993.

---------------. *Discovering African Art*. Worcester, MA: Davis Publications, 1996.

Gelber, Carol. *Masks Tell Stories*. Brookfield, CT: Millbrook Press, 1992.

La Duke, Betty. *Africa: Women's Art. Women's Lives*. Trenton, NJ: Africa World Press, 1997.

---------------. *Africa Through the Eyes of Women Artists*. Trenton, NJ: Africa World Press, 1996.

McKissack, Patricia and Fredrick McKissack. *The Royal Kingdoms of Ghana, Mali, and Songhay*. NY: Henry Holt & Co., 1994.

Mexico, Mesoamerica, Latin America

Baquedano, Elizabeth, *Eyewitness Books: Aztec, Inca, and Maya*. NY: Alfred A. Knopf, 1993.

Berdan, Frances F. *The Aztecs*. NY: Chelsea House, 1989.

Braun, Barbara. *A Weekend with Diego Rivera*. NY: Rizzoli, 1994.

Cockcroft, James. *Diego Rivera*. NY: Chelsea House, 1991.

Goldstein, Ernest. *The Journey of Diego Rivera*. Minneapolis, MN: Lerner, 1996.

Greene, Jacqueline D. *The Maya*. NY: Franklin Watts, 1992.

Neimark, Anne E. *Diego Rivera: Artist of the People*. NY: Harper Collins, 1992.

Platt, Richard. *Aztecs: The Fall of the Aztec Capital*. NY: DK Publishing, 1999.

Sherrow, Victoria. *The Maya Indians*. NY: Chelsea House, 1994.

Turner, Robyn Montana. *Frida Kahlo*. Boston, MA: Little, Brown, 1993.

Winter, Jonah. *Diego*. NY: Alfred A. Knopf, 1991.

Asia

Doherty, Charles. *International Encyclopedia of Art: Far Eastern Art*. NY: Facts on File, 1997.

Doran, Clare. *The Japanese*. NY: Thomson Learning, 1995.

Ganeri, Anita. *What Do We Know About Buddhism*. NY: Peter Bedrick Books, 1997.

---------------. *What Do We Know About Hinduism*. NY: Peter Bedrick Books, 1996.

Lazo, Caroline. *The Terra Cotta Army of Emperor Qin*. NY: Macmillan, 1993.

MacDonald, Fiona, David Antram and John James. *A Samurai Castle*. NY: Peter Bedrick Books, 1996.

Major, John S. *The Silk Route*. NY: Harper Collins, 1995.

Martell, Mary Hazel. *The Ancient Chinese*. NY: Simon & Schuster, 1993.

Pacific

D'Alleva, Anne. *Arts of the Pacific Islands*. NY: Harry N. Abrams, 1998.

Haruch, Tony. *Discovering Oceanic Art*. Worcester, MA: Davis Publications, 1996.

Niech, Rodger and Mick Pendergast. *Traditional Tapa Textiles of the Pacific*. NY: Thames and Hudson, 1998.

Thomas, Nicholas. *Oceanic Art*. NY: Thames and Hudson, 1995.

Studio

Drawing Basic Subjects. Hauppauge, NY: Barron's, 1995.

Ganderton, Lucinda. *Stitch Sampler*. NY: DK Publishing, 1999.

Grummer, Arnold. *Complete Guide to Easy Papermaking*. Iola, WI: Krause Publications, 1999.

Harris, David. *The Art of Calligraphy*. NY: DK Publishing, 1995.

Horton, James. *An Introduction to Drawing*. NY: DK Publishing, 1994.

Learning to Paint: Acrylics. Hauppauge, NY: Barron's, 1998.

Learning to Paint: Drawing. Hauppauge, NY: Barron's, 1998.

Learning to Paint: Mixing Watercolors. Hauppauge, NY: Barron's, 1998.

Learning to Paint in Oil. Hauppauge, NY: Barron's, 1997.

Learning to Paint in Pastel. Hauppauge, NY: Barron's, 1997.

Learning to Paint in Watercolor. Hauppauge, NY: Barron's, 1997.

Lloyd, Elizabeth. *Watercolor Still Life*. NY: DK Publishing, 1994.

Slafer, Anna and Kevin Cahill. *Why Design?* Chicago, IL: Chicago Review Press, 1995.

Smith, Ray. *An Introduction to Acrylics*. NY: DK Publishing, 1993.

---------------. *An Introduction to Oil Painting*. NY: DK Publishing, 1993.

---------------. *An Introduction to Watercolor*. NY: DK Publishing, 1993.

---------------. *Drawing Figures*. Hauppauge, NY: Barron's, 1994.

---------------. *Oil Painting Portraits*. NY: DK Publishing, 1994.

---------------. *Watercolor Color*. NY: DK Publishing, 1993.

Wright, Michael. *An Introduction to Pastels*. NY: DK Publishing, 1993.

Wright, Michael and Ray Smith. *An Introduction to Mixed Media*. NY: DK Publishing, 1995.

---------------. *An Introduction to Perspective*. NY: DK Publishing, 1995.

Perspective Pack. NY: DK Publishing, 1998.

Glossary

Abstract art Art that is based on a subject you can recognize, but the artist simplifies, leaves out, or rearranges some elements so that you may not recognize them. (*arte abstracto*)

additive process Sculptural process in which material (clay, for example) is added to create form. In a subtractive process, material is carved away. (*proceso aditivo*)

aesthetician (*es-tha-TISH-un*) One who wonders about art or beauty. A person who asks questions about why art was made and how it fits into society. (*estético*)

allover pattern A design or pattern that covers an entire surface. (*dibujo entero*)

analogous colors (*an-AL-oh-gus*) Colors that are closely related because they have one hue in common. For example, blue, blue-violet, and violet all contain the color blue. Analogous colors appear next to one another on the color wheel. (*colores análogos*)

appliqué (*ah-plee-KAY*) A process of stitching and/or gluing cloth to a background, similar to collage. (*aplicación*)

architectural floor plan A diagram of an architectural complex (a building or group of buildings) seen from above. (*diagrama de planta arquitectónica*)

art critic One who expresses a reasoned opinion on any matter concerning art. (*crítico de arte*)

art form A technique or method that is used to create an artwork, such as painting, photography, or collage. (*forma artística*)

art historian A person who studies art—its history and contributions to cultures and societies. (*historiador de arte*)

art media The material or technical means for artistic expression. (*medios artísticos*)

artist A person who makes art. (*artista*)

assemblage (*ah-SEM-blij*) A three-dimensional work of art consisting of many pieces joined together. A sculpture made by joining many objects together. (*ensamblaje*)

asymmetrical (*a-sim-MET-tri-kal*) A type of visual balance in which the two sides of the composition are different yet balanced; visually equal without being identical. Also called informal balance. (*asimétrico*)

atmospheric color (*at-mos-FER-ik*) Colors in nature that seem to change as natural light changes. (*color atmosférico*)

atmospheric perspective (*at-mos-FER-ik per-SPEK-tiv*) A way to create the illusion of space in an artwork, based on the observation that objects look more muted and less clear the farther they are from the viewer. (*perspectiva atmosférica*)

background Parts of artwork that appear to be in the distance or behind the objects in the foreground or front. (*fondo*)

balance A principle of design that describes how parts of an artwork are arranged to create a sense of equal weight or interest. An artwork that is balanced seems to have equal visual weight or interest in all areas. Types of balance are symmetrical, asymmetrical, and radial. (*equilibrio*)

Baroque (*bah-ROKE*) 1600–1700. An art history term for a style marked by swirling curves, many ornate elements, and dramatic contrasts of light and shade. Artists used these effects to express energy and strong emotions. (*barroco*)

bas-relief (*bah ree-LEEF*) Also called low relief. A form of sculpture in which portions of the design stand out slightly from a flat background. (*bajorrelieve*)

batik (*bah-TEEK*) A method of dyeing cloth that uses wax to resist dye. Wax is used where the color of the dye is not wanted. (*batik*)

caricature (*cah-ri-CAH-chur*) A picture in which a person's or an animal's features, such as nose, ears or mouth, are different, bigger or smaller than they really are. Caricatures can be funny or critical and are often used in political cartoons. (*caricatura*)

center of interest The part of an artwork which attracts the viewer's eye. Usually the most important part of a work of art. (*foco de atención*)

ceramics (*sir-AM-miks*) The art of making objects from clay, glass, or other minerals by baking or firing them at high temperatures in an oven known as a kiln. Ceramics are also the products made in this way. (*cerámica*)

color Color is another word for hue, which is the common name of a color in or related to the spectrum, such as yellow, yellow-orange, blue-violet, green. (*color*)

color scheme A plan for selecting or organizing colors. Common color schemes include: warm, cool, neutral, monochromatic, analogous, complementary, split-complementary and triad. (*combinación de colores*)

complementary (*com-ple-MEN-tah-ree*) Colors that are directly opposite each other on the color wheel, such as red and green, blue and orange, and violet and yellow. When complements are mixed together, they make a neutral brown or gray. When they are used next to each other in a work of art, they create strong contrasts. (*complementarios*)

concertina (*con-ser-TEE-nah*) A type of book made from a long strip of paper that is folded accordion-style to form the pages. (*concertina*)

continuity (*con-tin-OO-ih-tee*) To carry on, as a tradition or a custom. (*continuidad*)

contour A line which shows or describes the edges, ridges, or outline of a shape or form. (*contorno*)

contrast A principle of design that refers to differences in elements such as color, texture, value, and shape. Contrasts usually add excitement, drama, and interest to artworks. (*contraste*)

cool colors Colors often connected with cool places, things, or feelings. The family of colors ranging from the greens through the blues and violets. (*colores frescos*)

crest In many North American communities, a grouping of totems used to show the identity of a tribe or family group. (*poste totémico*)

Cubism 1907–1914. An art history term for a style developed by the artists Pablo Picasso and Georges Braque. In Cubism, the subject matter is broken up into geometric shapes and forms. The forms are analyzed and then put back together into an abstract composition. Often, three-dimensional objects seem to be shown from many different points of view at the same time. (*cubismo*)

cultural meaning Meaning that only the members of a specific culture or cultural group can understand. (*significado cultural*)

cuneiform (*kew-NAY-i-form*) Early form of writing developed in Mesopotamia as early as 3000 BC. Made up of wedge-shaped symbols that were pressed into clay. (*cuneiforme*)

document (*DOK-you-ment*) To make or keep a record of. (*documentar*)

earthwork Any work of art in which land and earth are important media. Often, large formations of moved earth, excavated by artists in the surface of the earth, and best viewed from a high vantage point. (*obras de tierra*)

elevation drawing A drawing that shows the external faces of a building. It can also be a side or front view of a structure, painted or drawn to reveal each story with equal detail. (*plano de alzado*)

emboss To create a mark or indentation by pressing objects into a soft surface, such as clay. (*grabar o tallar en relieve*)

emphasis Area in a work of art that catches and holds the viewer's attention. This area usually has contrasting sizes, shapes, colors or other distinctive features. (*acentuación*)

Expressionism 1890–1920. A style of art which began mostly in Germany but spread to other parts of Europe. The main idea in expressionist artworks is to show strong mood or feeling. (*expresionismo*)

fan A type of book whose pages—usually strips of paper—are loosely bound at one end. (*abanico*)

Fauves (*fohvz*) 1905–1907. A group of painters who used brilliant colors and bold exaggerations in a surprising way. (*fauvistas*)

fiber artists Artists who use long, thin, thread-like materials to create artwork. (*artistas de fibra*)

foreground In a scene or artwork, the part that seems closest to you. (*primer plano*)

form An element of design; any three-dimensional object such as a cube, sphere, pyramid, or cylinder. A form can be measured from top to bottom (height), side to side (width) and front to back (depth). Form is also a general term that means the structure or design of a work. (*forma*)

fresco (*FRES-coh*) A technique of painting in which pigments are applied to a thin layer of wet plaster. The plaster absorbs the pigments and the painting becomes part of the wall. (*fresco*)

genre (*ZHAHN-rah*) Subjects and scenes from everyday life. (*género*)

geometric Mechanical-looking shapes or forms. Something that is geometric may also be described using mathematical formulas. (*geométricas*)

geometric shapes Shapes that are regular in outline. Geometric shapes include circles, squares, rectangles, triangles and ellipses. Geometric forms include cones, cubes, cylinders, slabs, pyramids and spheres. (*figuras geométricas*)

Gothic art 1100–1400. A style of art in Europe of the twelfth-fifteenth centuries, emphasizing religious architecture and typified by pointed arches, spires, and verticality. (*arte gótico*)

handscroll A long, horizontal painting. (*makemono*)

hanging scroll A long, vertical painting. (*kakemono*)

horizon line A level line where water or land seem to end and the sky begins. It is usually on the eye level of the observer. If the horizon cannot be seen, its location must be imagined. (*línea de horizonte*)

ideal A view of what the world and people would be like if they were perfect. (*ideal*)

identity The distinguishing traits or personality of a person or individual. (*identidad*)

illuminated manuscript A decorated or illustrated manuscript popular during the medieval period in which the pages are often painted with silver, gold and other rich colors. (*manuscrito iluminado*)

illuminators (*il-LOO-min-ay-torz*) Artists who illustrate certain parts of a book. (*iluminadores*)

implied line The way objects are set up so as to produce the effect of seeing lines in a work, but where lines are not actually present. (*línea implícita*)

implied texture The way a surface appears to look, such as rough or smooth. (*textura implícita*)

Impressionism 1875–1900. A style of painting that began in France. It emphasized views of subjects at a particular moment and the effects of sunlight on color. (*impresionismo*)

installation art Art that is created for a particular site. (*arte de instalación*)

intermediate color A color made by mixing a secondary color with a primary color. Blue-green, yellow-green, yellow-orange, red-orange, red-violet and blue-violet are intermediate colors. (*color intermedio*)

kinetic art (*kih-NET-ick*) A general term for all artistic constructions that include moving elements, whether actuated by motor, by hand crank, or by natural forces as in mobiles. (*arte cinético*)

line A mark with length and direction, created by a point that moves across a surface. A line can vary in length, width, direction, curvature and color. Line can be two-dimensional (a pencil line on paper), three-dimensional (wire), or implied. (*línea*)

linear perspective (*lin-EE-er per-SPEK-tiv*) A technique used to show three-dimensional space on a two-dimensional surface. (*perspectiva lineal*)

maquette (*mah-KET*) A small model of a larger sculpture. (*maqueta*)

mezuzah (*muh-ZOO-sah*) A piece of inscribed parchment, rolled up in a scroll, and placed in a small wooden, metal or glass case or tube. It is then hung to the doorpost of some Jewish homes as a symbol and a reminder of faith in God. (*mezuza*)

middle ground Parts of an artwork that appear to be between objects in the foreground and the background. (*segundo plano*)

mobile (*MOH-beel*) A hanging balanced sculpture with parts that can be moved, especially by the flow of air. Invented by Alexander Calder in 1932. (*móvil*)

model To shape clay by pinching and pulling. (*modelar*)

monochromatic (*mah-no-crow-MAT-ik*) Made of only a single color or hue and its tints and shades. (*monocromático*)

montage (*mahn-TAHZH*) A special kind of collage, made from pieces of photographs or other pictures. (*montaje*)

mosaic (*mo-ZAY-ik*) Artwork made by fitting together tiny pieces of colored glass or tiles, stones, paper or other materials. These small materials are called tesserae. (*mosaico*)

motif (*moh-TEEF*) A single or repeated design or part of a design or decoration that appears over and over again. (*motivo*)

movement A way of combining visual elements to produce a sense of action. This combination of elements helps the viewer's eye to sweep over the work in a definite manner. (*movimiento*)

mudra (*muh-DRA*) Symbolic hand gestures. Most often associated with Buddha in the Buddhist religion. (*mudra*)

mural (*MYOR-ul*) A large painting or artwork, usually designed for and created on the wall or ceiling of a public building. (*mural*)

narrative (*NAR-ah-tiv*) Depicting a story or idea. (*narrativa*)

negative shape/space The empty space surrounding shapes or solid forms in a work of art. (*forma o espacio negativo*)

Neo-Classicism 1750–1875. A style of art based on interest in the ideals of ancient Greek and Roman art. These ideals were used to express ideas about beauty, courage, sacrifice and love of country. (*neoclasicismo*)

neutral color A color not associated with a hue—such as black, white, or a gray. Architects and designers call slight changes in black, white, brown and gray neutral because many other hues can be combined with them in pleasing color schemes. (*color neutro*)

nonobjective art 1917–1932. A style of art that does not have a recognizable subject matter; the subject is the composition of the artwork. Nonobjective is often used as a general term for art that contains no recognizable subjects. Also known as non-representational art. (*arte no figurativo*)

organic shapes Shapes that are irregular in outline, such as things in nature. (*formas orgánicas*)

patron (*PAY-trun*) A wealthy or influential person or group that supports artists. (*mecenas*)

pattern A choice of lines, colors or shapes, repeated over and over in a planned way. A pattern is also a model or guide for making something. (*patrón*)

perspective (*per-SPEK-tiv*) Techniques for creating a look of depth on a two-dimensional surface. (*perspectiva*)

planned pattern Patterns thought out and created in a systematic and organized way. Whether manufactured or natural, they are precise, measurable and consistent. (*patrón planificado*)

Pop Art 1940 to the present. A style of art whose subject matter comes from popular culture (mass media, advertising, comic strips, and so on). (*arte pop*)

porcelain (*POR-suh-len*) Fine white clay, made primarily of kaolin; also an object made of such clay. Porcelain may be decorated with mineral colorants under the glaze or with overglaze enamels. (*porcelana*)

positive space/shape The objects in a work of art, not the background or the space around them. (*espacio o forma positiva*)

Post-Impressionism 1880–1900. An art history term for a period of painting immediately following Impressionism in France. Various styles were explored, especially by Cézanne (basic structures), van Gogh (emotionally strong brushwork), and Gauguin (intense color and unusual themes). (*postimpresionismo*)

pre-Columbian art 7000 BC to about 1500 AD. An art history term for art created in North and South America before the time of the Spanish conquests. (*arte precolombino*)

primary color One of three basic colors (red, yellow and blue) that cannot be made by mixing colors. Primary colors are used for mixing other colors. (*color primario*)

proportion The relation of one object to another in size, amount, number or degree. (*proporción*)

radial A kind of balance in which lines or shapes spread out from a center point. (*radial*)

random pattern Patterns caused by accidental arrangement or produced without consistent design. Random patterns are usually asymmetrical, non-uniform and irregular. (*patrón aleatorio*)

Realism 1850–1900. A style of art that shows places, events, people, or objects as the eye sees them. It was developed in the mid-nineteenth century by artists who did not use the formulas of Neoclassicism and the drama of Romanticism. (*realismo*)

relief print A print created using a printing process in which ink is placed on the raised portions of the block or plate. (*impresión en relieve*)

relief sculpture A three-dimensional form designed to be viewed from one side, in which surfaces project from a background. (*escultura en relieve*)

representational Similar to the way an object or scene looks. (*realista*)

rhythm A type of visual or actual movement in an artwork. Rhythm is a principle of design. It is created by repeating visual elements. Rhythms are often described as regular, alternating, flowing, progressive or jazzy. (*ritmo*)

Rococo (*roh-COH-coh*) 1700–1800. A style of eighteenth-century art that began in the luxurious homes of the French nobility and spread to the rest of Europe. It included delicate colors, delicate lines, and graceful movement. Favorite subjects included romance and the carefree life of the aristocracy. (*rococó*)

Romanesque (*ROH-man-esk*) 1000–1200. A style of architecture and sculpture influenced by Roman art, that developed in western Europe during the Middle Ages. Cathedrals had heavy walls, rounded arches, and sculptural decorations. (*románico*)

Romanticism (*ro-MAN-ti-sizm*) 1815–1875. A style of art that developed as a reaction against Neoclassicism. Themes focused on dramatic action, exotic settings, adventures, imaginary events, faraway places and strong feelings. (*romanticismo*)

scale The size relationship between two sets of dimensions. For example, if a picture is drawn to scale, all its parts are equally smaller or larger than the parts in the original. (*escala*)

scroll A decorative motif consisting of any of several spiral or convoluted forms, resembling the cross-section of a loosely rolled strip of paper; also, a curved ornamental molding common in medieval work. (*voluta*)

secondary color A color made by mixing equal amounts of two primary colors. Green, orange and violet are the secondary colors. Green is made by mixing blue and yellow. Orange is made by mixing red and yellow. Violet is made by mixing red and blue. (*color secundario*)

self-portrait Any work of art in which an artist shows himself or herself. (*autorretrato*)

shade Any dark value of a color, usually made by adding black. (*sombra*)

shading A gradual change from light to dark. Shading is a way of making a picture appear more realistic and three-dimensional. (*sombreado*)

shape A flat figure created when actual or implied lines meet to surround a space. A change in color or shading can define a shape. Shapes can be divided into several types: geometric (square, triangle, circle) and organic (irregular in outline). (*forma*)

simplify To create less detail in certain objects or areas of an artwork in order to highlight other areas. To reduce the complex to its most basic elements. (*simplificar*)

space The empty or open area between, around, above, below or within objects. Space is an element of art. Shapes and forms are made by the space around and within them. Space is often called three-dimensional or two-dimensional. Positive space is filled by a shape or form. Negative space surrounds a shape or form. (*espacio*)

split complement A color scheme based on one hue and the hues on each side of its complement on the color wheel. Orange, blue-violet, and blue-green are split complementary colors. (*complemento fraccionario*)

stele (*steel*) An upright slab, bearing sculptured or painted designs or inscriptions. From the Greek for "standing block." (*estela*)

still life Art based on an arrangement of objects that are not alive and cannot move, such as fruit, flowers, or bottles. The items are often symbols for abstract ideas. A book, for example, may be a symbol for knowledge. A still life is usually shown in an indoor setting. (*naturaleza muerta*)

stupa (*STEW-pah*) A hemispherical or cylindrical mound or tower artificially constructed of earth, brick or stone, surmounted by a spire or umprella, and containing a relic chamber. (*estupa*)

style The result of an artist's means of expression—the use of materials, design qualities, methods of work, and choice of subject matter. In most cases, these choices show the unique qualities of an individual, culture or time period. The style of an artwork helps you to know how it is different from other artworks. (*estilo*)

subject A topic or idea shown in an artwork, especially anything recognizable such as a landscape or animals. (*tema*)

Surrealism 1924–1940. A style of art in which dreams, fantasy and the human mind were sources of ideas for artists. Surrealist works can be representational or abstract.

symbol Something that stands for something else; especially a letter, figure or sign that represents a real object or idea. A red heart shape is a common symbol for love. (*símbolo*)

symmetrical (*sim-MET-ri-kal*) A type of balance in which both sides of a center line are exactly or nearly the same, like a mirror image. For example, the wings of a butterfly are symmetrical. Also known as formal balance. (*simétrico*)

tesserae (*TESS-er-ah*) Small pieces of

glass, tile, stone, paper or other materials used to make a mosaic. (*teselas*)

texture The way a surface feels (actual texture) or how it may look (implied texture). Texture can be sensed by touch and sight. Textures are described by words such as rough, silky, pebbly. (*textura*)

theme The subject or topic of a work of art. For example, a landscape can have a theme of the desire to save nature, or to destroy nature. A theme such as love, power, or respect can be shown through a variety of subjects. The phrase "theme and variations" usually means several ways of showing one idea. (*idea central*)

tint A light value of a pure color, usually made by adding white. For example, pink is a tint of red. (*matiz claro*)

totem (*TOH-tem*) An object that serves as a symbol of a family, person, idea, or legend. (*tótem*)

triad (*TRY-ad*) Three colors spaced equally apart on the color wheel, such as orange, green, and violet. (*tríada*)

triptych (*TRIP-tick*) An altarpiece consisting of three panels joined together. Often, the two outer panels are hinged to close over the central panel. (*tríptico*)

tympanum (*TIM-pah-num*) The arched space above a church doorway. (*tímpano*)

unity A feeling that all parts of a design are working together as a team. (*unidad*)

value An element of art that means the darkness or lightness of a surface. Value depends on how much light a surface reflects. Tints are light values of pure colors. Shades are dark values of pure colors. Value can also be an important element in works of art in which there is little or no color (drawings, prints, photographs, most sculpture and architecture). (*valor*)

vanishing point In a perspective drawing, one or more points on the horizon where parallel lines that go back in space seem to meet. (*punto de fuga*)

variety The use of different lines, shapes, textures, colors, and other elements of design to create interest in a work of art. (*variedad*)

warm colors Warm colors are so-called because they often are associated with fire and the sun and remind people of warm places, things, and feelings. Warm colors range from the reds through the oranges and yellows. (*colores cálidos*)

abanico Tipo de libro cuyas páginas (por lo general, tiras de papel) se encuentran ligeramente encuadernadas en un extremo. (*fan*)

acentuación Parte de una obra artística que captura y retiene la atención del espectador. Por lo general, esta área exhibe contrastes en tamaño, forma, color u otros rasgos distintivos. (*emphasis*)

aplicación Proceso parecido al collage en el cual trozos de tela se cosen y/o se pegan a un fondo. (*applique*)

arte abstracto Arte que se basa en un tema reconocible pero en el que el artista ha simplificado, excluido o reordenado algunos elementos de modo que no podamos reconocerlos. (*Abstract art*)

arte cinético Término general que se usa para describir cualquier construcción artística que incluya elementos móviles, ya sea mediante un motor, una manivela o fuerzas naturales, como en el caso de los móviles. (*kinetic art*)

arte de instalación Arte que se crea especialmente para un lugar en particular. (*installation art*)

arte gótico 1100-1400. Estilo de arte europeo que se desarrolló del siglo XII al XV. Ponía énfasis en la arquitectura religiosa y se caracterizaba por arcos ojivales, capiteles y verticalidad. (*Gothic art*)

arte no figurativo 1917-1932. Estilo de arte que no posee un tema reconocible; el tema es la composición de la obra artística. A menudo, se usa como un término general para el arte que contiene temas irreconocibles. También se le conoce como arte abstracto. (*nonobjective art*)

arte pop De 1940 hasta el presente. Tendencia artística cuyos temas provienen de la cultura popular (medios de comunicación, publicidad y tiras cómicas, entre otros). (*Pop Art*)

arte precolombino 7000 a.C. hasta aproximadamente el siglo XVI d.C. Término que se utiliza para referirse al arte creado en Norteamérica y Sudamérica antes de la llegada de los conquistadores españoles. (*pre-Columbian art*)

artista Persona que hace arte. (*artist*)

artistas de fibra Artistas que utilizan materiales largos y filamentosos en la creación de sus obras de arte. (*fiber artist*)

asimétrico Tipo de equilibrio visual en el cual los dos lados de una composición son diferentes pero están equilibrados; son iguales visualmente pero no idénticos. También se denomina equilibrio irregular. (*asymmetrical*)

autorretrato Cualquier obra artística en la cual el artista se muestra a sí mismo. (*self-portrait*)

bajorrelieve Forma de escultura en la cual las partes de un diseño resaltan poco del plano. (*bas-relief*)

barroco 1600-1700. El barroco es un término de arte relativo a un estilo que se caracterizó por curvas turbulentas, por estar excesivamente ornamentado y por presentar dramáticos contrastes de luz y sombra. Mediante estos efectos los artistas expresaban energía y emociones exaltadas. (*Baroque*)

batik Procedimiento de teñido de un tejido que usa cera para impedir el tinte. La cera se aplica en las partes donde no se desea teñir. (*batik*)

caricatura Ilustración en la cual los rasgos de una persona o de un animal, como por ejemplo, la nariz, las orejas o la boca, son diferentes, más grandes o más pequeñas de lo que son en realidad. Las caricaturas pueden ser divertidas o críticas y se usan, a menudo, en las tiras cómicas políticas. (*caricature*)

cerámica Arte de fabricar objetos de barro, vidrio u otros minerales cociéndolos o quemándolos a altas temperaturas en un horno de secar. La palabra también se refiere a los productos que se forman de esta manera. (*ceramics*)

color Otro término para denominar el matiz, que es el nombre común de un color que está en el espectro o que está relacionado con él, por ejemplo, amarillo, amarillo anaranjado, azul violeta y verde. (*color*)

color atmosférico Colores de la naturaleza que parecen cambiar según cambia la luz natural. (*atmospheric color*)

color intermedio Color que se produce al mezclar un color secundario con un color primario. El azul-verde, el verde-amarillo, el amarillo-anaranjado, el rojo-anaranjado, el rojo-violeta y el azul-violeta son colores intermedios. (*intermediate color*)

color neutro Color que no se asocia con un matiz, como por ejemplo, el negro, el blanco o el gris. Los arquitectos y los diseñadores llaman neutros a los leves cambios en negro, blanco y gris debido a que pueden combinarse con diferentes matices para crear combinaciones atractivas de colores. (*neutral color*)

color primario Uno de los tres colores básicos (amarillo, rojo y azul) que no se puede producir mezclando colores. Los colores primarios se usan para formar otros colores. (*primary color*)

color secundario Color que se produce al mezclar dos colores primarios en cantidades iguales. El verde, el anaranjado y el violeta son colores secundarios. El verde es la combinación de azul con amarillo. El anaranjado se obtiene al mezclar el rojo y el amarillo. El color violeta se produce al mezclar el rojo con el azul. (*secondary color*)

colores análogos Colores estrechamente relacionados debido a un matiz que comparten en común. Por ejemplo, el azul, el azul-violeta y el violeta contienen el color azul. En la rueda de colores, los colores análogos se encuentran uno al lado del otro. (*analogous colors*)

colores cálidos Reciben este nombre porque a menudo se les asocia con el fuego y el Sol. Asimismo, nos recuerdan lugares, cosas y sensaciones cálidas. Los colores cálidos van desde distintas tonalidades de rojo hasta el anaranjado y amarillo. (*warm colors*)

colores frescos Colores que se relacionan, a menudo, con lugares, cosas o sentimientos que proyectan frescura. Familia de colores que va del verde al azul y violeta. (*cool colors*)

combinación de colores Plan para seleccionar u organizar los colores. Entre las combinaciones de colores comunes se encuentran las siguientes: cálido, fresco, neutro, monocromático, análogo, complementario, complementario fraccionado y tríada. (*color scheme*)

complementarios Colores directamente opuestos entre sí en la rueda de colores. Por ejemplo, el rojo y el verde, el azul y el anaranjado, el violeta y el amarillo. Cuando los colores complementarios se mezclan, el resultado es un color marrón o gris neutro. Cuando se usan uno al lado del otro en una obra artística, producen contrastes intensos. (*complementary*)

complemento fraccionario Combinación de colores que se basa en un matiz y en los matices de cada lado de su complemento en la rueda de colores. El anaranjado, el azul-violeta y el azul-verde son colores complementarios fraccionados. (*split complement*)

concertina Tipo de libro hecho de una tira larga de papel que se dobla como un acordeón para formar las páginas. (*concertina*)

continuidad Condición de continuar, seguir o persistir. Por ejemplo, la continuidad de una tradición o una costumbre. (*continuity*)

contorno Línea que muestra o describe los extremos, las salientes o el perfil de una figura o forma. (*contour*)

contraste Principio de diseño que se refiere a las diferencias en elementos como el color, la textura, el valor y la forma. Por lo general, los contrastes añaden vivacidad, drama e interés a las obras de arte. (*contrast*)

crítico de arte Persona que expresa una opinión razonada acerca de cualquier asunto relacionado con el arte. (*art critic*)

cubismo 1907-1914. Término de arte que denota un estilo desarrollado por Pablo Picasso y Georges Braque. En el cubismo, el tema se descompone en formas y figuras geométricas. Éstas se analizan y luego se vuelven a juntar en una composición abstracta. A menudo, da la impresión de que los objetos tridimensionales se están mostrando desde muchos puntos de vista diferentes al mismo tiempo. (*Cubism*)

cuerpo geométrico Cualquier objeto tridimensional, como un cubo, una esfera, una pirámide o un cilindro. Éstos pueden medirse desde arriba hacia abajo (altura), de lado a lado (ancho) y de adelante hacia atrás (profundidad). (*geometric form*)

cuneiforme Sistema antiguo de escritura que se desarrolló en Mesopotamia alrededor del año 3000 a.C. Este tipo de escritura consistía en símbolos en forma de cuña que se presionaban sobre arcilla. (*cuneiform*)

diagrama de planta arquitectónica Esquema de un complejo arquitectónico (un edificio o un grupo de edificios) visto desde arriba. (*architectural floor plan*)

dibujo entero Diseño o modelo que cubre una superficie completa. (*allover pattern*)

documentar Llevar un registro de algo. (*document*)

ensamblaje Obra artística tridimensional que consiste en muchas piezas unidas. Escultura realizada reuniendo diversos objetos. (*assemblage*)

equilibrio Principio de diseño que describe la manera en que se encuentran ordenadas las partes de una obra artística con el fin de crear la sensación de igual peso o interés. Una obra artística equilibrada ofrece un peso visual o un interés igual en todas sus áreas. Los tipos de equilibrio son simétrico, asimétrico y radial. (*balance*)

escala La relación de tamaño entre dos conjuntos de dimensiones. Por ejemplo, si se hace un dibujo a escala, todas sus partes son igualmente más pequeñas o más grandes que las partes del original. (*scale*)

escultura en relieve Forma tridimensional diseñada para observarse desde un lado, en el cual las superficies se proyectan desde el fondo. (*relief sculpture*)

espacio La extensión vacía o abierta que se encuentra entre objetos, alrededor de ellos, encima de ellos, debajo de ellos o dentro de los mismos. El espacio es un elemento artístico. Las figuras y las formas se producen debido al espacio que existe a su derredor y dentro de ellas. A menudo nos referimos al espacio como tridimensional o bidimensional. Una figura o una forma llenan el espacio positivo mientras que el espacio negativo rodea una figura o una forma. (*space*)

espacio o forma positiva Los objetos de una obra artística que no constituyen ni el fondo ni el espacio que se halla a su alrededor. (*positive space/shape*)

estela Losa o monumento que se dispone en forma vertical y que lleva diseños esculpidos o pintados o inscripciones. Viene del latín stelam, y éste del griego, que significa "bloque de pie". (*stele*)

estético Persona que se dedica al estudio del arte o la belleza. Persona que cuestiona cómo se produce el arte y el papel que juega en la sociedad. (*aesthetician*)

estilo Resultado de los medios de expresión de un artista: el uso de materiales, la calidad del diseño, los métodos de trabajo y la selección del tema. En la mayoría de los casos, estas selecciones muestran las cualidades singulares de un individuo, una cultura o un período de tiempo. El estilo de una obra artística nos ayuda a distinguirla de otras obras de arte. (*style*)

estupa Montículo o torre hemisférica o cilíndrica que se construye artificialmente usando tierra, ladrillos o piedras coronada con un capitel o sombrilla y que contiene reliquias. (*stupa*)

expresionismo 1890-1920. Estilo artístico que originalmente se desarrolló en Alemania pero que más tarde se propagó a otras partes de Europa. La idea principal de las obras expresionistas es mostrar estados de ánimo o sensaciones intensas. (*Expressionism*)

fauvistas 1905-1907. Grupo de pintores que hacían uso de colores brillantes y exageraciones audaces de una manera sorprendente. (*Fauves*)

figuras geométricas Formas de perfil regular. Entre las figuras geométricas se encuentran los círculos, los cuadrados, los rectángulos, los triángulos y las elipses. Entre los cuerpos geométricos se incluyen los conos, los cubos, los cilindros, las losas, las pirámides y las esferas. (*geometric shapes*)

foco de atención Parte de una obra de arte, atractiva a la vista del espectador. Por lo general, constituye la parte más

importante de una obra artística. (*center of interest*)

fondo Parte de una obra artística que parece estar a la distancia o detrás de los objetos que se encuentran en primer plano. (*background*)

forma Elemento de diseño. Término general que se usa para referirse a la estructura o diseño de una obra. También se define como una figura plana que se produce al juntarse líneas reales o implícitas alrededor de un espacio. Se puede definir una forma mediante un cambio en color o sombreado. Las formas se pueden dividir en varios tipos: geométricas (cuadrado, triángulo, círculo) y orgánicas (de perfil irregular). (*shape*)

forma artística Técnica o método utilizado en la creación de una obra artística, como una pintura, una fotografía o un collage. (*art form*)

forma o espacio negativo El espacio vacío que rodea las formas o los cuerpos geométricos en una obra artística. (*negative shape/space*)

formas orgánicas Formas cuyos perfiles son irregulares, como por ejemplo, los objetos que se hallan en la naturaleza. (*organic shapes*)

fresco Técnica de pintura mural que consiste en aplicar pigmentos a una capa delgada de yeso húmedo. El yeso absorbe los pigmentos y la pintura se convierte en parte de la pared. (*fresco*)

género Temas y escenas de la vida cotidiana. (*genre*)

geométricas Figuras o formas que parecen mecánicas. También se pueden usar fórmulas matemáticas para describir algo que es geométrico. (*geometric*)

grabar o tallar en relieve Crear una marca o depresión al presionar objetos en una superficie suave, como por ejemplo, la arcilla. (*emboss*)

historiador de arte Persona que estudia el arte: su historia y aportaciones a las culturas y sociedades. (*art historian*)

idea central Tema o tópico de una obra artística. Por ejemplo, un paisaje puede tener como idea central el deseo de salvar la naturaleza o de destruirla. Una idea central como el amor, el poder o el respeto se pueden mostrar a través de una variedad de temas. Por lo general, la frase "idea central y variaciones" se usa para expresar varias maneras de mostrar una idea. (*theme*)

ideal Opinión de cómo sería el mundo y sus habitantes si éstos fueran perfectos. (*ideal*)

identidad La personalidad o los caracteres distintivos de una persona o individuo. (*identity*)

iluminadores Artistas que decoran e ilustran ciertas partes de un libro. (*illuminators*)

impresión en relieve Impresión que se crea al usar un proceso de imprimir en el cual se coloca tinta en las partes elevadas del clisé topográfico. (*relief print*)

impresionismo 1875-1900. Estilo de pintura que surgió en Francia. Ponía énfasis en la visión del individuo en un momento en particular y en los efectos de la luz solar sobre los colores. (*Impressionism*)

kakemono Pintura realizada en un rollo largo y vertical. (*hanging scroll*)

línea Trazo que muestra longitud y dirección, creado por un punto que se mueve por una superficie. Una línea puede variar en longitud, ancho, dirección, curvatura y color. Puede ser bidimensional (una línea hecha con un lápiz sobre papel), tridimensional (alambre) o puede estar implícita. (*line*)

línea de horizonte Línea de nivel donde parece que el agua o la tierra terminan y comienza el cielo. Por lo general, se encuentra al nivel de los ojos del espectador. Si el horizonte no se puede ver, entonces se debe imaginar su ubicación. (*horizon line*)

línea implícita Manera en que se arreglan los objetos con el fin de producir el efecto de que se vean líneas en una obra, aunque estas líneas en realidad no están presentes. (*implied line*)

makemono Pintura realizada en un rollo largo y horizontal. (*handscroll*)

manuscrito iluminado Tipo de manuscrito decorado o ilustrado que fue popular en la Edad Media. A menudo, sus páginas se pintaban con plata, oro y otros colores intensos. (*illuminated manuscript*)

maqueta Modelo, a escala reducida, de una escultura. (*maquette*)

matiz claro Valor leve de un color puro, que se produce generalmente al añadir blanco. Por ejemplo, el rosado es un matiz claro del rojo. (*tint*)

mecenas Persona o grupo adinerado o influyente, protector de las letras y las artes. (*patrons*)

medios artísticos Material o medios técnicos para realizar una expresión artística. (*art media*)

mezuzá Trozo enrollado de pergamino grabado que se coloca en un estuche o en un tubo de madera, metal o vidrio. Luego se cuelga en el marco de la puerta de algunas casas judías como símbolo y recordatorio de la fe en Dios. (*mezuzah*)

modelar Apretar y tirar de una sustancia como la arcilla para darle forma artística. (*model*)

monocromático Hecho de un solo color o matiz y sus tintes y tonos. (*monochromatic*)

montaje Tipo especial de collage, hecho con trozos de fotografías u otro tipo de ilustraciones. (*montage*)

mosaico Obra artística compuesta de pequeños trozos de vidrio o azulejos, piedras, papel u otros materiales, de diversos colores. Estos materiales reciben el nombre de teselas. (*mosaic*)

motivo Diseño individual o repetido o parte de un diseño o decoración que se presenta constantemente. (*motif*)

móvil Escultura equilibrada en suspensión que tiene partes que pueden entrar en movimiento, especialmente por la acción del viento. Ideada por Alexander Calder en 1932. (*mobile*)

movimiento Manera de combinar elementos visuales con el fin de producir una sensación de acción. Gracias a esta combinación de elementos, los ojos del espectador recorren la obra de arte de una manera definida. (*movement*)

mudra Gesto simbólico efectuado con las manos y los dedos. Relacionado a menudo con Buda, el predicador de la doctrina budista. (*mudra*)

mural Pintura u obra artística que, por lo general, se realiza o se aplica a un muro o al cielorraso de un edificio público. (*mural*)

narrativa Que describe un cuento o una idea. Este término se puede utilizar como un sinónimo no despectivo de literario. (*narrative*)

naturaleza muerta Arte que se basa en un arreglo de objetos inertes e inmóviles, como por ejemplo, frutos, flores o botellas. Estos objetos expresan, a menudo, ideas abstractas. Por ejemplo, un libro puede representar un símbolo para el conocimiento. Por lo general, una naturaleza muerta se muestra en un ambiente interior. (*still life*)

neoclasicismo 1750-1875. Estilo de arte que se basaba en un interés por los ideales del arte de la Grecia y Roma antiguas. Estos ideales se utilizaban para expresar ideas sobre la belleza, la valentía, el sacrificio y el amor a la patria. (*Neo-Classicism*)

obras de tierra Cualquier obra artística en la cual el terreno y la Tierra son medios importantes. A menudo, el término se refiere a extensas formaciones de tierra removida, excavadas por artistas en la superficie de la Tierra, y que se pueden observar mucho mejor desde una posición ventajosa de altitud. (*earthwork*)

patrón Selección de líneas, colores o formas, que se repiten constantemente de manera planificada. Un patrón es también un modelo o guía para realizar algo. (*pattern*)

patrón aleatorio Patrones originados por arreglos accidentales o que se reproducen sin un diseño consistente. Por lo general, los patrones aleatorios son asimétricos, irregulares y no uniformes. (*random pattern*)

patrón planificado Patrón desarrollado y creado de manera sistemática y organizada. Ya sean manufacturados o naturales, estos patrones son precisos, mensurables y consistentes. *(planned pattern)*

perspectiva Técnica para crear una sensación de profundidad sobre un plano bidimensional. *(perspective)*

perspectiva atmosférica En las artes gráficas, el efecto emocional que se produce o el estado de ánimo que se crea. Indica también el espacio tridimensional en una composición, en particular cuando se produce mediante una perspectiva aérea. *(atmospheric perspective)*

perspectiva lineal Técnica que se utiliza para mostrar un espacio tridimensional sobre una superficie bidimensional. *(linear perspective)*

plano de alzado Dibujo que muestra las caras externas de una edificación. También puede ser un costado o la vista frontal de una estructura, pintada o dibujada para revelar cada piso con detalles iguales. *(elevation drawing)*

porcelana Arcilla blanca y de poco espesor, hecha principalmente de caolín; objeto hecho de este material. La porcelana se puede decorar con colorantes minerales antes de vidriar o con un esmaltado. *(porcelain)*

poste totémico Conjunto de tótems que se usa para identificar una tribu o un grupo familiar en diversas comunidades de Norteamérica. *(crest)*

postimpresionismo 1880-1900. Término que designa un período de la pintura que siguió inmediatamente al impresionismo en Francia. Se exploraron diversos estilos, en especial Cézanne (estructuras básicas), van Gogh (intenso manejo emocional del pincel) y Gauguin (colores intensos y temas insólitos). *(Post-Impressionism)*

primer plano En una escena o en una obra artística, es la parte que parece estar más cerca del espectador. *(foreground)*

proceso aditivo Sustancia que se añade a otra en cantidades relativamente pequeñas con el fin de impartir las propiedades deseadas o de suprimir las propiedades indeseables. *(additive process)*

proporción Relación de un objeto con otro en cuanto a tamaño, cantidad, número o grado. *(proportion)*

punto de fuga Punto donde parecen converger las rectas paralelas en el dibujo en perspectiva. *(vanishing point)*

radial Especie de equilibrio en el cual las líneas o las formas se extienden a partir de un punto central. *(radial)*

realismo 1850-1900. Estilo de arte que muestra los lugares, sucesos, personas u objetos tal como son. Desarrollado a mediados del siglo XIX por artistas que no usaban las fórmulas del neoclasicismo o el drama del romanticismo. *(Realism)*

realista Semejante a la manera en que se ve un objeto o una escena. *(representational)*

ritmo Tipo de movimiento visual o real en una obra artística. El ritmo es un principio de diseño. Se crea mediante la repetición de elementos visuales. A menudo, el ritmo se describe como regular, alternativo, fluido, progresivo o animado. *(rhythm)*

rococó 1700-1800. Estilo artístico del siglo XVIII que se inició en las mansiones lujosas de la nobleza francesa y que se propagó al resto de Europa. Incluía colores suaves, líneas delicadas y movimientos elegantes. Entre los temas favoritos de esta tendencia se encontraban las aventuras románticas y el estilo de vida despreocupado de la aristocracia. *(Rococo)*

románico 1000-1200. Estilo arquitectónico y escultural influenciado por el arte romano que se desarrolló en la Europa occidental durante la Edad Media. Las catedrales tenían paredes gruesas, arcos redondeados y decoraciones esculturales. *(Romanesque)*

romanticismo 1815-1875. Estilo artístico que surgió como una reacción contra el neoclasicismo. Los temas se concentraban en la acción dramática, ambientes exóticos, aventuras, acontecimientos imaginarios, lugares remotos e intensas emociones. *(Romanticism)*

segundo plano Partes de una obra artística que parecen hallarse entre los objetos del primer plano y el fondo. *(middle ground)*

significado cultural Significado que sólo comprenden los miembros de una cultura específica o de un cierto grupo cultural. *(cultural meaning)*

símbolo Algo que representa otra cosa; especialmente una letra, una figura o un signo que representa un objeto o una idea real. Una figura roja en forma de corazón es un símbolo común del amor. *(symbol)*

simétrico Tipo de equilibrio en el cual los dos lados de una línea central son exactamente o casi iguales, como un reflejo exacto. Por ejemplo, las alas de una mariposa son simétricas. A este tipo de equilibrio también se le denomina equilibrio formal. *(symmetrical)*

simplificar Crear menos detalles en ciertos objetos o áreas de una obra artística con el fin de destacar otras áreas. Reducir lo complejo a sus elementos más básicos. *(simplify)*

sombra Cualquier pigmento oscuro de un color que, por lo general, se crea al añadir negro. *(shade)*

sombreado Cambio paulatino de claro a oscuro. El sombreado es una manera de producir un efecto más realista y tridimensional en una ilustración. *(shading)*

tema Tópico o idea que se muestra en una obra artística, en particular cualquier cosa que sea reconocible, como un paisaje o los animales. *(subject)*

teselas Pequeños trozos de vidrio, azulejo, piedras, papel u otros materiales que se utilizan en la confección de mosaicos. *(tesserae)*

textura Manera en que se siente una superficie (textura real) o cómo se ve (textura implícita). Podemos sentir la textura gracias al tacto y a la vista. Palabras como áspera, sedosa, rugosa se usan para describir la textura. *(texture)*

textura implícita Manera en que parece verse una superficie: áspera o lisa. *(implied texture)*

tímpano Espacio arqueado sobre el pórtico de una iglesia. *(tympanum)*

tótem Objeto que sirve como emblema o símbolo de una familia, persona, idea o leyenda. *(totem)*

triada Tres colores igualmente espaciados entre sí en la rueda de colores, como por ejemplo, el anaranjado, el verde y el violeta. *(triad)*

tríptico Retablo que consiste en tres paneles unidos. A menudo, los dos paneles exteriores giran sobre un gozne y se cierran sobre el central. *(triptych)*

unidad Sensación de que todas las partes de una obra artística funcionan juntas como un conjunto. *(unity)*

valor Elemento artístico que denota el grado de oscuridad o claridad de una superficie. El valor depende de la cantidad de luz que puede reflejar una superficie. Los matices claros son valores leves de los colores puros. Las sombras son valores oscuros de los colores puros. El valor también tiene importancia como elemento en las obras artísticas que muestran una cantidad mínima o inexistente de color (dibujos, grabados, fotografías, la mayor parte de la escultura y la arquitectura). *(value)*

variedad Uso de diferentes líneas, formas, texturas, colores y otros elementos del diseño con el fin de crear interés en la obra artística. *(variety)*

voluta Motivo decorativo que consiste en alguna forma espiral o enrollada que se asemeja a la sección transversal de una tira de papel ligeramente enrollada; moldura decorativa en forma de curva, común en las obras de arte medievales. *(scroll)*

Index

Index

Anonymous, *Dragons,* China, Southern Sung dynasty, mid-13th century.
Handscroll, ink, and a touch of color on paper, 17 $^5/_8$" x 100 $^5/_{16}$" (44.8 x 254.8 cm). Chinese and Japanese Special Fund, 14.423. Courtesy Museum of Fine Arts, Boston.

Teacher's Reference Material

Photo courtesy Karen Miura, Kalakaua Middle School, Honolulu, Hawaii.

Program Overview

Why Themes?

We believe that art is inescapably linked to the experience of being human. As humans throughout the world and over time have sought ways to understand the world and their place within it, they have created objects and rituals to assist them. The series draws upon the activities and inclinations that humans have in common. It makes the connection between those commonalities and the art that people have made in the past and continue to make in the present.

The themes found throughout the program are informed by the ideas of educator Ernest Boyer, who proposed a list of shared human experiences. Boyer generally proposed that all humans experience life cycles, develop symbols, respond to the aesthetic dimension of experience, and develop various forms of bonding together socially. He claimed that humans have the capacity to recall the past and anticipate the future. Humans are inseparably a part of nature and, as such, are connected to the ecology of the planet. Humans share a tendency to produce—to work—and to consume. Boyer also proposed that all humans seek to live their lives with a sense of meaning and purpose. Boyer proposed that a quality curriculum might be grounded in a recognition of these shared human needs and interests—that all school subjects include directly-related content and inquiry modes.

In the chapters throughout the series, art is presented as an inseparable part of each of these common human themes. Art is an important way in which people communicate their ideas while seeking to live a meaningful life. In cultures throughout the world, people develop ways to communicate through visual symbols. The ideas are tied to cultural value and belief systems, as are the specific purposes that art serves within the culture. Art forms vary according to traditions within the culture. Changes in tradition occur when cultures connect, or when individuals and groups seek to expand ideas and techniques central to art-making practice. Understanding art made throughout the world and over time is inextricably linked to the study of culture and tradition.

Curriculum Structure

The art curriculum presented in *Art and the Human Experience* builds upon student learning in relation to expression through and response to art. Students learn to create artworks and to express their experiences visually. They also learn how and why artists of the past and present have created art. Students learn to perceive, think, talk and write about art they encounter—their own artworks, those made by their classmates, and those created by others throughout the world and over time. Students become aware of beauty in the environment, understanding the importance of art and design in everyday life. They learn about careers in art and community art resources. Students learn to truly enjoy the processes involved in creating and responding to art.

Text Organization

The texts are organized into two major parts. **"Foundations"** includes an overview of basic content in and inquiry approaches to art. Depending upon your students' prior knowledge, you may wish to use the Foundations chapters as a way of reviewing or, in some cases, introducing this content. **"Themes"** approaches the content through multi-layered themes drawn from Boyer's list of human commonalities. The Core Lesson of each chapter introduces the theme and its art-related key ideas. The additional four lessons of the chapter explore the theme in more depth, considering the ideas through art history, art foundations, global connections, and studio production. Depending upon the structure for teaching art in your school, you may only have the opportunity to explore the Core Lesson of each chapter. Alternatively, you may be able to include one or more of the additional lessons, providing your students with opportunities for gaining deeper understanding of the thematic content.

Creating and Responding to Art

Art is above all a creative activity, one that develops students' abilities to visually express their experiences. Throughout the many studio experiences in the program, students are encouraged to be purposeful as they make artworks. They are helped to generate ideas and to develop skills in the use of materials and techniques to achieve desired effects.

Photo courtesy Betsy Logan, Samford Middle School, Auburn, Alabama.

Learning to perceive artworks with an active eye and responsive mind is the foundation for a lifelong interest in, and appreciation of, art. The program is designed so that students gain new insights as they examine and investigate artworks and offer possible interpretations about their meaning. They learn from each other in discussing important questions about art. Talking about art provides students with opportunities to voice their opinions and hear those of their classmates. Writing about art also provides them with opportunities to clarify their own thinking about the artworks they encounter.

The Disciplines of Art

The content of *Art and the Human Experience* is based upon knowledge in the various disciplines of art. These include the creation of art (art production), art history, aesthetics and art criticism. The content is informed by research in related areas of inquiry such as art education, the psychology of art, the sociology of art, and cultural anthropology. Students are introduced to central ideas and perspectives of the disciplines as well as to the characteristic methods of disciplinary inquiry.

Art Production The program includes many opportunities for students to express their ideas and feeling by using a variety of materials and techniques. As students observe the world, recall and reflect upon past experience, and use imagination to engage purposefully in the creation of their own artworks, they learn that reflection is an important part of the art-making process. Through discussion and self-reflection, students consider the ways their artworks reflect their ideas and feelings. They consider the decisions they make during the creative process, focusing on their ideas, their choice of materials, their ways of using materials, as well as their work habits. Reflection upon the creation of art involves consideration of artworks students have made in the past and how their current work builds upon or departs from past art-making experiences. Reinforcing the notion that much of what humans make reflects memories of, preferences for, or connections to certain artworks or art traditions, students consider the influences that other artworks have had on their art-making decisions.

Art History Students learn to seek information regarding the social and historical context in which artworks are made. The study of human history and cultures reveals how humans have created and used art for important social and individual purposes. Students study themes, styles, traditions, and purposes of art throughout the world and over time. They learn about individual artists and how their artworks reflect or influence ideas and beliefs of the time in which they were created. Using art-historical inquiry processes, students learn to consider their own perceptions of artworks along with contextual information, and to propose historical explanations.

Art Criticism Art criticism is critical thinking about individual artworks or groups of artworks. Students learn how to carefully observe and describe details in artworks. They learn how to analyze the structure and organization of artworks. Interpretation involves making inferences about possible meanings of artworks. Students learn how to offer interpretations of artworks, supported by what they perceive, relevant contextual information, and their own experiences and points of view. As they learn how to offer interpretations, they also learn how to make judgments about the plausibility of those offered by others. Students also learn how to judge the merit and significance of artworks, using standards from individual and socio-cultural beliefs, values, purposes and traditions.

Photo courtesy Bunki Kramer, Los Cerros Middle School, Danville, California.

Aesthetics Aesthetics is a branch of philosophy that developed out of an interest in explaining the concept of beauty. It has evolved into a discipline in which a wide range of philosophical questions are addressed. Rarely do students engage in inquiry about the meaning or merits of particular artworks, about the history of art, or about the processes involved in making art without asking questions that are essentially philosophical questions. Students wonder what art is, why people create it, why people in some cultures are considered artists while others are not, what counts as good art, and how we can know what an artwork means. In *Art and the Human Experience*, students are provided opportunities to raise and address philosophical questions related to their art

study. They are encouraged to reflect on their ideas about art in general and to keep track of their changing ideas. Through reflection and discussion, students learn that ideas about art vary among individuals and cultures. They are encouraged to respect alternative points of view. They learn to listen to and learn from their classmates as they engage in the study of art of the past and present from around the world.

Multicultural and Global Content

As we become increasingly aware of cultural and ethnic diversity in our nation and increasingly aware of the broad spectrum of artistic expression throughout the world, teachers of art are challenged to create ways in which this diversity can be recognized and understood by our students. We must provide students the opportunity to gain insights about themselves, about others, and about the world in which they live by attending to diversity in artistic expression. *Art and the Human Experience* addresses this task in two ways: 1. through the study of art that reflects ethnic and cultural diversity within our own culture, and 2. through the study of art with a global perspective. The disciplines of art provide lenses through which students learn to understand and appreciate the richness of artistic expression close to home and throughout the world.

The Importance of Contemporary Art

If students are to understand and appreciate the integrative role that art plays in their lives, they need to see, study, and appreciate artworks made by people living along with them in their local and worldwide communities. The study of art from the past helps students understand the origins of and traditions associated with contemporary artworks. They learn that artists today, as in the past, respond to ideas, needs, issues, and events in the time and place in which they live. *Art and the Human Experience* includes many examples of contemporary art from close to home and around the world. It proposes that students be encouraged to seek out contemporary artworks and to learn from local artists.

Content Knowledge, Disciplined Inquiry, and Learning for Life

When students construct knowledge, they organize, synthesize, interpret, explain, or evaluate information. To do this well, they must build upon prior knowledge that others have produced—the content knowledge in the art disciplines. As students assimilate prior knowledge, they hone their skills through guided practice in producing artworks, conversation, and writing. *Art and the Human Experience* encourages thoughtful use and application of content knowledge.

Disciplined inquiry is important cognitive work. It employs the facts, concepts, and theories that other inquirers have produced. Students are encouraged to develop in-depth understanding of problems as they raise questions and explore issues, relationships, and complexities within focused topics and themes.

Through the construction of knowledge through disciplined inquiry, students are offered opportunities to produce artwork and discourse that have aesthetic, useful, and personal meaning and value beyond demonstration of success in school. *Art and the Human Experience* proposes connections to life in the school and local community, to the performing arts, and to other curriculum areas.

Program Fundamentals

Photo courtesy Karen Miura, Kalakaua Middle School, Honolulu, Hawaii.

The Importance of Inquiry

Teaching strategies within *Art and the Human Experience* are aimed toward developing deep understanding. Toward this end, we have included many opportunities for students to raise and address questions prompted by the chapter content. Such opportunities can be found in the student book where questions are posed in the body of text, in captions, and in review questions in the lessons and at the end of each chapter. The teacher's edition includes many suggestions for engaging students in inquiry. These can be found in sections such as "Using the Text," "Using the Art," and "Teaching Options." We believe that inquiry is enhanced when students collaborate with each other. Many teaching suggestions include activities in which students collaborate in pairs or in small or large groups.

Creating an Environment for Learning

We know that teachers want their artrooms to be safe places—places where students feel comfortable sharing their ideas, concerns, fears, and dreams. Students need to know that they are respected as learners. They need to know that their ideas are valued, that what they have to say will be heard. They need to trust that they will not be put down by their peers. If students are to be comfortable raising and addressing questions, they need to

know that they are free to voice their concerns and their ideas—that their opinions matter.

The learning environment must be a place where inquiry is encouraged and where curiosity is important. These aspects not only need to be valued, but they also need to be modeled. Teachers who want their students to ask and address questions must be willing to ask questions themselves. Learners are far more likely to engage authentically in inquiry when their teacher assumes the role of a fellow inquirer, someone who is curious and who shares with students that sense of wonder that is at the root of all learning.

The teacher's role is as a facilitator or "coach" in the learning process. Breaking away from the role of one who has most of the answers is not always easy. It means shifting away from the experience of our own schooling, where the teacher knew the answers and we saw the teacher as one who imparts truth. In many cases, it means being willing to admit to not having all the answers. This takes confidence, and it takes commitment to the belief that students learn best when they are addressing questions that stem from their own experiences.

Instructional Strategies

In *Art and the Human Experience*, students are engaged in the fundamental activities of learning; along with art-making, they are engaged in reading, listening, speaking, and writing. Suggested strategies aim toward helping students acquire, evaluate, organize, interpret, and communicate information. You will note that many suggested strategies involve helping students to learn to reach beyond resources in the school for information.

Reading the Text Students' interests and abilities in reading vary within and across classes. It is important to recognize that reading in art, like reading in other subjects, is a tool for learning and a means of communication. Students who are still learning to read may not be able to acquire information from the text rapidly. Even so, slow readers are often fascinated with art texts precisely because the written text is a supplement to the visual information.

Throughout the student text, captioned images, boldface headings and topically coherent page layouts have been used to aid students. Many captions also contain questions to guide perception and reflective thinking.

Preparation for Reading Always plan ahead and read each chapter before making any assignments. You might assign a full lesson or divide it into manageable and meaningful units. When you give a reading assignment within a new lesson, first have students **preview** the text. Have students scan the reading assignment to understand the main ideas in each part. They should look at the introduction, headings, subheadings and images. If review questions come at the end of the section, students can use them to help identify main points of the reading assignment.

Students should next **analyze** the text. A useful strategy to help students understand the purpose of a particular section is to have them turn a heading into a question. If the heading is, "Artists Show Us at Work and Play," recast it as the question, "How do artists show us at work and play?" The question helps readers search for supporting details in the text. As students carefully **read** the text, they can jot down and try to find answers to questions they have about the topic.

As they read, they can **evaluate** the material in the text, taking notes about main ideas. Show students how to take brief notes that are clear enough to understand when they return to them. The teacher's text has many suggestions for discussing the ideas presented in the student text.

Review is the final important step in the reading process. Students should review their notes to make sure they have highlighted the most important information. They may need to reread a section to clarify the main ideas. Help students make connections, asking them how the new information challenges, refutes, supports, or enlarges their understanding of the subject.

One way to help students make sense of what they have read is to have them create **graphic organizers**. The Teacher's Resource Binder (TRB) has blank concept maps and other organizers to assist students in this process. In completing a concept map, students can put the main idea in the center of the map and draw spokes to connect related ideas. Graphic organizers can be used to study or to take notes for discussions, art-making experiences, and written or oral work. The teacher's text periodically suggests that students create graphic organizers to help understand or explain the major ideas in a lesson.

Class time devoted to reading can be reduced by assigning sections of chapters as homework, by assigning teams to read and report on sections, and by selective oral or silent reading within the text. Oral reading by students is most effective when it is preceded by silent reading. This gives students time to become familiar with the content and try out unfamiliar vocabulary.

Writing Assignments Written assignments can be an integral part of learning about art. Writing is a form of reflective thinking, and is especially helpful for developing vocabulary, practicing art criticism, and reflecting about artwork, and keeping a journal. Various assignments engage students in descriptive, persuasive, expository, narrative, and imaginative writing. Students can apply what they have learned in other subjects about preparing drafts, revising, and completing finished work. Throughout the program, they are encouraged to share their writing with peers.

Photo courtesy Betsy Logan, Samford Middle School, Auburn, Alabama.

Talking About Art Throughout the program, you will find suggestions for having students engage in discussions about specific artworks and issues related to art. At times, we suggest large group discussions in which the teacher functions as the facilitator. Eventually, students can assume the facilitator role, using the teacher as a model. Talking about art also takes place in small groups or in pairs of students. Students who are reluctant to contribute to large group discussions often will gain confidence by working in smaller groups. We can help students to hone their listening skills and their skills in providing cogent arguments for their positions. Through these discussions, students gain insights about their own thinking as well as that of their peers. These insights are important to their experiences in meaningful art making.

Assessment

As we encourage students to acquire deep understanding of important concepts and skills associated with art, it is important to establish means for determining the extent to which students have developed such understandings. The objectives within *Art and the Human Experience* are aligned with national standards. The content of the student text and the instructional strategies in the teacher's edition are aligned with these standards and the lesson objectives. There are opportunities throughout the program to assess student learning. For example, each lesson is followed by a Check Your Understanding component, aimed at helping students identify the main ideas of the lesson. In addition, the Teaching Options within the teacher's edition contain suggestions for assessment. In some cases, the assessment strategies are designed so that the teacher reviews the work and determines the extent of learning on the part of the student. Such strategies are marked as "Teacher Assessment." Strategies are also designed for "Peer" or "Self" Assessment. In every case, criteria are embedded in the description of the assessment strategy.

We suggest that teachers discuss the learning objectives for each lesson with the students. Students and teachers can plan and negotiate activities that will pave the road to achievement. Inform students about what they are expected to know and be able to do as a result of their engagement. The road to achievement should be clearly marked so as to avoid the appearance of a guessing game or treasure hunt—a frustrating state of affairs for all involved.

The questions in each Chapter Review are based on the commonly used system for asking questions and developing tests, *The Taxonomy of Educational Objectives: Handbook I: Cognitive Domain* (White Plains, NY: Longman 1956, 1977). Higher-order thinking is used increasingly as students move through questions requiring them to recall important information, show that they understand key ideas, apply their understanding to new situations, analyze information, synthesize and communicate what they have learned, and make judgments based upon criteria. Negotiate which of the items students will complete in order to demonstrate their understanding.

Teaching suggestions and options provide opportunities to engage in Formative Assessment, judging the extent to which students understand key ideas and demonstrate important skills stated in the objectives. In addition, each chapter contains a Reteach component, with suggestions for reviewing major concepts and skills.

Meeting Individual Needs

The lessons in *Art and the Human Experience* were designed with attention to the challenge that teachers face in adapting instruction to the needs of all learners. After defining and identifying students' areas of strength, teachers can adapt suggested strategies in the lessons to address the different ways in which their students best learn.

Kinesthetic Learners Some students learn best when actively engaged in hands-on approaches, body-movement activities, and other tactile experiences.

Verbal Learners Verbal or auditory learners seem to learn most readily through speaking and listening activities.

Logical Learners Some students seem to learn best when engaged in problem-solving or step-by-step explorations. Logical learners tend to seek quantitative results.

Spatial Learners Spatial learners tend to explore the world around them. They are visually oriented and learn best with pictures, three-dimensional props, and with activities that require them to translate verbal or written materials into visual terms.

Musical Learners Some students learn best when they have the opportunity to listen to or create rhythms. Such students tend to be musically inclined.

Gifted and Talented Learners Students who learn at an accelerated pace or show a particular talent need assignments that challenge their abilities. When working with these students, teachers can employ the strategies suggested for all of the learning styles above.

ESL Learners Students acquire English as a second language in successive stages, from nonverbal understanding to fluency. To aid these students, consider using picture clues, real-life scenarios, and peer work with English-speaking classmates. Students who are learning English as a second language may exhibit characteristics of any of the above learning styles.

Other Special Needs

To the extent possible, introduce the regular curriculum to students with special needs.

Visual impairments These students can respond to discussions of artwork, especially themes related to the students' experiences and imagination. For studio work, create tactile, kinesthetic artwork out of materials such as clay, textured paper and cloth, small boxes or wood blocks to arrange.

Speech and hearing impairments Slow down the process of verbal communication, and use nonverbal means of communication. Have students point out what they see or encourage them to use pantomime to express their responses. Present information through diagrams, charts, and other visual aids. These nonverbal forms of communication are valuable for all students.

Impaired mobility and medical problems These students may require the use of alternate tools and materials for some activities. In most instances, rehabilitation specialists can help you solve unique problems. A number of special tools—such as scissors and a mouthpiece that holds a pencil or brush—are available for students who have physical impairments.

Photo courtesy Karen Miura, Kalakaua Middle School, Honolulu, Hawaii.

The subject of art is a distinct and important part of the total curriculum. Just as the study of art can enrich students' understanding of other subjects, so, too, can their studies of other subjects be linked to art. A few of these possibilities are outlined here.

Language Arts

1. Develop the art vocabulary of students.
• Write art terms and concepts on the chalkboard. Refer to them during the entire lesson.
• Develop lists of adjectives and adverbs to describe art elements and moods in artworks: Lines can seem lazy, energetic, or bold. (A useful resource is the set of Expressive Word Cards found in the Teacher's Resource Binder.)
• Ask for complete and complex descriptions: "I see a large, red square near the center of the painting."
2. Encourage reflective inquiry into art.
• Engage students in analysis and comparison: "This large, simple form seems to balance this small, patterned form." "This drawing has many more details than that one."
• Develop skills in critical thinking. Ask for interpretations of visual evidence, explanations based on "visual facts." Hypothesize about what an artist wanted us to see, feel, and imagine.
3. Have students read about art.
• Encourage oral and written reports on favorite artworks and artists.
• Create original art based on poems or stories.
• Study the arts of book illustration, alphabet design, and calligraphy.

Social Studies

1. Teach students about the role of art in everyday life.
• Acquaint students with places where they can see art in their community: parks, malls, and plazas; outstanding examples of architecture; and art museums and galleries.
• Study the useful products artists design, such as advertisements, illustrations in books and magazines, dinnerware, appliances, automobiles, and clothing.
• Introduce students to careers in art and to people in their communities whose primary work centers on art and design.
2. Teach students about the rich heritage of art, past and present.
• Stress the process of looking at art and reasons people around the world create art. Appreciation of varieties of art is more important than names, dates, and technical information.
• Make students aware of the accomplishments of men and women and specific cultural groups.

Science, Mathematics, and Technology

1. Teach students how artists interpret the natural world and use scientific knowledge.

• Emphasize the importance of careful observation in art and in science, identifying things by their shape, size, texture, color, weight, and so on.

• Explore the many ways artists have expressed their ideas and feelings about the natural world—changing seasons, weather, the beauty of forms in nature, etc.

• Have students create original artwork based on their observations of the subtle colors, textures, patterns, and movement of natural forms, plants, animals, and clouds.

2. Teach students how skills in mathematics and computer technologies apply to art.

• Emphasize how artists use their knowledge of measurement and geometric shapes and forms in designing architecture, in planning beautifully proportioned vases, and in many other aspects of art.

• Demonstrate the many uses of computers in creating art and in research on art.

Other Arts

A complete education in the arts will include studies of the visual arts along with the language arts (written and oral expression) and performing arts (music, dance, and theater). Each art form provides a unique avenue for sharing ideas and feelings with others.

1. Teach concepts that apply to all the arts.

• In each art form, there are creative originators of ideas—composers of music, choreographers of dance, playwrights, poets, and authors.

• All artists explore and master their chosen media. Artists transform sounds into music, movements into dance, interactions of people into theater, qualities of paint into images, and words into meaningful poems and stories.

• Every art form has compositions, designs, or arrangements that are unique to its medium. This explains why each artwork and each art form is unlike others.

2. Illustrate relationships among the arts.

• Note how terms from music are sometimes used to describe things we see: "loud" colors, "rhythmic" patterns of shapes, and "harmonious" designs.

• Relate the qualities of movement in dance to actual or implied movement in visual art: A line may seem to "twist and turn" in space, as if it is "dancing."

• Have students create masks, puppets, and plays. Discuss the visual qualities of these elements, including stage scenery, makeup and costumes, as important facets of the art of theater.

• Help students appreciate how television, video, and film, major art forms of our time, uniquely combine other art forms: music, choreography, etc.

Photo courtesy Bunki Kramer, Los Cerros Middle School, Danville, California.

Building Support for the Art Program

It is important to have support for your program. Educate teachers, administrators, counselors, parents, and community groups about your program. Prepare information on how they can assist your efforts. Organize a parent or business group to give special support by volunteering—arranging field trips, collecting recyclable materials, or sponsoring special events.

Develop a teacher-student art newsletter or Web page. It might include samples of artworks, aesthetic observations, special requests for the art program, invitations to see exhibits, and the like.

Develop a plan and timetable for student involvement in exhibitions within and beyond the school. Delegate some of the responsibilities to students. For example, rotate student work in main offices, the teacher's lounge, and halls. Always include captioned descriptions of the art concepts or student descriptions of the ideas and processes.

There are several periods during which you may plan special exhibits and related activities to focus attention on the art program. In the United States, for example, March has been designated Youth Art Month by the National Art Education Association. At this time, teachers in all schools are urged to make parents and the community aware of the enthusiasm young people have for art and the ways they are engaging in creating and studying art. In addition, many teachers in North America have special exhibitions near the end of the year, when students are best able to demonstrate what they have learned.

Develop skills in preparing press releases and contacting the news media, so that exceptionally newsworthy or timely activities can be reported to the community.

Participate in art education and art associations. They are the most valuable paths to professional growth, renewal, and awareness of developments that might help you in your work.

Find out about artists-in-education programs available in your community. Art supervisors and arts councils can provide information. Find out about the educational programs offered by art museums and what is required of you and your students to take advantage of them.

Maintaining the Artroom

Safety

Concerns about safety make it essential for you and your students to be particularly aware of hazardous art materials or processes. Safety glasses, dust masks or respirators, and rubber gloves are among the most common items you should have on hand.

Throughout *Art and the Human Experience*, Safety Notes are highlighted. However, the responsibility for safety in your artroom rests first and foremost with you. Review all safety procedures required for an art activity with students. Before you allow them to begin, make sure all students understand safety precautions and the reasons for them. Written safety rules with tests and active demonstrations of understanding are especially important prior to beginning any activity that involves chemicals, fumes, dust, heat, cutting tools, or electricity.

Art programs utilize all kinds of specialized equipment, materials and tools. Precautions must be taken to insure that working with art materials does not lead to student illness or injury. Failure to take necessary precautions may result in litigation if students become ill or are injured in the artroom. While restrictions are necessary, the teacher should be assured that nontoxic materials can usually be substituted for toxic ones with little or no extra cost, and good artroom management will prevent accidents.

Under the art material labeling law passed by Congress in October, 1988, every manufacturer, distributor, retailer and some purchasers (schools) have a legal responsibility to comply with this law. The law amended the Federal Hazardous Substances Act to require art and craft materials manufacturers to evaluate their products for their ability to cause chronic illness and to place labels on those that do.

The Art and Craft Materials Institute, Inc. has sponsored a certification program for art materials, certifying that CP, AP, and HL labeled products are nontoxic and meet standards of quality and performance.

CP (Certified Product) are nontoxic, even if *ingested, inhaled* or *absorbed*, and meet or exceed specific quality standards of material, workmanship, working qualities and color.

AP (Approved Products) are nontoxic, even if *ingested, inhaled* or *absorbed*. Some nontoxic products bear the HL (Health Label) seal with the wording, "Nontoxic," "No Health Labeling Required." Products requiring cautions bear the HL label with appropriate cautionary and safe use instructions.

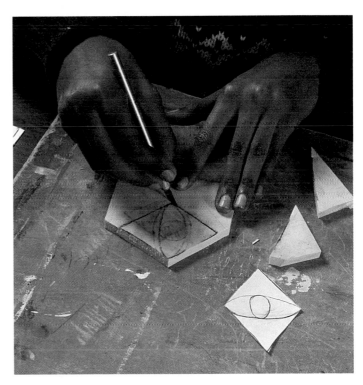

Photo courtesy Sara Grove Macauley and Sharon Gorberg, Winsor School, Boston, Massachusetts.

Teachers should check with their school administrators to determine if the state board of education has prepared a document concerning art and craft materials that cannot be used in the artroom, and listed products that may be used in all grade levels. If no list is locally available, contact The Art and Craft Materials Institute, Inc., 715 Boylston Street, Boston, MA, 02116 for a list of art products bearing the CP, AP, or HL/Nontoxic Seal.

In addition to determining that only nontoxic media are available in the classroom, the teacher is responsible for instruction in how to use all tools and equipment correctly and safely.

Make sure that the artroom has accident-preventing items such as the following:
• Signs on or near all work areas and equipment where injury might occur if students are careless, or should have instruction prior to use of the equipment.
• Protective equipment such as safety glasses, respiratory masks and gloves.
• A first aid kit containing antiseptics, bandages and compresses.
• Adequate ventilation to exhaust fumes.
• Safety storage cabinets and safety cans for flammable liquids. It is preferable not to keep them in the classroom.
• Self-closing waste cans for saturated rags.
• Soap and water wash-up facilities.
• Lock cabinets for hazardous tools and equipment.
• Rules posted beside all machines.

Precautions the teacher may take:
• Always demonstrate the use of hand and power tools and machines.
• During demonstrations, caution students concerning any potential hazards related to incorrect use of equipment.
• Give safety tests before permitting students to use tools and machines, and keep the tests on file.
• Establish a safety zone around all hazardous equipment.
• Establish a dress code for safety indicating rules about clothing, jewelry and hair in order to prevent accidents.
• Establish a code of behavior conducive to the safety of individuals and their classmates, and enforce it.
• Keep aisles and exits clear.
• Be aware of any special problems among students such as allergy, epilepsy, fainting or handicap.

Some "Do Nots" for the Safety Conscious Art Teacher:

• Do not absent yourself from the studio when pupils are present.
• Do not ignore irresponsible behavior and immature actions in the artroom.
• Do not make the use of all tools and machines compulsory.
• Do not permit students to work in the artroom without supervision.
• Do not permit pupils that you believe to be accident prone to use power equipment. Check on the eligibility of some mainstreamed students to use power tools.

Teachers should demonstrate constant concern for safety in the artroom, and teach by example to help students accept responsibility for accident prevention. For a thorough discussion of health and safety hazards associated with specific media and procedures see *Safety in the Artroom* by Charles Qualley, 1986.

Finding and Organizing Resources

Most teachers realize that the environment of the artroom should announce its purpose and be pleasing and functional. The following ideas may help achieve these goals.

Room-Organizing Resources Save sections of newspapers with colored advertising, and unusual black-and-white photographs of people, places, and events. Picture-dominated magazines that can be cut up will be useful for a variety of activities. Old newspapers should be available in quantity for covering tables or other uses. Save and develop a file of all news and magazine articles related to art.

Color-code storage bins and boxes. Cover the boxes with contact paper or paint them (with interior house paint) so they reflect definite color schemes.

Reserve space in the room for display of student work, art reproductions, and related teaching aids. If you want to feature biographies and works by selected artists on a regular basis, develop a weekly or monthly plan that provides for balance among art forms, and among men, women, and art from various cultures.

Visual Resources Images are essential for teaching about the world of art. A few of the most common types of resources are described below.

Collections of everyday objects. Use ordinary objects to help students understand basic art concepts. Reserve an area for display of still-life items. Stacked wood or plastic crates can double as shelves for the items. Move and rearrange the crates and items within them. Living or dried plants, shells, pinecones, and other intriguing natural forms are valuable resources for drawing, design, and other activities.

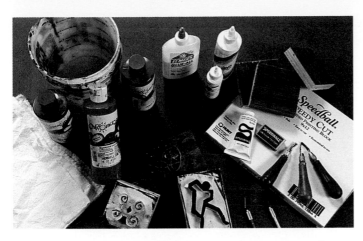

Photo courtesy Sara Grove Macauley and Sharon Gorberg, Winsor School, Boston, Massachusetts.

Field trips to see original art. Plan carefully for trips to art museums and artists' studios as well as tours to study architecture, murals, public sculpture, and the like. To enhance the educational value of such trips, plan several lessons that focus on the purpose of the trip and what students should notice during it. Always follow district rules and procedures for trips beyond school grounds.

Many art museums have special programs for schools. Some programs offer an orientation to the museum so students are well-prepared for their first visit. Other programs introduce students to the process of looking at artworks and acquaint students with the differences between original works and reproductions.

Visiting experts on art. You may also invite local artists, craftsworkers, designers, and architects to school for special demonstrations. Arrangements for this should be made with your art supervisor or state or local arts council. Always interview guests in advance to assess their qualifications and ability to present ideas related to your educational goals.

Reproductions of artwork. Photographic reproductions of works of art are available in different sizes. Although they are not a substitute for seeing original works of art, every teacher should have access to a library of art prints. Larger prints can be displayed to make part of the room resemble an art museum. Intermediate sizes are excellent for study at a table or desk. Use smaller postcard prints for matching and sorting games.

Art resource books for students. Your library or resource center should routinely order art books for students. (See the bibliography in the student text, page 309, for ideas.) Students should also be introduced to the artistry of book design and illustration.

Publisher's Acknowledgments

Publisher: Wyatt Wade

Editorial Directors: Claire Mowbray Golding, Helen Ronan

Fabrication: C.S. McQuillen

Editorial/Production Team: Nancy Bedau, Nancy Burnett, Carol Harley, Colleen Strang, Mary Ellen Wilson

Editorial Assistance: Laura Alavosus, Frank Hubert, Victoria Hughes, David Payne, Lynn Simon

Illustration: Susan Christy-Pallo, Stephen Schudlich

Design: Douglass Scott, Cara Joslin, WGBH Design

Manufacturing: Georgiana Rock, April Dawley

Teacher Bibliography

Teaching and Learning

Alger, Sandra L.H. *Games for Teaching Art.* Portland, ME: J. Weston Walch, 1995.

Barton, James and Angelo Collins. *Portfolio Assessment.* Reading, MA: Addison-Wesley, 1996.

Beattie, Donna Kay. *Assessment in Art Education.* Worcester, MA: Davis Publications, 1997.

Comstock, Charles W. Jr. *How to Organize and Manage Your Art Room.* Portland, ME: J. Weston Walch, 1995.

Cook, Ande. *Art Starters.* Worcester, MA: Davis Publications, 1994.

Ervin, Barbara Mickelsen. *Making Connections: Interdisciplinary Art Activities for Middle School.* Portland, ME: J. Weston Walch, 1998.

Greer, W. Dwaine. *Art as a Basic: The Reformation in Art Education.* Bloomington, IN: Phi Delta Kappa, 1997.

Greh, Deborah. *New Technologies in the Artroom.* Worcester, MA: Davis Publications, 1999.

Hume, Helen D. *Art History & Appreciation Activities Kit.* Paramus, NJ: Prentice Hall, 1992.

Hume, Helen D. *A Survival Kit for the Secondary School Art Teacher.* Paramus, NJ: Prentice Hall, 1990.

Hume, Helen D. *The Art Teacher's Book of Lists.* Paramus, NJ: Prentice Hall, 1998.

Lazear, David. *Multiple Approaches to Assessment.* Tucson, AZ: Zephyr Press, 1998.

Levi, Albert William and Ralph A. Smith. *Art Education: A Critical Necessity.* Chicago, IL: University of Illinois Press, 1991.

Qualley, Charles. A. *Safety in the Artroom.* Worcester, MA: Davis Publications, 1986.

Thompson, Kimberly and Diana Loftus. *Art Connections: Integrating Art Throughout the Curriculum.* Reading, MA: Addison-Wesley, 1994.

Walkup, Nancy Reynolds. *Art Lessons for the Middle School: A DBAE Curriculum.* Portland, ME: J. Weston Walch, 1992.

Watson, George. *Teacher Smart: 125 Tested Techniques for Classroom Management & Control.* Paramus, NJ: Prentice-Hall, 1996.

Aesthetics

Dissanayake, Ellen. *What is Art For?* Seattle, WA: University of Washington Press, 1988.

Parsons, Michael J. and H. *Gene Blocker.* Aesthetics and Education. Chicago, IL: University of Illinois Press, 1993.

Parsons, Michael J. *How We Understand Art.* NY: Cambridge University Press, 1987.

Stewart, Marilyn. *Thinking Through Aesthetics.* Worcester, MA: Davis Publications, 1997.

Art Criticism

Artchart Poster Series: Elements and Principles of Design Posters. Glenview, IL: Crystal Productions.

Barrett, Terry. *Talking About Student Art.* Worcester, MA: Davis Publications, 1997.

Barrett, Terry. *Criticizing Art. Understanding the Contemporary.* Mountain View, CA: Mayfield Publishing Co., 1994.

Hobbs, Jack and Richard Salome. *The Visual Experience.* Worcester, MA: Davis Publications, 1995.

Wolff, Theodore F. and George Geahigan. *Art Criticism and Education.* Chicago, IL: University of Illinois Press, 1997

Art History

General

Addiss, Stephen and Mary Erickson. *Art History and Education.* Chicago, IL: University of Illinois Press, 1993.

Art: A World History. NY: DK Publishing, 1997.

Artchart Poster Series: Know the Artist Posters: Sets 1 and 2. Glenview, IL: Crystal Productions.

Brommer, Gerald F. *Discovering Art History.* Worcester, MA: Davis Publications, 1997.

Cerrito, Joan, ed. *Contemporary Artists.* Detroit, MI: St. James Press, 1996.

Chilvers, Ian, Harold Osborne and Dennis Farr. *The Oxford Dictionary of Art.* NY: Oxford University Press, 1994.

Cumming, Robert. *Annotated Guides: Great Artists.* NY: DK Publishing, 1998.

Chronicle Encyclopedia of History. DK Publishing. (CD-ROM)

Chronicle of the 20th Century. DK Publishing. (CD-ROM)

Eyewitness History of the World 2.0. DK Publishing. (CD-ROM)

Janson, H.W. *History of Art.* NY: Harry N. Abrams, Inc., 1995.

Sister Wendy Beckett. *Sister Wendy's 1000 Masterpieces.* NY: DK Publishing, 1999.

Sister Wendy Beckett. *Sister Wendy's Story of Painting.* NY: DK Publishing, 1997.

Stokstad, Marilyn. *Art History.* NY: Harry N. Abrams, Inc., 1995.

Strickland, Carol and John Boswell. *The Annotated Mona Lisa: A Crash Course in Art History from Prehistoric to Post-modern.* Kansas City, MO: Universal Press Syndicate Co., 1992.

Time Lines

Bridges, Barbara and Peter Furst. *Arts of Mexico Timeline*. Tucson, AZ: Crizmac.

Mackey, Maureen. *Ceramic Innovations: Global Art Timeline*. Worcester, MA: Davis Publications, 1997.

Millard, Anne. *A Street Through Time*. NY: DK Publishing.

Millennium Timeline Sticker Book. NY: DK Publishing, 1999.

Scarre, Chris. *Smithsonian Timelines of the Ancient World*. NY: DK Publishing, 1993.

Time Line of Culture in the Nile Valley and its Relationship to Other World Cultures. NY: Metropolitan Museum of Art, 1979.

Ancient World

Arnold, Dorothea. *An Egyptian Bestiary*. Metropolitan Museum of Art, 1995.

Burenhult, Goran, ed. *The First Humans*. San Francisco: Harper San Francisco, 1993.

Celenko, Theodore, ed. *Egypt in Africa*. Indianapolis Museum of Art, 1996.

Chauvet, Jean-Marie, Eliette Brunel Deschamps, and Christian Hillaire. *Dawn of Art: The Chauvet Cave: The Oldest Known Paintings in the World*. NY: Harry N. Abrams, Inc., 1994.

Clottes, Jean and Jean Courtin. *The Cave Beneath the Sea: Paleolithic Images at Cosquer*. NY: Harry N. Abrams, Inc., 1991.

Haynes, Joyce L. *Nubia: Ancient Kingdom of Africa*. Boston: Museum of Fine Arts, 1992.

O'Halloran, Kate. *Hands-on Culture of Ancient Egypt*. Portland, ME: J. Weston Walch, 1997.

Reeves, Nicholas. *The Complete Tutankhamun*. NY: Thames and Hudson, 1995.

Rhodes, Toni. *Wonders of World Cultures: Exploring Near & Middle East*. Portland, ME: J. Weston Walch, 1999.

Sandison, David. *The Art of Ancient Egypt*. San Diego, CA: Laurel Glen Publishing, 1997.

Taylor, Tim & Mick Aston. *The Atlas of Archaeology*. NY: DK Publishing, 1998.

Classical World

Boardman, John. *Greek Art*. NY: Thames and Hudson, 1996.

Boardman, John. *Greek Sculpture*. NY: Thames & Hudson, 1985.

Boardman, John, Ed. *The Oxford Illustrated History of Classical Art*. NY: Oxford University Press, 1993.

Moatti, Claude. *In Search of Ancient Rome*. NY: Harry N. Abrams, Inc., 1993.

O'Halloran, Kate. *Hands-on Culture of Ancient Greece & Rome*. Portland, ME: J. Weston Walch, 1998.

Philip, Neil. *Myths & Legends*. NY: DK Publishing, 1999.

Ramage, Nancy H. and Andrew. *Roman Art: Romulus to Constantine*. NY: Harry N. Abrams, Inc., 1991.

Wheeler, Mortimer. *Roman Art and Architecture*. NY: Thames and Hudson, 1985.

The Middle Ages

Biedermann, Hans. *Dictionary of Symbolism*. NY: Facts On File, 1998.

Favier, Jean. *The World of Chartres*. NY: Harry N. Abrams, Inc., 1990.

Ferguson, George. *Signs and Symbols in Christian Art*. NY: Oxford University Press, 1972.

Korn, Irene. *A Celebration of Judaism in Art*. NY: Todtri, 1996.

Treasures of the Holy Land: Ancient Art from the Israel Museum. NY: Metropolitan Museum of Art. 1986.

Renaissance

Labella, Vincenzo. *A Season of Giants*. Boston, MA: Little, Brown, 1990.

Vasari, Giorgio. *The Lives of the Artists*. NY: Oxford University Press, 1991.

Impressionism & Post Impressionism

Adriani, Gotz. *Cezanne: Paintings*. NY: Harry N. Abrams, Inc., 1995.

Bade, Patrick. *Degas: The Masterworks*. NY: Portland House, 1991.

Barnes, Rachel, ed. *Degas by Degas*. NY: Alfred A. Knopf, 1990.

Barnes, Rachel, ed. *Monet by Monet*. NY: Alfred A. Knopf, 1990.

Cachin, Francoise, et al. *Cezanne*. Philadelphia, PA: Philadelphia Museum of Art, 1996.

Effeny, Alison. *Cassatt: The Masterworks*. NY: Portland House, 1991.

Feaver, William. *Van Gogh*. NY: Portland House, 1990.

Forge, Andrew. *Monet*. NY: Harry N. Abrams, Inc., 1995.

Freches-Thory, Claire, et al. *Toulouse-Lautrec*. New Haven, CT: Yale University Press, 1992.

Herbert, Robert L., et. al. *Georges Seurat*. NY: Metropolitan Museum of Art, 1991.

Loyette, Henri. *Degas: The Man and His Art*. NY: Harry N. Abrams, Inc., 1995.

Mathews, Nancy Mowll. *Mary Cassatt: A Life*. New Haven: Yale University Press, 1998.

Sutton, Denys. *Degas: His Life and Work*. NY: Abbeville Press, 1991.

Tucker, Paul Hayes. *Claude Monet: Life and Art*. New Haven, CT: Yale University Press, 1995.

Witzling, Mara R. *Mary Cassatt: A Private World*. NY: Universe, 1991.

Zemel, Carol. *Vincent Van Gogh*. NY: Rizzoli, 1993.

20th Century

Christo & Jeanne-Claude, *Wrapped Reichstag, Berlin, 1971–1995*. Benedikt Taschen, Cologne, Germany, 1995.

Elderfield, John. *Henri Matisse: A Retrospective*. NY: Museum of Modern Art, 1992.

Eldredge, Charles C. *Georgia O'Keeffe: American and Modern*. New Haven, CT: Yale University Press, 1993.

Herrera, Hayden. *Matisse: A Portrait*. NY: Harcourt Brace, 1993.

Kordich, Diane. *Images of Commitment: 20th Century Women Artists*. Tucson, AZ: Crizmac, 1994.

Paul, Stella. *Twentieth Century Art: A Resource for Educators*. NY: Metropolitan Museum of Art, 1999.

Phillips, Lisa. *The American Century, Art & Culture, 1950–2000*. Whitney Museum of American Art, New York and W. W. Norton, New York, 1999.

Popular Culture

Ash, Russell. *Factastic Millennium Facts*. NY: DK Publishing, 1999.

Hamilton, Jake. *Special Effects in Film and Television*. NY: DK Publishing, 1998.

Karney, Robyn. *Chronicle of the Cinema*. NY: DK Publishing, 1997.

1000 Makers of the Millennium. NY: DK Publishing, 1999.

Thorgerson, Storm and Aubrey Powell. *100 Best Album Covers*. NY: DK Publishing, 1999.

Art in the United States, Multicultural

Albany Institute of History and Art. *The Natural Palette: The Hudson River Artists and the Land*. Tucson, AZ: Crizmac, 1997.

Hispanic Folk Art and the Environment: A New Mexican Perspective.

National Museum of American Art. *African American Artists: Affirmation Today*. Glenview, IL: Crystal Productions, 1994.

National Museum of American Art. *Latino Art & Culture in the United States*. Glenview, IL: Crystal Productions, 1996.

National Museum of American Art. *Land & Landscape: Views of America's History and Culture*. Glenview, IL: Crystal Productions, 1997.

National Museum of American Art. *Public Sculpture: America's Legacy*. Glenview, IL: Crystal Productions, 1994.

Native American

America's Fascinating Indian Heritage. Pleasantville, NY: Reader's Digest Association, Inc., 1990.

Feder, Norman. *American Indian Art*. NY: Harry N. Abrams, Inc., 1995.

Hill, Tom and Richard W. Hill Sr., eds. *Creation's Journey*. Washington DC: Smithsonian Institution Press, 1994.

Jacka, Lois Essary. *Enduring Traditions: Art of the Navajo*. Flagstaff, AZ: Northland Publishing, 1994.

Jonaitis, Aldona. *From the Land of the Totem Poles*. Seattle, WA: University of Washington Press, 1991.

Penney, David W. and George C. Longfish. *Native American Art*. Southport, CT: Hugh Lauter Levin Associates, 1994.

Rosenak, Churck and Jan. *The People Speak: Navajo Folk Art*. Flagstaff, AZ: Northland Publishing, 1994.

Stewart, Hilary. *Totem Poles*. Seattle, WA: University of Washington Press, 1993.

Art of Global Cultures
General

Bowker, John. *World Religions*. NY: DK Publishing, 1997.

Chalmers, F. Graeme. *Celebrating Pluralism: Art, Education, and Cultural Diversity*. Los Angeles, CA: The Getty Education Institute for the Arts, 1996.

Mack, Stevie and Deborah Christine. *Tribal Design*. Tucson, AZ: Crizmac, 1988.

Museum of International Folk Art. *Recycled, Re-Seen: Folk Art From the Global Scrap Heap*. NY: Harry N. Abrams, Inc., 1996.

World Reference Atlas. NY: DK Publishing, 1998.

Eyewitness World Atlas. DK Publishing (CD-ROM)

Africa

Courtney-Clarke, Margaret. *African Canvas: The Art of West African Women*. NY: Rizzoli, 1990.

National Museum of African Art. *The Art of West African Kingdoms*. Washington, DC: Smithsonian Institution Press, 1987.

O'Halloran, Kate. *Hands-on Culture of West Africa*. Portland, ME: J. Weston Walch, 1997.

Rhodes, Toni. *Wonders of World Cultures: Exploring Africa*. Portland, ME: J. Weston Walch, 1999.

Robbins, Warren M. and Nancy Ingram Nooter. *African Art in American Collections*. Washington, DC: Smithsonian Institution Press, 1989.

Mexico, MesoAmerica, Latin American

Herrera, Hayden. *Frida Kahlo*. NY: Harper Collins, 1991.

Lowe, Sarah M. *The Diary of Frida Kahlo*. NY: Harry N. Abrams, Inc., 1995.

Poupeye, Veerle. *Caribbean Art*. NY: Thames and Hudson, 1998.

Mack, Stevie. *Gente del Sol*. Tucson, AZ: Crizmac, 1991.

Mack, Stevie, Amy Scott Metcalfe with Nancy Walkup. *Days of the Dead*. Tucson, AZ: Crizmac, 1999.

Mack, Stevie and Jennifer Fiore. *Oaxaca, Valley of Myth and Magic*. Tucson, AZ: Crizmac, 1995.

Mack, Stevie and Jennifer Fiore. *World Beneath a Canopy: Life and Art in the Amazon*. Tucson, AZ: Crizmac, 1997.

Miller, Mary Ellen. *The Art of MesoAmerica*. NY: Thames and Hudson, 1996.

O'Halloran, Kate. *Hands-on Culture of Mexico and Central America*. Portland, ME: J. Weston Walch, 1998.

Poupeye, Veerle. *Caribbean Art*. NY: Thames and Hudson, 1998.

Rochfort, Desmond. *Mexican Muralists: Orozco, Rivera, Siqueiros*. NY: Universe Publishing, 1994.

Stebich, Ute. *A Haitian Celebration: Art and Culture*. Milwaukee, WI: Milwaukee Art Museum, 1992.

Walkup, Nancy and Judy Godfrey. *Haitian Visions*. Tucson, AZ: Crizmac, 1994.

Walkup, Nancy and Sharon Warwick. *Milagros: Symbols of Hope*. Tucson, AZ: Crizmac, 1996.

Asia

Baker, Joan Stanley. *Japanese Art*. NY: Thames and Hudson, 1984.

Berinstain, Valerie. *Discoveries: India and the Mughal Dynasty*. NY: Harry Abrams, 1998.

Cooper, Rhonda and Jeffery. *Masterpieces of Chinese Art*. London: Tiger Books International, 1997.

Craven, Roy C. *Indian Art*. NY: Thames and Hudson, 1997.

Fong, Wen C. and James C.Y. Watt. *Possessing the Past: Treasures from the National Palace Museum, Taipei*. NY: Harry N. Abrams, Inc., 1996.

Kerry, Rose, ed. *Chinese Art and Design: Art Objects in Ritual and Daily Life*. NY: Viking, 1992.

O'Halloran, Kate. *Hands-on Culture of Japan*. Portland, ME: J. Weston Walch, 1997.

O'Halloran, Kate. *Hands-on Culture of Southeast Asia*. Portland, ME: J. Weston Walch, 1998.

Pearlstein, Elinor L. and James T. Ulak. *Asian Art in The Art Institute of Chicago*. Chicago, IL: The Art Institute of Chicago, 1993.

Rawson, Jessica, Ann Farrer, Jane Portal, Shelagh Vainker, and Carol Michaelson. *The British Museum Book of Chinese Art*. NY: Thames and Hudson, 1993.

Rhodes, Toni. *Wonders of World Cultures: Exploring Asia & The Pacific Rim*. Portland, ME: J. Weston Walch, 1999.

Zephir, Thierry. *Khmer: The Last Empire of Cambodia*. NY: Harry Abrams, 1998.

Pacific

Nordin, Julee and Pat Johnson. *Australian Dreamings*. Tucson, AZ: Crizmac, 1996.

Pacific Resources for Education and Learning. *Island Worlds: Art and Culture in the Pacific*. Tucson, AZ: Crizmac, 1999.

Art Studio

Artchart Poster Series: Drawing Posters. Glenview, IL: Crystal Productions.

Artchart Poster Series: Watercolor Posters. Glenview, IL: Crystal Productions.

Artchart Poster Series: Ceramics Posters. Glenview, IL: Crystal Productions.

Brown, Maurice and Diana Korzenik. *Art Making and Education*. Chicago, IL: University of Illinois Press, 1993.

McKim, Robert. *Thinking Visually*. Palo Alto, CA: Dale Seymour Publications, 1997.

Roukes, Nicholas. *Art Synectics*. Worcester, MA: Davis Publications, 1982.

Internet Resources

American Museum of Natural History
www.amnh.org/
Use this site to inspire students about the natural world, or check out art-related special features.

Andy Warhol Museum
www.clpgh.org/warhol/
Take an online tour of the seven floors of the special exhibitions and permanent collection of this museum devoted to the premier Pop Artist Andy Warhol.

Any1CanFly
www.artincontext.com/artist/ringgold/
This site has images of Faith Ringgold's art, information about her life and work, and more.

Artonline: Printmaking Techniques
www.nwu.edu/museum/artonline/resources/prints.html
Printmaking processes are explained on this site.

Art Learner Guides
http://schools.brunnet.net/crsp/general/art/
Developed for secondary students, these extensive PDF files are available on a wide variety of media and techniques.

ArtLex Visual Arts Dictionary
www.artlex.com/
This online dictionary provides definitions of more than 3,100 art terms, along with numerous illustrations, pronunciation notes, artist quotations, and links to other resources on the Web.

Asian Art Museum of San Francisco
www.asianart.org/
The Asian Art Museum is one of the largest museums in the Western world devoted exclusively to Asian art. The museum is a public institution whose mission is to lead a diverse global audience in discovering the unique material, aesthetic, and intellectual achievements of Asian art and culture.

Bill Viola
www.cnca.gob.mx/viola/
Experience the artist's video/sound installations.

Canadian Museum of Civilization
www.civilization.ca/cmc/cmceng/welcmeng.html
Take a virtual tour of the halls; investigate diverse works of art from Japanese kimonos to African ritual figurines.

Chaco Culture National Historical Park
www.nps.gov/chcu/
Learn about the distinctive architecture and pottery of Chaco Canyon in New Mexico, a major center of ancestral Pueblo Indian culture between A.D. 850 and 1250.

Christo and Jeanne-Claude
www.beakman.com/christo/
This fascinating site includes many images of the diverse projects these artists have worked on and are currently working on; also plenty of background information.

Color Theory
www.presscolor.com/library/ctindex.html
Learn more about the physics of color theory and concepts of light.

Cooper-Hewitt, National Design Museum
www.si.edu/ndm/
The collection of this museum contains both historic and contemporary design, from one of a kind to mass-produced objects. The Museum's collection encompasses graphic design, applied arts and industrial design, architecture, urban planning, and environmental design.

Dia Center for the Arts
www.diacenter.org/
Check out artists' Web projects, environmental art, earthworks, and installations, along with contemporary works using more traditional art forms.

Diego Rivera Virtual Museum
www.diegorivera.com/diego_home_eng.html
Available in both Spanish and English versions, this extensive site highlights the artwork and life of the celebrated Mexican muralist Diego Rivera.

Drawing Grids and Tile Floors in Perspective
pc38.ve.weber.k12.ut.us/art/ChalkBoard/lp-grids.htm
Diagrams and text explain linear and atmospheric perspective, shading, and composition.

Drawing in One-Point Perspective
www.olejarz.com/arted/perspective/
A step-by-step guide with interactive features and explanatory text.

Exploring Leonardo
www.mos.org/sln/Leonardo/LeoHomePage.html
Visit this extensive site to discover more about Leonardo da Vinci's futuristic inventions and use of perspective. Lesson ideas are also to be found here, such as Sketching Gadget Anatomy.

George Segal
www.artcyclopedia.com/artists/segal_george.html
This directory includes the artist's work in museum collections, exhibitions, and image archives online.

Georgia O'Keeffe Museum
www.okeeffemuseum.org/
This Santa Fe museum offers online a biography of the artist and images from its collections and exhibitions.

Getty Museum
www.getty.edu/museum/
Take an architecture tour of the Getty Center, investigate the museum's collections and history, and more.

Glenbow Museum
www.glenbow.org/home.htm
Located in Calgary, Alberta, the Glenbow showcases Canada's Native and Inuit art in their online Art Gallery.

Guerilla Girls
www.guerrillagirls.com/
Learn more about the Guerilla Girls' use of humor to effect social and political change in the art world.

Guggenheim Museum, Bilbao
www.guggenheim-bilbao.es/idioma.htm
Investigate the museum's breathtaking architecture, its exhibitions and permanent collection.

Hayward Gallery on the South Bank, London
www.hayward-gallery.org.uk/
Visit this contemporary arts center that contains the largest and most versatile temporary exhibition space in London.

Ho-Am Art Museum
www.hoammuseum.org/english/index.html
Browse the collection of more than 15,000 artifacts and artworks belonging to the largest private museum in Korea.

Hints and Tips from Grumbacher
www.sanfordcorp.com/grumbacher/hints_and_tips_from_grumbacher.htm
Advice on using watercolor, oil, and acrylic paints.

Jacob Lawrence Catalogue Raisonné Project
www.jacoblawrence.org/
This online archive and education center provides images and documentation of the entire body of Lawrence's work.

Japan Ukiyo-e Museum
www.cjn.or.jp/ukiyo-e/index.html
Compare works by Hokusai and Hiroshige, plus see other works of ukiyo-e artists, at this museum.

Jaune Quick-To-See Smith
www.nmwa.org/legacy/bios/bjqsmith.htm
Learn more about this renowned Native American artist on her biographical page at the National Museum of Women in the Arts.

Jenny Holzer
http://adaweb.walkerart.org/
Enter the artist's elegant and constantly changing interactive Web project.

Louis Comfort Tiffany
www.artcyclopedia.com/artists/tiffany_louis_comfort.html
Explore the work of Louis Comfort Tiffany.

Louvre Museum Paris, France
http://mistral.culture.fr/louvre/louvrea.htm
In a virtual tour of one of the most famous museums in the world, you will find a broad spectrum of subjects, styles, and themes of art, including the *Mona Lisa*.

Mary Cassatt, WebMuseum, Paris
http://sunsite.icm.edu.pl/wm/paint/auth/cassatt/
This site offers biographical information and links about Mary Cassatt.

Modern Art Museum of Fort Worth
www.mamfw.org/menu.htm
Search the collections and view the special exhibitions that focus on modern and contemporary art.

Moravian Pottery and Tile Works
www.libertynet.org/bchs/TileWork.htm
An elegantly-designed introduction to Henry Chapman Mercer's life and work, including Fonthill Museum (Mercer's home in the early twentieth century).

MuralArt.com
www.MuralArt.com/
This site features murals in various categories, including a mural of the month.

Museum of Indian Arts and Culture Laboratory of Anthropology
www.miaclab.org
Extensive information about the Museum's collections of Indian pottery, paintings, textiles and clothing, basketry, and jewelry, and archeology is presented here.

Museum of Modern Art
www.moma.org/
The Museum of Modern Art in New York City houses the world's first curatorial department devoted to architecture and design, established in 1932. The design collection contains more than 3,000 everyday objects that are both functional and well-designed, including furniture, tableware, tools, sports cars, and even a helicopter.

Nam June Paik
www.reynoldahouse.org/leonardo.htm
Investigate further the work of Nam June Paik, a leader in the art movement of video art.

Nasjonalgallerlet
www.museumsnett.no/nasjonalgalleriet/eng/index.html
This Oslo museum houses the largest collection in the world of artwork by Edvard Munch. See selected paintings and descriptions online.

National Gallery of Canada
http://national.gallery.ca/
Search the exhibitions and collections; experience CyberMuse.

National Museum of African Art
www.si.edu/organiza/museums/africart/nmafa.htm
Experience online tours of current exhibitions as well as the permanent collection.

National Museum of American Art

www.nmaa.si.edu/

The NMAA in Washington, D.C. is home to American paintings, sculptures, graphics, folk art, and photographs from the eighteenth century to the present. Browse the online collection of more than 3,000 digitized images classified by subject and artist.

National Museum of the American Indian

www.si.edu/nmai/

Explore the Smithsonian's National Museum of the American Indian online. See artifacts and find links to other Native American Web sites.

National Museum of Natural History

www.mnh.si.edu/

The seven scientific departments of the National Museum of Natural History offer comprehensive collections and research information online.

Nelson-Atkins Museum of Art

www.nelson-atkins.org/

This Kansas City museum includes a sculpture park with works by many modern masters. Don't miss *Shuttlecocks*, four larger-than-life sculptures of badminton "birdies."

Oakland Museum of Art

www.museumca.org/

Check out past, present, and upcoming exhibitions such as *What is Art For?* and *Women of Taste: A Collaboration Celebrating Quilt Artists and Chefs*.

Picasso Museum

www.musexpo.com/english/picasso/index.html

Tour the Paris museum dedicated to Pablo Picasso.

Pueblo Cultural Center

www.indianpueblo.org/

Visit the eight Northern Pueblos in New Mexico to compare cultural traditions specific to each pueblo. See twelve outstanding artworks (with explanations) completed for the Mural Project.

Roxanne Swentzell

www.artsednet.getty.edu/ArtsEdNet/Read/4p/clowns.html

Read a discussion about Swentzell's work from the perspectives of an artist, an art historian, an art critic, and an aesthetician.

Roy Lichtenstein Foundation

www.lichtensteinfoundation.org/

Browse through this site to learn more about the artist's paintings, sculpture, and drawings, along with ongoing exhibitions, publications and photographs.

Sandy Skoglund

www.artsednet.getty.edu/ArtsEdNet/Images/Skoglund/gallery1.html

ArtsEdNet offers images, activities, artist interviews, an online discussion, analysis, and interpretive questions—all related to Skoglund.

Save Outdoor Sculpture! (SOS!)

www.heritagepreservation.org

Save Outdoor Sculpture! is a collaborative effort to document, repair, and preserve public monuments and outdoor sculpture in the United States. Inventories on the site detail public art from every state being preserved. There are also interactive activities for students and teachers.

Space Art through the Ages

www.artsednet.getty.edu/ArtsEdNet/Resources/Space/index.html

Discover how space exploration and astronomy have inspired artists in the past and present. Includes lesson plans, images, and more.

Statue of Liberty and Ellis Island Monument

www.nps.gov/stli/mainmenu.htm

Tour these two national monuments to learn more about American immigration

Sydney Opera House

www.soh.nsw.gov.au/

View Australia's international cultural landmark designed for its harbor setting. Explore *The Past* for planning and construction details.

Teaching About Architecture and Art

www.artsednet.getty.edu/ArtsEdNet/Resources/Maps/Sites/index.html

World cultural heritage places are featured in detail on this site, including Trajan's Forum, Rome; Pueblo Bonito, Chaco Canyon, New Mexico; Great Mosque, Djenné; Katsura Villa, Kyoto; and the Sydney Opera House.

The AIDS Memorial Quilt

www.AIDSQuilt.org

Browse or search thousands of homemade quilted panels. Find answers to your questions about the quilt.

The Art Gallery of New South Wales

www.artgallery.nsw.gov.au/about/index.html

The Collection of Aboriginal Art and Torres Strait Islander Art, the largest collection of the Art Gallery of New South Wales' collections in Australia, includes a wide range of artworks from historic bark paintings to contemporary sculptures.

The Bayeux Tapestry: The Battle of Hastings 1066

http://battle1066.com/index.html

This site documents an important artwork that has survived from the eleventh century. Individual highlights and the complete tapestry are included. There is a section on tapestry construction.

The British Museum

www.british-museum.ac.uk/

The British Museum is particularly notable for its collection that includes the Greek world from the beginning of the Bronze Age, Italy and Rome from the Bronze Age; and the whole of the Roman Empire except Britain under the Edict of Milan (AD 313). You can visit the Egyptian Antiquities department; this site includes extensive information and images.

Also at the British Museum: *Cracking Codes: The Rosetta Stone and Decipherment.* The Rosetta Stone is the remains of a stele in three scripts; hieroglyphic, a cursive form of ancient Egyptian, and ancient Greek. The Stone is a cultural icon of script and decipherment, and is one of the most sought-after displays at the British Museum.

The Civilized Explorer: Art on the Internet

www.cieux.com/Arthome.html

This is worth a visit simply for the annotated listing of fascinating Web sites that originate outside the United States—but there is much, much more, including experimental sites, galleries, and museums. Have fun!

The Electric Franklin

www.ushistory.org/franklin/index.htm

Browse for resources, interactive games, a time line, and streaming videos about Benjamin Franklin. See Franklin's print shop, artworks, and other artifacts at Franklin Court.

The Labyrinth: Resources for Medieval Studies

www.georgetown.edu/labyrinth/

Everything medieval is here, including manuscripts, music, mythology, maps, fonts that recreate medieval handwriting, a virtual tour of a medieval city, and more.

The Metropolitan Museum of Art

www.metmuseum.org

The world-renowned Metropolitan Museum of Art houses a collection of over three million objects. The site is an excellent one to explore, especially for the Museum's Egyptian and Byzantium collections. A time line of museum objects, highlighted by thumbnail images, is particularly useful.

The Periodic Table of Comic Books

www.uky.edu/~holler/periodic/periodic.html

This clever table of periodic elements links each element to comic book pages involving that element.

The Photography of Lewis Hine

www.ibiscom.com/hnintro.htm

View photos of miners, mill workers, and newsboys taken by Lewis Hine while investigating child labor practices. Includes some of Hine's field notes.

The Saint Louis Art Museum

www.slam.org/

This beautifully designed site has examples of works from the collections, plus information about the current Featured Exhibition.

The Victoria and Albert Museum, London

www.vam.ac.uk/

Explore the Victoria and Albert Museum in London, the world's finest museum of the decorative arts. Founded in 1852, the Museum's vast collections include sculpture, furniture, fashion and textiles, paintings, silver, glass, ceramics, jewelry, books, prints and photographs.

The White House

www.whitehouse.gov/

Visit "White House History and Tours: Art in the White House" to view artwork from the White House collection.

Uffizi Gallery

www.uffizi.firenze.it/welcomeE.html

Take a virtual tour of the Uffitzi Gallery in Florence, Italy. Enter the gallery and click on the floor maps to discover which artworks are in each room.

UNESCO World Heritage List

www.its.caltech.edu/~salmon/world.heritage.html

Visit more than 500 sites which have been designated as deserving of protection and preservation.

University of British Columbia Museum of Anthropology

www.voice.ca/tourism/moa/anthrop.htm

Art and artifacts in the Museum of Anthropology illustrate the achievements of the First Peoples of the Northwest Coast.

Vietnam Veteran's Memorial Homepage

www.nps.gov/vive/index2.htm

Learn more about the three Vietnam veterans' memorials in Washington, D.C.

WebMuseum, Paris

www.oir.ucf.edu/wm/

This site delivers more than ten million documents, with special focus on artist biographies, works of art, and art history concepts.

William Wegman World

www.wegmanworld.com/index2.html

Learn everything you want to know about William Wegman and his celebrity Weimaraner dogs.

Winsor & Newton

www.winsornewton.com/

Visit the site of a major manufacturer of artist materials, the inventor of the world's first moist watercolor pan. Take an online factory tour and browse an encyclopedia of hints, tips, and techniques for using pastels and watercolor, acrylic, and oil paints.

World Art Treasures

http://sgwww.epfl.ch/BERGER/

Browse a significant collection of images and theme-based "itineraries" that concentrate on art history, art criticism, and aesthetics.

National Visual Arts Standards

1. Content Standard: Understanding and applying media, techniques, and processes
Achievement Standard:
a. Students select media, techniques, and processes; analyze what makes them effective or not effective in communicating ideas; and reflect upon the effectiveness of their choices.
b. Students intentionally take advantage of the qualities and characteristics of art media, techniques, and processes to enhance communication of their experiences and ideas.

2. Content Standard: Using knowledge of structures and functions
Achievement Standard:
a. Students generalize about the effects of visual structures and functions.
b. Students employ organizational structures and analyze what makes them effective or not effective in the communication of ideas.
c. Students select and use the qualities of structures and function of art to improve communication of their ideas.

3. Content Standard: Choosing and evaluating a range of subject matter, symbols, and ideas
Achievement Standard:
a. Students integrate visual, spatial, and temporal concepts with content to communicate intended meaning in their artworks.
b. Students use subjects, themes, and symbols that demonstrate knowledge of contexts, values, and aesthetics that communicate intended meaning in artworks.

4. Content Standard: Understanding the visual arts in relation to history and cultures
Achievement Standard:
a. Students know and compare the characteristics of artworks in various eras and cultures.
b. Students describe and place a variety of art objects in historical and cultural contexts.
c. Students analyze, describe, and demonstrate how factors of time and place (such as climate, resources, ideas, and technology) influence visual characteristics that give meaning and value to a work of art.

5. Content Standard: Reflecting upon and assessing the characteristics and merits of their work and the work of others
Achievement Standard:
a. Students compare multiple purposes for creating works of art.
b. Students analyze contemporary and historic meanings in specific artworks through cultural and aesthetic inquiry.
c. Students describe and compare a variety of individual responses to their own artworks and to artworks from various eras and cultures.

6. Content Standard: Making connections between visual arts and other disciplines
Achievement Standard:
a. Students compare the characteristics of works in two or more art forms that share similar subject matter, historical periods, or cultural context.
b. Students describe ways in which the principles and subject matter of other disciplines taught in the school are interrelated with the visual arts.

Notes

Notes

Notes

Notes